Dan Graham

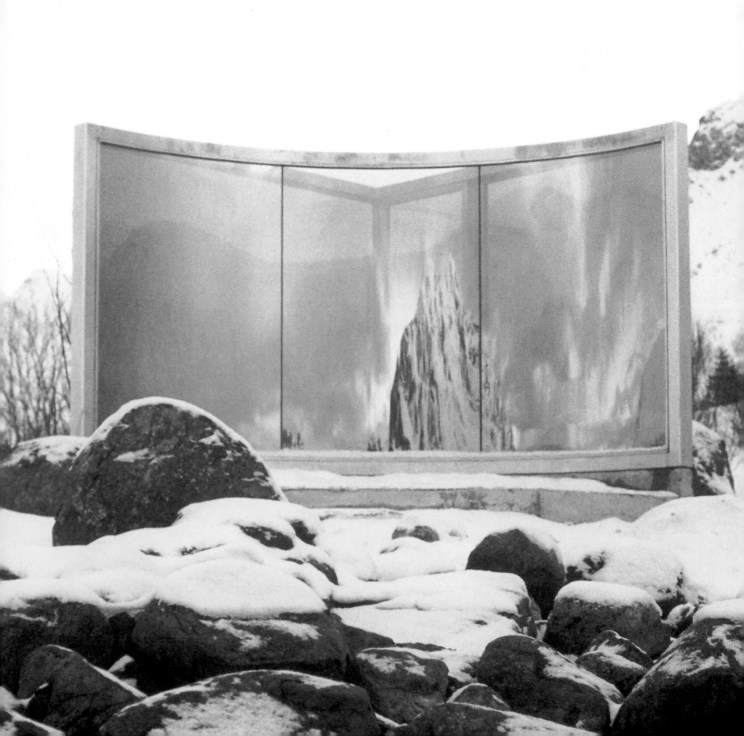

Works

1965

2000

Dan Graham

Richter

Verlag

Dan Graham
Works
1965-2000

This book is published on the occasion of
the exhibition *Dan Graham Works 1965–2000*
organized by the Museu de Arte Contemporânea
de Serralves, Porto and co-produced by
the following museums:

Museu de Arte Contemporânea de Serralves, Porto
January 13 through March 25, 2001

Musée d'Art Moderne de la Ville de Paris, Paris
June 21 through September 30, 2001

Kröller-Müller Museum, Otterlo
November 25, 2001 through February 10, 2002

Kiasma – Museum of Contemporary Art, Helsinki
May through August, 2002

Editor
Marianne Brouwer

Associate Editor
Rhea Anastas

Coordination
Maria Ramos, Cláudia Gonçalves

Foreword
Vicente Todolí, Suzanne Pagé,
Evert J. van Straaten, Maaretta Jaukkuri

Texts
Marianne Brouwer, Eric de Bruyn,
Thierry de Duve, Brian Hatton, John Miller

Interviews
Benjamin H. D. Buchloh, Markus Müller

Chronology and Bibliography
Rhea Anastas

Dan Graham's Cartoon-Biography
Fumihiro Nonomura (script)
Ken Tanimoto (drawings)

Translation
Brian Holmes
(from the French, text by Th. de Duve)
Peter Ingham (from the Portuguese, Foreword)
Victor Joseph
(from the Dutch, text by M. Brouwer)

Typography
Walter Nikkels, Dordrecht NL/Köln D

Production
Heinrich Winterscheidt GmbH, Düsseldorf

Copyright 2001
© Richter Verlag GmbH, Düsseldorf

ISBN 3-933807-31-x

Printed and bound in Germany

Exhibition

Curators
Marianne Brouwer, Corinne Diserens

General organization and coordination
Museu de Arte Contemporânea de Serralves,
Porto

Local organization and coordination
Vicente Todolí, Director and Marta
 Moreira de Almeida, Curator,
Museu de Arte Contemporânea de Serralves,
 Porto
Suzanne Pagé, Director and
 Béatrice Parent, Curator,
Musée d'Art Contemporain de la Ville de Paris,
 Paris
Kröller-Müller Museum, Otterlo
Maaretta Jaukkuri, Chief Curator,
Kiasma – Museum of Contemporary Art, Helsinki

Acknow-
ledgements

The Fundação de Serralves,
the Musée d'Art Moderne de la Ville de Paris,
the Kröller-Müller Museum, and
Kiasma – Museum of Contemporary Art
wish to acknowledge the Coutts Bank
for supporting the present catalogue.

We would also like to thank all the collectors
who have kindly loaned their works to the
exhibition:

Jo Baer, Amsterdam, Holland
Dieter Bogner, Vienna, Austria
Sabine and Martin Bown-Taevernier, Gent,
 Belgium
City of Antwerp, Openluchtmuseum voor Beeld-
 houwkunst Middelheim, Antwerp, Belgium
Herman Daled, Brussels, Belgium
Gerald Ferguson, Halifax, Nova Scotia, Canada
Flick Collection, St. Gallen, Switzerland
Fonds National d'Art Contemporain, Puteaux,
 France (long-term loan from the Château
 d'Oiron, Oiron, France)
FRAC Nord-Pas de Calais, Dunkerque, France
Fundação de Serralves, Museu de Arte Con-
 temporânea de Serralves, Porto, Portugal
Galerie Hauser & Wirth, Zurich, Switzerland
Galerie Marian Goodman, Paris, France
Galerie Meyer Kainer, Vienna, Austria
Galerie Micheline Szwajcer, Antwerp, Belgium
Galerie Roger Pailhas, Marseille, France
Galleria Massimo Minini, Brescia, Italy
Gallery Shimada Tokyo, Japan
Generali Foundation, Vienna, Austria
Marc and Josée Gensollen, Marseille, France
Dan Graham, New York, USA
Anton Herbert, Gent, Belgium
Kunsthaus Bregenz, Bregenz, Austria
Le Consortium, Dijon, France
Bruno van Lierde, Brussels, Belgium
Lisson Gallery, London, UK
Marie-Paule Macdonald, Halifax, Nova Scotia,
 Canada
Marian Goodman Gallery, New York, USA
Moderna Museet, Stockholm, Sweden
Musée d'Art Contemporain de Lyon, Lyon,
 France
Musée Nationale d'Art Moderne, Centre de
 Création Industrielle – Centre Georges
 Pompidou, Paris, France
Nalbach + Nalbach, Berlin, Germany
Reinhard Onnasch, Berlin, Germany
Sammlung Hauser & Wirth, St. Gallen,
 Switzerland
Städtische Galerie im Lenbachhaus, Munich,
 Germany
Stedelijk Van Abbemuseum Eindhoven, Holland
Nicole Verstraeten, Brussels, Belgium
*and all those who preferred to remain
anonymous.*

A further word of thanks is due to all those who, in many other ways, have helped us prepare the exhibition and/or the catalogue, namely:

Jon Abbott
Nathalie Abou-Isaac
Alexander Alberro
Monica Amor
Pablo Azul
Dara Birnbaum
Michel Blancsube
Glenn Branca
Sabine Breitwieser
Elsbeth Brouwer
Claire Daigle
Pascale Dauman
Barbara Ess
Thierry de Duve
Agnès Fierobe
Karin Frei
Kim Gordon
Carol Greene
Robin Hurst Hanway
Jon Hendricks
Julian Heynen
Chrissie Iles
Ruth Katz
Nicole Klagsbrun
Chien Ko
Laura Larson
Pedro del Llano

Frank Lutz
Marie-Paule
 Macdonald
Sherry and Joel Mallin
Christian Marclay
Mele Mauala
Jean-Noel Merlin
Thurston Moore
Tom Mulcaire
Robert Orton
Tony Oursler
António Cerveira Pinto
Julian Pozzi
Rebecca Quaytman
 and Jeff Preiss
Petra and Klaus-W.
 Richter
Eileen Rosenau
Karin Schneider and
 Nicolas Guagnini
Rüdiger Schöttle
Teresa Seeman
Bennett Simpson
Leni Sinclair
Susanna Singer
Jeff Wall

ARKEN Museum of Modern Art, Ishøj, Denmark
Bayrische Hypotheken- und Wechselbank AG, Munich, Germany
Benesse House/Naoshima Contemporary Art Museum, Naoshima Island, Japan
Berliner Kraft und Licht (Bewag) AG, Berlin, Germany
Castello di Rivoli, Museo d'Arte Contemporanea, Rivoli-Turin, Italy
Centre Georges Pompidou, Paris, France and their Documentation Générale
Centro Cultural de Belém, Lisboa, Portugal
Centro Galego de Arte Contemporánea, Santiago de Compostela, Spain
Claes Oldenburg Studio, New York, USA
Collection of the Chiba City Museum of Art – Hikari Areba, Japan
Collection Marzona, Udine, Italy
David Zwirner and the staff of the David Zwirner Gallery, New York, USA
Dia Center for the Arts, Dia Foundation, New York, USA
Electronic Arts Intermix, New York, USA

FRAC Bourgogne, Burgundy, France
FRAC Rhône-Alpes, Villeurbanne, France
Franklin Furnace, New York, USA
Fundació Antoni Tàpies, Barcelona, Spain
Galerie Marian Goodman, Paris, France
James Cohan Gallery, New York, USA
Jiri Svestka Gallery, Prague, Czechoslovakia
John Gibson Gallery, New York, USA
Kirishima Open Air Museum, Kagoshima, Japan
Kunsthalle Bern, Bern, Switzerland
Kunst-Werke, Berlin, Germany
Laumeier Sculpture Park, St. Louis, Missouri, USA
Lisson Gallery, London, UK
Marian Goodman and the staff of the Marian Goodman Gallery, New York, USA
Middlebury College Museum of Art, Middlebury, Vermont, Canada
Museo de Bellas Artes, Caracas, Venezuela
Museum Boijmans Van Beuningen, Rotterdam, Holland
Museum Haus Esters, Krefeld, Germany
Museum Moderner Kunst Stiftung Ludwig Wien, Vienna, Austria
Museum of Contemporary Art, Tokyo, Japan
Museum of Modern Art Oxford, Oxford, UK
Museum van Hedendagse Kunst, Gent, Belgium
National Gallery of Canada, Ottawa, Ontario, Canada
P.S. 1 Contemporary Art Center, Long Island City, New York, USA
PaceWildenstein, New York, USA
Patrick Painter Editions, Vancouver, Canada
Renaissance Society at the University of Chicago, Illinois, USA
San Francisco Museum of Art, San Francisco, California, USA
Santa Barbara Contemporary Arts Forum, Santa Barbara, California, USA
Städtische Galerie Nordhorn, Nordhorn, Germany and Martin Köttering
Tel Aviv Museum of Art, Tel Aviv, Israel
The Carnegie Museum of Art, Pittsburgh, USA
The Wanås Foundation, Laholm, Sweden
Walker Art Center, Minneapolis, Minnesota, USA
Westfälisches Landesmuseum für Kunst und Kulturgeschichte, Münster, Germany
Whitney Museum of American Art, New York, USA
Wiener Secession, Vienna, Austria

Contents

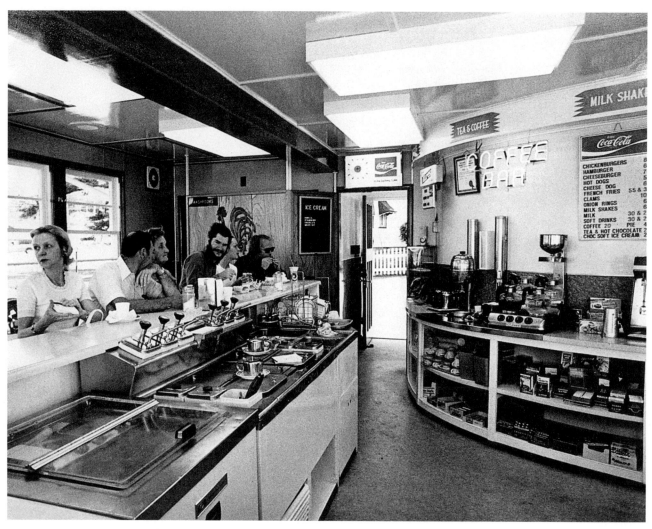

Dara Birnbaum,
Untitled
(Dan Graham in a Diner),
1975.

Foreword

Since the mid-sixties Dan Graham has been numbered among the artists who have changed the concepts that the art world has always endeavored to express and to apply. His work is inseparable from the critical lucidity with which he has taken part in some of the most important discussions of the history of contemporary art. From consideration of the media as a new support for creation to the appraisal of particular expressions of architecture and of the new popular urban cultures, Dan Graham's work constitutes an individual reflection on the place and experience of works of art within the political and cultural context at which they are directed. Graham never tries to avoid confrontation with the limits and stereotypes that characterize the codification of the dominant concepts surrounding the creation and reception of art in our days.

This exhibition is the most comprehensive retrospective of the work of Dan Graham ever assembled. The diversity of the themes represented in the exhibition is the result of the critical resistance that Dan Graham applies to reality at all times, regardless of the ideological or aesthetic classifications that might confine it. His performances, writing, films, videos or photographs, and his sculptural/architectural models always manage to escape categorizations based upon the nature of their support or dictated by the mainstream of current aesthetic discussion. Dan Graham's work systematically subvertes and destabilizes any theoretical classification that could summarize or condense it. With a tenacious ethical radicality, Graham always explores possibilities that go beyond the bounds that the history or sociology of art could impose on him. The spectator is called upon to take part in his work and to question codes or ideologies that could otherwise be understood as stereotypes. Thus the surprise and challenge that this exhibition constitutes for a new kind of public, providing a deeper vision of the work of the artist and of the political and social questions faced by Dan Graham, fully aware as he is of the models of information and power circulation in our days.

The present catalogue includes the first chronological survey of Graham's works by Rhea Anastas, assembling information that, till now, was available only through catalogues for the most part already out of print. We wish to thank all those who have contributed to such a comprehensive view of the artist's production and in particular the Coutts Bank for their financial support.

We would like to address a very special word of thanks to the exhibition curators – Marianne Brouwer and Corinne Diserens – for their determinant contribution to the concept of the catalogue and of the exhibition, as well as for their exceptional commitment. We also wish to thank Marian Goodman for her invaluable help in this project. And, last but not the least, we want to say how grateful we are to Dan Graham for having been so extensively involved in this show, which, we hope, will underscore his work as an essential reference for young artists of today.

Vicente Todolí
Director, Museu de Arte Contemporânea de Serralves, Porto

Suzanne Pagé
Director, Musée d'Art Moderne de la Ville de Paris, Paris

Evert J. van Straaten
Director, Kröller-Müller Museum, Otterlo

Maaretta Jaukkuri
Chief Curator, Kiasma – Museum of Contemporary Art, Helsinki

Note by
the Editor

No up-to-date survey exists of Dan Graham's works. His œuvre has become largely inaccessible, because it is scattered over many catalogues, most of which are out of print and in some cases have become collector's items. Moreover, his output since 1997 has not yet been published in its entirety. We felt that only a catalogue survey of works would do justice to a major Dan Graham exhibition survey.

Graham's œuvre is unique, not only for its place within contemporary art but for its scope and multiformity. It falls, broadly speaking, into two distinct periods. The first ten years from 1965 until the mid-seventies were characterized by his conceptual works (the works for magazine pages), his essays, his films, his performances, the video and time-delay installations, and the three-dimensional mirror spaces which culminated in *Public Space/Two Audiences* exhibited at the Venice Biennale of 1976. In the period since then, his work has concentrated on the architectural models and pavilions, although it has also included the monumental video *Rock My Religion* and the libretto for a mini rock opera *Wild in the Streets* with Marie-Paule Macdonald. Strikingly, it is his pavilions and architectural models that have been least fully documented and perhaps least well understood. This is partly because they have to be seen and experienced, and partly because art and architecture are still worlds apart both in theory and in practice.

The format of the conventional œuvre catalogue, with its emphasis strictly on the visual product, would clearly be inappropriate to an œuvre such as this. Not only would it do injustice to an essential element of Graham's art, namely his writings, but it would ignore the developments which have taken place in art since the sixties and in which Graham has played such a crucial part. To produce the ideal catalogue, with Graham's essays and articles published in full alongside his other work, was not feasible. So we must still await a book that will elucidate how intimately Graham's writings are related to the genesis and development of his other works. Writing is his main medium of theorization and has long been at least as important a part of his work as his more visual and architectural output. The two modes of work run parallel and have developed with reference to each other. In the present catalogue, we have made every effort to respect the conceptuality of Graham's œuvre. Rhea Anastas introduces her chronology of works with an account of the decisions that determined the contents. The accompanying articles examine, at Dan Graham's request, specific aspects of his work. Eric de Bruyn's article examines (among other things) certain phenomena from the history of optical instruments in relation to Graham's films, phenomena with which Graham himself is not unacquainted. Benjamin Buchloh's interview with Graham submits the status of the pavilions, in particular, to critical scrutiny. The broad-ranging article by Thierry de Duve, previously published in the 1983 Graham catalogue of the Kunsthalle Bern, appears here for the first time in an English translation. The interviews conducted by Markus Müller with artists, musicians and architects about their collaboration with Dan Graham include much previously unpublished material. Brian Hatton concentrates on the relationship of text and architecture in Graham's work, and John Miller explores the link between suburbia and rock music. Graham's biography appears in the form of a Japanese *manga* cartoon strip written by Yoshihiro Nonomura and drawn by Ken Tanimoto.

Dan Graham has always provided exhaustive explanations and interpretations of his own work, making his catalogues a historiography of his œuvre. In them, he continuously reformulates, redescribes and reconsiders his work in the light of the times and his own developing theories. The distinctions between essay, descriptions and definitions, and the work itself are very precise. At times the text is a work in its own right, at times it is

an essay possibly anticipating future work, and at times it is a definition of its meaning or an instruction for making and use of the work. This is why our aim has been to republish Dan Graham's works as they originally appeared in his own catalogues, except that we have not arranged them by subject but in chronological order. Considering the care with which Graham has treated his genealogy of works, it was unlikely that we would find many that were unknown or previously unpublished; nor did we, although there were a couple of significant exceptions. One of them was the drawing *I = Eye* (*Untitled,* 1966, cat. no. 13).

A further exception were the so-called 'scotch tape models.' However, Graham does not consider these to be 'works.' The models are small, informal *bricolages,* generally made of curved mylar glued on perspex which served Graham mainly as an aid to clarify his ideas about architecture and because they were useful to give a potential patron an idea of what the pavilion would look like. Their status and function were altogether different from those of the architectural models.

Graham's first architectural models date from a few years after the exhibition of *Public Space/Two Audiences* at the Venice Biennale of 1976. *Public Space/Two Audiences* is a rectangular room proportioned in the golden section and divided into two equal halves by a transparent sound proof partition of clear thermopane. The back wall (facing the partition) on one side is of mirror glass, and on the opposite side is painted white. Graham's point was that the Venice Biennale and similar large-scale art events are like World Fairs in which every country has its own pavilion and the art is the merchandise. At the Biennale, he was trying to undermine the system by transforming the viewing public into an exhibit in its own right, as in a show one word only case window. Afterwards, however, Graham felt that *Public Space/Two Audiences* was still too limited by the conventions of the gallery space – that it was still a 'white cube.' He started thinking about making free-standing pavilions, which would take his work away from these conventions. In 1978, when the Museum of Modern Art Oxford, invited him for a show, Graham started having architectural models made for him. He was influenced to do so on seeing an exhibition of models of conceptual architecture by the 'New York Five' (Peter Eisenman, Michael Graves et. al.) in the Castelli Gallery in New York around that time. Whereas architects showed models to possibly be sold as art objects, Graham as an artist wanted to propose work that would exist somewhere between art and architecture while being neither. The architectural models fell into two categories. The first kind were proposals for vernacular architecture in suburbia or modifications of suburban architecture. The other category were works that were sculpture/pavilions. In other words, the spectator could enter the pavilion and from within could be aware of his own perceptual processes in relationship to the perceptual processes of others inside and outside. The architectural models which Graham presented in Oxford included the famous group *Alterations to a Suburban House, Clinic for a Suburban Site* and *Video Projection Outside Home* as well as the model for *Two Adjacent Pavilions.*

Much original documentation of Graham's early work has been lost – photographs of performances and film productions, diagrams and some original texts. His archives yielded a number of early 'shaped' poems, most of them incomplete or rejected by the artist. They had been written after his period as the director of the John Daniels Gallery. The only one which he eventually published, *Foams* (1966), was a precedent for his articles about pop culture and rock music like 'Eisenhower and the Hippies.' After the gallery failed, Graham took a commuter train from New York back to his parents house in New

Jersey to avoid the creditors and started photographing suburbia with his Kodak Instamatic. The photographs later became part of his article 'Homes for America' (1966-67). 'Homes for America' is a parody of a sociological 'think piece,' the type of intellectualized article about the banality of the suburbs that appeared in magazines like *Esquire*. Graham started writing articles in art magazines for money but also because he wanted to write about pop culture in the way the American literary critic Leslie Fiedler wrote about American literature and culture. Graham has said repeatedly that Judd's art reviews and Smithson's essays were important examples to him of how one could pursue an art that also took the form of authorship. Because artists wanted to be writers and distrusted 'high art' art criticism, writing was as important to them as the art they were making. A lot of Graham's writing had to do with satire and humor. His magazine pages and other writings were not only made to achieve a 'zero degree of content' but also to be mass-disposable and have no monetary or historical value. Several of the early typescript pages that have been preserved are studies which show interesting transitions from language to number and from metaphor to schema. They have a direct bearing on the designs for magazine pages.

Graham's text accompanying the first publication of *Schema (March 1966)* still refers to a poetic relation between form and content: "Schema for a set of poems whose component pages are specifically published as individual poems in various magazines. Each poem is to be set in its final form by the editor of the publication where it is to appear [...]"[1] Graham probably rejected this as being too 'literary,' for he later changed the instructions to read: "Schema for a set of pages whose component variants are specifically published as individual pages in various magazines [...]"[2]

Graham's poetic output eventually "came down more and more to making lists and enumerations."[3] In the essay 'Homes for America,' he organized the house variants according to typical rhyme schemes (e.g. AABBCCDD). *Figurative* (1965), a supermarket sales slip, was published (against Graham's intentions) as 'Poetry' by the editor of *Harper's* in 1968. The optical data grids of scientific phenomena such as *Side Effects/Common Drugs* (1966) were made in parallel with the first shaped poems. The most important variants of all these more or less ideogrammatic works are *Scheme* (1965), an infinite series of numbers limited only by the practical possibilities of the page sheet, and *Schema (March 1966)*, a non-tautological list of adjectives, verbs, etc. which appears in the printed matter it enumerates. Graham's most important synoptic essay on the subject of information was 'Information' (1967). It presented a brilliant summary of the radical design for a performance/book by Mallarmé, a summary which could be read as a description of his own works for magazine pages: "All units are interchangeable in a serially ordered set of permutations by mixing and exchange so that words, lines, pages, page-groups, volumes and books are randomly (within a limited scheme) distributed in terms of ordinal placement with relation to each other."[4]

In 1969, the gallery owner John Gibson invited Graham to contribute to his 'Ecological Art' exhibition by writing the catalogue. The catalogue was never finished. The preserved manuscript pages of Graham's draft for this catalogue include texts on Dibbets, Oppenheim, Oldenburg, Andre, Insley, Smithson and others. They still present various instances of shaped writing although these are much more accomplished than the early poems. It wasn't until the essay 'Subject Matter' (1969), which he wrote soon afterwards, that he asserted his position as an artist-writer, as distinct from an art critic or poet. The essay includes texts on Andre, Serra, Nauman, Steve Reich, Lee Lozano et. al.[5] 'Subject Matter'

[1] *Aspen* no. 5/6 (Fall-Winter 1967): n.p.
[2] Dan Graham, *For Publication* (Los Angeles: Otis Art Institute of Los Angeles County, 1975): n.p.
[3] Dan Graham in conversation with the author.
[4] in *For Publication* 1975: n.p.

is comparable in its style and form to Graham's best essays of the same period such as 'Muybridge Moments' (1967), 'Eisenhower and the Hippies' (1969) and 'Dean Martin/Entertainment as Theater' (1969). From the outset, Graham's essays are replies to and analyses of cultural phenomena. They explore 'contemporary mythologies' and include everything that excites him and concerns him as an artist, both historically and in the present. Graham's poems are mentioned here chiefly because they reveal decisions and choices made by the artist at an early stage. Still, considering that all poetry is "the attempt to express your own position in relation to the universe, as you have first grasped it with your conscious mind – an attempt that springs from an immemorially ancient drive…"[6], Graham's poetics and authorship must have been critical to the development of his art. One of the most elegant instances of this is *March 31, 1966,* an enumeration of distances from the furthest reaches of the universe to the retinal wall, recorded on his birthday (March 31). Many people will recognize this kind of attempt to define one's own place in the cosmos as something they did as children, although such thrilling experiments in cosmic consciousness usually stop at the front door address rather than zooming right in to the eyeball. However, a preliminary study for *March 31, 1966* bears the inscription 'exclusion principle' – not, as you might expect, inclusion. In other words, the universe is a function of the eye.

At thirteen years of age, Graham built his own telescope. He invited children from the neighborhood to view the stars and he organized trips to the planetarium of the Smithsonian Institute. "In my early youth," Graham says, "I wanted to be a dictator, but I also wanted to be a teacher."[7] Information of this kind would be of purely anecdotal value if it were not that the combination of observation and gregariousness were to remain essential to Graham's work. His building of the telescope must moreover have laid the basis for the sound knowledge of the properties of mirrors and optical phenomena in general which was later to feature in his texts and in the construction of his visual/architectural works. The optical and the textual are interwoven from the outset in Graham's work. Subsequently Graham was to question the apparent synchronicity between the physical world and the viewing subject. He started using time-delay as a mechanism to invoke a 'shift' between the moment of perception and that which is perceived.

The drawing *I = Eye* is the first explicit reference to the human eye in Graham's work. *Project for Slide Projector* was the first time Graham actually used an assembly of mirrors to create a slide sequence that gradually brings about a 'zero degree of viewing.' Graham was well acquainted with the writings of Lacan, and *Project for Slide Projector* is the first of his works which attempts to eliminate any suggestion of focus or perspective. The classical, historical nature of the Cartesian subject (as the thinking center of existence), the same as that projected in Renaissance central perspective, is the subject of the chapter 'Of the Network of Signifiers' in Lacan's *Four Fundamental Concepts of Psycho-Analysis*.[8] The thesis that classical perspective no longer represents the status of the modern subject, is a topic to which Graham's essays often return.

Considering how early *Project for Slide Projector* was made (1966), it could well relate to the work of two artists with whom Graham had a special affinity, Dan Flavin and Robert Smithson. In a conversation with Benjamin Buchloh, Graham comments on this connection as follows: "I also liked the nasty criticality of what Flavin was doing. In other words, because he was using colored lights, they replaced the normal lights that illuminated the white cube and thereby destroyed all the other art on view in that space."[9] Flavin has made an almost identical statement about his own work, namely that it makes viewing

[5] Dan Graham, 'Subject Matter' in *Articles,* exh. cat. (Eindhoven: Stedelijk Van Abbemuseum, 1978): 63-71.
[6] Vladimir Nabokov, *Speak, Memory. Geheugen, Spreek,* translation M. and L. Coutinho (Amsterdam: De Bezige Bij, 1968): 195. This quotation retranslated from Dutch.
[7] Dan Graham in conversation with the author.
[8] Jacques Lacan, *The Four Fundamental Concepts of Psycho-Analysis,* trans. Alan Sheridan (London/New York: Norton, 1981): 42.
[9] Benjamin H. D. Buchloh, 'Dan Graham/Benjamin H. D. Buchloh, Four Conversations December 1999 – May 2000', in this catalogue: 69-84.

impossible, firstly because it dazzles the viewer and secondly because of the after-images it produces.[10] A similar nasty humor was also present in Smithson's work. In 1964 Smithson made a neon work tellingly titled *The Eliminator,* in which the after-image functions in a similar way to that produced by Flavin's work. Smithson followed this with a series of works using anamorphic mirrors which were contrived to eliminate, as though by magic, the viewer's own image from the reflection; this was tantamount to the destruction, not only of the viewer's own image from the reflection, but also of his expectations about 'art.' On the effect of his own mirror works, Graham was to write: "The observer becomes conscious of himself as a body, as a perceiving subject, and of himself in relation to his group. This is the reversal of the usual 'loss of self' when a spectator looks at a conventional art work."[11]

For Graham the mirror takes on a much wider meaning because he uses it as a device for creating awareness of identifications and identities that are essentially social; for "Das Selbstbewußtsein ist [...] nur ein Anerkanntes." (self-awareness is [...] mere acknowledgement).[12] All Graham's works are directly or indirectly concerned with bringing about such identifications. He refers to his performances and mirror spaces as being "a feed back device governing behaviors – a 'superego' or 'subconscious' to the consciousness and response of others."[13] But these identifications are in turn related to alienation, specifically to the longing for a sense of identity and home. The mirror as used by Graham therefore has a direct connection with architecture, and not only with architecture as such but also with power. It is in this sense that Thierry de Duve, in his essay 'Dan Graham et la critique de l'autonomie artistique,' categorizes Graham's work as "political allegories."[14] The consumerism of the 'hale world' propagated after the Second World War challenged art to invent new techniques, in order not to serve once again as an alibi for a spurious humanism. It was therefore crucially important to art from the early sixties onwards to explore the new media (TV, video) and their techniques of image-making and advertising. The necessity of de-constructing the image and the position of the subject has produced, in a true Kuhnian sense, a paradigm shift in the art.[15] The inappropriateness of previous forms of art is neither the cause of that paradigm shift nor a mere fad, but a necessary and logical consequence of the shift.

In his essay 'New Wave Rock and the Feminine,' Graham wrote: "An art that is plurivocal, heterogenous, and polymorphous can [...] create a place 'where the social code is destroyed.'"[16] What was true for his early work, namely that the text and visual work were more or less inseparable, applies in an entirely different sense to his pavilions. Here, the architectural vocabulary itself refers to an architecturally impossible and exploded language: Laugier's 'hut', the modernism of Mies and Kahn, the oculus of the Pantheon, Boullée's sphere, the mirror-glass corporate office block, fragments of the classical, baroque and romantic garden and the filmic landscape of the modern metropolis. In terms of real architecture it is a subversive and often hilarious mix. But it would be wrong to conclude that the pavilions are a form of minimalist sculpture which can be reproduced in countless transformations for placing to order within the urban grids of parks, squares and buildings. Such a critique not only ignores the conceptual character of these works but their architectural intentions. These intentions are moreover not to be confused with those of the folly, which Graham dismisses as an "aristocratic dalliance."[17] Graham's pavilions are developments on a time-honored tradition of pavilion-building which originated in classical antiquity, was revived in the Renaissance and survives to this day in many different guises, ranging from music kiosks in village squares to Mies

[10] *Dan Flavin, all the Monuments for Vladimir Tatlin,* exh. brochure, ed. Marianne Brouwer (Otterlo: Kröller-Müller Museum, 1985): n.p.
[11] Dan Graham, 'Intention – Intentionality Sequence,' in *Theatre* (Gent: Anton Herbert, 1981): n.p.
[12] G.W.F. Hegel, *Phaenomenologie des Geistes,* ed. Ph. Meiner, 1952: 141.
[13] Dan Graham, 'Public Space/Two Audiences,' in *Buildings and Signs*, exh. cat. ed. Anne Rorimer (Chicago: The Renaissance Society at the University of Chicago and the Museum of Modern Art Oxford, 1981): 24.
[14] Thierry de Duve, 'Dan Graham et la critique de l'autonomie artistique,' in *Dan Graham, Pavilions,* exh. cat. (Bern: Kunsthalle Bern, 1983): 45-73.
[15] Cf. T. S. Kuhn, *The Structure of Scientific Revolutions* (Chicago: 2nd ed, n.d.).
[16] Dan Graham, 'New Wave Rock en et Feminiene,' first published in Dutch in *Museumjournaal* no. 26/1 (1981): 16-32.
[17] Dan Graham in conversation with the author.

van der Rohe's glass pavilion for the World Fair in Barcelona or Rietveld's sculpture pavilion for Sonsbeek Park. The pavilion is both dependent on its context – a park, a city – and a concentration of that context; a moment between memory and utopia. It is neither inside nor outside but marks an imaginary intersection between the two. An empty pavilion is a shell, a mere object, but when in use it is transformed into a platform where image and language meet and fuse into a cultural allegory. Graham draws on the prototype of the romantic vista, the baroque hall of mirrors, the mirror funhouse, the Arcadian landscape, on high and low art, and combines these as quotations in his pavilions which may take the form of video lounges, revolving doors, a skateboard pavilion, pergolas, swimming pools or a children's CD-ROM library. The mirror architecture of the pavilions creates structures that situate people inside the picture with an image of themselves together with others and with the surroundings. People move through the pavilion like actors in a filmic space. Everything in this space – architecture, landscape, individual – is a term in a process of endless reflection that narrates culture, individuality and identity. Graham has described his pavilions as "psycho-philosophical models."[18] His texts accompanying the designs for pavilions repeat time and again the theoretical points of departure of his essays, starting with 'Homes for America.' It is as though he is forever driving home his main viewpoints.

Graham's architectural models for pavilions are more than preparatory mock-ups for buildings. They are prototypes of, or experiments in, the breathtaking wealth of possible variations on a theme – or rather, the instances of a schema. The most formidable example of this is the series of variants of *Pavilion Influenced by Moon Windows,* 1989. The triangular version (*Triangular Solid with Circular Inserts,* 1989) alone has 25 types (A to Y), each with three variants, giving a total of 75 variants – and there are other versions, such as the hexagonal and square ones. In relation to all the conceivable variants of all possible models, very few have indeed been executed as models and even fewer have made it to a definitive existence as an actual pavilion. In the end, however, I believe the executed examples of Graham's works stand in the same relationship to the dizzying number of possible variants as do the executed instances of *Schema (March 1966)* to its concept. The work would not exist without the concept, but neither would it exist if it were not executed; and each instance of these executed forms is unique and irreducible to a general abstraction, although it does resolve to a special principle which is "a veritable study in difference to its apparent referent."[19] In the case of *Schema,* this referent is the text as printed information; in that of the architectural models, it is the infinite series of possible variations on basic architectonic forms.

Graham makes repeated use of the device of video time-delay in his early video rooms. However, he considers it to be present in all his works, including the pavilions, although these do not need a camera and video recorder to generate the effect.[20] It is the effect of time-delay that makes Graham's works into political allegories. He uses it as a technique to create a dissonance between perception and belief that is analogous to the Brechtian dramatic tactic of estrangement. But whereas Brecht wanted to achieve a liberation of the subject, Graham maintains that there is no autonomous subject. He uses mirrors to create alluring spaces that at the same time impose subtle forms of authority and self-censorship. What Graham offers the spectator is the mitigating awareness of manipulation.

One of the most beautiful examples of such an inherent time-delay is the pavilion *Double Exposure* (its first model proposal dates from 1995). Dan Graham describes it as

[18] Dan Graham in conversation with the author.
[19] Anthony Vidler, *The Architectural Uncanny, Essays in the Modern Unhomely* (Cambridge, Mass.: MIT Press, 1992): 110.
[20] Dan Graham in conversation with the author.

follows: "This pavilion is sited in a landscape with trees. The triangular pavilion, which is enterable through a sliding door has two, two-way mirror sides, while the third is a huge cibachrome transparency. The transparency is of the landscape as viewed from within the structure, 50 meters in front of the transparency side. The transparency is taken on a spring day, nearly at sunset. Spectators inside the pavilion can see the present, slowly changing as to sunlight and time of day, landscape through the static image of the lightly exposed transparency of the past view."[21] The pavilion is to be sited in surroundings such that the photograph and the countryside of which it is a framed view have the characteristics of a traditional, romantic landscape, as in a nineteenth century romantic landscape painting. Image and representation, present and historicity, art and nature are thus superimposed to form an illusionistic vista, but they are never identical because the transparency can not be synchronous with the landscape (the transparency is retaken annually from the same camera standpoint). Visitors exist in an out-of-synch present, before a panorama of an eternal spring, observed by and observing one another as figures in a landscape.

In a rough draft of a letter to the American filmmaker Erika Beckman, Graham noted: "World is a Huge Amusement/Theme Park. In the Future it has categories like Disneyland – but not identified. It has Paradise. It has Purgatory. It has Hell. It has our Future's re-use of the past Arcadias. It has the primitive hut. Some of it based on Panoramas of the Past. It is a vast educational Theme Park in an Abandoned Space Capsule."[22]

[21] Dan Graham, text for *Double Exposure* in *Dan Graham,* exh. cat., ed. Gloria Moure (Santiago de Compostela, Centro Galego de Arte Contemporánea, 1997): 17.
[22] Dan Graham, personal archive.

Dan Graham: Collaborations, in Other Words, Not Alone

The Super Super Blues Band

Too many collaborations of musical giants turn out to be bummers where either the forces nullify each other, or only the mere fact of collaboration, and not the end product, is what matters. This collaboration is no bummer. It is, in fact, the paradigm meeting of titans on record. Description adds little to the event, but it is hard to resist throwing in your own critical gravy when men are throwing in so much of their own art. So here is perhaps the most awesome case of men getting their teeth into each other's viscera, each other's clichés. Muddy, Bo and Wolf stay out of each other's way, step all over each other, laugh at and with each other. They intimidate each other, shrug off and ignore each other, groove on and with each other. Equal moves from all directions come out of all this pressure, further insuring the same total nibbling at the entire cosmic scene – where everything is relevant because everything is visible and nothing is relevant because visibility is nothing and nothing is everything. Everything appears as hint because nothing is there, and there are no hints because everything is there. And the blues is all. And Muddy, Bo and Wolf are the blues. They are the Nietzschean multiple divinity at the very least.

Richard Meltzer,
A Whore Just Like the Rest: The Music Writings of Richard Meltzer (New York: Da Capo Press, 2000): 42.

Interview with Kim Gordon
February 6, 2000

KG: Dan is one of the first people I met when I moved to New York. Actually I met him before I moved here and ended up getting an apartment right below him. Eventually Thurston and I lived there together and Dan was always around the scene. He was still going to shows with probably the first stereo Sony tapeplayer which was THAT big at the time and he got really amazing recordings off it. Thurston and I were really into No Wave and although Dan's not the most adept person technically, it was amazing that he got that machine and got great recordings out of it. He was kind of like a neighbor and we had a running conversation on music and TV shows and architecture and art and stuff. He was the reason why I started doing music in New York, because he asked me if I wanted to be involved in a performance piece involving an all girl band and do a kind of interactive performance together with this girl Miranda Stanton and with Christine Hahn. I played guitar and Miranda played bass and Christine played drums. We did one performance in Boston (as part of 'Eventworks '80,' in April 1980, the performance actually took place on April 4, 1980, organized at the Massachussetts College of Art by Christian Marclay), which I think (laughs) we didn't do what he wanted us to do because by then we were our own rebellious girl band. I knew Dan, so I was protective of his idea but I was also part of this band so the allegiance was complicated. Basically we didn't know what to do as it was such a loose interpretation. One girl was supposed to go to the bathroom during the set and we were supposed to stop during songs and do things and we were so nervous, I mean, I for one was so nervous but it was really thrilling. I actually played in a band at art school, not an instrument, just singing. After that perfor-

Eventworks '80

EVENTWORKS 1980 is a festival focusing on New Wave Rock music and its relation to performance and the visual arts. During the last 3 weekends of April, artists from California, New York and Boston will appear.

Once again playing its rebellious role, rock music of the 70's has offered an energic alternative for many performers repressed by a highly established art world. For a new generation of artists utilizing multiple mediums and performance in a format which allows this intermedia relationship, rock music has become the common denominator.

EVENTWORKS is the fourth annual festival presented by the Studio for Interrelated Media of the Massachusetts College of Art. EVENTWORKS has earned a reputation for presenting new works by contemporary artists.

For further information : 731-2040

Series tickets are available at reduced cost : $20.00

Mass. College of Art is located at 364 Brookline Ave., Boston, Ma.
The Boston Film and Video Foundation is located at 39 Brighton Ave., Brighton, Ma.
The Bradford Hotel is located at 275 Tremont St., Boston, Ma.

each evening starts at 8:00

APRIL 10 thursday — $3 at Mass. College of Art.

ROSELEE GOLDBERG
former Curator at the Kitchen Center for Video and Music in NY, and a regular contributor to Artforum, Studio International and other art journals in the US and UK. She will give a lecture entitled : Performance: a hidden history from futurism to "almost" prime time.

KULTURE
a new band with Julia Heyward. "To say at this point that we are trying to make cinematic rock and roll is too simple but will suffice."

APRIL 11 friday — $3 at Mass. College of Art.

VIVIENNE DICK
"I want to make films that people will see and that won't get stuck in some independent film art house. I'm thinking of drive-ins, rock clubs, prisons and television."

KULTURE
with Julia Heyward. "We want to be a video disc band in the future and this body of work is representative of that intention."

APRIL 12 saturday PARTY — $4 at the Bradford Hotel.

THE AIDES
"Breaking out of suburban bondage, we disrupt the mirages of contemporary culture to resuscitate the undertow survivors."

THE BACHELORS, EVEN
are engaged in an affair with words, sounds, images, materials and action.

ERIC BOGOSIAN
from NY will appear as Rickey Paul in one of his night-club style "party" performance.

MISSION OF BURMA
stark trio assaulting and advancing with waves of harmonics and relentless fury.

APRIL 17 thursday — $3 at Mass. College of Art.

DAN GRAHAM
Video and performance artist from NY will give a lecture entitled: "Feminism" and the "New Wave".

JUDITH FEINGOLD
"The Oblong Rhondas Movie" is a documentary on a New Wave dance company from San Francisco.

APRIL 18 friday — $3 at Mass. College of Art.

ERIC MITCHELL
USA UNDERGROUND, a 16 mm movie by an important figure of NY underground scene.

DAN GRAHAM
with all girl band : INTROJECT
ALL GIRL BAND : IDENTIFICATION PROJECTION
"the basis of the performance is to invert and reverse the normal (unconscious) identification the spectator projects onto a film, theater or music performer."

NON
...genuine INDUSTRIAL music...noise manipulation units...repetitive structures... from San Diego California.

APRIL 19 & 20 saturday & sunday — $3 at the B.F.V.F.

JACK SMITH
"He is the hidden source of practically everything that's of any interest in the so-called experimental American theater today. Absolutely. And I mean everybody from Wilson to myself to Ludlam to Vaccaro, and many other people, owe a great deal to Jack Smith." Richard Forman

APRIL 24 thursday — $4 at Mass. College of Art.

DNA
the original No-Wave band from NYC.

ZEV
"Shake, Rattle and Roll", an extraordinary percussionist from LA, with his unusual homemade acoustic instruments, creating complex rhythms and varied timbres, building to exciting climaxes...

HYMIE and GLINDA
electric Stone Age music.

APRIL 25 friday — $3 at the B.F.V.F.

BETH B AND SCOTT B
From the New Wave scene in NY, they will show "Black Box" a Super 8 film featuring singer Lydia Lunch.

LARRY BANGOR
will show a series of Super 8 films. Larry Bangor is a member of Human Sexual Response.

APRIL 26 saturday — $4 at Mass. College of Art.

KAROLE ARMITAGE
who has been with the Merce Cunningham Dance Co. since 1976 is working with movement based in rhythm and energy rather than shape or line.

RHYS CHATHAM
will play electric guitar for Karole Armitage.

BOUND AND GAGGED a six women band.
"loves the starched collar cuff dress in silk brightened with polka dots."

JOHANNA WENT
from LA, a combination Dali-Artaud-Baglady whose whose belie description.

Program, 'Eventworks '80,' Massachusetts College of Art, Boston, MA, USA.

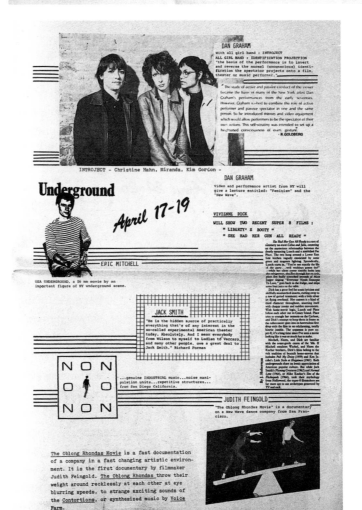

INTROJECT - Christine Hahn, Miranda, Kim Gordon -

DAN GRAHAM
With all girl band : INTROJECT
ALL GIRL BAND : IDENTIFICATION PROJECTION
"the basis of the performance is to invert and reverse the normal (unconscious) identification the spectator projects onto a film, theater or music performer."

The study of active and passive conduct of the viewer became the basis of many of the New York artist Dan Graham's performances from the early seventies. However, Graham wished to combine the role of active performer and passive spectator in one and the same person. So he introduced mirrors and video equipment which would allow performers to be the spectator of their own actions. This self-scrutiny was intended to set up a heightened consciousness of every gesture. - R. Goldberg

DAN GRAHAM
Video and performance artist from NY will give a lecture entitled: "Feminism" and the "New Wave".

Underground *April 17-19*

ERIC MITCHELL
USA UNDERGROUND, a 16 mm movie by an important figure of NY underground scene.

VIVIENNE DICK
WILL SHOW TWO RECENT SUPER 8 FILMS :
" LIBERTY'S BOOTY "
" SHE HAD HER GUN ALL READY "

JACK SMITH
"He is the hidden source of practically everything that's of any interest in the so-called experimental American theater today. Absolutely. And I mean everybody from Wilson to myself to Ludlam to Vaccaro, and many other people, owe a great deal to Jack Smith." Richard Forman

NON
...genuine INDUSTRIAL music...noise manipulation units...repetitive structures... from San Diego California.

JUDITH FEINGOLD
"The Oblong Rhondas Movie" is a documentary on a New Wave dance company from San Francisco.

The Oblong Rhondas Movie is a fast documentation of a company in a fast changing artistic environment. It is the first documentary by filmmaker Judith Feingold. The Oblong Rhondas throw their weight around recklessly at each other at eye blurring speeds, to strange exciting sounds of the Contortions, or synthesized music by Voice Farm.

Newsprint flyer, 'Eventworks '80,' Massachusetts College of Art, Boston, MA, USA. Collection Christian Marclay, New York, USA.

Collaborations

mance in Boston it was like, 'well, now that I played what do I do? Do I continue, or do I stop, or do I do art,' and at that time I was really more excited by the music that was going on.

MM: How did you work on that 'Eventworks' performance specifically, did Dan give you written instructions or did he just talk to you about what kind of ideas he had?

KG: Yeah, we were supposed to interact with the audience in some way and whatever we did (laughs) we did not follow through correctly. We were just more caught up in playing the music and the adrenaline of the moment. We thought we fulfilled it but (laughs) you know [...] Dan always had some inside scoop on the art world which was all very, very interesting for me. You know, gossip and the politics of things. He was definitely a very influential important figure, and that was before I met Thurston. Meeting an artist who was not satisfied with just doing art, with just making his art objects, that was Dan. He was writing and so on, he was doing other things and that always impressed me and so actually writing was one of the first things that I also did, because he would say: "You have to do something! Because otherwise you are just taking from the community. You have to have a position. It is the only honest thing to do." And I thought that was quite an interesting sort of motivation.

MM: You and Thurston are credited in *Rock My Religion* for "special ideas". Was that the result of an actual collaboration?

KG: He was talking about it then and whatever Dan was interested in, he would talk with you about it. It was always very interesting because I was kind of an outsider to music. I wasn't trained as a musician. I was always very interested in ideas about music, whether it was male bonding or that sort of musical hysteria group thing that Dan wrote about. I was very

interested in his ideas and he really turned me on to writers like Greil Marcus and Leslie Fiedler and that whole Shaker thing. You know, Dan is such a voyeur and he was always obsessed with Patti [Smith]. There were definitely subtle influences but it was more like a dialogue, there wasn't any real physical collaboration in those terms. We would go and see Hard Core, Thurston was into the whole Hard Core scene and that was very eye-opening for Dan.

MM: On the *Kill Yr Idols-EP* by Sonic Youth there is this one song called 'Shaking Hell' [...]

KG: Yeah, that was directly and definitely right out of the whole Shaker thing. Thank you (laughs), I knew I missed something concrete that was definitely based on the discussions with Dan.

MM: A year after *Rock My Religion* was finished the Sonic Youth did a performance in 1985 at the Brooklyn Anchorage with Mike Kelley called *Plato's Cave, Rothko's Chapel, Lincoln's Profile*. Is there any way to compare the dialogue with Dan Graham to the collaboration with Mike Kelley?

KG: Not really. Mike was a friend of mine and his interest in music comes out of his Detroit rock background. There wasn't so much of a crossing over of ideas and when we did the thing with Mike it really felt as if we were a live soundtrack. The attention wasn't on us, so it was much different whereas in Dan's thing we were instruments gone away (laughs). We were put in this specific situation but because we were rockers we also had license not to do what he wanted. The audience on the other hand was probably completely befuddled (laughs). Which I think is always interesting, because when I go to a concert and unless I really love the music, I get really bored halfway through and there is something about seeing something falling apart, which makes for (laughs) better

entertainment. Mike's thing was more like Vaudeville, a burlesque to me.

MM: Dan said in an earlier interview we did that *Rock My Religion* is an anthropological study on what the music scene was like at that moment in the 80s.

KG: It is about so many things. It has aspects of that and the whole Hard Core thing in it, but I always thought it was about architecture (laughs).

MM: How would you describe other sets and modes of collaboration like your painting project with Jutta Koether and Rita Ackermann or *Kim's Bedroom?*

KG: First of all it is about working with other people for a short period of time. You are dealing with different personalities. Because most of the music I do is improvisational, it does rely on other peoples' personalities. With that painting project involving Jutta and Rita we had to decide on a conceptual approach so no one's individual gesture would really be dominant due to career issues or whatever. I don't know how it occurred to me but I said, "Why don't we copy Coco's, my daughter's paintings, these great abstract expressionists things?" So we decided to use our hands to do these big paintings, but we didn't seem to be able to continue that project for certain (laughs) personality conflicts. I liked the idea of doing paintings by committee. It is like making music, in a certain way. I thought that it was an interesting way to paint. I like the idea of collaborating with people and I think it is a myth about the way artists work anyway, that you are alone and no one gives you any ideas. I think that may be true about a few people and it's probably not very interesting anyway, but that is certainly not the way it works for me, or for Dan for that matter.

MM: Could you describe that design project that you worked on?

KG: There is this art piece I did in Dan's apartment which came out of this thing

called Design Office I had at the beginning of the 80s. I used to have these conversations about art and design with Dan and the way that they both fed off each other. So I started the Design Office together with a Canadian artist called Vicky Alexander for a while. We did the logo for this together. I did things in people's apartments where I would go in and do something psychological that was about them and something that was physical. That is, I made a physical change and then I would write about it and reprint it in a magazine. I did one for Dan. He lived in this railroad apartment in this place on Eldridge Street with the bathtub in the kitchen. First I did a watercolor of Blondie on typewriter paper and then I got rid of his stove and I put in a vinyl flooring in the kitchen (the kind you see in bank areas). He was constantly talking about that stuff and then I wrote about it and published it in *Metropole,* a Canadian art magazine. I always did it with people I knew because I didn't feel confident enough to approach people that I didn't know with this concept. I did one in Glenn [Branca] and Barbara Ess's place. There is so much inter-connectedness with all these people. Thurston and I lived below Dan for such a long time.

I originally met Dan through John Knight in L.A. and the first time I ever met Mike Kelley was at a lecture of Dan's at CalArts and Mike was arguing with Dan about something like The Stooges versus The New York Dolls, that kind of classic thing.

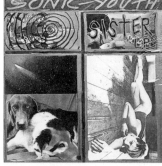

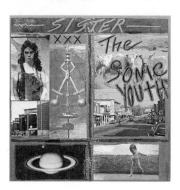

Sonic Youth, *Sister*, cover and backside with photo by Dan Graham, *Housing Development*, Bayonne, NJ, 1966.

Interview with Thurston Moore

February 6, 2000

MM: How do you remember the making of *Rock My Religion?*

TM: When I met Kim she was living in the same apartment building as Dan. We played music together and it was sort of very small-worldish. I went out with some people to do some work at Vito Acconci's place and I met Ann Meredith and we started playing music together. I remember Ann telling me about Dan Graham and the strange relationship he had with Vito. There was this kind of strange animosity at that point between the two of them and Dan was painted as this character that was kind of this dark force to Vito's life force (laughs). Then I met Kim through the same woman who introduced me to Ann and Kim told me that she was moving into this place in the apartment building below Dan Graham and I said (laughs) "Sure I heard about Dan Graham." Kim said that Dan was a really good friend of hers, so I became very confused (laughs) about this animosity. I met Dan and I found him interesting and I struck up more of a relationship with Dan than I ever had with Vito. They were both completely involved with underground music to such an extent that they bought all the records that were out there. They were buying records that were completely subterranean, like the first Fall singles. They were extremely hip that way and they were utilizing a lot of ideas out of that Punk Rock Underground thing, which I thought was pretty great. Dan went to all the No Wave gigs and he was taping everything too. Basically I would just go up to Dan's apartment and we would talk about music every day. Maybe that's why he put that credit in there, because of our discussions and a lot of his ideas derived from our discussions. He was really a great conversationalist. Dan was doing all that research on the Shaker religious stuff and putting it side by side with the emerging US Hard Core scene which at that time was really pretty small. We would go and see that kind of circle dancing and the way these teenagers were going for it seemed very authentic and not very premeditated. Dan was really interested in how something like that could actually happen and he was relating it to this very base ritualistic practice. I took him to a couple of Minor Threat gigs and he has really great shaky camera footage of that.

We have used a couple of Dan Graham images on our covers, for *Sister* we used a Dan Graham.

MM: That was a *Homes for America* image.

TM: Yes, Dan was really happy that we used it. To me, we have a certain kind of relationship with New York City and the community here and Dan is very much a part of it. I find to this day that a lot of ideas that really interest me are very related to a lot of his ideas, to ideas he would express. Maybe not so explicitly but for our next record (Sonic Youth, New York City: *Ghost and Flowers*), I really wanted to use an image created by a New York artist that was related to our world. I immediately thought of Dan and Dan's work and his visual ideas and then I saw this image in the *Rock My Religion* book and it is that same still that we are using now. It is a picture taken from a TV so it has that imperfect quality and what he is capturing there is the performer in the state of expressionistic ecstasy. It is also very black and white and has this certain kind of No Wave quality to it and I just thought that this is perfect. It is also a little romantic in a way, it is a little sad and it has a certain brittleness to it. It is a very serious looking kind of image.

MM: Who is in charge of the Sonic Youth covers, does the band discuss the options?

TM: Yeah, we do not necessarily have to use an artist's image but usually we do

Minor Threat, 1983, video still.

and it's an artist we have a relationship with and share a vision with. It is always a band decision.

But thinking back and putting it all in a historical perspective, you know, I was 18 when I met Dan and all these artists that I was involved with were older so I was always the kid and I was treated as such. Jenny Holzer used to have those weekly things with bands playing at her place like The Static and other No Wave bands. Now, being able to look at it, I have more of a sense where I am coming from being with Dan. Using one of Dan's images also has a lot to do with my own romantic notions. Dan has always been very supportive of us and he really was an inspiration. Dan and my collaboration was always kind of just between us. I remember Dan asked me to come up and paint his kitchen or something and I said, "Yes, I'll do that," but I was having a horrible migraine that day so I couldn't get up. He called again and I finally made it up there and Dan was feeling really good, actually he just wanted to play me all that stuff and all these records and talk about it and I felt so bad and I was totally unable to say a word […]

Lee Renaldo: Hey, we have to listen to this (recording) […]

Interview with Dara Birnbaum
February 8, 2000

MM: When did your collaboration on *Local Television News Program Analysis for Public Access Cable Television* begin?

DB: There was a project done by Michael Asher that was inspirational to Dan, which he referred me to. I believe that it was based upon a fixed camera, which showed the inner workings of a broadcast studio. I think it was actuated during one of the 'Superbowls,' through a studio in Portland, Oregon. Dan wanted to see if Michael Asher's project could reach another level, one which focused on the process of receivership, the social contact and engagement within a family-at-home receiving a specific program, in addition to the deconstructive aspect of the broadcast studio, the place of issuance of the program. I believe that in the original Michael Asher project everyone was watching the 'Superbowl,' but he managed to get hold of one channel in Portland, Oregon and to get the cameras to turn around and show the inside of the broadcast studio in the process of putting this type of programming out, of broadcasting that huge event.

I don't remember the year when Dan approached me about that project. We had originally met early on, perhaps in 1976. I was very interested in the language of television. My earliest works from that time were investigating those ideas, such as analyzing the structure of television. My original degree was in architecture and I practiced professionally for a few years, which of course further welded the friendship with Dan. I think that our friendship provided both of us with a companionship with regard to talking about these ideas. There was a strong dialogue between us. Dan had revised and enhanced the Asher project in a work entitled *Production/Reception,* which is documented in the Nova Scotia College of Art and

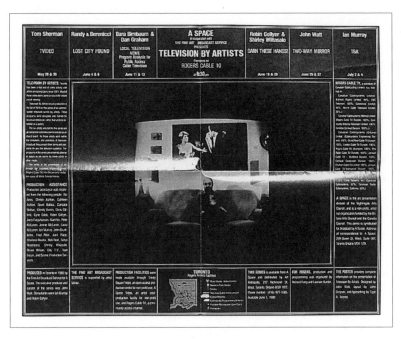

Poster, 'Television by Artists,' 1980, A Space and Rogers Cable TV, Tononto, Ontario, Canada.

Design Press book *Video-Architecture-Television,* edited by Benjamin Buchloh. He later told me that he was thinking of bringing that project to Nova Scotia, which was actually my first teaching job. Dan had recommended about five of us for teaching a full year. We all went up there and broke the year up amongst us.

Dan approached me about the *Local Television News* project because he knew that I was already interested in trying to analyze the structure of television and in finding out what was the operation, the hidden agendas within TV. Dan saw the Nova Scotia situation as a fertile ground to utilize our developed ideas and we did have the possibility of cable access up there. The project was then developed to involve the class in advanced media at the Nova Scotia College in the process of producing this work and we had the additional advantage of working inside the cable system.

MM: Did you actually write the initial concept together or how did that come about?

DB: Our project was an extension of Dan's original project *Production/Reception.* The revised project was called *Local Television*

News Program Analysis for Public Access Cable Television. Its original concept is documented in the Nova Scotia book. It was a very strong concept, it just never was brought to fruition. For whatever reasons, limitations developed so that we couldn't get the two simultaneous open-access cable channels that were needed.

Later, in 1980, we were able to take the project to A Space in Toronto. Dan asked me to collaborate by providing a new structure, based upon our having only one open-access channel. He felt that he could rely on the type of analysis which I could provide and structure. We were attempting to look at local television analytically, to provide a heuristic model. I was already developing these tools in my own work, as with *Technology/Transformation: Wonder Woman.* We both wanted to get video away from the type of art making practice that existed at that time. I wanted to recognize the double-root of video: that of art and that of television. Therefore, it made total sense to bring this work to local 'free' access cable TV, which was a common interest between us. Initially we wanted it to be a live event: the broadcast of the news simultaneously cablecast with the transmission of an image of the family-at-home and the image of the interior of the broadcast studio which was transmitting the news live. Early on we knew that these elements could not all exist simultaneously, as we did not have two channels, so the question was: Is this project still possible with only one channel of cable access and how does one do it? How is it structured? Basically I feel as though I am the person who structured that.

MM: And then you realized it in 1980.

DB: We realized it in 1980 with the one open-access cable channel. Also, the program could not – unfortunately – go out live. So our project's program occurred exactly twenty-four hours after the original broadcast of the news, at exactly the

same time that the next day's news was being broadcast. We structured it around that premise that you could have only one cable channel that is accessible and then what meaning could we still bring to the project that gives the cable television viewer a kind of window into the way this type of program was structured. All the components of the structure of the program had to be covered, which were: the broadcast itself; the family-at-home receiving the broadcast; and the studio delivering the broadcast. These were the three simultaneous realities and I wanted to know how we could portray them on a twenty-four hour delay and what meaning that would have.

Dan had seen the earliest piece I did about television, which was exhibited at Artists Space (Lesson Plans to Keep the Revolution Alive, 1977). That work incorporated television stills and the audio portion of the program, revealed as printed text. Everything was based upon reverse-angle shots used during prime-time TV programs. I tried to break apart prime-time TV. At that time, the news also occurred in a similar prime-time spot. So Dan's idea of a project about the delivery of local TV news of course interested me. My problem was to solve the representation of all three simultaneous realities, as limited by the one cable access channel that was allotted to us. I wanted to find a way to deconstruct the stereotypes which are typical of TV, as I previously had done with Laverne and Shirley and Wonder Woman. Dan showed me that many stereotypes were also existent in the news, including even the way that the nightly news is formatted. When we would get samples of previous newscasts, you could easily read these stereotypes throughout the transcripts. For example, there always is an area for 'chit-chat' and everybody on the newscast team seemed to play a specific role, as if they were members of

a 'TV-news family.' It was also easy to identify and feel the sense of the inflated programming of the news.

I really had a passion for television as the most common language in America at that time. However, no one was really analyzing it. So I was involved in the analysis and Dan was attempting to crack open this analysis via local cable TV.

MM: When the concept was published you posted two questions at its end. First: What is the meaning of 'local' news coverage (to the community), if the framework for 'local' news is a fictional, conventionalized national formula? And second: Can an analytical, didactic de-construction of media, such as we propose, be of cultural and political value to the community? Directly and indirectly you have pointed out that those questions are issues that you were and are very interested in.

DB: What I felt we were doing is that we set up a representational model. I think it had very positive attributes. It also had attributes which could be questioned after the fact. What we had to do is, we also had to make our own fiction in a way. That is my opinion. I was critical of that aspect of the project, especially in the way we probably had to fictionalize the family-at-home, almost the way television would. I was at the broadcast studio, so I did not take part in picking the home. The thing I now lecture on is: if you did an analysis of homes in the downtown area of Toronto at that time, which the cablecast would predominantly be reaching, it may come up that your average family would have been two gay guys living together. And meanwhile we used a nicely conventionalized husband, wife and child situation.

That seems to mean that if you have to choose one representational model, you end up stereotyping just like television. But what I felt was the best part of the project actually was the formula that

we developed – and that formula could act as a representational model, meaning that anyone could do this. Thirty years later you may have, for example, an exhibition curated by Hans-Ulrich Obrist, like 'Do It,' which seems based on Larry [Lawrence] Weiner's and on Dan's previous work. In 'Do It,' you are given a set of instructions by the artist and the viewer becomes a participator in the event by following these. Dan and I could sit down and make this project, as well, into an easy set of instructions on how to do-it-yourself. The point was simply to break open a spot of viewing that allowed an exposure to the simultaneity of these events. Even though we had to broadcast it twenty-four hours later, it was still incredibly interesting on a twenty-four hour delay. By cablecasting the next night, exactly at the same time of the next evening's news, you start to see the formulas all the more clearly. You see that the entire program is readily structured, as when they cover one kind of story, then a second type of story, then the weather. You can also observe how the anchorman covers a story, like the head of this 'news family,' as compared to how the weather guy covers his news – which is more like the young child of the family. And the next night the structure is the same. The news may be a little different, for example someone else might unfortunately get killed, but the structure is still basically the same.

The important question here is what is the meaning of 'local' news coverage to the community, if the framework is fictionalized conventional? There was a feeling at this time that through cable you have the ability to have 'free' public access and that the public could be more involved, treated in a different way than by large-scale broadcast TV. In cable, the community can become much more a participant than a passive viewer.

MM: How important was the more or less positivistic idea that public TV could help to democratize the information flow […]
DB: Very important, although it may have been a pretense. There was also the feeling that the given local cable networks were able to give more attention to and to reflect on what was supposed to be important within a smaller, localized, community. Even at the level of a giant in broadcast TV, like ABC today, they have learned that they also need to flavor the news differently for various regional areas, so that local interests – such as the weather – can be more meaningful to the attendant viewers. Cable was supposed to be one step closer to reflecting and representing local interests by having a more developed sense of community. That concept was strengthened by the mandate which had to be attended to by the cable stations – of providing a two-camera color studio that was to be accessible to the local community, so that they could produce their own programs of local interest. That was exactly how we did our project. The most important requirement to meet was that your project had to be in the community's interest. That was the bottom line.

Actually, within the cable industry itself, their main initiative was to sell cable as a way to bring their viewers better reception of broadcast signals. The selling item was the actual selling of the cable itself; it was not a real interest in local programming and a responsiveness to its community's more ideological interests. However, at that time, if you wanted to be a cable dealer you had to set up a cable TV Station by mandate, by law. And God knows what blessed period of America this was – you had to give to your community access to a certain number of hours per week. You had to be open to any project that was community-minded. Whereas, in Germany I believe cable TV was, from the

beginning, much more of a direct commercial enterprise. If we could say that there is a 'right' and a 'left' political position here, then in Germany cable was more to the 'right' and the cable here in the United States, at least for a short while, was much more to the 'left.' It was to be very much in the public's interest and our project was meant to show that if television was a window onto the world, we were trying to provide yet another window – and that window would open you up to the fact that there were these three simultaneous realities co-existent and co-dependent on each other.

MM: Did you actually discuss the "use value potential," in Buchloh's terms of that project?

DB: These were the years when Walter Benjamin was a heroic figure for me.

I was interested in his idea of the viewer becoming more of a direct user of media; a producer within its process. TV seemed to me to be the best and most powerful place to enact this. It certainly was the most current.

Television was the most common language within North America – and the idea was that the more people who became participators within that system, there would supposedly be a developed aspect of democratization, as well. Maybe that word is too predetermined but at least we hoped that the viewer would be less the consumer of these visuals and more the producer within its process. And I think that would come closest to Buchloh's analysis and idea of "use value potential". That was foremost in our mind and that's why I refer to this collaborative project as a representational model. It was my hope that anybody could do this and especially could do this again and again.

Interview with Glenn Branca
April 9, 2000
MM: When did you actually meet Dan Graham?

GB: The very first time […] Dan was a friend of Jeff Lohn, who I was doing a band with in 1977 [Theoretical Girls] and I remember that they were pretty close and Dan would call him and in those days when Dan would call you he wouldn't say, 'Hello,' he would just start talking and continue talking nonstop. So we were having a rehearsal with the band, we had never done any gigs, we had just started the band and after Jeff had sat on the phone listening to Dan talking for 5 minutes, he just handed the phone to me (laughs) and I listened to Dan talk for another 5 minutes. I think we actually did speak a little bit but that was the first time I think that I actually met Dan so to speak. Jeff had a very beautiful ground floor loft and Dan would use it to do some of his teaching. There were certain gigs he had where he would bring students to New York and so he used Jeff's very large loft to do it. My first introduction to Dan's work was because I got to see one of his classes which was about his own work, of course, and I was completely flipped! I mean I had only been in New York for about a year and to tell you the truth the conceptual art scene was something fairly new to me, this was in 1977. I knew a lot about performance art and that interested me. But I had come mainly to do theater.

MM: That was what you had done in Boston […]

GB: Yes, and the kind of very experimental theater I was doing was clearly more related to performance art, so I was sort of more Vito Acconci-connected and interested in the Viennese body artists, Schwarzkogler and those people. I used to hang out at René Block's that was my favorite gallery in New York. I didn't really know a lot about the conceptual art

scene, which wasn't exactly as highly publicized as these very sensationalistic performance art pieces, you know with masturbating under the stage and stuff like that. But with Dan's work I immediately felt a very strong connection because, see, to me Dan was doing theater, he just wasn't using actors, the audience became the actors. The very first thought that went through my mind was that this guy had already gone 20 years beyond everything I have even imagined. So we spoke and Dan was flattered that I was so excited about his work and as it happened Dan also loved rock music, which we all know, so when his good friend Jeff told him that he was starting a band Dan was excited about it. Dan said that he had a performance coming up at Franklin Furnace in three weeks, "Why don't you do your first performance after my show?" That was good for us because now we had a deadline. It was a good idea because we needed to write all the songs, we needed to find some musicians, we needed to get the instruments (laughs). I was using an acoustic guitar and Jeff was using an acoustic piano, so we had to get out and get an electric guitar and a drummer and write a bunch of songs and rehearse everything. We got seven songs together for the gig, it was incredible and that was the beginning of Theoretical Girls. The audience was maybe 40 or 50 people which is what was usually the case when these things happened but out of those 40 or 50 people at least 20 of them are names that most people would probably recognize today. I mean Dan was even then, in 1977, the guru of what I would call underground conceptualism. He wasn't Joseph Kosuth, he wasn't Vito Acconci, even though Dan claims – as I am sure is true and will be spoken about – that he had a very important influence on Vito's career. Dan had been there in the trenches and continued to be in the trenches even

when I met him in '77 and then he became our biggest fan and our biggest supporter. He recorded every damn show and I have already released on CD some of the recordings Dan made with his broken down piece of junk fucking cassette machine that he would hold above his head for the entire damned show. But the fact is that in some cases the only good recordings that I have of certain songs by Theoretical Girls and later on by my band The Static were recordings that were made by Dan. The only existent half-decent recordings were these recordings that he made. Actually he recently told me that he had handed over a pile of very early recordings of the No Wave bands to Thurston [Moore], who is a real historian and collector and seriously so. Dan is sort of a collector too but he likes to have things and that is different than being obsessed with cataloging every last little piece and having to have every last thing. Dan spotted Thurston from almost the beginning. He remembered when Thurston started living with Kim and Kim was a very good friend of Dan's. Very early on, Dan was telling me that Thurston is an historian. Thurston was just this kid but Dan spotted him right away and as we all know Dan was a very big, big patron of Sonic Youth. I don't see how the band would have survived without Dan.

MM: What happened after the Franklin Furnace event? Was the music you did in 1980 with the Glenn Branca Ensemble for a film by Dan Graham your first collaboration (as it reads in your bio) and was that film Dan's *Westkunst* project?

GB: That was exactly what it was. It's *Westkunst.* It was a commission. One of my first commissions. It wasn't a lot of money and I didn't go into a studio to do it. It was something I did on my four-track cassette machine. But I liked it and it worked very well in the film.

MM: How did that exactly come about?

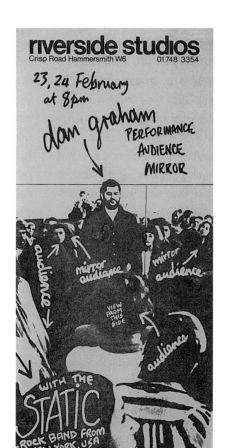

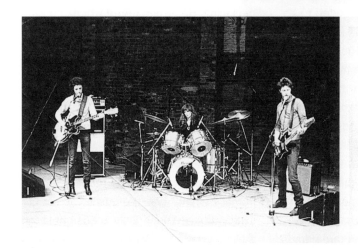

Flyer, *Performance/Audience/Mirror* with The Static, February 1979, Riverside Studios, London, UK (top). Record and record sleeve, The Static, *Theoretical Record*, 1979. The Static (Glenn Branca, Barbara Ess, Christine Hahn) and photograph of Glenn Branca (center).

GB: It was pretty straight forward, let's see […] 'Westkunst' was, what the hell was 'Westkunst' […]

MM: That was an exhibition in Cologne […]

GB: Right, so they commissioned a film on the work of Dan. Dan decided to basically film the kind of things that he had been photographing up to that point which was the housing and the fast food restaurants, we went to Wendy's and so on. I went on some of the shoots with him. But we actually worked together even before that. We did the thing with my band, The Static (with Barbara Ess and Christine Hahn) at Riverside Studios. Dan did the *Audience/Mirror* piece [*Performer/Audience/Mirror,* 1977] at the Riverside Studios in London in 1979 and it was similar to the situation with the Theoretical Girls. Dan had that gig in London and since the Theoretical Girls was broken up Dan said, "Why don't you have your band The Static come and play on the bill?" The first half of the program was Dan doing the *Audience/Mirror* piece, which was his early one which is a gorgeous incredible piece and which pretty much the only thing anybody wanted him to do in these days. He had become a kind of a star with that piece, and he was getting fed up with it, but still this was on a really major scale. They brought in a gigantic mirror on wheels for him and we had large audiences. We did two shows; he started and then my band came out and played after that. It was a very important concept, not just for my band but for me as well. The music was very […], well I thought of it as a performance art band. I don't think Dan knew that. He definitely saw the connection, there was a real connection between what he was doing and what we were doing, because by that time I had become extremely familiar with his work and I had become a tremendous fan of his work. I mean, if he was a fan of my music, belie-

ve me I was at least as much a fan of his work. People didn't know this, I was still a pretty boy rocker. They had no idea that in fact at heart I was a conceptual artist but at the same time I didn't have a particular desire to advertise that fact. I just did what I did.

Of course I also met Gerhard Richter round about that time, in 1979. Dan was very close with Gerhard back then and Gerhard was the king. Even back then, of the whole Cologne/Düsseldorf scene. He was teaching at the art school and he was with Isa [Genzken] and we got a chance to hang, actually the band stayed at Isa's bed, the whole band. We looked at the pretty minimal type stuff Gerhard was doing back then in his studio, the painted panels, and we hung out with Thomas Schütte and we became very close to Thomas and all of that was through Dan. Dan's connections made it possible to have a couple of gigs to go to Europe and do the SO36 in Berlin which was Kippenberger's gig which was all through Dan. We were on the same bill as the Einstürzende Neubauten and they played their first gig ever that night. The dominoes began to fall after that because through me then Sonic Youth was able to go through into that same territory. It was Dan who had opened up that door for that kind of art rock to be booked into museums the way performance art pieces would be or into the art world for that matter. When we played that club in Düsseldorf, I can't remember the name right now […]

MM: The Ratinger Hof […]

GB: […] the Ratinger Hof, how could I forget that, well, I mean the whole god damn Cologne art world was there. I don't think there were any rockers there, they had no idea who we were. Gerhard went crazy, he completely flipped over it but it all comes back again to Dan at the bottom. That's the pre-1980 stuff before the *Westkunst* film.

MM: Were you involved in *Rock My Religion,* you are credited […]

GB: Oh no, he used my music off of records that is as far as I was involved with that. I don't have that much to say about it beyond that, except that I got to see a couple of first, second or third drafts of the film, which in every single case I thought were brilliant. As much as Dan was complaining about editing and that stuff I thought the film was a masterpiece really and extremely important.

Our first true cooperation was the performance we did in Bern together *(Musical Performance and Stage-Set Utilizing Two-Way Mirror and Time Delay,* 1983).

MM: And you played with your trio with Axel Gross and Margaret De Wys.

GB: Yes. I mean Dan certainly didn't need my help on the piece but he wanted it somehow to be a real collaboration. We had a number of meetings discussing that piece and it really was something that we developed together. The basic idea was dealing with the kind of mirror reflection of the audience that he wanted to have but then we had to work out exactly how that was going to work in the context of a musical performance. I can remember any number of meeting over coffee or drinks with napkins and pens, you know, figuring out exactly what form that was going to take. Being a theater artist myself it was something that interested me tremendously to find how to make it work. It was in the context of a first major retrospective and they did a beautiful job installing some of the early installations and in fact it was also the first time that I was able to see how powerful those pieces were in the flesh. The piece of music I wrote, well the performance gave me an opportunity to work on a couple of things I had been thinking about and eventually the music that I wrote for Bern was called 'Acoustic Phenomena' which was only for three musicians and I rarely ever work with

small groups, even at that point. I just finished performing 'Symphony No. 3' at the Brooklyn Academy and I was working on 'Symphony No. 4.' 'Acoustic Phenomena' became like a first draft basis for 'Symphony No. 4,' which we would do then in Europe a couple of months later.

MM: That was after the time (1982) when John Cage said "If it was something political it would resemble fascism."

GB: Yeah, it was just a couple of months later and when we played in Munich they were chanting "Fascist, Fascist" between the movements of my Symphony. I was damned pissed off, yeah that Cage thing got way out of hand.

But we were using these harpsicord-like instruments, which bring up images of Mozart, right, but they were altered to the extreme. On one of the instruments I had as many as 32 intervals to the octave and we were playing massive clusters, sometimes with our fists, you know, American style.

MM: What was the instrumentation of the Bernpiece?

GB: We had two of the modified, not modified, they were built from scratch harpsicord-like things and what I call harmonic guitar. I was truly interested in acoustic phenomena at that time and this was like the most extreme version I had done. The recordings of the performance are pretty nice.

MM: How much of the music for that performance was improvised?

GB: It went back and forth between improvisation and composition and at some point structured improvisation. It was interwoven. I opened the piece with about ten minutes of improvisation on the harmonic guitar. I have never actually written a piece of music for this instrument, as far as I know it can only be improvised on, it is a very unusual instrument and in fact it was the instrument that was really most interesting for Dan. He wanted a

JUST ANOTHER ASSHOLE

$4.95

JUST ANOTHER ASSHOLE #6

ISBN 0-913803-93-6

Just Another Asshole #6
(with Dan Graham, 'Rock
Religion'), 1983, cover and
back.

piece that dealt with the acoustics in a physical way. In his mind it somehow created an aural space that was similar to the visual space that he was setting up.

Dan was a huge La Monte Young fan and at least in discussions I have had with him he considered La Monte Young a very major influence. There is a definite connection between what La Monte does and what I am doing. We both work with harmonic series or at least a kind of microtonal just intonation sort of approach.

All I can say is musically you are in philosophical space there. I am not gonna make a big discussion about it because there is not a literal direct connection between this sound and what Dan was doing. There is no way I would try to make some kind of a discussion about that but at the same time Dan understood a connection and basically we created, we gave him a piece that gave him acoustically the kind of reflective space he wanted becau-

se the harmonics series is nothing if it is not self-referential and reflective within itself. What the hell was the audience gonna know about all this? As far as they were concerned we were some kind of experimental noise group that was doing a gig in front of some mirrors. No, I am sure it was a very intelligent and (laughs) thoughtful audience but (laughs) we kikked their asses hard. I should tell you this: it was one of the loudest concerts that I have ever played. We blew everybody's ears out and Dan probably sat in the back giggling his ass off. He couldn't wait, that was exactly what he wanted, he wanted confrontation. In those days when his performances were nothing else, they were confrontational so we gave them pain and a little bit of heaven as well, believe me.

That reminds me of *Rock My Religion,* which reminds me of that *Minor Threat* video *[Minor Threat,* 1983] Dan made. That is a truly important historical docu-

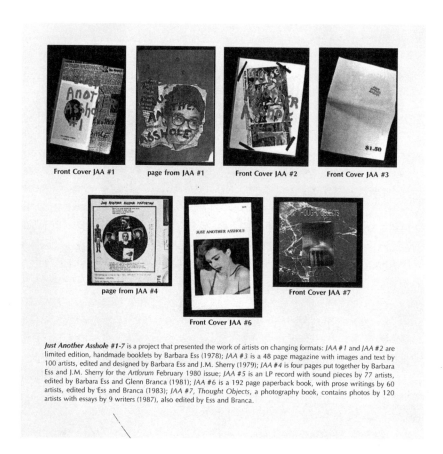

Front Cover JAA #1 page from JAA #1 Front Cover JAA #2 Front Cover JAA #3

page from JAA #4 Front Cover JAA #7

Front Cover JAA #6

Just Another Asshole #1-7 is a project that presented the work of artists on changing formats: *JAA #1* and *JAA #2* are limited edition, handmade booklets by Barbara Ess (1978); *JAA #3* is a 48 page magazine with images and text by 100 artists, edited and designed by Barbara Ess and J.M. Sherry (1979); *JAA #4* is four pages put together by Barbara Ess and J.M. Sherry for the *Artforum* February 1980 issue; *JAA #5* is an LP record with sound pieces by 77 artists, edited by Barbara Ess and Glenn Branca (1981); *JAA #6* is a 192 page paperback book, with prose writings by 60 artists, edited by Ess and Branca (1983); *JAA #7, Thought Objects,* a photography book, contains photos by 120 artists with essays by 9 writers (1987), also edited by Ess and Branca.

Just Another Asshole # 7,
1987, cover and back.

ment. This was about as far back as you are going to get with Hard Core. Hard Core had been around for maybe a year at that time. I mean Dan is not a filmmaker, ok, you will not necessarily find great videos in his personal collection (laughs) but in this particular case every thing was perfect. The audience was in fact pretty calm and pretty relaxed. They were relaxed in such a way that they were sitting all over the stage all on the ground in front of the stage and when they would get excited, as happens in Hard Core, they jumped up and went NUTS. Then they would sit down again when they weren't excited but the point is that this was the first manifestation of moshing-style, this was still when moshing was being invented because no one knew or understood what it was at that time. Dan gets this almost painterly kind of effect at least to my eyes. I haven't seen the thing for ten or twelve years so maybe it no longer has the

impact that it had but I am sure historically it's got to be very important, if anyone gives a shit about Hard Core anymore. Dan of course sensed immediately that Minor Threat was THE Hard Core band. He became an over the top Minor Threat fan, just like five or six years earlier when he was a fan of The Fall and Mark E. Smith. I had never heard of that band until I heard Dan raving about them and he ran all over the world screaming about Mark E. Smith and The Fall, The Fall, The Fall. I can't help but think that Dan might have been of some assistance to that extremely abrasive and difficult band. It is possible. No one wanted to know about The Fall, no one wanted to listen to The Fall, no one wanted to have anything to do with them, except for Dan, Dan, Dan (laughs).

In my case everything happened between 1979 and 1985, I mean as far as when it was MAGIC, because it was magic, and there is a point at which magic goes

away, just goes away and then it just became music again but there was a period when it wasn't music [...] and that's when Dan was there (laughs). Dan was there and he stayed with it. It is not that he ever went away, it is just that I moved into another direction, into the classical field.

You know, I never wanted to be a magician. I wanted to be a musician. I never said that before and I will never say that again. Jesus.

But as far as support goes, I think Dan was even more important when he supported Jenny Holzer and Barbara Kruger and Sherry Levine. You have to realize that back then Dan was the champion of all of those women and many others. He was a true feminist in the late 70s and early 80s. He knew that it was extremely important to allow women, Dan will probably take this out, into what was truly a man's world. And Dan knew, he knew. I mean it is not as if he went out and found these women. They were there but once he discovered them he made sure that they were going to be seen, that they were going to be known and he went to a tremendous amount of trouble to support their careers. He made that very serious effort to allow the door to be opened. None of this was ever discussed at the time and from 1985 on when neo-conceptualism was bubbling I told Dan that he was going to be the father of it. And I told him and believe me, he needed to hear something good. This was still during hard times, very long and bleak years, he lost everything and everybody in the mid-late-80s.

MM: When did you begin to work on *Wild in the Streets*?

GB: Oh, Dan and I worked on that for a long time, this goes back to the late 80s and actually the very last manifestation of it was extremely exciting to me, this is when he brought Tony Oursler into the project. We came up with something that was sort of in the groove of what Tony does but also is in the groove of what I am interested in, which is to do an opera without actors, which really interested me. The whole thing would be on tape but the actual performance would take place at an installation. I understood it as an extreme, meta-Brechtian performance. We thought about an installation that would be like some kind of 18th century mechanical permanent outdoor sculpture with computer-controlled projection that you could walk into. We had so many versions of this piece together with Marie-Paule Macdonald. It is just a pity that it can't be performed. The only documentation is this book he did in 1994, but I don't know if anybody has told you, but Dan is very difficult to work with. I m not afraid to say it. It must be known. I mean what we have actually DONE together and what we have DISCUSSED doing together and what we have PROPOSED doing together are two whole different things. It has only been the last seven years maybe that we stopped being in a continuous discussion, just because Dan's gotten so busy and things got so problematic for me that it was not really possible to hang out together in a casual way. He is my friend, my very, very good friend and he knows that I love him.

MM: Could you tell a little bit about *Just Another Asshole?*

GB: *Just Another Asshole* was a magazine that was Barbara Ess' project, her personal project. She did two issues that were really just her work. But then the two of us were together and we decided why don't we take this idea of that magazine that you have and invite people to do pieces, short pieces. That became the concept of the magazine; short pieces, easy pieces. The first was kind of an *Interview*-kind-of-size-and-style-magazine. We did a record and everybody had to do a 45 second

piece and Dan did one and that was the first issue Barbara and I did together. Then we did a book of short writings and Dan has a first draft of *Rock My Religion* in there, called 'Rock Religion.' There was a book of photography and Dan was in that too. This was all pre-neo-conceptualism and of course as Barbara and I were very good friends of Dan's so of course anyone Dan would recommend or suggest was immediately included. Dan was kind of the silent partner of the *Just Another Asshole*-stuff and I am not sure if he would entirely agree with that because he didn't have any kind of editing privileges but we didn't really edit. We asked people to submit and if they submitted, we would print it. There was no editing policy except for the fact that we would choose the order.

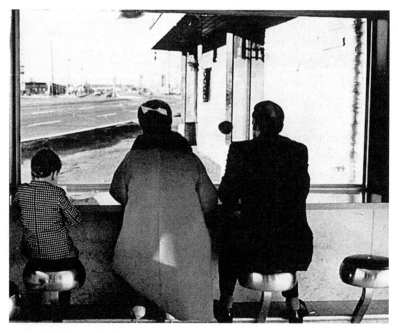

Photo by Dan Graham, *Untitled (Family in New Highway Restaurant), Jersey City, NJ,* 1967 published in *Just Another Asshole # 7,* 1987.

Interview with Tony Oursler
April 13, 2000
MM: You are collaborating with Dan on *Wild in the Streets,* the rock opera that Dan published with Marie-Paule Macdonald?
TO: I first, let me go back, met Dan in 1977. I was at CalArts and I saw Dan Graham lecture in the spring of 1977 at CalArts and it was one of the most intense things I had ever seen. I was right at the point at which I was giving up, not giving up but expanding my idea of how I could work. That is what the whole thing is about, redefinition of the world, exhilarated not annihilated. One main point was visiting artists so I went to see whoever I could see and at that point – and I remember it very clearly because I just started making my very first video tapes – and I was really completely amazed at the time element. The fact that video was an instant device and the fact that you could do these kind of real time mediated personal performances was what I was doing. I was watching the TV and shooting things in my studio as I was watching the TV, so the camera was looping over the TV and I was doing some pseudo animation or performance and I think that was the standard motive for video art production. Previous to that and after that for a while it was the artist alone in their studio with the rickety tripod and the old camera that would make everything seem like this amazing ghost and then kind of seeing themselves on the TV in real time and interacting with that. Having themselves inside a media space which had been reserved for television was important. For people of my generation being interested in pop culture was about being able to puncture that space and to get inside it. Psychologically it drove a wedge into this wall of media that we had grown up with, this kind of super, super capitalistic wave of overwhelming kind of dream space that

TV represented. For children of my gene-
ration it was important to actually get into
it with these Camcorders and as you can
see now, the seeds of it have been finally
sown in the art world. Our generation was
the one that really extended it permanent-
ly into the cultural field.

To go back to Dan, there he stood in his
socks on this carpeted stage and this
beard and he was from New York talking
about these installations that were the
most incredible thing I had ever seen.
They were just so far in advance of any-
thing that I could have imagined at the
time because they were taking the
mechanics of the television and the
question of the role of the artist and this
kind of loop system which had all these
psychological implications and extending
that in such a robust way into architecture
and social settings into an entirely diffe-
rent level of art production. There was this
kind of deconstruction in the political sen-
se as well as the social sense and then
reconfiguring that. The great thing about
Dan is that he never really is satisfied with
just deconstructing, what he is really try-
ing to do is set a new social context, a
further amplified social context and that's
what always comes out in his work. He
was not just trying to do this Brechtian
awareness-of-the-viewer thing. The pieces
I remember most were about that archi-
tectural shifting, where he had cameras in
other buildings *(Yesterday/Today,* 1975).
That's the thing I remember most, besides
the fact that he had spoken for 4 hours
straight (laughs) without stopping which
was really amazing.

I never really talked to him at that time,
at CalArts, so we have to fast-forward.
When I moved back to New York in about
'81, '82, I almost immediately started a
little video commune. It was a cooperative
situation between three or four artists. We
bought equipment and we were trying to
make some money and also trying to help

other artists to produce things. I ran into
Dan and at that time I just had to realize
that the public side of The Poetics (a
band with Mike Kelley and others) never
really worked out. We never had enough
equipment to play what we wanted to play
live or what I wanted to play live to get the
sounds that I was making on my sound-
tracks. I was making all these elaborate
sounds by layering and using all these
tape recorders but you couldn't do that
live back then. That was very frustrating
and I was really down on Rock 'n Roll as
something that I believed in as an art
form, which I kind of had believed in befo-
re. Rock 'n Roll has no criticism built into
it, it is about complete expression and the
natural tendency in that situation is not to
look at what is really happening. I like to
balance these two things out, the concep-
tual side of me and the intuitive side and
they never quite were able to meet with
the Rock 'n Roll and I actually really
thought that Rock was super-retrograde
at that time. I really thought that it was a
totally lost thing. With this background
I came back to New York and I ran into
Dan through Kim [Gordon] or maybe just
through my business. I was working on
a video-piece by Kim back then, it is the
LOST video that nobody knows where it
really is and that video was very along the
line of Dan's thoughts. What we were
doing with this tape was shooting all the
interiors of all the rock clubs in New York.
I was always interested to get out of that
ivory tower called art and rock clubs at
that time were filled with video and I
showed a lot of my work in rock clubs at
that time. I was interested in what this
context is about, the mechanics of the
rock context and so on. It was problema-
tic, because of sound issues and so on
but it was also very exciting too because
you really felt your art work could be con-
nected to real life somehow outside of the
white cube. The first thing I tried to produ-

UJ3RK5, 1980, cover and
backside, 'Eisenhower &
the Hippies' lyrics based on
Graham's 1969 article.

ce with our production company was Kim's thing. We went from the Danceteria to the Peppermint Lounge to all these different places and shot the interiors, the social areas, the bars, the off-rooms were people would get high or just talk or theoretically have sex. The thing Kim was working on was very much akin to what Dan was up to. It was very perfect for me at that time, because I was very much into analyzing these rock spaces too and that lost tape was as I recall the re-introduction to Dan Graham and some day we will find that tape. I was shooting in these clubs and he was always shooting in these clubs too and I have all these black tapes with (laughs) early Sonic Youth noise on it. There was really not enough light for the camera it was just disastrous. But I would always see Dan, this guy crouching around with this small camera and all these people jumping around him. I became one of the many editors of *Rock My Religion* and I don't know how many hundreds of hours we spent together in a dark room in front of two TV-sets trying to put that thing together. That was really how I got to know Dan in a much more intimate way and really bounded with him on certain issues, like The Fall. He was always giving me The Fall records and Glenn Branca and Sonic Youth. He was relentless in terms of his ability to re-contextualize these things into an overall global structure of the way art and music were being made at this time. One of the things that I really love about Dan is his structures. His art work for me is about building these conceptual structures that are constantly opening back up into social and personal spaces. To be able to work with him on *Rock My Religion* and to see how he associated these things that were more pop than his other work I thought was so daring and incredible for him. Even though his early pieces were very kind of hippie, these naked performance pieces *[Body Press* 1970–1972] and so forth and although the-

se pieces were super personal and super social, his works actually seemed to be much more about theorizing about those possibilities than actually being in a personal situation. To see him go back and just nail it with *Rock My Religion* was amazing. He really went outside of that ivory tower conceptual position and that really was very important for me because that is what my generation wanted to do. That was in a weird way what I wanted to do, to go back more into these pop cultural situations.

A lot of the conceptual artists touched on these things but it was in a very distant and clean way, whereas he just went in and *Rock My Religion* marks this point where he really went beyond the white page and the beautiful type-set design of conceptual art.

The intricacies of that work where he is able to take these historic figures and loop history into the present are just amazing.
MM: Did you ever work with Kim Gordon and Thurston Moore on *Rock My Religion?*
TO: No, but it is hard to tell because all these ideas were kind of overlapping. Kim and Thurston really play down their conceptual roots for some reason. I don't know why. It was an amazing time. One of the things I really bonded with Dan on at that time was that the art world was really fragmented. I really, really identified with conceptual art and I still really do. It is still my space. I remember walking around New York at that time and there was something called neo-expressionism which was being shown in galleries. It was very problematic because it was like conceptual art didn't happen. I came back to New York and the art world [...] there was just a skip in the record and conceptualism was gone. I would look at Dan and I would see this guy who had made these incredible pieces and I still think that that is some of the best work ever made and (laughs) also see these neo-expressionist paintings it made you wonder: "What happened?"

There was a cognitive dissonance happening for me. If you look at this social or political background of the time, you have this weird resurgence of paintings in the galleries and you still have a really vital alternative scene happening in New York in the early 80s with probably more video on public TV than MTV. This was basically pre-MTV, they might have started already but they were not visible yet. You had the notion that there could be some kind of new form actually existing with video that was a kind of fusion of rock and cinema or television into another form. Eventually it would be exploited by rock video and MTV, but it was one of the few optimisms that there was this kind of cross section of television and rock. I was right there in it for obvious reasons and that made the rock clubs a lot more interesting kind of cauldrons for the kind of experiments we talked about and for places to kind of study and try things out. It's gonna be hard for people to imagine but I will just keep on talking about it for a few minutes. Laurie Anderson just had had these first kind of crossover successes and there were all these other people around Laurie Anderson at that time doing other things. The Talking Heads and people like that were leaving art school so there was this kind of ten year loop from the early 70s in England, when similar things had happened there with all these bands leaving art school. At that time in New York in the early 80s, people really believed in video art being able to create a new visual language. Even in terms of the laser disc, people believed it to be replacing the record and seriously believed that and pursued it. Video art then languished for ten years afterwards and was completely marginalized but at that time there was the potential.

MM: How would you describe the potential of that puppetry rock opera *Wild in the Streets,* was that ever more than a mere idea?

TO: Well, I still would really like to do it.

First of all puppetry is a real pigeonhole, I had a few problems with that term, figurative automatons seem to be more interesting to me. We might at one point do it. Marian Goodman tried to help us find some funding for it and I know Glenn [Branca] wants to do it. *Wild in the Streets* is a four-way collaboration and I like Marie-Paule Macdonalds' sets very much. Dan loved to find that story, it exemplifies an important time for him. For me it has a creepy kind of feel to it. It reminds me of my adolescence and pre-adolescence which is when it took place so for me it really is a mental trip, going back to that other time, which I sort of lived through but not really as an adult. It is the perfect story as a metaphor for transition from one time to the other, especially the idea of the LSD drug camps because if you look at the Cold War it was kind of a Dickian, as in Phillip K. Dick, an inversion on itself. You have this kind of White House which is actually the capital of the Soviet Union, which is actually going to be a collaboration with the Americans, which in a weird way come to pass. *Wild in the Streets* looks at the duality of the Cold War and it's eventual decline and collapsing and inversion on itself.

As far as I am concerned I am still working on the question of how do we make a project which furthers the film *Wild in the Streets?* That has been my problem with it. Wilson is the best example of someone doing those kind of homages (laughs) although he strips the meaning out of everything and I would want to further the meaning, if possible. Just talking to you is about resolving some of these problems. The fantasy I had when Glenn and Dan and I met in some Chinese restaurant was this giant moving machine that would be almost like Disneyesque and light up in different ways and so on, but I guess we have to solve some of the other problems first.

Dan Graham and Marie-Paule Macdonald, *Wild in the Streets*, 1987, study photos 'country hippie' (right) and 'gogo cage' 'rustic hut' official residence President Sky (left). *Wild in the Streets*. Gent: Imschoot, 1994.

E-mail Interview with Marie-Paule Mcdonald
July 7, 2000

MM: When did you meet Dan?

MPM: Sometime in early March 1980 while finishing study at the School of Architecture in Halifax, Nova Scotia. Dan Graham was in the city and well known as visiting studio artist at the Nova Scotia College of Art and Design.

MM: Was the interview for the ICA Publication *[Nightclub for Rolling Stones,* interview with Dan Graham, ICA, London, 1983]* the first time you worked together?

MPM: Yes, the interview derived from the exchange of letters 1982-3.

MM: That is, did he 'find' you or did you 'find' him?

MPM: Larry Richards taught architecture design studio at the School of Architecture when I was a student. One day he invited Dan Graham to look at three student projects. That day I showed in-progress drawings for the Nightclub project. After graduating I moved to Vancouver, Baffin Island, and received a letter from Dan and we continued corresponding. By 1983 I was in Paris and as a result of the previous correspondence with Dan Graham, the Nightclub drawings were included in a group exhibition at the ICA which featured photographs by Dan Graham as well as work by Judith Barry, Kim Gordon and quite a few others. I was able to go to London for that opening in March 1983.

MM: And when exactly did the idea for the *Project for Matta-Clark Museum* for Paris, 1984 evolve?

MPM: By mail Dan Graham told me about and proposed a collaboration for the serial exhibition 'A Pierre et Marie,' which had many segments. I went there, to rue d'Ulm, nearby, and picked up a text on Gordon Matta-Clark that Dan had written. We agreed that my proposal would develop a response to the text. I made a proposal to

Michel Claura and wrote Dan with the particulars. I made the architectural model by visiting the Centre de Documentation at Centre Pompidou that had the *Splitting* catalogue, and used the scale of the photographs of *Splitting* as the model scale. Dan Graham responded in turn with an interpretation of the model as filled by the program of the *Museum for Matta-Clark.*

MM: How did you actually work on those projects?

MPM: For the time I was in Paris, we had opportunities for discussion when Dan Graham occasionally visited because he had work in shows in Paris. I studied urbanism at Université de Paris VIII. Dan Graham occasionally came through town for exhibitions; for example around the time of 'Les Immatériaux' – his Cinema was in that exhibition and he also did a performance in a Paris Biennale. Mostly it was in writing, by letter back and forth. Where I lived there were poor telephone connections.

MM: Did you participate in the various forms of publications/exhibitions of the *Project for Matta-Clark Museum* for Paris?

MPM: In 1983 I proposed the model, made it and in June brought it over to the 'A Pierre et Marie' shows by bus a day after one of the openings. Months later in October I picked up the model when that segment was over. It was a bit soiled by pigeon droppings. Because information about the 'A Pierre et Marie' shows was vague, Dan inserted a quite clear explanatory publication in a Moderna Museet catalogue, *Flyktpunkter,* in 1984, although that work did not appear in the Moderna Museet show.

While working in London I drew a diagrammatic drawing for that publication which appeared in *Flyktpunkter*. There were a number of other places where versions of the model were exhibited, but if I wasn't there I don't know too much about it.

In 1989 I was working in Montreal. To prepare for the gallery show there (Galerie Chantal Boulanger, Montreal) I asked Duncan Swain, with Eduardo Aquino, to build a larger scale version – double the scale of the first – which was made of fine-quality so-called Russian plywood. That is the wood version which I have now along with the original model.

MM: How would you qualify and describe this collaboration in relationship to architectural practice?

MPM: The work is like a prototype or maquette for a project, like a maquette for work in sculptural practice or a design development model for unbuilt architecture. In fact the proposal would be very easy and inexpensive to build. All that is needed is to acquire a site. It would be cheaper to make than a TV beer commercial.

MM: When did *Wild in the Streets* evolve and how did this collaboration develop over the years?

MPM: In 1987 I moved to Montreal, and around that time Dan Graham told me about a project commissioned by the Brussels Opera. He was invited and proposed a 15 minute mini-rock opera. He contacted me to work on the project, on a set design proposal. *Wild in the Streets* was part of an ambitious series of works questioning the concept of 'opera' that the Brussels Opera proposed (while under the direction of Gerard Mortier) with a live television tie-in. There was a meeting and tour of the opera house. Later the performance event was postponed, then cancelled. By this time the *Wild in the Streets* project was well formulated. We corresponded frequently, sending photographs, slides from travel, articles, etc. I sent versions of drawings. It was great that it went on for so long. Also again Dan Graham occasionally came through town while I was working in Montreal, once on his way to Banff, once he gave a talk at a Montre-

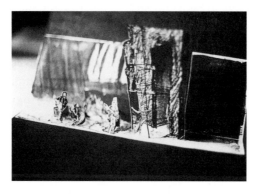 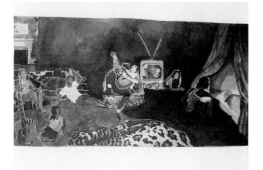

Marie-Paule Macdonald, scenography and pop-up designs, *Wild in the Streets*, 1987. Pop-up maquettes for scenes:

1. *Inauguration: State of the Union Address by the President.*
2. *In his crash pad, twenty-four-year-old Neil Sky puts his small adopted child to sleep.*
3. *President Sky's First Press Conference at the country White House.*
4. *Alternate version last scene Kid: – We are going to put everybody over ten out of business.*
Scenography for scenes.
5. *In his crash pad, twenty-four-year-old Neil Sky puts his small adopted child to sleep.*
6. *Political Rally for Congressman Fergus.*
7., 8. *Newscast: 'Teenagers have gathered on the Strip.'*

al Biennale. Eventually, in 1989 there was an exhibition at the gallery in Montreal. For that, in discussion with Dan Graham, I arranged for the large scale Russian plywood model of the Matta-Clark project, and a suite of drawings for *Wild in the Streets* were shown.

MM: Did you participate in the various forms of publication/exhibition of *Wild in the Streets: The Sixties?*

MPM: In the case of the show in Montreal in 1989, I was working in town and met with the gallery to show drawings and models. The show also included classic photos by Dan Graham, who was in town for the opening. When Dan Graham first proposed a pop-up book I made a version where each page was a pop-up. I have seen vintage Archigram pop-up books but making this turned out to be expensive, although the prototype was shown in Toronto.

Dan Graham and Kaatja Cusse kept me informed about the book from time to time, over a long process. Eventually problems were resolved in Belgium. I brought the drawings from Canada to an exhibition of the drawings in New York for the book launch in 1994, as an element of a larger show of work including video and pavilions by Dan Graham.

MM: How would you describe the different modes of collaboration, that is, doing an interview, being a co-author, writing on Dan, etc.?

MPM: The collaborations on projects came from subjects of mutual interest: the overlap of art and architecture, pop music and the relation of the aural and the visual in art, houses, popular or junk culture; building and social questions in mass culture. Working together and making something together is maybe the most fun and rewarding activity. Usually architectural design work involves some form of collaboration. Collaborative work with Dan Graham has been exciting to say the least. The writing was, in the case of the Dis Voir book, at the invitation of editor Jacinto Lagueira. After the initial research, writing is more solitary and so sometimes less appealing although the effort is ultimately beneficial – writing is slow but good for you.

E-mail Interview with

Robin Hurst Hanway

May 15, 2000

MM: How did you meet Dan?

RHH: My recollections of work with Dan are colloquial in nature – I met Dan in New York City the fall of 1995, at an AIA open house at the Society for Ethical Culture, to welcome incoming architecture students to the city. Dan was talking with Glen Weiss, whom I knew, who ran the Storefront for Art and Architecture. Anyway, Glen had introduced me to Dan's work and writing after seeing slides of my constructions so I sauntered right up when I saw them talking before we were to give our presentations and Dan gave me the complete cold shoulder. Literally wouldn't even look at me. So we each gave a [slide] presentation of our work and I knew right away I was in trouble. I was not only the youngest artist there, I was the worst! But I had a narrative and soldiered on through. I had prepared, as part of my talk, to speak about Dutch architect Rem Koolhaas and his wonderful book *Delirious New York,* and his writing on Coney Island. Well, when I got to that part of my talk, one person in the front row started clapping, and I peered out in the audience and saw that it was Dan. So we talked a little afterwards and he gave me his card. Of course I called him immediately to have coffee and naturally he was leaving for Europe so we didn't get together until a month later.

MM: And when exactly did the idea evolve/take shape to work on the *Private 'Public' Space: The Corporate Atrium Garden* together? Was it meant to be published in *Artforum* right away and who did actually edit the piece (as the *Artforum* version differs from the one, the *original* I have seen in Vienna)?

RHH: The idea to write an article on what became 'Corporate Arcadias' was mine. Both Dan and I liked to visit these urban spaces as a kind of mini-vacation and I suggested that we interview some of the architects and write an article, just as a thing to do as friends. We both saw these spaces as a kind of urban hybrid conservatory, although their purpose was not primarily the display of horticultural specimens. I am such a horrible procrastinator that Dan finally warned me that he was going to write the whole thing himself if I didn't hurry up and get down to it. We interviewed the architects together, and visited the spaces and shot photos together. But most of the writing and the historical scope are his work. He is a much more sophisticated writer. I knew perfectly well that *Artforum* would pick it up because they had already published many of his pieces. That article was edited by myself and David Frankel, the associate editor. (I have not seen the *original* one in Vienna that you refer to.) I did not work further on the article – in fact I was quite surprised and pleased to be paid for it. Dan is always very good and fair about money and credit.

MM: Did you also work on the 'transformation' of the text into the video that Dan made in 1992 in relationship to the Dia piece?

RHH: I keep Dan's pavilion/park at the Dia art foundation roof as my desktop wallpaper. I think how unusually philosophical he is as an artist, how rigorous, simple and profound his 'sculptures' are – these glass/mental constructions that gain in meaning by architectural context, but are not architecture. They dissolve and reflect the crystalline hard edges endlessly. [...]

Only Dan would make a rooftop park consisting of sky and glass and people.

I helped Dan with the *Pergola/Conservatory,* 1987, installation, and also with plans and sketches before the installation, which we presented as part of the Dan Graham team to Marian Goodman.

I completely objected to the 'shrubbing it up' portion of that installation – I wanted it very clean and geometric, with turf patterns and with shadows and light patterns (dappled shade) coming only from ceiling lights through a suspended linen ceiling above the glass structure – this was installed by the lighting designer in my office; I worked for a penthouse garden design firm at the time. Naturally the fire department inspected the building just before the show and made us take the fabric down as it covered the sprinkler system. So we provided shadow patterns with giant golden pothos (a common house plant that is tropical in origin) in a kind of fake simulation of exterior vines, which were unavailable in any case. One of the funniest things about that show was that when I unrolled the sod (with a guy from the Green Guerrillas), everything living in the sod and soil layer came with it – worms and crickets, etc. The gallery staff was convinced that the cricket sounds were provided by a natural recording when the truth was far simpler. […]

E-mail Interview with Jeff Wall
September 15, 2000
MM: When did you meet Dan Graham?
JW: In London in 1971, at the Lisson Gallery. I was introduced to him by Duane Lunden and Charlotte Townsend, who had met him at the Nova Scotia College of Art a year or so before. I think he was having his first exhibition in London at the time we met. My relationship to Dan began then and has mostly had to do with art and with our own personal concerns, which is not just about art or being artists. We have had hundreds of conversations over the decades, on all kinds of different subjects. Dan became a good friend and an enthusiastic supporter of my work from the early 70s on. So we've had a long relationship that has changed a bit over time, as we have changed. It's hard to describe because it has lasted so long and there have been so many occasions, meetings, phone calls, letters, postcards, visits, happy and sad times. It's an old friendship that is probably like other friendships, with the added element of a serious artistic discussion going on in one form or another.
MM: How was your relationship to Dan at Nova Scotia?
JW: I'm not sure what you mean. We may never have been in Nova Scotia at the same time. I was on the faculty there in 1974-75, and Dan might have come during that time as a visiting teacher, but I don't remember. He included me in a project he was doing there in 1979, I think. I went and taught there for two or three weeks, but he was not there at the time.
MM: Did you discuss the making of Dan's essay 'The Destroyed Room of Jeff Wall' (1980) with him?
JW: I think so, I'm quite sure I read it before it was published in *Real Life* magazine.
MM: Both of your *Kammerspiele* are considered to be two of the most influential

and most important critical contributions to the discussion on Dan's work. What motivated these essays and did you discuss them with Dan before and/or after publication?

JW: The immediate circumstance was a conversation with Tom Lawson, who was at that time running *Real Life* magazine in New York. He wanted artists to write about each other, and asked Dan and I to do that. Dan did the essay you mentioned above, on 'The Destroyed Room.' I set out to write something of about the same length, but some ideas that had been in the back of my mind took over, and the essay just kept evolving as I worked on it. I was putting quite a bit of energy into teaching and lecturing at that time, and so some of that went toward the essay. It took quite a while to finish it, probably almost a year. During that time, I sent parts to Dan to read, and I remember reading him the whole thing when it was more or less completed, at his place on Eldridge Street, one night, probably in 1981. So I discussed the ideas with him as I went along. But, at the same time, he didn't interfere with what I was doing or try to redirect the study in any way. He did argue with some of the things I developed, but I forget the content of those arguments now. The essay was just a formalization of the kind of things Dan and I talked about normally.

MM: When exactly did the idea for a collaboration come about?

JW: I think we were on a train somewhere in Europe talking, and we began to talk about circles, circular forms, I can't remember why. It must have been in 1987 or 88, but it could have been a year earlier. Both of us traveled a lot then, and we must have been going somewhere together. We might have been going to Münster for a meeting on another collaborative project, 'The Theatre-Garden Bestiarium' show, done by Rüdiger Schöttle

and Chris Dercon. I think Dan wanted to do some works with circles, or maybe the circular openings, the 'moongates' he later did in some pavilions.

We were probably also talking about urban projects like those at La Villette in Paris, because Dan was interested in pleasure parks, and things like that. Somehow those things led to the idea of making a pleasure pavilion with pictures, and that everything should be circular. It should be for children for some reason, and children like circles, balls, bubbles, things like that. It just came from another of many such conversations, just bubbled up sort of out of nowhere.

MM: When did the *Children's Pavilion* (1989) evolve/take shape? How did you specifically work on that project, how was the collaboration structured and when did you decide to publicize it the way it was publicized in the 1989 FRAC catalogue?

JW: We started working on it in 1987 or 88, and I agreed to make a first set of architectural drawings. Dan was very interested in the genre of the architectural drawing, but was too busy with his own things to take that on then. So I worked with some people here in Vancouver to do a first draft. Those drawings were the basis for the first model of the pavilion, made by Roger Pailhas in Marseille, in 1989. Pailhas made posters of those drawings and plans, and the exhibition traveled to Lyon and then to Santa Barbara, California, over the next year or two. Meanwhile, I did the photos in the fall of 1988. I had spent about a year previously making photographs of the sky at all different times of day, different seasons, etc., here and there, while I was traveling or at home. Then I selected nine of the few hundred I'd done, along with nine children I'd been able to audition at two or three elementary schools here in Vancouver. The photos were made as a full size edition, and were exhibited outside the half-

scale pavilion model, which contained another set of pictures, also at half-scale. We didn't do much further work on the pavilion design for a while.

There were attempts to realize it in Lyon, then in New York, then in Rotterdam, between about 1990 and 1995 or 96, but they all failed. Dan reworked aspects of the design during that time, but we did not make many major changes.

We made a model for the project for an exhibition in Montreal in 1995. The model did have some structural developments, but did not really take the first design anywhere new.

MM: Did you ever revise the first version for any of the reprints, e.g. Dan's Santiago de Compostela catalogue?

JW: By 1996 I felt I could do nothing more useful on the architectural aspects. In fact, I never really did anything useful on that aspect. Dan invented everything about the building and the landscape. I tried to interpret his ideas in the drawings I got done, but I don't think any of the presented versions really captured what we were looking for. I have zero aptitude for those sorts of things. So, after the Rotterdam proposal failed, I felt the project would likely never be realized, and decided not to work on it very actively anymore. Moreover, I knew that if there was to be a realized version, structural changes would have to be made, and that Dan would be the person to take care of all that.

By about 1998, there was the most recent attempt to realize the pavilion, for the Celebration of the Year 2000 in Blois, France. Dan took over the project, and worked with some French architects on it. Their revised version is far better than any previous one, and I was very excited when I saw the plans for it. I think Dan had developed the whole pavilion idea enormously and made it into something really viable as a space and as

a project that could actually be built successfully. So it was even more of a disappointment when that attempt collapsed this year.

MM: Is the *Children's Pavilion* the only work that you would consider a collaboration with Dan or is there anything that is lost/has been overlooked so far?

JW: There are no others, though we've talked about doing another pavilion, this one with video and pictures together, but we have not even started with that yet. Maybe when we are very old [...]

Interview with Dan Graham
April 27, 2000

MM: How did the collaboration with Glenn Branca evolve?

DG: I came up with the name for the Theoretical Girls together with Jeff Wall and I produced a record, in other words paid for a record, of The Static [*The Static/Theoretical Records,* 1979, produced by Dan Graham and Glenn Branca]. So as a producer I decided it would be a lot of fun to bring over The Static and have a situation like we had in the small clubs in New York because in England all the people who went to art schools and became musicians had no relationship with art, whereas in New York artists were doing music and it was a total relationship. So I thought to do a show in England and do a performance by an artist and then have the first performance by a new band with a record I produced, The Static. My hero John Peel (BBC) played The Static on his radio program and he said, "This is the new record by this great group The Static and if you want to see The Static, they are appearing with an *artiste*, Dan Graham, at Riverside Studios." That made my day.

The *Westkunst* music was done almost instantaneously by Glenn [Branca]. I asked Glenn for a soundtrack which would sound like a 'suburban' pastoral, but a little nauseous as well, like a pastoral nausea. The feeling of driving in a family car in the suburbs on the weekend. We were very close friends and we could read each other's minds but everything was unstable back then, he got out of Rock'n Roll and into classical music.

I met Glenn through Jeff Lohn. Jeff, who at one point showed up in Berlin in my apartment demanding that I get him a stipend at the DAAD. Then it turned out he spoke German, which I didn't and I was very lonely there and he became a roommate. When he came back to New York

this totally mad person discovered punk rock, he didn't know anything about rock music, or music. And then Glenn, who had just come in from Boston, and Jeff had that idea of starting a rock band, a punk rock band. Then Jeff Wall and I came up with the name, I told Jeff, "the name should be about women conceptual artists, theoretical women." And Jeff said, "What about Theoretical Girls for a name?"

MM: Did Kim Gordon already live in your house then?

DG: No. Kim came to New York later as a friend of John Knight, he referred her to me. When she came to New York, she was a bit depressed and we were reading astrology together and she would say, "I am a Taurus and can only be a helpmate or somebody interested in other peoples' psychology." And I said, "That was Freud, Freud was a Taurus." And I was thinking of the fact that although John Knight could talk brilliantly, he couldn't write. Tauruses have a great stream of consciousness, and I said, "Why don't you write?" I had written 'New Wave Rock and the Feminine' and Kim came up with this piece about male bonding and recreational drugs. It begins backstage where Rhys Chatham, Robert Longo and somebody else were sniffing some kind of antiseptic to get high. It was published in *Real Life.* Then she did a piece on Jeff Wall, the second piece on Jeff after my piece on 'The Destroyed Room of Jeff Wall' (1980) and another piece on Glenn Branca. She discovered [Raymond] Pettibon and two young artists at CalArts, Mike Kelley and Tony Oursler (laughs) and she did the first article on them in *Artforum*, edited by Ingrid Sichy, an incredibly brilliant writer she was. About a week after I got her the place on Eldridge Street below me she met Thurston and they moved in together. Thurston, whose father is a musicologist, had the best historical library on music

and I had a great record collection. He used to come upstairs to borrow my records and I would come downstairs to look at his files. He had files on Patti Smith and all these people, when I was doing the 'New Wave Feminism' article, he had these great files on Lydia Lunch. A lot of the idea for *Rock My Religion* came from his love of Patti Smith. He loves women Rock 'n Rollers and everything was in the files. I took everything from these files. It was not the only place where the ideas came from but I was not so big on Patti Smith. A great way of researching is to search through other people's collection when they are gone (laughs). Incredibly nice people. Nobody went to their gigs and when I was taping *Rock My Religion* there were about ten people there. I heard the sound and said, "This could be a great group like the Rolling Stones, they have the most unbelievable sound!" I asked Kim to do a song about the Shaker ecstatic circle dance. She and Thurston wrote 'Shaking Hell' and also 'Brother James,' both of which I used with Kim singing live in performance.

The main thing about collaboration I want to say is its about getting out of the business of art and having fun with your friends. Particularly in male bonding but also for male/female bonding. When artists become famous, they have things like *Parkett*, where they never meet somebody and they have to do a collaboration, it became such a terrible idea, this idea of 'collaborations' by star artists.

There is a big problem with giving Marie-Paule Macdonald equal credit. I met her in Nova Scotia where she was in the architecture school because even though she did more than 50 % of some of our projects, curators used to take her name off everything. It also happened with Jeff Wall and me and *The Children's Pavilion*. When it was shown in *Parkett* there was hardly any mention of me. This is not Jeff Wall's

fault, this is about the pressures that happen commercially and people do it even though you don't want it to happen.

Also nobody likes to be alone.

When Dara was teaching at Nova Scotia, I failed to realize my original idea *Production/Reception,* I suggested we do a didactic, a more practical version with a Toronto cable station and realized that in 1980.

MM: How did you meet Robin Hurst [Hanway]?

DG: We picked each other up. At Ethical Culture. Turned out she also had another boyfriend she was not telling me about. And then when she traveled with me to Europe, secretly she was going to see an old boyfriend, who she wanted to go back with, a designer. Robin is a Cancer and Cancer's being interested in gardens, I pushed her into becoming a landscape architect, just like I pushed Kim Gordon into writing.

MM: How did the collaboration with James Coleman come about?

DG: That was done in a half-hour conversation with James. He calls that period of his work 'juvenalia', It is about tourists who go to old castles. James' middle period work is incredibly funny. But I wasn't there for the realization.

MM: Would you consider the *Pergola/Conservatory* installation at Marian Goodman's in 1987 a collaboration with Robin Hurst Hanway?

DG: Whenever I had landscape gardening ideas and I had problems, I discussed it with her. The real collaboration is the 'Corporate Arcadias' article we did. I was pushing this idea of the new garden being inside of the corporate atrium because I also wanted to get rid of the *Homes for America* image. When we did the *Westkunst* video, it begins with a corporate atrium, Citicorp. I started researching it because I was interested in where landscape gardening was going. I had already

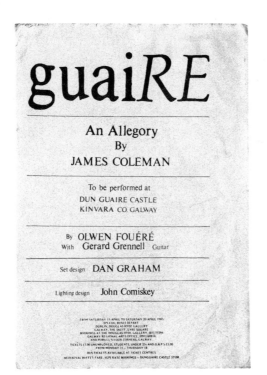

guai*RE*

An Allegory
By
JAMES COLEMAN

To be performed at
DUN GUAIRE CASTLE
KINVARA CO. GALWAY

By OLWEN FOUÉRÉ
With Gerard Grennell Guitar

Set design DAN GRAHAM

Lighting design John Comiskey

FROM SATURDAY 13 APRIL TO SATURDAY 20 APRIL 1985.
SPECIAL BUSES DEPART
DUBLIN, DOUGLAS HYDE GALLERY
GALWAY, THE SKEFF, EYRE SQUARE
BOOKINGS AT THE DOUGLAS HYDE GALLERY, (01) 772594
GALWAY REGIONAL ARTS OFFICE, (091) 68816
AND POWELL'S FOUR CORNERS, GALWAY.
TICKETS £3.00 UNEMPLOYED, STUDENTS, UNDER 25s AND O.A.P.'s £3.00
FROM MONDAY 15 – THURSDAY 18
BUS TICKETS AVAILABLE AT TICKET CENTRES
MEDIAEVAL BUFFET FARE, SEPERATE BOOKINGS – DUNGUAIRE CASTLE 37108

Program,
James Coleman,
Guaire, 1985,
cover.

concluded that the museum went back to the Renaissance and the Baroque garden and that it had nothing to do with the Enlightenment museum that Benjamin Buchloh and Daniel Buren keep saying is the enemy. The idea of the Enlightenment museum is a middle class Enlightenment idea about education for the middle class and actually museums were pushing into gardens and the cityscape and with shows like the Münster sculpture show. By that time I had found out that the corporate atrium garden, for example 'Chem Court' garden, had seasonal planting from suburbia instead of the traditional wintergarden. Every season changed, there would be a different seasonal suburban garden. The idea was to have suburbia inside the building. The pseudo-suburban idea was an idea to attract suburbanites back into the city, which by then was dangerous, the city had become like a medieval castle, they also used surveillance cameras.

Strange thing is that when Robin and I were working on that article I believed that the corporate atrium garden, that the corporate arcadia would be the future but now they are all finished. The office towers were overbuilt.

Robin Hurst [Hanway] did the model for the Bestiarium *Cinema-Theater* piece too. Robin was amazing. She had never done writing before I met her, but I wanted her to write about the landscape aspects of things because she was interested in landscape architecture and I am not that poetic in my writing but I was interested in the old late 19th century idea of the wintergarden and it seemed to be that that was her interest and she got right into that style. So I thought it was a pretty good stylistic match in writing.

Dan Graham and the Critique of Artistic Autonomy

Dan Graham, *Performer/ Audience Sequence*, San Francisco Art Institute, December 1975

[1] Dan Graham, *Theatre* (Gent: Anton Herbert, 1981): n.p. Initially entitled *Performer/Audience Projection,* this performance was carried out for the first time at the San Francisco Art Institute in December 1975.
[2] "Mirrors are metaphors for the Western concept of the 'self.' In his theory of the 'mirror phase,' Jacques Lacan has posited that a developing child first discovers his 'self' by a mirror-like identification with the image of an other. [...] The child identifies itself with an image of an other, or an image which is outside its body sensations, but, in terms of social reality, must be taken to be its identity." Dan Graham, *Video-Architecture-Television* (Halifax: Nova Scotia College of Art and Design, 1979): 67.
[3] *Theatre* 1981: n.p.
[4] *Theatre* 1981: n.p.

1. Performer/Audience Sequence 197[5]

"I face the audience. I begin continuously describing myself – my external features – although looking in the direction of the audience. I do this for about eight minutes. Now I observe and phenomenologically describe the audience's external appearance for eight minutes. I cease this and begin again to describe the audience's responses... The pattern of alternating self-description/description of the audience continues until I decide to end the piece."[1]

This program is a sequence of very simple instructions given to the artist-performer, to be transformed into behavior. Dan Graham's language in the instructions is deliberately behaviorist. He describes – and prescribes – a behavior in terms of outside appearances and tasks to be accomplished, in conformity with the first axiom of behaviorism, which says that introspection is impossible and makes subjectivity into a set of observable behaviors. The situation is similar to the ones commonly set up by the experimental psychologists: a subject is instructed to execute a task and his performance is evaluated as a function of the linkage between the stimuli and the responses. In this type of arrangement all the knowledge and power go to an outside observer, who is of course the psychologist; but in Graham's set-up there is no outside observer. The performer and the audience are coupled into a loop by the experimental apparatus [*dispositif*], such that each of them is both subject and observer, together or alternately, in an uncontrollable oscillation. The performer himself is the behavioral psychologist, and his speech presents the results of his observation. But he is nonetheless an observed observer, subject to the experimental conditions. He is the subject of a task to be accomplished according to the program's instructions, and when he describes himself, he is also the test case of the description.

In notes accompanying the statement of the program, Dan Graham exchanges this behaviorist language for that of a projective psychologist inspired by his reading of Lacan's *mirror phase*.[2]

"When I am looking at the audience and describing myself, I am looking at them to help me see myself as I might be reflected in their responses [...] by the second stage of my self-description I (my idea or projection of 'myself') am becoming more influenced or 'contaminated' by my impressions of the reactions of the audience."[3]

The behaviorist model undergoes a subtle parody. The performer's *self* is not discovered by introspection, nor is it reduced to the objective description of its performances. It is produced by the work as a projective imaginary whose 'location' is the public, which is taken overall as an uncertain surface of projection. Reciprocally, this overall projection surface is no less imaginary. It is the "public's self-awareness as a group," itself produced by the description given of it by the performer. Such that at the end of the performance, "the audience's projected definition of me helps to define themselves as a group and my projected definition of the audience tends to define my sense of myself."[4] Reading this comment, one might be surprised by a slightly utopian or idealistic connotation, as though the 'political' aim of the performance were to raise the audience's consciousness of its existence as a collective, and to engender in the performer an identity in synch with this raised consciousness. Perhaps there is an *orthopedic* use (as Lacan says with respect to the mirror) for this double and intersecting identification, whose motivation or justification would be the utopia of a disalienated society. But the actual unfolding of the performance disavows such an orthopedic use and parodies it in its turn. When the performer describes the audience, he constantly induces changes in its behav-

ior which he then attempts to account for – but always too late. And when he describes himself, he subjects himself to a procedure that overtly depends on the passage through the Other, a procedure whereby he shows himself to be flagrantly incoherent, psychologically blocked, perpetually making all kinds of slips. In both cases the feedback of the identifications struggles with the irreversibility of time and the uncertainty of space, parodically exposing the difficulties that the experimental set-up has in establishing its own space-time as a point of reference.

For this is the task of the *dispositif:* to produce its own space-time. The performance and the public, the before and the after, are not givens of the experience, they are neither natural nor even conventional. The experience – what is commonly meant by experience, i.e. lived time, cumulative memory, learning capacity, etc. – does not lodge itself in them as though in *a priori* forms. Modernity lost its confidence in transcendentals long ago, and performance, which is considered an art of the here and now, really is that because its performative task is to produce its here and now in the very time and place where it records them and offers them to lived experience. The here and now are produced by the experience whose precondition they are. This, to be all too brief, is what one might call the epistemological dimension of the performance-phenomenon.[5]

In *Performance/Audience Sequence,* Dan Graham goes one step further. What is experimental in the mechanism annihilates what could still be 'experiential' in the art of performance. In other words, Graham's *dispositif* produces its space-time but does not record it. Spatial indicators such as *here* and *there* are indissociable from the subject of their enunciation, and vice versa. Thus they are also indicators of identity, positioning the 'self' that pronounces them: *here* is by definition the place where *I am.* But precisely, in this performance as in a great deal of contemporary theater/performance generally, 'I' am *there.*[6] The identity of the performer is a projection whose 'place' is the audience, and vice-versa. Similarly, the temporal indicators *before, after,* are indissociable from the *now* of the subject of enunciation. But precisely, the *now* in which the performer describes the audience (or himself) cannot be the *now* in which the audience receives its description. The audience is always too early relative to the self-image that the performer reverberates back to it, and the performer is always too late relative to the image of the audience that he is about to describe. The enunciation is performative, it creates the event of which it seeks to give an account. But it does not give an account of the event it creates, or only belatedly, rushing after it in a circuit of retroaction that leaves no room for experience, for 'lived experience.' The only 'lived experience' that a member of the audience takes away from *Performer/Audience Sequence*[7] is the experience of taking nothing away, for lack of reference points or spatiotemporal invariants that could be shared by performer and audience. The performer is the cause of his *here.* He produces it by speaking, as he produces his 'self' by describing it. But he projects it *over there,* onto an evanescent surface of projection: the faces of the audience, where he seeks the signs of recognition. And this surface records nothing, it reverberates the effect while becoming a cause in return. The audience *does not have the time* to memorize, because its coupling to the performer makes it a producer and not a possessor of time. The feedback set-up keeps the effect from recording the cause.[8]

This peculiar 'phenomenology' – which is impossible to establish phenomenologically – makes *Performer/Audience Sequence* into an extraordinary allegory. There is nothing psychological about it, despite what is suggested by the theoretical models called upon to decode it (behaviorism, projective psychology, or the mirror phase). The allegory is

[5] For an analysis of performance which takes account of the collapse of the Kantian transcendentals, cf. Thierry de Duve, 'La performance hic et nunc,' in *Performance, Texte(s) & Documents,* ed. Chantal Pontbriand (Montréal: Editions Parachute, 1981): 18-27, and 'Performance ici et maintenant, l'art Minimal, un plaidoyer pour un nouveau théâtre,' *Alternatives théâtrales* 6-7 (January 1981): 40-63.

[6] "I am I and I am here and how do I know how wild the wild world is how wild the wild woods are […]. Once I am in I will never be through the woods are there and I am here or I am there oh where oh where is here oh where oh where is there and animals wild animals are everywhere." Gertrude Stein, *Doctor Faustus Lights the Lights.* A French translation of this text was published by Clair Pasquier in *Théâtre Public* 48 (Nov.-Dec. 1982): 35.

[7] This holds even more true for a performer. I had that luck in 1978 in Brussels, where Dan Graham needed a French-speaking performer (although in principle, the performer for this piece should be the artist himself).

[8] "The meaning of the word *recording* is given with that of *production,* because […] the operation of recording is the complement of the operation of production. The cause produces the effect, the effect records the cause." H. Reichenbach, *The Direction of Time* (The University of California Press, 1956): 156.

political. The performer makes an instrumental use of his subjection to the audience, who returns the favor in kind. The question of his identity is not posed in terms of autonomy: he describes himself in vain, for he is not able to define himself, much less govern himself. Instead he manages an imaginary – that of the Other – to which he deliberately subjects himself, to which he connects himself in a closed circuit, and which is the sole effective narrator of the performance. Through the failures of the circuit, the incoherencies of the self-description, and the slips of the subject of enunciation, a 'self' produces itself and immediately destroys itself to make room for another, closer to the momentary expectations that the performer thinks he glimpses in the reactions of the audience. It would seem that this 'self' has no other finality than to be regulated by this imaginary. Reciprocally, the identity of the audience depends on the passage through the 'self' of the performer. What Graham in his notes calls the "public's self-awareness as a group" is only the projected image of the performer whereby the audience feeds its desire for self-recognition. Then it is the turn of this individual image to be the homeostat of a collective imaginary, the parody of a 'self-consciousness' without any *raised* consciousness. If there were a raised consciousness, it would be that of the most radical heteronomy (which is why there cannot be any, 'consciousness-raising' being at the very heart of the problematic of autonomy).

Now, this double homeostasis is the exact allegory of the politician's relation to the mass media in the advanced industrial societies. A candidate in an election campaign does exactly what the performer does here. He describes himself and produces an image of himself 'in real time,' an image which cannot help but slip away from the reality of this time. The candidate will speak of his past successes and above all of his future promises. He cannot speak of the fact that he speaks, for he is possessed by the *here* of his discourse, rather than having it at his disposal. And the self-image that he projects by the intermediary of television, radio, and the press does not only feed on the expectations of the mass that he hopes to make into his electorate, but also comes back to him from these same media, as far as possible 'in real time.' Polls, press reviews, and instantaneous popularity ratings constitute the vast homeostatic machinery of a well-conducted electoral campaign. The politician also describes his audience. At one moment it will be the undifferentiated mass that he attempts to rally around an image, a sensibility, a program or a slogan in which it will recognize itself, at the next it will be its different components, social levels or age groups, interest groups or pressure groups, which he will address selectively, and which he will endow by this very selection with an imaginary of allegiance to a cause. Here again, the media are homeostatic: they couple into a loop two images which aim to be the reflection of each other.

People have often worried about this phenomenon, because it seems to leave no more room for any kind of social project of whatever sort. Is the political world, and with it perhaps even civil society, becoming a great self-regulated machine that knows no other finality than those its own retroactive circuits generate, reinforce, or moderate within it? A society without transcendence? That has often been said, and therefore must be true – the whole question being whether this is to be regretted or whether one should not instead look for the political where it actually is, where there is decisiveness without eschatology.

In any event, *Performer/Audience Sequence* is an allegory of this kind of society, with neither transcendence nor finality. It is a political work, whereby Dan Graham clearly aims to contribute to a political project whose aims run counter to that society. And it seems

to rest on a philosophy of autonomy and disalienation. The role of such a philosophy in Graham's work is difficult to establish. It is true that in the explanations he gives of his work, words like alienation, reification, etc., return periodically, suggesting references to the Frankfurt School and more broadly to a 'negative' Hegelianism (indeed, the mention of Lacan intersects with these references). It is also true that Graham's work often consists in exposing the mechanisms of alienation and reification, and not at all in proposing an emancipatory alternative.[9] But in his art there are the traces of a utopia which does not fit these references and which a criticism based strictly on the negative dialectic (which also has its utopia, but a different one) would no doubt find too idealistic or 'affirmative.'

This is because Dan Graham approached the work of the Frankfurt School not through Adorno and Horkheimer, but through Marcuse, and through a Marcuse strongly tinged by his American reception in the culture of the hippies and Woodstock. Thus his insistence on 'self-awareness as a group' has much less to do with the Marxist horizon of 'class consciousness' than with the American dream: the commune as the incarnation of Walt Whitman's 'transcendental I,' pop music as the basis of great ritual gatherings, the 'tribalism' of the media as an answer to the crisis of familialism. Like Vito Acconci or Bruce Nauman, Graham belongs to a generation of American artists who have one foot in this culture and another outside it, for whom conceptual art was the terrain of a critical analysis of their own utopia. The resonances of his work – theoretical and artistic – are therefore mixed and doubly dated: first by their origin in the sixties, and second by the present moment and the reinterpretations that it imposes. Today the economic recession, the accelerated commodification of the service industry, the punk ambiance of 'no future,' and other characteristic features of the eighties sensibility exert pressure in favor of a clearly anti-utopian reading or rereading of the Frankfurt School, as far from the hippie side of Marcuse as the Sex Pistols are from Bob Dylan. In the art world, this rereading is sometimes translated by strategies of appropriation, quotation, or duplication, which play on the fetishization of the art object and accompany it in its negativity, as though a truth could emerge from the most extreme powerlessness, a truth that would at the same time be the redemption of the object and the disalienation of the subject.

Dan Graham's work does not partake of these strategies. At a time when the philosophy of autonomy and of disalienation is no more than a desperate clutching at straws, Graham's work refuses it, even when seeming to draw from it, if not explicit references, at least a vocabulary and a manner of speaking. The theoretical interest of a piece like *Performer/Audience Sequence* is not so much the philosophy on which it apparently rests as the philosophy which it implies. And it ought to be possible to uncover this philosophy, or at least its rudiments, in the work itself. If it is in fact a political allegory, and if the above analysis has any pertinence at all, then there is already enough here to strongly compromise such concepts as autonomy and alienation, in so far as they appeal to what we may call, too rapidly and naively, a philosophy of the subject (of the 'self' or 'ourselves,' the 'I' or the 'we') and of the spatiotemporal invariants that position this subject *a priori*. Such a philosophy is inoperative in *Performer/Audience Sequence,* as it is throughout Graham's work. Even if he refers to the Frankfurt School (politically) or to Lacan (psychologically), his work goes beyond the deconstructive horizon of these authors in their relation to the philosophy of the subject. In the most provocative way, it reconstructs the subject where one least expected it, in the media. The *tour de force* of this performance and of its experimental set-up, despite all its simplicity, is to allegorize

[9] This is notably the case of the video works placed in display windows and malls. Their explicit theme is the fetishization of the commodity, which Dan Graham treats with an ambivalence close to that of Walter Benjamin in his *Passagen-Werke* or in 'On Some Motifs in Baudelaire.'

the 'mediatization' of political life without the media being at all present in the perform-ance. And it is their very absence that confers upon them, *a contrario,* such a powerful theoretical presence.

The performance produces an 'I' and a 'we,' the projected identity of the performer and the public's self-awareness as a group. But nowhere are the 'I' and the 'we' recorded. Their *here* and *now* fail to be mediatized, spoken in a mediating or second discourse that can memorize them, transmit them, reproduce them. Which suggests, by this absence, that only the reproductive machines, the artificial intelligence, the recording technology, are repositories of memory and speakers of history, that only the media can make a 'sub-ject.'

2. Present Continuous Past(s) 1974

"The mirrors reflect present time. The video camera tapes what is immediately in front of it and the entire reflection on the opposite mirrored wall. The image seen by the camera (reflecting everything in the room) appears eight seconds later on the video monitor (via a tape delay placed between the video recorder which is recording and a second video recorder which is playing the recording back). If a viewer's body does not directly obscure the lens's view of the facing mirror, the camera tapes the reflection of the room and the reflected image of the monitor (which shows the time recorded eight seconds previous-ly). A person viewing the monitor sees both the image of himself eight seconds ago, and what was reflected on the mirror from the monitor eight seconds ago of himself, which is sixteen seconds in the past (because the camera view of eight seconds prior was playing back on the monitor eight seconds ago, and this was reflected on the mirror along with the then present reflection of the viewer). An infinite regress of time continuums within time continuums (always separated by eight second intervals) within time continuums is created."[10]

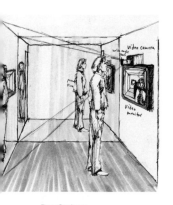

Dan Graham,
Present Continuous Past(s),
1974

With extremely simple technical means, Dan Graham has fabricated the perfect recorder and the absolute historical 'subject.' The screen in the screen in the screen real-izes not only the infinite regress or *mise en abyme* of space, but also of time. The infinite past is 'located' at the vanishing point. Like that of spatial perspective, this vanishing point is imaginary, for at least three reasons. First, it too is spatial, it is produced by the camera, i.e. by the same optical mechanism as Renaissance perspective. Second, because in order to reach it — to see the infinity of the past — one would have to sign away the infinity of the future. Because this machine for accumulating history has a beginning, the date of the work, but also the minute, the precise second when the video recorder was turned on. And the regression is not infinite from the very outset (as it is in the case of the two mirrors facing each other). The screen within a screen appears after eight seconds, two imbricated screens after sixteen seconds, three after twenty-four seconds, and so forth. To see the appearance of the minuscule screen that would take the place of the vanishing point and show a moment infinitely withdrawn in the past, you would literally need infinite patience. And finally, of course, the technology is limited, the definition of the video image is poor and at the third or fourth regression, the image of the screen in the screen is eaten up by the grain.

It should not be assumed that these last two limitations, our finite reserves of time and the entropy of the medium, are accessory, and that they can be neglected in favor of an idealized model. On the contrary, they have everything to do with what this mechanism models, which is the historical subject, the recording 'self' that was missing from *Per-*

10 Dan Graham, 'Present Continuous Past(s)', in *Video-Architecture-Television* 1979: 7; reprinted in Dan Graham, *Two-Way Mirror Power* (Cambridge, Mass.: MIT Press, 1999): 38.

former/Audience Sequence, the repository and restorer of memory. It would in effect be absolute – and therefore in a sense Hegelian, for Dan Graham's machine presents all the characteristics of a dialectical, speculative machine – if our time were not counted and if, another way of saying the same thing, information could be gained without paying its debt to entropy.[11] But the mechanism of *Present Continuous Past(s)* does not violate the Second Law. The narrator of the story is not outside the story, the viewpoint is carried along in the same temporal flux that erases the vanishing point, and Graham has not built a machine to travel backwards in time. What he has built is a new allegory, reciprocal and complementary to the first.

Apparently psychological, apparently concerned with intersubjective exchanges, the first allegory wiped out the possibility of any lived experience of the exchanges by the participants, and transferred it to the technology of exchange. Absent from the performance, the media became the true subjective instance where an 'I' and a 'we' could be recorded. The second allegory realizes this instance, and thereby reverses its significance. Apparently technological, apparently concerned with interspecular exchanges between two optical machines which practically exclude the spectator, in reality it is a model of the subject, or as Freud would have said, of the psychic apparatus – the *Wunderblock* of our time. A model which makes a violent appeal to the 'I' and the 'we' that it excludes.

For it begins by excluding them. The machine functions all the better (its subjectivity is all the more sovereign, its mastery of history all the more complete) when there is no one in the room. "If a viewer's body does not directly obscure the lens's view of the facing mirror, the camera tapes the reflection […]." Dan Graham takes care to specify the conditions of an ideal recording of history: let no one get the idea of actually *making history.* This is obviously the ideal of the 'society of the spectacle': that everything should be played out between a movie-star president and the television, without any static from the troublemakers, without all the parasites on the perfect homeostatic circuit (from the crazy assassin all the way to the congressmen, via the women's movement, the chicanos, the unemployed people). It is the ideal of the bureaucracy, or rather of the administration (in the American sense of the term): it records, and buries its recordings under other recordings, creating the illusion of a tranquil historical perspective where history is no more than the reproduction of the same, creeping softly toward oblivion. This is the ideal of the media. They need their daily feast of events, on the condition that these remain pseudo-events: some 'I' and some 'we,' some 'here' and some 'now' must be recorded, but above all not produced.

Yet these ideals also form the vulnerability of the system. It is sensitive to the excess of entropy but also to the lack of it, to static but also to the indelible document, and to parasites in every sense of the term.[12] At both extremities of the economic spectrum, the crisis has engendered its parasites. From the ruins of the Welfare Society there emerges a 'primitive' economy based on barter, black-market labor, and make-do, all of which escape the records of the statisticians. On Wall Street, where the accelerated accumulation of capital cannot fail to record the slightest movement of funds, the recent wave of corporate mergers has attracted a whole series of law offices which have made huge profits by playing messenger-boy between firms stuck in the middle of the desire to have more information and the repugnance to give any out. The enormous demand for pseudo-events generated by the media periodically leads to the authoring of unreal events which unfortunately make very real victims. The madness of the Tylenol murderer is perhaps to

[11] "What Hegel was never able to conceive, is a machine that would function," says Jacques Derrida, in *Marges* (Paris: Minuit, 1972): 126. To which Jean-François Lyotard adds: "Machines function at a loss. The speculative machine is a profitable machine, therefore deranged." 'Discussions, ou: Phraser *après Auschwitz,*' in *Les fins de l'homme* (Paris: Galilée, 1981).

[12] Cf. Michel Serres, *Le parasite* (Paris: Grasset, 1980).

[13] It is curious how Nixon's destiny seems to be pursued by negative entropy. Recently, an entire more-or-less underground market of video tapes has formed, selling 'Nixon's Last Video Tape,' which shows him, viler than ever, insulting the media (describe the public) and composing his image as well as possible (describe oneself) a few minutes before pronouncing his resignation speech on the airwaves. The tape was made without his knowledge by the technicians setting up the cameras.

14 Like the 'Mystic Writing-Pad' for Freud, its optimal functioning is not its ideal functioning. It must have something to record, it is a "two-handed device": "If we imagine one hand writing upon the surface of the Mystic Writing-Pad while another periodically raises its covering sheet from the wax slab, we shall have a concrete representation of the way in which I have tried to picture the functioning of the perceptual apparatus of our mind." Freud, 'Notiz über den Wunderblock' (1925), quoted by Jacques Derrida, 'Freud and the Scene of Writing,' in *Writing and Difference* (Chicago: University of Chicago Press, 1978): 226.

Dan Graham, *Present Continuous Past(s)*, 1974

15 The schema of *Schema* has been published in various catalogues of Dan Graham's work, for example in *For Publication* (Los Angeles: Otis Art Institute of Los Angeles County, 1975): n.p. It was actualized for the first time in *Aspen Magazine*, 1966-67. Facsimiles of various other actualizations of the piece, along with a French translation, can be found in Dan Graham, *Textes,* eds. Galerie 17 and Herman Daled (Brussels, 1974): n.p. For a reading of the self- and hetero-referentiality of *Schema*, cf. Benjamin Buchloh, 'Moments of History in the Work of Dan Graham,' in Dan Graham, *Articles* (Eindhoven: Stedelijk Van Abbemuseum, 1978): 75.

believe that he *produces* 'himself,' while in reality he only leads the media to *record* him as a 'self'. By sowing involuntary death, he may believe he is lending himself historical agency – as the subject of history's enunciation, as a performer of history – while in fact he is only the referent, and what is more, the referent of a rapidly amnesiac story. After three or four regressions of his image in the perspective-making machinery of the media, it disappears, eaten up by time. Everywhere static, random chance and rising entropy are the paradoxical precondition of homeostasis. If the media have become a kind of absolute subject of history, in any case the only one which seems to be gifted or endowed with autonomy, still they have to draw some semblance of finality from somewhere. From chance. And history itself is a semblance of history, made of pseudo-events. Ronald Reagan gets assassinated in front of the cameras, and escapes of course, like the real Hollywood cowboy that he is. Andy Warhol, the great unveiler of the logic of pseudo-events, gets assassinated by one of his former stars, Valerie Solanis, but on that day the front page is stolen from him by a very real event, the assassination of Robert Kennedy. Of course, Warhol escapes. As to Richard Nixon, he did not survive the nemesis of pseudo-events. You should never keep a record of yourself too long: one cannot lightly violate the Second Law.[13]

So, *Present Continuous Past(s)* begins by excluding its spectators, or rather by including them, but as pseudo-subjects producing pseudo-events. Ideally the machine should function all alone, but it functions even better when it is not ideal.[14] Like the society of which it is the allegory, it needs a source of static.

If nothing happened in the image, and in the image of the image, how would we know that they are regressing in time? If the audience were not also a performer, or at this stage, a pseudo-performer, how would it know that the infinite regress presents itself as a recording of history? The audience is therefore called upon to make gestures, insignificant but clearly recognizable – for instance, grimaces. The game is to see the face reappear after eight seconds, then again smaller after sixteen, and so on. The measure of history is given by the construction, but still an event – or a pseudo-event – has to take place there to render it visible. The spectators are witnesses, but not in the sense they think. They think they are seeing their own history, in fact they are swallowed up by it. They think they have created events to punctuate the time whose retrospective witnesses they will be, while in fact they have created witness-events – in the sense where, in French, the baton passed from hand to hand in a relay race is called a 'witness' – for a time that is punctuated in advance.

Here is where the allegory stops, for the mechanism is also practical. It incites behaviors which are political, or at least it proposes strategies, i.e. experimental models of political behaviors. *Present Continuous Past(s)* suggests three basic groups of strategies whereby individuals and groups can struggle against the media's claim to the sole subject of a history which is only recorded, never made. The first, which Dan Graham practices in all his works, is to render the medium explicitly self-referential. Perhaps it has not sufficiently been remarked that self-reference, which is a hackneyed theme of art criticism and passes for the quintessential strategy of modernism, is in certain cases – the best ones – the contrary of a tautological twisting of the medium back onto itself. A work like *Schema* (1966), which consists of a list of instructions for the composition of an indefinite set of poems published in form of inserts in journals or magazines, demands that the editor count the number of adjectives, adverbs, columns, lines, numbers, words in italics, etc. which will appear on the page where the insert is to be published (the

16 Dan Graham, 'Dean Martin/Entertainment as Theatre,' in *Articles* 1978: 43; reprinted in Dan Graham, *Rock My Religion,* ed. Brian Wallis (Cambridge, Mass.: MIT Press, 1993): 60.

17 Cf. Dan Graham and Dirna Birnbaum, 'Local Television News Program Analysis for Public Access Cable Television, 1978,' in *Video-Architecture-Television,* 1979: 58-61 and 77-85. Also see the work by Michael Asher for the group exhibition 'Via Los Angeles,' 1976, which Dan Graham included in his book as a source for his own work *Production/Reception (Piece for Two Cable* TV *Channels),* 1976, in *Video-Architecture-Television* 1979: 55-56.

18 "While the mirror alienates the 'self,' video encloses the 'self,'" in *Video-Architecture-Television* 1979: 69.

19 "The viewer gripped and released in the tranquil hallucination of a double indeterminacy, unmoored from his habitual spatialization, most definitely sees himself. But he only sees himself to exclude himself from the field in which he finds himself placed." Birgit Pelzer, 'Vision in Process,' *October* 10 (Fall 1979): 112 (quote translated here from the French original).

20 Dan Graham, 'Present Continuous Past(s),' in *Video-Architecture-Television* 1979: 7.

21 "A historical materialist cannot do without the notion of a present which is not a transition, but in which time stands still and has come to a stop. For this notion defines the present in which he himself is writing history." Walter Benjamin, 'Theses on the Philosophy of History,' in *Illuminations* (New York: Schocken Books, 1969): 262.

count includes the insert itself). This list then becomes the text of the poem.[15] The work is perfectly self-referential and yet anything but autonomous: it varies with each of its occurrences, for which it is also performative. The context determines the text, which in turn reveals the context. The homeostasis of the media, which is here caught in its own trap (for the execution of the work implies an iterative procedure that stabilizes at a certain moment), is not sufficient unto itself. The poem only produces its *here-now* when it is recorded, the medium only records the *here-now* of the poem when it allows it to produce the *here-now* of the medium. The page may be entirely covered by pseudo-events, the poem creates a real event.

Dan Graham has always been extremely attentive to the location in mass culture of this self-referential movement whereby a medium reveals itself to be heteronomous. What is more, he has been able to read its political meaning, sometimes despite his manifest ideology. For example, the behavior of Dean Martin in his televised show, "calling attention to the duplicity of his role playing" in an equivalent of Brechtian distancing.[16]

In the majority of Graham's television projects, the self-reference of the medium is a strategy that reveals its heteronomy.[17] It is a strategy practiced by the works, and *Present Continuous Past(s)* is no exception. It remains to see what use of the work it encourages. One of the possible uses can, relatively speaking of course, be called 'terrorist': it consists in breaking the closed circuit by introducing oneself into it, producing an event which the mechanism can no longer record as a pseudo-event. This is what happens when "a viewer's body directly obscures the lens's view." It suffices to pass one's hand for just a fraction of a second in front of the camera, and the whole *mise en abyme* is erased and the process of recording the infinite past forced to begin again from zero. Leaving his position as a peripheral witness of history, the viewer becomes a performer of history, but by the same token he annuls it and gives it a new beginning. Transposed into social life, this strategy resembles info-terrorism, computer piracy, and the erasure of data banks.

Yet the work reserves a third possible strategy, which brings in the lateral mirror. The viewer can see himself "in real time," he escapes the captivation of the feedback video, renews the experience of the mirror phase and, suggests Graham, *alienates himself* in his own image.[18] Paradoxically, this "alienation," which places the spectator in "the space of the gaze as an excluded third party,"[19] invites a use of the mirror phase which does not belong to the problematic of alienation. Graham describes the function of the lateral mirror in these terms: "The mirror at right angles to the other mirror-wall and to the monitor wall gives a present-time view of the installation as if observed from an 'objective' vantage exterior to the viewer's subjective experience and to the mechanism that produces the piece's perceptual effect. It simply reflects (statically) present time."[20]

The function of this mirror is to supply the viewer with a referential *now* which, as Walter Benjamin says, is "the present in which he himself is writing history."[21] This static or immobile *now* is withdrawn from both the empirical passage of time and its reiteration by the feedback video. It is – again quoting Benjamin – an *idea.* This idea implies that the viewer has been able to pull himself away from the fascination of the video, that he can turn to the lateral mirror and, seeing himself *there* as a virtual image produced on the other side of the mirror, record himself *here,* on this side of the mirror, by an act of reflection. The *here* of recording is not an *a priori* form that receives the viewer's self-perception, it is not an idea necessary for him to be able to reflect on the meanings of the allegory in whose contemplation, just an instant before, he was engulfed. Until now

everything was played out between the camera, the mirror facing it, and the video screen facing the mirror. This arrangement formed a speculative machine functioning at a loss and producing itself as a parody of the absolute subject, recording a history which is only an accumulation of ruins and in which the historical agents are only producers of random pseudo-events. With no other finality than homeostasis, the speculative machine proved to be nothing more than the reified ideal of the bureaucracy and the society of the spectacle. As long as the spectator remained riven to its axis, his only recourse (outside of 'terrorism') was to observe his own powerlessness, to accompany the fabrication of historical perspective all the way to its most extreme negativity and, as a last recourse, a last hope of redemption, to speculate on the ruins of speculative thought. Ultimately, the montage of *Present Continuous Past(s)* is not only a political allegory, it is also the allegory of a political philosophy, namely that of Adorno. It is the philosophy of the negative dialectic, the critique of alienation and reification, to which, as we have seen, Dan Graham sometimes makes explicit reference, albeit indirectly. But implicitly the work calls upon another political philosophy, which is still difficult to thematize. It implies in any case that the spectator take a viewpoint perpendicular to the axis of the video monitor, that he make (without any wordplay intended) a *reflective* use of the lateral mirror, rather than a *speculative* one. In short, Benjamin versus Adorno, Kant versus Hegel.

Indeed, going quickly – too quickly – we could even ask if Benjamin's thinking is not radically opposed to that of Adorno, particularly in their reading of historical materialism. Adorno remains a Hegelian who rebels against Hegel. Speaking of the Hegelian method, to which he opposes a writing of aphorisms and fragments, Adorno admits: "This book forgets neither the system's claims to totality, which would suffer nothing to remain outside it, nor that it remonstrates against this claim."[22] By contrast, Benjamin's writing, equally aphoristic and fragmentary, seems much more willing to forget the demand for totality than to remonstrate against it. Hegel is practically absent from Benjamin's work, but it is often Kant who is taken to task and 'played' against himself. Benjamin's philosophy of history is forged of a radical mistrust toward any *a priori* temporality: both Kantian time as an *a priori* form of inner meaning and Hegel's speculative dialectic as a *given* form of historicity. His double apprehension of history as a piling up of ruins and as the grasp of 'a memory as it flashes up at a moment of danger' cannot settle for a 'homogeneous, empty time,' nor for any kind of causality appearing as a historical form. It implies a 'now-time' pushed by the irreversibility of time, and as such it implies judgment in the Kantian sense at every instant, the *reflective judgment* which, we would have to show, is a political use of time. Nowhere does this appear more clearly than in 'For a Critique of Violence,' an admirable text aligned on the categorical imperative as the idea of a departure point of history which is constantly the 'now-time' of judgment: "The critique of violence is the philosophy of its history – the 'philosophy' of this history, because only the idea of its development makes possible a critical, discriminating, and decisive approach to its temporal data."[23]

3. Performer/Audience/Mirror 1977

"A performer faces a seated audience. Behind the performer, covering the front wall (parallel to the first row of seated viewers), is a mirror reflecting the audience."[24]

There exists an 'improved' version of *Performer/Audience Sequence,* in which a large mirror is placed behind the performer, facing the audience. Its function, like that of the lateral mirror in *Present Continuous Past(s),* is above all to allow the audience access to the production and recording of a referential *now* which is the idea of a historical depar-

[22] Theodor W. Adorno, *Minima Moralia* (London: Verso, 1991): 16.
[23] Walter Benjamin, 'Critique of Violence,' in *One Way Street and Other Writings* (London: Verso, 1985): 153.
[24] Dan Graham, 'Performer/Audience/Mirror,' in *Theatre*, 1981; reprinted in *Rock My Religion* 1993: 114-115.

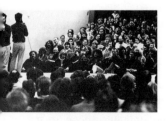

Dan Graham, Performer/
Audience/Mirror, 1977

ture point, the imperative prescribing to everyone the responsibility to make history: that is, to judge it.

The performance includes four phases which can be repeated, each approximately five minutes long. The first two are identical to what happens in *Performer/Audience Sequence*: facing the audience, the performer describes himself, then describes the audience. The second two phases are a repetition of the first, except that this time the performer turns toward the mirror. Thus he can describe himself while seeing himself; and when he describes the audience, what he is in fact describing is his virtual image, laterally reversed. Dan Graham insists on a few of the many aspects which distinguish this performance from *Performer/Audience Sequence*: "Through the use of a mirror, the audience is able to instantly perceive itself as a public mass (as a unity), offsetting its definition by the performer('s discourse). The mirror allows the audience an equal and equivalent position within the performance."[25] If we add that in the last two phases 'the performer is facing the same direction as the public, seeing the same mirror view,' then we realize that the political allegory of *Performer/Audience Sequence* has been significantly shifted. There, the performer was like a candidate in an electoral campaign. Turned in the same direction as the audience, he now appears even more legitimate in this role, as though he had been delegated by the group to be its spokesman. What is more, the public has at its disposal a projection surface where the self-image reverberated back to it by the performer can be compared to its own imaginary. The allegory becomes utopian: if the media immediately relayed its own self-image back to the mass, democratic control would be less uncertain, homeostasis less costly, power more legitimate and more transparent. A pessimistic allegory is followed by an optimistic one, which places autonomy at the end of homeostasis.

But Graham also remarks that when the performer describes the audience, "the audience sees itself reflected by the mirror instantaneously, while the performer's comments are slightly delayed and follow a continuous flow of time (since they are verbal). This effects cause-and-effect interpretation for the audience. [...] The slightly delayed verbal description by the performer overlaps/undercuts the present (fully present) mirror view an audience member has of himself or herself and of the collective audience; it may influence his or her further interpretation of what he or she sees."[26] The model of utopian democracy is therefore impure. The closer the regulatory process comes to autonomy, the more flagrant are the manipulations that preside over it, and the greater is the doubt about the immediacy of the feedback. In the best of cases, a perfectly self-regulated democracy would still be belated with respect to itself.

Finally, Graham underlines that the performer "is free to move about, to change his distance relative to the mirror, in order to better see aspects of his body movements" (when he describes himself), and "in order to view different aspects of the audience's behavior" (when he is describing them). "His changes of position produce a changing visual perspective that is correspondingly reflected in the description. The audience's view remains fixed; they are not (conventionally) free to move from their seats in relation to the mirror covering the front staging area."[27] Here, the powers of the performer and the audience are clearly dissymmetrical. The performer – or allegorically, the candidate, the legislator – can move about, he has the illusion (it is only an illusion, since he is looking in the mirror) of being able successively to occupy viewpoints which are representative of the different members of the audience. The audience – the mass, the people – does not have any choice about its point of view, it is collectively driven to its

[25] *Rock My Religion* 1993: 114-115.
[26] *Rock My Religion* 1993: 114-115.
[27] *Rock My Religion* 1993: 114-115.

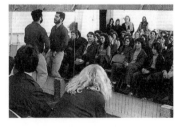

Dan Graham, *Performer/ Audience/Mirror*, New York, P.S. 1, 1977

28 Cf. Dan Graham, 'Eisenhower and the Hippies,' in *Articles* 1978: 23-26; reprinted in *Rock My Religion* 1993: 6-11.
29 Based on Lacanian psychoanalysis and, beyond it, on the explicit recognition of the social functions of the imaginary, Castoriadis's thinking shows that the *self-ness* [*ipséité*] of the subject (its here-now), is a defensive base in the struggle for political autonomy: "If autonomy is the relation in which others are always present as the otherness and as the self-ness of the subject, then autonomy can be conceived of, even in philosophical terms, only as a social problem and as a social relation." Cornelius Castoriadis, *The Imaginary Institution of Society* (Cambridge: Polity Press, 1987): 108.
30 "This is because alienation, social heteronomy, does not appear simply as the 'discouse of the other' – although the latter plays an essential role here as a determining function and as a content of the unconscious and of the consciousness of the mass of individuals. The other, however, disappears in collective autonomy, in the impersonal nature of the 'economic mechanisms of the market' or of the 'rationality of the Plan,' of the law of the few presented as the law itself." Castoriadis 1987: 109.

social destiny. Each member has an image of the group, but this collective, public image differs from the image his neighbor will have. The viewpoints that constitute it are private and individual, it is to each one in particular that the legislator speaks and the law is addressed.

The political lesson of this allegorical fable is that the production of a group imaginary – whether class consciousness or hippie conviviality – cannot result in a coherent vision of the world stated from a common viewpoint. And this is a severe critique of any political philosophy that remains captive to the autonomist ideal. Parliamentary democracy, even that of the workers' councils, lives off the fantasy of representativity. Political organization implies, at least ideally, that the different viewpoints expressed in society can be gathered into a single viewpoint where the representative of the people speaks in the name of all, here and now. The self-management model gets rid of representativity, but it clings all the more firmly, under pain of anarchy, to the fantasy of the common viewpoint. The autarkic hippie or ecologist commune is only unified by the dream of a great "togetherness."[28] As to French socialism, to the extent that it aims at self-management it attempts to forge ideological consensus by all possible means. In short, for the autonomist ideal, the 'we' in the mirror reflects the 'we' in the room. Even if the self-institution of society is imaginary, even if it takes place *there* through a 'mirror,' just as it takes place through the discourse of the other, it still must be gathered *here,* where you, me, he, and she can say 'I' together, that is, 'we.'[29] Self-management, and more generally autonomy, need the spatiotemporal invariants of political experience. Without them there is only the reign of heteronomy as alienation, and the submission of all to the great self-regulated machine of the market and the state, seemingly the only one to be endowed with autonomy, the only one able to make itself a "subject."[30]

Now, *Performer/Audience Sequence* had already shown that this horizon of autonomy had to be abandoned. The experience of the performance erased itself as experience, and nowhere did any 'we' succeed in recording itself. The performer and the public appeared to be equally alienated. *Present Continuous Past(s)* showed the counterpart of this alienation, transferring all the enunciative power of the 'we' to the media, the bureaucracy, the self-regulating social machinery. But in so doing it also showed the limits of the model of autonomy and alienation. When the recording machine functions at a loss, it is also heteronomous. When it does not function all alone, but needs a source of noise, its self-regulation does not signify its autonomy. It is not enough to say, like Marx and so many after him, that the machine of Capital is just as alienated as those it alienates. It is the horizon of a non-alienated subject that must be abandoned, and with it, the horizon of autonomy. For this horizon remains that of speculative thinking, which is to say, after Adorno, of hopeless, desperate thinking. *Present Continuous Past(s)* taught even more. Political praxis will not free itself of the speculative if it does not break entirely with history as a totalization of the past and a reserve of the future. Neither paradise lost nor revolution to come. The beginning and the end of history are *now*. This *now* is not a given of experience, it is not the ground of a praxis clinging to a past that it memorizes or erases, or swallowed up by a future that it anticipates or fears. It is the idea that praxis must suppose so as to give itself its own finality, the historical idea itself. *Performer/Audience/ Mirror* shows what is at stake: inscribing the social tie in the very midst of dissension and making the need to judge, each for him or herself, the maxim of today's time. Indeed, the 'we' in the mirror does not reflect the 'we' in the room. In the room there are apparently only 'I's. The group imaginary – class consciousness or togetherness – is only produced

31 "[…] and now there's a half smile that comes up to a full smile in the case of a couple of people… umm… and now I see two people in the third row and then a woman who wouldn't smile if nobody else did. […] (*Laughter*) everybody laughs… umm […] and as they laugh […] um they move their head and it's a much more animated laugh than before. […] (*Laughter*) and they now look at each other nodding as if they're collectively (*Laughter*) aware of this fact, umm (*much laughter*) as a group (*Laughter*)." Three excerpts from the transcription of the second performance of 'Performer/Audience/Mirror,' PS 1, New York, December 1977, in *Theatre* 1981.

32 Dan Graham himself made the comparison, but retroactively, between the *dispositif* of *Performer/Audience/Mirror* and the Serlian stage, or rather the Palladian stage that derives from it, the stage of the Teatro Olimpico in Vicenza. Indeed it is not by chance that he entitled the little book on his performances *Theatre*, which is somewhat provocative in a context where on all sides, artists and critics claim a *specificity* of performance that would distinguish it from theater. It is clear that an artist as concerned as he with warping viewpoints and perspectives, with dialecticizing windows and mirrors, calls on the contrary for us to seek the sources of performance in a critical return to the *inter-specific* complexity of the Renaissance *dispositif*, where painting, theater, and architecture join to prepare a political and philosophical order entirely assigned to the place of the subject. In this respect one can also point to the analogy between the *performer* in/before the mirror and the character of the *festaiulo* or the

there in the mirror, in real time perhaps, or in a slight desynchronization. It does not record the self-sameness of a 'we' on this side of the mirror. If it is recorded – and that is one of its stakes, the social tie must be inscribed – it will be in a multitude of interchangeable points of view.

Are these points of view really points of view? Have the members of the audience *taken a position* in the room? No, they have been placed, or they have placed themselves according to their luck; the optical apparatus has randomly distributed its visual pyramids. The same holds for the social world of which the room is an allegory: the social agents have been placed by the accidents of birth or the determinisms of their class. Their 'vision' of society will depend on these accidents or determinisms. The important thing is that once their place and viewpoint are assigned, everyone should nonetheless hear the same story: what the performer tells about himself or the audience, what the candidate, the legislator, tells of his past accomplishments or his future promises. Each one will hear the performer act on the behavior of the audience and the people's representative prescribe the law that the supposedly autonomous people has given to itself. The same, in principle, for everyone, the law speaks and addresses itself to everyone individually. What the multiplicity of visual pyramids position are not 'I's, but 'you's. If the 'we' is not given in advance, if autonomy is not attained – and it never will be – then 'I' am not the subject of the enunciation of the law, even by delegation, but only its recipient. And an accumulation of 'you's does not make a 'we,' but only a collective 'you.' If 'the people' is this sum, it will never be more than an aggregate, an anonymous mass beneath an anonymous law, summoned to listen to the same summoner. The performer is not its representative, but he risks being its *Führer.* For the political praxis that must respond to this danger, the social tie is not a 'we' or a collective 'you,' it is the prescription to each one to accept or reject the law in his or her own proper name, to judge the law without referring to the mirror of class consciousness, ideological consensus, or conviviality. This judgment is not much more than a certificate of reception, but it ties the instance of the law to the name of the recipient and to the *now* in which, as Benjamin said, 'he himself is writing history.'

But still this history must be transmitted for it to form a tie, the historical narrative must be articulated between the seat-rows of the audience, without passing through the mirror. In *Performer/Audience/Mirror,* there is always a moment where the attention slips away from what the performer says, where the heads turn away from the mirror and toward each other, as though the projected image of the group sought to reconstitute itself as such through lateral propagation. What is propagated in these moments is laughter: nothing that would form an agreement, much less a *public opinion,* nothing but the shudder of health shaking the great suspicion out of oneself.[31]

The mirror in *Performer/Audience/Mirror* has the emplacement, form, and format of a cinema screen. But the 'film' unfolds in real time, it is even fabricated *hic et nunc* without any previous recording or delay of projection (as in the video pieces). Its 'sound track' comes from the performer present in the flesh on the stage. By contrast with the art of film, the apparent immediacy of the performance underlines its theatrical aspect. The mirror-screen is an uninhabitable space, like the trompe-l'oeil backdrops or illusionistic constructions of the Serlian stage.[32] Like the Serlian actor, the performer can only 'play' on the proscenium, in the no-man's land between the seats (by metonymy, the city) and the stage (by metaphor, the *ideal city*). But unlike the Serlian mechanism, his play is not oriented toward the designation of a single viewpoint. The mirror does not refer to the

"admonisher" which Alberti (in *Della Pittura*) appears to have borrowed from the theatrical tradition and which he suggests should be placed in a corner of the painting, index finger pointing to the painted scene and face turned toward the viewers, displaying the *istoria*. Cf. Michael Baxandall, *Painting and Experience in Fifteenth-Century Italy* (Oxford: Clarendon Press, 1972): 72.

[33] Cf. George R. Kernodle, *From Art to Theater, Form and Convention in the Renaissance* (Chicago: The University of Chicago Press, 1994): 176-200.

[34] In conversation with the author.

[35] 16 mm, 70 minutes, black and white, filmed in January 1965. Warhol's meeting with the 'camp' poet Ron Tavel marked the beginning of his use of sound in film (*Harlot*, December 1964). Tavel did a dozen scenarios and dialogues for Warhol, which Warhol carried out faithfully in appearance, but whose theatricality he often interrupted, for instance (as in *Hedy*, November 1965), by turning the camera toward the ceiling of The Factory at the culminating moment of the dramatic action. Cf. Stephen Koch, *Star-Gazer, Andy Warhol's World and his Films* (New York: Praeger, 1973): 75.

[36] Dan Graham, 'Dean Martin/Entertainment as Theatre,' in *Articles* 1978: 43; reprinted in, *Rock My Religion* 1993: 60.

[37] Walter Benjamin, 'The Work of Art in the Age of Mechanical Reproduction,' in Benjamin 1969: 230-231.

[38] Dan Graham, 'Cinema', in *Buildings and Signs* (Chicago: The Renaissance Society at the University of Chicago and the Museum of Modern Art Oxford, 1981): 47; reprinted in *Rock My Religion* 1993: 168.

apex of a single visual pyramid, the privileged spot which, soon after Serlio, would be the royal *loge* whence history will be at once made, said, seen, and shown, in a word, projected.[33] The perspectives are multiple, each viewer occupies the place of the king or nobody's place, and also occupies, relative to the mirror-screen, the position of an individual, off-center 'projection booth.' It is up to each one to produce his historic *now* on the basis of a *here* which has been given to him. Far from being self-evident, the immediacy of the performance only appeals to references to the history of illusionist theater by contrast to the mediacy of film which is, according to Dan Graham, the only artistic form "through which it is still possible to look at theater."[34] He is thinking here of Rossellini, even more of Straub, and in particular of a Warhol film whose resemblance to *Performer/Audience/Mirror* is striking. This is the filmed version of a play for the theater by Ron Tavel, *The Life of Juanita Castro*.[35] Instead of acting the play, "the actors read their lines lolling on bleachers and photographed throughout from the identical off-center oblique angle. This is reversible with the experience available to members of the audience averting their eyes from the screen to observe the equally 'spaced' reaction of the rest of the audience."[36]

This film, Graham notes further, is the first where Warhol gives up the frontal framing that characterized his earlier films, shifting to an oblique viewpoint. For the viewer this creates the expectation of a camera movement that never occurs, finally provoking him, out of exasperation, to turn his head, mimicking the movements of the actors in the film. Actors and spectators have exchanged their roles, the performance is as much in the room as on the screen. In *Performer/Audience/Mirror,* Graham adopts this reversal and carries it out by restoring the supposed immediacy of the theater. The screen is the mirror, the actors on the screen are the spectators in the room. We can better understand how Graham transforms the thinking of alienation when we observe that he has created a response to a remark by Walter Benjamin on the film actor: "The feeling of strangeness that overcomes the actor before the camera [...] is basically of the same kind as the estrangement felt before one's own image in the mirror. But now the reflected image has become separable, transportable. And where is it transported? Before the public."[37] When the recording has been eliminated, when the metaphor of the mirror-screen has been materialized, when the audience has become an actor and has been brought back before the mirror, what we witness is not a 'redemption of the real,' as Kracauer said, nor a disalienation of the performer. The immediacy of the theater, its irreproducibility or non-transportability, is just an ideology which can only be interpreted through an explicit recognition of filmic culture. In return, this recognition calls for a strategy which, to avoid submission to the single viewpoint of reproducibility, must reestablish the necessity and the urgency of a judgment that produces a *now* in such a way that neither film, nor television, nor the media can record it.

4. Cinema 1981

"A cinema, the ground-level of a modern office building, is sited on a busy corner. Its facade consists of two-way mirrored glass, which allows viewers on whichever side is darker at any particular moment to see through and observe the other side (without being seen by people on that side). From the other side, the window appears as a mirror. When the light illuminates the surface of both sides more or less equally, the glass facade is both semireflective and partially transparent. Spectators on both sides observe both the opposing space *and* a reflection of their own look within their own space."[38]

From *Performer/Audience/Mirror* to *Cinema* (1970-[72]), the allegorical dimension would seem to have disappeared. Here the project is one of architecture, the political art *par excellence,* an art which is 'real' by definition. Dan Graham's reading of Lacan's 'mirror phase,' an unorthodox and assuredly 'unscholarly' reading, here becomes the touchstone for a practice of intervention in the city. It is in terms of *social reality* and not of 'access to the symbolic' that Graham had interpreted the mirror phase,[39] and it is in the terms of an architectural realization that he returns to this interpretation, in its relation to film.

He quotes Christian Metz, who in 'The Imaginary Signifier' had developed a semiology of cinema as a secondary symbolic, founded on the mirror phase: "Thus film is like the mirror. But it differs from the primordial mirror in one essential point: although, as in the latter, everything may come to be projected, there is one thing and one thing only that is never reflected in it: the spectator's own body. In a certain emplacement, the mirror suddenly becomes clear glass. [...] In the cinema, the object remains: fiction or no, there is always something on the screen. But the reflection of the own body has disappeared. At the cinema, it is always the other who is on the screen; as for me, I am there to look at him. I take no part in the perceived; on the contrary, I am *all-perceiving.*"[40]

By the choice of this quote, which he introduces by saying that at the cinema, the viewer has 'lost the consciousness of his body,' Graham rolls back, as it were, the Lacanian abstraction of the signifier and returns to Merleau-Ponty, to a phenomenology of vision which is not only the symbolic split of the eye and the gaze, but an incarnate chiasmus. His *Cinema* project also links back to his early films *Roll* (1970) and *Body Press* (1970-[72]), films which already brought in a double, chiasmatic filming (and in the case of *Body Press,* the topology of the mirror), where the body – of the performer, the cameraman, and the viewer – forms at once the subject, the question, and the stakes of the films. In this work, however, the film being projected is unimportant. *Cinema* is not a work of cinema but of architecture, it seeks to be effective rather than fictive. It is a matter of returning some reality to the symbolic, of giving body to the imaginary signifier and social effectiveness to the ideological superstructures, in a word, of putting politics into art. It is still the body which is in question here, but no longer the body of the performer-actor (the projected film can be anything), nor the body of the cameraman-artist (the projection is traditional).[41] It is only the viewer's body.

In the room surrounded with two-way mirrors, the cinema-goer is a voyeur who, by any sudden change in the light, can be offered as a spectacle for another voyeur outside the room. On the mirror-screen, the viewer's reflection intermingles with the figure of the actor; each image is as virtual as the other, bodies mingled into the same fiction. Out in the street, the spectacle of urban reality is superimposed on the cinematographic imaginary for a beholder who probably did not hope for so much, believing his fantasies to be safely sheltered in darkness, whereas from the street, when the fantasy-screen dims and the lights go on, it is the spectacle of society watching a spectacle that suddenly transforms the most innocent passer-by into an impenitent voyeur. In short, on the screen, behind and in front of it, in the movie theater and outside, there are only spectators. In the society of the spectacle, all the social agents are spectators. This resigned confirmation has to be turned around in order to graft any possible praxis on it: all the spectators are social agents, or at least could be, or should be. This is what Graham's *Cinema* invites us to believe. In 'mediated' society, it is no longer in a symbolic of production but in an imaginary of consumption, it is not longer in the instance of emission but in that of reception, it is no longer on the side of activity but on that of passivity, it is no longer in

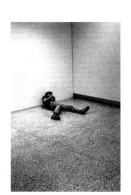

Dan Graham, *Roll*, 1970

[39] See note 2.
[40] Christian Metz, 'The Imaginary Signifier,' in *Screen* (Summer 1975); partially reprinted in the anthology *Narrative, Apparatus Ideology*, ed. Philip Rosen (New York: Columbia University Press, 1986): 250, 252. Quoted by Dan Graham (with a few elisions) in *Buildings and Signs* 1981: 47.
[41] Comparing his *Cinema* to the modernist architecture of the Handelsblad Cineac by Johannes Duiker in Amsterdam (1934), Dan Graham indicates clearly that for him it is no longer the machinery of production (shooting – projection) that should today be subject to a critical deconstruction, but the *dispositif* of reception: "it is the screen, instead of the machine, and the system of voyeuristic identifications that are exposed." 'Cinema' , in *Buildings and Signs* 1981: 49; reprinted in *Rock My Religion* 1993: 168.

action but in *Passion* (to use one of Godard's titles) that politics resides. In the great self-regulated machine, to act is to see and to see is to choose and to choose is to judge. The fact that we have become beholders [*regardeurs*] does not stop us choosing what we behold. The fact that we are also beholders beheld further imposes upon us the decision of what to show, when, and why, each time. Judging and exposing oneself to others' judgment, without any certainties on either side, is perhaps what politics consists of today.

That's not much, some will say. Yes, it's not much, but it is enough to begin relearning politics from the very start, now that the great eschatological narratives have lost all their credit, now that it is no longer a question of remonstrating against the demand for totality but of actively submitting it to the passion of oblivion, now that the threat of totalitarianism, far from residing in secret government, lies on the contrary in the excess of transparency and the overload of information. We must learn to be semitransparent and to play on that: now windows, now mirrors.

The history of architecture has not ceased to swing between two definitions and two treatments of the body. In the 'formalist' periods (fifth-century Greece, Brunelleschi's Renaissance, thirties modernism and the International Style, for example), architecture is abstract. It lodges the body of its inhabitants but refuses to be embodied itself. It partakes of space but as little as possible of matter. In the 'symbolist' periods (Egypt of the Old Kingdom, the Spanish or Bavarian Baroque, late nineteenth-century eclecticism, for example), architecture is metaphorical. It represents the bodies of its inhabitants and rivals with them for degrees of embodiment. But it is in the periods of restlessness and transition, that civilization has doubts about its subjectivity and begins to produce a new body, that architecture takes up its two poles simultaneously and pushes them to their paroxysm. The Baroque of Bernini and Borromini is a major example, as Rococo architecture is a minor one. At the moment when industrial capitalism begins to appear on the horizon, Lequeu overtly sexualizes the ancient classical and aristocratic space, making it into a lost and desirable body. At the same moment, Piranese projects the imprisoning space of the industrial metropolis as an infinite, centerless space, which at the same time is only a great sadistic metaphor of the body-machine that will soon be the proletarian body.[42]

Never have the two treatments of the body – inhabitant and habitation – been pursued together more obstinately than in modern architecture at its pioneering beginnings. The more architecture sought to be 'organic' (Sullivan, Frank Lloyd Wright) or 'machinic' and functionalist (Le Corbusier, the Bauhaus), and *corporeal* in either case, the more its keyword was *space.* The more its ideal was pure and abstract form, the more this form was charged with metaphorical meaning. And the more the metaphor was the Taylorized body of *Modern Times,* the more it was sublimated in notions like asymmetrical composition, fluid space, the open plan. This is why it is often so difficult to make the distinction, before constructivist or De Stijl architecture, for example, above all when it only exists in the state of projects or models, between architecture and sculpture.

This is an ambiguity to which Dan Graham lends much importance for his own 'architectural' work, less no doubt for *Cinema* than for other works already created or underway, such as *Two Adjacent Pavilions* and *Pavilion/Sculpture for Argonne.*[43] Their scale, carefully calibrated around that of a slightly oversized telephone booth or bus stop shelter, makes them objects which hesitate between urban furnishings and habitations. Their location in a park and their title – *Pavilions* – places them in the ambiguous cultural

[42] Cf. Manfredo Tafuri, *Projet et Utopie* (Paris: Dunod, 1979): 17.

[43] *Two Adjacent Pavilions* (1978-[82]) was created in the park of the Orangery in Kassel for the last documenta 7, and *Pavilion/Sculpture for Argonne* (1978-81), commissioned by the Argonne National Laboratory to be placed in a park near the new administration building constructed by Helmut Jahn, is under construction by Dan Graham. Cf., *Buildings and Signs* 1981: 26-31.

space of an urbanized nature reserved for leisure activities and bodily pleasures, strolls or pastoral love-affairs (like the Petit Trianon at Versailles). Their avowed references – the Rococo pavilion with all its windows and mirrors, but also Rietveld's sculpture pavilion in the park of the Kröller-Müller – exasperate their non-functional status as art objects even while elevating the ambiguity between their function as architecture for sculpture (or the body) and their symbolism as sculptural objects standing in for architecture. Their formal vocabulary of glass and steel, their functionalist appearance and their modernist faithfulness to the logic of materials poses them as an ironic quotation of the International Style, of Mies Van der Rohe and the corporate building, but off-scale and out of context.

All this weaves a subtle network of references to a lost Arcadia, voluntaristic allegiances to the most creative moments of architectural modernism, and distant critique addressed to the reduction of the modernist utopia in the one-dimensional logic of Capital.[44] All this is also contemporary to a far-reaching crisis in architecture. The inheritor of the modernist utopias and their failure, architecture today proves more powerless than ever to politically refashion *social* space. The inheritor of the formal inventions of modern architecture, but most often in rebellion against them, it proves even more incapable of metaphorizing the *body* inhabiting social space. Under the banner of postmodernism (as conceived by Charles Jencks, for example), contemporary architecture most often succeeds only in proposing an eclectic collage of the *disjecta membra* of bygone styles. That does not make a *body,* even if people are now persuaded that the unity of one's *own body [corps propre]* is missing.

Nonetheless, it is a body and at the same time a (social) space that Dan Graham's modest architectures propose as a metaphor. The body has the topology of a Klein bottle, with neither inside nor outside. In relation to the substances of its environment it has the osmotic permeability of a reticular membrane, in relation to its energies, the conductivity of a semi-conductor, in relation to its signs, the semitransparency of a two-way mirror. Why not give it back its name, despite the clumsiness of the metaphors that place it between the triangulation of biology, technology, and information? This body is the *subject.* It is dated, of course, like La Mettrie's machine-man, or Hegel's motor-man. But it is dated today. Throughout his work, Graham has not ceased to construct the model of this subject. It should come as no surprise that the model – made in turn of psycho-organic materials (the mirror phase), technological materials (the mirror of the media), and informational materials (the binarism of the two-way mirror) – should finally be architectural. It was not so long ago that a play on the word *castrum* still allowed the (Freudian) subject to be envisaged as a castle, a fortress, or a defensible camp. But this architecture is no longer in style today, in a society where power hides and exhibits itself all at once in semitransparent glass cages. The contemporary subject has the architecture of an office building or a mall, he is subjected throughout with no more regard for the old distinction between public and private. Graham, who unfailingly blurs and reverses these notions, reveals this at the same time as he suggests how to resist subjection today: by learning how to manage a certain semitransparency over time. It is of this subject struggling with its subjections that *Cinema*, and even more, *Alteration to a Suburban House,* are an allegorical model, a *scale model.*

Graham's *Cinema* does not exist. For the moment it is only an idea and it risks remaining that way for a long time. But the idea of his *Cinema* exists, in the form of texts, plans, and a model. It is not inhabitable but it should be conceived as though it were.[45] It

[44] For a rather distant critique of the ideology of the International Style, cf. Dan Graham, 'Art in Relation to Architecture/Architecture in Relation to Art,' *Artforum* (February 1979): 22-29; reprinted in Dan Graham, *Rock My Religion* 1993: 224-241.

[45] Like the models of his other architectural projects (*Clinic for a Suburban Site*, 1978, and *Alteration to a Suburban House*, 1978), the model of *Cinema* should be exhibited at eye level: "Exhibited at eye level, they are to be read by the spectator as if in actuality he were the subject of the clinic, house or cinema." Anne Rorimer, 'Dan Graham: An Introduction,' in *Buildings and Signs* 1981: 17.

is only a project but it is an architectural project. And when an artist who is not an architect does an architectural project which has little chance of leaving the institutional space of the art gallery where it will be seen as a kind of sculpture, at best as a scale model, and in any case as an *autonomous* work of art, the least one can do is to take this work for a very powerful declaration of the heteronomy of any work of art. Graham deliberately reverses the position of certain architects who cannot build, or perhaps no longer desire to build, and seek only to present drawings, plans, and models on the art market, as though they were autonomous works of art. He presents, on the same art market, models which he may not really wish to build, but he presents them as though they were already built and formed part of the city. This accounts for a disappointing aspect of his models. Technically they are not very well carried out, aesthetically they avoid like the plague all the seductions of the scale model (the 'toy train' effect). It is indispensable to their allegorical functioning that they erase the authority and the supposed autonomy of the *architect as artist,* in favor of the heteronomy and the as-if utility of the *artist as architect.*[46]

This is the very narrow maneuvering room that is available to the practice called art today when it challenges the autonomy of its name, even though it is still only admitted in the institutions and ideologies that remain specifically devoted to it. As an architect-artist, Dan Graham would show only his own extravagance. He would not be able to build, but this very difficulty would immediately predispose a certain public to see the mark of spurned talent in his work, and a certain market would rush to profit off objects all the more salable because the projects are unbuildable. As an artist-architect, it is probable that he will not build either, but it will not be for the same reasons. His models will not play on society's intolerance, they will reveal it, and their author will not hide behind their audacity as an alibi for his lack of social involvement. For Graham the art market is not a market, it is not the terrain of the commodity where the most extravagant social utopias enjoy a feigned autonomy. It is for the moment the sole terrain where the revelation of the heteronomy of art risks being understood by those whom it must address, at the price of being expressed only in the form of a utopia. *Cinema* or *Alteration to a Suburban House* feign to be commodities, the better to remain projects. For it is now the market and not utopia, it is heteronomous reality and not the autonomist ideal, which prescribe to a would-be critical art its projection into a hypothetical future. Not that one should still believe in the future, nor even desire it as the modernists did. The future is no longer either a promise or a reserve, it is one of the names of 'now-time.' Thus the attitude of Graham, the artist-architect, is astonishingly close to and at the same time opposed to that of Mondrian when he declared: "Even as a 'work of art,' however, Neo-Plastic architecture can only be realized under certain *conditions.* Besides *freedom,* it requires a certain kind of *preparation* not possible in ordinary building practice. If the founders of Neo-Plasticism in painting succeeded in fully expressing the 'new' plastic only at great sacrifice, to achieve this in the ordinary architecture of today is *virtually impossible.*"[47] Mondrian did not believe in the autonomy of painting or the art work on a specific market, but he dreamed of an autonomous society in which art, heteronomous in relation to this society, would be autonomous along with it. It is to the extent that Neo-Plasticism was perhaps above all a political project for him that the work of art – the only practice through which "can Neo-Plasticism be realized as 'our environment'" – had for the time being to "stand alone."[48] His efforts to establish autonomy in painting represented a provisional but necessary stage, the conquest of a specific

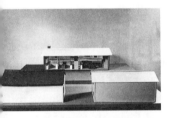

Dan Graham, *Alteration to a Suburban House*, 1978

46 Thus Anne Rorimer is quite right to underline that "The architectural style of each model gives a generalized appearance as opposed to one of having been designed by an individual architect," in *Buildings and Signs* 1981: 17.
47 Piet Mondrian, 'The Realization of Neo-Plasticism in the Distant Future and in Architecture Today' (1922, first published in 1925), in *The New Art – The New Life, The Collected Writings of Piet Mondrian* (New York: Da Capo, 1993): 170.
48 *The New Art – The New Life,* 1993: 170.

autonomy from which one could move, when society was ready, to the wider realm of "ordinary architecture."

Dan Graham's work evinces no such utopia. His models have not adopted the disguise of the modernist and autonomist art object in order to project themselves as the anticipation of the moment when society would be free and disalienated enough to allow itself to build them. If they were constructed, on the contrary, they would reveal an extreme of alienation. Who would like to live in *Alteration to a Suburban House,* under the permanent obligation to be a living emblem of the petty bourgeois dream deconstructed and exposed in all its futile pretensions to individuality and private life? Who would like to trade his movie-going leisure for exposure to the 'surgical' gaze (as Benjamin put it), to the instrumentalized gaze of a mass of voyeurs promoted to the rank of an all-seeing Big Brother? If these projects anticipate anything, it is certainly not the state of a society ready for their art to be built as "ordinary architecture," but rather a society where the public management of private affairs will have attained an as yet undreamed-of sophistication. As architectural *projects, Cinema* and *Alteration to a Suburban House* are destined not to be constructed, and this is the sole reserve of utopia that they allow themselves: the hope that we don't end up there. Conversely, as 'autonomous' objects of art they demand that we see them as though they were already built. This is their critical function as a warning, without any cynicism: Big Brother is among us. That is why it is important that Graham's architectural idiom be borrowed from the degenerative phase of the modernist ideals, where Philip Johnson meets the American suburbs, where the formal inventions of De Stijl cross paths with the repetitive aesthetic of *Homes for America.*[49]

For it is crucial that the contemporary subject allegorized by these models should be photographed, as it were, 'at a moment of danger,' too late to continue projecting himself into the image of a disalienated man, yet early enough for the memory of an abortive project to continue shining with all its subversive light. By quoting the formal heritage of Mondrian and Rietveld at the moment where, with the International Style, that heritage capitulates under the pressure of the monopolies and the 'system,' Dan Graham recalls that it could have had another destiny if the autonomy of a disalienated society had been realizable, and if autonomist thought itself had been a 'correct' political philosophy. Therefore what flashes up in the present moment is the place where the real difficulty lies. With all illusions lost and all idealism evacuated, it is dangerous to incriminate the formalism of modern architecture, since it also remains our heritage. The hour is not only one of ideological revision, but should also be one of theoretical reinterpretation. Far from being the ultimate capitulation, the abandonment of the autonomist utopia and the recognition of heteronomy are on the first page of the political calendar. History is produced and recorded, made and written, played out and judged, *now.*

First published in *Dan Graham: Pavilions,* exh. cat., ed. Jean-Hubert Martin
(Bern: Kunsthalle Bern, 1983).

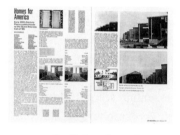

Dan Graham, *Homes for America*, 1966-67

[49] *Homes for America* is one of Dan Graham's very first works, published in *Arts Magazine* in December 1966. It presents itself as an article describing and developing the combinatory system of different models of prefabricated houses offered by the industry. The article is abundantly illustrated by articles which highlight the very 'minimal' qualities of these houses, which become abstract like sculptures. The work can be read as a critique of minimalism and as a reestablishment of its oft-denied link to pop art. It can also be seen as the source of Dan Graham's interest in the architectural theory and practice of Robert Venturi.

Dan Graham at Stonehenge,
c. 1972

Dan Graham filming
Body Press, 1970-72

Four Conversations: December 1999 – May 2000

Benjamin H.D. Buchloh/ Dan Graham

Some Early Data

BB: Was your mother a psychoanalyst or a psychologist?

DG: Psychologist. Educational psychology.

BB: What discipline, what type of formation?

DG: She studied with a German Gestalt psychologist. He was interested in topological psychology. His name was Kurt Lewin, and he was interested in applying topology from physics to psychological and social situations. I think he had an influence on Lacan.

BB: And what did your father do?

DG: Chemistry.

BB: And you grew up in New Jersey?

DG: In a town for ship workers, called Westfield.

BB: And you never went to art school.

DG: I just couldn't tolerate college or art school. I tried to drop out of high school.

BB: So when did you first get in touch with psychology and psychoanalysis? Was it of interest to you at a very early stage because of your mother's activities?

DG: No, I was more influenced by Margaret Mead. I read all her books because they were about sexuality. I was thirteen. Mead's influence gave me both an anthropological and a feminist outlook.

BB: So Margaret Mead would be your first intellectual reference when you were a teenager?

DG: Then it was Jean Paul Sartre.

BB: When was that?

DG: When I was fifteen or sixteen.

BB: Did you know that you wanted to be an artist at that time?

DG: I didn't know anything about art. I wanted to be a writer.

BB: What kind of writer?

DG: Well, we were all reading *Evergreen Review,* Barney Ross's magazine published by Grove Press.

BB: Which had a pretty wide array of mostly French and American texts, Jean Genet and Jean Paul Sartre among others.

So these were some of your philosophical references, French existentialism in particular?

DG: I would say more literary, in particular the Nouveau Roman.

BB: At that stage already? Are we talking about the late 1950s, the early 1960s? Because Barney Ross's magazine didn't really publish Nouveau Roman writers at that time or did it?

DG: Yes it did. I don't think he published my favorite writer which was Michel Butor.

BB: In what way did that appeal to you? Was there not a disjunction between the interest in existentialist philosophy and the writers of the Nouveau Roman? But we are jumping too fast. Let's go a little further backwards to the early 1960s when you go to New York. At that moment you don't have the intention to become an artist and you don't have much knowledge of art, but you want to be a writer. Did you write already at that time?

DG: No, I wasn't doing anything.

BB: What about your interest in music and pop culture?

DG: It was a little bit after that. But what was a big influence was the fact that *Esquire* magazine, which was a picture magazine that had sociological, photographic and famous writer's contributions, was featuring art. Art was the most fashionable area it dealt with.

BB: Was that your first encounter with Pop Art? When did you see Warhol? As early as that or later?

DG: I think somewhat later.

BB: And what about European art, did you have any interest in European pre-war modernism at that stage?

DG: We Americans hated European art.

BB: I know that.

DG: There was one exception. When I met Sol LeWitt, he and Dan Flavin had just finished working as guards at the Museum of Modern Art and there was a show called 'The Great Russian Experiment'.

BB: That was not a show but Camilla Grey's influential book *The Great Experiment: Russian Art 1863-1922* which had just been published in 1962.

DG: There was a show there, and it was a huge influence on everybody. Not Duchamp. The Russian Constructivists.

On Sol LeWitt and Theoretical Formations

BB: When did you actually meet Sol LeWitt? Do you remember that date?

DG: The same year when I opened the gallery, in 1964.

BB: So Sol LeWitt came into the gallery and you met him and that's how you became friends?

DG: Sol and I had a lot of things in common. Being Jewish, we hated the humanistic American Jewish novels by Saul Bellow or Philip Roth. We both loved Michel Butor, but he also hated Alain Robbe-Grillet. He said: Donald Judd likes that goddam romantic Robbe-Grillet. Everybody was trying to be anti-humanist, anti-romantic.

BB: And Robbe-Grillet was too romantic?

DG: According to Sol.

BB: So liberal humanism was the target.

DG: Sentimental. We liked things European.

BB: So you were not at all interested in European art but all the more so in European literature and philosophy. I have often wondered how one could discuss what is theoretically a very complicated interrelationship, artistically probably less so: the transition from phenomenological thought to structural linguistic thought, two models which somehow are integrated within your work.

The theoretical story has always been that the one displaces the other, namely that the linguistic paradigm displaces the phenomenological paradigm or the psychoanalytic paradigm, even though of course phenomenology had a tremendous impact on the formation of Lacan's work

and probably on the formation of Derrida's work as well. How do you feel about making claims to have integrated two opposing philosophical models?

DG: Well, my work has nothing to do with theory. It simply has to do with hobby and I enjoyed reading theories from different areas. Although I absolutely hate linguistic theory because it all goes back to Descartes. I hate de Saussure. I think everything is so limited in French thinking because it goes back to these very simple ideas of de Saussure.

BB: What about Russian formalism?

DG: I loved Russian formalism in the 1960s, but I think they're all different theoretical approaches. France is so obsessed with Cartesian logic and tries to pin everything on de Saussure's ideas about language, and just like America is so obsessed with positivism that you can't get by them. But in the great artists like Bruce Nauman and some of my work, we play with a lot of different theories.

BB: When does your interest in French writing shift from Sartre and phenomenology and Nouveau Roman to Roland Barthes?

DG: I discovered Roland Barthes because a magazine that Tibor de Nagy was doing in 1965 published 'The World as Object' about Saenredam's paintings. And also *Evergreen Review* was publishing Barthes essays on Robbe-Grillet. But the big influences have never been the philosophers and theorists but people who were actually working more closely with specific themes like Louis Marin's essay about Disneyland. And I also liked early Pierre Bourdieu when he was an anthropologist.

BB: But in terms of a theoretical formation, how would you describe your own gradual change from mid-60s interest in phenomenology and behaviorist psychology and then in the early 70s you gradually moved from that into reading Michel Foucault? Your particular synthesis of French

structuralist, post-structuralist, semiotic and psychoanalytic theory was in fact in the early 70s also linked with an interest in Frankfurt School critical theory. To my knowledge at least you were one of the first American artists to read Walter Benjamin and T.W. Adorno and to incorporate the ramifications of their theories into your artistic practice.

DG: What interested me even more in the early 60s was European music. Sol and I both discovered *Die Reihe* (The Serial Row), a German musical journal with English translations. And I think Sol was at that time very influenced by Pierre Boulez and his music. I think two other people among Sol's influences were Michael Kirby and his best friend Robert Mangold.

BB: What about John Cage at that time when you started reading *Die Reihe*? Was Cage a presence for Sol in 1964 as well?

DG: I don't think so.

BB: Was he for you?

DG: Werner Heisenberg's thinking was much more of an influence. In other words, we were reading a lot of science. We were also reading a lot of cybernetics.

BB: Norbert Wiener?

DG: Some people liked Wiener, and the cybernetics of feedback. But in my work *Schema* from 1966 I was interested in all of these things. In other words, we wanted to do work that was purely about information, very much what people are interested in now.

BB: What was Sol Lewitt's first work for your gallery?

DG: A booth made out of lacquered wood that you could enter.

BB: And what did it show inside?

DG: It was empty. It was like a stage set. It was a three-dimensional adaptation of a Frank Stella.

BB: About the size of a telephone booth?

DG: A little bit bigger. It was painted with a purple red lacquer, some kind of car color. Everyone was using Krylon Spray

paints. Sol used industrial lacquer. Sol's idea was that everything was to be discarded after the show, the work should become firewood in Sol's case or go back to the hardware store in Flavin's case. It was a kind of utopian materialism where they would get rid of the idea of art's monetary value.

On Robert Smithson and Other Early Friends

BB: Who else came to the gallery at that time?

DG: Well, there was this creepy but brilliant guy who used to come in and talk and wanted a show: Robert Smithson. He was changing from an identification with Warhol to an interest in Minimal Art. Smithson and I became close friends and we influenced each other a lot at that time. He had a lovely wife and we all got together at their salon. Bob had many contacts, actually it was through his friend Mel Bochner that my contact with *Arts Magazine* was made.

BB: And at that time, you still didn't consider yourself an artist?

DG: Well, what I liked about art in the 1960s was that you could do everything. Everybody I met, Robert Smithson, Donald Judd, Dan Flavin, all wanted to be writers.

BB: Even Flavin?

DG: Flavin wrote for *Artforum*. Every two or three months, he was a regular contributor.

BB: But when you say writers that didn't mean critics at the time, right? We are talking of writers of a different kind.

DG: Flavin thought he was like James Joyce. Smithson probably thought he was Borges.

BB: And what writer were you aspiring to be?

DG: Godard.

BB: So after your discovery of the Nouveau Roman, Godard became the key figure? Was he eventually the most important French influence on your work?

DG: Yes, because he was doing very

funny and instantaneous films that were like magazine essays. I remember in particular his films *The Married Woman, One or Two Things I Know About Her Weekend,* and of course the film today's neo-60s kids love, *Contempt,* which I loved. It was a huge influence on me. Sol was very influenced by Michelangelo Antonioni.

BB: How would that be evident in his work that he was influenced by Antonioni?

DG: Well, for one in his fascination with the emptiness of the city's architectural space, the empty grid of modern urban architecture. Sol worked for I.M. Pei. And he was later also a chief layout designer for *Seventeen Magazine.*

Sol got me very interested in architecture. But even more interesting was an article that Donald Judd wrote for *Arts Magazine* about city planning in nineteenth century Kansas City. So I think *Homes for America,* which was not about the white cube but about the suburban city plan as a basis for art, was influenced by all those things.

Furthermore, perhaps unconsciously, Robert Mangold had a huge influence on me. Mangold was ambiguously in between painting. He was doing reliefs. He was doing the same thing that Judd was doing. I saw their works as facades of suburban houses, do it yourself home masonite. My pavilions still derive from Mangold's paintings. He was also the first person to appreciate my work.

On Dan Flavin

BB: I am puzzled by your early and seemingly lasting fascination with Dan Flavin because both aesthetically and politically speaking there is a very reactionary dimension to Flavin's work. In his variation of post-painterly abstraction, he was deeply committed to a new spirituality of color generated by his chromatic readymades.

DG: When you're dealing with light and transparency, spirituality enters into it, but I think at first that Flavin was totally ironic. But he was also a priest, one day from being a priest. He was influenced by Medieval theologians like William of Ockham and by the orthodox icon tradition. I think that it also came from American culture influenced by German culture. Flavin encountered it in Barnett Newman, but he was also very involved in the Hudson River School, painters like Albert Bierstaedt and Frederick Church who had been influenced by Caspar David Friedrich. But I think that's true of most American art. My art is very much like that, particularly the outdoor pavilions. They are landscapes and they are not about spirituality but about a kind of ecstasy of the changing landscape. I think most art has that. In Russian art you have the same contradiction. Malevich was very spiritual but also very material at the same time.

BB: But in Russian art the concern with spirituality changes five years after Malevich's Suprematism with El Lissitsky and Alexander Rodchenko. In their work, in dialogue with Malevich's, spirituality is completely evaporated, and I thought that such an empirical-critical attitude was closer to your position?

DG: I also liked the nasty criticality of what Flavin was doing. In other words, because he was using colored lights, they replaced the normal lights that illuminated the white cube and thereby he also destroyed all the other art on view in that space.

BB: So can those positions be fused, to be a spiritualist in the mystical tradition of Barnett Newman and to be a materialist in the Duchampian tradition, to reflect upon the context of the gallery and its institutional framework?

DG: I think it was much better than Duchamp, who was being ironic.

BB: And Flavin was not ironic?

DG: I think he was ironic but he was also coalescing unlike things. But I think Flavin was more aggressive. He said art was

becoming interior decoration and he was thinking that the white cube was illuminated by spotlights and floods. So the idea was to install fluorescent lights that would destroy the neutrality of the white cube and also to make optical effects when you looked out the window.

On Roy Lichtenstein and Pop Art

BB: So the Minimalists would be one peer group, but what about the other group of artists of the early to mid-60s, the Pop Artists? What about the legacy of Marcel Duchamp at the moment of your formation?

DG: Duchamp had no effect. I think he only influenced Jasper Johns. Duchamp was sort of a gigolo hanging out with very rich older Philadelphia society people and we were just working people. In other words, he was a bit of an aristocrat.

BB: How would you have related to the generation of Pop artists after your encounter with Sol LeWitt for whom Johns and Stella were of course extremely important?

DG: I think everybody loved Stella and Johns.

BB: But you also knew Robert Ryman personally at that stage.

DG: We considered him a little narrow, a traditionally romantic painter.

BB: So it seems that painting was really not acceptable for you and your peers at all at that moment in spite of the veneration for Stella and Johns. Were they the last painters that were acceptable?

DG: Sol and I also loved Roy Lichtenstein's work – especially for its 'deadpan' humor.

BB: In retrospect, don't you think it's a strange choice to have chosen Lichtenstein over Warhol?

DG: Warhol had no sense of humor.

BB: Which is not true. You can think he did not, but of course he had a lot of humor.

DG: Also I guess he wasn't concerned with the reduction of representation. By contrast I thought Lichtenstein's work was about the representation of a representation. Also it had enormous humor. I think I also loved Lichtenstein because it was about printed matter.

BB: How was it about printed matter? Why not about painting?

DG: He took things from printed matter and he gave them the quality of printed matter. Judd wrote that he was representing representation in printed matter and images. Also he wanted to destroy painting.

BB: Did he really want to?

DG: He said he did. He said that he couldn't believe that it became valuable.

BB: But it was painting, and you just said a little while ago, painting was irrelevant for you and you basically hated painting. That's why you didn't like Robert Ryman. And in retrospect, don't you agree that Lichtenstein was a great, but a very traditional painter?

DG: Gerhard Richter said to me that he was most interested in Lichtenstein's work. I think the work that we loved was about anarchistic humor. Banality and humor were very important.

BB: That would have qualified Warhol, but for you it didn't evidently then. So there is a certain inconsistency in your argument and some contradictions that are pretty surprising. And Warhol's involvement with music was not interesting to you at that stage either? Was the Velvet Underground too sophisticated for your radical musical taste?

DG: No, I saw the Velvet Underground in their last concert at Max's Kansas City. It was wonderful, but nobody was there.

On Fluxus and An Anthology

BB: Strangely enough, it seems that none of your peers were ever interested in Pop Art's dialectical Other, the artists of the

Fluxus movement. What was the matter with Fluxus?

DG: Fluxus was just before Minimal art. So of course, Minimal artists were totally unaware of it, except Sol Lewitt's best friend Michael Kirby wrote the definitive book about Happenings. So we were very aware of Happenings.

BB: I have always been amazed at the peculiar hiatus between Conceptual art and the moment of Fluxus, since there seem to be many plausible connections and continuities. When one speaks to the artists of your generation, however, the opposite seems to apply: whenever I've spoken to either Sol LeWitt or Robert Morris, or more recently, to Lawrence Weiner or Robert Barry about the Conceptual artists' relationship to Fluxus, they all more or less explicitly seem to have hated or ignored it. Since 'printed matter' and new distribution forms would become so important for you, what was your relationship to a publication such as *An Anthology* for example? Was that an important book for you?

DG: I met La Monte Young in 1968 at which point I read the Fluxus *Anthology* and I realized it was wonderful. Walter de Maria, another artist included in *An Anthology* was an incredibly great artist, it took me a long time to understand how great he was. When I did the special issue of *Aspen* magazine, it was heavily Fluxus oriented and I asked George Maciunas to design it.

BB: Your *Aspen* issue on Conceptual Art with the Jo Baer cover was designed by Maciunas?

DG: Absolutely. I was turned on to him by David Antin. I had Ed Ruscha do something, Jo Baer, early Richard Serra, Phil Glass, we published a Steve Reich record and on the other side of the record were poems by Jackson MacLow who was also Fluxus.

BB: So there was in fact a bit more overlap and interaction than previously acknowledged, I suppose.

On Ed Ruscha and Photography

BB: So then in 1966, you repositioned yourself, when you decided to become an artist. Is *Schema* one of your first works, even before *Homes for America?*

DG: My first works as an artist are probably the photographs I took with the Instamatic camera which were included in a show called 'Projected Art' at Finch College. They were a little like my old friend Jeff Wall's cibachromes. They were back illuminated because they were slides. They had to be shown as slides.

BB: Enlarged back illuminations?

DG: No. They were just projected slides. I also wanted to reduce something to a simple transparency in a fixed focus Kodak camera, the cheapest camera you can get. What I was trying to get was the colors and irridescent transparency of Judd through projected slides. Their seriality was relating them to serial music and also to very simple Rock'n Roll like the early Kinks. Blam, blam, blam. Or actually to *Contempt* by Jean-Luc Godard.

BB: So these are the very first images that you showed? These are the homes from New Jersey, New Jersey architecture, the diner pictures?

DG: I used my Instamatic to go to New Jersey, taking railroads back to my parents' house where I was living, Westfield. And I saw a lot of things from the trains. I used to walk along the railroad beds, looking for things to photograph.

BB: What about your usage of vernacular photography as opposed to the high tradition of American WPA documentary photography, Walker Evans in particular?

DG: I didn't know anything about photography except good photography was very pretentious – trying to be 'high art.' Photography then meant the kind of

things that our friend Jeff Wall is interested in like Cartier-Bresson. In other words, official formal photography that museums collect, black and white photographs, people like William Eggleston. Not Walker Evans who had been combining photography and magazine pages, but the idea of the photograph as a work of fine art like a painting.

What I liked was amateur photography. Photography as a hobby. Ruscha and actually Smithson, he discovered the Kodak Instamatic camera. I think Douglas Huebler also did that. Also instantaneousness was very important and the fact that it was the kind of photography that anybody could do.

BB: Why is the model of art as a 'hobby' so interesting to you? Because it is against artistic virtuosity and professionalism? Is the concept of art as 'hobby' another kind of de-skilling project, de-skilling photography as much as high art subject matter by shifting to the vernacular?

DG: I think the artist as professional is the worst idea I have ever heard about.

BB: The critique of the artist as professional was of course also a crucial issue for Fluxus artists. But in your case, it didn't come from that, it came from a Pop Art perspective or possibly even from similar positions developed within the Russian and Soviet productivist project?

DG: Well, since I was very influenced by Flavin, I think it came from a Constructivist position. But also Flavin had a lot of Pop Art, nastiness and humor.

BB: Well, what was your relationship to Ed Ruscha's books at that time?

DG: Sol LeWitt loved them, but I'd never seen them.

BB: When did you see them? When they were done in 1962? The first, *Twenty Six Gasoline Stations,* certainly introduces the de-skilling of photography with a focus on vernacular architecture?

DG: I'd never seen it. Ruscha was the designer of the first issues of *Artforum* in San Francisco and we were all very influenced by this.

BB: So you had some sense of Ruscha even though you said you would not see the books until the late 60s?

DG: No, I had no sense, but I think in terms of Pop Art influencing Conceptual art, I think Ruscha is the key figure. Also his sense of humor. Since my early conceptual art is totally about humor and printed matter, of all the artists, I think it's closest to Ruscha except I couldn't paint.

On Bruce Nauman and the Critique of Minimalism

DG: I was the first person to criticize Minimalism in my essay 'Subject Matter' that was given to *Artforum* and they rejected it. Then I published it myself along with other rejected articles in a volume called *End Moments* in 1969.

'Subject Matter' was against formalism, in favor of content, and about the 'subject' in relation to the in-forming of matter as a process in time. It was also about optics. At that moment I was totally floored by discovering Bruce Nauman, but I was also influenced by Steve Reich and by conversations with Richard Serra. So the entire article is a critique of the objectivity of Minimal art. I was more interested in subjective, time based perceptual processes. At first, Bruce worked a lot from Dan Flavin.

BB: But when Bruce Nauman did the performance with the fluorescent light tube, I always thought that was a rather explicit critique of Flavin.

DG: Given Bruce's interest in humor, it was a parody. And it was an extension to the body. In other words, everything is part of the body of the performer, and also the body of the spectator.

BB: But to what degree does Nauman's conception of the body change when you

introduce the body into your own work, and to what degree does that conception change when Acconci introduces the body into his? That's a very important historical development. Your deployment of the body is very different from Nauman's, and Acconci's conception of the body is even more different.

DG: Well, I think I was more interested in audience participation than Bruce, especially when I conceived of spectators as a large group of people, because I was interested in rock concerts. So it was the body in relationship to a large audience, their bodies, their perceptual processes. In terms of Vito Acconci, he read my article 'Subject Matter' before it was published, and many of his ideas come from my description of Nauman and Serra. Acconci is very good at theater.

BB: Nauman is deeply engaged in a phenomenological conception of a transhistorical body. Whereas in your work the phenomenology of the body is already redefined at least in terms of a sociological dimension of bodily interaction, if not even in the conception of the body as socially gendered.

DG: I think that's too theoretical. I was interested in clichés. First I was a male feminist, second I loved the clichés of psychological models. Whereas I think Nauman was more serious. He was interested in working with sculpture, but subverting it. He had been very much involved with Anne Halprin's dance workshop in San Francisco, along with Simone Forti who would become the greatest influence on everybody. Steve Reich was in it as well. It had a lot to do with drugs, but it also had to do with the idea of process, with Terry Riley's and Steve Reich's use of just past time. We were interested in an extended present time, and process which Nauman, Eva Hesse and other artists were developing in contradiction to Minimal art. Steve learned a lot from Terry Riley who was

using time delay, and I think Nauman learned from Terry Riley and Steve Reich how to put time delay into video.

We 'minimal artist people' wanted to have the instant and then throw it away, because it was about subverting the idea of things that are collectible, that were heavy, and could be converted into precious objects. Nauman did this great piece at the Whitney Museum with Meredith Monk and his wife that I wrote about in 'Subject Matter.' It was also about architecture in a way that other people weren't. The architecture of the museum. As you walked through it, the museum became a sounding board.

BB: I would argue that the transition from Minimalism to Post-Minimalism, which is integral to your artistic project, has also generated a very problematic situation: sculpture that was once extremely radical and critical in many ways and that had been conceived for the discursive and institutional space of the gallery and the museum) became, as a result of its public attention and success, once again monumental sculpture rather than remaining a critical phenomenological project.

And of course that transition has generated a lot of the questions that your work addresses. Your work now seems to be situated between Richard Serra and Bruce Nauman on the one hand and Conceptual Art and Institutional Critique on the other. Except that you have addressed all the problems of public urban space and public social space in your models and have systematically incorporated those issues into the work.

But when it comes to the production of the pavilions, you seem to be more of a traditional sculptor once again, probably because that's the only way that public sculpture can be made, and you extract the work from urban space and transfer it to the pastoral context of the landscape garden.

You said in a recent interview that you have moved away from your educational and pedagogical interests with your work and that you find it more important that your pavilions now create something like a fascinating spectacle. Is that an indication of the gradual shift of aesthetics from the 70s to the 90s?

DG: No, I didn't say that. My work is still educational and it's also spectacle at the same time. *Children's Day Care, CD-ROM, Cartoon and Computer Screen Library Project,* 1998-2000, and the *Girl's Make-up Room,* 1998-2000, in other words, they're fitting into the museum area that gets the most money and is usually the most banal, the education area.

BB: Now we are getting to an issue that I wanted to bring up anyway: the question remains, what type of a spectator does the phenomenological address of your work really presume? Doesn't it still presume that neutral trans-historical spectator who is neither determined by class, by gender, by advanced conditions of reification? Isn't there a certain ideal utopian modernist dimension in the pavilion work that really still operates from the assumption that every spectator is equal, that every spectator has the constitution to define herself or himself within the act of perceptual embodiment?

DG: First of all, they are not for one person. They are always for people looking at other people looking at other people inside and outside. Second, what you are talking about seems to be a critique of what we cherish most in America, democracy, that every individual is equal and unique at the same time. In other words, my work is American populist and democratic.

BB: Well, things have become a little more complicated in the last ten years or so with regard to theories of subjectivity, haven't they? It has become evident that certain presumptions about the equality

and neutrality that phenomenology (and ideologies of democratic egalitarianism) inscribe into the public urban perception are rather dubious. As it has turned out, much more specific criteria are necessary to identify and critique the placement of the subject and the constitution of the subject and I think that is an issue that would be brought out in your model work much more explicitly than is being brought out in the pavilion work.

On Daniel Buren and Institutional Critique

BB: Let us return for a moment to the critique of the museum, as opposed to the involvement with public collective space and the perceptual processes of groups.

When did you meet Daniel Buren for the first time? What you just said of Bruce Nauman's work at the Whitney of course reminds one of Buren's approach even though what is always absent from his work is precisely the reflection on spectatorial perception and behavior. But the development of a critical analysis of the white cube and the museum institution is of course fully formulated in Buren's essay 'Limites Critiques' in 1969. Can you explain why you never seemed interested in the 'white cube' and the critique of the museum institution?

DG: I thought it was banal.

BB: Why was it banal?

DG: Because it's such a limited idea. It's an argument which says that the museum and the gallery represented the establishment. I got out of galleries long before by doing printed things in magazines, and I think Flavin effectively destroyed the museum and the gallery.

I think the best work of Buren's was when he was using advertising placards and it was very oriented toward his group BMPT and to the Situationists International. But I think his work was always very aesthetic, deriving from Ryman and from paper architecture in Japan.

BB: So you say the critique of institutions is a banal idea by comparison to your critique of urbanism. Can you explain that a little bit?

DG: It became very stupid. I think museums are great places. I realized that a museum could be a social space and I fell in love with the empty lobbies, the gift shop, coffee shop, areas where people could relax. So I did work like the *Three linked Cubes/Interior Design for Space Showing Videos,* 1986, where teenagers could lie on the floor. I think what I did was to discover the tradition of the museum instead of pursuing the stupid idea of Institutional Critique.

BB: It wasn't always stupid. It became stupid. But only as a result of the overall transformation of museum culture to become part of a larger project of leisure culture and the tourism industry.

DG: All my work is about city planning.

BB: So why do you think that dealing with the city plan and urbanism is more radical than the critique of the museum institution and the gallery space?

DG: I don't believe in that. I believe in constructing a new situation based on the just-past. See, with my pavilion at the Dia Art Foundation, it was a time when European sculpture and painting became important and people forgot about video and performance. The Kitchen was nearby, so I wanted to support the Kitchen. That's why I designed the video and coffee bar. The coffee bar came from the IBM atrium.

BB: So there's the radical utilitarian dimension again that you denied emphatically in our last conversation. I have always thought that this dimension was an important element in your work. The utilitarian function as much as the reflection on public conditions of simultaneous collective reception.

On Architecture and Related Matters

BB: The second major complex of historical information that I would like to introduce is your discovery of modernist architecture. Did your interest develop simultaneously with your involvement with Minimalism?

DG: Probably through Sol LeWitt who was interested in Lewis Mumford, so I read some Lewis Mumford. I could also have encountered it with early Judd since he was very interested in architecture. His interest were city plans of American cities. Also, once again, Michel Butor was a big influence on me since he was writing about the labyrinth of the city.

Then, in 1968 I went out to teach at UCSD and there John Baldessari introduced me to this great young artist, Michael Asher. I was staying with Michael and I met his best friend, John Knight, they were both very interested in architecture. But I think Michael wants to deconstruct architecture because he sees it as the establishment.

BB: So it's through the contact with Michael Asher and John Knight in 1968 and your subsequent reading of Venturi that your dialogue with modernist architecture begins?

DG: But what was also most important was *Oppositions,* the magazine published by the Institute for Architecture and Urban Studies which was directed at the time by Peter Eisenman. And I found that architectural historians and architects like Aldo Rossi and Anthony Vidler were doing more interesting writing than art criticism.

BB: So when did you actually start reading Venturi? Was *Learning from Las Vegas* the first book you read or *Complexity and Contradiction?*

DG: *Complexity and Contradiction.* And I became critical of Mies because Venturi was very critical of Mies after he had turned corporate. When I did *Alteration to a Suburban House,* I was trying to combine two works by architects who were perceived as opposites, Mies van der Rohe's Farnsworth House and Robert

Venturi's suburban facades. In retrospect, however, I see my work as being very much influenced by Mies, particularly after I saw the Tugendhat House in Brno. It has so many convex optical symmetries.

BB: You also say that you were always interested in vernacular architecture. When did that start?

DG: With the photographs.

BB: So that would actually be very early, 1966. What would be the first architectural model that you had actually built?

DG: Well, I think what happened was that I did this very good piece at the Venice Biennale in 1976. It was called *Public Space/Two Audiences*. And I realized the reason it worked was because it was a white cube situation: so I turned the one white wall into a mirror wall, and if I took away the other white wall in the other room it would make it into a window, it would become architecture. This is the promise of *Alteration to a Suburban House.*

Then, a year later, I saw a show that Leo Castelli did of architectural models by architects, so I thought why shouldn't an artist do architectural models? First, it's propaganda, to have a piece actually built, or it's cinematic fantasy.

Actually, I did them in England for a show at the Museum of Modern Art Oxford with some English people, architecture students, and they were all built at the same time: *Alteration to a Suburban House, Clinic for a Suburban Site, Two Adjacent Pavilions.*

But they were very detailed in terms of vernacular. It became factual. See, I wanted things to be on the edge between two things so they could criticize each other, very much like what Venturi was interested in, the hybrids between high modernist and low vernacular architecture. So I did about five suburban situations which were variations of the Venice piece in real architecture. Then I also started other works that were pavilions that you could walk into.

BB: But that's not quite plausible yet. Where would those ideas have come from at that time?

DG: Well, earlier when I was interested in video, I was comparing video with time delay to classic architecture ideas such as the Renaissance window, the mirror and instantaneous time in architecture. With video you can move into time delays and the disjunction between time and place. Remember, when I did the performance *Performer/Audience/Mirror,* 1977, I focused on the relationship between the consciousness of people in the audience and my consciousness as a performer. It was then that I discovered double sided mirrors and I wanted to use them in my work and in architecture.

I think the mirror was of interest to me also because I was always doing doubles. Things that are hybrids between one thing and the other thing, and I was very interested in the picture window. So in *Alteration to a Suburban House,* I wanted to combine Mies's Farnsworth House and a Venturi. I liked these impossible hybrids.

Since I was always interested in vernacular Century City office buildings, I discovered that two-way mirror material was increasingly replacing glass. In other words, people on the outside in the light could see simply the reflection of themselves in the sky. Whereas people on the inside could see through the transparent window.

BB: Without being seen. And those on the outside couldn't see the employees at work, but the employees could see outside.

DG: Without being seen, like surveillance.

BB: Is that where it came from?

DG: It came from both, psychology and ecology. The corporations were assimilating themselves to the environment and the sky through mirroring. Also of course,

mirrored glass was insulating, so it cut down the air conditioning costs.

BB: At what point does Mies van der Rohe's Barcelona Pavilion enter your awareness as a model for your own pavilion projects?

DG: Of course I knew Mies's Barcelona Pavilion, and I think it fits into the generic category of pavilions, which began in Renaissance and Baroque and Rococo parks. Finally, in the English garden where there were allegorical pavilions derived from philosophy and literature. Often they were political, and a case could be made for Mies's Barcelona Pavilion, to look at it as an English garden pavilion because it is allegorical. You walk through it; it's narrative and it's about the Weimar Republic and its products and its promises.

BB: That is a very interesting reading, but what if one would contradict that and say that the pavilion architecture of the 1920s becomes so central because architecture shifts from the tectonic to the semiotic? Architectural surfaces, rather than being oriented at structure and function, become sign oriented. That is why the pavilion both in the Dutch De Stijl, in Soviet Productivism as much as in German Weimar modernism acquires such a central function and popularity among architects. Don't you think that advertisement and architecture are fused for the first time in the architecture of the kiosk and the pavilion?

DG: I hadn't thought of that. It's Russian Constructivist architecture and it's pure Venturi. And of course Venturi's mentors were Ed Ruscha and Claes Oldenburg.

On Pavilions and Parks

BB: Your work with pavilions situated in parks has sometimes bewildered me. Isn't this type of garden culture a specifically European model that most American places would not offer you? Don't you think there is a strange historical hiatus in your work when you claim that you continue the tradition of the folly and the garden pavilion under the circumstances of a rapidly advancing ecological disaster and the imminent final destruction of nature? And here is this American artist who suddenly builds garden pavilions as though he was living in a world of the Rococo or Baroque garden?

DG: If you know the historical situation, parks outside of cities were originally landscaped cemeteries because the Enlightenment wanted to make the cities hygienic. So the cemeteries and then later the parks, which were on the outskirts of cities or inside cities, were utopian counter-forms to the destruction of the city interior.

I think I started being involved in gardens when I realized that the first museums were actually Renaissance gardens. The museum began near the Enlightenment to educate the middle class and to house artifacts. But actually the outdoor parks of the Renaissance, the Baroque period, and those in the time of the Rococo were also museums.

BB: In the sense that they were sculpture gardens?

DG: They related to philosophy, to political allegory, poetry, to science and archaeology, all those things that museums are involved in as well.

BB: But how do you think that could be translated into the present? Doesn't that trouble you when you pretend that there could be such a thing as continuity between the Baroque and Rococo garden and the present day?

DG: Well, all parks are an overlay. If you go back to Laugier's 'Rustic Hut,' the park was always a kind of utopian retort to the destruction of the city. In other words, these pavilions weren't follies, the 'Rustic Hut' was a model for a better city.

I always use materials for the modern city in the park pieces, two-way mirror,

which instead of being one-way mirror for surveillance, is always both transparent and reflective simultaneously, fluctuating back and forth. So in other words, I'm trying to utopianize or open up the materials of the city, but they're always in relationship to the city just like the park is in relationship to the city plan.

BB: So how could the two be interrelated, the feudal, aristocratic model and the advanced capitalist corporate model? I still don't see the connection. I can see that one can make a connection, but it's still puzzling and surprising that you link the two.

I have another, related question, concerning a strange discrepancy or possibly a dialectic between your models and your pavilions. One way of describing it would be to say that the models act out the Pop legacy, and the pavilions represent the continuation and transformation of the Minimal legacy in your work. Because in a strange way, the pavilions are very abstract and phenomenological and they omit literally every aspect that made your work so different from Minimalism.

Your work focused on social contexts as much as it focused on psychoanalytic knowledge, as much as it engaged in some form of critique of ideology. All of that is very poignantly present in the models as they reveal experiential conditions of everyday life and ideological intersections within public and private spaces.

Whereas the pavilions appear as pure Minimalism transformed into public urban sculpture with this peculiar aspiration towards what Thomas Crow has called the pastoral.

You yourself talk about the park and the tradition of the park as being very important for the formation of the pavilion, and there seems to be a strange disjunction between the radicality and the aggressivity of the architectural models and their social interventionism and the relatively

peaceful, relatively well-adjustable pavilion proposals that in fact are the ones that are being built. Whereas the radical models as we know, have not been and can not be built.

One could almost say that the underlying phenomenological theory in the pavilion pieces is not that different from the phenomenological work of Richard Serra. It just uses different materials.

DG: I think that what you say is totally incorrect, it's utterly different. Most of the pavilions, the best of my 'pavilions' are quasi-functional, like the DIA roof.

BB: Let's shift the same question into a different register. One could argue that in the initial phase of your pavilion work, there is a positive modernist dimension, which links you to Mies van der Rohe. As you have said yourself, in many ways the degree of self-reflexivity and self-criticism that is both modernist and Brechtian in your work has had a tremendous impact in forming your work into the mid-to-late 1970s. Then, as it seems, under the impact of a different type of theory, namely under the impact of your readings of Michel Foucault and Manfredo Tafuri, your work has taken a turn into a much more pessimistic outlook on the legacy of modernism and the practices of later modernism in the present day.

So what about this dialectics of modernism turning from an utopian project to a project of extreme criticality and self-inspection to a melancholic, not to say pessimistic criticism?

DG: My work is always critical. Never pessimistic.

On Albert Speer and Fascinating Fascism

BB: You were just talking about Flavin's attempt to synthesize Vladimir Tatlin and Albert Speer. That seems a really interesting, but rather bewildering idea because I actually think that there is a latent totalitarian dimension in Flavin and Judd, which

is one reason why I have become increasingly skeptical towards Minimalism at large.

Do you see the actual historical borders between American late capitalist corporate culture of the 1990s and fascist culture of the 1930s as being much more perforated and fluent than most other people would? Could that be one reason why you think American artists of the early 1960s were already interested in Speer? Is that how you would describe it? To establish the continuity and make that continuity visible?

DG: But it was parody. Because we were against official culture in America which was saying we Americans are always good. That was bad. Sol was also very involved with Speer because he hated liberal humanism. We distrusted the generation of our parents. And also we hated the gradual sliding of American liberal humanism toward the type of corporate liberal humanism that is now represented by Benetton.

BB: And a counter-identification with German fascism didn't seem outrageous or outlandish or overstating the problem? Since I would hope that in order to hate liberal humanism you don't have to make fascist resources available.

DG: I think it was the same as with our interest in the New Novel. We definitely wanted to eliminate subjectivity and we wanted to eliminate corporate iconography. And I think what was being used to support liberal humanistic corporate fascism was a hatred of Nazi icons. And in terms of Jews like myself, we loved everything German because it was our high culture.

BB: Pre-fascist German culture, I suppose.

DG: Well, also fascist culture for a while until I discovered how awful Philip Johnson was. But Speer was in some ways amazing.

BB: Was he really?

DG: In particular when he was working with Leni Riefenstahl.

BB: A genius of what, of propaganda?

That's probably why Andy Warhol venerated Speer and Riefenstahl as well? So your whole generation seems to have had an encounter with Speer and 'fascinating fascism' as Susan Sontag once called it. How did that work for Jewish artists of the early 1960s to rediscover and somewhat embrace German Nazi architecture?

DG: It's because Jewish and liberal people were making so much out of America being anti-fascist. When in fact all that we saw was corporate advertising taking over from Nazi propaganda and I think I write about this in my essay 'The End of Liberalism.' And it was also about not seeing ourselves as mean or troubling. I think advertising uses the graphic means that were discovered by fascism and I think very influenced by Swiss design, before these very same means went into corporate advertising. So I think it's part of the corporatization of the Nazi background.

BB: Do you still see that connection or do you see it even having increased?

DG: Well, I think there are now other ways toward that corporatization, like Disney. Wonderful cartoon figures becoming lovable, child-oriented corporate propaganda. I think what has happened now in the 90s, we are opposing the meanness and the greediness of the 80s and we are doing things that are child-oriented so that we can identify with ourselves as children and doing things for children.

BB: But we are also completing the project of the total dismantling of subjectivity that way, which is part of a proto-fascist agenda as well, to eliminate even the last resources of resistance and critique and oppositionality, so the identification with the child in a Disney mode is a perfectly consequent strategy to pursue.

DG: I think it's about consumerism.

On the Reception of Graham's Work

BB: I continue to be amazed that you as an artist who has now gained international

recognition of a considerable kind is still, at the best hesitantly, exhibited and collected in official American institutions. I don't know your recent collection history, but only a few years ago when I checked on these things a little bit, I had the impression that major American museums don't have any major work of yours. That might have changed in the meantime, but certainly there has not been a major American retrospective exhibition. All of the catalogues, and there are by now quite a few, have been published in Europe in the last five years alone. Of course, there is a book of essays that was published by an American publisher outside of the art world. Why is the American art world reluctant or recalcitrant regarding the reception of Dan Graham?

DG: I think more important was the reception I had by artists and younger curators in Europe. In other words, since I was a writer and I wrote about my own works and other people's works, people in America didn't take it seriously. They simply wanted me to be a writer.

BB: But Donald Judd wrote about art. And so did Smithson and so did Bochner and so did Flavin. We talked about that. And being a writer at the same time as being an artist is not what discredited you in the United States. It's actually somewhat of a tradition even, right?

DG: Well, I didn't have any money. I was living in a very inexpensive apartment. I had no teaching job, and in order to realize things, I had to go to other places and institutions where they would support production. So, in the 70s I went to the Nova Scotia College of Art where they had a lot of film and video and they did the first major book on my work.

BB: But still that doesn't answer why mainstream American institutions, even if they are very committed to some kind of contemporary art, have been so reluctant to get involved with late 60s Post-Minimal work that one could situate somewhere in the context of Conceptual Art and its aftermath. It's not just true for you. It's also true for Michael Asher and John Knight, and for Lawrence Weiner, and it is true for Robert Barry and for Douglas Huebler. They all have been skirted more or less by American institutions when all of them have had by now multiple publications and exhibitions in Europe.

DG: It's also a matter of defining high culture. I think for Germany after the war, everything American, high and low, was important, just as for Jews of my background, of my parents' background, high culture was Germany.

BB: But the same holds true for France and England, Italy and Spain where by now you have had equally strong interest in your work. Is it perhaps that the underlying model of complexity that your work represents complies more with a European aspiration towards what neo-avant-garde practices should do?

DG: I think it's the sheer spectacle and physicality of the work in Europe.

BB: Well, that would be applicable to Richard Serra as well, and he certainly by now has had a considerable American reception. Physicality and spectacle are two of his main features, after all. So I think it is precisely the complexity of your work inasmuch as it defies spectacle in certain ways and criticizes it, which is one of the aspects that American museum institutions don't seem to be able to respond to.

Could it also be that your apparently eclectic synthesis of pop culture, theoretical criticism, architectural models, undoubtedly perceived as a wide range of incompatible positions, disturbs people in America? There are other, monolithic genres and histories that they want to give preference to, namely the more conventionally defined positions of artists in painting and sculpture still reigning

supreme at least in the mainstream American museum reception.

The last question that I wanted to ask is whether for a moment you wanted to look at the 90s and the 60s in their relationship?

What is your perspective on the current situation both in terms of artistic production and in terms of the transformation of the institution of art? How would you describe your own place and position within that transformation and how would you evaluate these obvious changes?

DG: Well, for the Dia Art Foundation project I tried to reinstitute a video library, and to do performances. What actually was great about the 60s and 70s I think were the rock and performance clubs. Now what they want to do is to combine the music in the clubs in a crossover with galleries. They have a kind of fantasy idea of the 60s. Also in the 90s everybody thinks big is better and in the 60s, the idea was to do things for nothing, to defeat the system of value.

BB: So what about the professionalization of the art world as it has emerged now in the 90s? All political critique of one kind or another, and all forms of artistic rebellion and resistance seem to have disappeared and now artistic practices appear to be about total affirmation and total industrialization.

I think there are two formations that determine artistic practice now. One is the entertainment industry as a model and the other is the new development of digital technology and the huge complex of electronic culture which basically has made all artistic practices strangely obsolete, or hasn't it?

DG: I agree with you, but it's so fatalistic. I want my work to be for children and to work through entertainment by using parody. My *Ying/Yang* pavilion, 1997-98 is a parody of the corporate 'zen,' 'new age' works of Bill Viola. I did the I Ching in the 60s. But I don't want to be an aging 60s artist, but rather a 'neo-60s'/90s artist. I've learned a lot about parody by being influenced by a 'mocker' who was also a 'rocker': John Lennon. And also from Oldenburg.

A lot of problems for me were caused by European critics like yourself creating a somewhat elitist idea of the artist as some kind of genius. The other part was the way our culture changed in the 80s and 90s, becoming a totally corporate culture.

Chronology

Introductory Notes

This chronology is the first attempt to document comprehensively the works and writings of Dan Graham over a thirty-five year period. Departing from the conventional catalogue raisonné of an artist's œuvre based on the paradigm of painting, we have presented projects and accompanying texts following the record of their first publication and exhibition. Graham's earliest works were 'conceptual' works in language and printed matter for magazine pages. His artistic production was from the very beginning mirrored by a writing practice, including art criticism and essays. During the years 1969-1970, Graham produced no less than five catalogues documenting the body of work and writings he had been producing since the John Daniels Gallery closed in June of 1965, the first of which was the self-published book *End Moments* (New York 1969), a xerox book of approximately 150 copies.

This chronology is a survey of projects during the years 1965-2000 and texts on those projects, compiled from the extensive record of catalogues and writings collections on Graham's work since the origin of *End Moments*. Following the logic of this publication record, Graham's work has not been approached as a set of studio 'objects,' but rather as a complex record of a practice in its physical manifestations and written forms, and in its subsequent life through media and published forms. Thus we have not included every individual drawing, photograph, proposal or model known to us. Instead, our focus has been to present Graham's projects in various media – works for magazine pages; works in performance, photography, film and video; designs for exhibitions, stage sets, models and pavilion structures; and collaborative works – in a regular format reflecting their exhibited and published forms.

The format is based on Graham's own, whereby each project is presented with a text written by the artist. In almost all cases this text is presented as it was first published, or if there are several versions, by the definitive version, and without cutting. The texts have been left as they are with only corrections of spelling, punctuation, or syntax. To this we have added references to the exhibition and publication history of the project. The 'Notes' column includes a variety of additional details regarding the process from conception to realization of a project and the conditions of its exhibition or siting. 'Notes' also includes the collection information for the pavilion works only. Collection information, since it is specific to individual works and documentation of works loaned to the exhibition and not to the projects per se, can be found in the exhibition checklist.

Works in architecture – exhibition designs, models and pavilion structures – are presented in the year of their realization or exhibition. Our focus has been on realized pavilions or proposals that Graham has continued to publish even if they have not been realized. Since the models and pavilion structures engage the fields of art, architecture, and exhibition design all at once, art historical methods are hardly adequate to document these works.

Graham's written output is extensive, and has been considered here as a central facet of his visual production. This writing falls into two categories – writings on works and articles – yet they are hardly discrete. Each catalogue entry includes the text on that project (except in the few cases that one does not exist) and the bibliographical source. At the end of each year, we have listed all of Graham's articles in the year of their first publication. It should be noted that this list includes project texts and documentation of works that were published in periodicals. In the bibliography, this listing is presented again by year for reference, and supplemented with information regarding reprintings and an inventory of collected writings books.

Abbreviations Used in Chronology

End Moments 1969
End Moments. New York: Dan Graham, 1969.

Two Parallel Essays 1970
Two Parallel Essays/Photographs of Motion/ Two Related Projects for Slide Projectors. New York: Multiples Inc., 1970.

Some Photographic Projects 1970
Dan Graham: Some Photographic Projects. New York: John Gibson, 1970.

1966 Dan Graham 1970
1966 Dan Graham. New York: John Gibson Gallery, 1970.

Performance 1970
Performance 1. New York: John Gibson Gallery, 1970.

Selected Works 1972
Selected Works, 1965-1972. Exh. cat. London: Lisson Publications and Cologne: König Brothers, 1972.

For Publication 1975
For Publication. Los Angeles: Otis Art Institute of Los Angeles County, 1975.

Six Films 1976
Six Films. New York: Artists Space, 1976. Xerox brochure.

Basel 1976
Dan Graham. Exh. cat. Basel: Kunsthalle Basel, 1976.

Films 1977
Films. Exh. cat. Geneva: Éditions Centre d'Art Contemporain, Salle Patino and Ecart Publications, 1977.

Nova Scotia 1979
Dan Graham: Video-Architecture-Television, Writings on Video and Video Works, 1970-1978. Ed. Benjamin H. D. Buchloh, with contributions by Michael Asher, Dara Birnbaum. Halifax: Nova Scotia College of Art & Design Press and New York University Press, 1979.

Buildings and Signs 1981
Dan Graham: Buildings and Signs. Exh. cat. Ed. Anne Rorimer. Chicago: The Renaissance Society at The University of Chicago and Museum of Modern Art, Oxford, 1981.

Theatre 1981
Dan Graham: Theatre. Gent: Anton Herbert, 1981.

Perth 1985
Dan Graham. Exh. cat. Perth: The Art Gallery of Western Australia, 1985.

Munich 1988
Dan Graham: Pavilions. Exh. cat. Munich: Kunstverein München, 1988.

Yamaguchi 1990
Dan Graham. Exh. cat. Yamaguchi City: Yamaguchi Prefectural Museum of Art, 1990.

Bleich-Rossi 1990
Dan Graham: Drawings: 1965-69. Exh. cat. Graz: Galerie Bleich-Rossi, 1990.

Public/Private 1993
Dan Graham: Public/Private. Exh. cat. Philadelphia: Moore College of Art and Design, 1993.

Generali Foundation 1995
Dan Graham: Video/Architecture/Performance. Ed. Sabine Breitwieser. Vienna: Generali Foundation, 1995.

Nordhorn 1996
Dan Graham: Two-Way Mirror Pavilions/ Einwegspiegel-Pavillons 1989-1996. Exh. cat. Ed. Martin Köttering and Roland Nachtigäller. Nordhorn: Städtische Galerie Nordhorn, 1996.

Santiago de Compostela 1997
Dan Graham. Exh. cat. Ed. Gloria Moure. Santiago de Compostela: Centro Galego de Arte Contemporánea, 1997.

Architecture 1997
Dan Graham: Architecture. Exh. cat. London: AA Publications, Architectural Association, 1997.

Sharawagdi 1998
Sharawagdi. Exh. cat. Ed. Christian Meyer and Matthias Poledna, Baden: Felsenvilla with Verlag Walther König, Cologne, 1998.

Two-Way Mirror Power 1999
Two-Way Mirror Power: Selected Writings by Dan Graham on His Art. Ed. Alexander Alberro. Cambridge, Mass: MIT Press, in association with Marian Goodman Gallery, New York, 1999.

1964

Location
John Daniels Gallery
1964-65
17 East 64th Street,
New York, NY 10021

Notes
In his article 'Entropy and the New Monuments' (1966), Robert Smithson penned one of the only 'reviews' the John Daniels gallery would receive, on the solo exhibition of Sol LeWitt in May 1965. Smithson described the dark lacquer-painted wooden structures as 'monumental obstructions.' He also included an installation view of the works. Robert Smithson, 'Entropy and the New Monuments,' *Artforum* 5, 10 (June 1966): 26-31.

Exhibitions
Opening group exhibition, December 22, 1964 – January 23, 1965. No title, no invitation card.
'Fukui,' January 26 – February 13, 1965. Solo exhibition.
'4D,' February 16 – March 6, 1965. Group exhibition: di Suvero, Fleming, Forakis, Grosvenor, Magar, Meyers, Ruda, Tamara, Valledor, Villa.
'Plastics,' March 16 – April 3, 1965. Group exhibition: Amino, Arman, Cox, Dienes, Fleminger, Forakis, Gesner, Ginnever, Greenly, Judd, Katzen, Levinson, Mack, Meneeley, Myers, Navin, Pohl, Samaras, Seamus, Smithson, Sobrino, Watts, Weinrib.
'Tadaaki Kuwayama,' April 6 – May 1, 1965. Solo exhibition.
'Sasson Soffer,' 'Ceramic Masks,' April 10 – closing date unknown, 1965. Solo exhibition.
'Sol LeWitt,' May 4 – closing date unknown, 1965. Solo exhibition.

Dan Graham opened the John Daniels Gallery in late December 1964 and served as director until the end of June 1965. The gallery was located at 17 East 64th Street, in a space Andre Emmerich had previously occupied before moving to 57th Street. The gallery name was derived from the first names of two of the three founding partners in the gallery, Daniel Graham, John van Esen, and Robert Tera. Tera was a friend and neighbor of Graham's, and van Esen was a friend of Tera's. Graham was twenty-two at the time, and Tera and van Esen were a few years older. Graham was the director and sole staff member at Daniels gallery. He handled all of the duties of a gallerist, from visiting artists' studios and handling artworks to designing the invitation cards, installing the exhibitions, and making sales. Later, David Herbert was hired to serve as an additional salesman. At this time, Graham's professional interest was to be a writer. However it was during his tenure at the John Daniels Gallery that he was introduced to the contemporary art world in New York. The gallery was inaugurated with an open group exhibition just before Christmas 1964. During the gallery's first season, Graham exhibited works by Dan Flavin, Donald Judd, Robert Smithson, and many other artists in group exhibitions and gave Sol LeWitt a one-person exhibition in May 1965. Graham promised Smithson and Leo Valledor one-person shows in the fall season, but the gallery closed at the end of June due to insolvency. Graham briefly resurrected the John Daniels Gallery in January 1970 at 84 Eldridge Street, Apt. 7, New York (his apartment and studio during this period) in order to premiere his first two films: *Sunset to Sunrise* (1969), and *Binocular Zoom* (1969-70).

Based on an interview with the artist, April 11, 2000, New York.

In 1985 Graham wrote on his experience at the gallery: [...] I became involved with the art system accidentally when friends of mine suggested we open a gallery. In 1964, Richard Bellamy's Green Gallery was the most important avant-garde gallery and was just beginning to show people such as Judd, Morris and Flavin. Our gallery, John Daniels, gave Sol LeWitt a one-man show, as well as doing several group-shows which included all the 'proto-Minimalist' artists whether they already showed at Green Gallery or not. We had also plans to have a one-man exhibition of Robert Smithson – then a young 'Pop' artist. However, the gallery was forced to close due to bankruptcy at the end of the first season.

If we could have continued for another two years, with the aid of more capital, perhaps we might have succeeded. Nevertheless, the experience of managing the gallery was particularly valuable for me in that it afforded the many conversations I had with Dan Flavin, Donald Judd, Jo Baer, Will Insley, Robert Smithson and others who, if they were not able to give works for thematic exhibitions, supported the gallery by recommending other artists and by dropping in to chat. In addition to a knowledge of current and historical art theory, some of these artists had an even greater interest, which I shared, in intellectual currents of that moment such as serial music, the French 'New Novel' (Robbe-Grillet, Butor, Pinget, etc.), and new scientific theories. It was possible to connect the philosophical implications of these ideas with the art that these 'proto-Minimal' artists and more established artists such as Warhol, Johns, Stella, Lichtenstein and Oldenburg or dancers such as Yvonne Rainer or Simone Forti, were producing. [...]

Dan Graham, 'My Works for Magazine Pages: A History of Conceptual Art,' *Perth* 1985: 8.

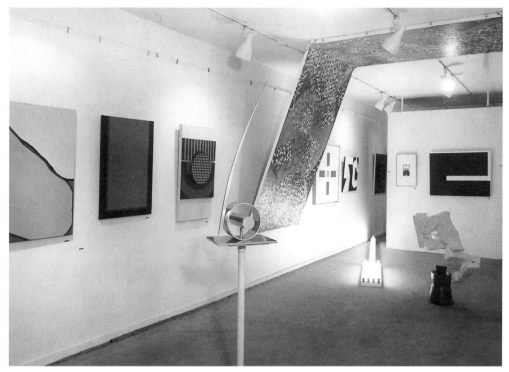

Invitation card, front and
back, 'Sol LeWitt,' 1965,
John Daniels Gallery,
New York, USA.

Installation shot, opening
group 'Christmas' exhibition,
1964-65, John Daniels
Gallery, New York, USA.

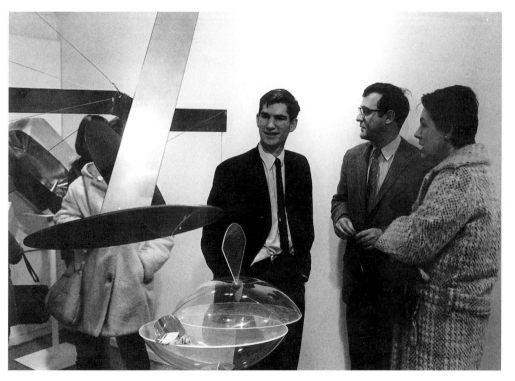

Invitation card, front and
back, '4D,' 1965,
John Daniels Gallery,
New York, USA.

Opening reception, '4D,'
1965, Dan Graham (center),
John Daniels Gallery,
New York, USA.

Title/Date
Scheme
1965

Materials
printed matter

Dimensions
variable according to
publication

First publication
Dan Graham, 'Discrete
Poem without Memory,'
0 to 9 no. 4 (June 1968):
94. Text first published
(with *Scheme*) *End
Moments* 1969: 50-51.

First exhibition
'Cre-Action,' Goucher
College, Baltimore, 1967.

Notes
Alternate titles: *Number
Scheme* or *0 to 9*. In a
reduced scale *Scheme*
(1965) appeared as an
illustration in Robert
Smithson's article
'Quasi-Infinities and the
Waning of Space,'
Arts Magazine 41, 1
(November 1966): 28.

[…] *0 to 9* is something like Jasper Johns' earlier series and also Pascal's probability tables. It was for use either as a page (to be truncated when the last line neared the bottom of the sheet) or to be extended indefinitely in a book. Composed in 1965, it was used by Robert Smithson in a 1966 article in *Arts Magazine* as an illustration boxed to the side of the page. If it is ever used in a book it would run page by page, so the angle of the triangle diminishing gradually to infinity with the progression and the type also necessarily doing likewise would cause a cessation at some point in the book's interior. It begins at a point and is read. Placing is the ordering of terms as in reading the reader's eye's place (or point of fixation) is continually shifting. […]

End Moments 1969: 51.

```
                              0
                              0
                          1   1
                          0   1
                      2   2   2
                      0   1   2
                  3   3   3   3
                  0   1   2   3
              4   4   4   4   4
              0   1   2   3   4
          5   5   5   5   5   5
          0   1   2   3   4   5
      6   6   6   6   6   6   6
      0   1   2   3   4   5   6
  7   7   7   7   7   7   7   7
  0   1   2   3   4   5   6   7
8   8   8   8   8   8   8   8   8
0   1   2   3   4   5   6   7   8
9  9  9  9  9  9  9  9  9  9
0  1  2  3  4  5  6  7  8  9
10 10 10 10 10 10 10 10 10 10 10
0  1  2  3  4  5  6  7  8  9  10
11 11 11 11 11 11 11 11 11 11 11 11
0  1  2  3  4  5  6  7  8  9  10 11
12 12 12 12 12 12 12 12 12 12 12 12 12
0  1  2  3  4  5  6  7  8  9  10 11 12
13 13 13 13 13 13 13 13 13 13 13 13 13 13
0  1  2  3  4  5  6  7  8  9  10 11 12 13
```

Title/Date
Scheme (book version)
1965/73

Materials
book: 130 leafs, front and
back cover of mylar,
bound with pins

Dimensions
7 1/4 x 8 1/2 in.
18.4 x 21.6 cm

First publication
Published by Gerald
Ferguson with assistance
by Ken Porter and Lyn
Horton, Nova Scotia College of Art and Design,
Halifax, Nova Scotia,
1973. *Scheme* 1965-73
was published in an edition of 10, with 6 copies
numbered 1-6/6 and 4
production proofs. The
master production proof is
a computer printout made
at a neighboring college to
the NASCAD, Dalhousie
University, in 1972. This
master was then xeroxed
to make the edition.

Notes
When *Scheme* is extended
over a number of pages it
generates a symmetrical
triangle measuring 630
inches (16 m) high.
As the width of the book's
pages is 7 1/4 inches, the
book represents that triangle by a cross-section
6 1/4 inches in width taking
into account the page's
margins. *Scheme* ends
with the row 999 at page
125, while the structure
may be extended *ad
infinitum.*

Scheme, 1965/73, master
production proof. Collection
Gerald Ferguson, Halifax,
Nova Scotia, Canada.

My number *Scheme* (1965) was designed for use either as a page (to be truncated when the last line nears the base of the sheet of paper) or to be extended indefinitely in book form (published by Gerald Ferguson). In the book the angle of the triangle diminishes gradually to infinity with the progression to cause a cessation at some point in the book's interior. It begins at a point and is read. Placing is the ordering of terms as in reading the reader's eye's place (or point of fixation) is continually shifting.

For Publication 1975: n.p.

Scheme, 1965, drawing.
Collection Gerald Ferguson,
Halifax, Nova Scotia, Canada.

Title/Date
Sequence Number
1965

Materials
drawing for a magazine
page: typewriter ink on
paper

Dimensions
8½ x 11 in.
21.6 x 28 cm

First publication
Bleich-Rossi 1990

```
                        0

                        0

                    1       1

                    0       1

                2       2       2

                0       1       2

            3       3       3       3

            0       1       2       3

        4       4       4       4       4

        0       1       2       3       4

    5       5       5       5       5       5

    0       1       2       3       4       5

  6       6       6       6       6       6       6

  0       1       2       3       4       5       6

7       7       7       7       7       7       7       7

0       1       2       3       4       5       6       7

8       8       8       8       8       8       8       8       8

0       1       2       3       4       5       6       7       8

9       9       9       9       9       9       9       9       9       9

0       1       2       3       4       5       6       7       8       9

10   10   10   10   10   10   10   10   10   10   10

0    1    2    3    4    5    6    7    8    9    10

11   11   11   11   11   11   11   11   11   11   11   11

0    1    2    3    4    5    6    7    8    9    10   11

12   12   12   12   12   12   12   12   12   12   12   12   12

0    1    2    3    4    5    6    7    8    9    10   11   12

13   13   13   13   13   13   13   13   13   13   13   13   13   13

0    1    2    3    4    5    6    7    8    9    10   11   12   13
```

Sequence Number, 1965

Title/Date
Figurative
1965

Materials
printed matter

Dimensions
variable according to
publication

First publication
'Figurative by Dan
Graham,' *Harper's Bazaar*
(March 1968): 90.

Figurative is a page for a magazine to be placed where the advertisements are. It is a grocery receipt that doesn't add up to anything. The grocery receipt presented at the end of a sale relates to the advertisements which are supposed to inspire the reader to buy something. The receipt is presented after the fact, and in this case doesn't add up to anything. A friend of Robert Smithson's, Dale McConathy, was the poetry editor at *Harper's Bazaar* magazine. He decided he wanted to publish the piece as a 'poem.' I called it 'Figurative.' It was supposed to appear re-typed, as a column of figures with no total amount. It was printed as a 'found object' with the edges of the receipt visible against the magazine page. It appeared with a title and a name due to the format of the poetry section. In terms of the advertisements appearing with *Figurative* on the magazine's pages, it was an accident that *Figurative* appeared with those advertisements in particular, with an advertisement for Tampax™ tampons and an advertisement for Warner's Comfort Curve™ bra.

Based on an interview with the artist,
February 7, 2000, New York.

2.1 1965

'Figurative by Dan Graham,'
Harper's Bazaar (March
1968): 90.

Title/Date
Figurative
1965

Materials
drawing for a magazine
page: typewriter ink on
paper

Dimensions
8½ x 11 in.
21.6 x 28 cm

First publication
Bleich-Rossi 1990

```
$  1.29
$   .89
$   .58
$   .29
$  4.78
$ 10.00
$   .79
$  1.25
$   .69
$  2.89
$   .40
$   .79
$   .79
$   .49
$   .19
$   .80
$  1.65
$   .45
$   .15
$   .94
$   .90
$   .30
$  1.29
$  5.98
$   .67
$   .45
$   .39
$   .20
$   .59
$  1.00
$   .99
$   .54
$   .89
$   .49
$   .09
$   .39
$   .25
$   .85
$   .75
$   .26
$  2.85
$   .59
$   .65
$   .50
```

Figurative, 1965, drawing.

Figurative, 1965. Collection
Herbert, Gent, Belgium.

Scheme for Magazine Page 'Advertisment' — 1965
Dan Graham

3 1965

Title/Date
Number Rungs Ladder
1965

Materials
drawing for a magazine
page: pencil on paper

Dimensions
8½ x 11 in.
21.6 x 28 cm

First publication
Bleich-Rossi 1990

Notes
This drawing was never
realized as a magazine
page.

Number Rungs Ladder	First Rung	Second Rung	Third Rung	etc.
First Rung				
Second Rung				
Third Rung				
etc.				

Number Rungs Ladder, 1965

4 1966

Title/Date
Schema (March 1966)
1966–67

Materials
printed matter

Dimensions
variable according to
publication

First publication
Aspen no. 5/6 (Fall-Winter
1967): Section 16, two-
pages folded, including
Schema and text, see
below, n.p. Additional
publications of *Schema*
1967 and 1975: *Exten-
sions* no. 1 (1968): 182;
Art-Language Vol. 1 no. 1
(May 1969): 14, text
15-16; *Konzeption – Con-
ception*. Exh. cat. Städti-
sches Museum Lever-
kusen, 1969: n.p.; *End
Moments* 1969: 44-46;

Schema for a set of poems whose compo-
nent pages are specifically published as
individual poems in various magazines.
Each poem-page is to be set in its final
form by the editor of the publication where
it is to appear, the exact data in each
particular instance to correspond to the
fact(s) of its published appearance.
1. Using any arbitrary schematic (such as
the example published here) produces a
large, finite permutation of specific, dis-
crete poems. 2. If a given variant-poem is
attempted to be set by the editor following
the logic step-by-step (linearly), it would
be found impossible to compose a com-
pleted version of the poem as each of the
component lines of exact data requiring
completion (in terms of specific numbers
and percentages) would be contingently
determined by every other number and
percentage which itself in turn would be
determined by the other numbers and
percentages, *ad infinitum*. 3. It would be
possible to 'compose' the entire set of
permutationally possible poems and to
select the applicable variant(s) with the
aid of a computer which could 'see' the
ensemble instantly.

'Poem-Schema' *Aspen* no. 5/6 (Fall-Winter 1967):
Section 16, n.p.

Schema for a set of pages whose compo-
nent variants are specifically published as
individual pages in various magazines and
collections. In each printed instance, it is
set in its final form (so it defines itself) by
the editor of the publication where it is to
appear, the exact data used to corre-
spond in each specific instance to the
specific fact(s) of its published appear-
ance. The following schema is entirely ar-
bitrary; any might have been used, and
deletions, additions or modifications for
space or appearance on the part of the
editor are possible.

For Publication 1975: n.p. Later variation of *Schema* script.

4 1966

Interfunktionen no. 8
(1972): 32; *Studio International* Vol. 944 no. 183
(May 1972): 212, text
213; *Flash Art* no. 35, 36
(September-October
1972): 8; *Selected Works*
1972: n.p.; *Possibilities of
Poetry* (1973): 182; *For
Publication* 1975: n.p.

Notes

For additional texts by
Graham on *Schema* see
'Thoughts on Schema
(March 1966)' and 'Other
Observations' in *For Publication* 1975: n.p. *Schema*
was published several
times under the title
Poem Schema. More so
than Graham's other
works for magazine pages,
Schema was realized in
print multiple times, as
each appearance is particular and unique to the
printed context in which it
appears. At the time, Graham thought multiple
appearances of the piece
would underscore its specific, self-reflective and
self-producing, multiple
structure. This piece is
materially context-specific
in addition to being disposable and topical, like
magazines and popular
culture in general. In
Schema Graham emphasizes a quantitative as opposed to a conventional
qualitative standard of fine
art value which is based
on an art object's physical
uniqueness.

DAN GRAHAM

SCHEMA for a set of pages whose component variants are to be published in various places. In each published instance, it is set in its final form (so it defines itself) by the editor of the particular publication where it is to appear, the exact data used to correspond in each specific instance to the specific fact(s) of the published final appearance. The work defines itself in place only as information with simply the external support of the facts of its external appearance or presence in print in place of the object

(March, 1966)

```
        (number of) adjectives
        (number of) adverbs
     (percentage of) area not occupied by type
     (percentage of) area occupied by type
        (number of) columns
        (number of) conjunctions
          (depth of) depression of type into page surface
        (number of) gerunds
        (number of) infinitives
        (number of) letters of alphabet
        (number of) lines
        (number of) mathematical symbols
        (number of) nouns
        (number of) numbers
        (number of) participles
      (perimeter of) page
         (weight of) paper sheet
           (type of) paper stock
        (number of) prepositions
        (number of) pronouns
  (number of point) size type
           (name of) typeface
        (number of) words
        (number of) words capitalized
        (number of) words italized
```

Art-Language Vol. 1 no. 1
(May 1969): 14.

In a *Schema* for a group of works of mine deriving from 1966 the fact(s) of the matter exist only as information, deriving their (its) value from the specific contingencies related to its (their) placement on the two-dimensional surface (or medium) upholding their appearance. A fact is simply the sign of its own presence. Sign unites the signifier and the signified, its 'language' being the fact of the matter. (In the sign the relation is unmotivated and exact – there is no analogy between word-image and objective factuality). [...] This schema was conceived in March, 1966. Using this or any arbitrary schema produces a large, finite permutation of specific, discrete poems. [...]

End Moments 1969: 44-45.

POEM SCHEMA DAN GRAHAM

1	adjectives
3	adverbs
1192½ sq. ems	area not occupied by type
337½ sq. ems	area occupied by type
1	columns
0	conjunctions
nil	depression of type into surface of page
0	gerunds
0	infinitives
363	letters of alphabet
27	lines
2	mathematical symbols
38	nouns
52	numbers
0	participles
8½ x 5	page
17½ x 22½	paper sheet
offset cartridge	paper stock
5	prepositions
0	pronouns
10 pt.	size type
Press Roman	typeface
59	words
2	words capitalized
0	words italicized
57	words not capitalized
59	words not italicized

Schema (March 1966).
Collection Daled, Brussels,
Belgium.

OTHER OBSERVATIONS

There is no composition.

No artistic or authorial 'insight' is expressed.

The work subverts value. Beyond its appearance in print or present currency, "SCHEMA (March, 1966)" is disposable; with no dependence on material (commodity), it subverts the gallery (economic) system.

It is not "art for art's sake." Its medium is in-formation. Its communicative value and comprehension is immediate, particular and altered as it fits the terms (and time) of its system or (the) context (it may be read in).

A page of "SCHEMA" exists as matter of fact materiality and simultaneously semiotic signifier of this material (present): as a sign it unites, therefore, signifier and signified.

It defines itself as place as it defines the limits and contingencies of placement (enclosing context, enclosed content). It is a measure of itself — as place. It takes its own measure — of itself as place, that is, placed two-dimensionally on (as) a page.

A specific 'material' in-formation supports its own decomposition (as it is composed) into the constituent material elements of its place.

The only relations are the relation of the elements to each other, the elements existing only by virtue of their mutual dependency — their material dependency.

Place is reduced to in-formation in terms of present appearance and so a specific variant, in a sense, does not actually exist, but under certain conditions can be made to appear.

In external fact, in-formation simply appears — to fill up available magazine space; it takes place as (is) the medium.

In the internal logic, there is the paradox that the concept of 'materiality' referred to by the language is to the language itself as some 'immaterial' material (a kind of mediumistic ether) and simultaneously is to it as the extensive space. There is a 'shell' placed between the external 'empty' material of place and the interior 'empty' material of 'language'.

(Systems of) information (in-formation) exist halfway between *material* and *concept,* without being either one.

— 1969/73

5 1966

Title/Date
March 31, 1966
1966

Materials
printed matter

Dimensions
variable according to
publication

First publication
Extensions no. 2
(1969): 59;
End Moments 1969: 54.

First exhibition
'Serial Art,' Finch College
Museum, New York, 1967.

(Solipsistic) 'insight' represented as a one-dimensional point-of-view extension making up a perspective from (at) my (its) moment of inception; the 'interior' plane inverted 'outside' as it is 'inside.'

End Moments 1969: 54.

The spectator's optical point-of-view is made to identify with the author's optical point-of-view and 'reduces' this conventional relationship to a loss of meaning or narrative.

Based on an interview with the artist,
February 7, 2000, New York.

```
1,000,000,000,000,000,000,000,000.00000000 miles to edge of known universe
  100,000,000,000,000,000,000,000.00000000 miles to edge of galaxy (Milky Way)
               3,573,000,000.00000000 miles to edge of solar system (Pluto)
                        205.00000000 miles to Washington, D. C.
                          2.85000000 miles to Times Sq., New York City
                           .38600000 mlies to Union Sq. subway stop
                           .11820000 miles to corner of 14th St. and 1st Ave.
                           .00367000 miles to door of Apartment 1D,153 1st Ave
                           .00021600 miles to typewriter paper page
                           .00000700 miles to lens of glasses
                           .00000098 miles to cornea from retinal wall
```

March 31, 1966, Extensions
no. 2 (1969): 59.

Title/Date
Detumescence
1966

Materials
printed matter

Dimensions
variable according to
publication

First publication of ad
National Tatler, November
21, 1966. Additional publi-
cations: *New York Review
of Sex*, August 1, 1969:
20; *Screw*, August 1969.

First publication of ad and
descriptive text
Selected Works 1972: n.p.

First publication of medical
writer's description
For Publication 1975: n.p.

Notes
Graham received only one
response to his adverti-
sement requesting a
description by a medical
writer of the post-climax
sexual experience of a
human male in 1974, by
a medical writer, Roger C.
Sharpe. Graham edited
the text of Sharpe in *For
Publication* 1975: n.p.

I had in mind a page, describing in clinical language the typical emotional and physiological aspects of post-climax in the sexual experience of the human male. It was noted that no description exists anywhere in the literature, as it is 'anti-romantic.' It may be culturally suppressed – a structural 'hole' in the psycho-sexual-social conditioning of behavior. I wanted the 'piece' to be, simply, this psycho-sexual-social 'hole' – truncated on the page alone as printed matter. To create it, I advertised in several places. In late 1966 I advertised for a qualified medical writer in the National Tatler (a sex tabloid). In early 1969 The New York Review of Sex gave me an ad. As both of these ads were somewhat edited, I bought an ad in SCREW in mid-1969. I HAVE RECEIVED NO RESPONSES.

Selected Works 1972: n.p.

Involuntary body contractions ensue bringing a steep drop in excitation. The most obvious indication of this is the rapid loss of penile erection and the return of the scrotum and testes to an unstimulated state. This action occurs in two stages. The first leaves the penis enlarged while a continued shrinkage takes place concurrently at a slower rate. The body slackens its tension. There is a loosening of physical tautness, and a simultaneous sense of release and relaxation. Sensations of orgasm or desire are extinguished; emotions recede; and ego is again bounded. Psychologically, there may be feelings of anxiety, relief, pleasurable satiation, disappointment, lassitude, leaden exhaustion, disgust, repulsion, or indifference, and occasionally hatred depending on the partner and the gratification achieved in the orgasm state.

For Publication, 1975: n.p.

DETUMESCENCE

I had in mind a page, describing in clinical language the typical emotional and physiological aspects of post-climax in the sexual experience of the human male. It was noted that no description exists anywhere in the literature, as it is "anti-romantic." It may be culturally suppressed — a structural "hole" in the psycho-sexual-social conditioning of behavior. I wanted the "piece" to be, simply, this psycho-sexual-social "hole" — truncated on the page alone as printed matter. To create it, I advertised in several places. In late 1966 I advertised for a qualified medical writer in the "National Tatler" (a sex tabuloid). In early 1969 "The New York Review of Sex" gave me an ad. As both of these ads were somewhat edited, I bought an ad in "SCREW" in mid-1969. I HAVE RECEIVED NO RESPONSES.

Involuntary body contractions ensue bringing a steep drop

in excitation. The most obvious indication of this is the

rapid loss of penile erection and the return of the scrotum

and testes to an unstimulated state. This action occurs in

two stages. The first leaves the penis enlarged while a

continued shrinkage takes place concurrently at a slower

rate. The body slackens its tension. There is a loosening

of physical tautness, and a simultaneous sense of release

and relaxation. Sensations of orgasm or desire are exting-

uished; emotions recede; and ego is again bounded. Psych-

ologically, there may be feelings of anxiety, relief, plea-

surable satiation, disappointment, lassitude, leaden ex-

haustion, disgust, repulsion, or indifference, and occasionally

hatred depending on the partner and the gratification achieved

in the orgasm state.

Title/Date
Side Effects/Common Drugs
1966

Materials
printed matter

Dimensions
variable according to publication

First publication
End Moments 1969: 52; text: 51 and 54 and *Konzeption – Conception.* Exh. cat. Städtisches Museum Leverkusen, 1969: n.p, in German. See later version of text *Perth* 1985: 13.

First exhibition
'Working Drawings And Other Visible Things On Paper Not Necessarily Meant To Be Viewed As Art,' organized by Mel Bochner, School of the Visual Arts Gallery, New York, December 2-23, 1966. Bochner exhibited xeroxes of drawings, diagrams, scores, notes and working drawings, organized alphabetically in 4 identical looseleaf binders, each containing 100 xeroxes. See James Meyer, 'The Second Degree: Working Drawings and Other Visible Things On Paper Not Necessarily Meant To Be Viewed As Art,' in Richard S. Field. *Mel Bochner: Thought Made Visible, 1966-1973.* Exh. cat. New Haven: Yale University Art Gallery, 1995: 95-106.

Notes
Side Effects/Common Drugs was never realized as a magazine page, though it has been published in numerous catalogues of Graham's work since it appeared in the catalogue *1966 Dan Graham* 1970.

[…] My *Extended Time/Extended Distance*, 1969, my *Side Effects/Common Drugs*, 1966 […] are all examples of gridded data fields generating an optical-matrix perspective. They can be read as 'spatialized' 'effects' in time. In *Side Effects/Common Drugs* the optical-reflexive time sequence of the reading constitutes the content. As the dots (like 'Poons' dots) have the sequence of effect/response plus 'spatial' 'density' so reading from the terms in horizontal/vertical order on the side (or obliquely) we 'see' that symptoms (causes or 'side' effects) produced by the cure (common drugs) which effect these 'side' responses necessitate another common drug to correct these side effects from the taking of the first and so on… The extension of the data field continues until all self-reflexive effects – vanishing/points – are optically cancelled out in the time of the reading process. […]

End Moments 1969: 51, 54.

SIDE EFFECT / COMMON DRUG	Anoxemia (Appetite loss)	Blood clot	Blurring of vision	Constipation	Convulsion	Decreased libido	Dermatosis	Depression, torpor	Headache	Hepatic disfunction	Hypertension	Insomnia	Nasal congestion	Nausea, vomiting	Pallor
STIMULANT also **APPETITE DEPRESSANT**															
Dextroamphetamine (Dexedrine)	•			•	•				•		•	•		•	
Methamphetamine chloride (Desoxyn)	•			•	•				•		•	•		•	
ANTI-DEPRESSANT															
Iproniazid				•					•	•	•				
Trofanil			•			•			•		•				
TRANQUILIZER															
Chlorpromazine				•		•	•	•	•						•
Hydroxyzine				•			•	•	•					•	•
Meprobamate					•			•				•			
Promazine			•				•	•	•						
Resperpine	•					•	•	•				•	•		
Thiopropazate			•	•	•		•	•	•	•	•	•			
SEDATIVE															
Barbitol			•					•						•	
Phenobarbitol			•					•							
ANTI-MOTION SICKNESS															
Dimenhydrinate (Dramamine)							•	•						•	
Marezine							•	•							
Meclizine							•	•						•	
CONTRACEPTIVE															
Norethynodrel (Enovid)		•	•						•	•				•	•

Side Effects/Common Drugs, 1966. Collection Daled, Brussels, Belgium.

8 1966

Materials
15 wooden puzzle pieces
with container and card-
board box

Dimensions
1½ x 1½ in. each
3.8 x 3.8 cm each;
box: 1¾ x 7 x 7 in.
4.4 x 17.8 x 17.8 cm

Notes
Graham renumbered the
tiles of a puzzle, each with
the number 'one' some-
time after 1966. This
wooden puzzle, and a lost
plastic one, are the proto-
types for the edition pub-
lished by Yves Gevaert
Éditeur, Brussels in 1991.

One, 1966, plastic prototype.

8.1 1966

Title/Date
One
1967-1991

Multiple
edition of 500

Materials
silkscreen type in black
on a magnetic puzzle of
off-white plastic

Dimensions
3 x 3½ x ¼ in.
7.4 x 9 x 0.7 cm

Notes
Published in 1991 by Yves
Gevaert Éditeur, Brussels.
Made in Bad Salzuflen by
Walter Breiter + Co. In
1995 a second version of
One featuring white type
on a magnetic puzzle of
black plastic was published
in an edition of 1000.

One puzzle is about nominalism and what is denoted by the word 'one.' It has a hole in the center, whereas the normal number puzzle would be numbered 1-16. It was inspired by articles in *Scientific American* about physics and the black hole. It is related to the piece *Detumescence* and its negation of role of advertisement, featuring instead a 'hole' in the magazine page.

Based on an interview with the artist,
April 11, 2000, New York.

9 1966

Title/Date
Homes for America
(slide projection)
1966-67

Materials
circa twenty 35 mm slides
and carousel projector

Dimensions
variable according to
installation

First publication
'Homes for America, Early
20th Century Possessable
House to the Quasi-
Discrete Cell of '66,' *Arts
Magazine* 41, 3 (Decem-
ber 1966 – January
1967): 21-22. Text on the
work first published *End
Moments* 1969: 34.

First exhibition
Homes for America was
first exhibited as a slide
projection using a single
carousel of circa twenty
35 mm slides at Finch Col-
lege Museum of Art in the
exhibition 'Projected Art,'
in December 8, 1966 –
January 8, 1967, organ-
ized by Elayne Varian.

Notes
In the months following the
closing of the John Daniels
Gallery, Graham began taking
color snapshot photographs in
suburban New Jersey, New
York City, and Staten Island.
The first camera he used was
an Instamatic fixed focus with
Kodachrome film. Later he
used a 35 mm camera.
Homes for America was re-
constructed as a slide projec-
tion for the exhibition, 'Dan
Graham,' Centro Galego de
Arte Contemporánea, Santiago
de Compostela, 1997, curated
by Gloria Moure. In this exhibi-
tion, Graham showed many of
his original images from the
1966-67 *Homes for America*
group, adding images from the
ongoing series taken later in
the 1970s.

[...] It wasn't until recently, with the 'Mini-malist' reduction of the medium to its structural support in itself considered as an 'object' that photography could find its subject matter.

The use of the inherent transparent 'flat', serialized space was why I turned to the 35 mm slide (color transparency) as art 'structure' in itself in a series shot in 1965 and 1966 of architectural alignments and another series of transparent-mirror 'spa-ces'; these were exhibited in 1966 at Finch College's 'Projected Art' (they dated from 1965 and 1966) and then in 'Focus on Light' in Trenton, N. J. Some of these photographs also appeared in black and white as 'documentation' contained in a two-dimensional projective network of schematic 'information' about land use economics, standardization and serializa-tion of building and buildings schematically relating the appearance of large-scale housing 'tracts' (See 'Homes for America,' *Arts Magazine*, December – January 1967). This was the first published appearance of art ('Minimal' in this case) as place conceived, however, solely in terms of information to be construed by the reader in a mass-readable-then-dis-posable context-document in place of the fact (neither before the fact as a Judd or after the fact as in current 'Concept' art). Place in my article is decomposed into multiple and overlapping points of refer-ence – mapped 'points of interest' – in a two dimensional point to point 'grid'. There is a 'shell' present placed between the external 'empty' material of place and the interior 'empty' material of language; a complex, interlocking network of systems whose variants take place as information present (and) as (like) the medium – infor-mation – (in) itself. [...]

End Moments 1969: 34.

Tract Houses, Bayonne, NJ, 1966

Hall of Model Home, Staten Island, NY, 1967

High School Doors, Westfield, NJ, 1965

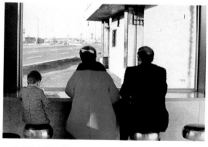
Untitled (Family in New Highway Restaurant), Jersey City, NJ, 1967

Warehouse in Neocolonial Style, Westfield, NJ, 1978

Two Entrance Doorways, 'Two Home Houses,'
Jersey City, NJ, 1965-70

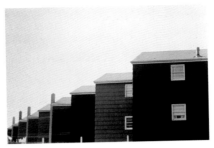

Row of Tract Houses, Bayonne, NJ 1966

Pink Kitchen Trays in Discount Store,
Bayonne, NJ, 1966

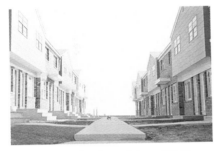

Courtyard, New Development, Jersey City, NJ,
1966

High School Corridor, Westfield, NJ, 1965

Housing Development, Bayonne, NJ, 1966

Row of New Tract Houses, Bayonne, NJ, 1966

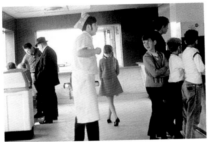

First Day Opening of Highway Restaurant,
Jersey City, NJ, 1967

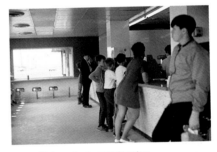

New Highway Restaurant Opening,
Jersey City, 1967

Row Houses, Bayonne, NJ, 1966

Row of Houses, Jersey City, NJ 1966

Back of New Housing Project, Jersey City, NJ, 1966

Hotel with Yellow Doors, Minneapolis, MN, 1975

Tourist Bus, Lisbon, Portugal, 1977

Tennis Lady, Palo Alto, CA, 1978

Title/Date
Homes for America (article
for *Arts Magazine*)
1966-67

Materials
printed matter

Dimensions
variable according to
publication

First publication
'Homes for America, Early
20th Century Possessable
House to the Quasi-
Discrete Cell of '66,' *Arts
Magazine* 41, 3 (Decem-
ber 1966 – January
1967): 21-22. Text on
the work first published
End Moments 1969: 42.
See later version in *Perth*
1985: 12.

Notes
During the exhibition at
Finch College Museum of
Art, *Arts Magazine* offered
to publish the slides. It
was Graham's proposal to
Susan Brockman, an
assistant editor at *Arts
Magazine*, to write an arti-
cle about tract-housing
development to accompa-
ny them. The article
appeared in the Decem-
ber 1966 – January 1967
issue, however *Arts Maga-
zine* removed all of Gra-
ham's own photographs,
using only a single visual
Graham supplied from the
brochure produced by
Cape Coral Homes, Flori-
da, a developer, for a
model home entitled 'The
Serenade.' The magazine
instead reproduced a pho-
tograph by Walker Evans,
Wooden Houses, Boston
(1930) with Graham's
text. See Jean-François
Chevrier, 'Dual Reading/
Double Lecture,' in *Walker
Evans & Dan Graham*.
New York: The Whitney

[…] In my article, 'Homes for America' writ-
ten and printed in December – January,
1966-67 for *Arts Magazine* […] in place of
the fact, all information (as photographic
and typographic schema) takes place as
in-formation 'abstracted' (by the peruser).
There are various points of reference in a
two-dimensional perspective 'gridwork' ge-
nerated by the correlation of the data and
abstracted into a complex, overlapping and
interlocking network of variables from the
'facts' of the 'matter' encountered. The
serial order dictates the formal structure
as the relation between schema and factic-
ity is as coded data: commutative and
positional subcodes (of information terms)
are then available for a 'visual' crossover
from graphic to photographic to linguistic
to 'abstract' serialization as 'spatial grid'
constructed in the *reader's* field of refer-
ence from the superimposed coding
arrangements. My idea was to present art
in-formed directly by the information
media: as information available *only* as
printed matter and not representing any-
thing but itself as read by the audience.
There was a desire to by-pass the gallery
framework for an immediate and throw-
away 'ready-made' 'experience' of reading.
The notion has more popularity today.

End Moments 1969: 42.

Museum, 1994, et. al.:
23, footnotes 4 and 5 and
Alexander Alberro, 'Reduc-
tivism in Reverse,' *Tracing
Cultures: Art History,
Criticism, Critical Fiction*.
New York: The Whitney
Museum, 1994: 25,
footnote 5. *Homes for
America* exists in several
layout forms in supple-
ment to the *Arts Magazine*
version. From 1970
onward, Graham present-
ed the piece according to
his original layout with his
own photographs intact.
This version has been
reprinted in numerous cat-
alogues and periodicals.
The original color layout

with photographs is in the
Daled Collection, Brussels.
A color lithograph edition
was produced in Halifax,
between February 19 and
May 10, 1971 at the
Nova Scotia College of
Art and Design, measuring
$22^{3}/_{8}$ x $30^{1}/_{8}$ in.
(56.8 x 76.5 cm).

[…] The one magazine piece which was
most like a conventional article was
Homes for America, printed in *Arts Maga-
zine*, December 1966 – January 1967. It is
an article designed around photographs of
suburban tract housing estates taken over
a period of two years. It is important that
the photographs are not seen alone, but
as part of the over-all magazine article lay-
out. They are illustrations of the text, or
inversely, the text functions in relation to
the photographs thereby modifying their
meanings. The photographs and the text
are separate parts of a two-dimensional,
schematic grid perspective system. The
photographs correlate to the lists and
columns of serial documentation and both
'represent' the serial logic of the housing
developments which the article is about. I
think the fact that *Homes for America* was,
in the end, only a magazine article, and
made no claims for itself as a work of art,
is its most important feature. […]

Perth 1985: 12.

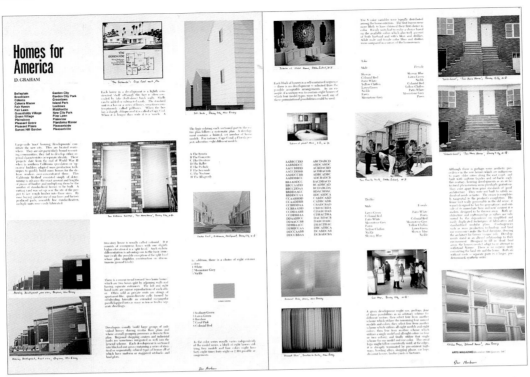

Homes for America, 1966-67,
layout boards. Collection
Daled, Brussels, Belgium.

10 1966

Title/Date
Project for Slide Projector
December 1966

Materials
eighty 35 mm color slides
and carousel projector

Dimensions
variable according to
installation

First publication
Project for Slide Projector
was first conceived in
1966 and later published
in 1969 as a descriptive
text (or proposal with
drawn diagrams) in 'Pho-
tographs of Motion,' *End
Moments* 1969: 34-36,
along with a second pro-
posal for a slide projection
piece involving the per-
ception of motion; see
*Untitled (Project for Slide
Projector II)*, 1966-67, cat.
no. 11. Both projects were

[…] In December 1966 I devised a project for 35 mm transparencies and Carousel projector designed for exhibition space installation: the Carousel slide projector as object: the message to be the mechanism of the medium in itself as object. Although the project was never done, a number of people have been influenced as a result of my writing or speaking publically about it to exhibit similar works dealing with pho-tography.

A Carousel slide projector is loaded with 80 slides which are projected on a screen every 5 seconds. The device is in continu-ous operation. The slides are of transpar-ent and mirror-images on glass which have been obtained in the following man-ner:

A structure is built utilizing 4 rectangular panes of glass joined to form a box with 4 sides. The top is open and the base is a mirror. A 35 mm still camera takes a shot on a parallel plane directed dead on focused on that plane and including noth-ing more than that plane in its periphery. Shot #2 is made similarly, but of the next side of the box rotating clockwise and the lens focused further back – on a point inside the box. Shot #3 is focused further still nearer the center of the box and an equal distance back, as the camera is aimed at the third side. #4 follows the same scheme, the focused point now at dead center of the box's interior.

Overhead view diagram

also published in *Two Parallel Essays* 1970: 4-7, Graham's inclusion in the 'Artists and Photographs' box (New York: Multiples, 1969). *Project for Slide Projector, 1966* was also published in *Some Photographic Projects* 1970: n.p. along with the first descriptions of the films *Sunset to Sunrise,* 1969, *Binocular Zoom,* 1969-70, *Two Correlated Rotations,* 1969, *Roll* 1970, and the work *TV Camera/Monitor Performance,* 1970. See also *Films* 1977: 3, 5.

First exhibition
Project for Slide Projector was realized as a student project at Nova Scotia College of Art and Design, Halifax in the early 1970s.

Next, 4 new panes are added to form a box within a box, building up a mirroring perspective within a perspective – and the

rotation of shots proceeds around the box clockwise, the focus moving back in the same succession until shot #8 when it has returned to its first position on the outer pane of the structure. This plan is followed as, from the inside, new boxes within boxes are added (5 in all) and photographed in sequence. 20 shots in all are taken.

These shots as transparencies are copied 4 times. They are inserted in the Carousel tray for projection in this fashion: the first 20 follow the order of the shooting outlined: the second 20 are flipped over (that is, placed in the tray flipped over in relation to the first series) in backwards sequence from the first 20; the next 20 are like the first 20, and the last 20 are like the second 20. [...]

End Moments 1969: 34-36.

[...] The effect of light changes: initially it is light through the transparent space, the 'illusionistic' effect of complex exterior and interior mirroring develops as successive boxes within boxes are added and filmed; finally the surface becomes more or less a mirror and the light opaque. The sculpture is the photographic residue, an effect of projected light. What is seen must be read in terms of the conventions of still photography; two-dimensional objects which appear at once solid and also transparent, and which function simultaneously in two entirely different planes of reference (the two-dimensional and the three-dimensional). The continuity of time present in the usual walk around the conventional three-dimensional sculptural object, as well as that three-dimensionality itself, is transposed to the two-dimensional screen projection's timed appearances (transposed to the illusion-produced, mechanical movements of the slide projector).

Films 1977: 3, 5.

Project for Slide Projector, December 1966, slide taken in the early 1970s.

Title/Date
Untitled (Project for
Slide Projector II)
1966-67

Materials
two camera operators,
two carousel projectors
with 160 slides, square
structure of wooden slats

Dimensions
variable according to
installation

First publication
End Moments 1969: 37.
See also addition of third
variant proposal, which
describes an early con-
ception of the film *Two
Correlated Rotations* 1969
cat. no. 28 in *Two Parallel
Essays* 1970: 7-8.

Notes
This project was con-
ceived during 1966-67.
Initial work was done on it
by the students of David
Askevold's class at the
Nova Scotia College of Art
in Halifax in the Fall of
1969. The work was never
completely realized. Three
photographs of this real-
ization were used on the
cover of *Two Parallel
Essays* 1970.

[...] Next, I wanted to relate perception to perceived motion and to the perception of depth/time. Using a double (steriopticon-like) simultaneous image seemed logical. [...] The device to be used is a square fence constructed with equal rectangular slats approximately one inch wide and the height of my neck-line. They are spaced at intervals of about three inches from one another. Maybe the perimeter of the fence would be about 24 feet.

There is a walker (me) with a camera at dead center *inside* the enclosure and a second walker with a camera at one of the corners *outside* the device and maybe 3 feet away from its sides. The exact distance is determined by having both performers aim their respective cameras at each other so as to locate the top of the slats with the top of each other's headlines. Both walkers are equipped with automatic advancing and repeating 35 mm cameras for taking a series of shots quickly. (Hopefully there will be a total of about 80 shots taken so as to completely fill one Carousel tray with 80 and a second 80).

They walk when the piece commences counter-directionally to each other, spiralling. The inside walker spirals out gradually to meet the edge of the slats and the outside walker spirals inside gradually to meet the slats. They walk at the same speed, aiming the camera at each other. The piece may have to be carefully rehearsed to correlate the two walker's movements and angles of spiralling in.

For exhibition two Carousel projectors would be loaded with 2 trays – one for each of the views of the respective walkers and shown very rapidly, continually repeated on tangentially placed screens in sequence.

End Moments 1969: 37.

12 1966

Title/Date
Foams
1966

Materials
poem: printed matter

First publication
Dan Graham, 'Foams,' *Extensions* no. 2 (1969): 34-35.

Notes
In 1966-67 Graham produced a small body of poetry. 'Foams' was the only one of these poems to be published. The published version combined two poems titled 'Foams' and 'Foams II.' In the same issue of *Extensions* Graham also published *March 31, 1966*, see cat. no. 5. *Schema*, 1966, cat. no. 4 was published under the variant title *Poem Schema*, suggesting some overlap between Graham's use of the magazine page and this brief investigation of poetry.

Notes
According to Graham the title of *Foams* was inspired by Carl Andre's first solo exhibition at Tibor de Nagy Gallery, April 20 – May 8, 1965. Andre exhibited three large structures built of stacked 9-foot styrofoam beams. He titled the three arrangements: *Crib, Coin* and *Compound*. In his article on Andre's work (*Arts Magazine* 42, 3; December 1967 – January 1968) Graham opens with a written account of the show.

Dan Graham

FOAMS

White bread is a solid foam. Most white bread is sanitary. It is also allotropic according to Dr. Charlton Fredericks. "In almost all storebought white bread the wheat germ has been ruthlessly sacrificed on the altar of modern milling process (denaturation) ...Much if not most of what poses as white bread is pure pap; a tribute to engineering ingenuity, advertising cleverness and packaging artistry. It is also an insult to human intelligence. Foams are agglomerations of gas bubbles separated from each other by thin liquid films. They constitute the first eight classes of colloidal systems. The first eight classes of colloidal systems are:
1 gasses dispersed in gas
2 gasses dispersed in solid (solid gel)
3 liquids dispersed in gas (fog, spray mist)
4 liquids dispersed in liquid (emulsion)
5 liquids dispersed in solid (some gels)
6 solids dispersed in gas (fume)
7 solids dispersed in liquid
8 solids dispersed in solid (many sols and gels)
Fire-fighting foam blankets fire preventing free access of vapor to air.
artifical flowers
artifical islands
artifical snow
astronaut chairs
ball floats for toilets
beer
book covers
breakable stage furniture
breakwaters
buoys
burial vaults
cabanas
caskets

The collapse is nearly complete. The white spreads more widely along the surface flattening the swell.
The face, now beyond the vertical, with a sharply defined crest or blade along the top, leans forward. The glassy blade appears to form a momentary tunnel before the pitch down and forward.
The break has begun, the white plunging into the trough ahead of the crest and forming a temporary vortex.
The next incoming swell is rising influenced by the shallowing bottom. For an instant, the outgoing wave meets the vertical obliquely. The overlapping of the two produces a complex pattern. At some points, peaks of twice the height of the incident creast and depressions of twice the depth of the incident troughs. Alternately, at another point, the superposition effectuates a standstill; troughs and elevations respectively cancelling each other out.
The wave breaks up into a bore of foam. As the froth meets the sand, the incoming swell is rising, influenced by the shallowing bottom. The recoil of the swash is transmitted now obliquely as a reflected wave.
The level is lowest now.

CRAZYFOAM
detergents
display racks, booths
encapsulating gasoline and corrosive chemicals
floating aquarium decorations
floating lounge chairs
floating ramps
floating soap dishes
floating tables
foam rubber
fossil shipping packing
frozen food containers
Gillete FOAMY shaving cream
GLASSFOAM
lampshades
mannequins
mothballs
partitions, temporary, non-supporting
perforated acoustic tile
pool kickboards
portable weather shields
rafts
scum slipped through sewage disposal systems into streams
seaplane pontoons
septic tank liners
soap bubbles
stage settings, columns, statuary
stancheons
storage vaults
STYROFOAM
surf boards
temporary shelters
toilet soaps
traffic barriers
void filling of deteriorating roofs, walls, gutters, columns
wall plaques
wheel chokes
whipped cream in cans

34

35

Foams, 1966, *Extensions* no. 2 (1969): 34-35.

Carl Andre's first one-man exhibition at the Tibor de Nagy Gallery in April of 1965 – a summation of the artist's previous five years' thinking – is a good introduction to his work. Stacks of standard nine-foot long slabs of styrofoam, an industrially neutral, homogeneously white, brittle and nearly weightless, insulating material seemingly devoid of internal structure or qualitative substance, subsumed the bulk of the gallery's interior space. The emplacement of the material literally impeded both any continuous perspective of the whole and the gallery audience's progress. [...] Andre's decision to employ industrially standardized styrofoam blocks served to disencumber the work of the weight of personal and historically evolutionary determination. The component units possessed no intrinsic significance beyond their immediate contextual placement, being 're-placeable.' [...] Unweighted with symbolic, transcendental or redeeming monetary values, Andre's sculpture does not form some Platonically substantial body, but is recoverable; for while no one may be *poetically* transported, the constituents *are literally* transported from view when the exhibiton is terminated (the parts having been recovered and perhaps put to an entirely nonrelated use as part of a different whole in a different future).

Excerpt, 'Carl Andre,' *Arts Magazine* 42, 3 (December 1967 – January 1968): 34.

Title/Date
Untitled
1966

Materials
drawing: pencil on paper

Dimensions
8½ x 11 in.
21.6 x 28 cm

First publication
previously unpublished

Notes
Also titled *I = Eye.*

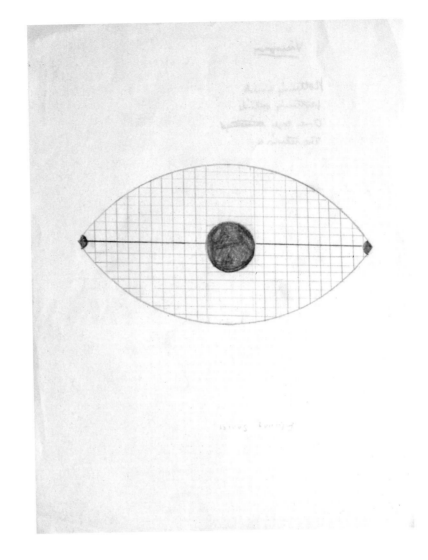

Untitled, 1966

W 1966

Writings

'Homes for America, Early 20th Century
Possessable House to the Quasi-Discrete Cell
of '66,' *Arts Magazine* 41, 3 (December 1966 –
January 1967): 21-22.

Title/Date
Proposal for Aspen
1967-68

Materials
printed matter

Dimensions
variable according to
publication

First publication
For Publication 1975: n.p.

Notes
This work exists as a
proposal text. The first
version was written in
1967-68 and published
in *For Publication* 1975:
n.p. The issue of *Aspen*
guest edited by Graham
was not realized until
1970-71 (see cat. 14.1
Aspen no. 8). In this issue
the editorial proposal of
1967-68 appears as an
editorial statement with
the addition of the section
'Genesis of Ad Forms' and
some other variations to
the text.

PROPOSAL FOR ASPEN MAGAZINE

I propose an issue on the subject of INFORMATION whose constituent parts would function doubly; as advertisements for designated information media (computer-data-processing, network television, radio, telephone, "think tank", dating service, duplication) companies and *also* as works of art. Artists (musicians, writers, artists, dancers) would be selected and arrangements made with various companies for their participation in-forming a work. This arrangement would serve a twofold function: the artist might help the corporation in establishing its corporate image while the corporation might help the artist in freeing some of the limitations in relation to the reader and social-economic frameworks. Beyond the initial selection of the artists and companies all decisions on the project would be corporate between the contributors themselves and between the individual contributor and his company. The company and the artist would be responsible for the production and design of their unit, the cost subsumed by the corporation in exchange for rights to its use in advertising and public relations. Companies would be free to use the ad/art-work in any context they think important: in trade shows, television , radio or other media campaign. As is in the nature of this type of information the usefulness (effect-impact-meaning) of these ads/artworks would be immediate, topical and more or less short-lived.

SPECIAL ISSUE OF ASPEN

The collected printed matter would be issued in a special issue of ASPEN, profits from its use going to the artists. Later the same information would be provided free of charge to any Museum wishing to use the contents in an exhibition with the provision that this Museum invites a number or all of the artists to discuss directly with the public the consequences and projected development of their working relationship with their corporate structure.

THEORY

(MOVING INFORMATION:) The information vector present would amount to re-directing the flow of traffic (it wouldn't be the sum of an individual artist's experience) in pointing directly to the outside world — to products to be played and services to be rendered (further in-forming the reader in real time). This is a radical revision of past procedures where the book and the magazine form have served to re-present (contain) the author's privileged insight (or several author's points of view) in translation to the masses of individual readers who've bought and identified (with) the experience. Under this kind of system magazines serve as part and parcel of a socio-economic structure which requires and perpetuates the 'system': a single dimension, single fixed point of view (of a complex of points in reality) representation.

DIFFERING VIEWS

It is assumed that each of the individual contributors to this proposed issue of information will undoubted have widely different views of their role than mine. Here my only relation to the subject matter of the issue of information is in placing these vectors in operation.

1967-68

Title/Date
Aspen no. 8
(Fall-Winter 1970-71)

Materials
printed matter

First publication
Aspen no. 8 (Fall-Winter
1970-71). *Aspen: the mag-
azine in a box.* Aspen
Communications, New
York, NY. Publisher and
editor: Phyllis Johnson.
Guest editor Dan Graham.
Editorial statement 'One
Proposal': n.p. Reprinted in
Rock My Religion 1993:
34-35.

Notes
Conceived in 1967-68 and
published late 1970-71.
Cover by Jo Baer. Guest
designer: George Maciu-
nas. Editorial statement:
Dan Graham. Boxed col-
lection of texts and pro-
jects by the following
artists: David Antin, Terry
Atkinson and Michael
Baldwin, Philip Glass, Dan
Graham, Richard Serra,
Steve Reich, La Monte
Young, Yvonne Rainer, Jo
Baer, Jackson MacLow,
Robert Morris, Dennis
Oppenheim, Robert Smith-
son, and Edward Ruscha;
sound recording 33⅓ rpm
by MacLow, including the
pieces *March 31, 1966*
by Graham on cover leaf,
'Art + Vision: Mach Bands'
by Jo Baer, a 16-page
illustrated pamphlet, and
the text by Smithson,
'Strata: A Geophoto-
graphic Fiction.' Issue title:
'Art information and
science information
share the same world and
language ...'

Editorial Note. This issue where artists have conceived and (in part) designed their contributions as *pieces* and part of a larger schema may aid in redefining the magazine's place in (and as) art in (and as participant in) the larger world. It suggests further scope and proposals.

One Proposal. (Might be:) an issue (a sort of *art and technology* exhibition) on the subject of INFORMATION, whose constituent units would function doubly: as advertisements for designated *informa-tion-media* (computer-data-processing, network TV, radio, telephone, *think tank*, dating service, duplication) companies and also works of art. Artists (musicians, writers, artists, dancers) would be selected and arrangements made with various companies for their participation in-forming a work. This arrangement would serve a twofold function: the artist might help the corporation in establishing its corporate image while the corporation might help the artist in freeing some of the limitations in relation to the reader and socio-economic frameworks. Beyond the initial selection of the artists and companies all decisions on the project would be corporate/between the contributors themselves and between the individual contributor and his company. The company and the artist would be responsible for the production and design of their unit, the cost subsumed by the corporation in exchange for rights to its use in advertising and public relations. Companies would be free to use the *ad/art* in any context they deem important: in trade shows or as part of a magazine, TV, radio or other media campaign. As is in the nature of this type of information the *usefulness effect-impact-meaning* of these *ads/artworks* would be immediate, topical and more or less short-lived. The collected printed matter would be issued in a mass magazine *special issue* as *information-art*, profits from the use going to the artists. Later the same information would be provided free of charge to any museum wishing to use the contents in a show providing that the museum invites some or all of the artists to continue first hand the in-formation process in meeting with the public.

Differing Views. *Some of the contributors in this proposed issue of information undoubtedly will have entirely different concepts than mine.*

Genesis of ad Form. While in the past the book and later magazine form has served to represent (re-present) (contain) the author's privileged *insight* (or several author's points of view) to the masses of individual readers who've bought and identified the *experience*, magazines serving as part and parcel of a socio-economic structure which necessitates and perpetuates this system of a single dimension, single fixed point of view (of a complex of points) representation (each magazine had covered a field – its form assuming that enough private points of view – static – of its readers and its authors can be brought in line with the line of its advertiser whose ads support the magazine's existence): my writing does not have a point of view (mine or *a priori* determined by form); instead its *point of view* is continually shifting, feedback contingent in its place (time and context) and its relationship to the readership who individually and collectively compose or in-form its meaning. The magazine as a static collection of points of view is easily subverted by placing an ad whose form and point is related directly to the readers' use of and response to: the astrology-dating ad (for instance), where categories or reference-fields have been severed for it's art and it's science and it's the sociology of art (no history) or none of these definitions.

Moving Information. In reading – in fact a reader's *mind's eye* is changing: his position is continually shifting. The signs on

Aspen no. 8 (Fall-Winter
1970-71). Collection Jo Baer,
Amsterdam, Holland.

the page function simply as vectors:
switching terminuses in the transaction
between the activating authorial *mover,*
the world out there and the activated
moved reader who, *finishing,* is left to shift
for himself in another place – continues
the transaction (in another time and
space); reading isn't another order of time
or experience apart. The *information* vec-
tor present would amount to re-directing
the flow of this traffic (it wouldn't be the
sum of *my* experience *per se* or add to
any ideas out of place) not by establishing
points, but pointing directly to the outside
world – to products to be played (maybe
records) and services to be rendered (fur-
ther in-forming the reader) as they in-form
that in-formation being correlated with the
previous in-formation which the user has
read in a magazine presentation. The two
in-formations would each function sepa-
rately and relatedly at the same time
rather than as one or a series of isolated
points in time. My one or only relation to
the subject matter of the in-formation
would be in placing these vectors in oper-
ation.

Dan Graham, 'Editorial: One Proposal,' *Aspen* no. 8: n.p.

Title/Date
Likes (A Computer-Astrological Dating-Placement Service) 1967-69

Materials
printed matter

Dimensions
variable according to publication

First publication
First published as an advertisement in the *Halifax Mall-Star,* October 11, 1969, designed by George Maciunas and *Konzeption – Conception.* Exh. cat. Städtisches Museum Leverkusen, 1969: n.p. The text and questionnaire page were published in 'Information' *End Moments* 1969: 48, 49, 51. *Likes* was also presented on a local TV program at a local station in Halifax, Nova Scotia, 1969 (documentation lost).

First exhibition
'555, 087,' Seattle Art Museum, Seattle, Washington, September 5 – October 5, 1969, curated by Lucy R. Lippard.

[…] In order to subvert the magazine which finds no support for my work requires the placing of an ad whose form and 'point' (that is, in-formation) would be directly correlated to the readers' use of and response to it: *Likes* was first designed in 1967 for an issue of *Aspen* which still hasn't gone to press. This year I re-wrote it to make a current interest, astrology, a part of its workings and showed it in Seattle in an exhibition of 'Concept' Art which Lucy Lippard and Seth Siegelaub organized. […] In more recent pages *(Likes)* or pieces *(Likes)*, the sign functions as a vector: switching terminus in a transaction between the activating mover, the world out there and the activated moved reader who, finishing is left to shift for himself in another place – continues that transaction (in another time and space). The artist's only relation to the subject matter is to place the vectors in operation. […]

End Moments 1969: 48, 51.

16.1-19 1967

Title/Date
Drawings for magazine
pages, 1967

Materials
pencil or ink on paper

Dimensions
circa 8½ x 11 in.
21.6 x 28 cm

First publication
Bleich-Rossi 1990

Notes
The following group of
drawings are proposals for
magazine pages made in
1967. They were never
realized as magazine
pages, and were not
included in the catalogue
For Publication 1975.
They were first published
by Galerie Bleich-Rossi
in 1990 in the catalogue
for the exhibition 'Draw-
ings 1965-69,' Galerie
Bleich-Rossi, Graz, 1989,
organized by Christian
Nagel.

16.1 *Untitled*, 1967

16.2 *Untitled*, 1967

16.3 *Untitled*, 1967

16.4 *Untitled*, 1967

16.5 *Untitled*, 1967

16.6 *Untitled*, 1967

16.7 *Untitled*, 1967

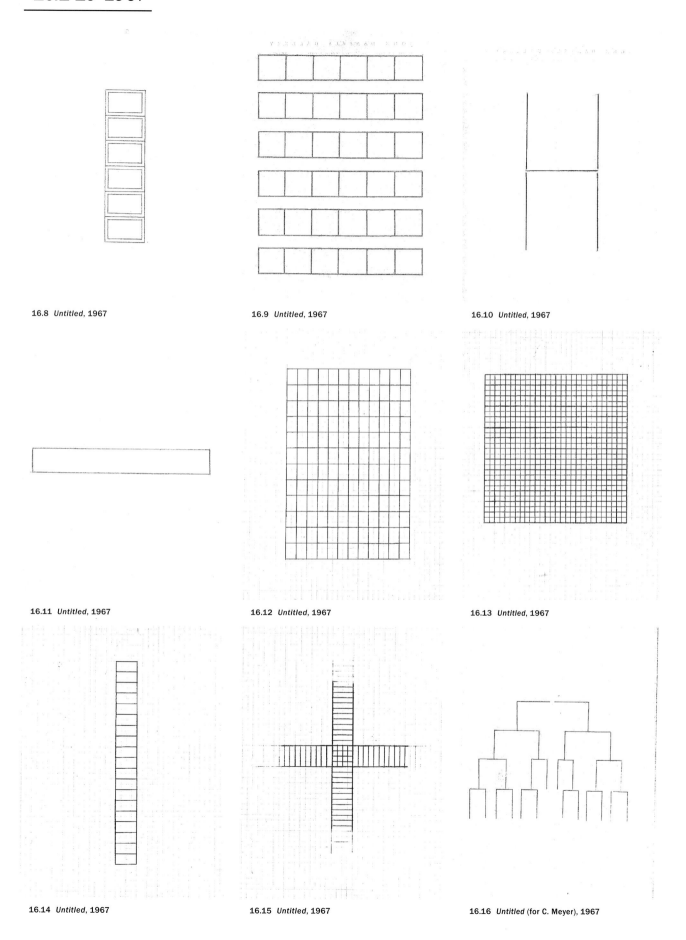

16.8 *Untitled*, 1967

16.9 *Untitled*, 1967

16.10 *Untitled*, 1967

16.11 *Untitled*, 1967

16.12 *Untitled*, 1967

16.13 *Untitled*, 1967

16.14 *Untitled*, 1967

16.15 *Untitled*, 1967

16.16 *Untitled* (for C. Meyer), 1967

16.17 *Strange and Square*, 1967 16.18 *I-they*, 1967 16.19 *I/II/III/IV/V*, 1967

W 1967

Writings

'Muybridge Moments' or 'Photographs of Motion,' *Arts Magazine* 41, 4 (February 1967): 23-24.

'Models and Monuments,' *Arts Magazine* 41, 5 (March 1967): 32-35.

'Of Monuments and Dreams,' *Art and Artists I*, Vol. 1 no. 12 (March 1967): 62-63.

'The Artist as Bookmaker [II]: The Book as Object,' *Arts Magazine* 41, 8 (Summer 1967): 23.

'Dan Flavin,' in *Dan Flavin: Pink and Gold*. Exh. cat. Chicago: Museum of Contemporary Art, 1967 n.p.

'Carl Andre,' *Arts Magazine* 42, 3 (December 1967–January 1968): 34-35.

'Exchange: Discussion between Carl Andre and Dan Graham,' conducted for *Aspen*, 1967, unpublished.

'Monuments,' manuscript for a book for the Museum of Contemporary Crafts, New York, 1967, unpublished.

W 1968

Writings

'Oldenburg's Monuments,' *Artforum* 6, 5 (January 1968): 30-37.

'Holes and Lights: A Rock Concert Special,' *Straight* Vol. 1 no. 1 (April 1968): 1-2.

Materials
printed matter

Dimensions:
variable according to
publication

First publication
Konzeption – Conception.
Exh. cat. Städtisches
Museum Leverkusen,
1969: n.p. See also *For
Publication* 1975: n.p.
where it is published
under the title: *Time
Extended/Distance
Extended.*

Notes
Alternate title: *Time/
Distance Extended.
Extended Distance/
Extended Time* was never
realized as a magazine
page.

17.1 1969

Title/Date
Time/Distance Extended
1969

Materials
drawing for a magazine
page: ink on paper

Dimensions
8½ x 11 in.
21.6 x 28 cm

First Publication
Bleich-Rossi 1990

[…] My *Extended Distance/Extended Time,* 1969, and *Side Effects/Common Drugs,* 1966, function as gridded data fields generating an optical-matrix perspective. They can be read as 'spatialized' 'effects' in time. In *Side Effects/Common Drugs* the optical-reflexive time sequence of the reading constitutes the content. The dots have the sequence of effect/response plus 'spatial' 'density'. Reading from the terms in horizontal/vertical order or the side (or obliquely) we 'see' that symptoms (causes or 'side' effects) produced by the cure or drug to correct these side effects from the taking of the first drug, and so on… The extension of the data field (in the time of the reading process) continues until all self-reflexive effects – points – are optically cancelled. […]

Perth 1985: 13.

Title/Date
Income (Outflow) Piece
1969

Materials
printed matter

Dimensions
variable according to
publication

First publication
Performance 1970: 13,
subsequently also in
Selected Works 1972: n.p.

First exhibition
'Language III,' Dwan
Gallery, New York,
May 24 – June 18, 1969.

Notes
Income (Outflow) Piece
was never realized as an
advertisement in a maga-
zine. It was published as a
proposal in the catalogue
For Publication 1975: n.p.
see text written in 1973,
cat. no. 40.

INCOME (Outflow) PIECE

STATEMENT OF THE ARTIST EXHIBITED AT DWAN GALLERY, NEW YORK, "LANGUAGE III"

From April 2, 1969 I have been performing activities required to allow my placing legally an advertisement (termed a 'tombstone') in various magazines offering the prospectus describing a public offering of stock in *Dan Graham, Inc.* The 'object' (my motive) of this company will be to pay Dan Graham, myself, the salary of the average American citizen out of the pool of collected income from the stock's sale. All other income realized from the activities of Dan Graham beyond the amount *will be returned to the investors* in the form of dividends. I, Dan Graham, am to be the underwriter of the forthcoming issue. Advertisements, it is planned, will be placed sequentially in a number of contexts-magazines. These are divided into 'categories' as, first: "The Wall Street Journal" (then in this order), "Life", "Time", "Artforum", "Evergreen Review", "Vogue", "Psychology Today", "The Nation". My intention is to solicit responses to my and my company's motives from a spectrum of 'fields.' Such responses *might* range from: "Mr. Graham is attempting to create socialism out of capitalism" (*political* motive) or, "Mr. Graham is a sick exhibitionist" (*psychological* motive) or, "Mr. Graham is making art" (*aesthetic* motive) . . . all categories of meaningful information feedback. Categories of responses will define feedback in terms of motive. A sampling of responses in print would be printed as additional in-formation as the advertisements progressed in their appearances. Author and place the comments appeared would also be printed. In placing the comments of additional in-formation, I would be motivated solely to induce (through 'come-ons') the greatest response in terms of new stock buyers. The prospectus outlining the terms of the offering will also include a valuation of myself and past activities by a friend, an artist, an astrologer, and an anthropologist, a doctor, and others. These individuals will each take a small percentage of shares of the stock in exchange for these services.

1. Money is no object, but a *motive,* a *modus vivendi,* a means to my support; the artist changes the homeostatic balance of his life (environment) support by re-relating the categories of *private* sector and *public* sector; a modus operandi, a social sign, a sign of the times, a personal locus of attention, a *shift* of the matter/energy balance *to mediating my needs* — the artist places himself as a situational vector to sustain his existence and projected future (further) activities in the world. Money is a service commodity: in come and out go while in-formation.

2. The artist will have as his object (*motive*):

a. to make *public* information on social motives and categorization whose structure upholds, reveals in its functioning, the socio-economic support system of media.

b. to support himself (as a service to himself).

c. for other persons to emulate his example and do the same.

The advertisement makes PUBLIC – publi-cizes – a PRIVATE need and, as a consequence, shifts categories of this relation. *Income (Outflow)* through this alteration, effects the larger homeostatic balance of my life.

The advertisement functions as 'expo-sure.'
There is a relation of a PUBLIC figure's PRIVATE 'piece' to PUBLIC exposure or the reverse (as in *Likes* where the spectator exposes his private needs).

Selected Works 1972: n.p.

This announcement is under no circumstances to be construed as an offer to sell or as a solicitation of an offer to buy any of these securities. The offering is made only by the Prospectus.

<u>NEW ISSUE</u>

June 2, 1969

1,500 Shares

DAN GRAHAM INC.

Price $10 per share

Dan Graham Incorporated (underwriter)
84 Eldridge St., New York, N. Y. 10002
Phone (212) 925-3490

19 1969

Title/Date
Proposal for Art Magazine
May 1969

Materials
printed matter

Dimensions
variable according to
publication

First publication
For Publication 1975: n.p.

Notes
Proposal for Art Magazine
exists as a proposal and
written description as pub-
lished in *For Publication*
1975. It was never real-
ized as a piece of criticism
for an art magazine.

PROPOSAL FOR ART MAGAZINE

A Museum or a gallery makes an 'important' exhibition of 3 artists presently working in the same genre all of whom are familiar with each other and each other's body of work. Dan Graham, a known art critic, is commissioned by this magazine to produce an article dealing with this exhibition.

I interview each artist, completely tape-recording their comments. I ask each of them to speak (also) about the work of the other two artists.

The magazine feature, appearing with my name as its author, will consist only of a *verbatum* transcript of:

1. The first artist's comments about the second and the third artist('s work).

2. The second artist's comments about the first and the third artist('s work).

3. The third artist's comments about the first and the second artist('s work).

The resultant structure is only the socio-psychological framework (a self enclosing triad), the reality that is 'behind' the appearance of any article in the art magazine, or *art criticism*.

May, 1969

Title/Date
Like
1969

Materials
sound piece: tape
recorders, tape loop,
about thirty participants

Dimensions
variable according to
installation

First publication
End Moments 1969: 63.
Performance 1970: 2-3.
See later version in
Selected Works 1972: n.p.

First performance
Nova Scotia College of
Art and Design, Halifax,
October 1969. Second
performance: 'Perfor-
mance, Film, Television &
Tape' produced by John
Gibson at Loeb Student
Center, New York Univer-
sity, December 14, 1970.

Like, 1969. Installation
October 1969, Nova Scotia
College of Art and Design,
Halifax, Nova Scotia, Canada.

A tape recorder and a one minute film loop played at a normal voice level in a gallery installation. People's voices are heard on the tape saying a single word or short phrases: (adore, dig, similar, such as, want, about, prefer, groove, fine, nice, like, same, like connotations, pretty close to, as far as, comparison, love a little, admire, fond, close, identical, friendly, to want perhaps, groovy, desire, love, compare, as, appreciate, o.k., in relation to, a like is like a like…). The people and words appear to be defining something.

Recording Process. A group of about 30 persons' responses to my request that they give a synonym for the word, *like,* are taped. Extraneous noise, comments, and redundant responses are edited out. The final tape is cut and looped to a tape recorder to be played back in the context of a gallery installation.

Reading Process. The deductive process on the spectator level – as the 'content' – involves inverting backwards the work's own process of construction as the system is read from the clues of morphenological subdivision – as the 'subject matter,' in the relation of part to part to whole by the viewer, is translated (back) into the system. The presence (mental occupancy) of the work by the spectator is the locus of evolved past order (the work's process)

and evolving future order (the viewer's process/conception of the content).

There is another 'level of meaning' in the system constructed by the members of the recorded group adding and subtracting in sequence from the progression of previously given 'meanings.' (The particular group usage in this sequential process is the defining context.)

Surface. As generally people tend to be saying, also, what *they are like*, vocal intonation provides salient clues to this for the spectator who is simultaneously (as he is led to the 'meaning') led to the surface (or personality) of the person who is doing the defining.

[…] In (*Like*) *all* categories are *merged* in the process; the *schema* (language in the sense of the larger institution or overriding form) has no historicity but *is the same container and moment as the norm-usage-speech* which is that which gives language substance in the exact and particular instant (instance) of social articulation.

Performance 1970: 2-3.

21 1969

Title/Date
Lax/Relax
May 1969

Materials
male and female performers, tape recorder, audience

Dimensions
variable according to installation

First publication
Performance 1970: 4. Later version: *Theatre* 1981: n.p.

First performance
'Coulisse,' an evening of performance organized by Dan Graham with works by Vito Acconci and Bruce Nauman at Paula Cooper Gallery, June 13, 1969. Second performance: Nova Scotia College of Art and Design, September 1969. Third Performance: 'Performance, Film, Television & Tape,' produced by John Gibson at Loeb Student Center, New York University, December 14, 1970.

Notes
A single channel videotape of *Lax/Relax* was published by Lisson Gallery Editions, London.

Lax/Relax, 1969. Second performance, September 1969, Nova Scotia College of Art and Design, Halifax, Nova Scotia, Canada.

A girl is instructed to say the word […] 'lax' […] to herself and then to breathe in and out, then to repeat this word […] and to continue in this pattern for 30 minutes. This is tape-recorded. The girl may be hypnotizing herself.

In front of a live audience, I say the word […] 'relax' to myself, breathe in and out, then repeat this pattern for the length of time of the recorded girl's voice tape. I speak into a microphone connected for amplification to a tape recorder whose self-contained speakers are playing (on one side) the girl's pre-recorded voice and (on the other side) my voice. Through absorption, the girl's recorded voice and my voice are tending in vocal intonation and in my body's posture to 'identify' with our particular phrase.

In the initial stages of performance my awareness is focused upon: myself (self relation), the voice of (and my relation to) the girl, and the audience's responses. My initial outward responses, my timing and phrasing, reflect my consciousness of all 3 inputs. But as I concentrate, gradually my awareness shifts to only myself and relating to the girl's voice; then finally I am centered in only self-absorption.

The performance begins with both words spoken in phase; the breathing reflects my (and the girl's) 'distance' as the words move in and out of phase with irregular breathing modules; as the piece continues and the breathing regularizes, the intervals gradually tend to regularize in phase.

The audience may become involved in its own breathing responses and thus locate the surface of its involvement; its attention is somewhere between 'inside' my breathing, its relation to the girl's or its own breathing. It may become hypnotically affected.

Theatre 1981: n.p.

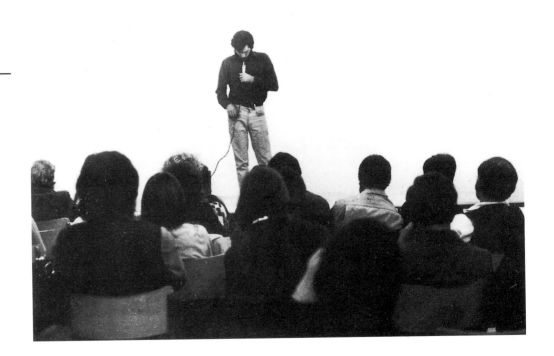

Title/Date
Time/Place Extension
1969

Materials
printed matter

Dimensions
variable according to
publication

First publication
End Moments 1969:
55-59. A second, longer
text was first published in
Selected Works 1972: n.p.

Notes
Time/Place Extension is a
work which extends the
concerns of the piece
March 31, 1966 to involve
the position of the specta-
tor. Graham executed the
piece with students at the
Nova Scotia College of Art
and Design in 1969. He
published copies of the
questionnaire filled out by
students in *End Moments*
1969: 55-58, including a
questionnaire filled out by
Eva Hesse.

Time/Place Extension, 1969.
Collection Daled, Brussels,
Belgium.

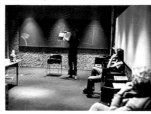

Collected responses […] to a sheet of questions given to students at the Nova Scotia College of Art in Halifax and other responses from miscellaneous sources re-ferring to a copy of *March 31, 1966* placed before them. These responses rep-resent (to me) many other 'points-of-view' – i.e. where many other 'heads are at.' My observation of this new data together (with the passage of time) yield (contain or make up for me) a new 'perspective' on my 1966 observation.

End Moments 1969: 59.

Copies of an earlier piece, *March 31, 1966,* are presented to a number of stu-dents seeing me as 'visiting artist' and learning about my work for the first time. I am developing (a concept of) this work in terms of my present identity (artist, physi-cally present, presenting a continuity, 'body of work').

By previous discussion to this point, *March 31, 1966* may in part be explained by my presence (my present concerns, projections) as I bring to its 'meaning' my memory of its inception; the content extends my (initial) projections of its point to its present(ation).

The responses to a questionnaire given out at the same time as copies of the piece, *March 31, 1966*, offer a 'perspec-tive' on the earlier work.

Reading each of the respondants projec-tions, I am also feeding back my present projections: insights, memory processes, psychological state in terms of a continu-ity; continuity in terms of earlier se-quences of thought about, thoughts, work:

1. My 'insight' – point of inception – *March 31, 1966* – extends here – from present backward in time; as its 'interior' plane inverts 'outside' while also 'inside.'

2. The responses as I read them to me represent many other 'points of view', 'insights', 'where other heads are at', as each of the respondants defines himself, introspectively, to me, as they define my projections to me.

3. My observation of this new data (added to the passage of time and memory of its point of inception) contains a new set of 'outside'/'inside' insights.

Selected Works 1972: n.p.

Title/Date
Piece
May 1969

Materials
black and white photo
documentation: text and
diagrams with handwriting

Dimensions
8 x 10 in.
20.3 x 25.4 cm

First publication
Interfunktionen no. 8
(January 1972): 33.

First exhibition
'No. 7,' Paula Cooper
Gallery, New York, May 18 –
June 15, 1969, organized
by Lucy R. Lippard.

Notes
Alternate title: *Base Ball
'Piece.'* Never realized
as a performance. Perfor-
mance would involve
about 24 naked perform-
ers, half of them male and
half of them female,
enacting the 'score' of
activity which, as Graham
writes: "may seem at
various points to be sex
education, art, exercise,
entertainment, sense
relaxation, therapy, the-
atre, encounter group, or
open to any other or
entirely undefined cate-
gories on how the specific
players relate their
responses to it."

(BASE BALL) **'PIECE'** For "no. 7" Exhibition organized by Lucy R. Lippard for Paula Cooper Gallery, June, 1969. Dan Graham 1969

"A state of neutral pleasure available to everyone" – Dan Flavin notes from "Artforum", November, 1967

POSTURES prop positions

I II III IV V VI

VII VIII IX X XI XII

Sets of positions of sexual intercourse

PERFORMANCE INSTRUCTIONS:

Members of the public are invited
to participate as a group of about
24 people (half male, half female)
to be selected at random freely
to realize the score. The activity
may seem at various points to be
sex education, art, exercise, en-
tertainment, sense relaxation,
therapy, theatre, encounter group,
or open to any other or entirely
undefined categories on how the
specific players relate their res-
ponses to it.

The players are naked. They 'com-
pose' the piece by 'playing' 1) any
member of the group, selected at
random freely. The initial posi-
tions are taken from the score and
decided by each couple jointly.
The object of each is to realize
as much sense, pleasure, while
releasing tension. 2)

The continuation of a player's act-
ive participation is dependent on
the continuation of his relaxation
of the tension level: if this should
increase, he or she must leave the
field of action and his or her choos-
en partner; if tension level is un-
changed or is rising for either of
the 2, activity must cease. The play-
ers will evolve a set of sexual sig-
nals to communicate these levels to
each other. A disengaged partner
selects the first available partner
and continues taking a position new
to both members of the second coupl-
ing. This continues until a state
of exhaustion or lack of available
players is reached.

PERFORMANCE INSTRUCTIONS

Players are to try to correlate,
tune in, concentrate their breath-
ing to merge with the physical act
of intercourse. So doing, they next
shift attention / the collective
breathing responses of the other
participants engaged in the process
is merged in consciousness with the
individual and couple's breathing.
Sensory mood is used as a collective
learning process: activities have
the **purpose** to 'break-down' previous
modes of manipulating art response.

NOTES:

1) PLAY 2. to perform an instrument
3. to take part in a game 4. to
act on or as on stage 7.(a) to move
or function freely within prescrib-
ed limits 8. to exhibit oneself
(said of a cock-bird)

PLAY 1.(a) to occupy oneself with
2. to do or execute for amusement
3. to contend with in a game

PLAY 1. any exercise or series
of actions intended for diversion
2. the representation or exhibit-
ion of some action on stage. 6.
scope for motion; space in motion
7.(a) OBS. brisk and vigorous phys-
ical action or exercise 12.(b) OBS.
pleasure; joy; enjoyment; cause or
source of pleasure or delight; dall-
iance; disport, as by way of sexual
intercourse (c) performance on an
instrument

2) TENSION 2. Electricity (b)
Potential 3. Mechanics A force
(either of two unbalancing forces)
causing or tending to cause exten-
sion

*DAN GRAHAM
May, 1969*

24 1969

Title/Date
Horizontal/Vertical
1969

Materials
drawing for a magazine
page: ink on paper

Dimensions
8½ x 11 in.
21.6 x 28 cm

First publication
Bleich-Rossi 1990

Notes
Horizontal/Vertical was
never realized as a
magazine page. The
published date of 1964
in the *Bleich-Rossi* cata-
logue is an error.

25 1969

Title/Date
Vanishing Point
1969

Materials
collage of thirty black and
white photographs

Dimensions
16 x 30⅓ in.
40.5 x 77 cm

First publication
'Body Works by Willoughby
Sharp,' *Avalanche* no. 1
(Fall 1970): 13-14, one
image only.

First exhibition
Unknown

Notes
Alternate title: *Beyond the
Vanishing Point. Vanishing
Point* exists in at least two

versions: a collage of 33
color photographs resides
in the collection of Marian
Goodman Gallery, New
York. The black and white
version resides in the col-
lection of the Serralves
Foundation, Porto, Portu-
gal. The color version was
used as the cover image

and announcement card for
'Artists and Photographs,'
New York: Multiples,
1969-1969, an edition of
artists projects using pho-
tography in a box, edition
of 1200.

Detail of *Vanishing Point*,
1969, announcement, 'Artists
and Photographs,' 1969,
Multiples, New York. Courtesy
Lisson Gallery, London,
England.

Title/Date
Sunset to Sunrise
(still photograph version)
1969

Materials
160 color photographs

Dimensions
variable according to
installation: to be placed
horizontally and adjacent
at eye-level and to be
read from left to right on a
wall

First publication
End Moments 1969: 38.
See also *Performance*
1970: 11 and *Some
Photographic Projects*
1970: n.p.

First exhibition
Unknown

[...] A series of 160 photographed views was taken September 21 and 22 from a point near Halifax, Nova Scotia at intervals of 6 seconds and 18 degree shifts in orientation relative to the sun's position beginning at sunset Sept. 21 and following this schema: a complete map of the sky is made, its point of inception being the sun setting across the horizon line. Beginning with this point as the nearest and most nearly measurable distance in space, the photographs extend in a spiraling pattern so that in 80 shots the top of the sky – the furthest extension of immeasurable 'space' – is reached. Beginning at the time of sunrise the next day at the same point at the top of the sky and place, the process is reversed, leading downward in a spiral to meet the sun as it rises above the horizon.

We would not notice the 'space' of the sky if it were never disturbed by clouds and the darkness of night. 'Space' reads as a time shift: the diurnal shift to darkness (relative to the sun as the source of illumination) and the relative shift of clouds (relative to each other and relative to the framing edge ending the view of one particular moment) – the atmospheric content (what's in the air at a particular point in time relative to our view): the 8 minutes duration it takes to realize the *a priori* schema of relative distance.

The schema is also executed as a continuously panning 16 mm color movie which is a different perceptual matter entirely.[1]

[1] Arranged as rows of prints in a series, the photographic record presents a map of the topographical inside of the spheroid 'heavens' (although slightly progressively set-back in time) as – on the wall or page – a flat, two-dimensional extension (an 'extended' sunset and sunrise). As a motion picture the continuous panning movement effects a visual distension, inverting 'inner' space to its topological opposite: observing the inside 'dome' of the sky as if the observer was situated outside the spherical surface; so the earth rotates about itself and about the sun, the viewer rotates in relation to the sky. [...]

End Moments 1969: 38.

Sunset to Sunrise
(still photograph version),
1969

Title/Date
Sunset to Sunrise
(film version)
1969

Materials
16 mm film, color

Dimensions:
variable according to
installation

First publication
Performance 1970: 12
and *Some Photographic
Projects* 1970: n.p. Later
versions of text used here
see *Six Films* 1976 and
Films 1977.

First exhibition
John Daniels Gallery,
New York, January 1970.
Second exhibition: 'Per-
formance, Film, Television
& Tape,' produced by John
Gibson at Loeb Student
Center, New York Univer-
sity, December 14, 1970.

Notes
Graham wrote: "Same
schema (as *Sunset to
Sunrise*, still version) but
done as a continuous,
slow pan in 16 mm color
film. (This owes a debt to
other artists' work: Nau-
man's *Clear Sky* booklet
and Snow's *Standard Time*
motion picture. I was un-
aware when *Sunset to
Sunrise* was conceived,
though, of Snow's latest
film, part of whose prem-
ise parallels mine. It's
dedicated to Bruce Nau-
man and Michael Snow –
and also to Richard Long
and Dennis Oppenheim.)"
Performance 1970: 12.

Sunset to Sunrise, 1969,
film stills. Courtesy Marian
Goodman Gallery, New York,
USA.

The film is made by continuously moving a 16 mm movie camera from a position oriented toward the sun on the horizon line at the moment of sunset, and proceeding in a slow spiral with gradual upward inclination toward the top of the sky. This spiral successively maps the complete topological surface area of the sky. The next morning at sunrise from the same geographical site, beginning at the top, center of the sky, a reverse spiral downward in opposite right-to-left rotation is filmed, ending on the sun rising above the horizon.

The sun's light is simultaneously the point-source of illumination defining the surrounding 360° spatial 'presence' and for the mechanical appearances of the film (document). The 'spatial' presence illuminated is also the distance from the presence of the camera to the presence of the closest surface (placed in front of the camera's lens – reflecting its frontal orientation at each moment) reflecting light back to the film in the camera. As the camera is hand-held it also reflects the filmmaker's body axis of 360° movement relative to the surrounding 360° space it documents (which the camera's image reflects).

For the spectator viewing the film, the continuous movement in time read kinesthetically is correlated to the identity of the filmmaker.

Six Films 1976: n.p.

Title/Date
Binocular Zoom
1969-70

Materials
two Super 8 mm films,
color, two projectors

Dimensions
variable according to
projection: shown with two
projectors simultaneously
as a split-screen image

First publication
Performance 1970: 12
and *Some Photographic
Projects* 1970. Later
versions of text used here
Six Films 1976 and *Films*
1977.

First exhibition
John Daniels Gallery,
New York, January 1970.
Second exhibition: 'Perfor-
mance, Film, Television &
Tape,' produced by John
Gibson at Loeb Student
Center, New York Univer-
sity, December 14, 1970.

Notes
Alternate titles: *Binocular
Zoom (Parallax or Distance
Between the Eyes)* and
*Binocular Zoom of High-
light*.

Two Super 8 mm movie cameras with identical zoom lenses are placed with the viewfinder flush to each of my eyes. Each of the cameras' images are focused on the sun somewhat obscured by a cloudy sky. The image of each camera corresponds to the double retinal images of the right and left eyes. Filming begins with both cameras simultaneously. Initially, the images synchronously are extreme close-up views, maximum disparity between the right and left images being caused as they 'halve' the sun. The two zoom lenses open their respective fields of view at the same rate until reaching their fullest extent. Both images diminish in size to a 'distance.'

In viewing, the films made by the two cameras are simultaneously projected as a 'split-screen' image.

Six Films 1976: n.p.

Binocular Zoom, 1969-70,
Dan Graham filming, framed
by film stills.

28 1969

Title/Date
Two Correlated Rotations
1969

Materials
two Super 8 mm films
converted to 16 mm,
black and white

Dimensions
variable according to pro-
jection: double projection
on synchronous loops
onto two right-angle walls

First publication
Performance 1970: 5 and
*Some Photographic Pro-
jects* 1970: n.p. See also:
Six Films 1976: n.p.

First exhibition
'Artists and Photographs,'
Multiples, New York,
March 28 – April 5, 1969.
Second exhibition: 'Perfor-
mance, Film, Television &
Tape,' produced by John
Gibson, Loeb Student
Center, New York Universi-
ty, December 14, 1970. A
16 mm enlargement was
shown at documenta 5,
Kassel, 1972.

Notes
See *Two Parallel Essays,
Photographs of Motion,
Two Related Projects
for Slide Projectors*.
New York: Multiples, Inc.,
1970: 7-8 for an early
description of *Two Corre-
lated Rotations* relating
this film to *Untitled
(Project for Slide
Projector II)*, 1966-67,
cat. no. 11.

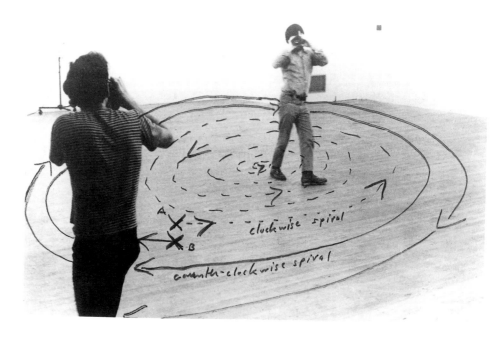

*Two Correlated Rotations,
1969, rehearsal.*

Two cameramen each hold cameras so that their viewfinders are extensions of their eyes and visual fields. They begin facing each other one foot away. They walk in counter spirals, the outside per-former moving gradually outward while the inside performer walks inward approach-ing the center. Their aim, which is still in the state of a learning process, is to be as nearly as possible continuously centering their cameras' (and eyes') view on the frontal eye position of the other.

Geometrically the rotation of the perform-ers' necks and the paths they walk keep the camera/eye sightline of both cameras' images when the cameras are absolutely facing each other, passing through the center of the spirals and the interior of the 360° topological spatial enclosure.

Each performer's moves (and image of the other) reflect the other's in the recip-rocal information feedback necessary to achieve continuous 'aim,' and 'aim' of the film, in the image read by the spectator's correlated rapid brain time apprehending the (feedback) relation of the reciprocal images. The two filmed images of the film-makers with cameras to their eyes are made by the opposite filmmaker as they are simultaneously each other's *subject* (observer) and the reverse at the same time. The spectator's attention is part of a three-way relation (circuit) between the two performers' and the spectators' atten-tion. In the spectator's view, it is impossi-ble to separate the two cameras' mecha-nisms, the two minds and bodies from the feedback of reciprocal intelligence be-tween them and read in the image by the viewer. The 'self' is not an atomistic entity, but is immanent in the network of interre-lationships or environmental structure.

In viewing the film on right-angle walls, both images are synchronous and simulta-neously projected. Both filmmakers' and viewers' responses appear in the present time to them. The film-recorded time is 'contained' in the mechanical operation of the cameras' and projectors' rotations. Due to mechanical irregularity, these may be slightly faster or slower in relation to each other in the screening, subtle timing differences affecting the spectator's per-ceptual (brain's) reading of that time.

Six Films 1976: n.p.

'Eisenhower and the Hippies,' *0 to 9* no. 6
(July 1969): 30-37.

'Live Kinks,' *Fusion* (1969).

'Synthetic High & Natural Low: Dean Martin on
TV' or 'Dean Martin/Entertainment as Theater,'
Fusion (1969): 12-13.

'Subject Matter,' in *End Moments* 1969: 15-30.

'Two Structures/Sol LeWitt,' in *End Moments*
1969: 65-68.

'Art Worker's Coalition Open Hearing Presenta-
tion,' April 10, 1967 in *Art Workers Coalition,
An Open Hearing on the Subject: What Should
be the Program of the Art Workers Coalition
Regarding Museum Reform and to Establish the
Program of an Open Art Workers' Coalition.* New
York: Art Workers' Coalition, 1969.

Fusion (1969): **12-13**.

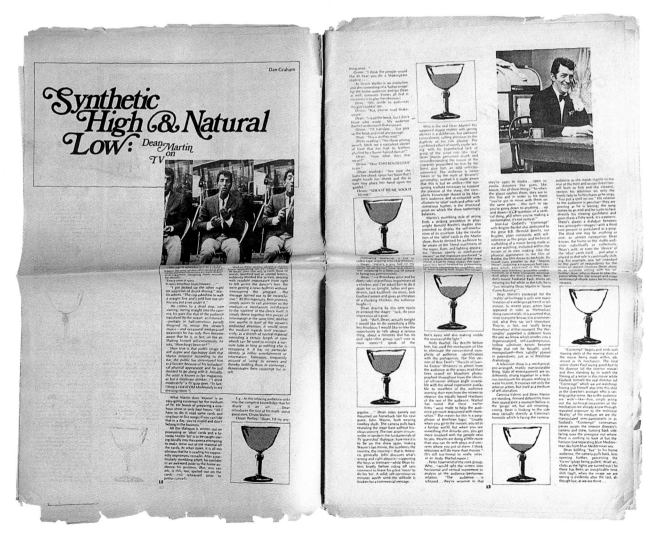

Title/Date
Roll
1970

Materials
two Super 8 mm films,
enlarged to 16 mm, color

Dimensions
variable according to
installation: two films are
projected on parallel and
opposite walls

First publication
Performance 1970: 8 and
*Some Photographic
Projects* 1970: n.p. This
version of text first
published *Six Films* 1976.

First exhibition
University of California,
San Diego, May 1970.
Second exhibition: 'Perfor-
mance, Film, Television &
Tape,' produced by John
Gibson, Loeb Student
Center, New York
University, December 14,
1970.

One filming camera is an inert *object,* detached (although within the performer's visual field), while the other camera, attached to his eye, is both *subject and object.* The 'objective' camera is placed with its base on the ground. After looking through its viewfinder to determine left and right extremities, which will frame the image, the performer positions his body and the second camera's front frame directly facing the inert camera's view and at the line of its left framing edge. With both cameras filming, the performer with his camera to his eye rolls slowly toward the right framing edge of the other camera's view, with the aim of continuously orienting his eye/camera's view to center on the other cameras' position (and image).

The performer's legs and frontal body trunk protrude at the bottom of the held camera's/eye frame through which the performer must observe his shifting postural placement as the feedback needed to achieve his orientation (and his image's). The spectator sees (from within) the body's kinesthetic sensations. From his eyeview inside the feedback loop, he observes the body's shifts as it changes position in space in relation to the position of the aim (fixed camera). The brain must correct the muscles to cause a skeletal alignment; this affects the camera's aim; it must be re-aligned by the neck's turning and the hands to keep open the visual feedback between the two cameras' images (upon which the perception of the piece depends).

The two films' images are projected for simultaneous viewing at eye-level on distant opposite, parallel walls. Observing the view from the first camera's body feedback loop, a continuously rotating image, the body appears unweighted. The view from the 'objective' 'black box' camera shows the body from outside as an object orienting with respect to universal gravity opposing a stationary, parallel force pressing the body's muscular/skeletal frame toward the horizontal.

Six Films 1976: n.p.

Roll, 1970, film stills, Central
Park, New York. Private collec-
tion. Courtesy Marian Goodman
Gallery, New York, USA.

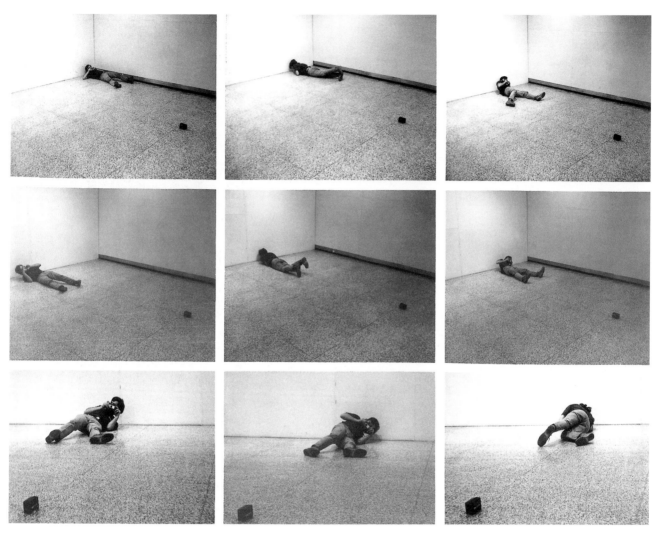

Roll, 1970, rehearsal.

Title/Date
Body Press
1970-72

Materials
two 16 mm films, color,
two synchronous loop
16 mm projectors

Dimensions
variable according to
installation: two films are
projected on two parallel
and opposite walls

First publication
Interfunktionen 7 (1971):
87, drawing with early ver-
sion of text dated 1970.
Later version used here
Selected Works 1972: n.p.
See also *Six Films* 1976:
n.p. and *Films* 1977: 21.

First exhibition
'Factory,' Philadelphia,
1970. Second exhibition:
'The Boardwalk Show,'
SJCC Convention Hall,
Atlantic City, organized by
Protetch-Rivkin, Washing-
ton, DC, May 18-20, 1971,
newsprint brochure
with documentation by
Graham.

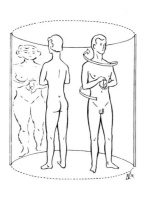

Two filmmakers stand within a surrounding and completely mirrorized cylinder, body trunk stationary, hands holding and press-ing a camera's back-end flush to, while slowly rotating it about, the surface cylin-der of their individual bodies. One rotation circumscribes the body's contour, spiralling slightly upward with the next turn. With successive rotations, the body surface areas are completely covered as a tem-plate by the back of the camera(s) until eye-level (view through camera's eyes) is reached; then a reverse mapping down-ward begins until the original starting point is reached. The rotations are at a correlat-ed speed; when each camera is rotated to each body's rear it is then facing and film-ing the other where they are exchanged so the camera's 'identity' 'changes hands' and each performer is handling a new camera. The cameras are of different size and mass. In the process, the performers are to concentrate on the coexistent, simultaneous identity of both camera's describing them and their body.[1]

Optically, the two cameras film the image reflected on the mirror which is the same surface as the box (and lens) of the cam-era's five visible sides, the body of the performer, and (possibly) his eyes on the mirror.[2]

The camera's angle of orientation/view of the area of the mirror's reflective image is determined by the placement of the cam-era on the body contour at a given moment. (The camera might be pressed against the chest but such an upward angle shows head and eyes). To the spec-tator the camera's optical vantage is the skin. (An exception is when the per-former's eyes are also seen reflected or the cameras are seen filming the other). The performer's musculature is 'seen' pressing into the surface of the body (pulling inside out). At the same time, kinesthetically, the handling of the camera can be 'felt', by the spectator, as surface

tension, as the hidden side of the camera presses and slides against the skin it cov-ers at a particular moment.

The films are projected at the same time on two loop projectors, very large size on two opposite, but very close, room walls. A member of the audience (man or woman) might identify with one image or the other from the same camera or can identify with one body or the other, shifting their view each time to face the other screen when the cameras are exchanged.

[1] The camera may/or may not be read as an extension of the body's identity.
[2] In projection what is seen by the spectator.

Selected Works 1972: n.p.

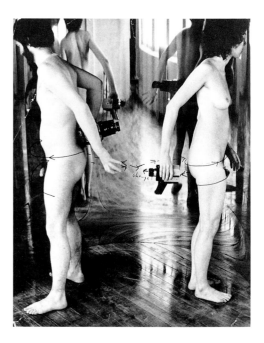

Body Press, 1970-72, rehearsal (top).

Body Press, 1970-72, film still. Collection Serralves Foundation, Museum of Contemporary Art, Porto, Portugal. Courtesy Serralves Foundation.

Title/Date
TV Camera/Monitor
Performance
1970

Materials
TV camera, TV monitor,
stage, audience

Dimensions
variable according to
installation

First publication
Performance 1970: 10
and *Some Photographic
Projects* 1970: n.p. This
version of text published
Nova Scotia 1979: 2.

First performance
Nova Scotia College of Art
and Design, Halifax,
November 1970. Second
performance: 'Perfor-
mance, Film, Television &
Tape,' produced by John
Gibson, Loeb Student
Center, New York Univer-
sity, December 14, 1970.

A stage facing and at the eye-level of a seated audience is utilized. A TV monitor is positioned to the rear of the audience and facing opposite to the middle of the stage. With my feet facing the audience and from a lying, prone position, I roll parallel to the left and right edges of the stage from one side to the other and back, repeating this. As I roll, I direct a TV camera, held constantly to my eye, extended by a cord to the monitor. As I roll, my goal is to, as much of the time as possible, have the camera's view oriented at the monitor image. When the camera *is* successfully aimed, the result is a pattern on the monitor of image-within-image-within-image-feedback. The monitor image represents a 'subjective' view from inside my 'mind's eye'. This view is continuously rotating as I roll. My legs protrude into this camera view and, as I look through the camera's viewfinder, I am observing their position as well as the image of the monitor in order to adjust my aim.

A member of the audience looking to the rear at the monitor view can observe the view from within my 'subjective' view (within my body's feedback system). A member of the audience looking to the front can observe my body from an external vantage – as an outside object. The monitor's view also shows the audience, placed directly between the camera and the monitor, observing the performer's process of orientation. A spectator turned to face the rear monitor can never observe (on the screen) his gaze directly (he sees the back of his head), but can observe the frontal gaze of other members of the audience.

Nova Scotia 1979: 2.

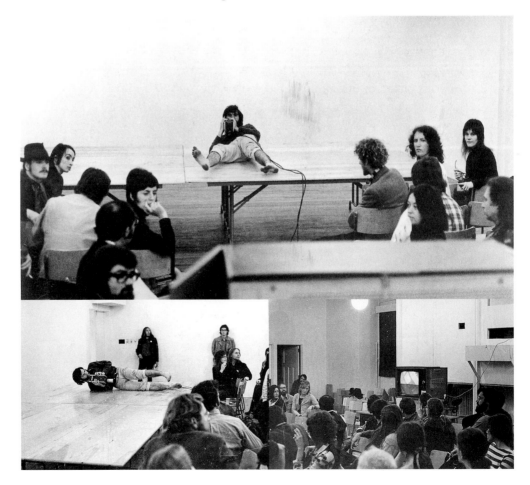

*TV Camera/Monitor
Performance*, 1970. First
performance, November 1970,
Nova Scotia College of Art
and Design, Halifax, Nova
Scotia, Canada. Collection
Daled, Brussels, Belgium.

Title/Date
Eleven Sugar Cubes
1970

Materials
printed matter

Dimensions
variable according to
publication

First publication
'Eleven Sugar Cubes,'
Art in America 58, 3
(May – June 1970):
78-79.

Notes
Eleven Sugar Cubes
consists of a two-page
spread, featuring a grid of
24 color photographs. It
was published with the
accompanying text by Dan
Graham.

I dropped eleven sugar cubes in the sea, after soaking them in detergent, and photographed the results. This presentation constitutes the intended work of art, which was designed to be mass-produced in a publication.

'Eleven Sugar Cubes,' *Art in America* 58, 3 (May–June 1970): 78.

Art in America 58, 3
(May – June 1970): 78-79.

Writings

'Late Kinks,' *Revista de Letras* (Universidad
de Puerto Rico Mayaguez) II, 5 (March 1970):
43-48.

'Ecological Rock,' in *Assembling.* Ed. Henry
J. Korn and Richard Kostelanetz. Brooklyn:
1970: n.p.

'Several Works,' *Interfunktionen* no. 5
(November 1970): 153.

'Editorial: One Proposal,' *Aspen* no. 8
(Fall-Winter 1970-71): n.p.

'Live Kinks,' in *Performance* 1970: 28-31.

'Ecological Art,' partial manuscript dated to
1969-70 for a book to be published by John
Gibson Gallery to accompany the exhibition,
'Ecological Art,' May 17 – June 28, 1969,
unpublished.

Title/Date
Like
1971

Materials
two performers

Dimensions
variable according to
installation

First publication
Selected Works 1972: n.p.
Later version *Theatre*
1981: n.p.

Notes
This work was never real-
ized before an audience.
It was performed by Dan
Graham, Ian Murray and
others and documented
with photographs at the
Nova Scotia College of Art
and Design, Halifax,
December 1971.

Two performers have both been instructed
to convince the other (the ways in which)
he is like him (or her). This performance is
continued with a continual coming closer
together, until (perhaps as boundaries of
the self are reached) this is reversed. To
communicate gesture, verbal means, hand
or skin manipulation, visualization or sets
of mental attention (or any form) may be
used.

Theatre 1981: n.p.

Like, 1971. Rehearsal
December 1971, Nova Scotia
College of Art and Design,
Halifax, Nova Scotia, Canada.

Title/Date
Project for a
Local Cable TV
1971

Materials
TV cameras, monitors
and studio audience for
broadcast television

Dimensions
variable according to
production

First publication
Nova Scotia 1979: 3.

First exhibition
Experimental set-up at the
Nova Scotia College of Art
and Design, Halifax, 1971.
*Project for a Local Cable
TV* was never realized for
local cable television and
exists as a written propos-
al and documentation.

This program would be broadcast on com-
munity television to provide feedback on
divisive local issues for that community.
There is a small studio audience, whose
individual members have opposing points
of view on various public questions. For
each question, two representatives of
opposing views are selected.

Stage 1. Each person is seated in front of a
small monitor and holds a portable video
camera to one eye, pointing it at the direc-
tion of the other person across the room.
They vary the zoom lens to reflect their feel-
ing of subjective 'distance' from the other's
'position.' As each talks, the director broad-
casts to the home screen the speaker's
view of the other person. They take turns
defending their respective points of view.

Stage 2. Next they reverse their respective
points of view, so that A defends B's view-
point and B defends A's. They are still con-
centrating their camera/eye on the posi-
tion of the other. However, the monitor
placed before them, seen by their other

eye, conveys to them the other person's
'inside' view (of them). For the home view-
ers, the director selects various sequen-
ces which are either:
1. A's voice, with the view of B whom he is
seeing through his camera/eye.
2. A's voice and B's view of him.
3. B's voice with the view of A whom he is
seeing through his camera/eye.
4. B's voice and A's view of him.

Stage 3. Still observing the other with cam-
era on their eye, A and B have a discus-
sion about what has just happened to see
if they can see merits in parts of the oth-
er's position. Both of their side monitors
show a split view, one half being the view
through their camera and the other half a
view through their other camera. The
director shows the home audience the
split-screen view. The function of this
piece is the effect it has when seen and
heard by the larger community through
their individual home TV screens.

Nova Scotia 1979: 3.

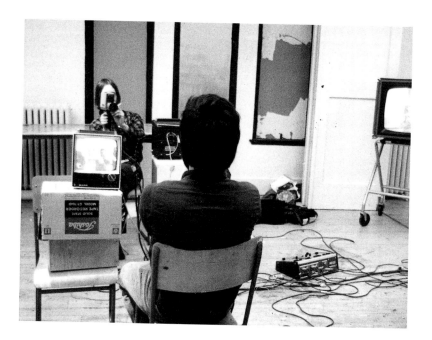

Project for a Local Cable TV,
1971, Nova Scotia College of
Art and Design, Halifax, Nova
Scotia, Canada.

Title/Date
Project for Pier 18
February 27, 1971
14.22ʰ – 14.37ʰ

Materials
layout combining twelve
incorporated coupler
prints by the artist and
nine gelatin silver prints by
Shunk-Kender

Dimensions
18⁵/₈ x 60³/₄ in.
47.2 x 154 cm overall

First publication
Unknown, see *Harry
Shunk: Projects – Pier 18.*
Exh. cat. Nice: Musée
d'art moderne et d'art
contemporain,
1992: 78-85.

First exhibition
'Projects: Pier 18,' The
Museum of Modern Art,
New York, June 18 –
August 2, 1971, installed
by Jennifer Licht. No
catalogue.

Notes
Alternate title: *Body Press –
Spin Off.* For the Pier 18
Project organized by
Willoughby Sharp, the pho-
tographer Harry Shunk
photographed a number
of artists, including Dan
Graham, on Pier 18, New
York, with the idea of pho-
tographically capturing the
artists using photography
as a performance. Gra-
ham's piece was to posi-
tion a camera, with its
back pressed to his body,
moving it in a slow spi-
ralling motion, from his
feet to the top of his
head. See *Body Press,*
1970-72, cat. no. 30. Here
Graham calls for the same
bodily motion for a film

camera, though the film is
executed by two opera-
tors, one male and one
female, who are posi-
tioned within a mirrorized
cylinder. This work com-
bines black and white
prints by Shunk and
Graham's own color pho-
tographs.

Body Press – Spin Off, 1971.
Collection Serralves
Foundation, Museum of
Contemporary Art, Porto,
Portugal. Courtesy Marian
Goodman Gallery,
New York, USA.

W 1971

Writings

'Several Works' and 'Performance as Perceptual
Process,' *Interfunktionen* no. 7 (1971): 83-89.

'TV Camera/Monitor Performance,' *Radical Soft-
ware* (Fall 1971).

'Like,' in 'Future's Fictions,' special issue ed.
Richard Kostelanetz, *Panache* (New York 1971):
n.p.

Title/Date
Two Consciousness
Projection(s)
1972

Materials
woman performer, male
performer, TV camera and
monitor

Dimensions
variable according to
installation

First publication
Selected Works 1972: n.p.
and *Studio International*
Vol. 183 no. 944 (May
1972): 210. This longer
version includes an ex-
tended analysis of the
performance, first pub-
lished: *Nova Scotia*
1979: 4.

First performance
98 Greene Street Loft,
New York, January 21,
1972. The work was also
performed at the Lisson
Gallery, London in March
1972. A nude version was
performed in 1975 at
Nova Scotia College of Art
and Design, Halifax.

A woman focuses consciousness only on a television-monitor-image of herself and must immediately verbalize (as accurately as possible) the content of her conscious-ness. The man focuses consciousness only *outside himself* on the woman, observing her objectively through the cam-era connected to the monitor. He also ver-balizes his perceptions. The man's and woman's self-contained conscious, uncon-scious, or fantasized intention – *con-sciousness* – is projected. The audience sees on the video screen what the man and woman 'objectively' are seeing at the same time they hear the two performers' interior views.[1] Because of each of the performer's time process of perception, verbalization and perception-response to the other's verbalization, there is an over-lap of consciousness (of the projections of each upon the other). Each's verbal impression, in turn, affects the other's per-ception: the man's projection on the pe-riphery of the woman's affect her con-sciousness or behavior.

A field is created in which audience and performers place reciprocal controls on the other. The audience's reactions to the man's responses (his projection of the woman) may function for him as a 'super-ego', inhibiting or subtly influencing the course of his behavior or consciousness of the situation. Likewise, the man's responses on the periphery of the woman's consciousness interfere with her self-consciousness so that her behavioral responses, including those of self-percep-tion, may be 'subconsciously' affected. Each of the three elements functions mutually as a feedback-device governing behavior – a 'superego' or 'subconscious' to the consciousness and response of the others. An abstractly presupposed psy-chological[2] (or social)[3] model is physically observable by the audience. The specific results of the piece vary according to the context in which it is performed, with changing historical circumstances, locale, or use of different social classes of audi-ence or actors.

[1] While an audience might initially assume that the woman was being 'made into an object', it becomes apparent that her position is more powerful than the man's, as her subject and her object are *not* separated (separable). Whereas, the more the man (to himself) strives to be objective, that much more does he appear unconsciously subjective to any observer from the outside (the audience).
[2] The Freudian axiom that one person is always projecting himself into his observation of a second person.
[3] Imposed behavioral ('psychological') differentiations between men and women.

Nova Scotia 1979: 4.

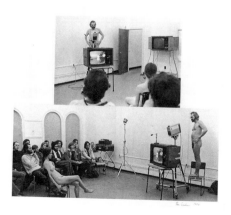

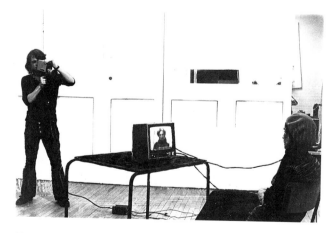

*Nude Two Consciousness
Projection(s)*, January 1975,
Nova Scotia College of Art
and Design, Halifax. Collec-
tion Herbert, Gent, Belgium.

*Two Consciousness
Projection(s)*, 1972,
Nova Scotia College of Art
and Design, Halifax, Nova
Scotia, Canada.

Title/Date
Past Future Split Attention
1972

Materials
two performers, two
microphones, TV camera

Dimensions
variable according to
installation

First publication
Selected Works 1972: n.p.
and *Studio International*
Vol. 183 no. 944 (May
1972): 210. See also
transcript of videotaped
performance *Theatre*
1981: n.p.

First performance
An early version of this
work entitled *Past Present
Divided Attention* was
performed at 98 Greene
Street Loft, New York,
January 1972 with *Two
Consciousness Pro-
jection(s)*, cat. no. 36. It
was performed without an
audience and video-taped
at Lisson Gallery, London,
March 1972. The single
channel videotape, *Past
Future Split Attention*,
1972, (black and white,
sound, 17:03 minutes) is
distributed by Electronic
Arts Intermix, New York.

Premise. Two people who know each other
are in the same space. While one person
predicts continuously the other person's
behavior, the other person recounts (by
memory) the other's past behavior.

Notes. Both performers are in the present,
so knowledge of the past is needed to
continuously deduce future behavior (in
terms of causal relation). For one to see
the other in terms of the present (atten-
tion) there is a mirror reflection or closed
figure-eight feedback/feedahead loop of
past/future. One person's behavior recip-
rocally reflects/depends upon the other's,
so that each one's information of his
moves is seen in part as a reflection of
the effect that their own just-past behav-
ior has had in reversed tense as perceived
from the other's view of himself. For
instance, the expectation of the person
predicting the other one's behavior may
be thwarted if the other person deliberate-
ly alters the course of his future behavior
and establishes an alternate or negating
series of actions. However, unconsciously
(conscious to an outside observer in a
longer span of time), he may perform as
predicted, but in a displaced or altered
sequence of responses which reflect his
reaction to the reaction of the other to his
projecting a 'past' identity upon them. Or
he may be projecting the behavior that the
other person is anticipating from him onto
the other person's past, trying to affect
that person's future predictions... and so
on. (As part of the thinking process in
terms of time continuum of cause and
effect, the observer, in dealing with what
he sees, extrapolates from the observed's
past behavior projected in a line to the
future.) For the performance to proceed, a
simultaneous – but doubled attention – of
the first performer's 'self' in relation to the
other (object) – the other's impressions –
must be maintained by each performer.
This affects cause and effect directionally,
as does the discrepancy in time between

words as linear projections and the very
different (but also linear) sequential direc-
tion of behavior. As video-tape is a contin-
uum (unlike film, which is discontinuous/
an analytic re-construction) with separate
sound (verbal) and visual tracks, it is an
ideal medium for presenting this se-
quence.

Theatre 1981: n.p.

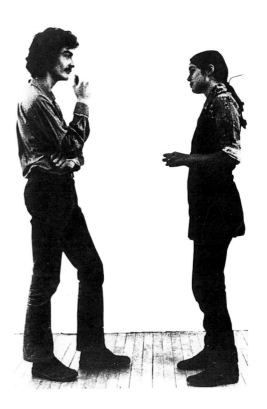

Title/Date
Intention Intentionality
Sequence
1972

Materials
performer, audience

Dimensions
variable according to
installation

First publication
Arts Magazine 47, 6 (April
1973): 64-65, transcript
of second performance:
Interfunktionen no. 9
(1973): 61-64.
Also: *Theatre* 1981, n.p.

First performance
Lisson Gallery, London,
March 1972. Second per-
formance: Protetch-Rivkin
Gallery, Washington D.C.,
May 1972. Third perform-
ance: Projects, Inc., Cam-
bridge, Massachusetts,
December 1972.

First Stage. *I face the audience. I form a mental set of total self-concentration, isolated from awareness of audience as I verbalize intentions.*

My intention is to do a piece that has to do with my intention. I sense that the word, *intention,* can be broken down or used in two different ways. One way is subjective, and the other is objective. The subjective is what I see; my intention – intentionality – is everything I see in the world. Just the way things appear to me. Or, my intention could be an attitude in my movements, appearing as my behavior. So I wanted to do a piece where I would arbitrarily split myself and time into these two facets of intention. Now I want to do something where the *audience* and I would be in a kind of cause and effect relationship, each other's cause and effect at nearly the same moment of stimulus/response. I might be doing something where I affected the audience, where they were the cause of that effect, and they would be able to see it in me as a consequence… If I wanted to have a perspective on this stimulus/response link, I could decide to arbitrarily alter my consciousness to different states in sequence. To cause a split that I wanted, first – in an abstract way before the fact to describe everything I knew about a piece that I was going to perform, or describe what my general state of intentions were in my mind, isolated from anything specific that actually would happen. At first, I would be isolated from seeing anything, but my physical attitudes as they are – physically present, expressed, which are for me just mental intentions – can be seen clearly by the audience as an expression of my intent would (already) be present in my behavior. Then mentally experiencing my sense of the piece, my actual intent would (already) be present in my behavior. Then I wanted to use another sense of the word, *intention,* describing exactly what my

consciousness saw in a physical sense, what is present. In other words, I would be seeing the audience in front of me. This would be for me my intention or attitude. What I perceive might be fed back, as my description would in turn affect what the audience's reactions would be showing. If I directly affected the audience, this might affect my next description as they – it – would affect me. This is close to a cliche of performance… Their intention would reflect my intentions plus the time it took them to respond. The audience and I would be in the same position, except that their cause and effect order, their perception of this, would be inverse in relation to me. And then I wanted to stop this kind of description and make a third stage when I think of a cause and effect relation between my original intentions in the art work – abstracted or timeless, before my involvement with the audience – and the sense I had when I was describing what I saw, my intentionality. In this third stage I would construct a cause and effect, linking the first and second stages while remaining aware of the audience present as I spoke.

Second Stage. *I look directly at the audience and observe and verbalize what appears at present in front of me. I speak directly to the audience in present tense.*
I see just about everybody in the front row in an absolutely static, almost timeless kind of statue-like expression except that the girl in the front row is fooling with her fingers, scratching on her legs and smiling, laughing, coming very, very close to my time, just sort of natural. And everyone else is very close to me now, except for Max, who is deliberately looking to the side, but out of the corner of his eye… Everybody is focused directly on Max… except Marta who turns to look behind her at other people in the audience looking. Now I am looking beyond that first row and see that the first row seems to be looking

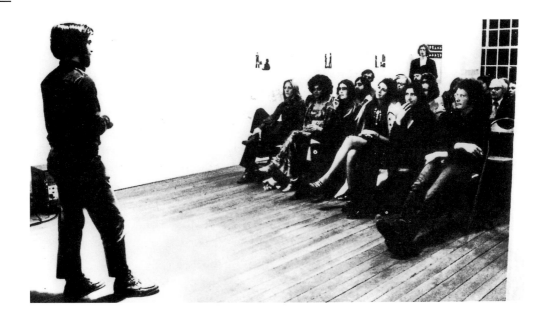

Intention Intentionality Sequence, 1972. Second performance, May 1972, Protetch-Rivkin Gallery, Washington, D.C.

behind them now... I forgot my glasses; it's very hard to see people that clearly. There is a man with a beard in the third row who is turning at an angle and chewing. Everybody else now is doing identical displacement gestures either with their legs, chewing or smoking, and, for some reason I can't really figure out, Max is a little bit looking away and lighting a cigarette. Everybody is doing that; one person, two people, everyone looks at him and back at me... it hasn't happened before in that sequence, people doing that – not looking at me. The people in the very front row are really indifferent, totally different from the people in the other rows. It seems the closer I am to the people the more quick is the time response in regard to what I am saying. Girl in the front row is now twisting her head back and forth a lot and her friend just turned to her, doesn't particularly know what to do, looked at her, looked down – they both have rings, they both look at their rings, and being reciprocal things. The two people on the end are looking to me at the center at what doesn't seem to be directly at me but seems to be looking below my eye-

level. Whereas the people in front of me are looking at me, but they are blinking, so they aren't really seeing. People are shifting... The two people at the end of the second row both moved – no – the two people at the end of the third row both swivelled at the same time back and forth, it had to do with where I was looking, at that row at a particular time. Maybe they were sensing that I would, because of my symmetry in responding, be looking at both of them one after the other. The man behind Marta is looking down and smiling, as if to himself, but now very, very broadly, in a public kind of way... and people are turning to see him, checking back to themselves; they seem to look at their hands first, for some reason. Maybe it has to do somehow with my hands. I just (had) looked at my hands. They are copying what I am doing... Max is very stoical. His hands are crossed in a peculiar way: his left hand is holding his right hand, almost as if it's a tourniquet. It's very strange. It's very stiff. He's smiling and grimacing. The more I say, he smiles, the more he really smiles. And now he's actually laughing. It's hard to tell what his attitude is. And

now everyone's smiling, It's hard to tell what that attitude is – what it represents. Why are people smiling at me? And... then... there are some people who aren't smiling. Then as soon as I look at them and say they aren't smiling, they smile. This is only true of people in the first row. People in the second or third row are always looking sort of across, beyond me, and also taking in the people in the first row at the other end... And then people have frozen attitudes. Maybe this is from waiting for me to see them. The girl looks at Max to light her cigarette and has really divorced herself from the piece for the first time. Now she looks up at me in a very direct, casual way – not a theatrical (way) – as if she is not in the audience category. So maybe the whole relationship in this part of the piece is breaking down. **Third Stage**. Maybe I could have said more specific things about people which would have brought me close to one or two specific people... focusing on them. Instead it seemed like a vacuum was forming. In other words, I had wanted to come as close as possible to the time of the audience, but I felt their position to be entirely different. Their responses can't correspond, so the spectator's sequences, order of relation, cause-to-effect perceiving, always would be inverse... or, one step ahead or behind mine. They can see my motives before I can see the motives in them. Perhaps this has followed and is a consequence of my decision to make arbitrary divisions in my consciousness and (then) my carrying this out; that is, I made a predetermined decision, so my pattern began in advance, one time sequence forever prior to the audience's first perceptions of the sequence.

Transcript of second performance *Theatre* 1981: n.p.

W 1972

'Film Pieces: Visual Field,' and documentation of works, *Interfunktionen* no. 8 (January 1972): 27-33.

'Eight Pieces by Dan Graham 1966-72,' *Studio International* Vol. 944 no. 183 (May 1972): 210-213.

'Dan Graham, Galleria Toselli, Milano,' *King Kong International* No. 2 (July 1972): 12.

'Pieces,' *Flash Art* no. 35-36 (September – October 1972): 8.

Title/Date
Helix/Spiral
1973

Materials
two 8 mm films, enlarged
to 16 mm, color

Dimensions
variable according to
installation; the two films
are projected on opposite
walls

First publication
Six Films 1976: n.p.
See also *Films* 1977.

First exhibition
First known exhibition:
'Artist Film Series: Dan
Graham,' Artists Space,
New York, January 2 and
3, 1976. All six of Gra-
ham's films were shown,
and the performance
*Performer/Audience
Sequence,* 1975, cat.
no. 58 was performed
January 2, 1976 and
shown on videotape with
the films January 3, 1976.

Notes
A variation of the film
under the title *Helix/Circle,*
1973, specifies for a cam-
era-woman in a text which,
with some slight varia-
tions, describes the same
filmic scenario as *Helix/
Spiral.*

A stationary inner cameraman slides the back end of his camera while pressing it flat against his body; it moves in a gradu-ally descending helix from eyes to feet so the entire surface area of his body is topo-logically covered. As the camera rotates, circumscribing the body, it films the out-side 360° of the surrounding space. At each moment and point on the body the specific angle of the body's contour deter-mines the camera's plane or angle of ori-entation; each second it is filming the light reflected from the particular environmen-tal plane facing parallel to the camera's front plane, while the other, obverse, side of the filmed exterior is the negative, cylin-drical 'hole' of the larger 360° topological hole occupied by that person's body.

At a distance on the horizon of the inner filmmaker's view, a second filmmaker with camera's viewfinder to his eye walks in-ward in a gradual spiral whose center is in the position of the first filmmaker. In walk-ing he maps in his spiralling the complete topographic surface area in 360° between the inner performer and his initial dis-tance. He reaches the point of the inner filmmaker when this performer has taken his camera to feet or ground-level. The outside man's aim is to continuously cen-ter his camera on the inside camera while continuously having himself centered in the view of that camera. To achieve this as he spirals, he adjusts his forward move-ment relative to the rate with which the inside cameraman manipulates the cam-era around his body.

The filmed images reflect all outer 'edges' meeting at that moment in the two films' surface. Kinetic reverberations of the images are caused by the camera's move-ment against the inner cameramen's changing contour as the instability in the outside cameraman's image is caused by his feet moving across the irregular topog-raphy of the land – both camera's lenses film the visual surface of the outside envi-ronment, film the other cameras' front plane and lens, film both performers' 'sub-jective' 'mind's eye' views, and film both performer's observed exteriors. At each moment in their cameras' continuous rota-tion, each projected film's view is an oppo-site 180° of the surrounding 360° space. The two films are projected for simultane-ous viewing on opposite walls.

Six Films 1976: n.p.

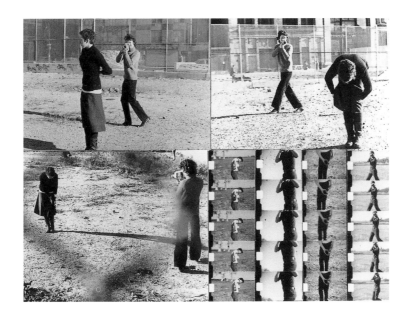

Helix/Spiral, 1973. Rehearsal
at Loeb Student Center, New
York University, New York.

Title/Date
Income Piece
1973

Materials
printed matter

Dimensions
variable according to
publication

First publication
For Publication 1975: n.p.

Notes
This piece exists as a
written proposal and a
lecture text. See cat.
no. 18.

This piece was a response to a piece Robert Morris had just proposed. This was spring, 1969. At that time artists in New York were starting to question the economics of and their role in the art world. Artists wanted to control the uses (economic and otherwise) their products were put to by collectors and museums. The United States economy was booming. Morris had been offered a one-man retrospective show (retrospectives are regarded as dangerous; if the artist defines himself in terms of his *past* he may be 'washed up') at the Whitney Museum. He proposed instead that the Museum, who it had been revealed had substantial monetary assets, simply loan Morris the total of these reserves for him to invest in the stock market for the duration of the show. Whatever money was made in that period he would take as his fee. Actually the idea was borrowed from Duchamp's raising money from collectors for him to 'invest' in a mathematical scheme to break the bank at the Monte Carlo Casino (an art historical precedent). Morris's closed-system strategy was a calculated success; in the context of the present art world it represented an example of an artist not being used by the system, but using it and as an artist (in the art history strategy of that moment) updating concerns of 'Concept' art to 'Process' art. It was very good individualistic game playing as the move's main feedback result was to re-affirm Morris's status as a top and not-dated artist. Instead of examining (or subverting) the relation of art as economic status to art content or of the art world as a part of the real economic/social world, it closed the issue off and closed off its continuation by other artists individually or collectively. The main 'value' of the 'move' was as 'Art'. It was a secure(d) structure – with a guaranteed result in that the feedback would be an affirmation of status and of the idea of 'Art' as a closed, elitely defined system.

Morris and the System are simultaneously validated.

I wished to open myself and a system to less psychologically deceptive motives and to the entire social-economic system of which art and the artist's 'self' had been considered closed-off sectors. An aim was to collect 'motives' from non-art viewpoints which regulated other self-enclosed categories of self-definition. This issue encompasses a situation where a socially defined idea of 'self' or 'individual' is used against oneself by society to coerce or control him. The 'self' is not an atomic entity, but is imminent in the network of interrelationships/environmental structure. As a defense the individual or groups of individuals self-define (as in Morris's use of art history) or *re-define* their network of relationships to various cybernetic parameters.

In *Income Piece* the areas of public/to private are altered. Money seems part of one's private life one can expose with minimal damage to notions of 'privacy' (although I was taught by my parents' example, never to discuss personal finances). In this control situation I gain power over my life situation by choosing to open one private sector of life-support to public mediation. For one thing, I feel guilty about making more money than other artists, which leads me to a more conservative, or defensive strategy in future works. Likewise if I am poor or have no status as a successful artist, the private necessity is not to fully expose my present or future moves or motives in order to achieve public gain – I am controlled by public pressures. In both situations I lose some feedback to the larger network. So a result of this re-arrangement of the relation of private to public 'self' is a gain in feedback and a lessening of guilt at each moment in the changing information loop I have with the art world. My position has potentially greater adaptability, open-end-

edness. For instance, the system (I have created) is designed as an exposure device; it 'uses' media to maximize availability to my ideas or art. The more people 'invest' in my work, the more it is in that many more people's interest that others are interested. It uses the trend of artists using the art magazines and their personalities to sell the magazines and their art (i.e. *Avalanche*). However, the model is open-ended. For instance, the Board of Directors may wind up controlling whatever my sense of 'self' is in a particular future. What moves I might make in this case would be a factor of my changed needs at this hypothetical time – or of the development of my work – or my projection of its development at this future time.

From a talk to students at the University of the State of New York at Oswego, New York, December 1973.
For Publication 1975: n.p.

Title/Date
Just-Past Present
1973

Materials
performer, video camera
and several monitors,
audience

Dimensions
variable according to
installation

First publication
previously unpublished

First performance
The work was never real-
ized as a performance and
exists as this performance
script.

Instruction to Performer

1. 7-minute duration

The performer is to concentrate his aware-
ness meditatively upon only what is pres-
ent in time – including his own state of
mind.

2. 7-minute duration

A video-tape is made of this duration. The
performer is to *verbalize* his conscious-
ness of present awareness *only* by com-
paring it (no matter how arbitrarily) to its
origin in a state of consciousness, event,
or thought during the previous 1., 7-mi-
nute duration.[1]

3. 7-minute duration

The video-tape just made is immediately
replayed on a monitor facing the per-
former. Simultaneously a second video-
tape is made of the performer and the
monitor image on which he observes his
behavior and words 7 minutes (2.) just-
past; he is to relate verbally his state of
consciousness now to his behavior/words
as displayed at the particular moment

observed on tape. In this stage that casual
link will not be to his own (internal) memo-
ry, but to the exact external behavior as
displayed on the screen.

Presentation to Audience

The audience sees the exercise on two
adjacent video monitors playing tapes of
stage 2. and 3. simultaneously in time.

[1] For example: 'My (present reaction) is like (x just-past
thought) because y happened.' Or: 'My (present reaction) is
caused by (z just-past event).'

Dan Graham, 'Just-Past Present,' 1973,
previously unpublished.

W 1973

Writings

Graham, Dan and Tomasso Trini, 'Dan Graham
I/Eye,' *Domus* no. 519 (February 1973): 51.

'Intention Intentionality Sequence,' *Arts Maga-
zine* 47, 6 (April 1973): 64-65.

'Dan Graham, Various Pieces,' *Interfunktionen*
no. 9 (1973): 57-64.

'Le Corps Matériel Perceptuel,' *L'Art Vivant* no. 1
(July 1973).

'Magazine/Ads,' and 'Income (Outflow) Pieces
1969,' *Deurle* 11/7/73. Exh. cat. Brussels:
MTL, 1973: n.p.

'Two Correlated Rotations,' in *Breakthrough
Fictioneers*. Ed. Richard Kostelanetz. Barton:
Something Else Press, 1973: n.p.

Title/Date
Present Continuous
Past(s)
1974

Materials
mirrored wall, video
camera and monitor with
time delay

Dimensions
circa 96 x 144 x 96 in.
244 x 366 x 244 cm
(overall)

First publication
Studio International Vol.
190 no. 977 (September/
October 1975): 144.
This later version first
published *Nova Scotia*
1979: 7-8.

First exhibition
'Kunst Bleibt Kunst:
Aspekte internationaler
Kunst an Anfang der 70er
Jahre Projekt '74,' Wallraf-
Richartz-Museum, Kunst-
halle Cologne and Kunst-
verein Cologne, July 6 –
September 8, 1974.

The mirrors reflect present time. The video camera tapes what is immediately in front of it and the entire reflection on the opposite mirrored wall. The image seen by the camera (reflecting everything in the room) appears 8 seconds later in the video monitor (via a tape delay placed between the video recorder which is recording and a second video recorder which is playing the recording back). If a viewer's body does not directly obscure the lens' view of the facing mirror the camera is taping the reflection of the room and the reflected image of the monitor (which shows the time recorded 8 seconds previously reflected from the mirror). A person viewing the monitor sees both the image of himself, 8 seconds ago, *and* what was reflected on the mirror from the monitor, 8 seconds ago of himself which is 16 seconds in the past (as the camera view of 8 seconds prior was playing back on the monitor 8 seconds ago and this was reflected on the mirror along with the then present reflection of the viewer). An infinite regress of time continuums within time continuums (always separated by 8 seconds intervals) within time continuums is created. The mirror at right-angles to the other mirror-wall and to the monitor-wall gives a present-time view of the installation as if observed from an 'objective' vantage exterior to the viewer's subjective experience and to the mechanism which produces the piece's perceptual effect. It simply reflects (statically) present time.

Nova Scotia 1979: 7.

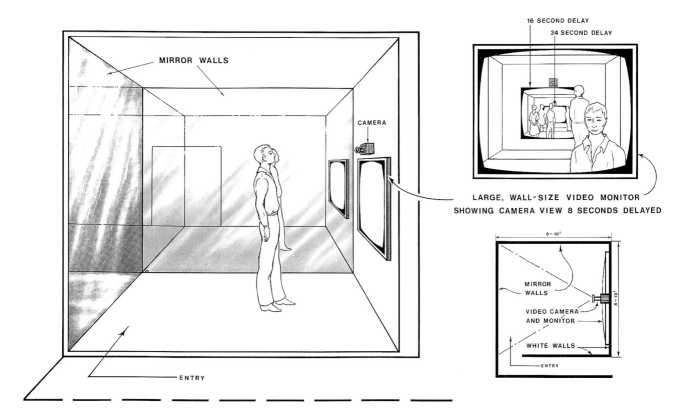

43 1974

Title/Date
Two Rooms/Reverse
Video Delay
1974

Materials
two rooms, mirrored walls,
two video cameras and
monitors on time delay

Dimensions
variable according to
installation

First publication
Video by Artists. Ed. Peggy
Gale. Toronto: Art Metro-
pole, 1976: 90. This later
version first published
Nova Scotia 1979: 9-10.

First exhibition
Museum van Heden-
daagse Kunst, Gent,
Belgium, 1977.

The camera in each room records the entire wall facing it. In either room an observer will see his present actions reflected in the mirrors. At the same time he will see his past behavior from the other room projected on the monitor as it is reflected in the opposite mirror. Monitor A shows the view of camera B, 8 seconds delayed; while monitor B shows the view of camera A live. On monitor A, an observer in room A perceives his behavior as reflected in the mirror in room B, 8 seconds ago. He perceives his behavior as it is being observed by another person in room B or, if no one else is present, reflected by the empty room. The reversed perceptual situation exists for someone in room B.

Nova Scotia 1979: 9.

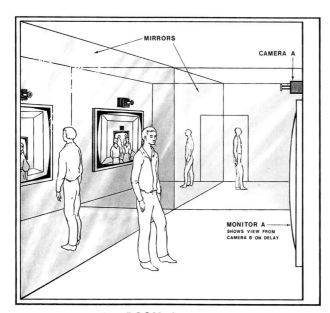

ROOM A

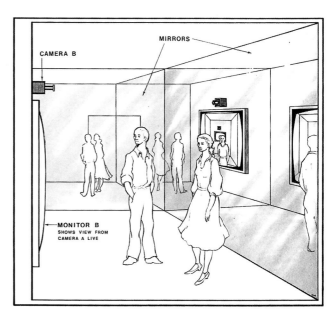

ROOM B

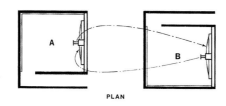

PLAN

Title/Date:
Time Delay Room 1
1974

Materials
two rooms with one entry/
exit, one video camera
and two monitors in each
room on time delay

Dimensions
variable according to
installation

First publication
Kunst Bleibt Kunst. Exh.
cat. Cologne: Kunstverein
Cologne, 1974, documen-
tation and early version of
text. This later version first
published *Nova Scotia*
1979: 11-12.

First performance
'Kunst Bleibt Kunst:
Aspekte internationaler
Kunst an Anfang der 70er
Jahre Projekt '74,' Wallraf-
Richartz-Museum, Kunst-
halle Cologne and Kunst-
verein Cologne, July 6 –
September 8, 1974.

On monitor 1 a spectator from audience A can see himself only after an 8 second delay. While he views audience B (in the other room) on monitor 2, this audience sees him live on the monitor whose image can also be seen by audience A. The same situation is true for audience B. A spectator may choose to pass from one room and audience to the other. To walk the passage-way takes about 8 seconds. A member of audience A entering audience B's room would *now* see the view of audience B that he had just seen 8 seconds previous when leaving the other room: but he is now part of that audience 8 seconds later. As 8 sec-onds have passed, the composition of the continuum which makes up audience B, has shifted as a function of time – he has joined it while other present members have arranged their relative positions within it or left and joined the other room.

Nova Scotia 1979: 11.

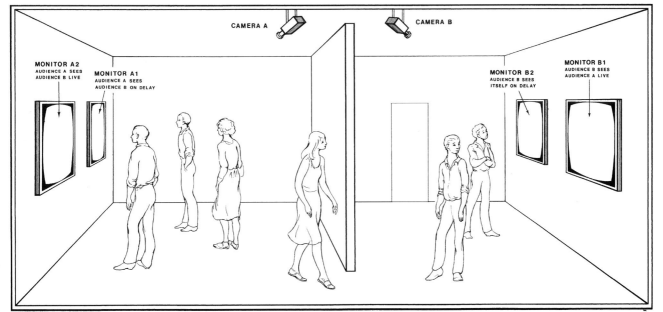

Title/Date
Time Delay Room 2
1974

Materials
one room with video
camera, two monitors,
speaker, entry/exit; one
room with performer,
video camera, monitor,
microphone

Dimensions
variable according to
installation

First publication
Nova Scotia 1979: 13-14.

First performance
Nova Scotia College of
Art and Design, Halifax,
January 1975.

The audience sees itself live on monitor 1. Simultaneously it could be seeing a replay on monitor 2 of its behavior from 8 seconds earlier. The performer's verbalization is heard by the audience to coincide with its delayed monitor view. As the performer verbally projects the audience's future, he is actually predicting a line of development beginning from a point 8 seconds before the present, while the audience:

1. is experiencing the time span of this predicted future (which can be seen on the live monitor).

2. may project a parallel linear future by 8 seconds ahead of the performer's predicted future perspective by connecting its present, seen on the live monitor, to its near past on the delay monitor.

The performer (seeing the audience on an 8 second delayed monitor) gives a behavioristic description of what he sees. Observing their behavior, he then projects their next line of behavior.

Nova Scotia 1979: 13.

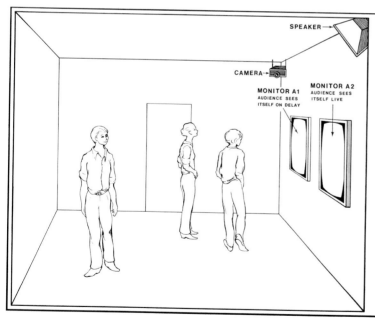

AUDIENCE

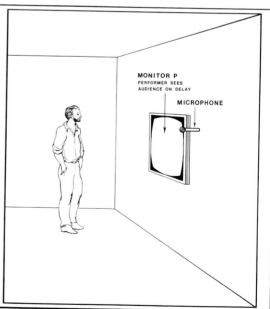

PERFORMER

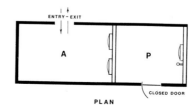

PLAN

Title/Date
Time Delay Room 3
1974

Materials
one room with video
camera, two monitors,
speaker, entry/exit; one
room with performer, cam-
era, two monitors, micro-
phone

Dimensions
variable according to
installation

First publication
Control Magazine no. 9
(1975): 7. This later ver-
sion first published *Nova
Scotia* 1979: 15-16.

First performance
Nova Scotia College of Art
and Design, Halifax, 1975.

When the performer sees the audience on the live monitor, the audience sees his reactions on monitor 1 at a time synchronous to their behavior. It takes about 3 seconds for the performer to verbalize a description of his response to what he sees. The audience sees their behavior 8 seconds delayed on monitor 2. If the performer is observing their behavior 4 seconds delayed, his reactions are seen on monitor 1 only 4 seconds before the audience sees itself on monitor 1, his comments sometimes foreshadow, sometimes slightly follow (going in and out of phase with) the view of their behavior played back 8 seconds delayed. The performer sees and describes the image on either the live-monitor or the 4 second-delayed-action-monitor. He briefly notes behavioral changes, constructing for each image a phenomenological continuity; then he switches quickly to the other image. He now constructs a projected line of devel-

opment or a continuity by observing *both* images simultaneously and then noting how the live behavior affects or determines the behavior of 4 seconds later. His responses are seen and his verbalizations heard by the audience at the time he makes them.

Nova Scotia 1979: 15.

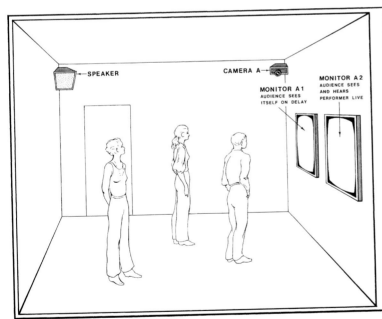

AUDIENCE

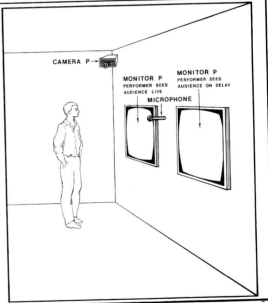

PERFORMER

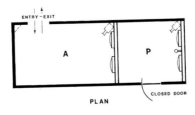

PLAN

Title/Date
Time Delay Room 4
1974

Materials
three rooms: two rooms
with video camera,
speaker, two monitors each
and a shared entry/exit;
and one room with
performer, camera, two
monitors, microphone

Dimensions
variable according to
installation

First publication
Nova Scotia 1979: 17-18.

Notes
Time Delay Room 4 was
never realized as an in-
stallation and exists as
this documentation: dia-
gram and written descrip-
tion.

On monitor 1 audience A sees itself live. On monitor 2 audience A hears the performer's description and sees his responses delayed 8 seconds after it has seen itself. On monitor 1 audience B sees itself on delay. On monitor 2 audience B sees the performer's responses and hears his descriptions before it sees the behavior of itself – before the performer has seen or described it. There is a passageway between audience A's room and audience B's room that allows members of these audiences to enter the time zone of the other audience. It is possible for spectators to enter audience A's room from audience B's room or *vice versa* so that members of these audiences enter the other audience's time zone. The performer sees the audience A on delay and audience B live. He describes the reactions of each audience alternately. In the next stage, observing them simultaneously, he places the behavior of the two audiences in the context of a cause and effect relation, projecting a line of influence between audience A's 'earlier' and audience B's 'later' lines of behavior. From the point of view of both of these audiences, however, this appears to be from a *temporally reversed perspective*.

Nova Scotia 1979: 17.

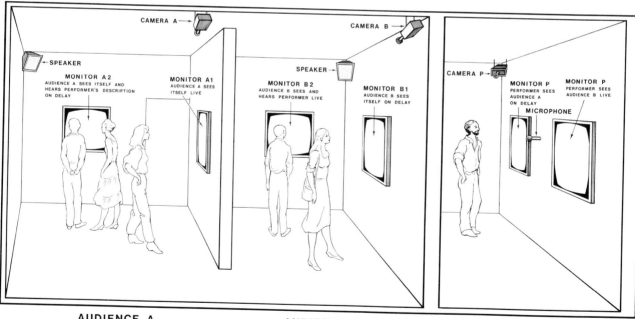

AUDIENCE A **AUDIENCE B** **PERFORMER**

PLAN CLOSED DOOR

Title/Date
Time Delay Room 5
1974

Materials
three rooms: two rooms
with video camera,
speaker, two monitors each
and a shared entry/exit;
and one with performer,
camera, two monitors,
microphone

Dimensions
variable according to
installation

First publication
Control Magazine no. 9
(1975): 7. This later
version first published *Nova
Scotia* 1979: 19-20.

Notes
Time Delay Room 5 was
never realized as an
installation and exists as
this documentation:
diagram and written
description.

Audience a may view itself on an 8 second delay on monitor 2. Or audience A may view audience b on monitor 1 which also shows audience B's (monitor 1) image of audience A's own behavior of 8 seconds ago. Simultaneously audience A hears a continuous description by the performer of their behavior, 8 seconds ago, or of their present behavior, or of their behavior as a casual influence on, or being influenced by, or being a temporal forerunner of audience B's behavior. When the performer ascribes the development of audience A's present behavior to the influence of audience B's earlier behavior, this may have the effect of imposing the causal interpretation in the performer's mind into the relationship between audience A and audience B. Alternatively, when audience A hears the performer's description of their behavior, this will anticipate by 8 seconds its own view, corresponding to this description, but not seen until 8 seconds after the description. As the description by the performer will in part refer to audience A's hearing and responding to the performer's own depictions, made before audience A is able to view for itself this behavior, a feedback interference or tautology (of effect to cause) is created.

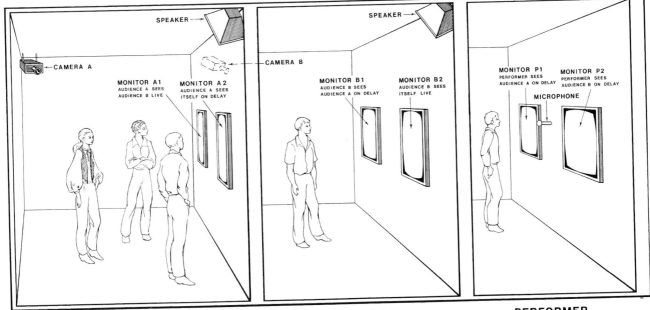

While the performer describes their behavior of 8 seconds ago, audience B may see their present responses on monitor 2. Or, correlated to the performer's description, they may see on the 8 seconds delayed image of audience A's room that room's monitor image of audience B (as they are being observed by audience A 8 seconds ago). An alternative possibility is that the performer is describing his live image of audience A's behavior, which, however, will not be seen by audience B for 8 seconds. Or the performer may be ascribing a causal connection between audience A's present behavior (not yet seen by audience B) and audience B's behavior of 8 seconds past (which is being seen by audience A) which provides an outside commentary on the image audience B sees on monitor 1. When the performer projects a relation between audience A's present behavior and audience B's earlier behavior before audience B can make these connections for itself, the performer('s behavior) may impose a causal reading-pattern into audience B's (and audience A's) behavior where none or a dissimilar one may have formed. This is reinforced as they see the delayed view on monitor 1 of audience A, hearing and responding to the connections drawn by the performer 8 seconds in the past, where also audience A is seeing and responding to the responses of audience B's responses.

The performer sees audience A live and audience B 8 seconds delayed. He alternates initially between observing and describing phenomenologically one or the other audience's behavior. He then observes both to connect the image of audience A's present behavior to that of audience B's earlier behavior – constructing a cause and effect chain of mutual influence, so that he may predict the future direction of either audience A's or audience B's behavioral moves.

Nova Scotia 1979: 19.

Title/Date
Time Delay Room 6
1974

Materials
three rooms: two rooms
with video camera,
speaker, two monitors each
and a shared entry/exit;
and one with performer,
camera, two monitors,
microphone

Dimensions
variable according to
installation

First publication
Nova Scotia 1979: 21-22.

Notes
Time Delay Room 6 was
never realized as an
installation and exists as
this documentation:
diagram and written
description.

Audience A sees audience B on monitor 1, which also shows them the view of 8 seconds earlier, seen by audience B on their monitor. Audience A cannot see itself on a present time monitor. It hears the performer's live description of its behavior 8 seconds before seeing it. Audience B sees audience A with 8 seconds delay on monitor 1, and sees audience A's monitor view of them, audience B, 8 seconds delayed. Audience B cannot see itself on a present time monitor. Audience B hears the performer's live description of its behavior 8 seconds before seeing it. Audience A also hears and responds to this. Audience B hears how it is affected by the response of audience A and of the performer. An audience (A or B) first sees itself as it is seen and described by the performer. Secondly, *later in time* and delayed by 8 seconds, it sees itself when it is seen by the other audience. The performer, seeing both audiences live, alternates between describing one or the other's behavioral reactions. He follows this by describing how audience A affects audience B and *vice versa* and how the performer affects audience A and audience B. Relations and effects, described by the performer, anticipate the audiences' experience of the connections.

Nova Scotia 1979: 21.

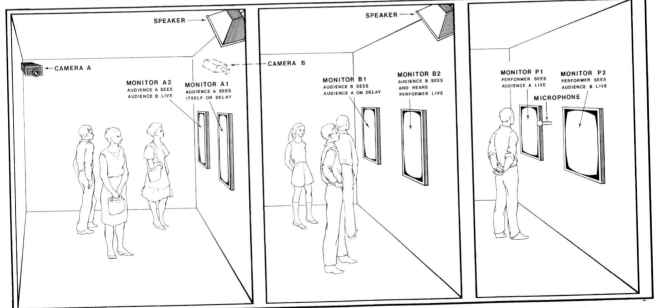

AUDIENCE A AUDIENCE B PERFORMER

PLAN

Title/Date
Time Delay Room 7
1974

Materials
two rooms: one with video
camera, two monitors,
speaker, entry/exit; one
with performer, video
camera, two monitors,
microphone

Dimensions
variable according to
installation

First publication
Control Magazine no. 9
(1975): 6. This later
version first published
Nova Scotia 1979: 23-24.

First performance
Nova Scotia College of Art
and Design, Halifax,
January 1975 and Inter-
national Cultural Centrum,
Antwerp, Belgium, 1975.

The audience via camera a may see itself displayed on monitor 1A, 8 seconds after its behavioral reaction, *after* the performer has verbally projected his outside obser-vation of this behavior.

At the same time the audience may see the view from camera P, transmitted live on monitor 2A. This shows the perfor-mer's room in (and simultaneous to the audience's) present-time, and the per-former reacting to and describing what he sees on either monitor 1P or monitor 2P of his room. Camera P's view (seen by the audience) also shows the view the per-former has of monitor 2P showing the image of the performer 8 seconds earlier. The performer via camera A sees the audience transmitted live on monitor 1P. The performer sees himself from the view of camera P on an 8 second delay on his room's monitor 2P.

The performance consists of the per-former's continuous description for an extended period of time (8-10 minutes) of the observed behavior of the audience, as seen transmitted live (at the same time as the actual behavior) from the view of cam-era A. His spoken responses (heard by the audience) will, if they follow by about 2-3 seconds after the actual behavior, *pre-cede* the audience's *visual* recapitulation on their monitor 1A.

Next, the performer switches to describing continuously for an extended period of time (perhaps 8-10 minutes) his own be-havior as he observes it on monitor 2P 8 seconds after its performance. On monitor 2A the audience first observes the per-former's live behavior, then observes as (what) the performer perceives his behav-ior 8 seconds later on his monitor 2P, and then hears (and sees) his subjective re-sponse (in the performer's description) to this delayed feedback, which reverses the 'subjective' experience of the performer's describing them in the previous sequence

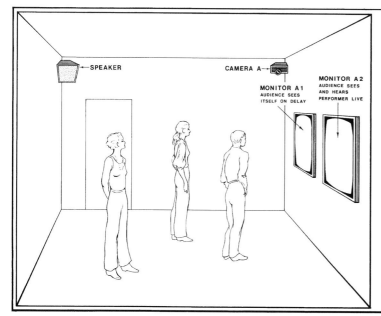

AUDIENCE

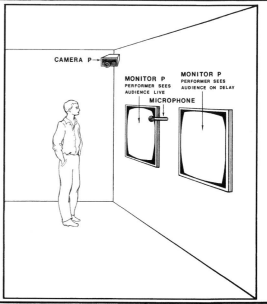

PERFORMER

PLAN

and allows them to observe more 'objectively' this effect on the performer's own behavior. Next, the performer again 'objectively' describes the audience's behavior

for an extended time. Next, the performer switches to describe himself 8 seconds past for an extended time.

Nova Scotia 1979: 23.

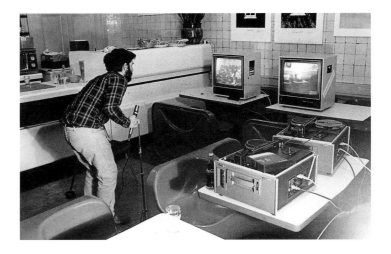

Time Delay Room 7, 1974. Installation January 1975, Nova Scotia College of Art and Design, Halifax, Nova Scotia, Canada.

51 1974

Title/Date
Two Rooms/Relative
Slow-Motion
1974

Materials
two rooms: one room with video camera and two monitors, entry/exit; one room with video camera, two monitors, entry/exit

Dimensions
variable according to installation

A performance begins at a specific time, as the audience separates into two audiences, one in either room.

A recording (from camera A1 and camera B1 respectively) of the responses of each audience is played back to them in slow-motion on monitor 1, a few seconds after the beginning of the performance. Simultaneously monitor 2 in the room displays as a live image *the other audience* observing itself on the screen/delayed and in slow-motion. Both of the machines' rates of slow-motion, *only slightly slower than reality,* are mechanically adjusted to be the same. Because the tape seen on monitor 2 in the room is replayed in slow-motion, the delayed time between its recording and its play-back increases continuously and progressively – the views

seen by the audiences from a time period sliding further back in their pasts (from memory connected to their present activities to distant memory).

An audience can *objectively* observe the effect of the delayed slow-motion play-back on a second audience at the same time it *(subjectively)* observes itself. One effect upon an audience watching itself in slow motion for a period of time may be to slow down its present time movement (this effect might be observed in watching the other audience).

Each audience would observe a recorded 'memory' from (about) the same period of time in the past (shared) time continuum. Although the two machines' rates of slow-motion appear correspondingly calibrated, an audience comparing the image of itself,

51 1974

First publication
Studio International Vol.
190 no. 977 (September/
October 1975): 145.
This later version first
published *Nova Scotia*
1979: 25-26.

First performance
Nova Scotia College of Art
and Design in 1975 in an
experimental form. Later
in 1975 it was performed
at Rhode Island School of
Design, Providence, Rhode
Island.

replayed in slow-motion, with the (live) view of a second audience, seeing itself in slow-motion, has no absolute way of judging:

1. the synchrony of the two audiences' relative times – positions – in the past as seen in the images playing back at present time.

2. whether the speeds of the slow-motions are the same, relative to each other. […]

Nova Scotia 1979: 25.

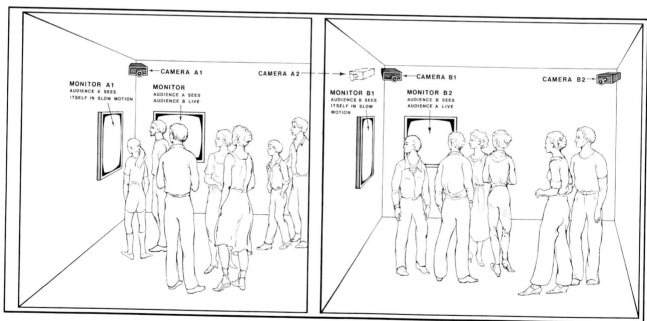

AUDIENCE A AUDIENCE B

PLAN

Title/Date
Opposing Mirrors and
Video Monitors on Time
Delay
1974

Materials
two mirrors, two video
cameras and two video
monitors with time-delay,
plywood, paint

Dimensions
circa 72 x 96 in.
183 x 244 cm

First publication
Studio International Vol.
190 no. 977 (September/
October 1975): 146. This
later version first pub-
lished *Basel* 1976: 32-33.
See also *Nova Scotia*
1979: 27-30.

First exhibition
Palais des Beaux-Arts,
Brussels, May 1975.
Also exhibited 1975
St. Lawrence University,
Canton, New York.

The length of the mirrors and their dis-
tance from the cameras are such that
each of the opposing mirrors reflects the
opposite side (half) of the enclosing room
(and also the reflection of an observer
within the area who is viewing the moni-
tor/mirror image).

The camera sees and tapes this mirror's
view.

Each of the videotaped camera views is
continuously displayed 5 seconds later,
appearing on the monitor of the opposite
area. Mirror A reflects the present sur-
roundings and the delayed image project-
ed on monitor A. Monitor A shows mirror B
5 seconds ago, the opposite side's view
of area B.

A spectator in area A (or area B), looking
in the direction of the mirror, sees: 1. a
continuous present-time reflection of his
surrounding space; 2. himself as observer;
3. on the reflected monitor image, 5 sec-
onds in the past, his area as seen by the
mirror of the opposite area.

A spectator in area A, turned to face moni-
tor A, will see both the reflection of area A
as it appeared in mirror B 5 seconds earli-
er and, on a reduced scale, area A reflect-
ed in mirror B now.

Basel 1976: 33.

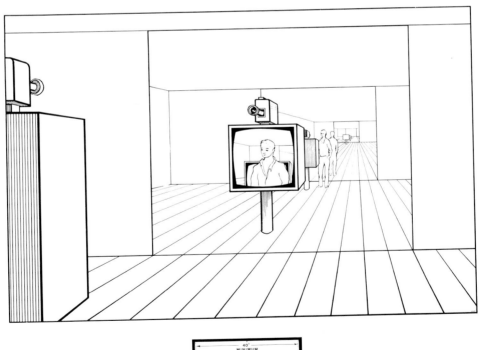

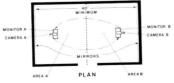

28

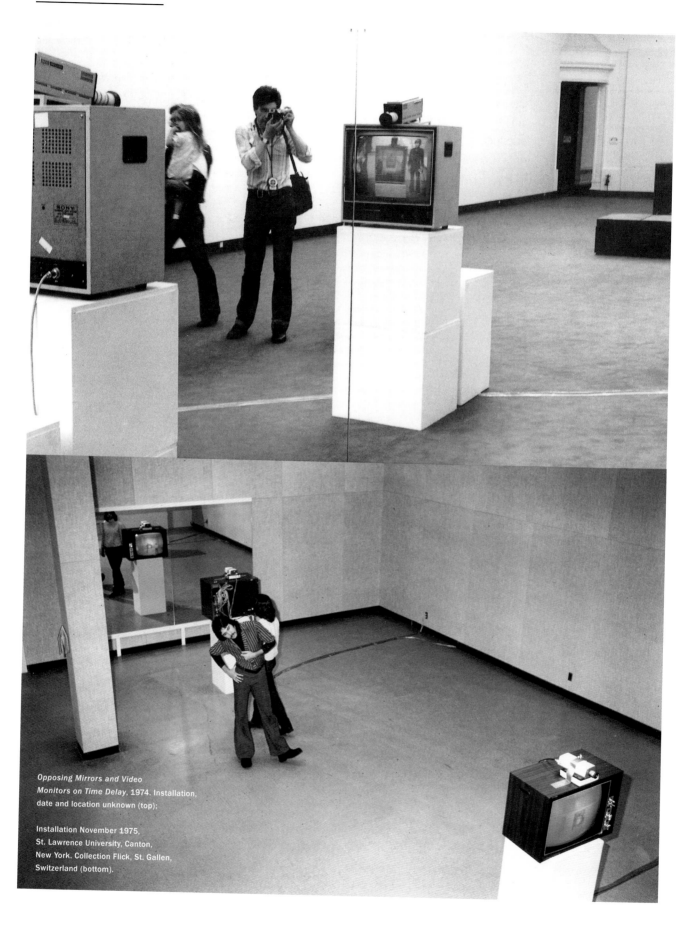

*Opposing Mirrors and Video
Monitors on Time Delay*, 1974. Installation,
date and location unknown (top);

Installation November 1975,
St. Lawrence University, Canton,
New York. Collection Flick, St. Gallen,
Switzerland (bottom).

Title/Date
Mirror Window Corner
Piece
1974

Materials
mirrored corner across from
windowed/glass corner
with two monitors and
cameras with time delay

Dimensions
variable according to
installation

First publication
+ - 0 no. 14 (September
1976): cover and p. 7.
This later version first
published *Nova Scotia*
1979: 31-34.

First exhibition
Galerie Vega, Liège,
Belgium, May 1976.

Camera B records images reflected in mirror B. Mirror B reflects the outside and inside now and the image of monitor B. Monitor B displays the images from camera B delayed 7 seconds. Camera A records images outside. Mirror A reflects outside now and inside now and the image of monitor A. Monitor A displays the images from camera A delayed 8 seconds.

Nova Scotia 1979: 31.

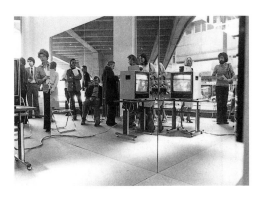

Mirror Window Corner Piece,
1974. Installation May 1976,
Galerie Vega, Liège, Belgium.

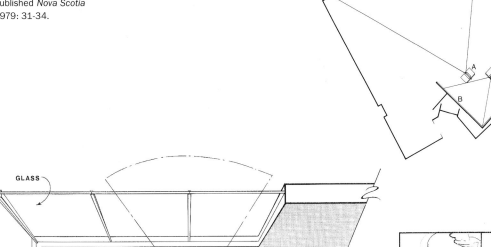

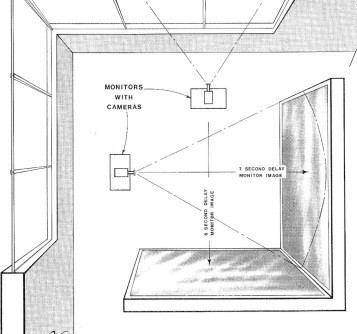

GLASS

MONITORS
WITH
CAMERAS

7 SECOND DELAY
MONITOR IMAGE

8 SECOND DELAY
MONITOR IMAGE

PERSPECTIVE PLAN

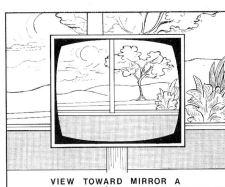

VIEW TOWARD MIRROR A

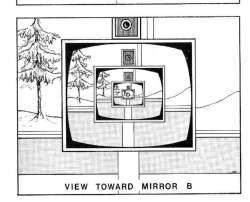

VIEW TOWARD MIRROR B

Title/Date
'Picture Window' Piece
1974

Materials
two video cameras and
monitors placed across
from one another on
either side of picture win-
dow in family home

Dimensions
variable according to
installation

First publication
First published under the
title *Interior Space/Exteri-
or Space, Studio Interna-
tional* Vol. 190 no. 977
(September/October
1975): 143. This later ver-
sion first published *Nova
Scotia* 1979: 35-36.

Notes
Alternate title: *Interior
Space/Exterior Space.*
'Picture Window' Piece
was never realized and
exists as this documenta-
tion: photograph, dia-
grams and written descrip-
tion. See cat. no. 66, the
model *Alteration to a Sub-
urban House,* 1978, and
cat. no. 68, the model
*Video Projection Outside
Home,* 1978, both featur-
ing a use of the picture
window.

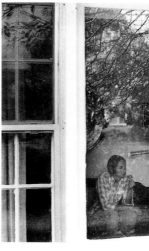

Picture Window, Westfield,
NJ, date unknown.

In many modern American houses a 'picture-window' in the living-room facade gives for those outside a view of the family's 'life-style,' while, inversely, for that family, it relates family to social surroundings (a community of more or less similar family units). What is pictured in the window represents for those outside the publicly accepted code of privacy; the interior seen by the spectator outside corresponds to the public image. Inversely, the portion of the outside viewed by those inside provides a frame for (is contextual to) their private existence. Although it would appear that the views from inside to outside, or outside to inside, are reciprocal, in practice a person outside quickly glances at the 'picture-window' and then averts his eyes, not desiring to look beyond the immediate sign of conventional normality to look closely at what might be seen inside.

The video camera/monitor is analogous to the window; they both mediate inside and outside space, but from an architecturally (socially) controlled vantage. These openings define a perspective on the other space by their exact size and shape (frame) and what part of the other space is in view at the central area of their picture plane.

Here each of the video monitor's images in conjunction with the window shows, simultaneously, both interior and exterior views, subverting the exclusive interior private or exterior public perspectives. Both interior and exterior observer's gaze (and behavior) are given a self-consciousness. A person is drawn in, towards the window. An observer drawn towards the window may alternate his focus:

1. to observe the 'picture-window' in itself: simultaneously, *material,* a certain dimension of glass with varying degrees of exterior- and self-reflections (depending on the interior illumination and exterior position of the sun's light) in relation to transparency, and *sign*, the architectural convention, the convention of transparency. 2. to look *literally* through the window at what is to be seen inside or outside. An observer drawn towards the 'picture-window' may mentally compare what it discloses when viewed from the 'normal' distance (it is conventionally intended to be seen from) and what is (differently) disclosed when he is immediately in front of it.

Nova Scotia 1979: 35.

Title/Date
Video Piece for Courtyard
1974

Materials
windows of two parallel
and facing rooms across
a courtyard, two video
cameras and monitors
with time delay, mirrored
walls

Dimensions
variable according to
installation

First publication
Casabella 411 (March
1976): 31 and *Video by
Artists*. Ed. Peggy Gale.
Toronto: Art Metropole,
1976: 93. This later ver-
sion was first published
Nova Scotia 1979: 37-38.

First exhibition
Galleria Marilena Bonomo,
Bari, Italy, 1974.

The video situation is for two opposite and parallel rooms whose windows are open. The sun illuminates the courtyard between the two windows and, as its position shifts throughout the day, it illuminates or throws into shadow either one or the other opposite facade of the windows.

Each room contains a mirrored wall, opposite and parallel to the window which reflects the contents of the room and view seen through the window. This view through the window includes the inside frame of the window, the outside facade of the other side of the building, and also what is observable inside the opposite window.

Each room has a large video monitor placed in front of its window, so that the screen faces the mirror reflecting its image as well as that of the observer. A camera placed on top of each of the monitors faces the mirror to record its entire view.

The view from the camera in the left side is transmitted live to the monitor in the right side, but the view from the camera in the right side is transmitted 8 seconds delayed to the monitor in the left side.

A spectator can either look at the mirror's view or look out through his window into the opposite room. In looking into the opposite room, it is possible to see that room's monitor-image reflected on the wall's mirror which shows a view of his room's mirror's reflected image.

Nova Scotia 1979: 37.

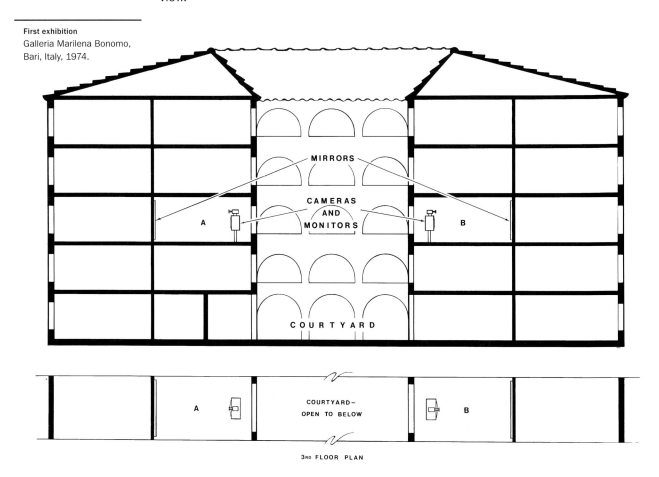

'Two Consciousness Projection(s),' *Arts Magazine* 49, 4 (December 1974): 63-66.

'Das Buch als Objekt/The Book as Object,' 'Notes on *Income (Outflow) Piece*,' *Interfunktionen* no. 11 (1974): 108-119.

56 1975

Title/Date
Two Viewing Rooms
1975

Materials
two-way mirror, fluorescent lights, video camera and monitor

Dimensions
98²/₅ x 98²/₅ x 236¹/₅ in.
250 x 250 x 600 cm

First publication
Nova Scotia 1979: 39-40.

First known exhibition
'Dan Graham: Two Viewing Rooms,' December 5, 1980 – January 13, 1981, Museum of Modern Art, New York, organized by Barbara London. Press release no. 66, Museum of Modern Art, New York.

Two Viewing Rooms, 1975. Collection Marc & Josée Gensollen, Marseille, France. Photo: Documentation Générale du Centre Pompidou, Musée National d'Art Moderne, Centre Georges Pompidou, Paris, France.

Room A. Room a is approached from an opposite direction than the approach to Room B (so that it is accidental which room a spectator might enter first). Room A is darkened. It contains a camera on a tripod at eye-level, placed against and facing the surface of what is for it and the spectator a transparent glass window. The camera's lens observes the other room, but it is itself unobserved through the back mirror or by those people facing it in Room B. A spectator in Room A may look either through the viewfinder of the camera or through the surface of the glass into the other room, unobserved by anyone in that room. The person in Room A may see a person in Room B looking directly at them in the (direction of) the

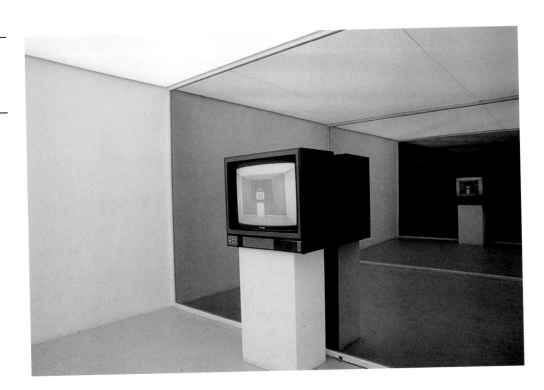

mirror/or TV-monitor (whose image, of themselves and not the person in Room A, they are seeing). The TV-monitor's view (the camera's view) corresponds nearly, but not identically, to that of the person or persons looking in the direction of Room B from Room A.

Room B. Room B contains 2 opposite mirrored walls. It is well-lighted. A TV-monitor is placed in front of the mirror-wall dividing Room A and B. Its image is reflected on the opposite mirrored wall. The monitor is at a height of 2 to 4 feet from the ground. The monitor shows an image of the spectator. If the viewer in Room B is facing the monitor (and front mirrored wall), the mon-

itor shows him a view of himself different in scale and mirror-reversed from that of the mirror wall above the monitor. The relative size of the mirror-image and the monitor image continue to change relative to the exact distance a viewer in Room B is from them. If this spectator faces the other, rear mirror, he sees the reflected view of the monitor image (which now shows his backside), and the mirror-view of his front. The view on the monitor will be smaller or larger in size from the mirror-view, depending upon the distance the spectator is from the mirror.

Nova Scotia 1979: 39.

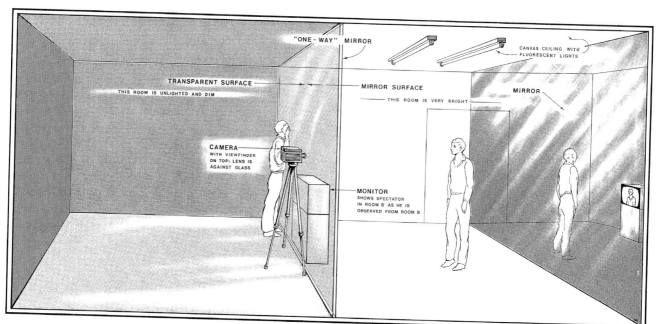

Title/Date
Yesterday/Today
1975

Materials
video camera and sound
recording device in room
A, video monitor (display-
ing what camera in room
A records) and sound
playback device in room
B with 24-hour time
delay

Dimensions
variable according to
installation

First publication
Nova Scotia 1979: 41-46.
See also 'Notes on Yes-
terday/Today': 44-46.

First exhibition
John Gibson Gallery, New
York, April – May, 1975. In
this installation, the moni-
tor and sound device were
placed in the public area
exhibition galleries, and
the camera and micro-
phone were placed in the
gallery office. Also exhibit-
ed 1975: International
Cultural Centrum, Ant-
werp, Belgium and Otis Art
Institute, Los Angeles,
California, USA, September
– October.

A video monitor in a public space displays
a present-time view of the visual activities
of a second, nearby room. This space is
one having a characteristic presence in
which the inhabitants' daily activities fol-
low a defined routine with rhythmic perio-
dicity related to a specific time of the day,
where people discuss ongoing activities
(informing an ongoing chronicle), and which
imposes a definite modification in role, or
of consciousness, upon someone entering
it. The visual scene on the monitor is
accompanied by an audio play-back of
sounds, tape-recorded from the second
room one day before, but at exactly the
same time of day. Two time continua hav-
ing a presumed same rate of forward flow,
one sound and the other visual, can be
observed separately or conjointly. The vi-
sual activities and the sounds may more
or less phase rhythmically, overlap or ac-
tually coincide. As the room is nearby, the
spectator may directly enter its actual
space if he desires. The installation may
be repeated daily indefinitely.

Nova Scotia 1979: 42.

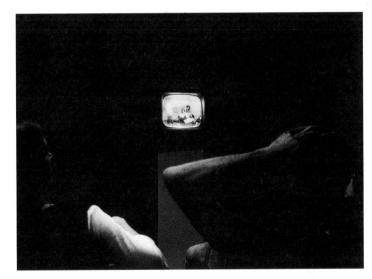

Yesterday/Today, 1975.
Installation April – May,
1975, John Gibson Gallery,
New York. Collection
Stedelijk Van Abbemuseum,
Eindhoven, Holland.

Title/Date
Performer/Audience
Sequence
1975

Materials
performer and audience

Dimensions
variable according to
installation

First publication
First published under the
title 'Performance/Audi-
ence Projection,' 1974, in
Control Magazine no. 9
(1975): 6. This later
version *Theatre* 1981: n.p.
See also transcript of
second performance at
Artists Space, New York,
January 2, 1976: *Theatre*
1981: n.p.

First performance
San Francisco Art Institute,
December, 1975. Second
performance: Artists
Space, New York, January
2, 1976, with screening of
six films.

Premise. I face the audience. I begin con-
tinuously describing myself – my external
features – although looking in the direc-
tion of the audience. I do this for about
eight minutes. Now I observe and phe-
nomenologically describe the audience's
external appearance for eight minutes. I
cease this and begin again to describe the
audience's responses... The pattern of
alternating self-description/description of
the audience continues until I decide to
end the piece.

Notes. When looking at the audience and
describing myself, I am looking at them to
help me see myself as might be reflected
in their responses. In the initial stage my
apprehension of their 'understanding' of
'me' will be imprecise as the meaning, for
me, of their gestures is more or less un-
clear. Similarly my initial description of the
audience in terms of their behavior may
appear to them as at variance with their
self-awareness of themselves as a group.
(However, this self-awareness of them-
selves as a group has not developed pre-
vious to my description.) But by the sec-
ond stage of my self-description I (my
idea or projection of 'myself') am becom-
ing more influenced or 'contaminated' by
my impressions of the reactions of the
audience. In the second description of the
audience (influenced by proximity to my
second description of myself) my view of
the audience would be seen to be closer
to my projection of myself onto them... in
time, and in terms of the specific time,
place and audience constitution, the audi-
ence's projected definition of me helps to
define themselves as a group and my pro-
jected definition of the audience tends to
define my sense of myself.

Theatre 1981: n.p.

W 1975

Writings

'Income (Outflow) Piece 1969,' and various
documentation of works, *Control Magazine*
no. 9 (1975): 5-7.

'Architecture/Video Projects,' *Studio International*
Vol. 190 no. 977 (September 1975): 143-146.

Title/Date
Video Piece for Two Glass
Office Buildings
1976

Materials
two cameras and two
monitors with time delay,
two mirrors in two oppo-
site and parallel rooms in
facing glass office build-
ings

Dimensions
variable according to
installation

First publication
Nova Scotia 1979: 47-50.

First exhibition
Leeds Polytechnic, Leeds,
England, June 1976.

The video situation is for two opposite and parallel rooms located in facing glass office buildings. Each room has a large window looking into a similar window in the other building. The sun illuminates the space between the two buildings' windows and, as its position shifts through the day, it alters the relative transparency/reflectiveness on the inside or outside of either windows. Each room contains a mirrored wall opposite and parallel to the window which reflects the contents of the room and the view seen through the window. This view through the window includes the reflections on the inside of the window, the outside facade of the other building, any outside reflections on the window opposite, and also what is observable inside the opposite room.

Each room has a large video monitor placed in front of its window so that the screen faces the mirror reflecting its image as well as that of the observer. A camera placed on top of each of the monitors faces the mirror to record its entire view. The view from the camera in the left building is transmitted live to the monitor in the right building; but the view from the camera in the right building is transmitted 8 seconds delayed to the monitor in the left building.

A spectator can either look at the mirror's view or look through his window into the opposite room. In looking into the opposite room, it is possible to see that room's monitor-image reflected on the wall's mirror which shows a view of his room's mirror's reflected image.

Nova Scotia 1979: 47.

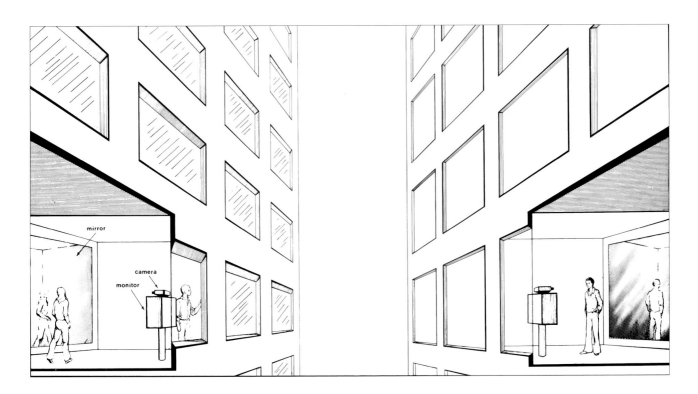

60 1976

Title/Date
Video Piece for Showcase
Windows in Shopping
Arcade
1976

Materials
two monitors, two cam-
eras, two mirrors, time
delay device, installed in
two facing and parallel
shop windows in a modern
shopping arcade

Dimensions
variable according to
installation

First publication
Nova Scotia 1979: 51-54.
See also 'Notes on Video
piece for showcase win-
dows in a shopping
arcade': *Nova Scotia*
53-54.

First exhibition
'Corps de Garde,'
Groningen, Holland,
August 12 – September 2,
1978.

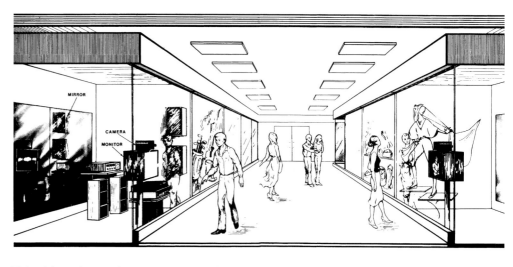

This video piece takes place in two facing and parallel shop windows, located in a modern shopping arcade where people pass through the arcade between the two windows. Each shop window contains a mirror on its back wall, opposite and paral-lel to the window. This mirror reflects what is inside the showcase and the view through the window. This view through the window includes the reflections on either side of both windows, the interior of the other window, and the spectators (shop-pers) passing in the arcade between the two facades.

Both shop windows have monitors placed in front of the window. The monitor within the left window faces outwards toward the window; whereas the monitor within the right window faces inward towards the mir-ror. The camera on the top of the left mon-itor faces inward towards the mirror; whereas the camera on top of the right monitor faces outward toward the window. The view from the camera in the left win-dow is transmitted live to the monitor in the right window; but the view from the camera in the right window is transmitted 5 seconds delayed to the monitor on the left window.

The shop window can be either empty or contain normal product displays. It may be possible for spectators to enter the shop window if it is part of a store. These details depend upon the specific situation of the piece's placement.

Nova Scotia 1979: 51.

Video Piece for Showcase Windows in Shopping Arcade, 1976. Installation August 1978, Groningen, Holland.

Title/Date
Production/Reception
(Piece for Two Cable TV
Channels)
1976

Materials
control room of studio at
cable TV channel produc-
ing local program, wide-
angle-lens camera and
multiple microphones
(production), locally pro-
duced program for com-
mercial broadcast TV
channel, room in typical
family house where TV is
watched with wide-angle
lens camera, TV set, and
multiple microphones
(reception)

Dimensions
variable according to
production/reception
conditions

First publication
Nova Scotia 1979: 55.

Notes
The work was never real-
ized and exists as a writ-
ten description.

The piece utilizes two cable channels in a local environment in addition to a normal commercial broadcast. Two cable programs are to be broadcast live, and at the same time as a commercial program, originating on a local station. Any locally produced commercial program can be used, for instance, a local evening news broadcast.

Cable channel A broadcasts a live view originating from a single camera placed inside the control room of the studio producing the local commercial program. A wide-angle lens is used and the camera, aimed through the glass panel at the stage, shows the entire stage-set, surrounding cameras, cameramen, director, assistants and the technicians and technical operations necessary to produce the program. Microphones placed in many locations within the stage-set, behind the stage, and in the control-booth are mixed together and accompany the visual image. They give a complete sense of all relationships occuring within the enclosed space of the commercial TV studio.

Cable channel B broadcasts a live view from a single camera from within a typical family house in the community. It shows viewers present observing the local commercial broadcast on their TV set (the view shows both the television image as well as the viewers present). The camera-view is fixed. Occupants of the household may or may not be present in the room watching the TV set at a given time. Sounds from *all* the rooms of the house, documenting all of the activities taking place during the duration of the broadcast, are mixed together and accompany the camera-view. Anyone in the local community with cable television in addition to the commercial channels may, by switching from channel to channel, see channel A's view framing the local program in the context of its process of production, or channel B's view showing the program's reception within the frame of a typical family's household, or turn to the commercial channel and be themselves receiving the particular local program in their house.

Nova Scotia 1979: 55.

Title/Date
Public Space/
Two Audiences
1976

Materials
two rooms, each with
separate entrance divided
by thermopane glass, one
mirrored wall, muslin, fluo-
rescent lights, wood

Dimensions
circa
86⅔ x 275⅔ x 86⅔ in.
220 x 700 x 220 cm
(overall)

First publication
Basel 1976: image p. 34.
The text 'Public Space/
Two Audiences' was
written in 1976 and first
published *+ - 0* (Revue
d'Art Contemporain)
no. 14 (September 1976):
6. This version was
first published *Buildings
and Signs* 1981: 23-24.

First exhibition
The work was created for
the exhibition, 'Ambient
Art,' curated by Germano
Celant, in the central
pavilion of the Venice
Biennale, 1976. It was
reconstructed for the col-
lection of Annick and
Anton Herbert, Gent.

Public Space/Two Audiences was one of a number of individual room-environments enclosed within a large building housing an elaborate thematic exhibition at the Venice Biennale, 1976, under the title 'Ambiente,' organized by Germano Celant. Just as the Venice Biennale functions metaphorically as a showcase for recent trends in art, each of the separate rooms of 'Ambiente' serves as a showcase displaying characteristic works of separate artists (each of the artists having his 'own' room). At the same time there is the presumption that all the individual rooms collectively represented a larger, socially relevant, unifying point of view: 'Ambiente' (i.e. 'The Environment,' environmental concerns).

Public Space/Two Audiences effects an inversion: the spectators, instead of contemplating an art production (products produced for the art market) encased within the room-environment (the architectural enclosure), are themselves placed on display by the container's structure and materials; similarly, the social and psychological effect of the pavilion's material construction, in contradiction to its presumed 'neutrality,' becomes apparent.

The supposed (artistic and formal) neutrality of the materials employed (thermopane, glass and mirror) is contaminated by their social connotations if they would have been used in the real world. 'Utopian,' idealized post-Bauhaus architecture and 'Minimal Art' both would reduce the spectator's perception of materials to the self-referring relation of the material elements of construction to a primal or logical elementalness, just as the structure is formally self-deductive. The art object/architectural form is reduced to a state of its materiality/abstract expressiveness alone; it is presumed to have no other connotation. But materials also function as social signs; the way that materials are employed affects a person's or a group's social perspective (social reality). For example, the glass par-

tition in the customs area of many international airports is acoustically sealed, insulating permissable residents of the country from those arriving passengers technically in limbo until they clear customs. Another example is the use of hermetically sealed glass in the maternity ward's nursery in some hospitals, designed to separate the observing father from his newly-born child. In this instance, the institution, having separated the child from its mother, now, in the interests of public health, claims rights to its body from the 'natural' father, who is initially allowed (as compensation) only a visual relation.

Public Space/Two Audiences functions doubly: at first glance, and especially when experienced by a lone observer in the space, it appears to read as conventional 'Minimal Art,' room-size, or as a post-Mies exhibition pavilion; its 'success' as art is closely related to the 'beauty' (i.e. the formal use of) the materials. Second, experienced with other people present, over a period of time, the first reading is increasingly contradicted – the materials and structure of the space are experienced as controllers of psychological and social behavior.

Psychologically, for an audience, the glass divider represents a visual window showing (objectifying) the other audiences' behavior (so that the observed, second audience becomes, by analogy, a 'mirror' of the outward behavior of the audience observing); at the same time the mirror at the end of one space allows the observing audience to view itself as a unified body (engaged in looking at the other audience). A similar situation, but reversed, exists for the second audience. For initially both audiences look for objective confirmation of their respective subjectively experienced social situations. The spectators of one audience tend to see the other objectively, while their own subjectivity seems insulated from the subjective experience of the opposite

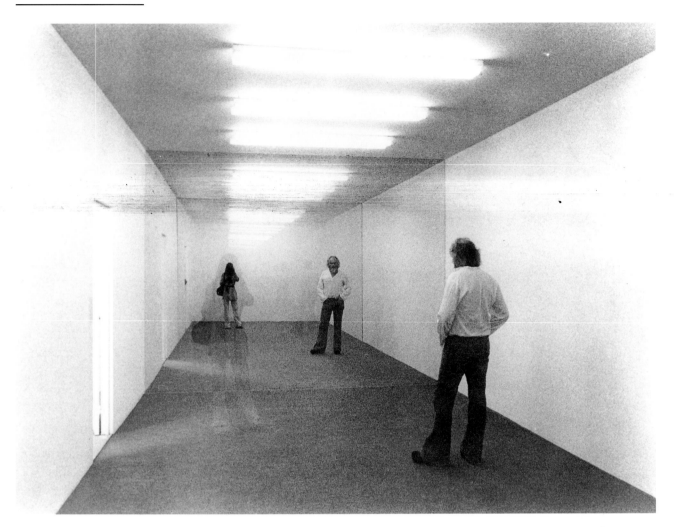

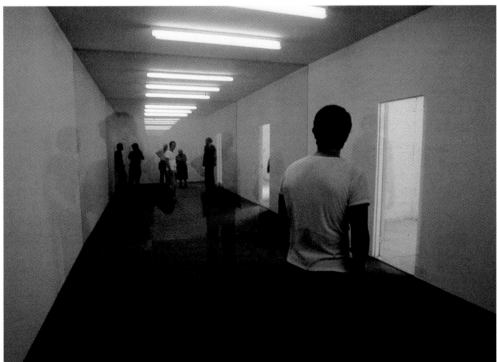

Public Space/Two Audiences, 1976. Installation 'Ambiente,' Venice Biennale, 1976, two views. Collection Herbert, Gent, Belgium.

audience. Normally neither observed nor observer on opposite sides of glass can be part of the other group's intersubjective framework. But here, while the glass partition on one hand places a distance between opposing spectators, on the other hand, the co-presence on the mirror of the two groups' bodies and the visual image of their process of looking make for an extreme visual inter-subjective intimacy.

The complexity of this relation of the spectators to their image, and to the image of the Other (reciprocal spectators), is a product of/is echoed in the relation of the material properties of mirror and glass.[1] Because glass as a material is itself mirror-reflective, observers in the room distant from the mirror, looking in the direction of the mirror through the glass divider, see a double reflection of their image, first in the glass and then, smaller in size but more distinct, in the mirror. From within the other room (with the mirror) an observer looking towards the glass and at the other space's opposite white wall, will see partially reflected on the glass's surface a faint projection of the space of both rooms... this image being reflected from the mirror's surface to illusionistically fill in the blank wall surface behind the glass.

Because of the placing of the mirror at only one end of the space, the two audiences' perceptual situations differ; this affects the relative behavior patterns of these two groups. In fact, the behavior of one does not mirror that of the other (although to a group on one side the opposing group will still appear to them as a 'mirror' of their own situation).

A spectator in the room with the mirror can choose several alternative ways of looking: he may look only at his own image in the mirror; he may observe himself in the mirror, but observing his relation to his group; he may, as an individual, observe in the mirror the other audience (seeing himself in relation to the other audience and per-

haps the audience observing him at the same time as he observes them); he may, feeling himself a collective part of the audience, observe both audiences observing each other. If the spectator changes his position and looks away from the mirror, he may observe his own audience (as in normal life). Finally, if he faces the glass divider, he may observe members of the other audience, but not see an image of himself looking (because the far wall of the other space is blank).

In contrast, members of the other audience tend to look collectively in only one direction, as both the image of the other audience and the image of themselves is to be found by looking towards the distant mirror. When members of this audience observe, they will always see at the same time their own image (an image of themselves looking) reflected in both the mirror and the glass.

The spectator is made socially and psychologically more self-conscious... the observer becomes conscious of himself as a body, as a perceiving subject, and of himself in relation to his group. This is the reverse of the usual loss of 'self' when a spectator looks at a conventional art work. There, the 'self' is mentally projected into (identified with) the subject of the art work. In this traditional, contemplative mode the observing subject not only loses awareness of his 'self,' but also consciousness of being part of a present, social group, located in a specific moment and social reality, occurring within the architectural frame where the work is presented. In *Public Space/Two Audiences* the work looks back; the spectators, inversely, see their projection of 'self' (conventionally missing) returned specularly by the material (by means of the structural) aspects of the work.

[1] This situation is comparable to being trapped in a crowded elevator; after a time the people present come to develop a shared verbal self-awareness and, in time, begin to sense a common group identity.

Buildings and Signs 1981: 23-24.

Title/Date
Record Cover
1976

Materials
proposal for record cover:
color photograph

Dimensions
13¾ x 12 in.
34.9 x 30.5 cm

First publication
Previously unpublished.

First exhibition
'Walker Evans & Dan
Graham,' Rotterdam:
Witte de With; Museum
Boijmans Van Beuningen;
Gent: Centrum Voor
Hedendaagse Kunst;
Marseille: Musée Cantini;
Münster: Westfälisches
Landesmuseum; New
York: Whitney Museum of
American Art, travelling
exhibition 1992-94.

Notes
This photograph was
made as a proposal for a
record cover. Graham
wrote that the proposal
was offered to *Just
Another Asshole* (New
York) for the cover of an
LP issue, however it was
never used. *Just Another
Asshole* was a project of

This photo was to be the cover of an issue of *Just Another Asshole* magazine, which for this issue, was to be an LP record. It is an image of the interior of the most important 'downtown' record shop, 'Sounds', on St. Marks Place. It was my assumption that the *Asshole* record would be stocked in the bins of 'Sounds.' A customer would see, self-referentially, the same store and its displaced current records, but at a time of day depicted on the cover. Except the

Barbara Ess, presenting the work of artists in various printed formats, including sound recordings. Issues # 1-7

appeared during the years 1978-1987. Other contributions by Graham were later published in JAA, see cat. nos. 80 and 86.1.

customer would be in the store seeing the record cover, the just-past interior, and the current situation.

Dan Graham, 'Record Cover,' date unknown, previously unpublished.

Record Cover, 1976.
Courtesy Marian Goodman
Gallery, New York, USA.

Writings

'Environment/Time-Delayed Reflections,' *Casabella* 411 (March 1976): 29-33.

'Dan Graham,' various documentation of works, 'Public Space/Two Audiences,' + - 0 *(Revue d'Art Contemporain)* no. 14 (September 1976): 6-7.

'Elements of Video/Elements of Architecture,' in *Video By Artists*. Ed. Peggy Gale. Toronto: Art Metropole, 1976: 193-195.

'Film and Performance/Six Films, 1969-74,' in *Six Films*. New York: Artists Space, 1976.

Title/Date
Identification Projection
1977

Materials
female performer,
audience seated in a
three-quarter ellipse

Dimensions
variable according to
installation

First publication
Theatre 1981: n.p. See
also transcript of first
performance at Leeds
Polytechnic, January 1977
Theatre 1981: n.p.

First performance
Leeds Polytechnic, Leeds,
England, January 1977.
Second performance:
De Appel, Amsterdam,
Holland, June 1977.

Identification Projection,
1977. First performance,
January 1977, Leeds
Polytechnic, Leeds, England.

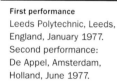

Premise. A woman performer looks at the audience, selects and describes the various men (perhaps also women) who charismatically ('sexually') attract her. The description and the feeling she expresses are to be as sincere, non-theatrical, as possible. The performer pauses between descriptions of people for a time the same length as her period of speaking (so that she appears as a sexual object). The pauses should seem a little too long. During this period she does not look at or acknowledge the presence of the audience; she moves slowly; she is for-herself (thinking private thoughts about herself).

Notes. When describing: the woman looks the man in the eyes, occasionally touching her body when describing this person; she speaks of the outer features of his body, including his eyes; she tries to visualize what he is looking at (so as to verbalize what she thinks he desires); he mentions sexual characteristics of his body (both physical and attitudinal), picking out which unique traits of the man's 'aura' make him attractive, that make her desire him; she looks for traits in the man which she shares with him (verbalizing in which ways she feels she is like him); she tries to express what the particular nature of his charisma is (and in so doing, expresses what it is that she desires).

The audience is arranged in a three-quarter complete and broad ellipse, seated facing the woman (no more than 3 or 4 rows deep), thus allowing people in the audience, when someone is being described, to view simultaneously, the woman performer making the description and the person being described. This gives them (psychologically) the option to desire to be (project themselves):

1. in the place of the person described;

2. to be in the place of the woman performer;

3. not to be in the place of the person being described;

4. or, not to be in the place of the performer.

Structurally, the basis of the performance is to invert and reverse the normal (unconscious) identification that the spectator projects onto a film or theater performer.

Theatre 1981: n.p.

Title/Date
Performer/Audience/
Mirror
1977

Materials
performer, mirror
positioned parallel to
the frontal view of the
audience, audience

Dimensions
variable according to
installation

First publication
New Art no. 3/4 (Fall
1980): 30-31. This ver-
sion of text first published
Theatre 1981: n.p. See
also transcript of the
second performance at
P.S. 1, Long Island City,
New York, December
1977: *Theatre* 1981: n.p.

First performance
De Appel, Amsterdam,
June 1977. Second per-
formance: P.S. 1 Institute
for Contemporary Art,
Long Island City, New York,
December 1977.

Notes
A single channel videotape
*Performer/Audience/
Mirror* was made (black
and white, 22:52 minutes,
sound) and is distributed
by Electronic Arts Intermix,
New York. *Performer/
Audience/Mirror* was
performed at Riverside
Studios, London with a
performance by The Static
(Barbara Ess, Christine
Hahn and Glenn Branca):
*Dan Graham at Riverside
Studios: The Static at
Riverside Studios.* London:
Audio Arts, 1980, sound
recording (cassette) with
interview by William
Furlong (textual sheet),
recorded at Riverside Stu-
dios, London, February 24,
1979. *Performer/Audi-
ence/Mirror* was per-
formed in October 1995
for the exhibition 'Dan
Graham, Video/Architec-

Premise. A performer faces a seated audience. Behind the performer, covering the back wall (parallel to the frontal view of the seated audience), is a mirror reflecting the audience.

Stage 1. The performer looks in the general direction of the audience. He begins a continuous description of his external movements and the attitudes he believes are signified by his behavior for about 5 minutes. The audience hears the performer and sees his body.

Stage 2. The performer continues facing the audience. Looking directly at them, he continuously describes their external behavior for about 5 minutes. (See Observation 2.)

Stage 3. The performer faces the mirror (his back being turned to the audience). For about 5 minutes he continuously describes his front body's gestures and the attitudes it may signify. He is free to move about, to change his distance relative to the mirror, in order to better see aspects of his body's movements. When he sees and describes his body from the front, the audience, inversely, sees his back (and their front). The performer is facing the same direction as the audience, seeing the same mirror-view. The audience can not see (the position of) the performer's eyes.

Stage 4. The performer remains turned, facing the mirror. For about 5 minutes he observes and continuously describes the audience who he can see mirror-reversed from Stage 2 (their right now being the same as his). He freely moves about relative to the mirror in order to view different aspects of the audience's behavior. His change of position produces a changing visual perspective which is correspondingly reflected in the description. The audience's view remains fixed; they are not (conventionally) free to move from their seats in relation to the mirror covering the front staging area.

Observations. 1. Through the use of a mirror the audience is able to instantaneously perceive itself as a public body (as a unity), offsetting its definition by the performer. This gives it a power within the performance equivalent to that of the performer.

2. In Stage 2, the audience sees itself reflected by the mirror instantaneously, while the performer's comments are slightly delayed and following, as they are verbal discourse, a continuous temporal forward flow. This affects cause and effect interpretation for the audience. First, a person in the audience sees himself 'objectively' ('subjectively') perceived by himself, next he hears himself described 'objectively' ('subjectively') in terms of the performer's perception. The slightly delayed verbal description by the performer overlaps/undercuts the present (fully present) mirror view an audience member has of himself and of the collective audience; it may influence his further interpretation of what he sees. Cause and effect relations are further complicated when members of the audience (because they can see and be seen on the mirror by other members of the audience) attempt to influence (through eye contact, gestures, etc.) the behavior of other audience members, which thereby influences the performer's description (of the audience's behavior).

Theatre 1981: n.p.

ture/Performance,'
October 5 – December 17,
Generali Foundation,
Vienna.

Performer/Audience/Mirror,
1977. Performance 1978,
Video Free America, San
Francisco, CA.

W 1977

Writings

'Duchamp/Morris,' response to questionnaire
by Philippe Sers on 'What does Duchamp Mean
to You Today? Do You Consider Him to Already
Belong to the Past?,' *Connaissance des Arts*
no. 299 (January 1977): 47-55.

'Three Projects for Architecture and Video/
Notes,' *Tracks* Vol. 3 no. 3 (Fall 1977): 52-61.

Title/Date
Alteration to a Suburban
House
1978

Architectural model
edition of 3
materials and dimensions
may vary over edition

Materials
painted wood, synthetic
material, plastic

Dimensions
$24^{4}/_{5}$ x $25^{1}/_{5}$ x $36^{2}/_{3}$ in.
63 x 64 x 93 cm
pedestal
$48^{2}/_{5}$ x $48^{2}/_{5}$ x $59^{2}/_{5}$ in.
123 x 123 x 151 cm

First publication
Buildings and Signs 1981:
34-35.

First exhibition
'Dan Graham: Installations/
Photographs/Videotapes/
Performances/Publica-
tions/Films/Architectural
Models,' September 3 –
October 1, Museum of
Modern Art Oxford, organ-
ized by David Elliott.

The entire facade of a typical suburban house has been removed and replaced by a full sheet of transparent glass. Midway back and parallel to the front glass facade, a mirror divides the house into two areas. The front section is revealed to the public, while the rear, private section is not disclosed. The mirror as it faces the glass facade and the street, reflects not only the house's interior, but the street and the environment outside the house. The reflected images of the facades of the two houses opposite the cut-away 'fill in' the missing facade.

The glass facade reveals the interior living quarters and displays it like a show window. The interior mirror shows the external observer as well, placed in his outdoor environment, seen within the mirror, perceiving. One could also see the cut-away facade as a metaphoric billboard, but one depicting a *non-illusionistic* view: a cut-away view of a family in their house surrounded by greenery and other houses in the background. But unlike a billboard, the outside spectator observes the actual space in the house behind the picture plane as well as the actual space he is in.

In the normal suburban house, the delimited view that an outside observer has of the interior of the house through its front window is arranged to give a picture of conventionally accepted normalcy. Where the facade of the suburban house, through nostalgic and conventional signs and symbols, expresses the individual home-owner's identity, *Alteration to a Suburban House,* by substituting the actual in place of the conventional sign, strips the house of its community-defined 'personal' identity.

The house can be read alternatively as art or as architecture. In the context of its residential surroundings, it might be read simply as an eccentric, 'do-it-yourself' home modification. It could also be seen as a work of 'high' architecture in the modern idiom. There is a relation to houses built by architects such as Michael Graves, Robert Venturi, or Frank Gehry. Venturi's houses often inflect toward details of surrounding, already existing vernacular architecture and incorporate into their compositions the signs and symbolism of these nearby buildings. Rather than mere semiotic allusion to surrounding vernacular architecture, *Alteration to a Suburban House* literally reflects the facades of the houses opposite. This work, like works by Graves or Gehry, takes away a section of the facade of an already existing vernacular-style house in order to reveal its social, archetypal qualities. Rather than building a novel form, it simply exposes the underlying material to reveal what is already there. The difference between *Alteration to a Suburban House* and 'high' architecture is that while these architects' works deconstruct an existing vernacular house or take the existence of surrounding vernacular meaning into their compositions, their works do not disturb existing public and private codes. Their works do not alter, decompose, disquiet, or affect the surrounding environment.

Alteration to a Suburban House relates to the 'glass houses' of Mies van der Rohe and Philip Johnson, set in isolated, private, wooded estates. Four-sided glass forms, these houses are derived from the glass office building of the city. Nature is seen on all sides and, in the optical merger of its image with the reflections of the interior space on the glass curtain wall, interior and exterior are made identical. Instead of a dialectical opposition between Nature, man-made architectural form and lifestyle, the glass building combines these into a 'utopian' language of pure transcendental materiality. Because these houses are on private estates, they are not meant to be seen by the community from the outside, and thus the question of the position of the building in the community, or of

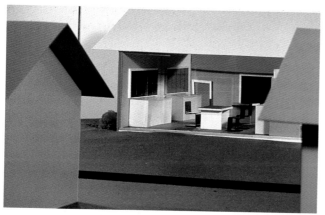

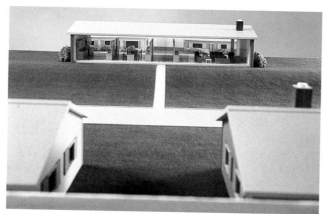

viewing by an outside spectator is not considered. These houses are seen the way a connoisseur examines a work of art. The use of a mirror in *Alteration to a Suburban House* arbitrarily separates private space, made more mysterious, from the full visible front areas. The traditional disposition of the family space is altered. The mirror's reflection also exposes the house's relation to the social environment, revealing the position of the spectator's gaze.

Buildings and Signs 1981: 35.

Alteration to a Suburban House, 1978.

Title/Date
Clinic for a Suburban Site
1978

Architectural model
edition of 3
materials and dimensions
may vary over edition

Materials
painted wood, plexiglas,
landscape material

Dimensions
12½ x 30 x 23½ in.
31.8 x 76.2 x 59.7 cm

First publication
Buildings and Signs 1981:
32-33.

First exhibition
'Dan Graham: Installations/
Photographs/Videotapes/
Performances/Publica-
tions/Films/Architectural
Models,' September 3 –
October 1, Museum of
Modern Art Oxford,
organized by David Elliott.

Clinic for a Suburban Site,
1978. Collection Bown-
Taevernier, Gent, Belgium.

Clinic for a Suburban Site is a two-level structure elevated on a hill. From the front, street-view, only the top, pavilion-like structure is visible. It contains a waiting room, which one enters from the front door, and just behind this, a consultation room. The front facade is a sheer pane of transparent glass, separating the waiting room from the rear consultation room. Half-way back is a glass panel, which forms a sliding door to the next room. In the consultation room a nurse takes records and dispenses medication. The far wall of this room is a sheer mirror, reflecting the activities of both of the rooms and of the sky. Stairs lead down into the examination rooms on the second level.

In *Birth of the Clinic*, Michel Foucault describes medical space as one which gives primacy to the 'pure gaze' of scientific observation. This gaze, as defined by Foucault, emphasizes the 'immediately visible.' The clinic, a neutral, totally illuminated, visible space for observation of patients is one of the new spaces of dispassionate surveillance which Foucault has identified with the new regime of power emerging with the Enlightenment:

"This enclosed, segmented space, observed at every point, in which the individuals are inserted in a fixed place, in which the slightest movements are supervised, in which all events are recorded..." From *Discipline and Punish.*

In normal practice this type of 'glass building' does not 'mirror' its own self-alienation; it hides this 'surveillance' function in its transparent 'openness.' A glass building

gaze away from the detail within the building. The *function* of the interior is lost to the function of the building's formal structure and to its 'materiality.' It is lost to the equation of structure and material with the transcendental natural environment. Instead of a dialectal opposition between the outer facade and the function of the inner space and between nature and culture, this type of architecture coalesces the two polarities into a utopian language of pure function and pure materiality. What is also never made evident is the position of the spectator on its outside, as compared to the user within the building. In *Clinic for a Suburban Site*, the placement of the mirror gives observers, in either of the two inner rooms or outside the building, a view of the position of their gaze and of the gaze of others. It shows the social, frontal spaces separated from each other and from 'Nature.'

Buildings and Signs 1981: 33.

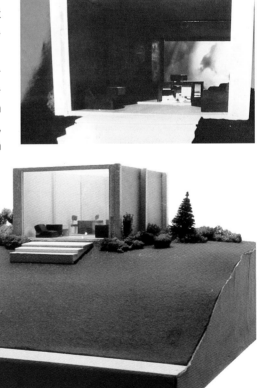

which one can 'see through' directs the outside observer's

68 1978

Title/Date
Video Projection Outside
Home
1978

Architectural model
edition of 3
materials and dimensions
may vary over edition

Materials
painted wood, plastic

Dimensions
9 x 30⅓ x 20 in.
22.9 x 77 x 50.8 cm

First publication
Buildings and Signs 1981:
36.

First exhibition
'Dan Graham: Installations/
Photographs/Videotapes/
Performances/Publica-
tions/Films/Architectural
Models,' September 3 –
October 1, Museum of
Modern Art Oxford, organ-
ized by David Elliott.

A large Advent video projection screen is placed on the front lawn, facing pedestrians on the sidewalk. It shows an image of whatever TV program is being watched by the family on their TV set within the house. When the set is off, the video projector is off; when the channels are being changed, this is seen on the enlarged public screen outside the house.

Buildings and Signs 1981: 36.

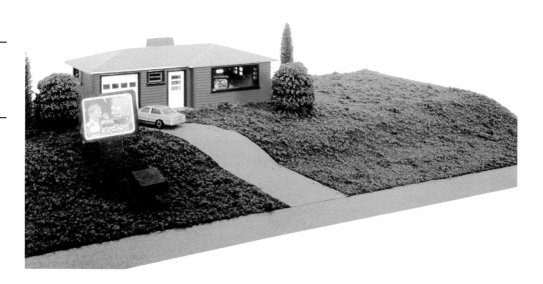

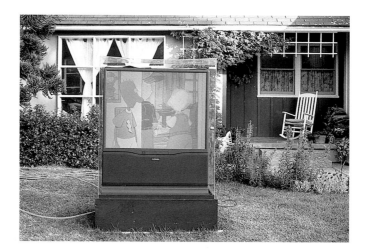

Video Projection Outside Home, 1978. Courtesy Marian Goodman Gallery, New York, USA.

Video Projection Outside Home, temporary installation, 1996, in private home, 1347 Santa Rosa Avenue, Santa Barbara, California, USA.

69 1978

Title/Date
Dan Graham and Dara
Birnbaum
Local Television News
Program Analysis for
Public Access Cable
Television
1978

Materials
local news program, local
cable TV channel and
production facility, wide-
angle lens fixed position
camera in family home

Dimensions
variable according to
installation

First publication
Text by Graham and
Birnbaum *Nova Scotia*
1979: 57-61; text and
drawings by Birnbaum:
'Working Notes for Local
Television News Program
Analysis for Public Access
Cable Television,' in: *Nova
Scotia* 1979: 77-85.

Notes
This work was proposed in
1978 as the production of
a daily series for cable TV
in cooperation with the
Advanced Media Course
of the Nova Scotia College
of Art and Design, 1978-
79. It was realized in a
modified form for single
channel cable access in
Toronto in 1979-1980 as
part of the program 'Tele-
vision by Artists.' The pro-
gram featured six commis-
sioned works by artists for
television for broadcast
via Rogers Cable TV, a
community access chan-
nel, serving the Metro
Toronto area. The program
was produced by Fine Art
Broadcast Service for A
Space; executive producer
and curator: John Watt;
consultants: Ian Murray
and Robin Collyer. *Local
Television News Program*

Premise. A collaborative work that calls for simultaneous recordings to take place within the broadcast studio as well as the home/receivership area during a prese-lected (local news) transmission. These 'documentary framings' are then to be cablecast within a time frame directly related to the original broadcast. Thus, the cablecast playback would provide an ana-lytic tool capable of starting an assess-ment of the structure and implications of the original (news) broadcast itself.

From Dara Birnbaum, 'Working Notes,' *Nova Scotia* 1979: 77.

Proposal. This is a tentative proposal for the production of a 4 part, 30 minutes each, daily cable TV-series in conjunction with NSCAD's Media course from Septem-ber, 1978 until April, 1979. It was firstly conceived as a didactic analysis of the way that broadcast television functions and the role that it performs in the culture of the community. It requires the coopera-tion of a local outlet of one of the two Hal-ifax national network affiliates and a chan-nel of the local free access cable TV.

This project attempts a structural and cul-tural analysis of the production and recep-tion of a typical daily local news program as seen on broadcast television. This genre of program is typically broadcast in the time period before or just after the national early evening newscast. A news team of reporters, sportscaster, and weather-person introduce stories of local interest in a round-table format. The atmosphere is more relaxed than during 'The National' news. Within a fictional matrix, which has been termed the 'happy news' format, the 'news team' is like a family at ease in a domestic setting.

We propose to examine the objective con-ditions of the production of the local news show by revealing the objective conditions (hidden by the fictional convention in which it is framed) of the people produc-ing it and the real conditions of the family-

life of those watching it – for whom TV is a substitute for the real world. By this com-parison of the two normally invisible spheres (production and reception), we want to observe/disclose the conditions obscured by the conventions of television. All videotaping and filming is done before, during and just after Monday evening's program. On Tuesday, Wednesday, Thurs-day and Friday at the same time that that day's version of the broadcast news pro-gram is taking place, the free access channel of cable TV presents our analysis of Monday's show. Each day's program on cable deals with an analysis of Monday's program as divided into three aspects. One aspect deals with the reception of the news program in the living room of a typi-cal local family residence. The second aspect deals with the way in which the newscast is produced in the studio. The third aspect deals with analyzing the for-mal elements of the program itself.

Tuesday's cable analysis of Monday's pro-gram would consist of:
1. the initial 10 minutes of the actual pro-gram re-played;
2. the initial 10 minutes of this program as viewed from within the living room of a typ-ical local family, using a wide-angle lens on a fixed position camera (to give classical Renaissance-space, centered view of the TV set with people sitting around it);
3. a 'behind the scenes' control-room-view as well as a wide-angle lens view of the stage-set as a whole, showing the sur-rounding technicians working as a 'team' in production (with the actors) of the 'news-team' – program... this is docu-mented during the initial 10 minutes of the TV program.

Wednesday's cable analysis of Monday's program would consist of:
1. the next 10 minutes of Monday's pro-gram analyzed using various techniques (sound separated from image, written dia-logue superimposed upon image, diacriti-

Analysis for Public Access Cable Television broadcast on June 11 and 13, 1980, 60 minutes. A video document was made of this broadcast.

cal analysis superimposed upon sound or image, are possibilities), to be worked out by the three collaborators;

2. the next 10 minutes of Monday's program as viewed from the living room of a typical local family, using a back and forth panning camera technique between the image on the TV set and the frontally observed watching TV viewers;

3. a didactic analysis of separate work roles and organizational responsibilities of the production staff of the news program. The exact structure of Thursday's and Friday's cablecast has not been determined; however, it is proposed that a portion of Friday's cablecast have the three collaborators and production staff itself appear live on television to discuss the content and the intentions of the series of programs. Perhaps viewers might telephone in their comments and questions directly to the station for the responses of the producers of the *Local TV News Program Analysis for Public Access Cable TV.*

Working notes. […] 13. An important question which we must ask and attempt to answer is: what is the meaning of 'local' news coverage (to the community), if the framework for 'local' news is a fictional, conventionalized national formula?

14. A last question: can an analytical, didactic de-construction of media, such as we propose, be of cultural and political value to the community?

Nova Scotia 1979: 58-59, 61.

Title/Date
Projections on a Gallery
Window
1979

Materials
35 mm slides, carousel
slide projector

Dimensions
variable according to
installation

First publication
New Art no. 3/4 (Fall
1980): 24-25. This later
version of text first
published *Buildings and
Signs* 1981: 38-39.

First exhibition
'Dan Graham, Window
Installation, images of
other exhibitions and
exhibition spaces,'
Franklin Furnace, New
York, January 2 - 20,
1979.

Notes
This work was realized for
the storefront window of
Franklin Furnace, an alter-
native exhibition and per-
formance space in Tribeca
on 112 Franklin Street.
The show inside the
Franklin Furnace galleries
during the period 2-20
January was a project by
Barbara Kruger, 'Photo-
graph/Paragraph.'

Projections on a Gallery Window [...] consisted of a series of color slides projected sequentially from inside the gallery onto an opaque screen covering the lower half of the window. A new slide appeared every 15 seconds and these could be seen from both inside and outside the gallery. All of the slides showed images of art exhibitions on view at the same time in art spaces in the vicinity of Franklin Furnace. All views were taken with a wide-angle lens, from the same perspective, with a camera positioned at the center point of the particular gallery's fourth wall which is not visible and usually the entrance or front window. The camera's view was a Renaissance perspective of the other three walls of the exhibition space, corresponding to the view which a spectator outside of the Furnace's front window would have if the projected images were not obscuring the view. As the opaque projection screen does not block the top of the window, the ceiling of Franklin Furnace's space was visible from outside.

Seen from the inside of the Franklin Furnace space, the slides must be considered in relation to the other art on view inside the gallery. (*Projections on a Gallery Window* was exhibited simultaneously with an exhibition by another artist in the Furnace gallery.)

Projections on a Gallery Window, viewed from the street outside the gallery, represents the perspective a viewer would normally have had of the Furnace exhibition space, except that the images are of other exhibition spaces. Where the outside viewer would have projected himself into the show seen behind the window, the projected slides of other spaces block the view of the actual interior space behind the window. They refer to all other gallery shows existing simultaneously and represent not the specific Furnace space, but the gallery space as such. This is in distinction to conventional modern art, whose content is inseparable from the gallery space and the spectator's present perceptions and which reduces itself to the perceptual or conceptual terms of itself as place. The projected slides, instead, allude to themselves as representations, connected to a chain of other representations in society beyond the immediate spatial context.

The slides could refer to the commercial world of street signs and advertisements, as well as to the Franklin Furnace window. They could be seen as advertisements for other art shows. Or, if the viewer has already seen some of the particular shows, the photographs give him another, more 'objective' perspective. The transparencies could relate to the conventions of photographic reproduction of art shows with reviews in art magazines after the termination of an exhibition. These photographs and reviews are the conventionalized, definitive representation of the exhibitions. The format and conventional perspective of the 'installation shot,' as well as its imagery, relates iconographically to the traditional 17th and 18th century Flemish and Italian paintings which have the art gallery as subject.

As the daylight diminishes, the window's exterior, due to the properties of glass, becomes a screen upon which a partial mirror-image of the surrounding buildings, including their windows and illuminated interiors, are superimposed onto the slide images of various galleries' interiors from the surrounding neighborhood. While art works hung in the interior art gallery are displayed by means of consistent illumination which ensures the neutrality of the art by ensuring the invariability of the architecture background, these projected images, seen either from within the gallery, or from the street outside the gallery, are affected by the constantly altering exterior light conditions.

Buildings and Signs 1981: 39.

Projections on a Gallery Window, 1979. Exterior views: slide of exhibition at Leslie Lorman Gallery, New York (left);
slide of exhibition at Heiner Friedrich Gallery, New York (right).

W 1979

Writings

'Art in Relation to Architecture/Architecture in Relation to Art,' *Artforum* 17, 6 (February 1979): 22-29.

'Punk: Political Pop,' *Journal: Southern California Art Magazine* no. 22 (March-April 1979): 27-33.

Graham, Dan, and L. Licitra Ponti, 'Dan Graham a Milano: Architectural Models and Photographs,' *Domus* no. 594, (May 1979): 55.

'The Lickerish Quartet,' in *12 Films*. Exh. cat. Ed. Barbara Bloom. Amsterdam: De Appel, 1979.

'Video Arbeit für Schaufenster,' 'Schaufenster aus Glas,' 'The Glass Divider,' 'Bild-Fenster Arbeit,' *Zweitschrift* no. 4/5 (1979): 108-113.

'Essay on Video, Architecture and Television,' in *Dan Graham. Video-Architecture-Television, Writings on Video and Video Works, 1970-1978*. Ed. Benjamin H. D. Buchloh, with contributions by Michael Asher, Dara Birnbaum. Halifax: Nova Scotia College of Art and Design and New York University Press, 1979: 62-76.

'Notes on 'Yesterday/Today,' in *Nova Scotia* 1979: 44-46.

'Notes on Video Piece for Showcase Windows in a Shopping Arcade,' in *Nova Scotia* 1979: 53-54.

Graham, Dan, and Dara Birnbaum, 'Local television news program analysis for public access cable television,' in *Nova Scotia* 1979: 58-61.

Title/Date
Two Pages for Artforum
February 1980

Materials
printed matter: black and
white photograph repro-
duced on two facing mag-
azine pages in *Artforum*

Dimensions
same as magazine:
10½ x 10½ in.
26.7 x 26.7 cm

First publication
Artforum 18, 6 (February
1980): 90-91. Reprinted
in *Ragile, Recherches
artistiques et théorétiques*
(March 1980): 22-23.
Text first published in
Buildings and Signs
1981: 37.

This work was published in the February 1980 issue of *Artforum* in response to the editor's invitation to produce 2 or 4 pages for an issue devoted to the artist's use of the page, work "intended for this, and only this format." The issue also carried its usual review and advertising sections. Other participating artists were: William Wegman, Jenny Holzer and Peter Nadin, *Art and Language*, Gilbert and George, Kim MacConnel, Heresies, Judy Rifka, Ed Ruscha, Victor Burgin, Laurie Anderson, Michelle Stuart, Anne and Patrick Poirier, *Just Another Asshole,* Richard Long, and Joseph Beuys.

My two pages were an 'installation shot' of a current gallery exhibition, a Renaissance perspective view, but larger than those usually used in the photographs reproduced in reviews of exhibitions or gallery advertisements. My pages related to the advertising and review sections, which were the only conventional features remaining in this issue of the magazine.

A magazine page which relates only to itself as art may seem free of the gallery and art magazine system. It becomes an 'advertisement' for the magazine's 'first-hand involvement' with the artist; the actual position of the magazine in the art world system is obscured. Art magazines mediate between gallery art and communications about art, reproducing, in terms of two-dimensional photographs and written texts or captions, art which first phenomenologically existed in galleries. Gallery art attains value (and meaning) by being exhibited in galleries *and* by being reproduced in art periodicals. The art periodical, in turn, depends upon the institution of the gallery, which supports its existence by purchasing ads. The value of art reproduced in the media is rapidly dissipated — conforming to magazine conventions of the transient value of information. This is the reverse from gallery art, which tends to accrue in value the more it appears in the media and/or galleries.

Buildings and Signs 1981: 37.

Title/Date
Video View of Suburbia in
an Urban Atrium
1979-80

Materials
one video monitor
installed in interior atrium

Dimensions
variable according to
installation

First publication
Buildings and Signs
1981: 42-43.

First exhibition
Atrium at Citicorp Building,
New York, August 1980,
organized by Barbara
London.

Notes
The Citicorp Building's
interior public atrium was
intended to be the loca-
tion for a series of video
installations organized by
Barbara London of the
Museum of Modern Art,
New York. Although the
series never materialized,
Graham's project was
temporarily installed in
August 1980 and filmed
by Ernst Mitzka for Ger-
man television in conjunc-
tion with the exhibition
'Westkunst', Cologne,
Germany, 1981, see cat.
no. 73. The video featured
footage of suburban archi-
tecture and came from a
real estate office special-
izing in Florida real estate.
The Citicorp work was
adapted from an earlier,
unrealized project pro-
posed in 1979 for an
exterior arcade in Liver-
pool, England where a
single video monitor was
to have been mounted on
a monumental base.

In the atrium of the Citicorp Building, an enclosed public space in the center of New York City, a continuously repeating film sequence is seen on several video monitors. The casual viewer sees a house and its landscaped suburban setting. This sequence might suggest a real estate advertisement or videotapes made of houses for sale by real estate agents. Instead of the viewer in a private home interior seeing a view of public life in the city (while safely ensconsed within his home), a public viewer in the center of the city sees a television image of the exterior of a suburban house.[1]

The interior atrium of the Citicorp Building is a patio-like seating area surrounded by various concessions selling coffee, des-serts and health salads. Real trees used with high-tech and breeze-way suburban design – green and white metal open-work chairs, green lettering on shop windows and the trees and earth – connote the 'ecological.' Something of a 'vest-pocket' urban park in a high-rise office building, Citicorp's atrium suggests suburban arca-dia in the midst of the city. If the atrium's design represents an urban fantasy of the picturesque brought to the city center, the image on the monitors represents the actual suburb on the edge of the city.[2]

The image of suburban 'Nature' links itself to other representations of 'Nature,' repre-sentations which seek to naturalize the city as an environment and 'smooth over' contradictions between city and country. The metaphor of 'Nature' in the urban order is an ideological rationalization, which conceals the contradictions be-tween the city and the countryside. Adver-tisements for products derived from the exploitation of natural resources, often will equate the product with an idealized and nostalgic image of 'the natural.' (Ciga-rettes are equated with springtime or rugged, western environments, although it

is known that they actually are unhealthy for both consumer and environment.) In 'buying' the image of the product, we are being sold a false idealization of nature, and made to forget that the product's manufacture exploits nature. The insertion of 'Nature,' in the form of advertising or design, conceals the economic contradictions between urban reality and nature (which the city must exploit for its survival). 'Nature,' having been ideologically de-naturalized, is returned, in the world of the commercial or package design, in place of nature's actual relation to the city. There the representations of advertising romantically equate the 'natural' product with the 'unspoiled paradise of Nature,' as opposed to the 'corrupt, non-natural city.' [...]

[1] The architect Leon Krier writes about the historical emergence of the modern suburb in relation to urban conditions of the 19th century: "The very concentration of people in the cities, which was a *conditio sine qua non,* for the industrial production represented [...] [a] threat [...] The technical answer to the political explosiveness of the 19th century city [...] consisted in widespread suburban settlements [...] [which led to] the dissolution of the political explosiveness of the traditional working-class districts into the ever-green peace of suburbia." (From 'The Blind Spot,' *Architectural Design Profile,* No. 12, 1978.)

[2] Television comes into existence after the settlement of suburbia and relocation of the working-class, who now work in the city by day and commute to their suburban homes at night. The working-class family changed into a small, nuclear unit which must be willing to pack up its belongings and move to another location rapidly as work conditions required greater mobility. The TV set, like the car and other modern appliances, was designed to be transportable. Products now were built to allow the worker/consumer to plug in quickly to whatever location he might find himself in. An explanation for the form that television historically took, that of a centrally controlled transmission sent to the passive home viewer on a privately owned TV set, is that television first came into being as a commodity item which had to be made cheaply to achieve a mass market and be transportable as the family moved from residence to residence. Further, the passive, one-way nature of broadcast TV transmission provided non-involving entertainment (like the movies, except at home) removed from the pressure of daily work-time. Because of the pressures of a more technically organized worklife, the private area of family and home became retreats for the worker on his 'time off.' Television programming allowed the person in his private space to feel connected to the larger, public world, but free of its demands, sheltered in the comforts of his home-life.

Buildings and Signs 1981: 43.

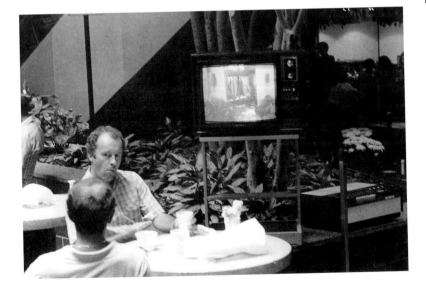

Video View of Suburbia in an Urban Atrium, 1979-80, installation view August 1980, Citicorp Building, New York, USA.

73 1980

Title/Date
Dan Graham and
Ernst Mitzka
Video for Westkunst
Exhibition
1980-81

Materials
single channel videotape,
7:10 minutes, color,
sound

Dimensions
variable according to
installation

First publication
Script first published
Zone no. ½
(1986): 363-365.

First exhibition
'Westkunst: zeitgenössi-
sche Kunst seit 1939,'
Museen der Stadt Köln,
Cologne, Germany,
May 30–August 16, 1981,
curated by Kasper König.

Notes
Commissioned by German
television and 'Westkunst'
exhibition. Produced by
WDR and Ernst Mitzka;
Directed by Ernst Mitzka;
Camera: Michael Oblowitz
and Michael Shamberg;
Sound: Glenn Branca;
Script by Dan Graham.
Filmed in August 1980
during installation of *Video
View of Suburbia in an
Urban Atrium,* cat. no. 72.
The video, produced from
a segment of the original
film made for the 'West-
kunst' exhibition, is distri-
buted by Electronic Arts
Intermix, New York under
the title *Westkunst
(Modern Period): Dan
Graham Segment.*

In the atrium of New York City's Citicorp Building an image of a house in suburbia is displayed on a series of television moni-tors. The style of the image suggests an advertisement for new houses, like video-tapes made by real estate agents of hous-es for sale. The viewers are not in a private house interior seeing life in the city; what they see rather is a television image of the exterior of a private house, typical of where they live or may fantasize living.

The typical corporate building atrium is a patio-like seating area surrounded by vari-ous concessions selling coffee, health sal-ads and desserts. Real trees used with 'high-tech' and breezeway suburban de-sign, green and white metal open-work chairs, green lettering on shop windows, and the trees and earth connote the 'eco-logical.' The atrium suggests suburban arcadia in the midst of the congested city. The feeling of the atrium/patio relates it to the general image of suburban Nature in the city, as in advertising for example, where it seeks to naturalize the urban environment and smooth out new contra-dictions which have developed between city and the country.

Advertisements for products derived from the exploitation of natural resources will often equate the product with an idealized and nostalgic image of 'the natural.' The insertion of Nature in the form of advertising or design conceals the economic contradic-tions between urban reality and nature, which the city must exploit for its survival. The representations of advertising romanti-cally equate the 'natural' product with the unspoiled paradise of Nature, as opposed to the corrupted non-natural city.

Fast food restaurants and housing 'devel-opments' are laid parallel to each other along the highway. The décor of the restaurant conveys the feeling of the 'nat-ural' and 'rustic.'

Alteration to a Suburban House, 1978: The suburb is the result of the growth of the industrial city; brought about because, in architect Leon Krier's words, "The very concentration of people in the city, which was a condition *sine qua non* for industrial production, represented a political threat." These widespread suburban settlements represented the dissolution of the explo-siveness of the traditional working class district. The worker worked in the city by day and escaped to the one-family subur-ban house, a commodity whose owner-ship, along with the automobile, now quali-fied the worker for membership in the new consumer-oriented middle class.

The full front facade of a typical suburban ranch style house has been removed and replaced with a sheet of transparent glass. Midway back and parallel to the front, a mirror divides the house into front and back. The mirror hides the private bed-room in the back from the visible kitchen and living room of the front. The mirror, as it faces the glass facade and street reflects not only the house's interior, but the environment outside the house.

Alteration to a Suburban House seen through the mirror yields a mirror-reversed view seen from the inside view of those who live in it. It is also a large billboard, or perhaps a show window whose image reflects literally the actual consumer envi-ronment of house and lawn as ideal 'arca-dian' setting.

The mirror reflection invades the public space in front of the property lines by pro-jecting an image of half of the private inte-rior. The reflected images of the facades of the two houses across the street appear, surrounded by lawn and street environment. Seen from a moving car it could be read as a billboard, showing a real, instead of illusory, view of a family in their house in suburbia. In many houses, the limited view of the interior provided by the picture window simply gives outsiders a picture of conventional normalcy. Other conventional ornaments placed in front of

Chronology

190

the suburban house also express the homeowner's individual identity. By substituting the actual in place of the conventional sign, *Alteration to a Suburban House* strips the house of its community and 'personal' identity.

A family is viewing images of the city inside their house. Television is a passive, one-directional environment; it allows them during leisure time to feel both connected and freed from the domination of the city.

Dialogue between family members as they watch *Charlie's Angels*.

Husband: "Hear that? She's beautiful, just like you."

Wife: "Oh."

Child turns away from his mother in embarassment.

Voice from the screen: "She's young, she's exciting; she's everything a man can ask for. And yet... sometimes... when I'm thinking of my first wife, she feels more like *home* to me."

Dan Graham, 'Urban/Suburban Projects,' *Zone no. ½* (1986): 363-365.

Dan Graham and Ernst Mitska, *Video for Westkunst Exhibition*, 1980-81, stills from film version.

Video Project for Two
Shops Selling the Same
Type of Goods
1978-80

Materials
two video monitors placed
in store windows of two
stores selling and display-
ing the same type of
goods

Dimensions
variable according to
installation

First publication
Buildings and Signs
1981: 40-41.

First exhibition
'Video: Dan Graham,'
P.S. 1, Institute for Art and
Urban Resources, Long
Island City, December 7,
1980 – January 25, 1981,
curated by Bob Harris.

Notes
Conceived in 1978 and
first realized for video
section of the Winter
1980-81 multi-disciplinary
program at P.S. 1 in
December, 1980.

Just inside or just outside the lower left or lower right side of a commercial store window is placed a video monitor which displays on a continuous tape loop a color image of the full show window display of another shop in the same city selling, and displaying in its window, the same type of goods.

For an exhibition at P.S.1, in New York in December 1980, a color video image of a Honda motorcycle show room window on East 14th Street was placed in the show display window of a Moped store on East 21st Street.

Buildings and Signs 1981: 41.

*Video Project for Two
Shops Selling the Same
Type of Goods*, 1978-80,
detail of Honda showroom
video in window of Moped
store, exact names and
addresses unknown.

Title/Date
Project for Mayfield Mall
1980

Materials
structure creating a
square enclosure:
diagonal in glass or plexi-
glas positioned between
escalator and four shop
facades parallel and
opposite to one another,
two-way mirror, white wall,
and mirrored wall

Dimensions
variable according to
installation

First publication
previously unpublished

Notes
This work was a proposal
for an exhibition Graham
was invited to participate
in, however the exhibition

and thus the work were
never realized. The pro-
posal exists as a written
text.

A temporary installation is proposed for the central corridor/lobby of a 1960's shopping center in Mountain View, CA.
The installation defines a square. This square is cut by a diagonal plane of transparent glass (or plexiglas) which abuts one corner (on the escalator side), but leaves a 3 foot passage at the other end. The glass show window facades of 4 shops, two on the left and two on the right sides parallel and opposite to each other, become part of the work, including the goods on display in each of the windows. Slough's Gifts' window is covered with semi-reflective, semi-transparent 'two-way' mirror plexiglas (that is, the window is lit in such a way that it functions both as a mirror and also as a semi-transparent display window). The other 3 shops' front windows are left intact. However the side of Stuart's (facing the East Mall passage-way) is also covered with a two-way mirror piece of plexiglas. A white wall which is perpendicular to the escalator and to Slough's shop window (and cut also by the diagonal glass/plexiglas element) closes off one-half of the escalator to the side of the square. On the square's opposite side, facing the open area to the other side of the escalator, a mirrored wall (mirrored on both sides) joins the corner of Stuart's. The mirror is continued on the inside of the square (the beginning of the East Mall) by the 'two-way' mirrorized plexiglas placed on Stuart's East Lobby window.

Dan Graham, 'Project for Mayfield Mall,' 1980, previously unpublished.

Writings

Response to questionnaire, 'Situation Esthetics: Impermanent Art and the Seventies Audience,' *Artforum* 18, 5 (January 1980): 24-26.

'The Destroyed Room of Jeff Wall,' *Real Life* no. 3 (March 1980): 5-6.

'L'Espace de la Communication,' *Skira Annuel* 1980: 90.

'Video Piece for Two Glass Office Buildings (1977),' in *En torno al Video*. Ed. Eugeni Bonet, Joaquim Dols, Antonio Mercader, Antoni Muntadas in Barcelona: Editorial Gustavo Gili, S.A., 1977: 212-213.

'Larry Wayne Richards' Project for 'Conceptual Projects,' in *Larry Richards: Works, 1977-80*. Halifax: Library of Canadian Architecture, Nova Scotia Technical College, 1980: 18-22.

'Dan Graham' and various documentation of works, *New Art* no. 3/4 (Fall 1980): 24-33.

Pavilion/Sculpture for Argonne, 1978-81, two views. Collection Argonne National Laboratory, Chicago, Illinois, USA.

76 1981

Title/Date
Pavilion/Sculpture for Argonne
1978-81

Materials
two-way mirror, transparent glass, steel frame

Dimensions
90 x 180 x 180 in.
228.6 x 457.2 x 457.2 cm

First publication
Buildings and Signs
1981: 26-29.

First exhibition
'Dan Graham: Installations/ Photographs/Videotapes/ Performances/Publications/Films/Architectural Models,' September 3 – October 1, Museum of Modern Art Oxford, organized by David Elliott, model only.

Argonne National Laboratory, an energy research facility 28 miles southwest of Chicago and jointly directed by the University of Chicago and the U.S. Government, commissioned this work, a structure measuring 7½ feet high x 15 feet wide x 15 feet deep. Each 15 foot side is subdivided into 7½ foot square frames. These frames have either mirrors on both sides, or transparent glass, or remain open. A sheet of transparent glass diagonally divides the form into two equal triangular units. A spectator is able to enter through one of the open frames, finding himself, because of the diagonal divider, in either one audience area or the other. *Pavilion/Sculpture for Argonne* is literally reflective of its environment. Reflections on its mirror and glass and the shadows from the framework are subject to continual variation from overhead sun and passing clouds. At the same time, the form is also architectonic, with inside and outside space, and open to use.

Because of its double function as architectural pavilion and as sculptural form, a comparison could be made to Rietveld's sculpture pavilion in the sculpture park of the Kröller-Müller Museum, which is both a sculptural and a utilitarian form. Pierced cinderblocks, a high interior window and one completely open side admit air, light and provide unobstructed views of the outdoor works in the surrounding park. There is an ambiguity as to whether the art it displays is in an exhibition space or is outside and still part of 'Nature.' A shelter for both the sculpture it displays and for people observing the sculpture, it makes spectators looking at the art within its space a cohesive group and, at the same time, it imposes an order on the works it groups for display. *Pavilion/Sculpture for Argonne* creates its own social order, one which is based on two sets of social divisions. The first is between two audiences within the pavilion on opposite

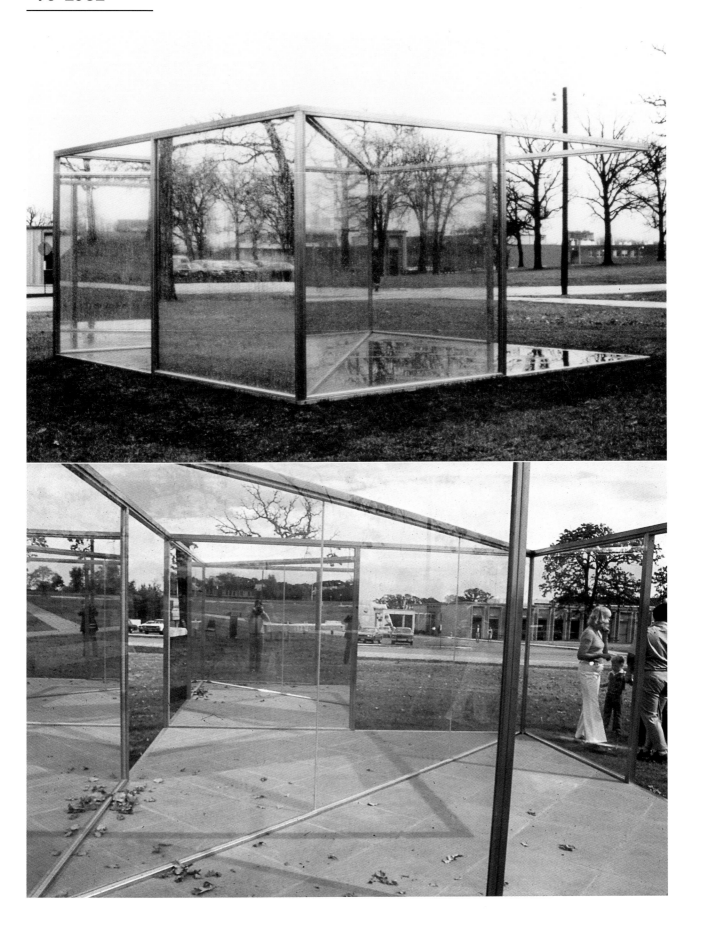

76 1981

Notes

Pavilion/Sculpture for Argonne was conceived 1978 and realized in 1981. This is the first outdoor pavilion Graham realized. Two models were made: a small model, see cat. no. 76.1, and a large model at approximately ¾ scale of the pavilion in wood and glass. The large model was exhibited in 1981 in 'Dan Graham: Selected Works,' The Renaissance Society at the University of Chicago, October 4 – November 8, 1981. Collection Argonne National Laboratory, Chicago, Illinois.

sides of the diagonal division. The second is between those inside the work and those outside.

The pavilion/sculpture will be situated in a wooded area at the front and to one side of a new Administration Building, designed by Helmut Jahn. This building makes use of a solar energy-efficient design which also symbolizes the sun as energy source. It is a semi-circular, glass-sheathed form, flat in the front, with the rest of the implied circle completed by a reflecting pond. Angled frames on the front facade are designed to accommodate solar collectors, should this become economically feasible; they would also prismatically reflect the sun. In this setting *Pavilion/ Sculpture for Argonne* is analogous to a small, rustic or rococo pavilion in relation to the larger building's technological 'Versailles' symbolism. The sculpture/pavilion is aligned to the point where the building's front facade ends and its left side begins to curve. It is also aligned with the curve of

the access road on its other side. It can be seen either from a car (where it is larger in scale than the Administration Building behind it) or approached on foot. Its orientation is such that the two interior mirrors catch the sun's reflection during the morning, creating a prismatic reflection in relation to the angled, sun-reflecting elements of the building. The diagonal element of *Pavilion/Sculpture for Argonne,* if extended toward the building, would perpendicularly bisect the diagonal floor plan of the building.

Buildings and Signs 1981: 27, 29.

76.1 1981

Title/Date
Pavilion/Sculpture for
Argonne
1978

Architectural model
unique

Materials
plastic and wood

Dimensions
unknown

77 1981

Title/Date
Square Room Diagonally
Divided
c. 1978-81

Materials
a square room featuring
a glass diagonal dividing
wall and two doors

Dimensions
not specified

First publication:
Buildings and Signs
1981: 25.

ENTRY-EXIT

ENTRY-EXIT

PLAN

77.1 1981

Title/Date
Square Room Diagonally
Divided/Two Audiences
c. 1978-81

Materials
a square room featuring a
glass diagonal wall with
two interior mirrored walls
and two doors

Dimensions
not specified

First publication
Buildings and Signs
1981: 25.

Notes
These works exist as pro-
posals only, as published
in *Buildings and Signs*
1981. They are permu-
tations of the mirror and
glass partitioned struc-
tures Graham started
making in 1976 with *Pub-
lic Space/Two Audiences*
cat. no. 62 and *Pavilion/
Sculpture for Argonne,*
1978-81, cat. no. 76.

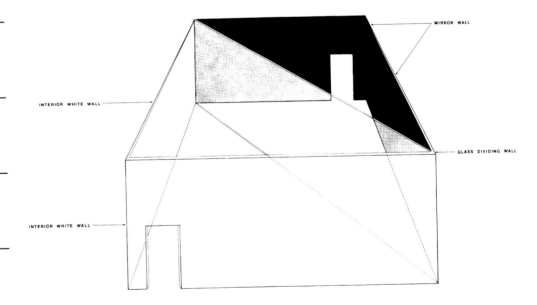

MIRROR WALL

INTERIOR WHITE WALL

GLASS DIVIDING WALL

INTERIOR WHITE WALL

Title/Date
Edge of the City
1981

Materials
three color video monitors
placed within rectangular
plywood bases in alignment
with existing columns; 1:00
minute from single channel
videotape, color, sound,
extracted from *Video
for Westkunst Exhibition,*
1980-81, cat. no. 73

Dimensions
variable according to
installation

First publication
Buildings and Signs
1981: 44-45.

First exhibition
'Street Sites 2,'
April 15–May 10, 1981,
Institute of Contemporary
Art, Philadelphia.

This work was a video and sound installation in the suburban Commuter Concourse of the 30th Street Station in Philadelphia, part of the 'Street Sites' exhibition, organized by the Institute of Contemporary Art, Philadelphia.

An image of the suburbs, where the train commuters are going (or have come from), was placed in the main city train station. Three video monitors mounted at eye-level in high, rectangular wood bases, were placed in alignment with existing columns in the center of the concourse's central corridor. Each monitor was positioned below one of the three overhead signs, reading STAIRWAY TO SUBURBAN TRAIN which were parallel to three stairways (A, B, C) leading up to the railroad platforms. The video screens showed advertisement-like images of suburban homes. The images moved across the screen in a direction parallel to that of the trains, but facing the approaching commuter.

Edge of the City, 1981,
video installation 30th Street
Station, Philadelphia.

The sequence depicted on the monitors was a one-minute long, but continuously repeating loop, extracted from a film dealing with my work.[1] It was a hallucinatory, slow, travelling shot of a row of newly built and newly occupied suburban houses taken with a camera mounted on the hood of a moving car. A sound track by Glenn Branca with a lush, gliding, 'pseudo-pastoral' feeling suggested the languor of the suburban, 'countrified' landscape seen through a car window. This work related to the installation in the New York Citicorp Building, *Video View of Suburbia In an Urban Atrium,* 1979-80.

[1] From an eight-minute film commissioned by German television and 'Westkunst,' directed by Ernst Mitzka and filmed by Michael Oblowitz and Michael Shamberg.

Buildings and Signs 1981: 45.

EDGE OF THE CITY VIDEO INSTALLATION / ARCHITECTURAL PLAN

**50TH STREET STATION
COMMUTER CONCOURSE**

Title/Date
Cinema
1981

Architectural model
unique

Materials
foam core, wood, two-way
mirror, plexiglas, Super 8
projector and Super 8 film

Dimensions
$23^2/_3$ x $22^2/_5$ x $22^2/_5$ in.
60.5 x 57 x 57 cm

First publication
Buildings and Signs
1981: 46-50.

First exhibition
'Dan Graham: Selected
Works,' The Renaissance
Society at the University of
Chicago, October 4 –
November 8, 1981 curat-
ed by Anne Rorimer.

A cinema, the ground level of a Modern office building, is sited on a busy corner. Its facade consists of two-way mirrored glass, which allows viewers on whichever side is darker at any particular moment to see through and observe the other side (without being seen by the people on that side). From the other side, the window appears as a mirror. When the light illuminates the surface of both sides more or less equally, the glass facade is both semi-reflective and partially transparent. Spectators on both sides observe both the opposing space *and* a reflection of their own look within their own space.

Stage 1. *The Film is Projected; The Interior is Dark.* A two-way mirror screen is substituted for the conventional screen. Located at the front of the building, it forms the longer side of an equilateral triangle whose apex is the front corner of the building. Because of the properties of the two-way mirror, when a film is projected, the mirror functions as a normal screen for the interior film-goer and also projects the film image so that it can be seen, in reverse, from the street through the building's facade. Although it is placed seven feet above the heads of the front row interior audience, the screen image appears at a street viewer's eye level. Further, when viewed from the street, the screen's image can be looked through to see the frontal gaze of the audience watching the screen. This is because the light of the projector falls on the interior of the screen, making the reverse side of this two-way mirror darker relative to its front and therefore slightly transparent. The position of the outside observer can be distinguished from that of the interior, seated spectator. The outside observer does not relinquish his consciousness of self or awareness of environment for the (silent) movie image. Further, he is free to move around the sides of the theatre and

remove himself from the cinematic illusion in order to obtain a general, outside perspective on the audience-film relationship.

During the film's showing to the interior audience occasional images from the external, real environment intrude through the side windows, mixing with the film's images reflected on the side walls. These external reflected images interfere with the film spectator's identification of his consciousness with the filmic illusion. Conventionally, identification with the film results from the spectator's consciousness identifying with the film projection itself: the screen which stands for and 'frames' the illusionary 'film world,' the invisible camera, the projector, the darkroom where he sits semi-somnolent and semi-aware. In a state of omniscient voyeuristic pleasure, much like a dream which can later be disavowed and discarded, he has lost the consciousness of his body since he has identified with the film as if it were "like the mirror. But it differs from […] (it in that) there is one thing […] that is never reflected in it: the spectator's own body. In (the cinema) […] the mirror suddenly becomes clear glass […] the object remains […] But the reflection of one's own body has disappeared. At the cinema, it is always the other who is on the screen; as for me, I am there to look at him. I take no part in the perceived; on the contrary, I am all perceiving." From Christian Metz, 'The Imaginary Signifier,' Screen, Summer, 1975

Stage 2. *The Film is not Projected; House Lights Are Up.* The house lights in the cinema are turned on after (or before) a film is projected. Interior spectators see the screen, as well as the side windows, as reflective mirrors – reminiscent of mirrored cinema lobbies. Where the Renaissance framing of the screen has, a few seconds ago, been a 'mirror' for the spectator's subjective projection of his body, which, disembodied and invisible, has

been 'lost' to his immediate environment in its identification with the film, the screen itself and sides of the theatre now become literal mirrors (as opposed to the illusory 'mirror' of the film), reflecting the real space and bodies and looks of the spectators. The spectator sees his real position represented on the mirror, relative to the presence of the rest of the audience, whereas in the fictional world of the film he was the phenomenological center of an illusionary world. He sees himself looking in relation to the looks of the others in the audience. Outside, the psychological position of the spectator also reverses for he is now able to look through the window, himself unseen. Awareness of *his* body and *his* environment is lost. His position as voyeur becomes akin to that of the movie audience the previous moment.

Bauhaus Paradigm. This cinema project relates to, but inverts, Bauhaus-period architectural conventions. It can be compared to the Handelsblad Cineac by Johannes Duiker (1934, Amsterdam) which is also sited on a corner with various levels of corner glass cutaway exposures. A cantilevered section of curved glass above the street-front corner and entrance-lobby exposes the function/mechanism of the projection room to observers on the street below. One level up, a rectilinear glass cut-out exposes to street view the audience on the balcony level. An heroic, elevated, billboard-like sign stands on top of the Constructivist scaffolding on the roof. By stripping away the architectural facade to reveal the 'machine as medium' (Walter Gropius), the literal technology which produces the illusion is exposed, in order to demystify it. The public observing from the street is placed, not in front of the illusion, but behind the equipment which produces it. Revealing the technical, man-operated

mechanism of the cinema's production gives the man-in-the-street visual access to the means of production of aesthetic experience by presenting its technical realization on an everyday level of labor.

In my cinema project it is the screen, instead of the machine, and the system of voyeuristic identifications, which is exposed. It is assumed that the cinema is prototypical of all other perspective systems which work to produce a social subject through manipulating the subject's imaginary identifications. Duiker's building involves a one-way perspective whereby the outside spectator, like a scientist, looks objectively at the machine to analyse the effect. In the cinema all looks are two-way and inter-subjective for it is difficult to separate the optics of the materials of the architecture from the psychological identifications constructed by the film images. The psychological circuit of intersubjective looks and identifications is echoed in and is a product of the material properties of the architectural materials, whose optical functioning derives from the properties of the two-way mirror glass. My cinema, like 'the cinema,' is a perceptual 'machine.' But unlike the cinema which must conceal from the spectators their own looks and projections, the architecture here allows inside and outside spectators to perceive their positions, projections, bodies and identifications. Topologically, an optical 'skin,' both reflective and transparent inside and outside, functions simultaneously as a screen for the film's projection, dialectically seen in the outside environment as well as in the normal cinema context as a point of transfer for the gazes of the inner and outer spectators in relation to each other and the film image.

Another inversion of Duiker's Bauhaus cinema is that the overhead signage has been lowered to street level eye-view. The

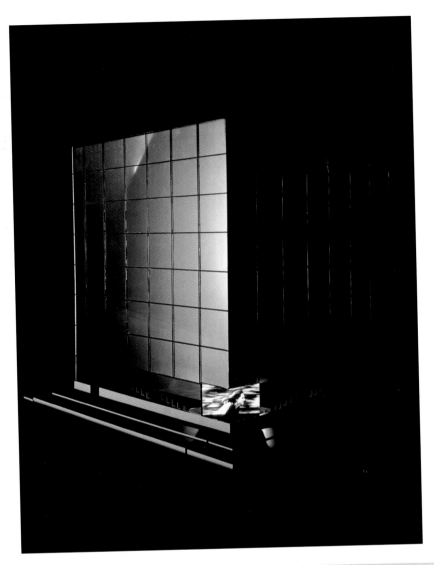

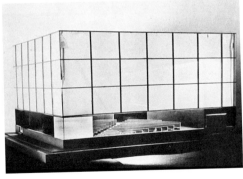

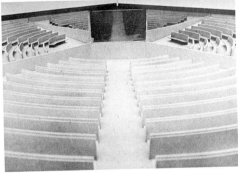

Cinema, 1981. Collection
Musée National d'Art
Moderne, Centre Georges
Pompidou, Paris, France.

outside screen is similar to the preview monitor of a film today, often placed just outside the entranceway and replaced here with the silent, reverse image of the actual film from the movie house simultaneously playing inside.

Buildings and Signs 1981: 47-48, 50.

Title/Date
45-Second Stereophonic
Work for 'Just Another
Asshole' Magazine Record
1981

Materials
sound recording on LP
record to be played on
two speakers separated
by the space of a room

Dimensions
variable according to
installation

First publication
JAA (Just Another Asshole)
#5, 1981. Text
previously unpublished.

Notes
JAA #5 was a sound
recording on an LP record
including contributions of
77 short sound pieces by
84 artists, edited by
Barbara Ess and Glenn
Branca. It was reissued as
a CD in 1995.

Stereo Channel A consists of fragments of vocal sections by all-female rock groups which express, in the lyric's meaning or phrasing, female sexual rhythms. The Slits, Klenex, Ut and The Raincoats are featured. In the fragment from The Raincoats, which goes, "This is/es/ee/lo/la/love/la/ov/or/oh/ho/ha/ah/ha/hey/hey/this/is/love/ha/ha/ha," the meaning is lost to the babble of what Julia Kristeva calls the 'semiotic chora.' Likewise The Slits rythmic babble of "eh/eele/it/eh/ehh/ee/e/it/eh" expresses a female erotic vocalization.

Stereo Channel B consists of fragments of vocals by male singers or all-male rock groups. 'Love Comes in Spurts' by Richard Hell and The Voidoids, 'Surfin' Bird' by The Cramps, and 'Barbara Ann' by The Beach Boys have sexually connotative lyrics and rhythms which rise, hysterically, toward sexual climax and which are specifically expressive of male erotic vocalization.

Channels A and B are played simultaneously on right and left speakers, separated by the space of the room. Standing between them, the listener can hear both channels overlaid. By standing nearer to one speaker than the other, s/he can identify with one channel (the male vocalizations or the female vocalizations) and may be aware of the other as background sound.

Dan Graham, '45-Second Stereophonic Work for *Just Another Asshole* Magazine Record,' 1981, text previously unpublished.

W 1981

Writings

'Signs,' *Artforum*, 19, 8 (April 1981): 38-43.

'Bow Wow Wow,' *Real Life* no. 6 (Summer 1981): 11-13.

'Films/Video/Performances,' *Art Present* no. 9 (Summer/Fall 1981): 14-19.

'Cinema," A.E.I.U.O., anno II no. 4 (July–December 1981): 38-47.

'Not Post-Modernism: History as Against Historicism, European Archetypal Vernacular in Relation to American Commercial Vernacular and City as Opposed to the Individual Building,' *Artforum* 20, 4 (December 1981): 50-58.

'New Wave Rock' en 'Het Feminiene,' *Museumjournaal* no. 26/1 (1981): 16-32.

'The End of Liberalism,' ZG no. 2 (1981): n.p.

'Pavilion/Sculpture for Park Setting,' in *Performance Text(e)s & Documents,* ed. Chantal Pontbriand. Montreal: Parachute, 1981: 199.

'Alteration to a Suburban House (1978),' in *Buildings and Signs* 1981: 35.

'Clinic for a Suburban Site,' in *Buildings and Signs* 1981: 32-33.

'Two Adjacent Pavilions,' in *Buildings and Signs* 1981: 31.

'Pavilion/Sculpture for Argonne,' in *Buildings and Signs* 1981: 27-29.

Title/Date
Two Adjacent Pavilions
1978-82

First exhibition
documenta 7, Kassel,
1982, curated by Rudi
Fuchs.

Materials
two structures: two-way
mirror, glass, steel

Notes
The work is now permanently installed near the
front entrance of the
Kröller-Müller Museum,
Otterlo. This site interested Graham because of the
Rietveld Pavilion located in
the sculpture park of the
museum. Collection
Kröller-Müller Museum,
Otterlo.

Dimensions
98³⁄₄ x 73¹⁄₅ x 73¹⁄₅ in.
251 x 186 x 186 cm
each

First publication
Buildings and Signs 1981:
30-31, text and model. A
postcard was produced by
documenta 7, Kassel,
1982. See also the text
'Two-Way Mirror Power,'
written in 1996, first published in *Two-Way Mirror
Power* 1999: 174-175.

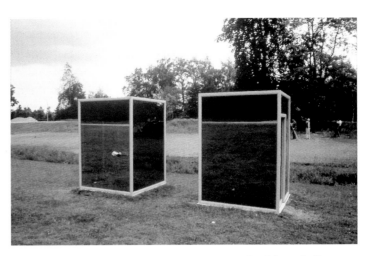

Two Adjacent Pavilions,
1978-82. Installation
documenta 7, Kassel,
Germany.

Two Adjacent Pavilions,
1978-82. Collection Kröller-
Müller Museum, Otterlo,
Holland.

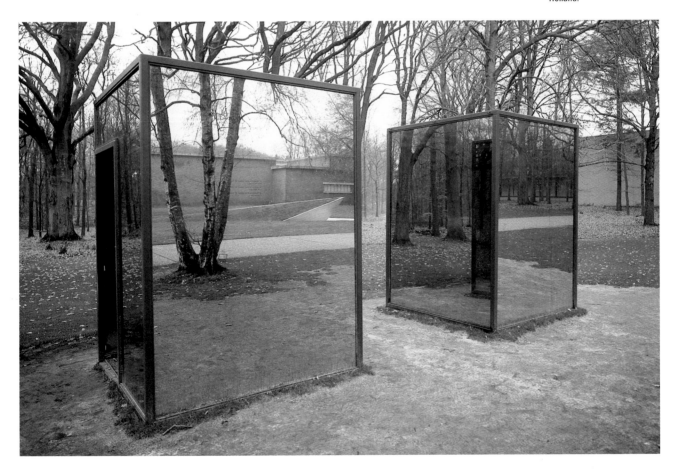

Title/Date
Two Adjacent Pavilions
1978

Architectural model
edition of 3
materials and dimensions
may vary over edition

Materials
two-way mirror, aluminum

Dimensions
9⁴/₅ x 9⁴/₅ x 13³/₄ in.
25 x 25 x 35 cm

First publication
Buildings and Signs
1981, 30-31.

First exhibition
'Dan Graham: Installations/
Photographs/Videotapes/
Performances/Publica-
tions/Films/Architectural
Models,' September 3 –
October 1, Museum of
Modern Art Oxford, organ-
ized by David Elliott, model
only.

The pavilions can be viewed either as sculpture or as architecture. Each structure can be entered through doors which close from the inside.

Each interior and exterior surface of the twin structures is coated with two-way mirror reflective glass. Because of the properties of the mirror coating, the particular side, interior or exterior, which receives more light is reflective, and the side which receives less light is transparent.

One pavilion has a transparent glass ceiling, while the other has an opaque ceiling blocking the sunlight. During daylight hours the opaque ceiling does not allow overhead sunlight to illuminate the pavilion. As its interior is dark relative to the exterior, people outside looking at the pavilion cannot see its interior; they see a mirror image of themselves in the reflected exterior environment. In contrast, the pavilion with the transparent ceiling allows overhead sunlight to fall directly upon its interior walls. Thus, when there are no clouds and the sun is overhead, the interior becomes brighter and its walls reflective. The exterior walls in this case become transparent. People outside can see inside, while people inside can see only a reflection of themselves and the interior space. When there is no direct sunlight, at dusk, dawn, or on cloudy days, the interior and exterior walls of each pavilion are equally transparent and reflective. During a normal day, due to the changing cloud cover, there is a continually shifting relationship between interior/exterior and transparency/reflectivity in both pavilions.

Buildings and Signs 1981: 31.

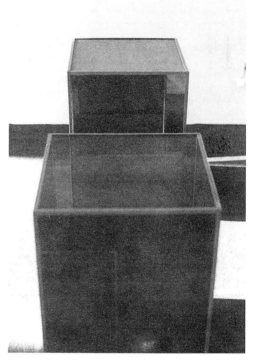

Two Adjacent Pavilions,
1978, architectural model.
Collection Micheline Szwajcer
Gallery, Antwerp, Belgium.

W 1982

Writings

'My Religion', *Museumjournaal* no. 27/7 (1982): 324-329.

'The End of Liberalism (Part II),' in *The Un/ Necessary Image.* Ed. Peter D'Agostino, Antoni Muntadas. New York: Tanam Press, 1982: 36-41.

Title/Date
Dan Graham and Glenn
Branca
Musical Performance and
Stage-Set Utilizing Two-
Way Mirror and Time Delay
1983

Materials
stage-set with video cam-
era with time delay and
mirrored wall; music by
Glenn Branca; musicians:
Axel Gross, Margaret De
Wys and Glenn Branca

Dimensions
variable according to
installation

First publication
Text and photos first
published Munich
1988: 45, 47, 48.

First performance
'Dan Graham Pavilions,'
curated by Jean-Hubert
Martin, Kunsthalle
Bern, 1983. It was
performed three times:
March 11, 16, 17, 1983.
Exh. cat. includes an EP
45, Glenn Branca
'Acoustic Phenomena.'

Notes
A musical channel video-
tape, Musical Performance
and Stage-Set Utilizing
Two-Way Mirror and Time
Delay, was made in 1983
(45:45 minutes, black and
white, stereo sound).
Designer: Dan Graham;
Music: Glenn Branca;
Musicians: Alex Gross,
Margaret De Wys and
Glenn Branca; Camera:
Darcy Lange and Judith
Barry. Distributed by
Electronic Arts Intermix,
New York.

[…] The audience is seated on the right; the three musicians are on the left in a tri-angle with Branca at the front or apex. Audience and performers face a wall-sized two-way mirror. Behind this two-way mirror is a video monitor, whose image is lumi-nescent enough to be seen through the mirror. The monitor image displays a view of the entire space. Its image comes from a camera mounted behind the two-way mirror, next to the monitor. A tape delay system causes the image to be delayed six seconds in the past.

The musicians must look toward the two-way mirror for cues from each other. They also may look to the 6-second delayed image as a compositional metronome.

The audience's best view of the musicians comes from looking at the mirror and monitor projecting behind it. They see oth-er members of the audience as well as their own looks. When the musicians look toward the mirror image to see other musicians playing or to see the 6-second delay video, the audience member's views are placed between the intersubjective gazes of the three musicians.

Munich 1988: 48.

Dan Graham and Glenn
Branca, *Musical Perfor-*
mance and Stage-Set
Utilizing Two-Way Mirror
and Time Delay, 1983, still
from videotape of perform-
ance March 1983, Kunsthalle
Bern. Courtesy Electronics
Arts Intermix, New York, USA.

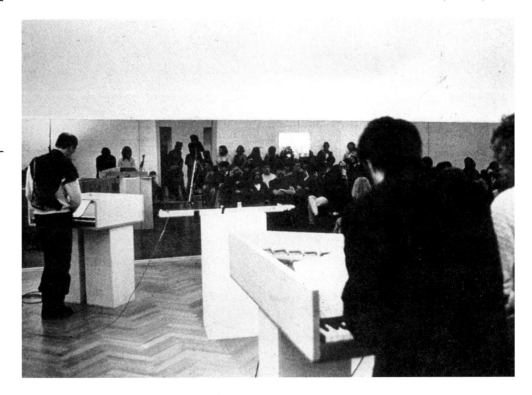

Title/Date
Dan Graham and Marie-
Paule Macdonald
Project for Matta-Clark
Museum
1983

Architectural model
unique

Materials
cardboard

Dimensions
seven elements:
six:
12 x 20 x 19^2/$_3$ in.
30.5 x 50.8 x 50 cm
(each)
one:
11^4/$_5$ x 28^1/$_3$ x 19^2/$_3$ in.
30 x 72 x 50 cm

First publication
Of Graham's article, 'Sur
Gordon Matta-Clark,' *Art
Press* (June–August
1983): 13.
Texts by Graham, Mac-
donald, and documenta-
tion of the work first pub-
lished in *Flyktpunkter/
Vanishing Points*. Exh. cat.
Stockholm: Moderna
Museet, 1984: 89-110.
This version *Munich* 1988:
52, 54.

First exhibition
'A Pierre et Marie III,'
September 25, 1983 –
February 12, 1984, Paris.
A series of exhibitions
organized by Jean Hubert-
Martin, Daniel Buren,
Michel Claura, Selman
Selvi and Sarkis were held
between 1982 and 1984
in an abandoned church
owned by the Marie Curie
Institute while the building
awaited demolition.

[...] *Project for Matta-Clark Museum* for Paris, 1984, a collaboration with an architect, Marie-Paule Macdonald, was first exhibited in 'A Pierre et Marie III,' in a ruined, late 19th century church scheduled to be demolished for an extension of the neighboring Pierre and Marie Curie Institute. The model we exhibited was for 6 'houses' of similar size and shape. It would be both a memorial for the American-French artist and a functional container for a museum and research center for urbanism. The premise and many of the ideas in the program were based on a text I had written for 'A Pierre et Marie' (later published in the catalogue for *Flyktpunkter Vanishing Points*, Moderna Museet, Stockholm, 1984); the specific design generated from the cuts Matta-Clark made in his suburban American work, *Splitting*, to create the 'blocks' of museum 'houses' for the *Matta-Clark Museum* came from Macdonald.
Matta-Clark is best known in Paris for *Conical Intersect*, a piece realized in Paris in 1978, in which two intersecting cone-shaped volumes were cut out of an abandoned department building (which in fact concealed from the public that it was two separate abutting apartment buildings) near the Pompidou Centre.

"The model refers to another work by Matta-Clark: Splitting, *executed in New Jersey in 1974. In* Splitting, *Matta-Clark operated on a standard suburban dwelling type in a working class neighborhood. He divided this building into two halves with a vertical cut, removed the four corners at the roof intersection, and removed material from the foundation so that one half of the house titled forward. In* Splitting *the cut, the operative element, opens the compartmentalized disposition of the rooms in the house to the sequence of suburban lots. Our project for a museum places the representation of this demolished house in* Splitting *in an abstracted context, sug-*

gesting the special condition which existed around the house and indicating its relationship to a system of division and distribution of (suburban) space and terrain at a larger scale." Marie-Paule Macdonald

By memorializing Matta-Clark's 'split'-suburban house in America in a Paris center city setting attention is called to Matta-Clark's dual French-American citizenship (and art historical lineage); by this artist and architect collaboration, attention is called to the hybrid nature as both art and architecture of Matta-Clark's practice. The image of the American work in a Paris context is designed to re-awaken the Parisian audience's memory of Matta-Clark's destroyed *Conical Intersect*. While *Conical Intersect* was an 'agit-prop' 'anti-monument' against the destruction of the Parisian inner city and alluded to other monuments such as the Eiffel Tower and the Victor Horta Metro entrances, *Splitting*, refers to the historical (post World-War I) American suburbs. Our museum sprawls on a scaledown reproduction of a suburban grid, each 'house' standing for one suburban block of houses.
Matta-Clark used houses and building structures which were about to be demolished and created de-constructed 'ruins' which reveal hidden layers of socially concealed architectural and anthropological, family meaning. In the early 18th century deliberately ruined pavilions which served as 'Temples of Contemplation,' 'Hermitages' (for homeless monks) and elegiac evocations of ruined classical structures were built in parks. Today ruins are created each moment as buildings are demolished and replaced as part of the cycle of endless architectural consumption. Matta-Clark's work attached itself to the notion of the instant ruin of today: the demolition. Half-remembered, the existence of a Matta-Clark work now takes the form of a photograph or film or drawing in conjunc-

Notes
The work began with Graham's text, included in phase two of the 'A Pierre et Marie' exhibitions in June 1983 to which Marie-Paule Macdonald was invited to respond, which resulted in her models. She based the scale of the models on the scale of photographic reproductions of Gordon Matta-Clark's work *Splitting*, 1974, from catalogues. *Project for Matta-Clark Museum* has been published with the date 1984 but was first exhibited in 1983. This version was made by Marie-Paule Macdonald in cardboard and paint, and later replaced by a travelling version in cardboard. Graham's text, a text by Macdonald, and documentation of the models appeared in the exhibition catalogue for the Moderna Museet exhibition in 1984, though the piece was not included in the exhibition. In 1989 for an exhibition at Galerie Chantal Boulanger, Montreal, a later version of the model, double the scale of the first, was made in fine quality plywood by Duncan Swain and Eduardo Aquino.

tion with the viewer's own memory and knowledge of the city. We used the outward media image of *Splitting* as 'ruin' to memorialize the late artist's work. However the intent of the *Museum* is to relate Matta-Clark's cutting methodology to urban planning. If his 'dematerialized' methodology is conceptual art, this *Museum for Matta-Clark,* a form of conceptual art, wishes to re-materialize his work. It also wishes to equate urban planning and conceptual art.

The cutting practice of Matta-Clark responded precisely to the imposed suburban order of the New Jersey site, and again with precision in the case of the dense urban space of the Parisian context of *Conical Intersect,* for example the object status of the suburban New Jersey houses lends significance to the corners of the building and its divisibility. Whereas the integration into the block characteristic of urban Parisian building type, renders important the later's 'secret' interior.

"Matta-Clark's negative architectural activity operated on an existing architectural logic; the interaction between the two pro-

duced an analytical transgression of a series of architectural and urbanistic constraints. The cut is able to emphasize the organizational capability of the architectural logic, as the observer realizes how the space was composed, how it 'should have been' before the cut, which has disclosed the order using a process of selection."
Marie-Paule Macdonald

Text by Graham with sections of text by Marie-Paule Macdonald as published *Munich* 1988: 52, 54.

Dan Graham and Marie-Paule Macdonald, *Project for Matta-Clark Museum*, 1983. Collection Le Consortium, Dijon, France.

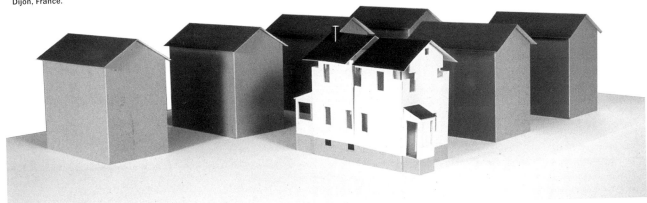

84 1983

Title/Date
Minor Threat
1983

Materials
single channel videotape,
38:18 minutes, color,
sound

Dimensions
variable according to
installation

Notes
Camera by Graham; Inter-
view with Ian MacKaye by
Craig Bromberg. In this
video Graham documents
'Minor Threat,' a hardcore
band from Washington
D.C., at a performance at
CBGB's, New York in
1983. Video is distributed
by Electronic Arts Intermix,
New York.

W 1983

Writings

'Sur Gordon Matta-Clark,' *Art Press, Special
Architecture* no. 2 (June-August 1983): 13.

'Theater, Cinema, Power,' *Parachute* no. 31
(June-August 1983): 11-19.

85 1984

Title/Date
Pavilion/Sculpture II
1984

Materials
glass, mirror, aluminum

Dimensions
$96^2/_5$ x 144 x 144 in.
245 x 366 x 366 cm

First publication
*Flyktpunkter/Vanishing
Points.* Exh. cat. Stock-
holm: Moderna Museet,
1984, listed in the check-
list only.

First exhibition
'Flyktpunkter/Vanishing
Points,' Moderna Museet
Stockholm, April 14 –
May 27, 1984, organized
by Olle Granath.

Notes
This work is a permutation
of *Pavilion/Sculpture for
Argonne,* 1978-81, cat.
no. 76. It was conceived
around 1978 and was
realized in 1984 for the
Stockholm exhibition.
Collection Moderna
Museet, Stockholm.

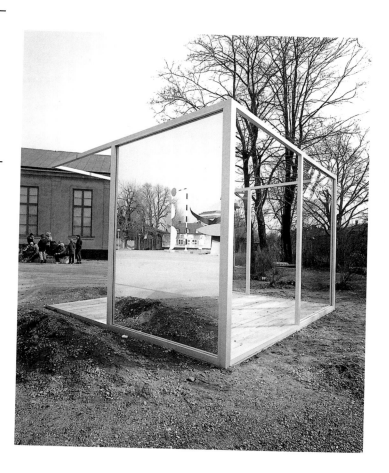

Pavilion/Sculpture II, 1984.
Collection Moderna Museet,
Stockholm, Sweden.

Title/Date
Rock My Religion (video)
1982-84

Materials
single channel videotape,
55:27 minutes, black and
white & color, stereo
sound

Dimensions
variable according to
installation

First publication
Dan Graham: Pavilions.
Exh. cat. Bern: Kunsthalle
Bern, 1983: cover, exhi-
bition plan 5, script 13-18.

First exhibition
'Dan Graham Pavilions,'
Kunsthalle Bern, March 12
– April 17, 1983, curated
by Jean-Hubert Martin. It
was next shown at the
Moderna Museet Stock-
holm in the exhibition
'Flyktpunkter/Vanishing
Points,' April 14 – May 27,
1984.

Notes
Music: Glenn Branca,
Sonic Youth; Sound: Ian
Murray, Wharton Tiers,
Narrators: Johanna Cypis,
Dan Graham; Editors: Matt
Danowski, Derek Graham,
Ian Murray, Tony Oursler.
The video is dated 1982-
1984 but Graham began
working on it and the
article in 1980-81. As the
various versions of the
script suggest, Graham
continued to work on *Rock
My Religion* between the
first and second showings
between 1982 and 1984,
with Graham acknow-
ledging the support of the
Moderna Museet with the
production credit in 1984.
The video is distributed by
Electronic Arts Intermix,
New York.

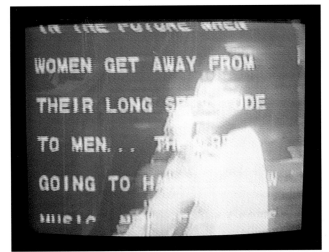

Title/Date
Rock My Religion
(video script)
1982

Materials
printed matter

Dimensions
variable according to
publication

First publication
'My Religion,' *Museum-
journaal* Vol. 27, no. 7
(1982): 324-329.

Notes:
The script of *Rock My
Religion* was first pub-
lished as an essay 'My
Religion,' *Museumjournaal*,
vol. 27, no. 7 (1982):
324-329, then in 1983,
as 'Rock Religion,' *Scenes
and Conventions in Archi-
tecture by Artists*. Exh. cat.
London: ICA, 1983: 80-81.
It was first published in
North America as 'Rock
Religion,' *Just Another
Asshole* #6 (1983). It
was published in French
and German in *Dan
Graham: Pavilions*. Exh.
cat. Bern: Kunsthalle Bern,
1983. An extensive pub-
lished version with stills
from the video appeared
in *Video by Artists 2*. Ed.
by Elke Town. Toronto: Art
Metropole, 1986: 81-111.
The collected writings by
Graham, edited by Brian
Wallis, is named for the
video, *Rock My Religion*
(Cambridge, MA: The MIT
Press, 1993).

Ann Lee, an illiterate factory worker in mid-eighteenth century Manchester, England, founded the Shaker religion.

She saw an answer to the troubles of the working class. Heterosexual marriage pro-duced a multitude of starving children whose cheap labor was exploited by factory owners. The Bible showed heterosexual marriage to be the unnatural result of Adam's sin in the Garden. Originally Adam had been created bisexual and self-con-tained. God punished Man and Woman by forcing them into alienated labor and by the tortures of childbearing. Ann Lee believed herself to be the female incarnation of God, Christ having been the male incarnation. She would create a utopian community based on sexual self-denial, strict equality between men and women, and an economy based entirely on craft with the ownership of goods held in common.

The first Shaker community was formed in America in 1774.

The Shakers devoted themselves to sober, simple work; they became known for inno-vations in furniture design as well as for their austerely functional architecture. All ornament was eliminated as sinful and false. Their meeting halls reflected the bilat-eral symmetry of the Shaker socio-sexual organization with two audiences facing each other, two separate exits and two stairways leading to the residence of the Elder and the Eldress.

The Shakers practiced an ecstatic trance dance, the purpose of which was to heal the soul and rout the Devil from his hiding place. They would roll on the floor and bark like dogs to free themselves from false pride. For many, Shaker communalism was an antidote to Puritan individualism. The Puri-tan was alone with his conscience and his guilt. Avoidance of damnation could only be achieved by the mind overcoming the body in the pursuit of gainful work. In reaction against this view and the official Deism of the Republic, 'The Great Religious Revival'

began in the South in 1800 and spread across America. At tent meetings many were roused to repent and began 'talking in tongues'; guitars were introduced into the service with people 'reeling and rocking,' as they recited Biblical phrases in their collec-tive desire to be reborn through Christ's suf-fering.

During the 1950s, a new class emerges: the adolescent. Its religion is rock'n'roll. This class has been freed from work so as not to add to postwar unemployment; the adoles-cent's role is to be a consumer. Although liberated from the parental work ethic, total leisure turns to boredom and revolt.

Rock appears to mock traditional religion, desublimating the repressed sexuality of the Puritan doctrine needed to justify work as salvation. Rock's form incorporates the tent revival's 'talking in tongues' and the shaking dance of the Shakers. However, rock demands sex now, free from the ties of old family and reproduction. It glorifies the unrepentant sinner, but also expresses a yearning for a new, non-Oedipal family structure in the notion of the rock group.

A new 'Teenage Heaven' is postulated. Ado-lescents are 'teenangels,' resembling angels in the way their voices mutate between 'manly' baritone and 'girlish' falset-to; and in the way their bodies are half-formed, their faces angelic. While adult cul-ture formerly viewed children as innocent 'angels,' teens saw the angelic as relating to the ecstasy of the first and purest sexual feelings. Sex is liberated from reproduction, family, and social responsibility.

Rock's theology of 'fun' is based on change, after the Second World War, in the concep-tion of the Apocalypse. For the religious of the eighteenth century, the Apocalypse rep-resented a yearned-for culmination of histo-ry which would realize their utopian visions and in which they, the Elect, would be saved. As religious belief declined during the nineteenth century, scientific progress replaced the belief that the solution to

social ills would be achieved through the evolution of technology. Suddenly, with the spectre of the atom bomb, this optimism was negated: man's technology had the potential to obliterate the world in a final, meaningless, negative Armageddon.

Rock's ideology is born of the futility of deferred pleasure if the world is soon to end, and disavowal of the regime of work and technology which brought the bomb into being.

During the 1950s and 1960s, family life is lived in isolated suburban houses. The family is linked to the outside world through radio, tv and the car. It is by these means that teenagers communicate the covert message of rock's new codes.

The rock club and concert performance are like a church, sanctuaries against the adult world. Electronic instruments unleash anarchic energies for the mass. The rock star sacrifices his body and life against the regime of work: by living his life and performing at the edge, he transcends the values of everyday work. His transcendence is achieved at the price of the sacrifice of his ability to become an adult. He must die, or fall from fame.

By the late 1960s rock groups live as extended families in large urban houses, travelling to concerts in buses outfitted for collective living. At outdoor rock festivals, the fans live together in tents.

Originally, rock expressed male, adolescent sexuality. The electrified guitar, microphone-projected voice and body of the performer became phallic symbols.

This was challenged by Jim Morrison in his notorious Miami performance in which he allegedly exposed himself. He had come to believe that rock, having become big business, was dead. The exposure of his penis was read by the public as a pathetic gesture; for Morrison, it meant the death of his prowess as a rock star. By showing his (pathetic) penis, instead of making his body and performance phallic, he wished to question the mystique of rock as spectacle. Morrison's earlier performances had taken the form of the ritual. In this 'death of rock' ritual, he wanted to re-enact the castration complex. Through the star's own emasculation, he expressed his desire to see rock bring about the destruction of the Oedipal order.

Patti Smith took Morrison's 'negative trip' and attempted to make it — and rock — into a positive social good. She is the first to make explicit the truth that rock is a religion. Patti believed that the role of the female prepatriarchal Egyptian priestess could be merged with the 'tent revivalists' talking in tongues' to create a new rock language, which would be neither male nor female.

The religion of the 1950s teenager and the counterculture of the 1960s is adopted by 'Pop' artists who propose an end to the religion of 'art for art's sake.' Patti takes this one step further: rock as an art form which will come to encompass poetry, painting and sculpture. If art is only a business, as Warhol suggests, then music becomes the more communal, transcendental emotion which art now denies.

Dan Graham, 'Rock Religion,' in *Scenes and Conventions in Architecture by Artists*. Exh. cat. London: ICA, 1983: 80-81.

'On John Knight's Journals Work,' *Journal: A Contemporary Art Magazine* no. 40 (Fall 1984): 110-111.

Title/Date
Dan Graham and James
Coleman
Video Projection Stage-
Set for *Guaire* by James
Coleman, Dun Guaire
Castle, Kinvara, Co.
Galway, Ireland
1985

Materials
stage-set with video
projection and time-delay,
curved two-way mirror,
designed for *Guaire* by
James Coleman

Dimensions
variable according to
installation

First publication
Munich 1988: 48.

First performance
Dun Guaire Castle in
Kinvara, Co. Galway,
Ireland, April 13 –
April 20, 1985.

Program Notes
Guaire, An Allegory by
James Coleman; Acted by
Olwen Fouéré with music
by Gerard Grennell
(Guitar); Set Design by
Dan Graham; Lighting
Design by John Comiskey;
Aebhric Coleman (child);
Painter: Tom Conroy; Light-
ing assistant: Gregory
Kyle; Costumes: Monica
Ennis; Production Manag-
er: Ciaran McGinley; Stage
Manager: David Heap;
Asst. Stage Manager:
Emer Monahan; Props:
Tom Conroy, asssisted by
Debi O'Hehir; Construction
Crew: Martin Kilkelly,
P. J. Fleming; Publicity and
Press: John O'Mara, Eoin
Foyle; Domestic catering:
Claire Stewart; Buffet:
Janet Sutton.

[…] The play, *Guaire,* by Irish artist, James Coleman, was set in the 16th-17th century Guaire Castle with the audience seated in the restored throne room where mock 'medieval banquets' were normally held for tourists. Seated on a long, narrow table to watch the play, performed by a single performer on a tiny stage where the king had once sat, the audience's position is identical to that of the traveling poets or bards, who sat in on banquets in various Irish courts and provided information and commentary to the ruler.

Behind the 'king' was a curved, two-way mirror which, when the lights are on, showed the audience an anamorphically distorted image of themselves. For most of the performance a recorded video was projected onto the back of the two-way mirror. Its image was of the throne room from the king's point of view. In the play's development the king's commanding view is gradually lost as he takes the position of his ruled subjects. The video-recorded image was a plastic death-mask of the king – a skull-like form. Projected into the two-way curved mirror, it was seen dis-tended anamorphically. The performer turned to face the video image through the mirror. Suddenly, the lights were turned on, and the audience saw an image of its own gaze superimposed on the combined images of the performer and the video recorded image of the death-mask of the performer. After the lights were again dimmed, the video was switched to a live image, photographed by a camera to the side of the stage on an eight-second delay. Next the performer lifted her mask. Turning back to the video image in the mirror she saw a masked image of herself, and made a gesture as if she could not bear to look at herself. Then as she looked back at the mirror, the image appeared to catch up in time and become simply a reflection.

Munich 1988: 48.

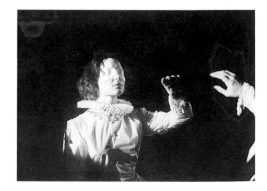

Dan Graham and James Coleman,
*Video Projection Stage-Set for
Guaire by James Coleman*, 1985.

Title/Date
Set for Two-Way Mirror
Piece (Project for the Paris
Biennial)
1985

Materials
stage-set with one-way
mirror, projector, TV moni-
tor, cameras, musicians

Dimensions
variable according to
installation

First publication
*Nouvelle Biennale de Paris
1985*. Paris: Electra
Moniteur, 1985: 188-189.

First exhibition
'Nouvelle Biennale de
Paris,' 1985.

Notes
The piece is a variation of
Dan Graham and Glenn
Branca, *Musical Perfor-
mance and Stage-Set Uti-
lizing Two-Way Mirror and
Time Delay,* 1983, cat.
no. 82. A drawing for the
piece titled *Projet pour la
Biennale de Paris* and in
the index titled *Mirror-
Video-Delay-Performance*
was published in the exhi-
bition catalogue in addi-
tion to the text for *Per-
former/Audience/Mirror,*
1977.

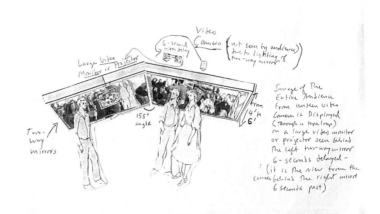

*Set for Two-Way Mirror
Piece (Project for the Paris
Biennial),* 1985, drawing
(top), installation view, Paris.

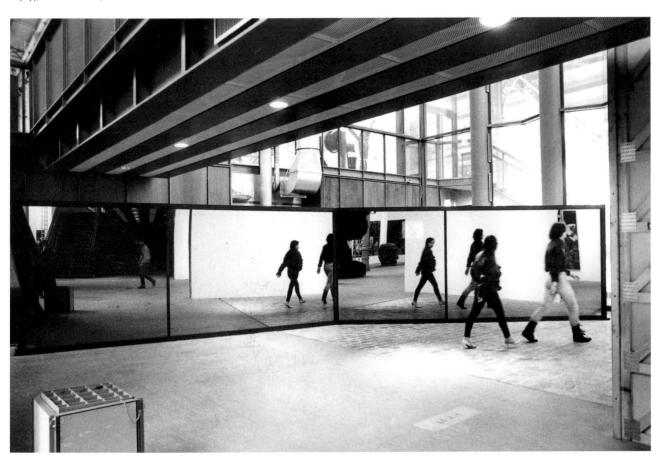

Title/Date
Base Design for Storefront
Progression
1985

Materials
architectural drawing:
graphite on paper

Dimensions
unknown

First publication
Dan Graham. Exh. cat.
Yamaguchi City: The
Yamaguchi Prefectural
Museum of Art 1990: 22.

First exhibition
'The Future of Storefront,'
January 8 – 30, 1987,
Storefront for Art and
Architecture, New York.

Notes
Proposal drawing for de-
sign of Storefront for Art
and Architecture, Kenmare
Street, New York. This pro-
posal is no longer extant.

*Base Design for Storefront
Progression, 1985*

W 1985

Writings

'My Works for Magazine Pages: A History of
Conceptual Art,' in *Dan Graham.* Exh. cat. Perth:
The Art Gallery of Western Australia, 1985: 8-13.

'Darcy Lange: Work and Music,' *New
Observations* no. 29 (1985): n.p.

'An American Family,' in TV *Guides – A
Collection of Thoughts About Television.* Ed.
Barbara Kruger. New York: Kuklapolitan Press,
1985: 13-14.

Title/Date
Cinema-Theater
1986

Architectural model
unique

Materials
wood, mylar, two-way
plexiglas, with super 8 mm
film, projector

Dimensions
23²/₃ x 47¹/₄ x 78³/₄ in.
60 x 120 x 200 cm

First publication
Munich 1988: 53-57. See
also *Theatergarden
Bestiarium:* The Garden as
Theater as Museum. Exh.
cat. Cambridge, Mass: MIT
Press and P.S. 1, Institute
for Contemporary Art,
1990: 42-43, 86-105.

First exhibition
'*Theatergarden Bestia-
rium:* The Garden as
Theater as Museum,'
travelling exhibition organ-
ized by Chris Dercon from
a concept by Rüdiger
Schöttle, The Institute for
Contemporary Art P.S. 1
Museum, Long Island City,
New York, January 15 –
March 12, 1989; Casino
de la Exposición. Seville,
June 26 – July 30, 1989;
Confort Moderne, Poitiers,
September 29 – Novem-
ber 29, 1989.

Notes
Alternate title and date:
Theater-Cinema, 1986-88.

Cinema-Theater, 1986.
Collection Fonds National
d'Art Contemporain, Puteaux,
France. Long-term loan from
Château d'Oiron, Oiron,
France.

[...] Italian Gardens of the Renaissance and Baroque periods were both *al fresco* museums *and* theaters in which the spectator doubled as performer. These gardens took their design from rediscovered Roman texts describing Roman country villas and gardens, knowledge augmented by archaeological discoveries, often on the precise site of the particular Roman garden. These excavated ruins, along with the remains of Roman statuary, were linked with newly built grottoes, fountains, waterworks, and perspectively organized *allées* and green theaters. The logic connecting 'rooms' and 'streets' often was based on a Roman literary text; Ovid's *Metamorphoses*, in which the natural is transformed into the unnatural, was one primary source. The Italian garden might display, as well, scientific curiosities, botanical species, and various artifacts from everywhere in the world. Italian gardens, as museums and as metaphoric and actual theaters, came to represent the world as microcosm and as macrocosm.

The first gardens were built on a hill, their vistas stretching below the owner's villa. They were entered through an apse-like addition to the ground level of the villa, which gave an ideal view of the garden below. Once in the garden the spectator was like an actor wandering through scenes in a play. Theater set-design and garden design influenced each other. The garden, treated metaphorically as a vast, outdoor theater, itself usually contained one or more theaters whose architectural boundaries were constructed from box hedges, grass, stones, statuary and fountains, all of which formed part of the stage-set and the seating area. Similarly, the axial perspective of Italian gardens was ideal for translation into sets of a perspectively based stagecraft. The set designer Torelli produced stage-sets of gardens which recreated what audiences would see in neighboring villa gardens. Inigo Jones, in his *masques* presented in royal gardens, involved the audience's experience of moving through a garden to narra-

tively confront mythological programs. The garden as theater and the garden theater within the garden gave a sense of a representation within a representation. To add to this effect, many of the plays performed within the garden's 'green theaters' had garden scenes. Often the 'real' garden (where the play was being performed) would become a part of the stage design.

An opera performed inside the Barberini Palace garden in 1656 had a painted set of a garden, while across the proscenium arch ran a row of fountains from which actual water was piped. A theater in a Madrid garden in the early 17th century had a rear wall which opened to show beyond the illusionist garden scenery of the stage.

My *Cinema-Theater* (1986) is a model that functions as part of a museological exhibition using various modern artists' models, and slide projections. The concept and schematic layout were designed by Rudiger Schöttle. The models and slides are to be projected into a large landscape model of a complete Baroque garden. This exhibition, titled 'Bestiarium,' is based on the idea of the theater-garden. As Schöttle had previously used a model of *Cinema* (1981) in his 'Louis XIV tanzt' exhibition, I decided to *reuse* both *Cinema* and the relation to Versailles in my contribution to the new project. The cinema would be attached to a 'green theater' located in a garden like Versailles. As in some of Torelli's and Inigo Jones's set designs for plays performed in outdoor theaters in gardens, the set would be a scene depicting an adjacent area of the same garden. The set's perspective would be nearly identical to the perspective that the spectator could see from the area in which he was positioned. The actors on stage would wear costumes which are nearly identical to the nobility who observed the play.

The rear of the stage set is designed as a two-way mirror which reflects the gazes of the nobility viewing the play and the garden's hedge-lined *allées*, in diminishing perspective. This rear stage-set as two-way mirror also functions as a rear-screen projection screen, superimposing images of the film being shown in the cinema, Rosselini's *The Rise to Power of Louis XIV* (1964). Two-way mirror mylar provides a normal (not transparent) screen for viewers located in the movie house. Because of its properties of being more transparent on the side which receives less light, at moments of greater image brightness in the film, spectators *in the theater* also see the faces of the viewing cinema audience through the image of the film. At this point the mirrored back-drop is giving superimposed images of the image of the theater audience; images of real garden *allées*, looking in the reverse direction of the stage; images from the film; and the image of the movie audience (confronting the image of the theater audience gazing at themselves and the theater actors).

Rosselini's *The Rise to Power of Louis XIV* was made for French television and later released for the cinema audience. The scene used in this project shows the young king and his entourage of court aristocrats walking in the garden of Versailles. This film focuses on Louis XIV's consolidation of his power through his reduction of the nobility to manipulated actors in a continuously staged spectacle. The king has become author and director as well as prime actor in a continuous theatrical fiction which is staged to reinforce an elaborate bureaucratic hierarchy, based on codes of court etiquette. He defines each courtier, all of whom are forced to live at court to preserve their roles, in terms of the limits of their function and position at court, through dress and dining codes and minute codes of court manners and ritual. The king as director has created a vast *mise-en-scène*, indistinguishable from 'real' life. Rosselini shows the king creating

an ideology of the unity of French nation-hood which depends upon recognition of Louis XIV as Sun God and absolute monarch of all of France. Rosselini's film films Louis XIV's performance or creation of his self-representation; it attempts to 'show the actor showing himself' and thereby show the actual historical creation, through Louis XIV's premeditated scenario that produced his (and France's) fiction of power. Rosselini's film is also a film about the film director's – Rosselini's – position as someone manipulating actors to create a fictional spectacle which purports to be historical reality.

The difference between Louis XIV's era and the present era is that royal stage-craft in the 17th century was linked to theatrical representation. Today political power and historical 'reality' derive from the subliminal effects of film and television, which substitute media representations for historical memory. In the age of Louis XIV, the monarch's power was represented through his position within theater architecture at the central point at which all perspectival lines culminated. His perspective was the ideal one; he was the viewpoint to which all the actions on stage were addressed; he was the central actor in a court drama which he staged and in which all the others functioned as foils.

Today's ruler's image is produced and manipulated in the same way that the film or television actor is made into a 'star.' Rosselini, in this educational film, tried to overcome the tyranny of this 'star' system and also the tyranny of his own hegemony as director, by giving all roles, including that of Louis XIV to unknown, French peasant non-actors from the Versailles region. Politically, Rosselini attempts to reawaken popular memory, the peasant class's potentially subversive historical view of the nobility, as against the media stereotype, controlled in the interest of those in power today, of Louis XIV's role in history.

Rosselini wishes to show how non-fore-ordained Louis XIV's power and creation of a national myth of French nationhood were.

Cinema-Theater takes the premise of Schöttle's exhibition, a return to archetypal German (and European) architectural, garden theatrical and urban typologies and proposes that in the present time the garden as theater and as museum still does have enormous importance – but as an 'educational' 'amusement park' influenced by cinema. The theater-cinema garden is based on the scenography derived from film's fantasy images of Hollywood set design. Disneyland and Parc de la Villette depend on the replacement of theater as a generator of education and political mythology by post-filmic representation.

This is an edited version of the original text:
Munich 1988: 54, 56, 58.

Title/Date
Children's Pavilion
(Chambres d'Amis)
1986

Materials
two-way mirror, glass,
aluminum

Dimensions
64½ x 123¼ x 91 in.
164 x 313 x 231 cm

First publication
Chambres d'Amis. Exh.
cat. Gent: Museum van
Hedendaagse Kunst,
1986: 76-81, with the text
by Graham 'Pavilion/
Sculpture Works' (1986):
80-81. Text first published
Munich 1988: 40.

First exhibition
'Chambres d'Amis,'
Museum van Heden-
daagse Kunst, Gent,
June 21 – September 21,
1986, curated by Jan
Hoet.

Notes
The exhibition located works
by contemporary artists in
the homes of local residents
throughout the city. Gra-
ham's temporary pavilion
structure was built on the
grounds of the home of
architect Dirk Defraeye, Pati-
jntjesstraat 137. The pavilion
was scaled down to 'chil-
dren's size' for the first real-
ization, see second larger
realization cat. no. 92. The
exhibited version remained
in the collection of the Ste-
delijk Museum Voor Aktuelle
Kunst, Gent. A second out-
door pavilion, a definitive
version made of sand-blast-
ed stainless steel, now re-
sides in the collection of
Karel and Martine Hooft,
Sint-Martens-Lathem, Bel-
gium.

[...] *Children's Pavilion*, 1986, shown at the
'Chambres d'Amis' exhibition in Gent in the
private backyard garden of an architect
was ambiguously private and public, with
professional and family needs. The garden,

after the exhibition, would mediate be-
tween the architect's private house on the
street front and his office (formerly his pri-
vate house) at the rear of the garden. Both
the architect's family and his clients would
make use of the garden path. My pavilion
consisted of two, interpenetrating two-way
mirror and transparent glass cubes. It was
placed on a wooden planked round node
where a wood walkway from the street
around the side of the house met an iden-
tical walkway extending to the front
entrance of the office. My form mimicked
the formal, architectural vocabulary of both
the office and the house which were each
designed by the architect. The children's
scale pavilion functioned as play space for
the architect's children. This was important
as their normal play area – formerly the
empty yard between the house and the
office – was in the process (during the
show) of being landscaped and re-planted.
Munich 1988: 40.

*Children's Pavilion
(Chambres d'Amis)*, 1986.
Two views, installation
'Chambres d'Amis,' 1986,
Patijntjesstraat 137, Gent,
Belgium.

Title/Date
Two Cubes/One Rotated
45°
1986

Materials
two-way mirror, glass,
aluminum

Dimensions
88²/₃ x 94¹/₂ x 118 in.
225 x 240 x 300 cm

First publication
Dan Graham. Musée d'Art
Moderne de la Ville de
Paris, ARC and Centro de
Arte Reina Sofia,
Ministerio de Cultura,
Madrid, 1987: 26. See
also *Munich* 1988: 40-41
and later version used here
Santiago de Compostela
1997: 144.

First exhibition
Musée d'Art Moderne de
la Ville de Paris, ARC,
1986-87, organized by
Suzanne Pagé.

Notes
*Two Cubes/One Rotated
45°* is the second, larger
scale realization of *Chil-
dren's Pavilion*, 1986, cat.
no. 91, whose small scale
was not the first proposal
but the final realized form.
Collection: FRAC Nord-Pas
de Calais, Dunkerque.
Graham wrote: "For my
exhibition at 'L'ARC' in
Paris in 1986, an 'adult'-
scale version of *Children's
Pavilion* 1986 was
constructed" (*Munich*
1988: 40).

The two cubes are constructed from an equal amount of two-way mirror and normal transparent glass. Its full-size initial manifestation, in the garden of an architect, interrupting a formal path between his private house and his office to the rear of the garden, was to be a quasi-conservatory (greenhouse) to house some plants in relation to the larger garden outside. Due to practical contingencies, it was built for the 'Chambres d'Amis' exhibition in Gent in the summer of 1986, as scaled down *Children's Pavilion* in the incomplete garden of the architect.

Santiago de Compostela 1997: 144.

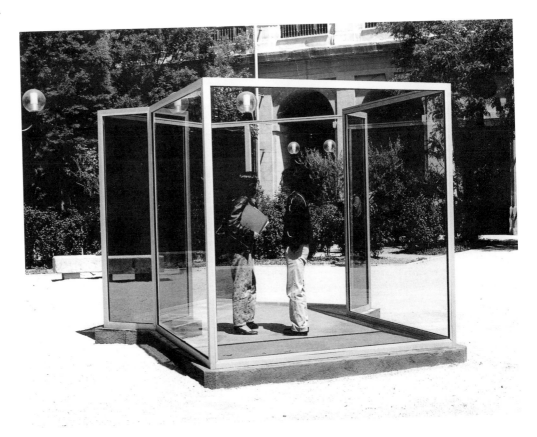

Two Cubes/One Rotated 45°,
1986, two views. Collection
FRAC Nord-Pas de Calais,
Dunkerque, France. Courtesy
FRAC Nord-Pas de Calais
(top).

Title/Date
Three Linked Cubes/
Interior Design for Space
Showing Videos
1986

Materials
two-way mirror, glass,
wood frames, video
monitor, players

Dimensions
6 panels, each panel:
88²⁄₃ x 39²⁄₅ x 1²⁄₅ in.
225 x 100 x 3.5 cm

First publication
*Interior Design for Space
Showing Videotapes*. The
Hague: Stichting Kijkhuis,
1986, exhibition brochure
and video program, includ-
ing the text 'Chamberlain's
Couches,' (1986):
1-2. A videotape interview
between Dan Graham and
Chris Dercon was made
on the work and the arti-
cle 'Kunst als Design/
Design als Kunst,' (1986)
in 1986, 45 minutes. Gra-
ham's text on work first
published in *Dan Graham*.
Exh. cat. Madrid: Ministe-
rio de Cultura 1987: 27.
See also *Munich* 1988:
46-47.

First exhibition
'Dan Graham: Interior
Design for Space Showing
Videotapes,' Stichting
Kijkhuis, The Hague,
Holland, May 15 – 31,
1986. Additional exhibi-
tions in 1986: 'Premier
Festival des Arts Électro-
niques,' La Criée, Halle
d'Art Contemporain,
Rennes, France,
June 7-14; 'Videowochen
im Wenkenpark,' Riehen
bei Basel, Switzerland,
July 2-13; 'op. cit,'
Beursschouwburg,
Brussels, Belgium, Sep-
tember 24 – October 3,
1986.

Notes
The first exhibition at the
Stichtung Kijkhuis featured
two video programs

[...] *Three Linked Cubes* (1986), a series of rectangular bays with one side open and with side panels of alternating two-way mirror or transparent glass, has a dual identity. Placed outside, it is an open pavil-ion illuminated by the sun; placed indoors, it is transformed into *Interior Design for Space Showing Videos* (1986). Here vari-ous video monitors and speakers are placed to allow three separate programs for audiences subdivided into six groups. The effect of the changing illumination from the video images reflected on the glass panels creates mirror 'ghosts' of audience members seen in other en-closed bays on the divider. The work is both a functional exhibition design and an optical artwork displaying the video images as well as the spectator's reactions to the video viewing process in the social space of the video exhibition.

Munich 1988: 46.

*Three Linked Cubes/Interior
Design for Space Showing
Videos*, **1986. Collection
Onnasch, Berlin, Germany.
Courtesy Reinhard Onnasch
Kunsthandel, Berlin.**

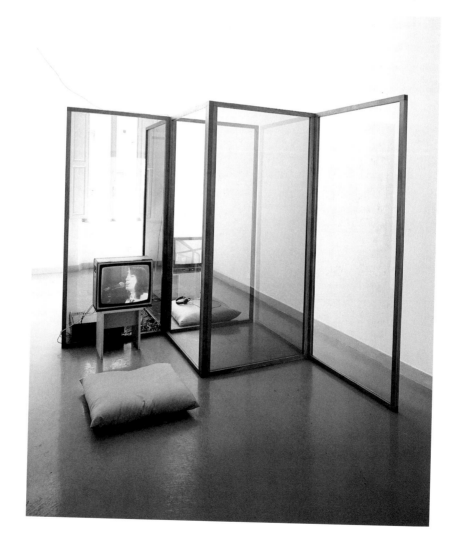

93 1986

selected by Graham which included tapes by artists Judith Barry, Dara Birnbaum, Tony Oursler, David Askevold, Lyn Blumenthal; tapes by Graham; a videotape interview by Chris Dercon (1985); 'The Fifth Republic: An Interview with Michel Foucault' by Branda Miller, Patti Podesta, and Jim Czarneckï; an episode of the television program *'Love Boat'* (1985) with guest appearance by Andy Warhol (1985), among others. The video program changes with each venue and features several programs running simultaneously in the divided viewing spaces. The work was realized in several versions, varying in size and the number of glass dividing panels. The original resides in a private collection: Onnasch, Berlin. In 1992 the work was reconstructed with changes in the number of panels and the placement of video players and seating for the travelling exhibition 'Walker Evans & Dan Graham' which originated at Witte de With, Rotterdam. This version now resides in the Collection of the Whitney Museum of American Art, New York, where it was exhibited in the 'New American Film and Video Series,' December 17, 1993 – March 20, 1994, curated by John G. Hanhardt in conjunction with the travelling exhibition. A second structure for showing videos was designed by Graham in 1995, see *New Design for Showing Videos* cat. no. 133.

Three Linked Cubes/Interior Design for Space Showing Videos, 1986, Installation 1986, La Criée, Rennes, France.

93.1 1986

Title/Date
Three Linked Cubes/ Interior Design for Space Showing Videos 1986

Architectural model
edition of 3

Materials
titanian coated glass with anodized aluminum

Dimensions
18 1/3 x 77 1/2 x 28 1/2 in.
46.5 x 197 x 72 cm

Normal size version (2.25 m each side) for the inside of a pavilion originally conceived for an outdoor site. This is a hybrid pavilion, because it is simultaneously an architectural pavilion and a formal sculpture. The side panels are made of regular transparent glass or of two-way mirrors. The center cube has no roof, whereas the roofs of the other two cubes are made of regular transparent glass and two-way mirror respectively. Before adding the two roofs and the lateral panel this pavilion worked as *Interior Design for Space Showing Videos*, 1986.

Ministerio de Cultura 1987: 27.

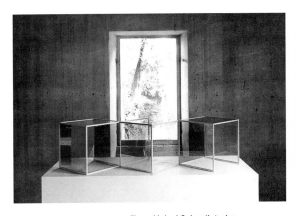

Three Linked Cubes/Interior Design for Space Showing Videos, 1986, architectural model. Installation June 1991, Castello di Rivara, Italy.

'Urban/Suburban Projects,' *Zone* no. 1/2 (1986): 363-365.

'Pavilion/Sculpture Works,' in *Chambres d'Amis*. Exh. cat. Gent: Museum van Hedendaagse Kunst, 1986: 80-81.

'Chamberlain's Couches,' in *Interior Design for Space Showing Videotapes*. The Hague: Stichting Kijkhuis, 1986.

'Kunst als Design/Design als Kunst,' *Museumjournaal*, 3 + 4 (1986): 183-195.

94 1987

Title/Date
Octagon for Münster
1987

Materials
two-way mirror, wood, steel

Dimensions
94 1/2 x 143 3/4 in.
240 x 365 cm
(height x diameter)

First publication
Skulptur Projekte Münster
1987. Exh. cat. Ed. Kaspar König. Cologne: DuMont Buchverlag, 1987. Text for work first published *Munich* 1988: 40, 46.

First exhibition
The work was conceived and realized for: 'Skulptur Projekte Münster,' June 14 – October 4, 1987, curated by Kaspar König and Klaus Bussmann.

Notes
Collection Westfälisches Landesmuseum für Kunst und Kulturgeschichte, Münster.

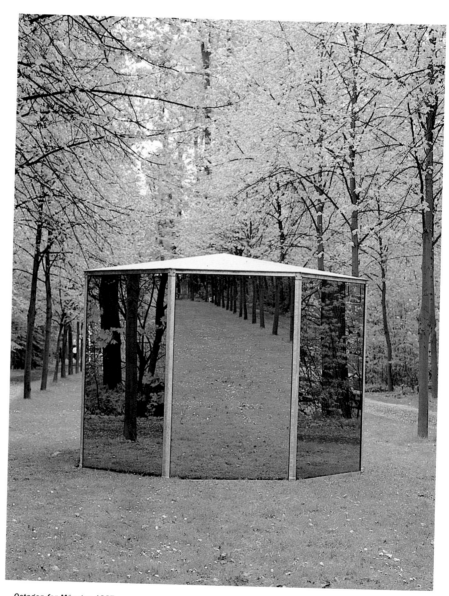

Octagon for Münster, 1987.
Collection Westfälisches Landesmuseum für Kunst und Kulturgeschichte, Münster, Germany. Courtesy Westfälisches Landesmuseum für Kunst und Kulturgeschichte.

[...] *Octagon for Münster*, 1987, built for the 'Skulptur' exhibition in Münster in 1987, consists of eight two-way mirror side panels topped by a wooden roof sloping at an angle of about 15°. One of the panels is a sliding door which allows spectators to enter the interior. A wooden pole in the center of the interior space connects roof to floor. The work was sited in the middle of a tree-lined *allée* in the park surrounding an 18th century palace of the ruling Prince. With the exception of this *allée*, the original baroque design for this park had been converted to a picturesque English garden, which was later subdivided into a university botanical garden and 19th century-style public park. When the park was still classical, various octagonal pavilions surrounded the palace at regular intervals. At present only one, now a music kiosk, has survived. My *Octagon for Münster* faced the rear of the palace to its left equivalent to the position relative to the palace at the rear on the right side at the music pavilion.

While the octagonal form, its siting in the *allée* and the use of mirrored surfaces related it to the classical baroque period, the use of wood, the 'primitive' wood pole and its compact scale alternatively related the pavilion to the simple 'rustic hut' associated with romantic, anti-urban ideology of the post-Enlightenment garden. The music pavilion, which is opened on 5 of its sides, is something like a gazebo. My pavilion has a similar relation to a 19th century gazebo, but contradicts this traditional form. Instead of the sides of my *Octagon* being open so that those inside might have the prospect of the natural setting and be better seen by those outside the pavilion, the use of the two-way mirror turns both inside and outside views into self-reflections.

The two-way mirror glass deliberately alludes to the modern bank and administrative building's facades in the surrounding city, while at the same time reflecting the arcadian parkscape.

Munich 1988: 40, 46.

Title/Date
Octagon for Münster
1986

Architectural model
unique

Materials
two-way mirror glass,
aluminum, wood

Dimensions
19¾ x 29½ x 29½ in.
50 x 75 x 75 cm

Octagon for Münster, 1986,
architectural model.

Title/Date
Pergola/Conservatory
1987

Materials
glass, wood, steel, giant
golden photos, sod

Dimensions
96 x 48 x 240 in.
244 x 122 x 610 cm

First publication
*Dan Graham: Pergola/
Conservatory.* Exh.
brochure. Text by Anne
Rorimer. New York: Marian
Goodman Gallery, 1987.
Graham's text first
published *Munich*
1988: 36, 38.

First exhibition
'Dan Graham, Pergola/
Conservatory,' Marian
Goodman Gallery, New
York, September 9 –
October 3, 1987.

Notes
Architectural design: Ken
Saylor; Landscape design:
Robin Hurst; Drawings:
Claudia Hart; Solarium
Fabricator: Brady & Sun,
Worcester, MA.

[...] *Pergola/Conservatory*, 1987 [...] is a longitudinal, open-ended walkway with a two-way mirror glass ceiling and sides. The structural ribs are natural wood on the inside and dark steel on the outside. This structure is identical to the arbor or pergola form, common in gardens since Roman times. My piece, like the garden pergola, has vines growing wrapped around its side and overhead supports, creating shadows and dappling light overhead. *Pergola/Conservatory* is a hybrid, in a contradictory way, partaking of both the pergola form and conservatory or conservatory-walkway form. And it has one feature which the conservatory does not have: the use of two-way mirror glass in place of transparent glass.

The dialectic between the city and an arcadian, uncorrupted natural possibility which might exist outside of the order of the city and present an utopian alternative to its corruptions was embodied in the picturesque park. Eventually what was viewed as the hygenic aspects of landscaped Nature were brought into the city with Baron Haussman's renovation of post-Napoleonic Paris. Large inner city park preserves and overscaled, tree-lined boulevards opened up Paris, making the city (in plan) resemble both the formal garden of the *ancien régime* and the natural, picturesque garden. Later the garden city – suburbia –

was created as an arcadia by social reformers in England as one answer to the unhealthy concentration and politically 'dangerous' explosiveness of the inner city slum. [...]

The work is subject both to the interaction of viewers entering within as well as viewing it externally as part of the environment. From inside, the curving two-way mirror anamorphically reflects the body of the spectator or bodies of a number of interior spectators. The viewers reflected in the mirror are not only perceiving subjects, but they are also perceived objects. The interior viewer sees an image of her/himself superimposed into the image of the shifting skyscape on the work's ceiling. [...]

Pergola/Conservatory could be placed either in a secluded, romantic area of a public park or, alternatively, in a suburban home-owner's private garden.

Munich 1988: 36, 38.

Pergola/Conservatory, 1987.
Courtesy Marian Goodman
Gallery, New York, USA.

Title/Date
Two-Way Mirror Bridge
and Triangular Pavilion to
Existing Mill House for
Domaine de Kerguehen-
nec
1987

Architectural model
unique

Materials
two-way mirror, steel, alu-
minum frame, landscape
materials

Dimensions
96 x 49 x 20 in.
244 x 124.5 x 50.8 cm

First publication
Munich 1988: 43, 45, 46.

First known exhibition
'Res Publica: Ideen und
Konzepte für öffentliche
Kunst,' Galerie Nikolaus
Sonne, Berlin, Germany,
October 1987 – Spring
1988. Catalogue lists
work in checklist only.

Notes
The work exists as a pro-
posal model. It was never
realized as a large scale
outdoor pavilion.

Two-Way Mirror Bridge and
Triangular Pavilion to
Existing Mill House for
Domaine de Kerguehennec,
1988, drawing for model
of proposed scheme by
Ken Saylor.

[...] The Domaine de Kerguehennec is a sculptural park and nature preserve in Brittany, France. It is based around a central *chateau* and originally was landscaped as a French formal garden which was converted to an English picturesque garden. It was re-landscaped early in this century, with the planting of many species of forest-like trees and the enlargement of its main lake. Remnants of both the French geometrical garden and the English garden remain.

I have proposed for Kerguehennec that two structures be built to create a 'modern' 'allegorical' 'narrative' form derived from the reflection of the oversized, triangular roof of the English garden mill. That reflection falls on the side of the lake near an existing 'Chinese garden style' wooden bridge traversing a small stream which runs into a large lake. The bridge, in my plan, is to be replaced with a two-way mirror, covered bridge whose form is an equilateral triangular solid, enterable and usable by the public. The bottom of the triangle — the walkway surface — is steel grating with an open square grid. It is the same surface used for Paris street air vents over sewers and the Metro. Because of its openness, a spectator walking over the bridge can view reflections on the water's surface below the bridge's surface; the water reflects the

reflected image of the sky and the reflections from the surfaces of the two-way mirror overhead, as well as views of the spectator's body and the surrounding landscape. The effect is prismatic.

In the distance from the bridge is an early 19th century mill house (a survivor of the earlier English garden design of the park). Toward the mill house, closer to the edge of the lake and about twenty meters from the entrance/exit to the bridge, would be built a second triangular solid pavilion in the form of an equilateral solid triangle. It would consist of two-way mirror glass on all sides, 2.5 meters square and 2.5 meters high. The roof would be clear glass. Its interior can be entered through a sliding door. Under most sun conditions a spectator inside the structure, with the door closed, could not be seen by an outside viewer. It would appear, at first, as closed as the mill house to penetration. The reflection of the mill house could be seen several feet from the mirrored triangular pavilion reflected in the lake.

There is a relation between the pyramidal, triangular form of the large roof of the mill house and the two triangles of the covered bridge, and the triangular pavilion. A path alongside the lake connects the two objects, their optical/geometrical prospect and alignment varies as the spectator traverses this pathway. The intention is to

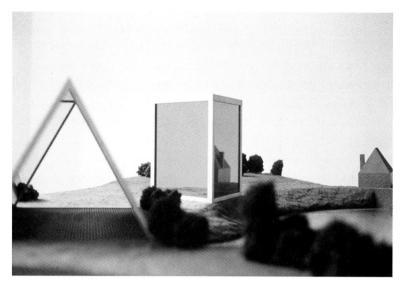

*Two-Way Mirror Bridge
and Triangular Pavilion to
Existing Mill House for
Domaine de Kerguehennec,
1987, architectural model.*

construct a partial allegorical circuit along the lake, much like a park such as Stourhead, in England. This garden's series of pavilions in relation to a central lake was based on Virgil's *Aeneid*. In the English garden, pavilions were laid out to represent a text which had variously political, literary or moral meanings, activated as people moved through the landscape. In Stourhead, for instance, the spectator walks around an artificial lake down to a grotto metaphorically representing the underworld, then reemerges to walk a replica of the Pantheon, symbolizing wordly greatness, then to the Temple of Apollo and to a Gothic cottage. The lake, viewed through various arches, reflects the sky and is the symbolic center around which the allegory takes place.

Munich 1988: 46.

97 1987

Title/Date
Altered Two-Way Mirror
Revolving Door and
Chamber with Sliding
Door (for Loie Fuller)
1987

Materials
two-way mirror, glass,
aluminum

Dimensions
88²/₃ x 118 x 157¹/₂ in.
225 x 300 x 400 cm

First publication
Munich 1988: 49-51.

First exhibition
Loie Fuller exhibition, Art
Center Le Consortium,
Dijon, France, September
1988.

[…] Altered *Two-Way Mirror Revolving Door and Chamber with Sliding Door (for Loie Fuller),* 1987, was designed for a pavilion showing the dance and recently re-discovered films of dancer-filmmaker Loie Fuller (1862-1928). This exhibition will be partly staged by dancer and writer, Brygida Ochaim, in Lyon and Dijon this September, 1988.

My work is a door and transitional passage from the lighted foyer into the full exhibition space. A conventional revolving door has two quarters of its usual four quarters or one of its usual two right angle planes of rotating glass removed. The remaining plane has been coated with lightly reflective two-way mirror glass. The cylinder within which it rotates has also been coated with light two-way mirror material. The spectator next passes into a small container in which the walls, equal in size, are also lightly reflective two-way mirrors. The six sides of this small chamber, if

extended into the space occupied by the revolving door, would have formed a hexagonal solid. This space leads through a sliding door into a large, darkened exhibition room.

My work is partly based on Fuller's invention, 'A System of Mirrors for Use on Stage.' The initial space of the 'Fuller Pavilion,' well-lighted, would exhibit introductory, archaical information, photos of the dances, drawings and texts pertaining to her work. The viewer would then move toward a more theatrical series of experiences in a darkened setting. He would pass by replications of various sculptures of Fuller by Pierre Roche and others. Through shadows and colored spotlights (typical 'Fulleresque' stage tricks) double images would result when shadows of two or more sculptures came together, creating the illusion of other figures. The colored illuminations would also fall on hangings of parachute silk, the material used

Notes
Collection. Le Consortium, Dijon.

by Fuller in her *Danses Lumineuses* such as the 'Fire Dance' of 'Salome' and other 'skirt' dances. The viewer would move through these materials and effects. The stage would present either the hitherto unavailable films of Romanian fairytales directed by Fuller or versions of her famous dances presented live.

Ochaim wishes for the spectators to experience an identification with the dancer and also with their own body movements. The entrance passage would provide the experience of narcissistic self-identification with both Fuller and the viewer's own body. The spectator's image can be seen anamorphically reflected in the half-mirrorized door cylinder and also in the rotating planes of the traditional, Renaissance perspective mirroring of the door planes and the chamber walls. This image appears and disappears with the effects of the lighting in the darkened rooms and as the door is turned. Spectators are made more *physically* aware of their body movements through space by the removal of one of the planes of the revolving door. This physicality and the 'play' situation result from the fact that the door is unexpectedly lighter (spins more freely) and can be entered *without* pushing the door (if the angle of the door is left in the right posi-

tion). Or the person entering can be in context with a second spectator on the other side of the door (leaving when one is entering). This relates Loie Fuller to later American dance in which motion is reduced to common, physical 'tasks.' This is true in the dance of Simone Forti, Yvonne Rainer, or Steve Paxton. The use of two-way mirrorized surfaces and the spinning planes of the modified revolving door create special effects like those Fuller used in her stage presentations. These gave many images of herself, sometimes appearing to levitate, to the audience. They also used half-silvered glass, which appeared to the audience as transparent, but actually deceived the audience with mirror reflective effects. Her effects and the optical effects of my design situate her work in terms of an archaeology of film. The pavilion culminates in the projection of her films. Fuller is seen as an important early figure, not only in dance and theater, but in the history of films by women.

Munich 1988: 50.

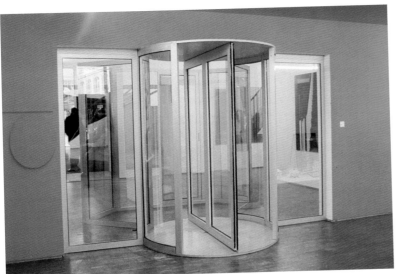

Altered Two-Way Mirror Revolving Door and Chamber with Sliding Door (for Loie Fuller), 1987. Installation 'Dijon, le Consortium collection,' 1998, Musée National d'Art Moderne, Centre Georges Pompidou, Paris. Collection Le Consortium, Dijon, France.

98 1987

Title/Date
Dan Graham and Robin
Hurst
Private 'Public' Space:
The Corporate Atrium
Garden
1987

Materials
layout boards for maga-
zine article with photo-
graphs
six panels: black and
white and color photo-
graphs with printed text
mounted on cardboard

Dimensions
6 framed panels:
40 x 30 in.
101.6 x 76.2 cm
(each)

First publication
The article was published
in two versions: as Dan
Graham and Robin Hurst,
'Corporate Arcadias,' *Art-
forum* 26, 4 (December
1987): 68-74 and
'Odyssey in Space: Dan
Graham and Robin Hurst
on the US Corporate
Atrium,' *Building Design*
(October 21, 1988):
38-43.

Notes
Alternate title: *Private
'Public' Space: Corporate
Park Artiums*. The article
exists in two published
versions and as this
original layout.

Dan Graham and Robin
Hurst, *Private 'Public'
Space: The Corporate Atrium
Garden*, 1987. Collection
Generali Foundation,
Vienna, Austria.

PRIVATE 'PUBLIC' SPACE:
THE CORPORATE ATRIUM GARDEN

Dan Graham and Marie-
Paule Macdonald
Wild in the Streets: The
Sixties
1987

Materials
libretto for rock opera
published as a book and
drawings by Marie-Paule
Macdonald
drawings: mixed media
and photo collage

Dimensions
9⅘ x 19⅔ in.
25 x 50 cm
(each)

First publication
Dan Graham and Marie-
Paule Macdonald. *Wild in
the Streets: The Sixties.*
Gent: Imschoot, 1994.
Text and photographs by
Dan Graham. Scenogra-
phy and pop-up design by
Marie-Paule Macdonald.
This version *Santiago de
Compostela* 1997: 177-
180.

First exhibition
Drawings first shown at
Galerie Chantal-Boulanger,
Montreal, 1989.

Notes
The work was never real-
ized as an opera. The
drawings were first shown
in 1989. For the book,
some of these were
added and subtracted,
and pop-up designs were
made by Marie-Paule
Macdonald for each of the
scenes. In the final ver-
sion of the book only one
pop-up design was pub-
lished. Sections of the
script are quoted from
Wild in the Streets, 1968,
directed by Barry Shear
and produced by American
International Films.

Wild in the Streets: The Sixties, a mini rock opera, originally designed for presentation simultaneously as a stage production for the *Monnaie* Opera in Brussels and as live television broadcast by Flemish Television (BRTN) in 1990, is adapted from the 1968 film, *Wild in the Streets.*

It charts the career of a rock singer, twenty-four-year-old Neil Sky, who is elected President of the United States after instigating teenage riots to change the voting age to fourteen. In the new administration, citizens over thirty face mandatory retirement and, at thirty-five, they are placed in re-conditioning camps and given LSD. Later, President Sky's very young adopted son runs away from home and joins a youth gang, whose leader threatens Sky that they will 'put everyone over ten out of business.'

The opera's tragi-comic narrative is the *reductio ad absurdum* of the hippies' 'generational politics' contained in the 1960s youth slogan, 'Don't trust anybody over thirty.'

The Sixties

Set # 1. A hybrid 'rustic hut', Dogpatch style (from the 'Li'l Abner' strip), and a partially finished, 60s, suburban house (in the film *Over The Edge* such a house, abandoned by the developers as the building boom ceased, was used as a temporary outlaw refuge by teenagers looking for their own space on the margins of an endless suburban planned community)…

In the background, another finished 60s ranch-house, which serves as official guest-house for visiting foreign leaders, is seen.

The President's house is called 'The Berry Farm.' Its surroundings and interior decoration are like a hippie commune of the late 60s (circa Woodstock). Although essentially the operative official residence of the President of the U.S., it is actually the 'Summer White House,' having re-

placed the former 'Summer White House': Camp David.

Because it is the communications center for the President, it is equipped with modern telecommunications equipment, including TV cameras and large monitor screens. The furnishings are crash-pad psychedelic – lots of psychedelic and op-art posters. But the largest poster is a huge photo blow-up of President Eisenhower. In the foreground of the landscape are pigs and goats, who ramble about unrestrained. Apple trees, vines and berry patches are evident. In all, the landscape is a curious mix of verdant, rolling Vermont and 'Grandma's Farm' countryside. But, in place of the conventional barns and cows in the distance, instead there are seen 60s suburban tract houses, some cylindrical oil storage tanks and an industrial building (galvanized aluminum, rectilinear forms) or two. This is one side of the landscape. On the other side, anonymously, the landscape is an idealization of the formal garden – a pseudo – Elizabethan royal estate garden associated in the California hippie mind with the 'Renaissance Fair' (note the song 'Renaissance Fair' by The Byrds… and a slide or color xerox from a French comic book visualization of this landscape).

There might be a swimming pool in the front-side yard as in *Wild in the Streets.*

Set # 2. In the opera house/TV production, set # 2 is a baroque garden with *parterres* and dual vanishing point perspective backgrounds. This landscape is to be a combination of a rug, painted backdrops and open scaffolding with inner open cubic scaffolding depicting the 'Summer White House' with rock performing stage. The woven landscape rug emblematizes the idea of the California 'Renaissance Fair,' pastoral shepherds and shepherdesses. The outer scaffolding, tree trunks and branches, is the President's

Dan Graham and Marie-Paule Macdonald, *Wild in the Streets: The Sixties*, 1994, pop-up page from the book published by Imschoot, Gent.

country retreat modeled after Rousseau and Laugier's notion of a 'primitive hut.' The inner scaffolding, resembling both the frames of an incomplete new suburban house or a 'Top of the Pops,' 'American Bandstand,' or 'Hullabaloo' 1960s rock TV program, is used by the President for press conferences and by his band as a stage. TV monitors are placed along the sides of this 'go-go cage' form – newsreels which advance the plot are viewable from these monitors.

Teenage rock musicians/performers will both speak and perform very short songs which advance the narrative.

Strobe lights and other psychedelic stage effects will occasionally be employed, especially for the Inaugural Ball celebration and the mass rally on Sunset Strip.

Musical style: influenced by The Seeds, Rory Gallagher, Eric Burdon's hippie period.
Operatic style: short, recitative half-singing/half-talking, as in early The Who mini

rock opera song, 'A Short One While He's Away.'

List of Speaking or Singing Characters
(this list is tentative and may be re-invented by the kids depending on other circumstances)

1. Jim Morrison. Ten-year-old adopted son of President Sky... a runaway. 'We're gonna put all you guys over ten out of business.'

2. President of the United States, Neil Sky. Approximately twenty-five years old. Looks 50% Native American and 50% pioneer farmer, buckskin vest, leather pants, black pioneer Western-style hat, long hippie hair bound by an Indian head-band, a cross between the young Neil Young and Sky Saxton of The Seeds.

3. Sally-Anne Rafael. President's old lady, Senator from California, twenty-seven years old, half-naked, blithe spirit, part girl-child/part lady/part 'Incense and Peppermint,' long blond hair. Various clothing

changes: gingham and granny-dress finery, see-through shifts, a mix of suburban upper-middle-class casual with hippie 'dress-up' finery, wears Paul Revere hat in official capacity as Senator from California.

4. J. S. Bach. President's number one 'brain-truster,' fifteen to sixteen years old, always dressed in J. S. Bach baroque outfit, modeled on the image of the electric organist of The Seeds, Daryl Hopper.

5. Mom. President's over-protective Mom, modelled on Shelly Winter's character in *Wild in the Streets.*

6. Congressman Max Fergus. Opportunistic sponsor of vote for eighteen-year-olds. Kennedy-image 'New Politician' of the late 60s.

Non-speaking Characters
Two friends of Jim Morisson, ten-year-old boys.
Approx. six to eight hippies in 'crash-pad' situation, part of Neil's 'tribe.'
President's dog, 'Eisenhower two other scenes,' perhaps a beagle modeled on President L. B. Johnson's dog.

If we can use the boxes to the right and left sides as wings there would be **two other scenes:**
1. Congress, from where the new Senator, Sally-Anne Rafael, and later the President, Neil Sky, make their respective inaugural addresses.
2. Concentration camp for those over thirty-five where LSD drugging is mandatory. These scenes may have to be located inside rooms (studios) and linked to the main stage-set via live TV transmission or pre-recorded and displayed on the TV monitors.
The plan is to have a cast consisting of ten-to-fourteen-year-old New York kids who would interpret the material musically (and narratively) in current urban styles – for instance, this might be a psychedelic

Beastie Boys set-up. English would be best for the production as it was going to be sponsored and broadcast on Belgian Flemish TV. English is also the language of rock music – just as Greek and Latin are the languages of classical myths.

Music
The songs will be very short, fifteen to thirty seconds and based on only one or two chords. Electric organ will alternate as lead with acoustic guitar. The electric organ will be crucial for a psychedelic sound. There will be an Overture (probably pre-recorded, such as Jack Nietzsche's 'Boot Hill Symphony' and 'Here We Are In The Years' on the first Neil Young L.P.). There will be 'muzak-type' music (emanating from the off-stage speakers near the stage but in the audience area) of sound of 'be-in' turned up higher than subliminal listening level at key moments – to 'dramatically' punctuate action.

Santiago de Compostela 1997: 177-180.

100 1987

Title/Date
Triangle Pavilion
1987

Materials
three-way glass, aluminum

Dimensions
88½ x 98⅖ x 84⅔ in.
225 x 250 x 215 cm

First publication
Munich 1988: fronti-
spiece, image only.

First exhibition
Le Consortium, Dijon,
France, September 1987.

Notes
The work was realized for
the above-mentioned
exhibition, and was also
included in the exhibition,
'Dan Graham – Pavillons/
Dan Graham – Pavilions,'
Kunstverein Munich,
September 17 – October
23, 1988. Collection
Fonds Regional d'Art
Contemporain, Burgundy,
France.

Triangle Pavilion, 1987.
Collection Fonds Regional
d'Art Contemporain,
Burgundy, France.

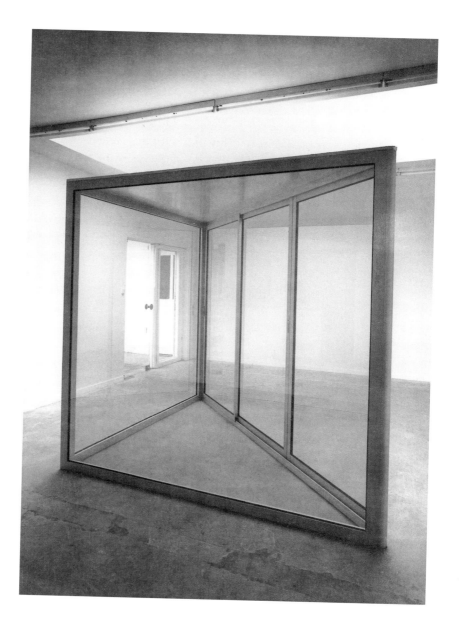

W 1987

Writings

'Legacies of Critical Practice in the 1980s,' in
*Dia Art Foundation/Discussions in Contemporary
Culture.* Number One. Ed. Hal Foster. Seattle:
Bay Press, 1987: 88-91 and discussion:
105-118.

Graham, Dan, and Robin Hurst, 'Corporate Arca-
dias,' *Artforum* 26, 4 (December 1987): 68-74.

Title/Date
Triangular Structure with
Two-Way Mirror Sliding
Door for The New Urban
Landscape
1988

Materials
laminated glass, laminated
two-way mirror glass,
brushed aluminum frame-
work

Dimensions
96½ x 92½ x 61 x 61 in.
245 x 235 x 155 x 155 cm

First publication
*The New Urban Land-
scape.* New York: Olympia
& York Companies and
Drentell Doyle Partners,
1989: 66-67. Exhibition
and catalogue coordinated
by Ann Philbin, Livet
Reichard Company, Inc.
Text for work first pub-
lished *Dan Graham: Two-
Way Mirror Cylinder Inside
Cube and a Video Salon.*
New York: Dia Center for
the Arts, 1992: 42.

First exhibition
'The New Urban Land-
scape, an exhibition of
installations by artists and
architects on issues in
contemporary city life,'
The World Financial Cen-
ter, Battery Park City,
October 14 –
November 27, 1988.

Notes
This work is a triangular
glass room with a sliding
door which was inserted
into the exterior glass
facade of Two World
Financial Center, 225 Lib-
erty Street. The temporary
structure formed a cage-
like wedge, interrupting
the square of the build-
ing's corner to create an
intermediary space visible
from the building's foyer
and the exterior courtyard.
The exhibition featured

[...] This temporary *triangle* [...] was part
of a large temporary exhibition organized
to inaugurate the World Financial Center.
The two-way mirror structure was placed
in a rectangular niche of the World Finan-
cial Center building as part of the tempo-
rary exhibition 'The New Urban Land-
scape.' It gave a partly kaleidoscopic view
to the enclosed spectator who perceived
his body and gaze as well as those of oth-
er spectators' inside the lobby of the atri-
um or outside of the enclosure in the
pedestrian courtyard. If not used by art
spectators, it might also serve as a tem-
porary shelter.

*Dan Graham: Two-Way Mirror Cylinder Inside Cube and a
Video Salon. New York: Dia Center for the Arts, 1992: 42.*

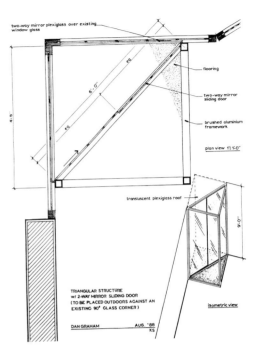

*Triangular Structure with
Two-Way Mirror Sliding Door
for The New Urban Land-
scape, 1988, World Financial
Center, Battery Park City, New
York. Collection Sammlung
Hauser & Wirth, St. Gallen,
Switzerland.*

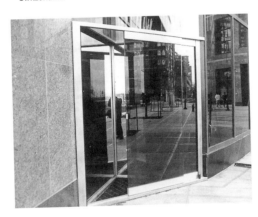

installations by artists and
architects in the new
development of Battery
Park City. Collection
Sammlung Hauser &
Wirth, St. Gallen, Switzer-
land.

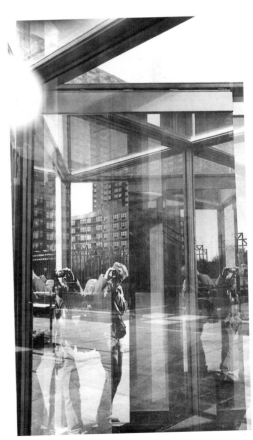

Title/Date
Triangular Two-Way Mirror
Walkway for Fort Asperen
1988

Materials
two-way mirror glass,
brushed aluminum frame,
metal ventilation grid,
lighting

Dimensions
94½ x 88½ x 45¼ in.
240 x 225 x 115 cm

First publication
previously unpublished

First exhibition
'Fort Asperen,' Utrecht,
Holland, 1988.

Notes
The architectural drawing
of the work dated October
1988 bears the title *Trian-
gular Two-Way Mirror
Walkway for Fort Asperen*,
while the text bears the
title *Walkway With
Triangular Two-Way Mirror
Roof: Fort Asperen
Project*. The work was
realized as a temporary
construction.

*Triangular Two-Way Mirror
Walkway for Fort Asperen,
1988, Utrecht, Holland.*

Two two-way mirror side panels form a narrow passage-way in the form of a long acute-angle open, solid triangle. The base of the form is the existing ventilation grill, an open metal grid located between the first and second floors. The passage is just wide enough for one spectator to walk through it. It must be traversed to begin a circuit around the second floor space. It leads from the landing of the stairway from the first floor to the second floor of the fortress. It culminates in an inner room which connects to the sequence of other rooms on the second level. As one walks through this passage to the end, an analogous triangular form, the peaked rooftop of an extension to the fort is visible from the window just in front of the end of the passage.

The passage-way is lighted from three sources: strong flood lights from the first floor directed up through the grating into the interior of the passage; from the natural light hitting the end of the triangle from the window in the inner room; and from the ambient artificial lighting on the second floor falling on the outside of the structure. The outdoor sunlight will vary as to the sky conditions and the time of day. The passage of people inside the structure temporarily blocking the interior lighting will also vary its lighting. As two-way mirror is either more or less reflective (as against being transparent, its normal state is a continually varying state of quasi-reflectivity/quasi-transparency), this quality of the piece will be in flux. Thus the work's specific optical relation to the environment, to the surrounding architectural context and to the self-reflections of the spectators both outside and inside its form is mutable.

Due to the dramatic lighting inside the piece emanating from below, spectators on the first floor passing below the work may see a fleeting reflection of their body mirrored on the sides of the overhead structure. Because of this first floor lighting, a spectator within the passage looking in the two overhead triangular sides will see a second, reflected image of their body as a shadow with the ventilation grid superimposed upon its form. They could also see reflected elements of the architecture of the first floor and the forms of any spectators passing beneath the grid. As the spectator within the passage approaches the end of the tunnel, the outdoor view through the window will be incorporated in the prismatic reflections centered on the spectator's own body.

The ventilation grid which forms the floor of the work is a twentieth century urban form; while the two-way mirror glass is linked to the modern, administrative, office building. These forms and modern urban materials modify the ancient form and pre-industrial administrative function of Fort Asperen's original architecture.

Dan Graham, 'Triangular Two-Way Mirror Walkway for Fort Asperen,' 1988, text previously unpublished.

103 1988

Title/Date
Pyramid
1988

Architectural model
unspecified edition

Materials
two-way mirror, glass,
aluminum

Dimensions
$23^2/_3$ x $20^4/_5$ x $20^4/_5$ in.
60 x 53 x 53 cm

First publication
Pyramiden. Exh. cat.
Frechen-Bachem:
Galerie Jule Kewenig and
Verlag Justus Presse,
1988: 70-71.

First exhibition
'Pyramiden,'
Galerie Jule Kewenig,
Frechen-Bachem, 1988.

Pyramid, 1988,
architectural model.

W 1988

Writings

'Pavilions, Stagesets and Exhibition Designs,
1983-1988,' in *Dan Graham: Pavilions*. Exh. cat.
Munich: Kunstverein München, 1988: 36-58.

Title/Date
Dan Graham and Jeff Wall
Children's Pavilion
1989

Architectural model
children's scale exhibition
model

Materials
wood, cibachrome trans-
parencies, light boxes

Dimensions
137¾ x 236¼ in.
350 x 600 cm
(height x diameter)

First publication
Dan Graham, Jeff Wall
Children's Pavilion. Exh.
cat. Lyon: Villa Gillet –
FRAC Rhône-Alpes, 1989,
images and short version
of text. This text was co-
written by Graham and
Wall and first published: *A
Guide to the Children's
Pavilion.* Exh. cat. Santa
Barbara: Santa Barbara
Contemporary Arts Forum,
1989. See also *Parkett*
no. 22 (1989): 66-70.

First exhibition
'Dan Graham and Jeff
Wall, The Children's
Pavilion,' FRAC Rhône-
Alpes, Villa Gillet, Lyon,
April 12 – May 13, 1989,
in cooperation with Galerie
Roger Pailhas, Marseille;
The Santa Barbara Con-
temporary Arts Forum,
Santa Barbara, California,
October 1 – November 4,
1989; Marian Goodman
Gallery, New York,
January 5 – 27, 1990.

Notes
The work was first con-
ceived in 1987: a scotch
tape model was made and
in 1988 Wall started
working on the photo-
graphs. The exhibition
model was made by the
FRAC Rhône-Alpes and
first exhibited at Villa

The *Children's Pavilion* is a public building located at the periphery of a playground. It is built into, and enclosed by, a land-scaped hill. The structural shell of the hill-form is engineered in concrete. It includes a network of stairways leading to a walkway around the summit. Large areas of the exterior surface are planted with lawn.

The structure is entered through a portal in the form of a three-quarter circle. The interior floor, made of concrete, is composed of three descending concentric rings with a system of steps leading from level to level. The central circle is a water basin.

The interior walls form a drum, which supports a low dome, at the apex of which is an oculus. In the oculus is installed a one-quarter sphere of two-way mirror glass, its convex surface facing the interior. Visitors inside the pavilion can look out through the oculus, and those on the walkway at the summit can look into the building. Both groups also see their own reflections on the partly-mirrored glass. The diameter of the water basin is the same as the por-traits. The diameter of the quarter-sphere in the oculus is twice that of the portraits.

Architectural Typology. Playgrounds are the special domain of children, but the chil-dren who inhabit them are usually attend-ed and observed by adults – parents or guardians. Playgrounds are therefore also for adults, who are given the opportunity to witness their children's experience of childhood. In this setting, however, the children behave less as members of indi-viduated nuclear families than as part of a horde of youngsters who mingle there in commotion.

The playground customarily features one or more symbolic mountain or hill forms. These are archetypes of complex experi-ences because they permit penetration

Gillet, Lyon, France. This model is not to the full-scale of the proposed pavilion but made in a children's or half-scale, large enough to be entered by spectators. Jeff Wall's ton-di transparencies featuring portraits of children line the interior as lightboxes. A full-scale set of Wall's photographs were exhibited outside the maquette. Collection of the FRAC Rhône-Alpes, Lyon, France. A second architectural model was also made, see cat. no. 104.1. *Children's Pavilion* has not been realized as a full-scale outdoor playground.

Dan Graham and Jeff Wall, *Children's Pavilion*, 1989, exhibition model. Courtesy Marian Goodman Gallery, New York, USA. Collection FRAC Rhône-Alpes, Lyon, France.

underground through various openings, a primal exploration of earth, and, at the same time, an occasion for ascent and conquest, for the attainment of a privileged overview as 'king of the mountain.' In this process, one child becomes a big-shot by gaining the special place at the summit. At the same time, others are burrowing below, lurking in dark hiding places, and springing back into the light. These might then go up to the top, while the one on the top tumbles or races back down, girls and boys chasing each other, round and round.

The inside of the hill is of course like a cave or grotto. Grottos are usually watery, and are associated with lunar goddesses, nymphs, prophecy, birth, and a passage through subterranean realms to rebirth. It suggests also the invisible, but often audible, flowing of water inside the earth, and the sudden, surprising appearances of springs.

Both grottos and the damp, but less watery caves are sites of primeval image-making. Prehistoric adults took shelter in caves from animals, and there created icons and pictures celebrating both their fear of these animals, and their triumph over them in the organized hunt. The totemic image is a powerful element in tribal self-identification as well as a symbol of the maturation of the hunter. The skill in depicting the animal is a mark of maturity and mastery, and parallels the skill in hunting it: these skills are those of the provider, the magician, the leader.

Another typological element for the *Children's Pavilion* is the Pantheon, which is a public temple and mausoleum, dedicated to the memory of gods and heroes, to patriarchs and to the state. The great Pantheon in Rome features an open oculus which permits a focused beam of direct sunlight to move around the interior in the course of the day. Depending on seasonal conditions, the light from the oculus

sweeps across an arc which may coincide with particular features of the interior, such as the tomb of Raphael, giving it a natural spotlight. The Pantheon has had an immense influence on the forms of modern state temples, notably the 'Dôme des Invalides' in Paris and the U.S. Capitol Building in Washington.

Follies and pavilions in landscaped gardens have a direct relationship with the *Children's Pavilion*, as the name indicates. These structures often replicate, on a reduced scale, ancient monuments with literary or mythological references, such as the tombs of Abelard and Heloise, which are found in English gardens in France. Patriotic and heroic memorials, as well as shelters for retreat and meditation, are also included in this type. These pavilions are places which combine the provision of temporary shelter with an inducement to participate in specific acts of memory, contemplation, and philosophical speculation. They are related to the process of creating literary and philosophical works, which may take as their subjects the nature of the environment in which the pavilion itself is sited. They often suggest utopian alternatives to present civilization.

Another aspect of this typology is provided by the observatory and the planetarium. Both derive from older things, structures like Stonehenge, for example, which was apparently used by the Druids for sighting positions of the planets. But they establish their generic identity in the modern, scientific epoch, the period of rationalism and world navigation. The planetarium belongs specifically to the era of democratically-inspired dissemination and production of knowledge, in which the study of the heavens was made available to all citizens, not just an esoteric caste, like the Egyptian priests who controlled the ancient calendars.

The observatory is a structure devoted to the optical study of the sky. It has no inter-

est in studying the earth, and never looks at it. It is most curious about the furthest reaches of the visible universe. It treats the Earth only as an Archimedean point from which it can calculate how far it can see. It does this by means of curvatures of glass or other materials which focus energy, whether in the form of light, radio signals or other things. It is a photographic or cinematographic apparatus, a solar eye. It scans the universe for signs of other life forms and for data necessary for developing cosmological theories.

The planetarium is, on the other hand, a cinema. It reproduces, stages, and projects cosmological narratives as entertainment and education. The darkened dome of the planetarium evokes the primitive world when early man first contemplated the stars and attributed totemic power to constellations, for example 'The Great Bear.' The modern totemism of the planetarium is, however, attached to telescopic power and cinematographic projection itself.

The spherical form of the planetarium is reiterated elsewhere. In recent World's Fairs, for example, spherical structures present the cosmos and our earth as one world. These are emblems of a promised future, to be achieved through scientific progress, which would unite us into one global community, one 'family of man.' The mirror-clad La Géode, in Parc de la Villette in Paris, is the most striking example.

The final element to be noted is something which is not, strictly speaking, architectural. This is the space capsule or flying saucer, which is round, cylindrical, disc-like, spherical or hemispherical. These are mostly seen in films, often films aimed at children, but are also featured as rides at amusement parks and science museums (which often resemble each other). The spaceship promises an adventure, a journey to other worlds, a voyage into a hypothetical future. It is often a toy played with

in the process of constructing adventure narratives of this kind, adventures in which past and future are intermingled, in which archaic forms appear futuristic and futuristic forms can be ruins.

Photographs of Children. The group of nine *rondels* or *tondi* includes portraits of children of different racial and ethnic backgrounds. The organization of the portrait group is related to the concept of the nation state and of its gathering of all its children into systems of universal public education, health, recreation, culture, and citizenship. The concept of the nation includes in its substance the outcome of the great immigration patterns of modernity in which a variety of peoples with different customs have confronted each other within the terms of a common body of law. The group of children can signify the nation, and specifically the nation's future, in a Pantheon-like assembly.

At the same time, the group's multi-racial composition implies the plurality of nations and therefore forms an image of world culture. One classic manifestation of this idea is the photographic exhibition and book, 'The Family of Man' organized by Edward Steichen in 1955. In his essay 'The Traffic in Photographs' (1981), Alan Sekula wrote, "'The Family of Man' moves from the celebration of patriarchal authority – which finds its highest embodiment in the United Nations – to the final construction of an imaginary utopia that resembles nothing so much as a protracted state of infantile, pre-Oedipal bliss."

The universal-national children of the portraits appear in circular frames. The tondo form is associated with ceremonial and decorative portraits and figure-groups often featuring women, children and angels; but it is also related to coins, on which the heads of rulers are minted.

The circular form also relates to the sphere, and therefore to a symbol of the

cosmos, but also to a rubber ball flying through the air above a playground. Balls, bubbles, lollipops and other round, shiny, happy forms are parts of the world of toys – roller skates, Frisbees and the like – which are vehicles in adventure fantasies.

Each of the children is viewed against a background of the sky. Each sky is unique, representing different times of day, different weather conditions, different seasons. The individuation of the children is expressed in the unique relation to the cosmos signified by the association of one specific child with one moment in time. Each child has a unique place, a special trajectory into the future, signified in part by the mood of the sky.

The celestial void is the home of angels or *putti*, infant beings without family, who emanate directly from God in infinite numbers at every second of endless time. They exist briefly, before vanishing again.

Oculus and Spectator. The oculus, as its name suggests, functions as the eye of the pavilion. The whole interior is gathered and reflected on the convex surface of the quarter-sphere of mirror glass. At the same time the transparent character of the glass allows the spectators inside the building to see the actual sky outside, and to see as well anyone looking in from the vantage point at the top of the mountain. Similarly, those outside can view the interior. Furthermore, distorted reflections of people looking down through the oculus from the outside, which are created by the concave form of the quarter-sphere's outer surface, may also be visible from inside and outside. The entire play of gazes and reflections generated by the architecture and the photographs is condensed onto the outer and inner surfaces of the glass. The optical dynamics are connected with the pavilion's relationship to observatories and planetaria, forms dedicated to inten-

sive searching, gazing and observation. Science and fatherhood are implied here, and this implication is augmented by the structure's references to national temples. At the same time, the oculus is set into the form of a hill or mountain, which suggests a more maternal enclosure, a cave or grotto, but one which includes an optical ordering principle. Thus, traditional systems of both parents are present in the architecture and organize the forms of interaction between adults and children in and around the building. All users of the *Children's Pavilion*, children, parents, and other adults, can be observers of the behavior of others, from a variety of positions. And all can be contemplated in comparison with the giant transparencies of children.

For safety, the exterior of the oculus at the summit is provided with a protective railing.

Dan Graham and Jeff Wall. *A Guide to the Children's Pavilion.* Exh. brochure Santa Barbara: Santa Barbara Contemporary Arts Forum, 1989: n.p.

Title/Date
Dan Graham and Jeff Wall
Children's Pavilion
1991

Architectural model
unique

Materials
concrete, glass, metal,
wood, plexiglas,
cibachrome transparen-
cies, fluorescent light,
cork, plastic trees

Dimensions
50 x 110¼ in.
127 x 280 cm
(height x diameter)

Dan Graham and Jeff Wall,
Children's Pavilion, 1991,
architectural model. Collec-
tion Galerie Roger Pailhas,
Marseille, France.

105 1989

Title/Date
Skateboard Pavilion
1989

Architectural model
unique

Materials
two-way mirror glass,
brushed aluminum, steel,
wood, graffiti

Dimensions
57 x 57 x 51⅖ in.
145 x 145 x 130.5 cm
base:
81 x 57 x 57 in.
206 x 145 x 145 cm

First publication
'Skateboard Pavilion,' in
*Jahresring 38: Der
öffentliche Blick*. Munich:

Skateboard Pavilion, consisting of a large cement, concave dish for skateboarding and a canopy of two-way mirror glass, a four-sided pyramidal form truncated at the top so that it is open, was first proposed for a 'stopping point' for the International Garden Year in 1993 in Stuttgart, Germany. It was not accepted, perhaps because the notion of a recreational attraction intended primarily for teenagers was not thought to be a good idea. It works maximally when the skateboarder approaches the lip or top edge of the concave dish and looks up toward the sky/canopy and sees a combined kaleidoscopic reflection and transparent image of himself and the surrounding environment in the canopy form. The cutaway top produces a diamond-like image also project-ed on the two-way mirror canopy.

Public/Private 1993: 41.

[...] The truncated two-way mirror pyramidal canopy alludes to the 19th century wrought-iron canopy of the park music gazebo and, simultaneously, to the 1980s 'Neoclassical' pyramid roof culminations on corporate office towers.
The experience also relates to amusement park mirror 'fun houses' and, in general, to kaleidoscopes with their diamond-like patterns. The skateboarders see themselves reflected in the canopy against a kaleidoscopic pattern of themselves floating weightless merging with the sky. Another aspect of the work is that it encourages graffiti on 'public sculpture.'

Two-Way Mirror Power 1999: 180.

105 1989

Verlag Silke Schreiber,
1991: 200. See also *Dan
Graham: Public/Private.*
Exh. cat. Philadelphia:
Goldie Paley Gallery, Levy
Gallerie for the Arts in
Philadelphia, Moore Col-
lege of Art and Design,
1993: 41 and later ver-
sion in *Two-Way Mirror
Power* 1999: 180.

First exhibition
'Dan Graham: Public/
Private,' Goldie Paley
Gallery, Levy Gallery of the
Arts in Philadelphia, Moore
College of Art and Design,
Philadelphia, September 7
– October 17, 1993. Small
scotch tape model first
exhibited: 'Dan Graham.
Pavilions,' Wiener Seces-
sion, Vienna, May 27 –
June 28, 1992.

Notes
Skateboard Pavilion was
proposed as a pavilion for
an outdoor site yet was
never realized. This model
now resides in the collec-
tion of the Generali Foun-
dation, Vienna. A smaller
scotch-tape model was
made. See cat. no. 105.1.

Skateboard Pavilion, 1989,
architectural model.
Collection Generali Founda-
tion, Vienna, Austria.

105.1 1989

Title/Date
Skateboard Pavilion
1989

Scotch tape model
unique

Materials
mirror, wood, scotch tape

Dimensions
31^4/$_5$ x 22^2/$_5$ x 22^2/$_5$ in.
81 x 57 x 57 cm
base:
80^7/$_{10}$ x 57 x 57 in.
205 x 145 x 145 cm

Skateboard Pavilion, 1989,
scotch tape model. Collection
Bruno van Lierde, Brussels,
Belgium.

Title/Date
Pyramid over Goldfish
Pond
1989

Materials
two-way mirror and
aluminum over concrete
goldfish basin

Dimensions
81⁹⁄₁₀ x 78¾ x 78¾ in.
208 x 200 x 200 cm

First publication
Nordhorn 1996: 30-31, 91.

First exhibition
'Pas à côté. Pas n'importe
où 4,' Villa Arson, Centre
National d'Art Contem-
porain, Nice, 1989.

Notes
*Pyramid over Goldfish
Pond* was realized for Villa
Arson, Centre National
d'Art Contemporain, Nice,
France.

A four-sided pyramidal canopy has been built over a concrete goldfish basin on the almost square terrace located in the École des Beaux-Arts in Nice. Three sides are of two-way mirror glass, one side is left open. Students and faculty take cigarette and conversational breaks sitting on the edge of the basin covered by the pyramidal enclosure. Both the sitters in this 'shelter' and the images of the goldfish will be re-reflected (along with pyramidal, crystallo-graphic images of the sky and the water's reflection in the mirroring glass above). The somewhat 'dumb' pyramidal form obviously derives from the multitude of pyramids placed over classrooms as dec-orative skylights. There is an overhead view above the pyramidal structure and basin from a higher level of the building. In using goldfish and water the work is something of a pun on the well-known Henri Matisse paintings.

Nordhorn 1996: 91.

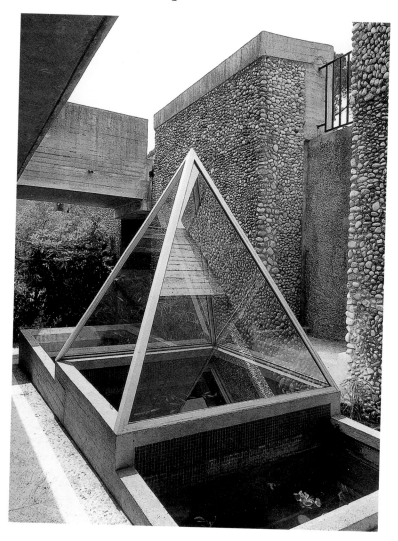

Pyramid over Goldfish Pond,
1989. Collection Centre
National d'Art Contemporain,
Nice, France.

Title/Date
Pavilion Influenced by
Moon Windows
1989

Architectural model
edition of 3
materials and dimensions
may vary over edition

Materials
clear glass, two-way
mirror, aluminum

Dimensions
20$\frac{1}{4}$ x 29$\frac{1}{10}$ x 29$\frac{1}{10}$ in.
51.5 x 74 x 74 cm

First publication
Nordhorn 1996: 14-15, 88.

Notes
Alternate title: *3-Part
Pavilion with Chinese
Moon Gates. Pavilion Influ-
enced by Moon Windows*
has never been realized
as a large-scale pavilion
structure. Several
models were made as
permutations, one with six
sides, see cat. no. 107.1.
A large-scale variation, a
triangular structure with
moongate-inspired circular
openings, was first real-
ized in 1989, see cat.
no. 108.

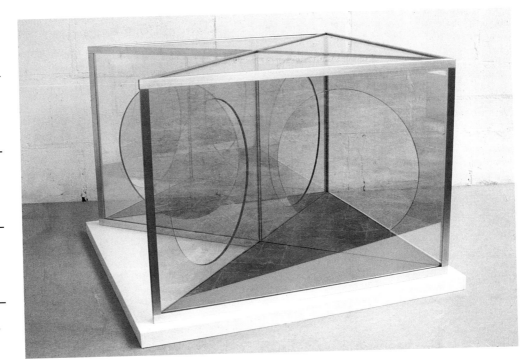

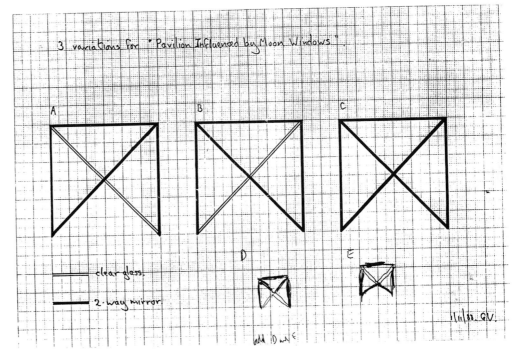

*Pavilion Influenced by Moon
Windows, 1989, architectural
model (top), drawing with
variations by Gary Woodley
(bottom).*

Chinese garden pavilions employed circular openings to frame a perspective of the next walled section of the garden. They were portals allowing access to the next enclosed section of the garden circuit. Strong overhead sunlight produced ellipsoid projections of both sunlight and shadows on the ground near the windows. The term 'moon windows' derived from the effect of moonlight: the wall would disappear in shadow while the shape of the circle as shadow would fall obliquely on the ground mimicking the moon overhead.

The moon window or moon gate represented heaven, dialectically contrasting with the rectangular wall it pierced, which was sym-

bolic of earth. The moon window opening in the walls of a Chinese garden functioned analogously to the iris of the eye, allowing a visual concentration on the next view. The moon gate opening made it necessary for visitors to step into the garden over the curved bottom of the circular form and to move straight towards the center of the composition.

In my *Pavilion Influenced by Moon Windows* this center of the composition is an image of the spectators themselves (and perhaps others just outside or inside the labyrinthian pavilion). Depending upon the overhead sky and sun (or lunar) conditions at a given moment, these half-transparent/half-mirrored two-way mirror walls show the superimposition of surrounding nature both through the pavilion walls and in front of the pavilion's opening in relation to the spectator's view of her/himself perceiving. In the modernist western tradition, the pavilion's

materials and the perceivers themselves in perceiving as viewers refer to their own optical/visual properties.

The pavilion simultaneously evokes the historical garden pavilion as type from the rococo mirror pavilion to the 19th century gazebo to urban bus shelters. The mirror rooms of rococo pavilions related the interior to the exterior and the exterior to the interior. They related sunlight to the material/optical qualities of mirrors and windows, and daylight to the artificial candlelight of night time. The sun rose and shone directly through an eastern window; it set along a path emanating from a western window. The sun's light turned the silvered mirrors and the entire room (including its intricate silver work of artificial foliage based on the landscape patterns outside) into the yellow of the sun. My pavilion also evokes the Indian and Pakistani architectural projects of Louis Kahn.

Nordhorn 1996: 88.

Title/Date
Model for Two-Way Mirror,
6-Sided, 6-Cut-Outs
1989

Architectural model
edition of 3
materials and dimensions
may vary over edition

Materials
two-way mirror, aluminum
frame

Dimensions
29¼ x 32 in.
74.3 x 81.4 cm
(height x diameter)

Model for Two-Way Mirror,
6-Sided, 6-Cut-Outs, 1989,
architectural model. Courtesy
Galerie Micheline Szwajcer,
Antwerp, Belgium.

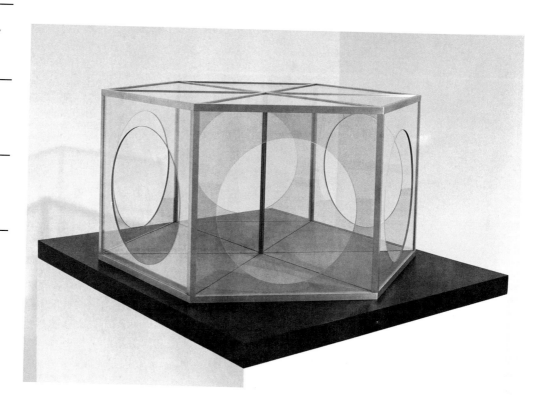

Title/Date
Triangular Solid with
Circular Inserts
1989

Materials
two-way mirror, clear
glass, aluminum

Dimensions
84 x 84 x 84 in.
213.4 x 213.4 x 213.4 cm

First publication
Nordhorn 1996: 16-19, 88.

First exhibition
Atlanta Contemporarary
Art Center, Atlanta,
Georgia. On permanent
display in front of Art
Center building since
1989.

Notes
Variation of *Pavilion Influ-
enced by Moon Windows*,
cat. no. 107, which takes
the form of a triangular
pavilion whose sides con-
tain circular openings or
cut-outs. *Triangular Solid
with Circular Inserts* is a
work whose concept gen-
erates the possibility of
multiple permutations. To
date, four large-scale
pavilion structures have
been realized, see cat.
nos. 121, 146, 147. Archi-
tectural models in at least
two different sizes have
been made, see cat. nos.
108.1, 108.2. The first
realization of the triangular
pavilion was in 1989 as
an outdoor pavilion for
Atlanta Contemporary Art
Center, Atlanta, Georgia,
formerly called Nexus, and
resides in their collection.

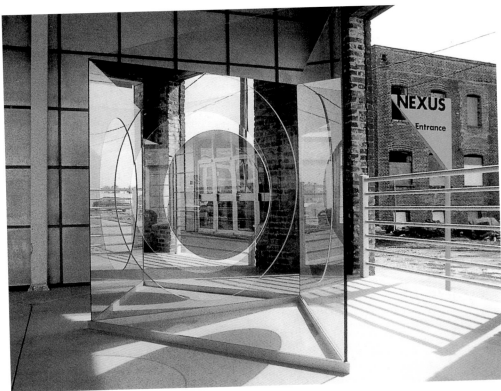

*Triangular Solid with Circular
Inserts*, 1989. Collection
Atlanta Contemporary Art
Center, Atlanta, Georgia, USA.

Triangular Solid with Circular Inserts is an
equilateral solid triangle with a circular
central opening allowing the spectator to
enter and have an interior view. There are
equally sized circles of glass centered in
relation to the side of the triangle and to
the central opening. The opening side is
transparent glass. The left side is two-way
mirror and the circular insert is mirror on
both sides. The right side is transparent
glass and the circular insert is two-way
mirror. This piece also refers to Chinese
garden pavilions as described in *Pavilion
Influenced by Moon Windows*.

Nordhorn 1996: 88.

108.1 1989

Title/Date
Model for Triangular Solid
with Circular Inserts
1989

Architectural model
edition of 3
materials and dimensions
may vary over edition

Materials
aluminum, glass, two-way
mirror

Dimensions
34 1/4 x 34 1/4 x 30 in.
87 x 87 x 76 cm

108.2 1989

Title/Date
Model for Triangular Pavil-
ion Influenced by Moon
Windows
1989

Architectural model
edition of 3
materials and dimensions
vary over edition

Materials
aluminum, glass,
two-way mirror

Dimensions
20 1/3 x 20 2/3 x 18 in.
51.7 x 52.5 x 45.5 cm

*Model for Triangular Solid
with Circular Inserts*, 1989,
drawing with variations by
Gary Woodley.

Title/Date
Star of David Pavilion
1989

Materials
two-way mirror, cement

Dimensions
86²/₃ x 102¹/₃ x 157¹/₂ in.
220 x 260 x 400 cm

First publication
Documentation, Hamburg-Projekt, 1989. See also
Nordhorn 1996: 52-53,
94-95.

First exhibition
'Hamburg-Projekt,'
Hamburg, October 13 –
November 11, 1989.

Notes
Alternate title: *Double
Triangular Pavilion for
Hamburg,* 1989. The work
was realized in 1989 for
'Hamburg-Projekte,' 1989
and since May 1990 is
installed in a park,
Fährhausstrasse, Aussen-
alster, Hamburg-Uhlen-
horst. Architect: Erik
Recke, Hamburg.

Enterable through a sliding door, this pavil-ion is for nonspecific public use. The re-flective glass of the sides of the pavilion makes all of its surfaces quasi-reflective and quasi-transparent at the same time. Reflections of people within are superim-posed for them to view upon images of the surrounding exterior environment (and exterior and other interior spectators). But the amount of reflectiveness of the interi-or surface as against the transparency of the exterior surface (viewed by the interior spectator) is in continual moment to moment flux.

[…] This pavilion leaves three triangular areas at the corners of the roof uncovered by the opaque roof. Under strong over-head sun, an intense kaleidoscopic effect of reflections of these wedges of intense light produce illusionistic, seemingly multi-dimensional patterns on the glass sides of each of the pavilion's interior corners. Sit-ed adjacent to the Alster, the reflective glass of the pavilion reflects the flowing water on its interior and exterior. The water can be compared to the semi-reflective/semi-transparent glass of the pavilion in that both change as to image and reflective qualities relative to light and environment conditions. The semi-reflec-tive walls reflect the spectators' bodies and eyes in the sculpture's material sup-port. They can perceive themselves per-ceiving; or they may perceive themselves as the subject of the perception of other (interior or exterior) spectators.

The reflective glass deliberately alludes to the facades of modern corporate and bureaucratic administrative buildings in the surrounding city, while reflecting the nature of Arcadian, utopian aspects of the pleasur-able park setting. The overhanging roof alludes to the shape of 1950s small restau-rants or imbisses in large parks; the general configuration of the two superimposed equi-lateral triangles, one 45° rotated, derives from Jewish and Islamic religious symbolism.

This version is slightly abridged. *Nordhorn* 1996: 94-95.

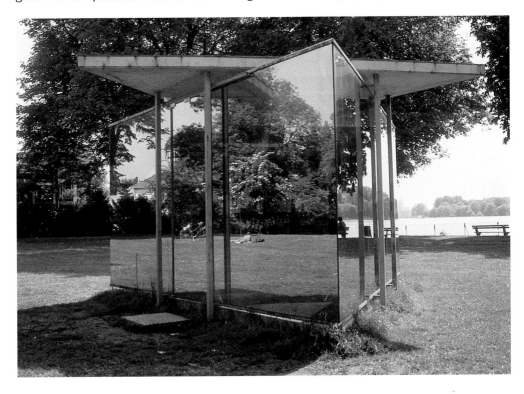

Star of David Pavilion, 1989.
Collection Stadt Hamburg-
Uhlenhorst, Germany.

109.1 1989

Title/Date
Star of David Pavilion
1989

Architecutral model
edition of 3
materials and dimensions
may vary over edition

Materials
glass, aluminum

Dimensions
$14^3/_4$ x $26^1/_3$ x $26^1/_3$ in.
37.5 x 67 x 67 cm

110 1989

Title/Date
Pavilion for Krefeld,
Version 1:
Two Dimensional Glass
Triangle over Reflective
Solid Triangle
1989

Architectural model
unique

Materials
glass, partially mirrored
glass, aluminum

Dimensions
circa
$15^3/_4$ x $31^1/_2$ x $15^3/_4$ in.
40 x 80 x 40 cm

First publication
Skulpturen für Krefeld I.
Exh. cat. Krefeld:
Museum Haus Esters,
1989: 62-65.

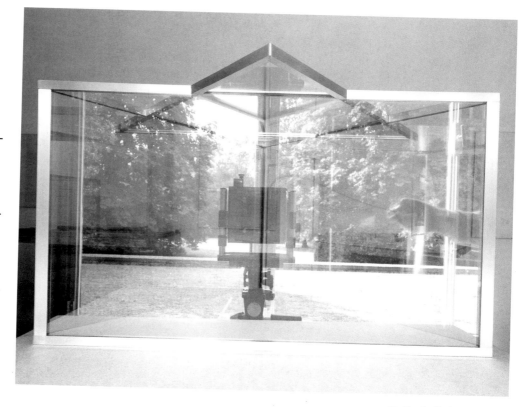

*Pavilion for Krefeld, Version
1: Two Dimensional Glass
Triangle over Reflective Solid
Triangle*, 1989, architectural
model. Courtesy Museum
Haus Esters, Krefeld,
Germany.

110 1989

First exhibition
'Skulpturen für Krefeld I,'
curated by Julian Heynen,
Museum Haus Esters,
Krefeld, September 3 –
October 22, 1989.

Notes
For the exhibition 'Skulp-
turen für Krefeld I,' Graham
developed two proposals,
both based on triangular
forms. The proposed site
was a triangular meadow
in the Kaiserpark in
Krefeld, situated at a
crossroads nearby a small
bridge. Both triangles had
one angle oriented
towards the bridge. Both
pavilions would feature
two-way mirror glass
framed in steel, with an
entrance of one or two
sliding doors and house
around four spectators,
measuring 2.4 m high and
4-6 m in length. The equi-
lateral triangle features a
shifted roof plane. The
second proposal features
two joined triangular
forms, which from the out-
side appear to enclose a
single space, but the
structure, is actually divid-
ed into two interior cham-
bers by a mirrored wall.
Neither proposal was real-
ized.

110.1 1989

Title/Date
Pavilion for Krefeld,
Version 2:
Two Equilateral Reflective
Glass Solid Triangles with
One Shared Side
1989

Architectural model
unique

Materials
glass, partially mirrored
glass, aluminum

Dimensions
circa
15³/₄ x 23²/₃ x 23²/₃ in.
40 x 60 x 60 cm

First publication
Skulpturen für Krefeld I.
Exh. cat. Krefeld:
Museum Haus Esters,
1989: 62-65.

First exhibition
'Skulpturen für Krefeld I,'
curated by Julian Heynen,
Museum Haus Esters,
Krefeld, September 3 –
October 22, 1989.

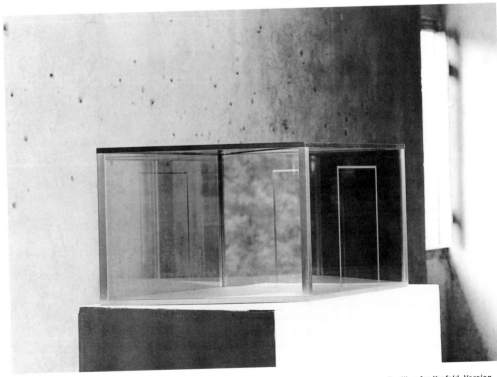

*Pavilion for Krefeld, Version
2: Two Equilateral Reflective
Glass Solid Triangles with
One Shared Side*, 1989,
architectural model. Courtesy
Castello di Rivara, Italy.

Title/Date
Proposal for Gift
Shop/Coffee Shop
1989

Architectural model
edition of 3
materials and dimensions
may vary over edition

Materials
aluminum, glass

Dimensions
14⁴/₅ x 22 x 38¹/₅ in.
37.6 x 56 x 97 cm

First publication
Nordhorn 1996: 62-63;
text 96-97.

Notes
This proposal was never realized as a functional pavilion structure/coffee bar. Also known as *Walkway for Munich Airport*. It was first proposed for the Munich Airport in Erdinger Moos in 1989. It was also proposed for the plaza of the Stuttgarter Southwest airport. For documenta IX an alternate parallelogram structure was realized in 1992, see cat. no. 123. Models in several sizes were made, for example see cat. no. 111.1. An indoor pavilion *Gift Shop/Coffee Shop* was made to the proposed scale of the parallelogram structure by the Lisson Gallery, London in 1989.

Two structures are proposed. The first structure is an open pyramidal form with a triangular passage or gateway through which spectators can walk. It is part of or attached to an existing firewall which would be clad with a continuous mirror. The wall is located in the main departure lounge.

The second art work, located approximately fifty meters from the pyramidal form and attached to the wall in the center of the main hall, consists of two equilateral, solid triangular forms or a parallelogram, bisected by a wall into two triangular spaces. Each space can be entered through a mechanically activated sliding door.

The two connected pavilions function as extensions of an adjacent coffee bar as an eating and resting area. Each wall is eight meters long with a height of 2.4 meters. All walls, five in all, are reflective glass. The open pyramid, whose apex nearly reaches to the upper edge of the side windows, is made of reflective glass. Its third side (the mirror wall is its second side) lies on the floor and is either mirrored stainless steel or water contained in a stainless steel basin. In either instance, the stainless steel plane or the water is covered by stainless steel tracks, enabling anyone to easily walk over its surface. People can pass through an open triangular gate from either side. Note that the open pyramidal form consists of a dialectic between the three different states of mirror materials which constitute its sides: a conventional mirror, a reflective glass mirror, and water which is walked on. The sides of the open pyramid are prismatically self-reflective. The form reflects images of the spectator walking through it from the bottom and left and right sides. It also reflects the skyscape from the windows and the structure of the overhead architecture. People on the overhead walkway can look down and see their images

reflected in the forms in relation to images of downstairs spectators. The work is constructed in terms of a dialectic between three mirror reflective materials/surfaces, each constituting one side of the pyramid. The mirror wall relates to the two-way mirror (half mirror and half transparent) and to the water or grating laid out on the floor of the walkway.

The coffee bar/pavilion/sculpture interiors […] are provided with comfortable chairs, stools and tables for coffee and snacks, and serve as simple quiet resting places. Their enclosure ensures seclusion from the restless flow of human traffic in the airport. The reflective glass dividers show the spectators within images of themselves experienced prismatically, and also superimposed on other levels of prismatic reflections of the surrounding exterior architecture and images of the sky outside the airport.

The specific light coming through the skylight and windows affects the relation of the superimposed outside reflected images to the images of the spectators' bodies in the pavilion's interior. As this exterior light depends upon the cloud conditions and time of day, the mirror-reflective quality of the space as against its transparency varies continually. The relation of both the interior and exterior glass walls' optical characteristics to the surrounding architectural context and the self-reflections of spectators both inside and outside is mutable.

This version is slightly abridged. *Nordhorn* 1996: 96-97.

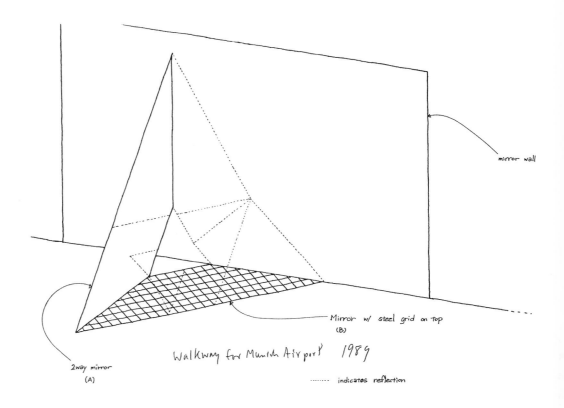

mirror wall

Mirror w/ steel grid on top
(B)

Walkway for Munich Airport 1989

2 way mirror
(A)

········ indicates reflection

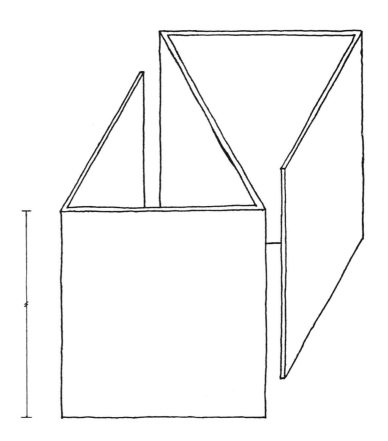

Proposal for Gift Shop/
Coffee Shop with *Walkway*
for Munich Airport, 1989,
drawings.

111.1 1989

Title/Date
Gift Shop/Coffee Shop
1990-91

Architectural model
edition of 3
materials and dimensions
may vary over edition

Materials
semi-reflective glass,
transparent glass, wood

Dimensions
23²⁄₃ x 70⁴⁄₅ x 39¹⁄₃ in.
60 x 180 x 100 cm

Gift Shop/Coffee Shop,
1990-91, architectural
model. Courtesy Galerie
Roger Pailhas, Marseille,
France.

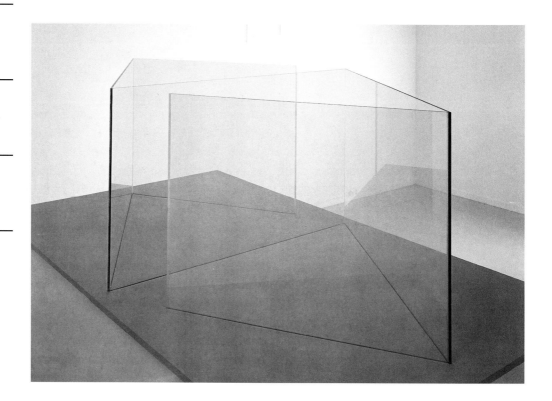

W 1989

Writings

'Garden as Theater as Museum,' in *Theater-garden Bestiarium*: The Garden as Theater as Museum. Exh. cat. Long Island City, NY: The Institute for Contemporary Art, P.S. 1 Museum and MIT Press, 1990: 53-64.

Artists' statement in section 'Forum – 1989,' *M/E/A/N/I/N/G* no. 5 (1989): 9.

Graham, Dan, and Jeff Wall. *A Guide to the Children's Pavilion.* Exh. brochure. Santa Barbara: Santa Barbara Contemporary Arts Forum, 1989: n.p.

Title/Date
Two-Way Mirror Pergola
Bridge
1988-90

Materials
two-way mirror, glass,
steel, aluminum

Dimensions
118 x 133⁴/₅ x 169²/₅ in.
300 x 340 x 430 cm

First publication
*Sixièmes ateliers interna-
tionaux des Pays de la
Loire 1989. Les grâces de
la nature.* Exh. cat. Clis-
son, Nantes: FRAC des
Pays de la Loire, 1989:
10-11. Text first published
Nordhorn 1996: 91,
see also 32-35.

First exhibition
'Les grâces de la nature,'
FRAC des Pays de la Loire,
Clisson, France, Summer
1989.

Notes
This work was conceived
in 1988 and realized tem-
porarily for the exhibition
'The Graces of Nature,' in
the Park La Garenne
Lemot, Clisson. Collection
FRAC des Pays de la Loire,
Nantes, in addition to one
scotch tape model.

It is proposed to create a bridge sculpture.
There are two possible ways to do the
bridges – one has a wood or aluminum
lattice from which ivy or any climbing
plants could grow and the other has two-
way mirror sides. As at least two of three
surfaces should be reflective, the lattice
version would only work if a very reflective
area of the river was visible beneath the
steel grid walkway. It was calculated that
the best situation would be an equilateral
triangular form whose three sides were
about ten feet in length or width. The
shorter the bridge the better. Ideally there
would be an entire plane of two-way mirror
glass, but if it must be broken in two
lengths, the break should be in the middle
of the bridge span, on the vertical.

Nordhorn 1996: 91.

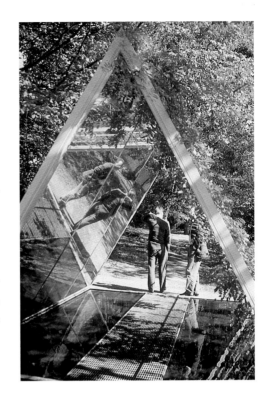

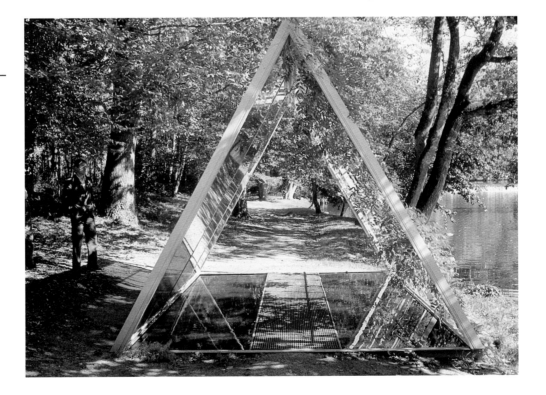

*Two-Way Mirror Pergola
Bridge*, 1988-90, two views.
Collection FRAC des Pays de
la Loire, Nantes, France.

Title/Date
Triangular Bridge Over
Water
1990

Materials
reflective laminated glass,
anodized aluminum,
concrete, painted steel,
vines

Dimensions
84 x 192 x 120 in.
213.4 x 487.7 x 304.8 cm

First publication
Laumeier Sculpture Park.
Ten Sites: Works, Artists,
Years. Exh. cat. St. Louis:
Laumeier Sculpture Park,
1992: 98-105.

First exhibition
Long-term site-specific
installation realized in
1990 as part of the exhi-
bition project 'Ten Sites,'
1980-1990, Laumeier
Sculpture Park, St. Louis,
Missouri, 1992.

Notes
This piece is a variation on
Two-Way Mirror Pergola
Bridge, Clisson, 1989-90,
cat. no. 112 and was com-
missioned by the Laumeier
Sculpture Park, St. Louis,
Missouri as a site-specific,
permanent installation as
part of the series 'Ten
Sites,' which brought ten
artists and workers from
the County Parks Depart-
ment together in colla-
boration. Two scotch tape
models were made in
1989 and given to the
Laumeier Sculpture Park.

Triangular Bridge Over
Water, 1990. Collection
Laumeier Sculpture Park,
St. Louis, Missouri, USA.

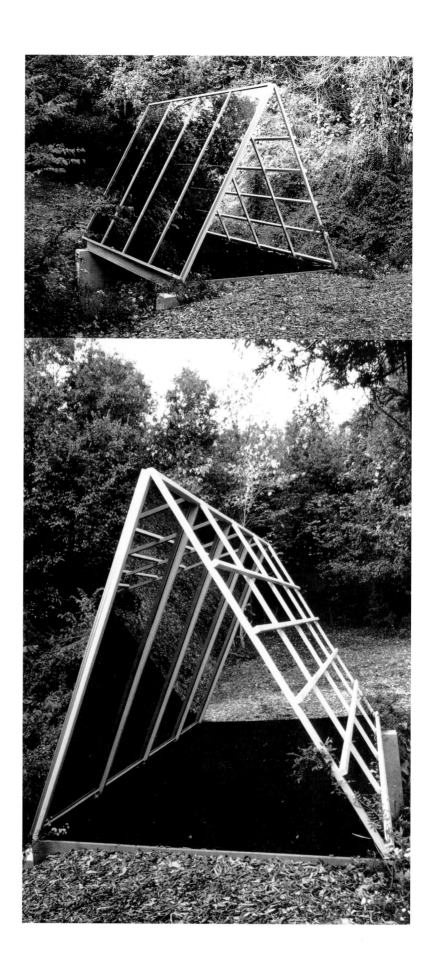

Title/Date
Two-Way Mirror Triangular
Pavilion with Shoji Screen
1990

Materials
two-way mirror, glass,
stainless steel, wood

Dimensions
98³⁄₈ x 98³⁄₈ x 98³⁄₈ in.
250.8 x 250.8 x 250.8 cm

First publication
Dan Graham. Exh. cat.
Yamaguchi City: Yama-
guchi Prefectural Museum
of Art, 1990: 5-11. Text
also published in *Private/
Public* 1993: 42 and
Nordhorn 1996: 95-96.

First exhibition
'Dan Graham,' Yamaguchi
Prefectural Museum of Art,
Yamaguchi City, Japan,
September 6 – 24, 1990.

Notes
This work was realized for
the Yamaguchi Prefectural
Museum in 1990. It was
first publised under the
title: *Two-Way Mirror and
Open Wood Screen Trian-
gular Pavilion*, 1990 and
later published as *Two-
Way Mirror Triangular
Pavilion with Shoji Screen*,
1990 in *Nordhorn* 1996:
56-59. Collection
Yamaguchi Prefectural
Museum of Art.

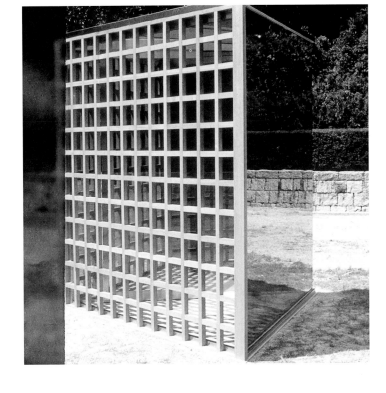

*Two-Way Mirror Triangular
Pavilion with Shoji Screen,
1990*. Collection Yamaguchi
Prefectural Museum of Art,
Yamaguchi City, Japan.

The work is a hybrid, one side derived from traditional Japanese architecture and two, two-way mirror sides, associated with modern corporate architecture. While the wood open grid functions as a physical barrier in part to people's gazes and access to either side, the effect of the two-way mirror is optical, cinematic and hallucinatorially involved with the psychological process of the spectator's perception.

Two-way mirror is both reflective and transparent. The side which receives more light (sunlight in this instance) will be more reflective than transparent, due to the continual sky changes; at a given moment this is always in a state of flux. The work shows the perceptual process of the spectators. The spectator outside or inside the pavilion will see other people inside or outside looking. Spectators might focus on the gazes of other spectators or at their own gazes in relation to the optics of the pavilion and to other's gazes. Visual relations are also affected when the spectator opens, closes or half-closes the door to one of the two-way mirror sides.

Two-Way Mirror and Open Wood Screen Triangular Pavilion as an architectural type derives from the 'primitive hut,' symbolic elemental shelters built from tree trunks and branches proposed by eighteenth-century theorists as an antidote to the confusion and artifice of the emerging bourgeois city. It also evokes small, wood temples used for meditation in Japanese temple garden complexes. In the theories of Marc-Antoine Laugier, following the thought of Jean-Jacques Rousseau, the 'primitive hut' symbolized a return to nature in its primary state and to architecture as it first emerged in the temples of Greek culture. The elementary Greek column was an abstraction of the tree trunk. By making one side of my structure 'traditional' wood, while the other sides use the material

which mediates the modern high-rise office building in the new city to the public and to its workers inside the form, a hybrid is created. The two-way mirrors of the pavilion reflect the rear sheer glass wall of the museum, an example of modern urban architecture, while also reflecting the transitory state of the reflection as against the relative transparency of nature and the spectator's perceptual process. The spectator inside, gazing at the corners of the form, sees a kaleidoscope-like reflection and re-reflection of nature which suggests, like a child's kaleidoscope, visual pleasure in excess as opposed to the monolithic and subtly alienating effects of the two-way mirror office building.

One two-way mirror side of my pavilion is angled parallel, but slightly acutely to the museum's glass wall. In the late afternoon, spectators looking out through the glass wall and spectators looking at the pavilion's two-way mirror walls from inside or outside the pavilion see, superimposed on the wooden lattice of the pavilion, images of a modern Japanese artist's sculpture placed just inside near the window.

Yamaguchi 1990: 10.

114.1 1990

Title/Date
Model for Triangular
Pavilion with Shoji Screen
1990

Architectural model
edition of 3
materials and dimensions
may vary over edition

Materials
glass, aluminum, maple
wood

Dimensions
34 1/4 x 34 2/5 x 30 in.
87 x 87.5 x 76 cm

*Model for Triangular Pavilion
with Shoji Screen, 1990,
architectural model. Private
collection, Dallas, Texas, USA.
Courtesy Lisson Gallery,
London, UK.*

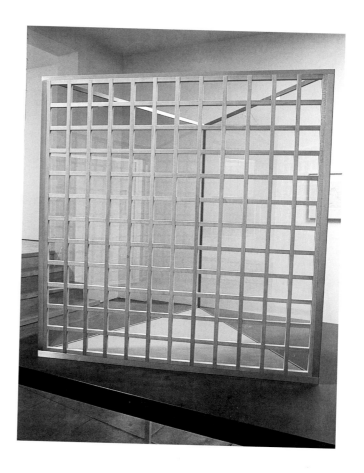

Title/Date
Triangular Pavilion Inside
Triangular Pavilion
1990

Architectural model
edition of 3
materials and dimensions
may vary over edition

Materials
two-way mirror glass

Dimensions
$34^2/_3$ x $34^2/_3$ x $34^2/_3$ in.
88 x 88 x 88 cm

First publication
Yamaguchi 1990: 23.

Notes
This work was never
realized as a large-scale
pavilion structure. A
photograph of the archi-
tectural model in two-way
mirror on a pedestal with
an accompanying drawing
for a pavilion with a sliding
door were published in
the *Yamaguchi* 1990
catalogue.

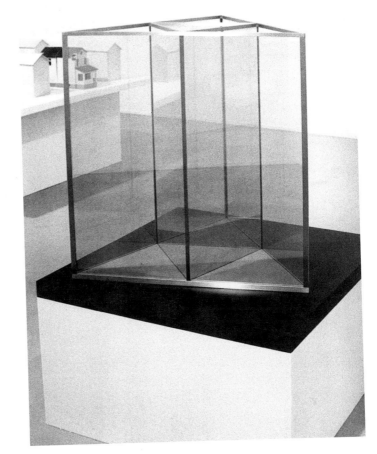

*Triangular Pavilion Inside
Triangular Pavilion*, 1990,
architectural model.

W 1990

Writings

'Video in Relation to Architecture,' in *Illuminating
Video: an Essential Guide to Video Art.* Eds.
Doug Hall and Sally Jo Fifer. New York: Aperture
Foundation, Inc. in association with Bay Area
Video Coalition, 1990: 168-188.

Title/Date
Two-Way Mirror Cylinder
Inside Cube and a Video
Salon: Rooftop Urban Park
Project for Dia Center for
the Arts, New York
1981/91

Materials
two-way mirror, glass,
steel, wood, rubber

Dimensions
108 x 432 x 432 in.
274.3 x 1097.3 x 1097.3 cm;
video salon and café:
144 x 276 in./366 x 701 cm

First publication
*Dan Graham: Two-Way
Mirror Cylinder Inside
Cube and a Video Salon.*
New York: Dia Center for
the Arts and Dan Graham,
1992. Video of long-term
exhibition and printed
catalogue. Video: color,
sound, 19:34 minutes.
Directed by Michael
Shamberg. Music by Glenn
Branca. Catalogue, edited
by Karen Kelly, includes
the text, 'Urban Allegory:
Museum/Park as Micro-
cosm of the City' by
Graham and foreword by
Charles Wright. See also
*Dan Graham: Rooftop
Urban Park Project.* New
York: Dia Center for the
Arts, 1992. Brochure with
text by Lynne Cooke. Gra-
ham's text on the work
first published in: 'Two-
Way Mirror Cylinder Inside
Cube and a Video Salon:
Rooftop Urban Park Pro-
ject for Dia Center for the
Arts,' in *The End(s) of the
Museum.* Exh. cat.
Barcelona: Fundació
Antoni Tàpies, 1991:
126-128. See also *Two-
Way Mirror Power* 1999:
165-167.

First exhibition
'Rooftop Urban Project,'
Dia Center for the Arts,
New York, opened
September 12, 1991.

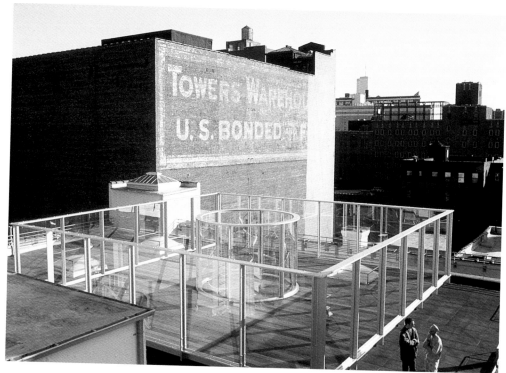

*Two-Way Mirror Cylinder
Inside Cube and a Video
Salon: Rooftop Urban Park
Project for Dia Center for the*
*Arts, New York, 1981/91.
Collection Dia Center for the
Arts, Dia Foundation, New
York, USA.*

Model for a piece conceived as an out-
door pavilion. The external shapes of the
internal cube and cylinder are made of
two-way mirror. It is possible to see
through both shapes from the inside and
the outside, depending on varying lighting
conditions. Spectators can enter either of
the two shapes through sliding doors. A
spectator watching his own reflection from
the inside of the cylinder will see his own
image anamorphically distorted. This dis-
tortion will change as the spectator
changes position.

Dan Graham. Exh. cat. Madrid: Centro de Arte Reina Sofia,
Ministerio de Cultura 1987: 28.

This project took as its program the recon-
figuration of the function of the museum
space of the Dia Center for the Arts in New
York City as a social and artistic showing
space, while at the same time it functioned
as an autonomous artwork within the exist-
ing Dia program of elite artists realizing
perfect works under ideal conditions.

The piece is both an optical device and an
architectural modification of a previously
unused rooftop, giving the Dia exhibition
complex a variety of new functions.

The Dia spaces had previously been used
as interior, meditative, 'ideal' showing
spaces for 'great' art works or installations,
meant to be viewed by single spectators,
under prime showing conditions. My work
necessitates a large public audience
aware of each other's, as well as their
own, gazes at the art works under continu-
ally altering outdoor solar and sky condi-
tions.

The work is an open-air, or roof-top park,
performance space, observatory/camera
obscura/optical device/video and coffee
bar/lounge, with multi-use possibilities.

In the center of the roof is a raised board-
walk-like wooden platform containing a
two-way mirrorized cylinder with a door
allowing spectators to enter its interior.
The interior view shows spectators a con-

Notes
First conceived as *Cylinder Inside Cube,* 1986. *Cylinder Inside Cube* is dated 1981/91 in the Dia catalogue. The pavilion is dated 1981/1988-91 in *Nordhorn* 1996. Realized in 1991 as a long-term exhibition, curated by Gary Garrels, Director of Programs at Dia until 1991, with Lynne Cooke, Karen Kelly and James Schaeufele. Architects: Mojdeh Baratloo and Clifton Balch, New York. Collection Dia Center for the Arts, Dia Foundation, New York. The press release (August 16, 1991, Dia Center for the Arts) states that a monitor will be set up in the café/video viewing room showing five pre-selected video programs (chosen by the artist) for at least the first year following the opening of the work: 'Architectural Video,' 'Fairy Tale and Narrative,' 'An Anthology of Performance,' 'Cartoon and Animation,' and a selection of videos by Graham.

cave, enlarged anamorphic view of themselves against the sky and urban landscape. The exterior view shows spectators a convex anamorphic view of themselves. At the margin of the raised platform is a two-way mirror cube. The cylinder is centered on and has the same dimension as an overhead New York City wooden water tower. It reflects the 360° surrounding sky horizon line. The cube represents the urban grid of the New York mid-town street plan.

There is a dialectic between the perception of oneself and other bodies perceiving themselves, making the spectator conscious of him or herself as a body, as a perceiving subject, in isolation from an audience. This reverses the usual loss of 'self' that occurs when a spectator looks at a conventional work of art, where the 'self' is mentally projected onto and therefore identified with the subject of art. My sculpture/pavilions call attention to the look of the spectator, who becomes the subject of the work. A two-way mirror and steel structure is an analogue of the surrounding city. The two-way mirror has 'cinematic' special effects.

My sculpture/pavillions allude to modern office buildings. The 1980s corporate office building's two-way mirror glass facades are one-way reflective on the outside (reflecting the sky and other building facades) and do not allow visual penetration by the spectator of the interior, but give the interior viewer a transparent view of the exterior. My pavilions subject this one-way relation to a serious transformation, being equally transparent and reflective both inside and outside. The changes in overhead sunlight affected by altering cloud-cover continuously alter the relation between reflectivity and transparency of each side.

The Dia roof plan alludes to the solar lighted atriums extending 1980s corporate office building lobbies with a video/coffee lounge developed from an existing roof storage space. The central area is raised to give a better view of the Hudson River and the surrounding city skyline above the obstrusive existing skylight domed top.

My work requires a large, socially self-aware public audience, in contradiction to the Dia's 1970s and 1980s meditative interior, with its artificially well-lighted, perfect viewing conditions.

Programmatically, I also intended my 'installation' to modify Dia's function, in order to initiate its transition into a 90s merging of 70s alternative space – like its geographically adjacent neighbor, The Kitchen, which features work by a large variety of artists working in video, performance, and music – with 80s corporate atrium 'museum' spaces like the IBM atrium or the Wintergarden in the New Financial Center in Battery Park City, which also incorporate park-like settings and coffee and pastry bar concessions. To facilitate the historical links to video, music and performance works featured in spaces such as The Kitchen, I organized a program at Dia which purchases and screens an archive of videos selected by guest curators, focusing on music, performance, animation and architecture.

My original plans for the design of indoor (coffee/video lounge) inflatable two-way mirror furniture, giving a soft, intersubjective body feeling analogous to the 'hard' effects of the two-way mirror glass surfaces, have proved temporarily unrealizable, but are still being researched.

Dan Graham, 'Two-Way Mirror Cylinder Inside Cube and a Video Salon: Rooftop Urban Park Project for Dia Center for the Arts,' in *The End(s) of the Museum.* Exh. cat. Barcelona: Fundació Antoni Tàpies, 1991: 126-128.

116.1 1991

Title/Date
Cylinder Inside Cube
1986

Architectural model
edition of 3
materials and dimensions
may vary over edition

Materials
two-way mirror, glass,
aluminum

Dimensions
$16\frac{1}{2}$ x 41 x $40\frac{1}{2}$ in.
42 x 104 x 103 cm

Notes
This model is the initial
concept for *Two-Way Mir-
ror Cylinder Inside Cube
and Video Salon: Rooftop
Urban Park Project for Dia
Center for the Arts*, New
York, 1981/91, dating the
concept to 1981, though
the model was made in
1986, see cat. no. 116.

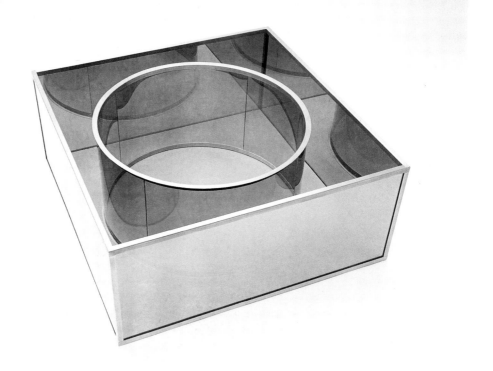

Cylinder Inside Cube, 1986,
architectural model. Flick
Collection, St. Gallen,
Switzerland.

Title/Date
Heart Pavilion
1991

Materials
two-way mirror glass,
aluminum

Dimensions
94 x 196⁴/₅ x 196⁴/₅ in.
240 x 500 x 500 cm

First publication
*Carnegie International
1991.* Ed. Lynne Cooke
and Mark Francis. Exh.
cat. Pittsburgh: The
Carnegie Museum of Art,
1991: Vol 1: 78-79. Vol-
ume two of the catalogue,
completed later, includes
an image of the realized
work: 46-47. The text was
written in 1991 and first
published *Nordhorn*
1996: 98. It was reprinted
in *Two-Way Mirror Power*,
1999: 172-173.

First exhibition
'1991 Carnegie Interna-
tional,' October 19, 1991
– February 16, 1992,
curated by Lynne Cooke
and Mark Francis, The
Carnegie Museum of Art,
Pittsburgh.

Notes
This work was realized for
the '1991 Carnegie Inter-
national' and is now in the
collection of The Carnegie
Museum of Art, Pittsburgh.

*Heart Pavilion, 1991,
installation for '1991
Carnegie International.'
Collection of The Carnegie
Museum of Art, Pittsburgh,
Pennsylvania, USA.*

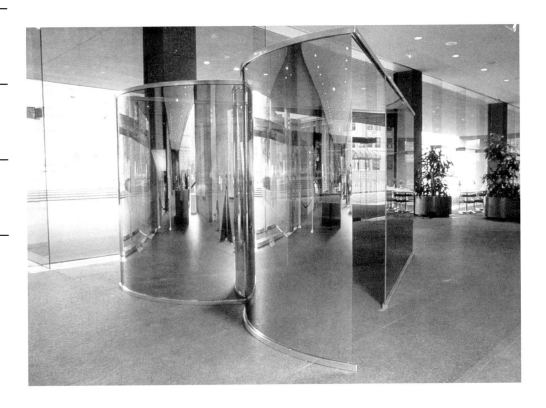

Contemporary art museums function as locations for romantic rendezvous, just as 18th century landscape gardens encouraged purposeful strolling, punctuated by pauses at pavilions and arbors. The form of this sculpture comes from a popular symbol for Valentine's Day. It is a romantic abstraction of an anthropometric form which can serve as a meeting point. Here the two-way mirror glass pavilion is in a lobby or corridor space which generally is a dead space for art, but is related to the look of recent atria in corporate buildings or hotels, with their plants, reflective surfaces, and curved columns, in which an illusory space, neither inside nor outside, is constructed.

All my glass pavilions are made in relation to architectural forms as well as to the sculptural (haptic) and visual (optic) senses. In its siting, this pavilion is deliberately positioned between the glass entrance doors of the museum and a reflective silver painting, Andy Warhol's *Elvis Eleven Times*, mounted on a dark granite surface opposite. Its aggressive American subject contrasts with the function of the pavilion. Looking at the hemispherical reflections on one side of the triangular pavilion, the viewer on the inside sees a distorted double image of him or herself. From the outside the viewer sees two convex images, squeezed together like the effects of a fish-eye lens. Where the two curved mirror glass sheets meet a strange illusion occurs – another mirrored column appears. At the corner of the triangle are prismatic reflections and secondary reflections of the anamorphic reflections. Both inside and outside spaces are in constant flux according to the changing light conditions and the position of the sun, which affects the reflection and transparency of the glass.

Rectangular and cylindrical forms repeatedly occur in the work. This piece relates to my early film *Body Press* (1970-1972), in which two cameras form rectangular framing elements and human figures circle around each other within a cylinder. In all

my work – whether in the fields of video, film, and performance or in the sculptural/ architectural pavilions – geometric forms are inhabited and activated by the presence of the viewer, and a sense of uneasiness and psychological alienation is produced by a constant play between feelings of inclusion and exclusion.

Nordhorn 1996: 98.

117.1 1991

Title/Date
Heart Pavilion
1991

Architectural model
edition of 3
materials and dimensions
may vary over edition

Materials
two-way mirror, aluminum

Dimensions
25²/₃ x 25¹/₄ x 35 in.
65 x 64 x 89 cm

Heart Pavilion, 1991,
architectural model. Courtesy
Lisson Gallery, London, UK.

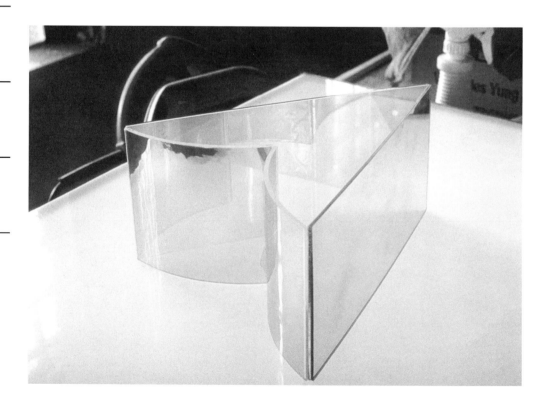

Title/Date
Robert Mangold Pavilion
1990-91

Materials
two-way mirror, aluminum,
sliding door

Dimensions
98½ x 118 in.
250 x 300 cm

First publication
Nordhorn 1996: 70-71, 97.

First exhibition
'Dan Graham,' Galerie
Roger Pailhas, Marseille,
June 28 – July 31, 1991.

Notes
According to Graham this
pavilion structure was
inspired by the work of
Robert Mangold, especial-
ly the work of the late
1960s and 1970s. Two
paintings by Mangold are
among the works in Gra-
ham's private collection:
½ Brown Circle Area,
1967 and *Straight Curved
Bent Line X Set (Grey)*,
1971. The form relates to
*Parabolic Triangular
Pavilion* I cat. no. 139.

All sides of the pavilion are of two-way mir-
ror glass. The work is a triangle whose
straight sides meet at 30° and whose third
side is curved. The straight sides are each
twice the length of the curved side (if the
curved side were straight). The pavilion
can be entered by a sliding door on one of
the straight sides.

Nordhorn 1996: 97.

Robert Mangold Pavilion,
1990-91. Installation
Museum Villa Stuck, Munich,
1994. Collection Galerie
Roger Pailhas, Marseille,
France.

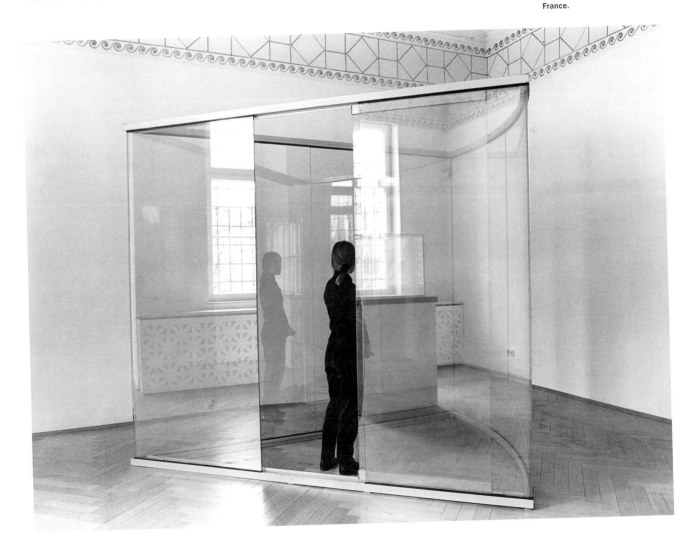

118.1 1991

Title/Date
Model for Robert Mangold
1990

Architectural model
edition of 3
materials and dimensions
may vary over edition

Materials
two-way mirror glass,
aluminum

Dimensions
34¼ x 34¼ x 50 in.
87 x 87 x 109 cm

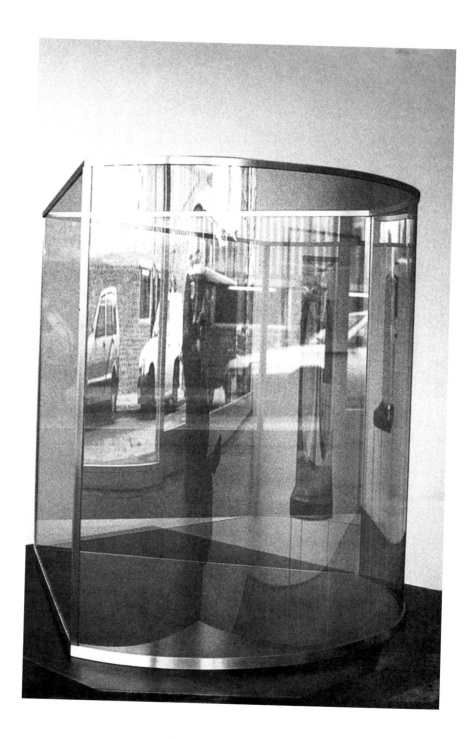

Model for Robert Mangold,
1990, architectural model.

119 1991

This three-sided pyramidal enclosure in two-way mirror is an outdoor entrance/exit lobby approached via an upward spiraling walkway from an underground parking garage of a modern apartment house. The spectator emerges spiraling into the sky; landscape and self-image are mixed pris-matically by the pyramid form emerging onto the front lawn. People outside the pyramid have an overhead view of their own bodies and of their own view of fig-ures spiraling upward.

Nordhorn 1996: 92.

Germany, above a stair-
case which leads to an
underground parking facili-
ty. Architect: Erik Recke,
Hamburg.

*Open Two-Way Mirror
Pyramid for Günter Steinle,
1991, detail of architectural
drawing by Erik Recke.*

120 1991

Sited as a resting place with one or two benches provided, this was to be located for pedestrians crossing a large bridge tra-versing a major roadway and railway line. The work combines the traditional land-scape or modern 'suburban' landscape garden hedge boundary with both trans-parent and two-way mirror glass. The re-sulting hybrid creates a continuously shift-ing optical surface emblematic of the modern urban corporate office building facade and the baroque garden maze.
The effect of the changing sunlight illumi-nation produces mirror 'ghosts' of specta-tors on either side of the two-way mirror glass/conventional glass or hedge. The viewers see images of themselves gazing and other spectators gazing either at themselves or at them.

Nordhorn 1996: 93.

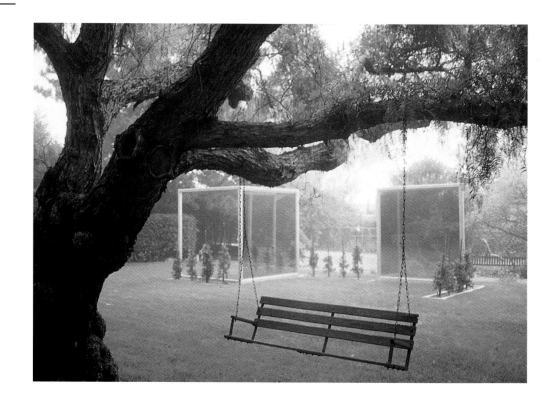

*Two-Way Mirror Hedge
Labyrinth*, 1989-1991.
Collection Robert Orton, La
Jolla, California, USA.

120.1 1991

Title/Date
Two-Way Mirror Hedge
Labyrinth
1989

Architectural model
edition of 3
materials and dimensions
may vary over edition

Materials
aluminum, glass, chrome,
metal

Dimensions
6⅓ x 43⅓ x 48 in.
16 x 110 x 122 cm

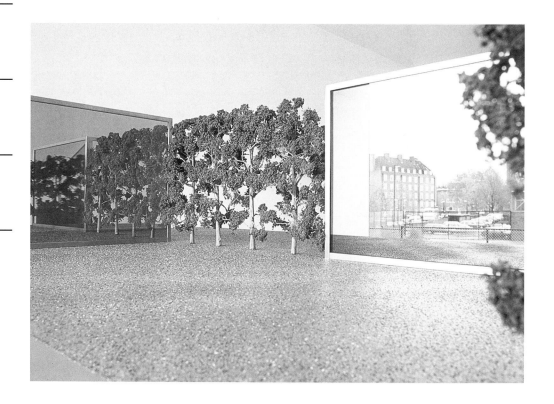

*Two-Way Mirror Hedge
Labyrinth*, 1989, architec-
tural model. Collection
Kunsthaus Bregenz, Austria.

121 1991

Title/Date
Triangular Solid with
Circular Inserts, Variation B
1989-91

Materials
two-way mirror, clear
glass, mirror, aluminum

Dimensions
83½ x 83½ x 72²/₅ in.
212 x 212 x 184 cm

First publication
*Collection 1992/Musée
d'Art Contemporain de
Lyon.* Eds. Isabelle
Bertolotti and Philippe
Grand. Lyon: Musée d'Art
Contemporain de Lyon,
1994. See also *Nordhorn*
1996: 16-19, 88.

First exhibition
'Dan Graham, travaux
1964-92,' Nouveau Musée
de Villeurbanne, Dec. 4,
1992 – Feb. 28, 1993.

Notes
This is the second realized
permutation of the work
Triangular Solid with Circular Inserts, 1989 cat. no.
108. Collection: Musée
d'Art Contemporain de
Lyon.

*Triangular Solid with
Circular Inserts, Variation B,
1989-91.* Collection Musée
d'Art Contemporain de Lyon,
Lyon, France.

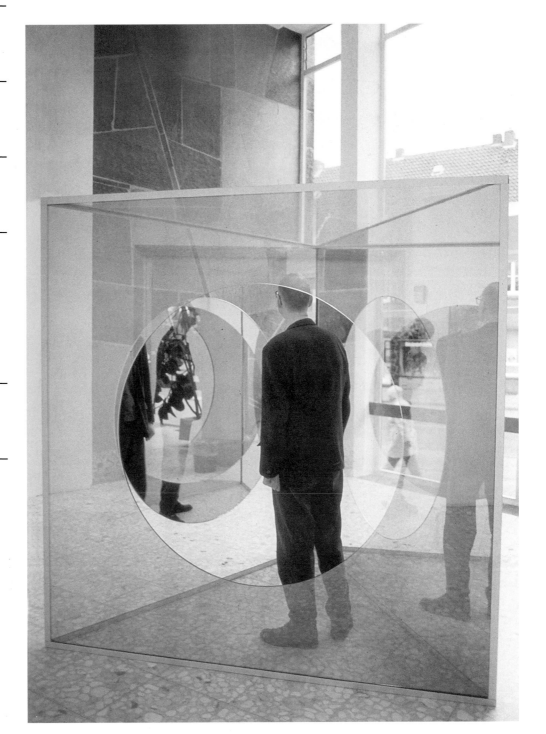

W 1991

Writings

'Two-Way Mirror Cylinder Inside Cube and a
Video Salon: Rooftop Park for Dia Center for
the Arts,' in *The End(s) of the Museum*. Exh. cat.
Barcelona: Fundació Antoni Tàpies,
1991: 126-128.

'Skateboard Pavilion,' in *Jahresring 38: Der
öffentliche Blick*. Munich: Verlag Silke Schreiber,
1991: 200.

Title/Date
Two-Way Mirror and
Hedge Labyrinth
1989-92

Materials
zinc sprayed steel, two-
way mirror, clear glass,
blue cypress trees

Dimensions
86²⁄₃ x 236¹⁄₅ x 354¹⁄₃ in.
220 x 600 x 900 cm

First publication
*Like Nothing Else in
Tennessee*. Exh. cat.
London: Serpentine
Gallery, 1992, model
only. See also: *Nordhorn*
1996: 44-47.

First exhibition
'Like Nothing Else in
Tennessee,' Serpentine
Gallery, London,
March 17 – April 26, 1992.

Notes
This large scale version of
*Two-Way Mirror Hedge
Labyrinth,* 1989-91, cat.
no. 120 was temporarily
realized for the above-
mentioned exhibition.

*Two-Way Mirror and Hedge
Labyrinth,* 1989-92. Installa-
tion 'Like Nothing Else in
Tennessee,' Serpentine
Gallery, London, 1992.
Courtesy Lisson Gallery,
London, UK.

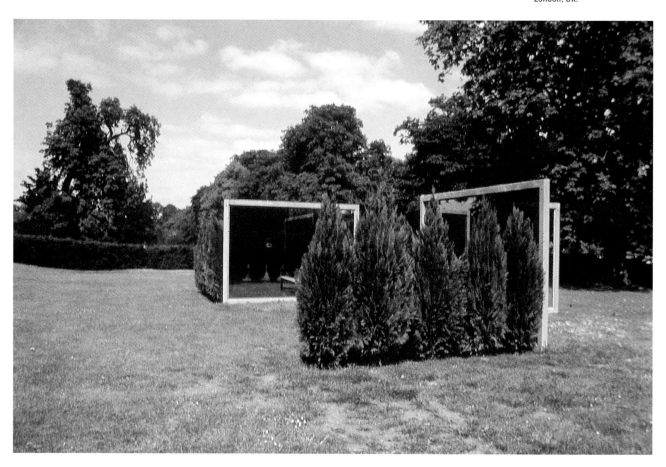

123 1992

Title/Date
Parallelogram for
documenta IX
1992

Materials
two-way mirror, aluminum

Dimensions
126 x 185 x 132 1/3 in.
320 x 469 x 336 cm

First publication
documenta IX. Exh. cat.
Kassel, 1992. See also
Nordhorn 1996: 66-67
and 97.

First exhibition
'documenta IX,' Kassel,
Germany, June 13 –
September 20, 1992,
curated by Jan Hoet.

Notes
This pavilion was tem-
porarily realized for 'docu-
menta IX.' It was designed
as an entrance doorway in
one of the five Aue Pavil-
ions by architects Paul
Robbrecht and Hilde
Daem, commissioned as
temporary exhibition pavil-
ions by Jan Hoet and
installed at the Auepark,
Kassel for 'documenta IX.'
The work is alternately
titled *Parallelogram for
Glass Door.* A scotch tape
model is in the documenta
archives, Kassel.

*Parallelogram for
documenta IX*, 1992.

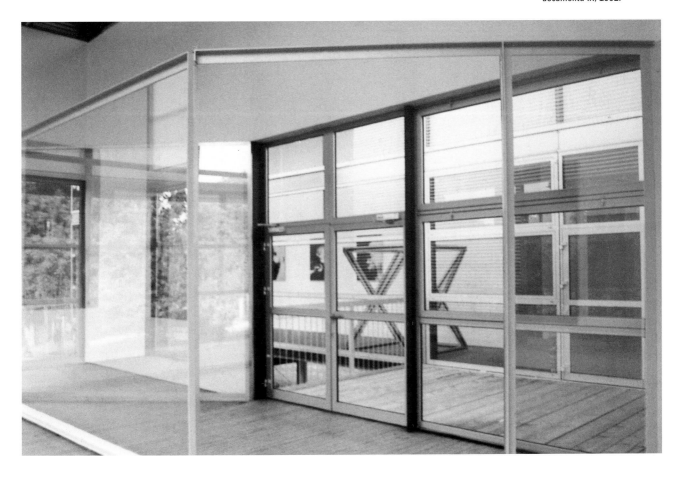

Title/Date
Triangular Pavilion for
Wiener Secession
1992

Materials
two-way mirror, aluminum

Dimensions
height: 94 1/2 in.
sides: 126 x 126 x 177 in.
height: 240 cm
sides: 320 x 320 x 450 cm

First publication
*Dan Graham: Triangular
Pavillion for Secession
Wien.* Exh. brochure. Vien-
na: Wiener Secession,
1992. See also: *Nordhorn*
1996: 68-69, text 97.

First exhibition
'Dan Graham. Pavilions,'
Wiener Secession,
May 27 – June 28 1992.

A two-way mirror right-angle solid triangle
is bisected by a two-way mirror plane to
create two identical, smaller triangular
enclosures. A large sliding door on the
longer side can be manipulated to admit
spectators to either the right-sided or the
left-sided smaller triangular interior.

Nordhorn 1996: 97.

Notes
This pavilion was realized
in the garden of the
Wiener Secession for the
exhibition, 'Dan Graham.
Pavilions,' May 27 – June
28, 1992 and now resides
in the private collection of
Franz Seilern, Retenegg,
Austria.

*Triangular Pavilion for
Wiener Secession*, 1992,
installation Wiener
Secession. Collection of
Franz Seilern, Retenegg,
Austria.

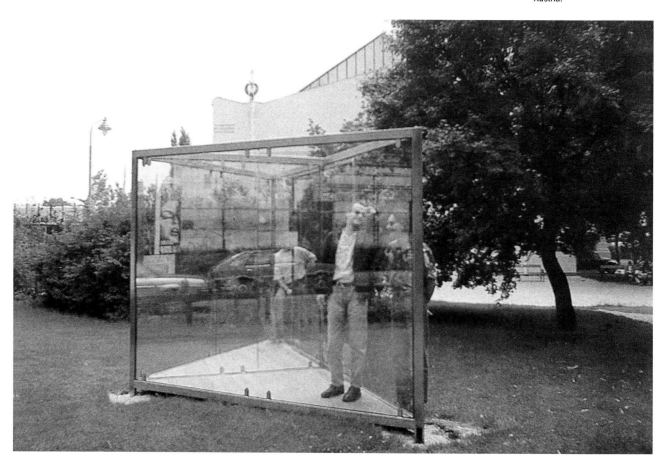

125 1992

Title/Date
Swimming Pool
1992

Scotch tape model
unique

Materials
two-way mirror, plastic,
aluminum

Dimensions
24 x 34 x 48 in.
61 x 86.4 x 122 cm

First publication
Models to Projects
1996: 40, image only.

Notes
Proposal for a swimming
pool, unrealized. See related proposal, cat. no. 148,
Swimming Pool/Fish Pond,
1997.

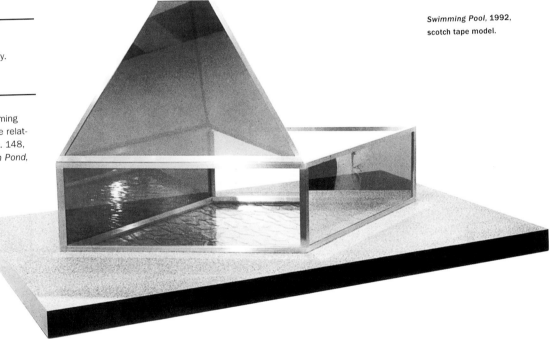

Swimming Pool, 1992,
scotch tape model.

W 1992

Writings

'Ma Position,' in *Ma Position: Écrits sur mes
œuvres*. Vol. 1. Villeurbanne: Nouveau
Musée/Institut, Les Presses du Réel, 1992:
10-54.

'Performance: The End of the 60s' (1985) in *Ma
Position: Écrits sur mes œuvres*. Vol. 1. Villeurbanne: Nouveau Musée/Institut, Les Presses du
Réel, 1992: 112-125.

Title/Date
Gate of Hope
1989-93

Materials
two-way mirror, aluminum

Dimensions
319 x 401½ x 204¾ in.
810 x 1020 x 520 cm

Notes
Two sizes of models were
made.

First publication
Nordhorn 1996: 38-39,
92.

First exhibition
'Internationale Garten-
bauausstellung,'
Stuttgart, Germany, 1993.

Gate of Hope is a two-way mirror arch built as part of the International Garden Year in Stuttgart and permanently part of the park where it is sited. Conceived in 1989 and built in 1993 it is a triangular arch circa 6.52 meters in length with two triangular openings of unequal size. The roof is two-way mirror. The base is an open steel grid over a reflective water basin. One opening of the arch is circa 12.77 meters wide, the other circa 6.25 meters. The strange perspective through these disparate openings is made even stranger by the continually changing mix of the sky as seen transparently and reflectively through the two-way mirror roof in relation to the reflecting water basin.

Nordhorn 1996: 92.

Gate of Hope, 1989-93,
installation Stuttgart,
Germany.

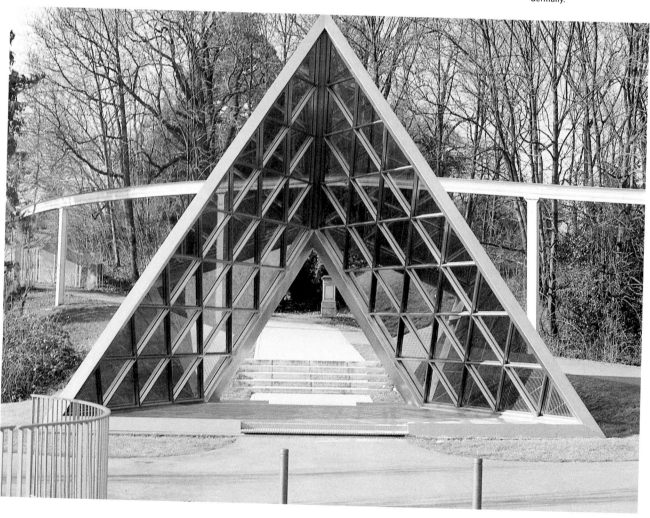

Title/Date
Heart Pavilion Version II
1992-93

Materials
two-way mirror, glass,
steel

Dimensions
96 x 153 x 196 in.
244 x 389 x 498 cm

First publication
Nordhorn 1996: 74-75;
98.

Notes
This is a variation of *Heart
Pavilion,* 1991, cat. no.
117 using perforated
stainless steel. The work
was permanently realized
in 1993 for the garden of
Eileen Rosenau, Bryn
Mawr, Pennsylvania, USA.
Architect: Dan Hill, New
York.

Version II. This version of the *Heart Pavil-
ion,* situated outdoors in a private collec-
tor's patio garden, uses a punched stain-
less-steel sheet in place of one of the
two-way mirror sides of the Carnegie Art
Institute version. The holes are small
enough so that the screen reads as
opaque from a distance, but becomes
transparent when the spectator gazes
flush against [it].

Nordhorn 1996: 98.

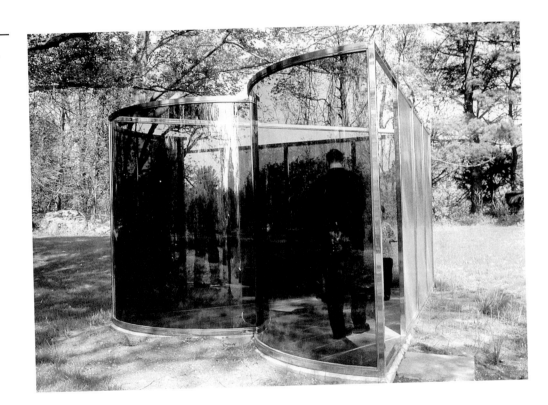

*Heart Pavilion Version II,
1992-93. Collection Eileen
Rosenau, Bryn Mawr,
Pennsylvania, USA.*

W 1993

Writings

'City as Museum,' in *Rock My Religion.* Ed. Brian
Wallis. Cambridge, Mass.: MIT Press, 1993:
244-263.

'Video in Relation to Architecture,' in *Dan
Graham: Public/Private.* Exh. cat. Philadelphia:
Goldie Paley Gallery, Levy Gallery for the Arts in
Philadelphia, Moore College of Art and Design,
1993: 6-17.

Title/Date
New Labyrinth for Nantes
1992-94

Materials
glass and two-way mirror,
aluminum, cement, trees

Dimensions
each element:
124 x 216½ in.
315 x 550 cm
plaza:
circa 105 x 210 ft.
32 x 64 m

First publication
*Dan Graham: Nouveau
Labyrinth pour Nantes.*
Exh. cat. Nantes: Ville de
Nantes/DGAU, 1994. See
also *Nordhorn*: 48-51,
93-94.

Notes
This pavilion is a site-
specific version of
*Two-Way Mirror Hedge
Labyrinth*, 1989-91,
cat. no. 120. It was real-
ized in 1993-94 at the
Place du Commandant
Jean l'Herminier and is
owned by the City of
Nantes, France. Architect:
Erik Recke.

The plaza makes use of optically active rectilinear walls of two-way mirror glass, transparent glass and hedges placed in right-angle configurations to each other, forming a series of rectangular bays with one or two sides open to the grid of the park's pavement. Benches are positioned in front of and parallel to many of the hedges or glass/mirror walls.

The properties of the mirror-reflective glass cause a continuous change in the simultaneous reflectiveness as against transparency of one side due to greater or lesser amounts of sun or artificial light striking either of the sides. The greater the light, the greater that side's relative reflective properties. Reflections from both sides can be viewed through the transparency superimposed on each other. The image of spectators on both sides of the glass, reflections of the urban and sky-scape surrounding environment, re-reflections from other two-way mirror or glass panels at right angles, and of the hedges (which are opaque seen from a distance and semi-transparent seen upclose) create a modern equivalent of a baroque or romantic garden hedge maze. The use of two-way mirror glass and transparent glass is emblematic of the modern city, relating to the facades of high-rise office buildings in the civic and commercial center. The introduction of two-way mirror glazing from the early 70s by corporate buildings replaced an earlier 20th century use of transparent glass in skyscraper-style buildings. Conventionally, during the day, the two-way mirror glass totally reflects the surrounding environment, while allowing interior workers a transparent view outside without being seen by the public. The building reflects solar heat, being ecologically more efficient in conserving energy, while it imagistically equates the corporate image to the 'natural' skyscape which the building reflects. The use of two-way mirror glass in Place du Commandant L'Herminier contradicts this uni-directional total exterior daytime reflectiveness against interior transparency allowing hidden surveillance.

The optics of the glass structure in the square superimpose reflections of surrounding buildings, people in the public space, automobiles and images of people inside automobiles passing on the highway which abuts one of the long sides and the water of the river parallel to the highway on its other side. The glass windows of the motor vehicles and the river's water are themselves semi-reflective surfaces of the park's 'maze' structures. At sunset and nighttime the shifting light from the headlights of the passing traffic affects the optics of the maze.

The two-way mirror glazing and transparent glass is materially self-reflective, reflective of the environment and reflective of the perceiving spectators on both sides of the glass. The viewer sees an image of her/himself superimposed on images of other viewers on other sides as well as the shifting skyscape and urban environment. The interaction of perceivers' gazes on both sides of the mirror glass are superimposed onto the reflections of the exterior environment. The private, psychological space of an individual viewer is correlated to her/his sense of being part of a public, social space.

The sun and shifting skyscape are responsible for creating a continuously alternating visual variation within the reflections on the mirror-glass, while altering shadows of the plants create a 'romantic' melancholic 'chiaroscuro'.

The roofs mediating the transition from the staircases of the underground parking garage at either side of the square to the surface also juxtapose two-way mirror glass with vegetation, vines growing on a wood-lattice pergola which forms the second, right-angled surface of the overhead structure. The roof is tilted at a 45° angle

toward the sky, allowing a view of 'real' sky and park environment which is walked through. The open wood grid which supports the plants creates shadows and a physical barrier to the overhead sky in relation to the two-way-mirror side with its optical, cinematic and hallucinatory effect on the psychological process of the spectator's perception. The two-way mirror superimposes reflections of the sky, the wood-lattice planter side of the roof, and the spectator's gaze. The clouds, continuously changing in relation to the sun, produce greater or lesser reflections of the spectator's views of themselves superimposed on the image of the sky. The square's self-reflective architecture can be viewed from a multitude of different visual vantage points:

1. from inside passing cars – either in movement or stopped for the traffic light,
2. from across the river,
3. on a bridge crossing the river,
4. from a park above 'la place' on an overlooking hill connected by the street to the descending approach to the square,
5. or on the stairs by car parkers coming up from the underground garage.

As a hybrid of kaleidoscopic fun house, cabinet of mirrors, and 20th century garden, including a sports field, this plan for Place du Commandment L'Herminier should be of fascination and practical use to the mixture of children and parents from the various neighboring schools and residential buildings.

Nordhorn 1996: 93-94.

New Labyrinth for Nantes, 1992-94. Collection City of Nantes, France.

Title/Date
Double Cylinder (The Kiss)
1994

Materials
two-way mirror, glass,
steel

Dimensions
each circle:
96 x 96 in.
244 x 244 cm
(height x diameter)

First publication
*Public Information: Desire,
Disaster, Document.* Exh.
cat. San Francisco: San
Francisco Museum of
Modern Art, 1995: check-
list only. Text first pub-
lished *Nordhorn* 1996:
76-77 and 98.

First exhibition
'Public Information: Desire,
Disaster, Document,' San
Francisco, Museum of
Modern Art, San Francis-
co, January 18 – April 30,
1995.

Notes
This pavilion was commis-
sioned by the San Francisco
Museum of Modern Art. The
pavilion was realized in late
1994-95 for a site on the
third floor terrace of the
museum as part of one of
the exhibitions which inaugu-
rated the new building de-
signed by Mario Botta. Pro-
ject Coordinator/Design
Consultant: Dan Hill. Archi-
tect: David Hill, New York.
Collection San Francisco
Museum of Art, Accessions
Committee Fund.

*Double Cylinder (The
Kiss),* **1994. Collection
San Francisco Museum
of Art, California, USA.**

The *Kiss* pavilion for the small roof on the third floor of the San Francisco Museum of Modern Art, designed by Mario Botta, relates to the over-sized 'oculus' on the building just behind it as well as being an eccentric lens showing a view of the city in relation to spectators' gazes inside and outside the form. The $^3/_4$ two-way mirror cylindrical forms have been joined. Spectators outside the pavilion see a convex anamorphic view, whereas spectators inside the form see a concave anamorphic form. From the outside spectators see virtual 'columns' on either side where the $^3/_4$ cylindrical forms join each other. Symbolically this pavilion resembles oversized lips.

Nordhorn 1996: 98.

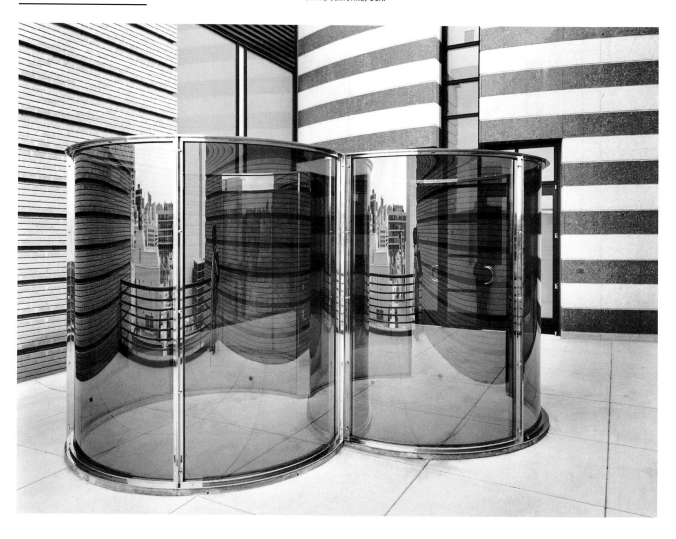

129.1 1994

Title/Date
Double Cylinder (The Kiss)
1994

Scotch tape model
unique

Materials
reflective plastic, scotch
tape

Dimensions
4 1/4 x 7 1/2 x 5 in.
10.8 x 19 x 12.7 cm

Double Cylinder (The Kiss),
1994, scotch tape model.

W 1994

Writings

'Arcadia,' *Peep* no. 1 (Spring 1994): 10-11.

Title/Date
Double Exposure
1995-96

Architectural model
edition of 3
materials and dimensions
may vary over edition

Materials
two-way mirror,
cibachrome transparency

Dimensions
19³/₄ x 41¹/₃ x 41¹/₃ in.
50 x 105 x 105 cm

First publication
Models to Projects 1996:
5, image only. Text first
published *Santiago de
Compostela* 1997: 171,
short version.

First exhibition
'Dan Graham, Models to
Projects,' Marian Goodman
Gallery, New York, January
18 – March 2, 1996.

Notes
Alternate title: *Double
Exposure (Landscape Pho-
to Pavilion)*, 1994. This
work was submitted as
a proposal for 'docu-
menta x,' 1997, for a pavil-
ion with a sliding door and
large cibachrome trans-
parency of the surround-
ing landscape, but was not
realized for the exhibition.
Double Exposure will be
realized as a full scale out-
door pavilion on the
grounds of the Serralves
Foundation, Museum of
Contemporary Art, Porto,
Portugal, in conjunction
with the exhibition
'Dan Graham, Works
1965-2000,' January 13 –
March 25, 2001. Archi-
tect: Pedro del Llano.

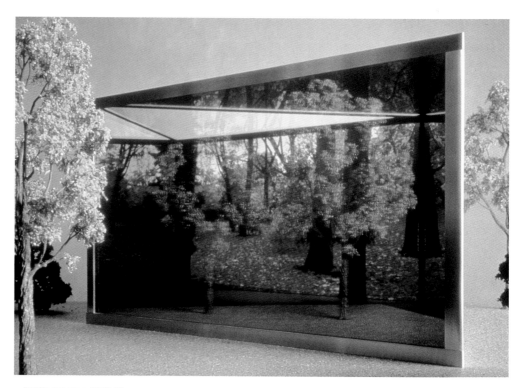

Double Exposure, 1995-96,
architectural model. Courtesy
Marian Goodman Gallery,
New York, USA.

This pavilion is sited in a landscape with trees. The triangular pavilion, which is enterable through a sliding door has two, two-way mirror sides, while the third side is a huge cibachrome transparency. The transparency is of the landscape as viewed from within the structure, 50 meters in front of the transparency side. The transparency is taken on a spring day, nearly at sunset. Spectators inside the structure can see the present landscape, slowly changing as to sunlight and time of day, landscape through the static image of the lightly exposed transparency of the past view. Each year, one year later, the photographed transparency is aligned, but slightly different from the original photographed view. This creates a time-delay with a still photo. Spectators inside the pavilion see a prismatically re-reflected, superimposed and continuously fluctuating (due to the change in outside lighting) image on the two-way mirror sides. There

*Double Exposure (Landscape
Photo Pavilion),* **1994**, print.

are continuous reflective and transparent views of the immediately surrounding land-scape on both sides of the pavilion super-imposed on images of gazing spectators inside and outside the pavilion's sides, superimposed on the cibachrome distant landscape view through the actual present distant landscape view.

Dan Graham, 'Double Exposure,' 1995-96, this version of text previously unpublished.

131 1995

Title/Date
Double Binocular: Two-Way Mirror Transparent Glass Room
1995

Architectural model
edition of 3
materials and dimensions may vary over edition

Materials
two-way mirror, transparent glass, aluminum

Dimensions
22³/₄ x 44 x 44 in.
58 x 112 x 112 cm

First publication
Models to Projects 1996: 2-3, image only.

First exhibition
'Dan Graham, Models to Projects,' Marian Goodman Gallery, New York, January 18 – March 2, 1996.

Notes
This work is unrealized as an outdoor pavilion and exists as a model only.

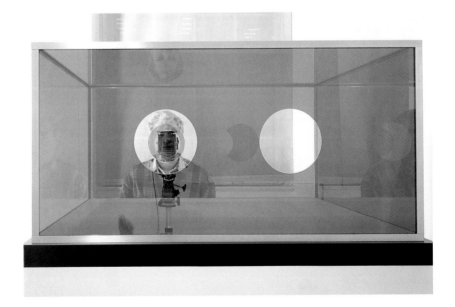

Double Binocular: Two-Way Mirror Transparent Glass Room, 1995, architectural model. Courtesy Marian Goodman Gallery, New York, USA.

Title/Date
Serpentine II
1995

Architectural model
edition of 3
materials and dimensions
may vary over edition

Materials
two-way mirror, transparent glass, punched aluminum, aluminum

Dimensions
14 x 36 x 30 in.
35.5 x 91.4 x 76.2 cm;
overall including base:
17 x 42 x 36 in.
43.2 x 106.7 x 91.4 cm

First publication
Models to Projects 1996:
4, image only.

First exhibition
'Dan Graham, Models to
Projects,' Marian Goodman
Gallery, New York, January
18 – March 2, 1996.

Notes
This work is unrealized as
an outdoor pavilion and
exists as a model only.

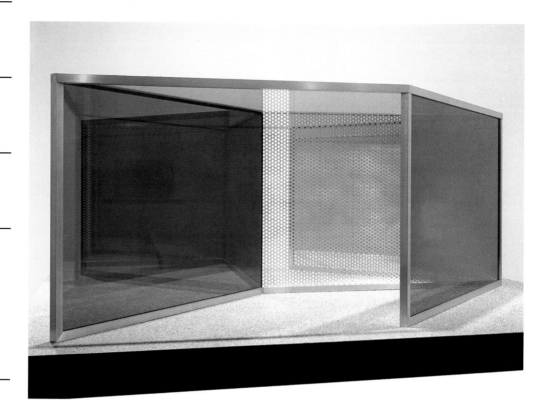

Serpentine II, 1995,
architectural model. Courtesy
Marian Goodman Gallery,
New York, USA.

Title/Date
New Design for Showing
Videos
1995

Materials
oak frames, transparent
glass, two-way mirror,
punched aluminum, six
video sets on shelves,
cushions

Dimensions
86²/₃ x 244 x 342¹/₂ in.
220 x 620 x 870 cm

First publication
*Dan Graham: Video/Archi-
tecture/Performance.* Ed.
Sabine Breitwieser. Vien-
na: Generali Foundation,
1995.

First exhibition
'Dan Graham, Video/
Architecture/Perfor-
mance,', Generali Founda-
tion, Vienna, October 5 –
December 17, 1995. On
the opening night, October
4, Graham performed his
1977 work *Performer/
Audience/Mirror*, see cat.
no. 65.

Notes:
Graham designed this
work for the presentation
of his own videos at his
video and performance
exhibition at the Generali
Foundation in 1995 and
for the video collection of
the Foundation. The work
is in the collection of the
Generali Foundation, Vien-
na. Like *Three Linked
Cubes/Interior Design for
Space Showing Videos*,
1986, cat. no. 93, the
work is a functional space

The *New Design for Showing Videos* uses punched aluminum (two aluminum sheets with punched holes). The small holes relate to the small pixels on the video image. They are semi-transparent when seen nearby and completely transparent when the viewer presses his eyes to look directly through a hole. This is in relation to the transparency and shifting semi-reflec-tiveness/transparency on the two-way mir-ror panels, a shift caused by changes in

for video viewing. *New Design for Showing Videos* is the larger of the two video viewing structures and features punched alu-minum. The work exists in two variations, the sec-ond, *New Space for Show-ing Videos* 1995, uses mahogany wood frames and has no punched alu-minum surfaces.

the projected video images. The specta-tors' images of themselves and others observing the videos and each other/and their own gazes and 'other spectators' gazes are the content of the intersubjec-tive philosophical aspect of the structure.

Generali Foundation 1995: 11.

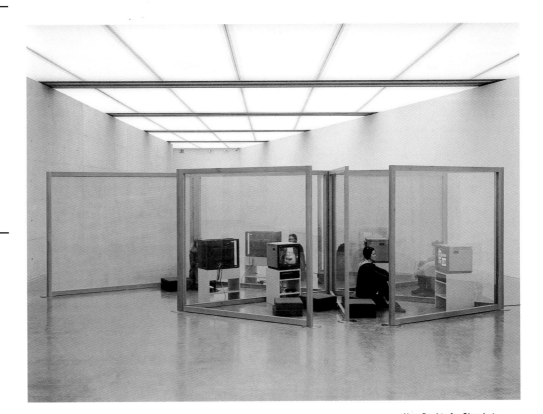

*New Design for Showing
Videos*, 1995. Collection
Generali Foundation, Vienna,
Austria.

134 1995

Title/Date
Cylinder Bisected by Plane
1995

Materials
two-way mirror, steel

Dimensions
82^2/$_3$ x 177^1/$_6$ in.
210 x 450 cm
(height x diameter)

First publication
Remain in Naoshima. Exh.
cat. Benesse House/Nao-
shima Contemporary Art
Museum, 2000: 178-181.

First exhibition
Long-term installation,
Benesse House/Naoshi-
ma Contemporary Art
Museum, Naoshima
Island, Japan.

This two-way work was constructed near the seashore in the center of a campground consisting of various oversized circular 'Mongolian' tents for families on one side, and on the other side, a semi-circular food and toilet wing designed by the architect Tadao Ando. The work, looking something like a UFO, can be entered from either of the two sides of the two-way mirror cylinder. Spectators on either side of the form see images of themselves reflected on the images of the other observing spectators. The work's two-way mirror sides implode the image of the surrounding sky and seascape onto its surfaces.

Dan Graham, 'Cylinder Bisected by Plane, Naoshima, Japan,' 2000, text previously unpublished.

Notes
This pavilion was commissioned by the Benesse House/Naoshima Contemporary Art Museum for the grounds of the Naoshima Cultural Village, Naoshima Island, Seto Inland Sea. Collection Benesse House/Naoshima Contemporary Art Museum.

134.1 1995

Title/Date
Outdoor Theater Pavilion
1986

Architectural model
edition of 3
materials and dimensions
may vary over edition

Materials
plexiglass

Dimensions
18 x 24 in.
45.5 x 61 cm
(height x diameter)

Notes
Model dated to 1986 for
Cylinder Bisected by Plane
realized in 1995.

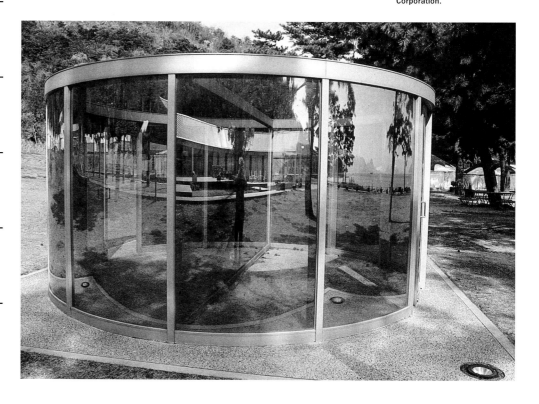

Cylinder Bisected by Plane, 1995. Installation Naoshima Cultural Village, Naoshima Island, Japan. Collection Benesse House/Naoshima Contemporary Art Museum. Courtesy Benesse Corporation.

Title/Date
Two-Way Mirror Glass
Pavilion
1995

Materials
two-way mirror glass,
perforated aluminum

Dimensions
94½ x 118 x 118 in.
240 x 300 x 300 cm

First publication
María Elena Ramos and
Raquel Bentolila. *Interven-
ciones en el espacio, la
historia de un proyecto/
Interventions in Space, the
history of the project.*
Caracas: Museo de Bellas
Artes, 1995. See also
*Intervenciones en el espa-
cio.* Caracas: Fundacion
Museo de Bellas Artes,
1998: 300-301, and
interview between Dan
Graham and María Elena
Ramos, 145-169.

First exhibition
'Intervenciones en el espa-
cio/Interventions in Space,'
Museo de Bellas Artes,
Caracas, 1995. Graham's
work was realized in 1995
as part of an exhibition of
permanent site-specific
works in the sculpture gar-
den of the museum.

Notes
Collection Museo de
Bellas Artes, Caracas,
Venezuela.

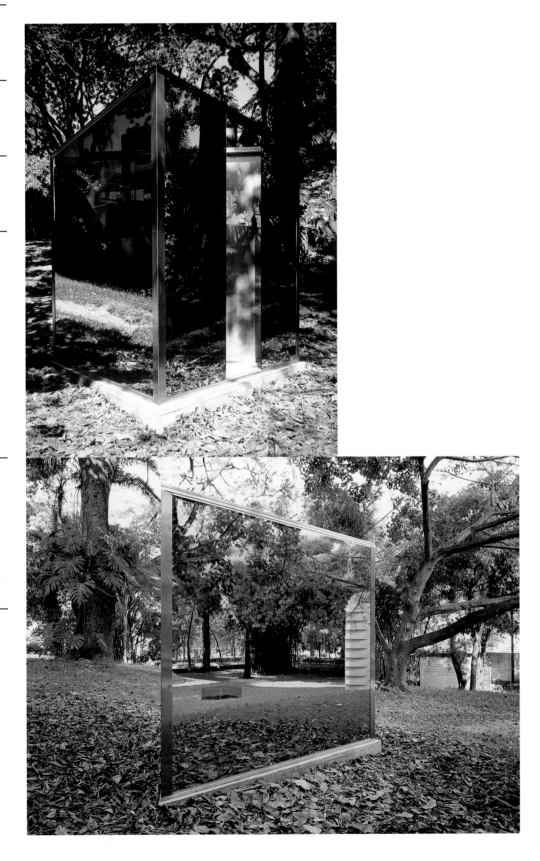

**Two-Way Mirror Glass
Pavilion, 1995. Collection
Museo de Bellas Artes,
Caracas, Venezuela.**

Title/Date
Truncated Garden Pyramid
1995

Materials
two-way mirror glass,
white oak, perforated
metal

Dimensions
91½ x 79 x 79 in.
232.4 x 200.7 x 200.7 cm

First exhibition
'Die Neue Sammlung,'
Museum Moderner Kunst
Stiftung Ludwig Wien, 20er
Haus, Vienna, February 3 –
March 7, 1999.

Notes
The work was realized for
the above-mentioned
exhibition and now resides
in the collection of the
Museum Moderner Kunst
Stiftung Ludwig Wien,
Vienna.

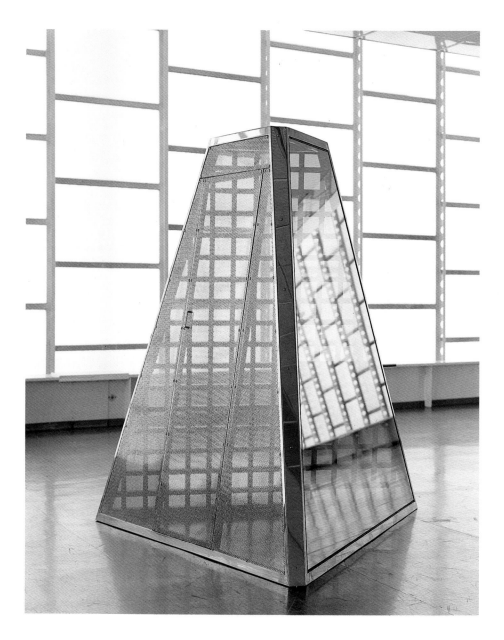

Truncated Garden Pyramid,
1995. Collection Museum
Moderner Kunst Stiftung
Ludwig Wien, Vienna, Austria.

Title/Date
Two-Way Mirror and
Punched Aluminum Solid
Triangle
1996

Materials
two-way mirror, punched
aluminum sliding door

Dimensions
94½ x 157½ x 134 in.
240 x 400 x 340 cm

First publication
*City Space. Sculptures and
installations made for
Copenhagen 96.* Ed.
Anette Østerby. Copen-
hagen: City Space, 1996:
54-57, text by Kristine
Kern.

First exhibition
'City Space,' May 15 –
October 1, 1996, Skyde-
banehaven, Copenhagen,
curated by Anette Østerby
and Mikael Andersen.

Notes
Realized for the exhibition
'City Space,' a group exhi-
bition including over 20
artists. Graham's work
was sited in Skydebane-
haven, a small intimate
park in the center of
Copenhagen, next to a
playground for children.
Collection: ARKEN Muse-
um of Modern Art, Ishøj,
Denmark. This pavilion is
a variation of cat. no. 135.

This work consists of a solid triangle, two
sides of two-way mirror, with a third side in
punched aluminum sliding door entrance.
As the doors slide open or shut, a re-
reflected *moiré* pattern is created on the
other two, two-way mirror sides. The work
is located in a grassy park setting, adja-
cent to a children's playground.

Dan Graham, 'Two-Way Mirror and Punched
Aluminum Solid Triangle, Skydebanehaven,' 2000,
text previously unpublished.

*Two-Way Mirror and
Punched Aluminum Solid
Triangle*, 1996. Two views,
installation 'City Space,'
Skydebanehaven, Copen-
hagen, 1996. Collection
ARKEN Museum of Modern
Art, Ishøj, Denmark.

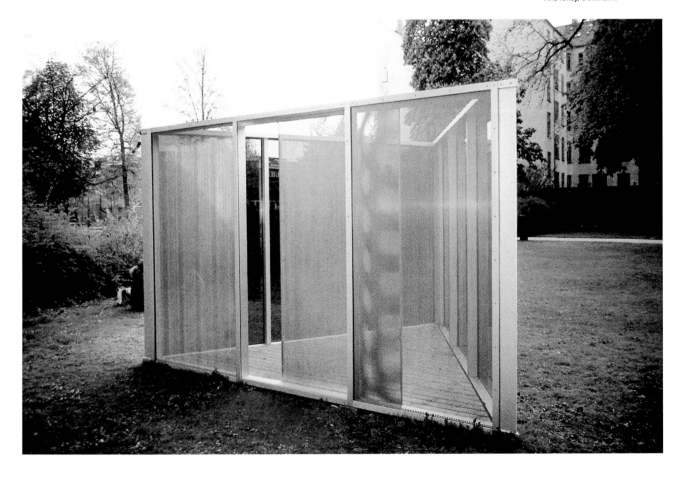

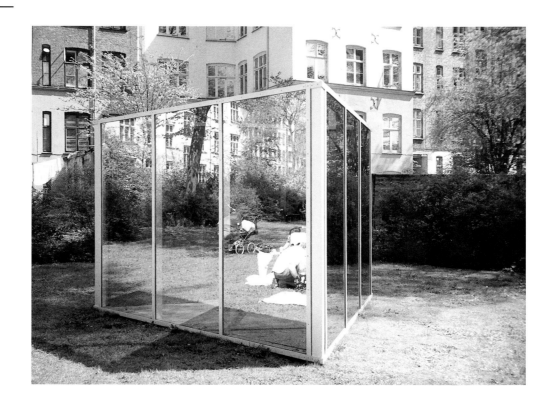

137.1 1996

Title/Date
Two-Way Mirror and
Punched Aluminum Solid
Triangle
1996

Architectural model
edition of 3
materials and dimensions
may vary over edition

Materials
two-way mirror, punched
aluminum

Dimensions
$21^2/_3$ x $36^1/_5$ x $36^1/_5$ in.
55 x 92 x 92 cm

138 1996

Title/Date
Two-Way Mirror Triangle
with One Curved Side
1996

Materials
two-way mirror, stainless
steel

Dimensions
99 x 118 in.
250 x 300 cm

First publication
Santiago de Compostela
1997: 172. See also:
*Skulpturlandskap Nord-
land, Artscape Nordland.*
Ed. Maaretta Jaukkuri. For-
laget Geelmuyden. Kiese/
Nordland Fylkeskommune,
1999.

First exhibition
Long-term installation,
'Artscape Nordland,'
curated by Maaretta
Jaukkuri beginning in 1992
with permanent works by
Dan Graham, Anish Kapoor,
Raffael Rheinsberg, Tony
Cragg, Per Kirkeby, Luciano
Fabro, and others.

Notes
Realized for 'Artscape
Nordland,' Norway, 1996,
an exhibition of works
installed on the Lofoten
Islands off the coast of
Northern Norway. The
pavilion structure is placed
beside the main road run-
ning through the geo-
graphical formation of the

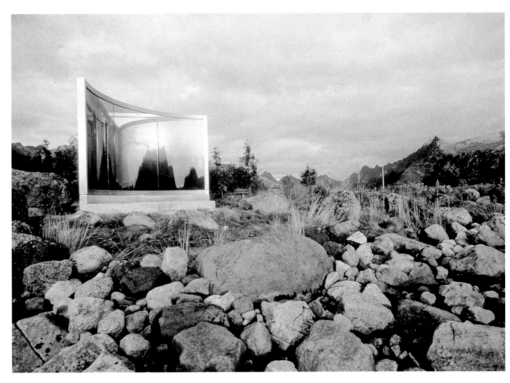

*Two-Way Mirror Triangle with
One Curved Side,* 1996.
Installation 'Artscape Nord-
land,' Lofoten Islands,
Norway. Collection Vågan
County, Norway.

Lofoten Islands, and cap-
tures the light and image
of the surrounding land-
scape on its concave
panorama-like wall. Pub-
lished as *Untitled* 1996.
Collection Vågan County,
Norway. An architectural
model, see cat. no. 138.1,
and a scotch tape model
were made.

This work which is enterable by spectators
through a side sliding door has its sides in
two-way mirror. The work is sited on a fjord
in Northern Norway. The concave, outside,
curved side provides a panoramic view of
the seascape it faces while it anamorphi-
cally distorts spectators observing just
outside. The interior provides a convexly
distorted view of the mountain landscape
in the distance and of the overall form and
spectators gazing on both sides.

Santiago de Compostela 1997: 172.

138.1 1996

Title/Date
Two-Way Mirror Triangle
with One Curved Side
1996

Materials
two-way mirror, aluminum

Architectural model
edition of 3
materials and dimensions
may vary over edition

Dimensions
35²/₅ x 35²/₅ x 22²/₃ in.
90 x 90 x 57.3 cm

Title/Date
Parabolic Triangular
Pavilion I
1995-96

Materials
two-way mirror, aluminum,
perforated steel

Dimensions
90$\frac{1}{2}$ x 118 x 185$\frac{2}{5}$ in.
230 x 300 x 471 cm

First publication
*Dan Graham: Two-Way
Mirror Pavilions/Ein-
wegspiegel-Pavillons
1989-1996.* Exh. cat. Ed.
Martin Köttering and
Roland Nachtigäller.
Nordhorn: Städtische
Galerie Nordhorn,
1996: 82-85, 99.

First exhibition
The work was realized for
long-term exhibiton, part
of the outdoor project,
'Kunstwegen,' Städtische
Galerie Nordhorn,
Germany, 1996.

Notes
Realized in 1996 for
'Kunstwegen,' a long-term
outdoor project curated by
the Städtische Galerie
Nordhorn. The work is sit-
uated on the Eastern part
of the lake Vechte near to
the landing stage on a
floating wooden platform.
Architect: Martin Schütt-
pelz, Stuttgart. One model
is in the collection of the
Städtische Galerie Nord-
horn, see cat. no. 139.1.
A scotch tape model was
also made.

This triangular pavilion has two sides at right angles to each other. One side is punched stainless steel and the other sides are two-way mirror glass. The curved side distorts people on the inside concavely and people on the outside convexly. The regular geometry of the remaining two sides is also anamorphically distorted. The punched steel appears as a nearly opaque screen when viewed from a distance but allows a transparent view close up. By contrast, the two-way mirror glass is filmic and hallucinatory in its effects. It is optically in continual flux with the sunlight which continually changes the relation of the relative reflectiveness as against the transparent views of the interior and exterior spectators' images of themselves superimposed on the surrounding landscape. The pavilion is for restful play, a 'fun-house mirror' device for children and a romantic retreat for adults. The interior is spacious enough for five to six people standing up and for two people lying down.

There is a relation to the spectator's experience encountered in the passageways of a shopping mall, where one's gaze is often simultaneously superimposed onto other people looking at the commodity by one's side. Here these cinematic, urban, psychological effects are superimposed onto an Arcadian parkscape, for the pavilion is sited in an area for leisure activities at the lakeside, installed on a platform in the water. Close by people are swimming in the water, surfing and boating.

Nordhorn 1996: 99.

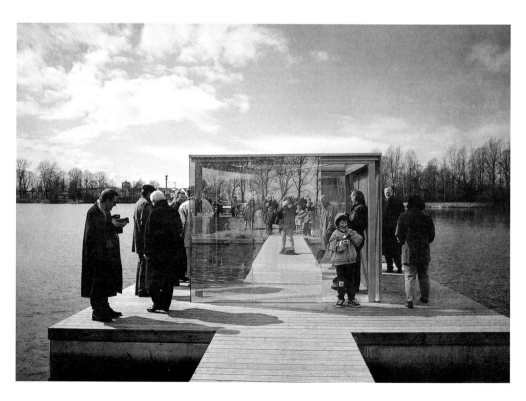

Parabolic Triangular Pavilion I,
1995-96, installation 'Kunst-
wegen,' 1996. Collection Städti-
sche Galerie Nordhorn, Germany.

139.1 1995

Title/Date
Parabolic Triangular
Pavilion I
1995

Architectural model,
unique

Materials
glass, aluminum, punched
stainless steel

Dimensions
$36\frac{1}{5}$ x 50 x $40\frac{1}{6}$ in.
92 x 127 x 102 cm.

140 1996

Title/Date
Two-Way Mirror Punched
Steel Hedge Labyrinth
1994-96

Materials
glass, stainless steel,
arborvitae

Dimensions
90 x 206 x 508 in.
228.6 x 523.2 x 1290.3
cm

First publication
*Minneapolis Sculpture
Garden: A Collaboration
Between the Walker Art
Center and the Minneapo-
lis Park and Recreation
Board.* Ed. Janet Jenkins.
Minneapolis: Walker Art
Center, 1998: image #6.

First exhibition
Long-term installation,
Minneapolis Sculpture
Garden, Walker Art Center,
Minneapolis, Minnesota.

Notes
This pavilion was commis-
sioned by the Walker Art
Center for the Minneapolis
Sculpture Garden in 1994
and realized in 1996. It is
a variation of *Two-Way
Mirror Hedge Labyrinth*,
1989-91, see cat. no. 120
with surfaces in punched
stainless steel. Collection
Walker Art Center, Min-
neapolis, Gift of Judy and
Kenneth Dayton, 1996.

*Two-Way Mirror Punched
Steel Hedge Labyrinth,
1994-96, Minneapolis Sculp-
ture Garden. Collection Walk-
er Art Center, Minneapolis,
Minnesota, USA. Courtesy
Walker Art Center (top) and
Dan Graham's archives
(bottom).*

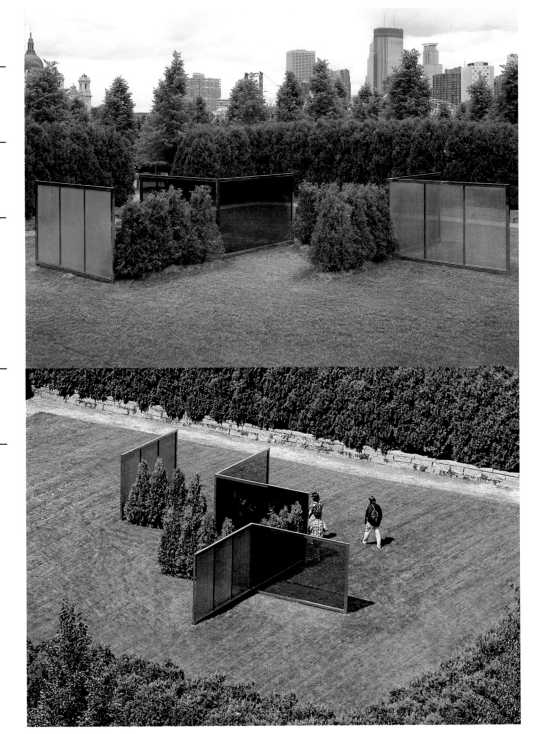

141 1996

Title/Date
Two-Way Mirror Curved
Hedge Zig-Zag Labyrinth
1996

Materials
glass, steel, arborvitae
nigra

Dimensions
90 x 180 in.
229 x 457.2 cm
(height x diameter)

First publication
*After Eden: Garden Vari-
eties in Contemporary Art.*
Exh. cat. Middlebury, VT:
Middlebury College
Museum of Art, 1998: 6-7,
image on back cover.

First exhibition
'After Eden: Garden Vari-
eties in Contemporary Art,'
Middlebury College Muse-
um of Art, Vermont, March
14 – May 31, 1998.

Notes
Commission for the plaza
of the Middlebury College
Center for the Arts, real-
ized in 1996 for long-term
exhibition. Two scotch
tape models were made
and also reside in the
Middlebury Collection.
Collection Middlebury
College Museum of Art,
Middlebury, Vermont.

*Two-Way Mirror Curved
Hedge Zig-Zag Labyrinth,*
1996. Collection Middlebury
College Museum of Art,
Middlebury, Vermont, USA.

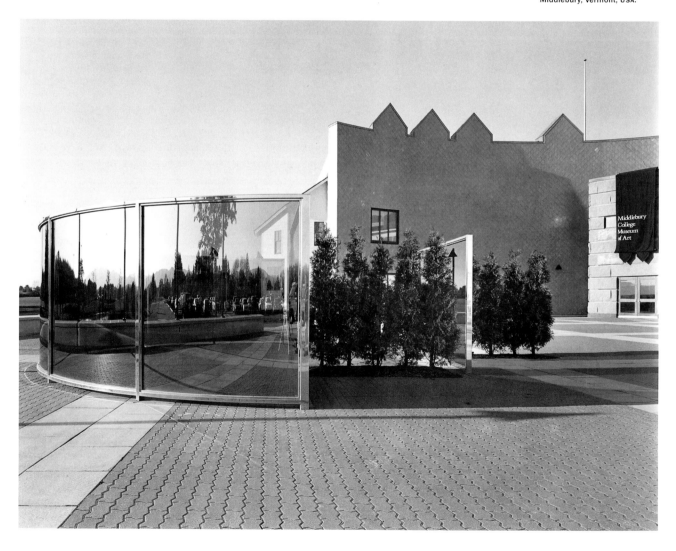

142 1996

Title/Date
Star of David Pavilion for
Schloss Buchberg, Austria
1991-96

Materials
two-way mirror, aluminum,
plexiglas

Dimensions
102³⁄₄ x 165²⁄₅ x 94 in.
261 x 420 x 238 cm

First publication
*Dan Graham: Raumkon-
zept Buchberg* XII, *Star of
David Pavillion.* Exh.
brochure. Gars am Kamp:
Kunstraum Buchberg,
Schloss Buchberg, 1996.
See also *Nordhorn* 1996:
54-55, 95.

First exhibition
'Dan Graham: Raum-
konzept Buchberg XII, Star
of David Pavillion,' Kunst-
raum Buchberg, Schloss
Buchberg, Gars am Kamp,
Austria 1996.

Notes
Realized for the park of
Schloss Buchberg, Gars
am Kamp, Austria in 1996.
This is a variation of *Star
of David Pavilion,* Ham-
burg, 1989, cat. no. 109
and is distinguished by the
presence of a basin of
water which lies beneath
the structure. The com-
mission is a part of the
project 'Buchberger Raum-
konzepte' of the Kunst-
raum Buchberg series of
works for the castle site
since 1981.

*Star of David Pavilion for
Schloss Buchberg Austria,
1991-96. Collection Schloss
Buchberg, Gars am Kamp,
Austria.*

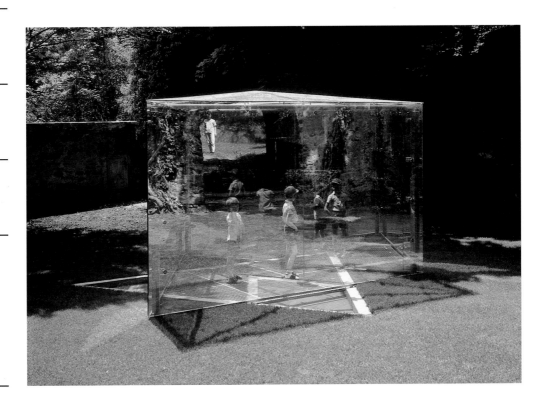

This pavilion, consisting of two superimposed equilateral triangular forms – one a basin of water, the other a 2.5-meter-high enclosed, two-way mirror glass pavilion – will be positioned to the side of and below the bridge leading to the castle's entrance. Originally this area was a moat; now it will be landscaped into a grassy, tree-shaded area ideal for picnics or quiet, restful leisure activity. The choice of water as an active element relates to a nearby river, which leads to an ecologically efficient electro-power dam designed by students of the curator of Schloss Buchberg. The pavilion is intended for access and possible use by year-long residents of the local village as well as temporary use by visitors.

Each triangular form is four meters on each side. The enclosed pavilion is entered through sliding doors. The sides of the exterior triangular water basin and the other stone-based outer triangular points measure 1.33 meters. The interior area is filled with water (continuing the water of the triangular basin). The spectator can walk over the water on an overlying steel grid similar to the urban grids on sidewalks. On the ground level three equilateral triangular water ponds are adjacent to the grass. The reflective glass pavilion can be entered through a sliding door on one of its triangular points, where the spectator first steps onto a stone floor.

The entire pavilion can be seen from above by looking through the overgrown ivy on the top of the wall at the side of the bridge leading over the 'moat-area' into the castle entrance. From this vantage both water and two-way mirror become a complex of crystalline multi-reflective surfaces in relation to the people in the pavilion and beside the 'Star of David' form. The Jewish 'Star of David' iconography of the configuration is very clearly apparent.

Nordhorn 1996: 95.

Title/Date
Star of David
1991-96

Architectural model
edition of 3
materials and dimensions
may vary over edition

Materials
aluminum, glass, wood

Dimensions
14½ x 26⅓ x 26⅓ in.
37 x 67 x 67 cm
base:
43⅓ x 39⅖ in.
110 x 100 cm

Star of David, 1991-96,
architectural model.
Collection Bogner, Vienna,
Austria. Courtesy Kunstraum,
Buchberg, Austria.

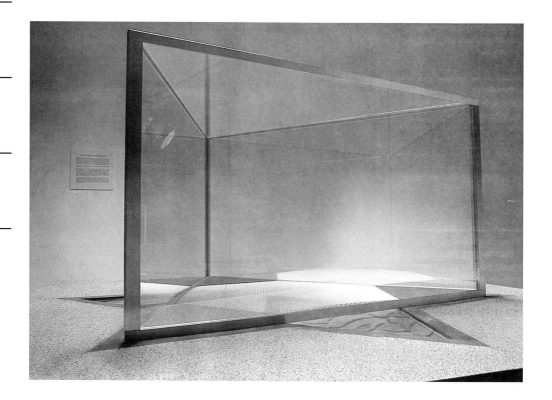

W 1996

Writings

'Short Statement on My Two-Way Mirror
Pavilions,' in *Dan Graham: Two-Way Mirror
Pavilions/Einwegspiegel-Pavillons 1989-96.*
Exh. cat. Eds. Martin Köttering and Roland
Nachtigäller. Nordhorn: Städtische Galerie
Nordhorn, 1996: 87.

Title/Date
Leipzig Messe Structure
1997

Materials
two-way mirror, perforated
stainless steel, transparent glass

Dimensions
90½ x 22⅖ x 157½ in.
230 x 570 x 400 cm

First publication
*[Realization] Kunst in der
Leipziger Messe/Art at the
Exhibition Center Leipziger
Messe.* Exh. cat. Ed.
Brigitte Oetker and Christiane Schneider. Oktagon,
1997: 232-235.
Text on Graham by Rainer
Metzger.

First exhibition
'[Realization] Kunst in der
Leipziger Messe/Art at the
Exhibition Center Leipziger
Messe,' 1997.

Notes
Realized permanently for
the Leipziger Messe
(Leipzig Fair), Germany.
Leipzig built a new modern
glass and steel Messe
outside of the city, replacing the old Messe in the
inner city in 1997. Graham's pavilion structure
refers to the glass and
steel architecture of the
new Messe building.

The pavilion for a courtyard intended for relaxation has a closed section and open section. […] Two sides are two-way mirror and the larger side with a sliding entrance door is perforated stainless steel. The ceiling is transparent glass. Completing one side of what would be a square if not truncated by the water basin is a freestanding 2.66 m sheet of two-way mirror. The pavilion can be viewed from above from a glass-sided walkway.

The triangle perforated/truncated structure is in direct relation to the water basin, whose movements and reflections are re-reflected in the two-way mirror sides of my project. Conversely, the two-way mirror-perforated stainless steel form is reflected in the water basin.

When the perforated steel door is opened and closed a moving *moiré* pattern is created, re-reflected in the four sides of the structure. The perforated steel appears as a nearly opaque screen when viewed from a distance, but allows a nearly transparent view close up.

By contrast, the two-way mirror glass is filmic and hallucinatory in effects. It is simultaneously transparent and reflective and continually in flux with the relative overhead sunlight/cloud cover which, as it changes, changes the relation of relative reflectiveness as against the transparent views of the inside and exterior spectators' images of themselves, superimposed on each others' gazes and bodies and the surrounding architecture and water basin.

Dan Graham, 'Messe Leipzig Structure,' 1997,
text previously unpublished.

Leipzig Messe Structure,
1997, postcard. Collection
Leipziger Messe, Germany.

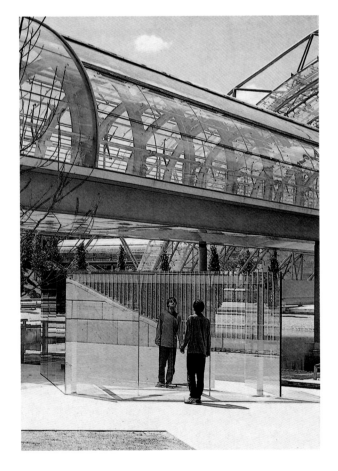

144 1997

Title/Date
Two Joined Cubes
(Dedicated to Roy
Lichtenstein)
1996-97

Materials
two-way mirror, perforated
steel

Dimensions
98$\frac{1}{2}$ x 263$\frac{3}{4}$ x 145$\frac{3}{5}$ in.
230 x 670 x 370 cm

First publication
*Kunstausstellung Holder-
bank.* Exh. cat. Holderbank:
Holderbank Management
und Beratungs AG, 1998.

First exhibition
'New Works/New Age,'
Galerie Hauser & Wirth,
Zürich, November 15,
1997 – January 5, 1998.

Notes
This pavilion was realized
in two large-scale ver-
sions, one with perforated
steel, dedicated to Roy
Lichtenstein and one with-
out. This version resides in
the Sammlung Hauser &
Wirth St. Gallen, Switzer-
land. The second version,
Two Joined Cubes,
1996-97, and one scotch
tape model of the perfo-
rated version reside in the
Flick Collection, St. Gallen,
Switzeland.

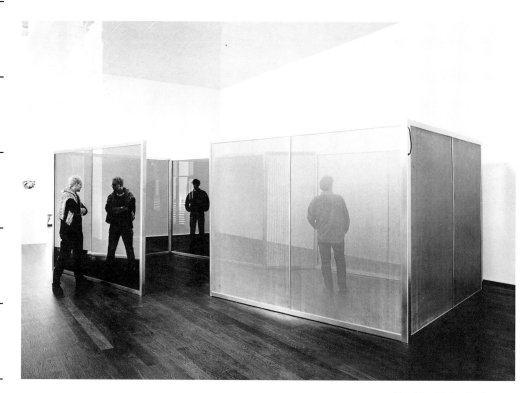

*Two Joined Cubes (Dedica-
ted to Roy Lichtenstein),
1996-97. Sammlung
Hauser & Wirth, St. Gallen,
Switzerland. Courtesy Galerie
Hauser & Wirth, Zürich,
Switzerland.*

144.1 1997

Title/Date
Two Joined Cubes
1996-97

Dimensions
35$\frac{2}{5}$ x 35$\frac{2}{5}$ x 22$\frac{4}{5}$ in.
90 x 90 x 57.5 cm

Architectural model
edition of 3
materials and dimensions
may vary over edition

First exhibition
'New Works/New Age,'
Galerie Hauser & Wirth,
Zürich, November 15,
1997 – January 5, 1998.

Materials
two-way mirror glass,
aluminum, perforated
steel

145 1997

Title/Date
Empty Shoji Screen
Pergola/Two-Way Mirror
Container
1991-97

Materials
glass, metal, wood, and
gravel

Dimensions
94 x 236⅕ x 141⅓ in.
238.5 x 600 x 350 cm

First exhibition
'Lothbury Gallery, NatWest
Group,' London, May 18 –
August 28, 1998, organ-
ized by Rosemary Harris.

Notes
Conception and first mod-
el dated 1991. The work
was realized as a commis-
sion for the Camden Arts
Centre, London in 1997.
The pavilion now resides
in the Flick Collection,
St. Gallen, Switzerland.

This is a solid parallelogram-like form. Two
sides are incomplete opposing two-way
mirror planes, the other two opposing
sides are open shoji screens. Two areas
of the enclosure are created for specta-
tors. One of the shoji screen sides is
planted with vines, while the other shoji
screen wall is left open. The site is for a
suburban back-yard garden-entertainment
area.

Nordhorn 1996: 96.

First publication
Nordhorn 1996: 60-61,
model only. See also exhi-
bition brochure published
by Lothbury Gallery,
NatWest Group, 1998,
with text by Kathy Battista.

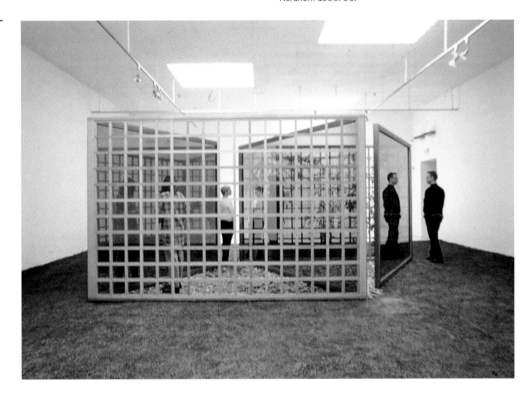

Empty Shoji Screen
Pergola/Two-Way Mirror
Container, 1991-97.
Courtesy Lisson Gallery,
London, UK.

145.1 1997

Title/Date
Empty Shoji Screen
Pergola/Two-Way Mirror
Container
1991

Architectural model
edition of 3
materials and dimensions
may vary over edition

Materials
two-way mirror, wood,
aluminum, gravel

Dimensions
24 x 34 x 48 in.
61 x 86.4 x 121.9 cm

146 1997

Title/Date
Triangular Solid with
Circular Inserts,
Variation D
1989-97

Materials
two-way mirror, glass,
aluminum

Dimensions
82²/₃ x 82²/₃ x 81⁴/₅ in.
210 x 210 x 208 cm

First publication
previously unpublished

First exhibition
The work was realized for
the re-opening exhibition
of P.S. 1 Contemporary Art
Center, October 29, 1997,
Long Island City, New York.

Notes
Third large scale realiza-
tion of *Triangular Solid
with Circular Inserts,*
1989, cat. no. 108. Col-
lection Dan Graham,
Courtesy Marian Goodman
Gallery, New York.

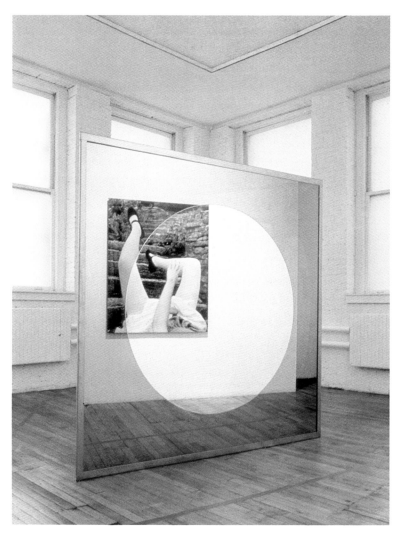

*Triangular Solid with
Circular Inserts, Variation D,*
1989-97. Installation P.S. 1
Contemporary Art Center,
Long Island City, New York,
reflecting Anna Gaskell, #3
(wonder), 1996. Courtesy
Marian Goodman Gallery,
New York, USA.

147 1997

Title/Date
Triangular Solid with
Circular Inserts
1989-97

Materials
two-way mirror glass,
stainless steel

Dimensions
44²/₅ x 44²/₅ x 44²/₅ in.
113.5 x 113.5 x 113.5 cm

First publication
previously unpublished

First exhibition
'Collection of the Chiba
City Museum of Art,' Hikari
Areba, Chiba City Museum
of Art, Japan, January 10 –
February 15, 1998.

Notes
Fourth realization of *Trian-
gular Solid with Circular
Inserts,* 1989, cat. no.
108. Collection Chiba City
Museum of Art, Japan.

Title/Date
Swimming Pool/Fish Pond
1997

Architectural model,
edition of 3
materials and dimensions
may vary over edition

Materials
wood, metal, glass

Dimensions
12½ x 42 x 42 in.
31.8 x 106.7 x 106.7 cm

First publication
previously unpublished

First exhibition
Patrick Painter, Inc., Santa
Monica, California, 1997.

Notes
This model is a proposal
for a swimming pool and
fish pond. Graham's first
model for a swimming
pool dates from 1992,
see cat. no. 125.

Swimming Pool/Fish Pond,
1997, architectural model.
Flick Collection, St. Gallen,
Switzerland.

A swimming pool whose space is a lightly reflective two-way mirror cylinder is divided into a larger two-third and a smaller one-third by a lightly reflective elliptical two-way mirror enclosure to create, in the smaller area, a fish pond.

A wooden ramp allows swimmers access to the top and diving board area of the swimming pool. Underneath the wooden rungs, under the diving board side, is a café. People looking through the glass from the café see people and fish underwater, as well as a 'fish eye' lens view of their own space and gazes.

The two-way mirror sides of the swimming pool give anamorphically distorted views to swimmers of their own and other swimmers' bodies, as well as distorted views of the fish. In Australia, the surrounding garden area of a house often contains, separately, a fish pond and a swimming pool.

Dan Graham, 'Swimming Pool/Fish Pond,' 2000, text previously unpublished.

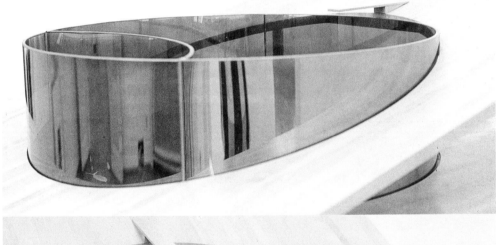

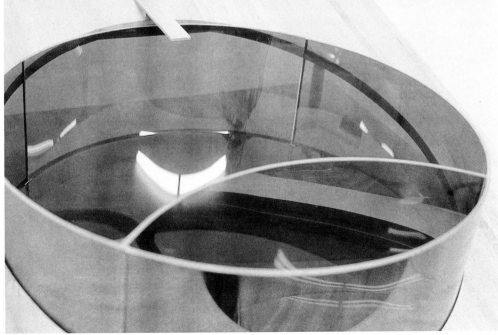

Title/Date
Yin/Yang
1997-98

Architectural model,
edition of 3
materials and dimensions
may vary over edition

Materials
two-way mirror, acrylic,
lead, plexiglass, linoleum,
small stones, water

Dimensions
11⁴/₅ x 42¹/₈ x 42¹/₈ in.
30 x 107 x 107 cm
base:
47¹/₂ x 42¹/₈ x 42¹/₈ in.
120 x 107 x 107 cm

First publication
Two-Way Mirror Power
1999: 182.

Notes
This model proposal will
be realized as a unique
pavilion structure:
Yin/Yang, 1997-2001, a
steel and curved glass
pavilion, pool and lounge
area. The work is currently
in the design phase for an
undergraduate dormitory,
Simmons Hall, Massachu-
setts Institute of Technol-
ogy, Cambridge, Massa-
chusetts, designed by
Steven Holl Architects.
Anticipated completion:
2001.

This is a fairly large-sized building, sited as part of a landscaped hill, giving access underneath the water area to a space for a café and/or children's space. The yang part of the circle site, which is white raked sand or gravel, alludes to the classic Japanese 'Zen garden' and parodies works that are 'neo-60s' (i.e. 1990s) 'lite' religion style.

The pavilion is situated on a slight incline. This allows the deeper water area to be adjacent to the sand area. The level of water diminishes as it approaches the rim above the underground space. There it is so shallow that it allows people in the space underneath the water to have a glimpse of the skyscape through the water.

The play of two-way mirror anamorphic reflections, both concave and convex, the superimposition of people's bodies and gazes on each other inside and outside the form, the superimposition of people on the changing skyscape, and the reflections on the water are all in a constant flux of relative reflectiveness as against relative transparency as the overhead light conditions continually change.

Two-Way Mirror Power 1999: 182.

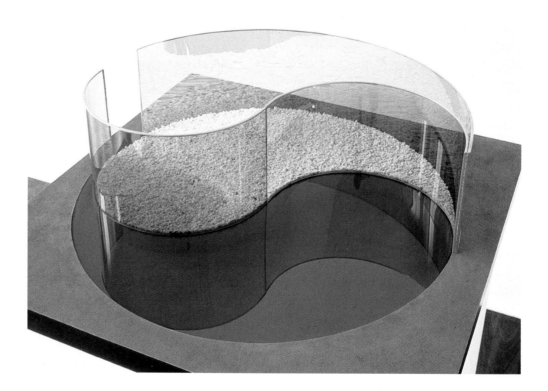

Yin/Yang, 1997-98,
architectural model. Private
collection, Gent, Belgium.

Title/Date
Triangular Pavilion
1997

Materials
two-way mirror, steel

Dimensions
197 x 145³/₅ in.
500 x 370 cm

First publication
Huellas de un siglo. Exh.
cat. Santiago de Com-
postela: Colección CGAC
and Colección Fundación
ARCO, 1999.

First exhibition
Permanent installation on
the rooftop terrace of the
Centro Galego de Arte
Contemporánea, Santiago
de Compostela, Spain,
opened September 1998.

Notes
The Centro Galego de Arte
Contemporánea organized
a major survey exhibition
of Graham's work,
June 26 – November 7,
1997 and accompanying
publication (see biblio-
graphy). During the
planning of the exhibition
Graham proposed this
pavilion for the rooftop
stone terrace of the
Centro Galego de Arte
Contemporánea building
designed by Portuguese
architect Álvaro Siza. The
pavilion was realized in
1997 and now resides in
the collection of the CGAC.
One scotch tape model
was made.

A two-way mirror three-sided pavilion with a circa 4 x 4 x 4 m base and a 5 m height is placed on a roof. Spectators can enter through one of the sides. The shifting reflectiveness as against transparency caused by the sky/sunlight conditions superimposes the skyscape and urban skyline on images of spectators gazing upwards. A diamond pattern is created and re-reflected by the clear glass pinnacle cut-away. The glass pyramid mimics the pyramidal pinnacle or skylights of buildings of corporate and official power in the 1980s in the symbolic 'neo' neoclassical and 30s style of these buildings.

Office buildings of the 70s and 80s often also used two-way mirror glass. My use of reflective glass is open to both transparency and reflectiveness as this contradicts facades of the corporate building's totally reflective exterior facade and totally transparent interior view (a form of corporate surveillance power). The cut-away top has a similar effect. My work is a kaleidoscopic pleasure folly.

The cut-away pyramid also alludes to the spiritual use of light within monumental forms of Louis Kahn's architecture, in his later years, built for energizing third-world democracies in the 50s.

Dan Graham, 'Pyramid with Top Cut Off,' 1997, text previously unpublished.

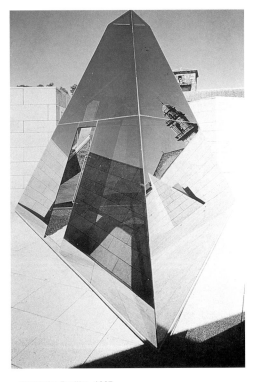

Triangular Pavilion, 1997.
Collection Centro Galego
de Arte Contemporánea,
Santiago de Compostela,
Spain.

Title/Date
Fun House for Münster
1997

Materials
two-way mirror, stainless
steel

Dimensions
90½ x 216½ x 78¾ in.
230 x 550 x 200 cm.

First publication
*Skulptur Projekte in
Münster 1997.* Exh. cat.
Stuttgart: Verlag Gerd
Hertje, 1997: 183-185.

First exhibition
'Skulptur Projekte in
Münster,' June 14 –
October 4, 1997, curated
by Kaspar König.

The original theme for this outdoor sculp-
ture exhibition involved the city plan. The
artists were instructed to realize two
works, one for the outer circular bicycle
and walking paths on the ring of the circu-
lar Roman city plan and a second, inside
the Landesmuseum, at the center of the
city.
I designed the *Funhouse* as a narrow,
open two-way mirror parallelogram with
one side curved to relate to the children's
playground on the other side of the path.
It is also related to my museum interior,
*Children's Day Care, CD-ROM, Cartoon
and Computer Screen Library Project*

(1998-2000) which uses two different
two-way mirror curves as well as flat two-
way mirror and perforated aluminum
planes with surmounted screens. Both
works are for children's amusement and
learning. My work usually relates the
museum to the city plan and is often quasi-
utilitarian.

Dan Graham, 'Fun House for Münster,' 2000,
text previously unpublished.

Notes
Graham first proposed two
works, the *Children's Day
Care, CD-ROM, Cartoon
and Computer Screen
Library Project*, see cat
no. 164, for an indoor
pavilion, and the *Fun
House* for outdoors. Only
the latter outdoor pavilion
Fun House was realized

for the 'Skulptur Projekte
in Münster 1997' exhibi-
tion. It now resides in the
collection of the Museum
Boijmans Van Beuningen,
Rotterdam.

Fun House for Münster,
1997, installation 'Skulptur
Projekte in Münster 1997.'
Collection Museum Boijmans
Van Beuningen, Rotterdam,
Holland.

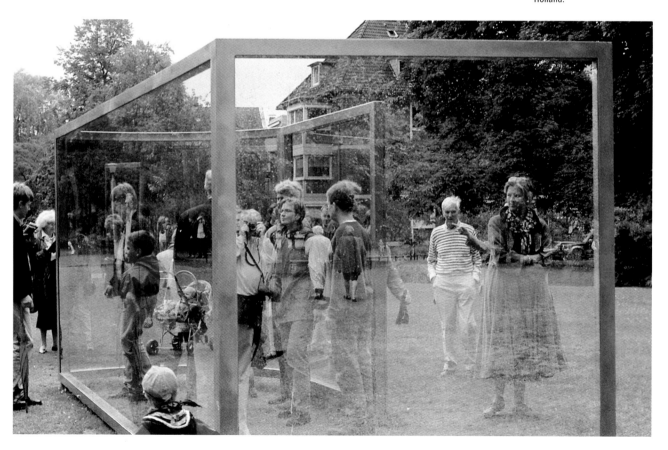

152 1997

Title/Date
Fun House for the Children
of Sint-Jansplein
1997

Architectural model
edition of 3
materials and dimensions
may vary over edition

Materials
glass, wood, acrylic

Dimensions
9⁴/₅ x 42¹/₈ x 42¹/₈ in.
25 x 107 x 107 cm
base:
51¹/₅ x 43¹/₃ x 43¹/₃ in.
130 x 110 x 110 cm

First publication
previously unpublished

Notes
This proposal was original-
ly made to the City of
Antwerp, Middelheim
Sculpture Park. The work
was then proposed for
another site, in the city
center. The large scale
pavilion, *Fun House for the
Children of Sint-Jansplein*,
1997-2000, is currently in
construction.

*Fun House for the Children
of Sint-Jansplein*, 1997,
architectural model. Collec-
tion City of Antwerp, Open-
luchtmuseum voor Beeld-
houwkunst Middelheim,
Antwerp, Belgium.

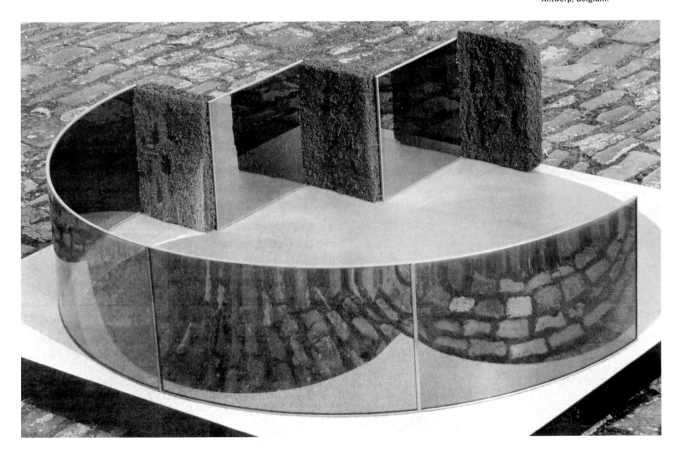

Title/Date
Dan Graham and Apolonija
Sustersic
Liza Bruce Boutique Design
1997

Materials
mixed media on paper

Dimensions
eight framed works:
9⁴/₅ x 12²/₃ in.
25 x 32 cm
(each)

First publication
previously unpublished

First exhibition
'Dan Graham, Unrealized
Projects,' Christian Meyer
and Renate Kainer Gallery,
Vienna, Austria,
October 21 – November 28,
1998.

Notes
Proposed design for a Liza
Bruce boutique in London
which was not executed.
The proposal exists as a
set of eight drawings.

The shop faces an open sky and a park with gardens. Goods are displayed between the showcase windows and the curved two-way mirror. Passing shoppers can see images of both the clothes and themselves observing. These are superimposed due to the partial transparency of the two-way mirror as well as images of people inside on the partition.

From the outside, there is an optical superimposition between the weak mirror reflection of the showcase window's right angle, glass corners' and the anamorphic distorting perspective of the two-way mirror. People entering the shop who decide to walk into the display alcove will see on the two-way mirror their body enlarged, anamorphically 'fattened'. When they walk to the side of the two-way mirror in the main area they see on the concave surface an image of themselves 'miraculously' thinner.

As the sunlight continuously changes due to moving clouds, there is also flux between the relative reflectiveness as against the relative transparency of the two-way mirror's image. The rubber floor surface, identical to that used in work-out gyms, gives the potential customer a buoyant feeling to her body.

The dressing room's three interior walls are mirrorized, while the entrance door side consists of two sliding panels of perforated aluminum. As the sliding doors are moved the interior mirrors re-reflect *moiré* patterns from the sliding door. The tiny holes of the perforated aluminum allow the person dressing/undressing to be seen almost naked. This effect is caused by the small peep-holes, and relates to the near transparency of Liza Bruce's designs.

Dan Graham, 'Liza Bruce Boutique Design,' 1998, text previously unpublished.

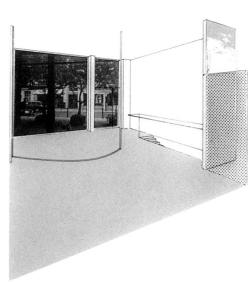

Dan Graham and Apolonija
Sustersic, *Liza Bruce
Boutique Design*, 1997.
Courtesy Galerie Meyer
Kainer, Vienna, Austria.

Title/Date
Portal
1997

Architectural model
unique

Materials
smoked glass, aluminum,
wood

Dimensions
30 x 42 x 36⅕ in.
76 x 107 x 92 cm

Portal was proposed as an entrance portal to a late 1990s airport hotel. The sides are curved, two-way mirror glass, concave on the inside. The roof is also an interior concave two-way mirror arch. The sides are the 'inside' of the typical 1980s-90s over-sized mirrored columns used to articulate center-city high-rise buildings. Spectators passing through see anamorphically enlarged views of their bodies as well as re-reflected views of the arch's skyscape and the surrounding city.

Dan Graham, 'Portal,' 2000, text previously unpublished.

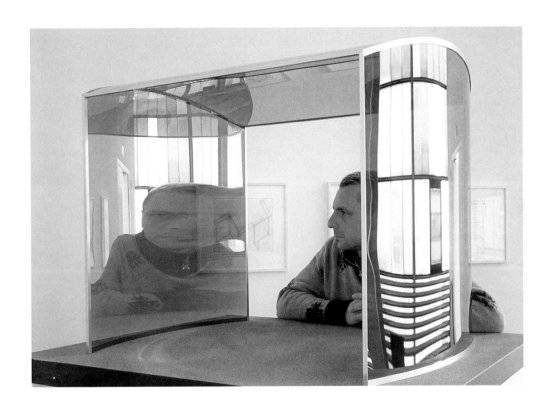

Portal, 1997,
architectural model.

W 1997

Writings

'The Development of New York From the 1970s to the 90s in Relation to Urban Planning,' in *[Realization]: Kunst in der Leipziger Messe/Art at the Exhibition Centre Leipziger Messe.* Cologne: Oktagon, 1997: 246-249.

Title/Date
Pyramid for Chistian Meyer
1997-98

Materials
mirrored glass, clear glass,
stainless steel

Dimensions
138 x 138 in.
350 x 350 cm

First publication
Sharawagdi. Exh. cat. Ed.
Christian Meyer and
Matthias Poledna. Baden:
Felsenvilla, with Verlag
Walther König, Cologne,
1998: 70-73 and cover.

First exhibition
'Sharawagdi,' Felsenvilla,
Baden, Austria, October 18
– December 20, 1998,
curated by Christian
Meyer.

Notes
Realized for the collection
of Christian Meyer, Baden,
Austria.

This 'neo-classical,' pyramidal form's apex is cut short by transparent glass cut-away. The canopy is elevated above the heads of the viewers, who can walk or rest under the form.

The sides of the pyramidal canopy reflect kaleidoscopically the surrounding Baden cityscape. Baden was originally built in Biedermeier ('neo-classical') style.

Located in a garden-area adjacent to a three-story house, is a modern 'rustic hut,' alluding to Laugier's 18th century 'rustic hut.' The canopy's typology also alludes to the 19th century raised metal canopies of park music gazebos, as well as the 1980s-90s 'neo-classical,' neo-30s two-way mirror corporate office buildings. These buildings are often surmounted on their tops by glass pyramids.

Like all my two-way mirror sculpture/pavilions, the two-way mirror reflects the material qualities of the modern corporate city; the use of surveillance power is undermined. Unlike the corporate buildings' one-way mirror where the outside surface is a mirror and people inside can see transparently outside, my pavilions are simultaneously reflective and transparent from both sides. They superimpose inter-subjective images of inside and outside viewers' gazes and bodies along with images of the shifting landscape. This contradicts the one-way mirror situation of the office building. In the corporate building, the outside public sees only a mirror image of themselves and the environment. The corporate building identifies with the 'environment' or sky.

The spectator experiences the effect of being inside a kaleidoscope or 'diamond.' This turns a 1980s corporate form into a psychedelic 1960s effect. It alludes as well to the early 20th century glass utopias of Bruno Taut as well as to the 1950s light effect caused by cut-outs of the utopian monumental forms in Louis Kahn's later buildings.

Sharawagdi 1998: 73.

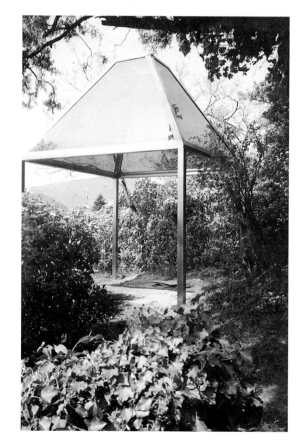

Pyramid for Christian Meyer,
**1997-98. Collection Christian
Meyer, Baden, Austria.**

Title/Date
Café Bravo for
Kunst-Werke, Berlin
1998

Materials
two-way mirror, opaque
glass, transparent glass,
polished steel frame,
reflective aluminum walls,
painted blue tables and
wooden chairs, plywood
counter, concrete floor

Dimensions
177 x 177 in.
405 x 405 cm
(each cube)

First publication
Berlin Berlin. Exh. cat.
Berlin Biennale. Cantz Ver-
lag, 1998. See also: *Café
Bravo in Berlin:* Nalbach +
Nalbach. Sonderdruck aus
Baumeister April 1999,
Callway Verlag, München.

First exhibition
'Berlin Biennale,'
Akademie der Künste,
Postfuhramt und Kunst-
Werke, Berlin, September
30, 1998 – January 3,
1999, organized by Klaus
Biesenbach.

Notes
Café Bravo was realized
for Kunst-Werke, Berlin,
Germany in 1998 as part
of the 'Berlin Biennale.'
Graham provided the con-
cept. It was realized in col-
laboration with the archi-
tect Johanne Nalbach,
Nalbach + Nalbach, Berlin.
The pavilion takes the
form of two adjacent
cubes which are placed at
an angle and project from
a gap between two build-
ings. It is a functional bar
and café with food/kitchen
service area. *Café Bravo*
is located on the August-
strasse in Berlin's Mitte
section, and situated in
the rear courtyard of a for-
mer margarine factory
which has been trans-
formed into the exhibition
space Kunst-Werke.

*Café Bravo for Kunst-Werke,
Berlin,* 1998, Auguststrasse.
Courtesy Nalbach + Nalbach,
Berlin, Germany.

156.1 1998

Title/Date
Café Bravo
1998

Scotch tape model
unique

Materials
cardboard, plastic,
scotch tape

Dimensions
2 x 8 x 8 in.
5.1 x 20.3 x 20.3 cm

Café Bravo, 1998,
scotch tape model.

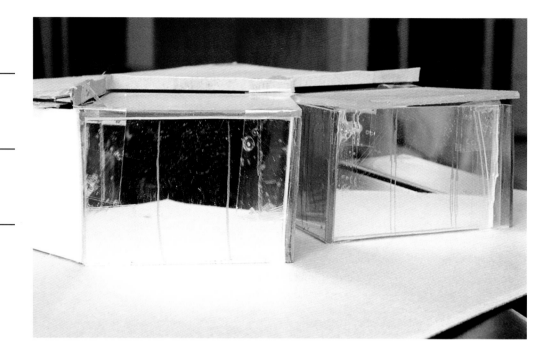

157 1998

Title/Date
Bisected Two-Way Mirror
Triangle
1998

Materials
two-way mirror glass,
stainless steel

Dimensions
90½ x 236¼ x 236¼ in.
230 x 600 x 600 cm

First publication
previously unpublished

Notes
The pavilion was realized
for Collection Marzona,
Udine, Italy.

*Bisected Two-Way Mirror
Triangle*, 1998. Collection
Marzona, Udine, Italy.
Courtesy Galleria Minini,
Brescia, Italy.

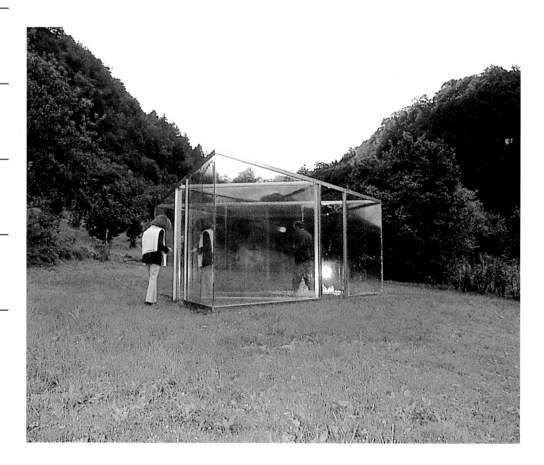

Writings

'Zweiweg-Spiegel-Macht,' in *Peripherie ist Überall*. Ed. Walther Prigge. Frankfurt am Main: Campus Verlag, 1998: 240-245.

'The Artist as Producer,' in *Crossings: Kunst zum Hören und Sehen*. Exh. cat. Vienna: Kunsthalle Wien and Cantz Verlag, 1998: 117-122.

158 1999

Title/Date
Walkway for Hypo-Bank
1995-99

Materials
two-way mirror, glass

Dimensions
110 x 374 x 2087 in.
280 x 950 x 5300 cm

First publication
Nordhorn 1996:
78-79, 99

Notes
Collection Bayerische Hypotheken- und Wechsel-bank AG, Munich, Germany, conceived in 1995 and realized in 1999. Two models c. 1994-95 are also in the collection.

A walkway, with a two-way mirror barrel vault ceiling and sides which alternate between punched stainless steel, transparent glass and two-way mirror, connects the 80s bank structure to the new addition. At one point the walkway turns at a right angle. There is a reference to the baroque ceilings of Munich church architecture which have anamorphically distorted images of angels and saints against the heavens. Here walkers see their own and other walkers' anamorphically distorted images partly reflected and superimposed against the real sky. The shifting clouds and light cover of the actual sky continuously alter the relative reflectiveness of the interior figures as against the transparent image of the changing sky.

Nordhorn 1996: 99.

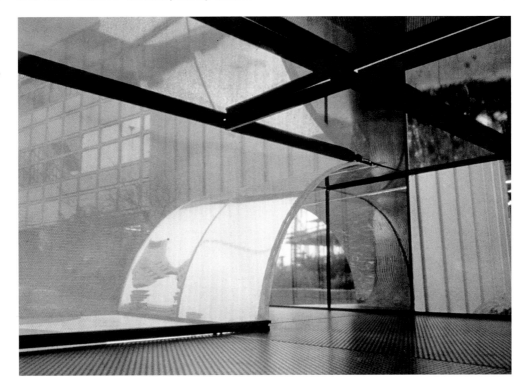

Walkway for Hypo-Bank, 1995-99, architectural model. Collection Bayerische Hypotheken-und Wechsel-bank AG, Munich, Germany.

Title/Date
Elliptical Pavilion
1995-99

Materials
two-way mirror, aluminum

Dimensions
94½ x 197 x 71 in.
240 x 500 x 180 cm

First publication
Nordhorn 1996: 80-81,
99, model only.

Notes
Large scale pavilion real-
ized in June 1999 for new
building of Berliner Kraft
und Licht (Bewag) AG,
Berlin, Germany.

This open elliptical pavilion/sculpture is five meters on the longer interior diagonal and 1.8 meters on the short diagonal. Its height is 2.4 meters. One side is curved two-way mirror glass and the opposing side is curved punched stainless steel.

The two-way mirror side has anamorphic visual properties creating a concave 'fun-house' mirror enlargement of the specta-tor's body inside and convex optical re-duction when viewed from the vantage of an exterior spectator. The punched stain-less steel produces *moiré* patterns when the spectator moves. It is more or less transparent when viewed up close but gradually becomes opaque seen from a distance.

Two-way mirror glass is simultaneously re-flective and transparent. The properties of this material cause one side to be either more reflective or more transparent than the other side at any given moment.

Spectators inside and outside see super-imposed views of their bodies and gazes as well as the surrounding landscape. The two-way mirror is cinematic and hallucina-tory.

The structure, which mimics the three elliptical buildings directly across the Spree River, is designed for restful play – a 'fun-house' for children and a 'romantic' retreat for younger and older adults.

Nordhorn 1996: 99.

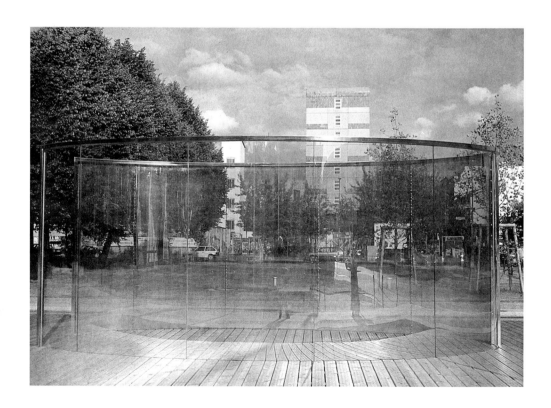

Elliptical Pavilion,
**1995-1999. Collection
Berliner Kraft und Licht
(Bewag) AG, Berlin, Germany.**

Title/Date
Elliptical Pavilion
1995

Architectural model
edition of 3
materials and dimensions
may vary over edition

Materials
two-way mirror, punched
aluminum

Dimensions
22$\frac{1}{2}$ x 30 x 40 in.
57.2 x 76.2 x 101.6 cm

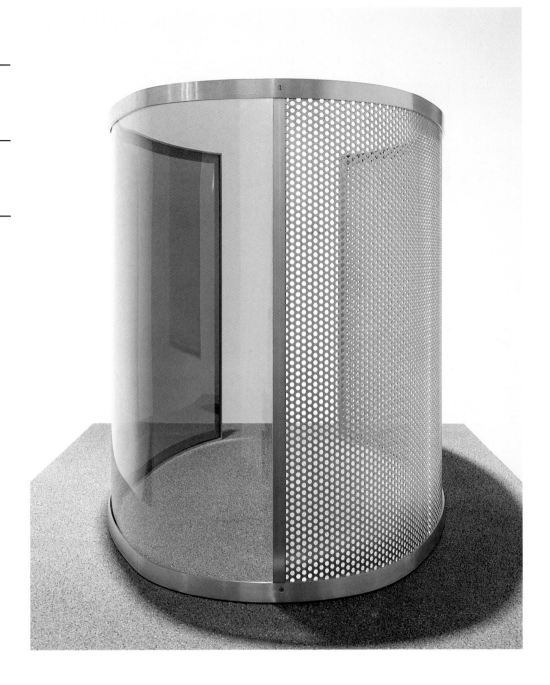

Elliptical Pavilion, 1995,
architectural model. Courtesy
Marian Goodman Gallery,
New York, USA.

Chronology

160 1999

Title/Date
Two-Way Mirror Curved
and Straight Open Shoji
Screen Triangle
1991-99

Materials
two-way mirror, aluminum,
shoji screen

Dimensions
91 1/6 x 158 x 158 in.
231.5 x 401.5 x 401.5 cm

First publication
I love New York. Exh. cat.
Cologne: Museum Ludwig,
1999: 80-84, 236-237,
text by Rita Kersting.

First exhibition
'I love New York,' Museum
Ludwig, Cologne, Germany,
November 6, 1998 – Jan-
uary 31, 1999, curated by
Jochen Poetter.

Notes
This work was conceived
in 1991 and realized in
1999 for the exhibition,
'I love New York.' It now
resides in the collection
of the Museum Ludwig
Cologne, Germany.

The orthogonal grid of the open shoji screen is re-reflected by the curved two-way mirror side anamorphically. This dislocated Euclidian geometry relates to the 360° curvature of the surrounding skyscape and the 360° curvature of the spectator's body.

Dan Graham, 'Two-Way Mirror Curved and Straight Open Shoji Screen Triangle,' 2000, text previously unpublished.

*Two-Way Mirror Curved
and Straight Open Shoji
Screen Triangle,* 1991-99,
architectural drawing by
Martin Schüttpelz.

160.1 1999

Title/Date
Two-Way Mirror Curved
and Straight Open Shoji
Screen Triangle
1990

Architectural model
edition of 3
materials and dimensions
may vary over edition

Materials
two-way mirror, aluminum,
wood

Dimensions
30 x 34 1/4 x 34 1/2 in.
76 x 87 x 87.5 cm

*Two-Way Mirror Curved
and Straight Open Shoji
Screen Triangle,* 1990,
architectural model.

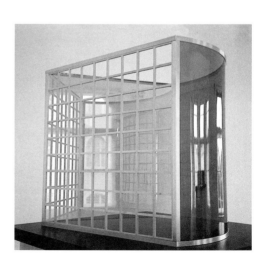

Title/Date
Star of David Pavilion,
Tel Aviv
1989-99

Materials
reflective glass, aluminum,
concrete

Dimensions
101½ x 156⅓ x 205½ in.
258 x 397 x 522 cm

First publication
'Dan Graham: Star of
David Pavilion,' in *Tel Aviv,
Museum of Art Review No.
7/1998-2000*. Tel Aviv:
Tel Aviv Museum of Art,
2000: 51-56. Text by
Varda Steinlauf.

First exhibition
Long-term exhibition in the
Lola Beer Ebner Sculpture
Garden, Tel Aviv Museum
of Art, Israel.

Notes
This second variation of
Star of David Pavilion,
Hamburg, 1989, see cat.
no. 109, was realized with
aluminum of a blue color
used as the material for the
pavilion roof. Collection Tel
Aviv Museum of Art, Israel
through the Lola Beer
Ebner Fund.

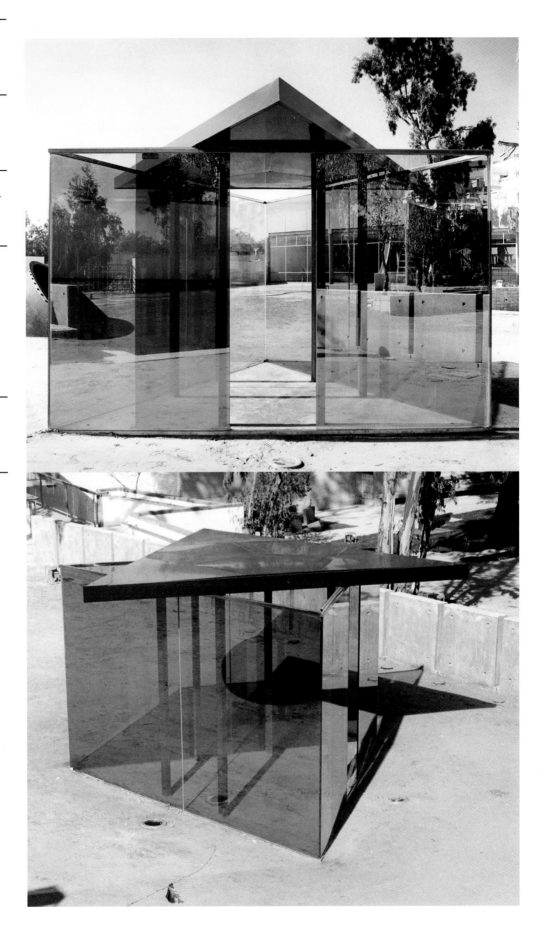

*Star of David Pavilion,
Tel Aviv*, 1989-99. Installed
in the Lola Beer Ebner
Sculpture Garden, Tel Aviv
Museum of Art, Israel.
Collection Tel Aviv Museum
of Art.

162 1999

Title/Date
Fun House for Mallin
1997-99

Materials
two-way mirror glass,
stainless steel

Dimensions
84 x 131⁷⁄₈ x 52³⁄₄ in.
213.4 x 335 x 134 cm

First publication
previously unpublished

Notes
This is a variation of *Fun House for Münster,* 1997, cat. no. 151, with a different location for the curved panel. The work was realized in 1999. Private collection, New York.

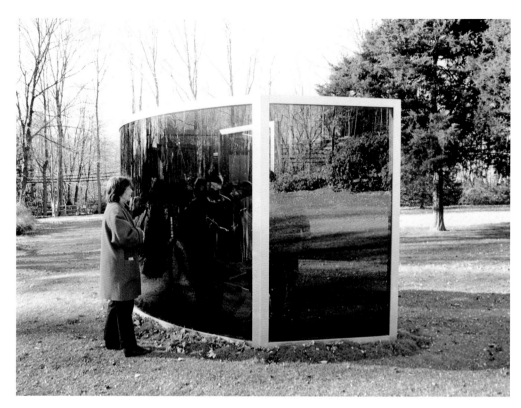

Fun House for Mallin,
1997-99. Private collection,
New York, USA.

Canopy (Second Version),
1999, architectural model.
Flick Collection, St. Gallen,
Switzerland. Courtesy Hauser
& Wirth, Zurich, Switzerland.

163 1999

Title/Date
Canopy (Second Version)
1999

Architectural model
edition of 3
materials and dimensions
may vary over edition

Materials
aluminum, three concave
two-way mirror glass
elements

Dimensions
35²⁄₅ x 42¹⁄₈ x 31 in.
90 x 107 x 79 cm

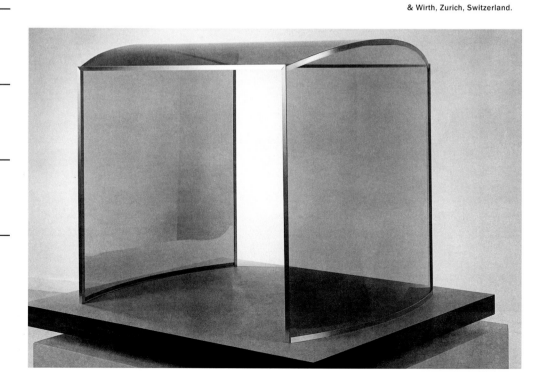

Title/Date
Children's Day Care,
CD-ROM, Cartoon and
Computer Screen Library
Project
1998-2000

Materials
two-way mirror, stainless
steel, rubber, computer
screens and computers,
CD-ROM and cartoon
library, desks and stools

Dimensions
90 x 296 x 273 in.
228.6 x 751.8 x 693.4 cm

First publication
previously unpublished

First exhibition
'Dan Graham, Children's
Day Care, CD-ROM,
Cartoon and Computer
Screen Library Project,'
Marian Goodman Gallery,
April 5 – May 20, 2000,
New York.

Notes
Pavilion structure with G4
computer stations and
desks for program of CD-
ROM and cartoon materi-
als and internet access for
children. The pavilion is
intended for a museum or
library or similar institu-
tion. The work was origi-
nally proposed to 'Skulptur
Projekte,' Münster in
1996. The model was first
exhibited in the exhibition
'Dan Graham, Unrealized
Projects,' Christian Meyer
and Renate Kainer Gallery,
Vienna, October 21 –
November 28, 1998. The
indoor pavilion was first
realized for the exhibition,
'Dan Graham, Children's

The three flat panels have a CD-ROM, a cartoon screen and a computer screen as a library for children in a museum or library situation. The smaller children can be entertained by the curved anamorphic 'fun-house' surface of the larger curved side.

The two-way mirror curved side has ana-morphic properties creating on the interior a concave 'fun-house' mirror enlargement of the children's bodies. On the reverse side there is a concave optical reduction.

The facing side, with concave two-way mirror, flat two-way mirror and two punched aluminum screens, creates a labyrinth of somewhat 'virtual reality.' The punched aluminum gives a 'peep show' look at oth-er children on the reverse side, while the two-way mirror is more 'filmic.'

The punched aluminum seen in relation to the curved and flat two-way mirror sides produces *moiré* patterns, especially ar-resting when the spectator moves.

Two-way mirror is both reflective and trans-parent. The side which receives more light at a given moment will be more reflective than transparent, but is in a constant state of flux. In my room the shift of lighting occurs as the light of the computer screens changes, sometimes being tem-porarily blocked by moving children.

Children might focus on the bodies and eyes of other children on either side of the two-way mirror or on themselves being looked at by the children on the other side who also see themselves in a mirror reflec-tion. The work shows to viewers their own perceptual process.

Dan Graham, 'Children's Day Care Centre, CD-ROM, Cartoon, Computer Screen Library,' 1998, text previously unpublished.

Children's Day Care, CD-ROM, Cartoon and Computer Screen Library Project, 1998-2000. Installation Marian Goodman Gallery, New York, USA, April 5 – May 20, 2000. Courtesy Marian Goodman Gallery, New York, USA.

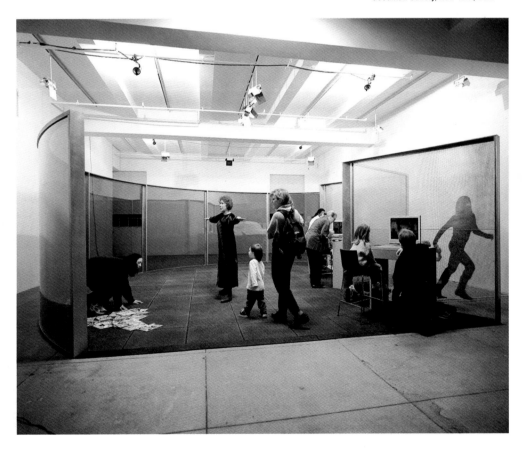

164 2000

Day Care, CD-ROM, Cartoon and Computer Screen Library Project,' Marian Goodman Gallery, New York in 2000. For the first exhibition at Marian Goodman Gallery, the cartoon library included: Betty Boop, Fantasia, Krazy Kat, Mickey Mouse, Monkey Magic, Little Nemo, Popeye, Porky Pig, Ranma 1/2, Sailor Moon, The Three Caballeros, Totoro.

The CD-ROM archive included: Fantastic Prayers, 2000, Constance De Jong, Tony Oursler, Stephen Vitiello, published and produced by the Dia Center for the Arts and Prop

Foundation and Puppet Motel, by Laurie Anderson. Collection Dan Graham, Courtesy Marian Goodman Gallery, New York.

164.1 1998

Title/Date
Children's Day Care, CD-ROM, Cartoon and Computer Screen Library 1998

Architectural model
edition of 3
materials and dimensions may vary over edition

Materials
aluminum, concave mirror glass, wood, various plastic toys, plastic toy screens

Dimensions
$10^4/_5$ x $28^3/_4$ x $37^4/_5$ in.
27.5 x 73 x 96 cm

164.2 2000

Title/Date
Children's Day Care, CD-ROM, Cartoon and Computer Screen Library 1998

Scotch tape model
unique

Materials
reflective plastic, plastic figures, scotch tape

Dimensions
$6^1/_6$ x $18^1/_2$ x $15^1/_2$ in.
15.6 x 47 x 39.4 cm

Children's Day Care, CD-Rom, Cartoon and Computer Screen Library Project, 1998, architectural model. Courtesy Marian Goodman Gallery, New York, USA.

Title/Date
Girl's Make-up Room
1998-2000

Materials
two-way mirror glass,
perforated stainless steel

Dimensions
67 x 118 in.
170 x 300 cm

First publication
previously unpublished

Notes
Indoor pavilion structure
comprised by a curved
concaved mirror to be
realized in 2000. Collec-
tion Dan Graham,
Courtesy Galerie Hauser &
Wirth, Zurich. A make-up
mirror with a fish-eye lens
and a magnetized back
will be produced as a

The pavilion consists of a curved, semi-cir-
cular, circa 4½ foot high concave two-way
mirror. Inside, 'girls' can see an anamorphic,
'fun-house' enlargement of their bodies.
The semi-circular form is bisected by two,
slideable, perforated stainless steel pan-
els which allow for entrance and exit from
the enclosure. When these panels slide
open, the shifting intersection of the small
'peep-holes' creates, by reflection on the
curved mirror, a *moiré* pattern.

multiple edition in conjunc-
tion with the pavilion.
Scotch tape models in two
sizes were made of the
Girl's Make-up Room, see
cat. no. 165.1.

The spectators will be provided with spe-
cial small mirrors which are normal flat
make-up mirrors with a small, convex,
'fish-eye' lens attached to their centers.
They also have magnets attached to their
backs so the mirrors can be left on the
metal wall. Manipulating the relative posi-
tion of the make-up mirror to the sur-
rounding curved mirror creates various
optical distortions of the body and space.

Dan Graham, 'Girl's Make-up Room,' 1998,
text previously unpublished.

Title/Date
Girl's Make-up Room
1997

Scotch tape model
unique

Materials
reflective plastic, perforat-
ed metal, scotch tape

Dimensions
2 x 3¾ x 2 in.
5 x 9.8 x 4.9 cm

Girl's Make-up Room, 1997,
scotch tape model.

Title/Date
Girl's Make-up Mirror
1998-2000

Multiple edition
protoype for an edition

Materials
reflective plastic with 'fish-eye' lens and magnetized back

Dimensions
11²/₃ x 8¹/₄ x 1 in.
29.5 x 21 x 2.5 cm

Girl's Make-up Room, 1997,
scotch tape model with
Girl's Make-up Mirror.
Flick Collection, St. Gallen,
Switzerland (top).
Girl's Make-up Room,
1997, scotch tape model
in the artist's studio, New
York, USA.

Chronology

Brian Hatton

Dan Graham in Relation to Architecture

Since the 1980s, Dan Graham's work has consisted in the design of pavilions in two-way mirror glass, an increasing proportion of which have been realized, not in museums or exhibitions, but as permanent structures in architectural settings. In addition to staging those plays of reflections and montages in interpersonal images which are their motivating subject, the pavilions perform functions of shelter and rendezvous. They may then prompt a question: "Is Graham now an architect?" For Mark Pimlott in the 1997 AA catalogue, the answer was presumptive: "Dan Graham may be an architect."[1] But the form of the question returns us to that put to Graham in a 1970 radio symposium: "Dan, you've been called a poet and a critic and photographer. Are you an artist now?"[2] Graham replied by saying that what he did was defined by the medium, which in turn is defined by the reader/beholder, and by the context in which work is placed: "I was interested in a system that is tied into a medium rather than in my saying I am an artist."[3] Might we say then, that, rather than being an architect, Graham uses architecture as a medium? That is, that architecture is adapted as a cliché, whose stereotypes can become a device for the placing of subjects in a milieu where their interrelations become the subject of the work? And let us qualify that by noting Alexander Alberro's comment on Graham's *Schema,* a work in print which adapted the cliché of a magazine page, yet presented no content but a list of its own material characteristics: "*Schema* is clearly less interested in subject matter than in how subject matter is made possible, less interested in content than in the differentiating features of the formal frame."[4] Its subject is not an integral self-presence but a continuously elusive phenomenon of information fed back from context. *Schema* is a mirror which offers an account of its placement wherever it is published. (At the same time it is quite transparent, one sees 'nothing' there; one sees 'through' it.) It attempts to fuse and keep true to its subject (itself in context) much as a running commentary tries to keep up with the events it is witnessing. But just as a relay will always be too late, *Schema's* list is never quite entirely of what and where it is.[5] The effect of its highly structured placement is, in fact, as in all Graham's works, to release the subject from structures and regimes which seem its own, but to which it is in fact *subjected.* Later on in the radio symposium, Graham added, "I'm interested in fusing something in the present without documentation. I was never interested in words or syntax in poetry, but more in information. I wanted the things I did to occupy a particular place and be read in a particular present time. The context is very important. I wanted my pieces to be about place as in-formation which is present."[6]

But the 'present' is the one moment when the thing one does and the place one is are identical. It is significant that, in the same month of *Schema (March 1966),* Graham also wrote on *March 31, 1966* – a list of distances to his retinal wall at that moment, descending from 'edge of known universe' through Washington DC, Times Square, his front door on 1st Avenue, his typewriter page, glasses, and cornea. Like *Schema,* this situates a site, but in this case not the art-object but the artist-subject, fusing subject and object in a single identification.[7]

In a note, Graham remarks that *Schema's* "medium is in-formation," meaning it is constituted in its immediate rendition of its appearance in a magazine, "between the external 'empty' material of the place and the interior 'empty' material of 'language'."[8] Looked at in this way, *Schema* uses the ostensive medium of poetry without any intrinsic interest in poetic technique to effect a difference in the social sign that is art. Neither poetry nor the magazine, but in the form of both, it occupies a medial term: "(Systems of) information (in-formation) exist halfway between *material* and *concept,* without being either

[1] Mark Pimlott, 'Dan Graham and Architecture,' in *Dan Graham Architecture* (London: Architectural Association/Camden Arts Centre, 1997): 49.
[2] Symposium broadcast by WBAI-FM New York, March 8, 1970, moderated by Lucy Lippard, with Carl Andre, Jan Dibbets, Dan Graham, Douglas Huebler. Published in *Six Years: The Dematerialization of the Art Object,* ed. Lucy Lippard (London: Studio Vista, 1973): 155.
[3] Lippard 1973: 156.
[4] Alexander Alberro, 'Structure as Content. Dan Graham's *Schema (March 1966)* and the Emergence of Conceptual Art,' in *Dan Graham* (Santiago de Compostela: Centro Galego de Arte Contemporanea, 1997): 21.
[5] The *mise-en-abyme* that occurs in Graham's video works was already implicit in his 'Thoughts on '*Schema (March 1966)*' No. 2.' "If a given variant is attempted to be set up by the editor following the logic step-by-step (linearly) it would be found impossible to compose a

completed version as each of the component lines of exact data requiring completion (in terms of specific numbers and percentages) would be contingently determined by every other number and percentage, which itself would in turn be determined by the other numbers or percentages, *ad infinitum*." In *For Publication* (Los Angeles: Otis Art Institute of Los Angeles County, 1975): n.p.

6 Lippard 1973: 158.
7 *March 31, 1966*, in *For Publication* 1975: n.p.
8 'Other Observations 1969/'73', in *For Publication* 1975: n.p.
9 'Other Observations,' in *For Publication* 1975: n.p.
10 "The forms [of the pavilions] are usually clichés of modern architecture." Interview with Brian Hatton, Fondation pour l'Architecture, Brussels 1991.
11 Michel Foucault described a mirror-image as between/both utopia and what he called heterotopia: "In contrast to the utopias [there] are places which are absolutely other with respect to all the arrangements which they reflect and of which they speak. [Such] places might be called Heterotopias. Between these two I would set that sort of mixed experience which partakes of the qualities of both kinds of location – the mirror. It is after all a utopia [...] I see myself where I am not. At the same time [...] a heterotopia. The mirror really exists and has a sort of comeback effect on the place which I occupy. I turn back on myself, beginning to turn my eyes on myself and reconstitute myself where I am in reality [...]" Foucault's idea of this double-place makes an initial account of the terrain across which Graham has sought at the same time to make abstraction socially operative and to formalize the

one."[9] The pavilions occupy a similar systemic position. They make minimal investment in tectonic values, not in order to achieve some austere aesthetic, but to enter as "clichés of architecture,"[10] an ambit of the circulation of social signs, which architecture, as the expression of power, monopolizes, or rather, orders in the interest of monopoly. They are only partially isotopic with site-specific installation, which participates in the physical order of architecture, but not in its symbolic order, which it situationistically subverts. Unlike Matta-Clark or Krzysztof Wodiczko, Graham works not with/against architectural fabric and monumental iconography, but at ground level, amid the vernacular glance of a social world, where monuments and clichés exist on a common scale on the cognitive maps described in Kevin Lynch's *The Image of the City*. Disappearing amid blank structure (as in *Schema*. Can one ever see a mirror?), Graham reflects back contradictory identifications between ideal forms and popular clichés, utopian models and alienated stereotypes in mass media, in architecture, and indeed in daily social interactions. It is as if they become mirror-images, parallel utopias/'heterotopias'.[11] As J.-F. Chevrier put it: "This is effected less by discriminating between things or ideas [...] than by constructively dramatizing ambiguity as the coexistence of contradictory points of view and the montage of dissimilar historical moments."[12]

An early model of this *modus operandi,* but also indicative of the confusions which it may sow, was 'Homes for America.' If Lippard cited Graham as a photographer on the basis of this work, she was not alone. As Benjamin Buchloh noted, Dan Flavin had also thought so.[13] But its highly original format (form/medium/mode) could also ratify her reference to poet and critic; for it functions in all these registers; and it is this heteronymous modality which makes *Homes* perhaps the most multivalent of Graham's early works, and the most significant for his later architectural direction.

At the time of its publication in *Arts,* December 1966, Graham was writing criticism on art and rock music. Moreover, there were precedents for using criticism to set out artistic tenets and themes. Donald Judd's descriptive mode of analysis became a model for his serial mode of production. Seriality, if not the 'idea-machine that makes the art' that it became for Sol LeWitt, was for Judd a generative means. Likewise Judd's idea of specific object expanded art from closed meters of painting/sculpture to an open category of artifact.[14] Seriality and open order were given an exponential cast by Robert Smithson, who mapped them onto the extended entropic field of the New Jersey suburbs.[15] 'Homes' adapted both these approaches, but, setting aside Judd's focus on art alone, and Smithson's yen for the sublime, Graham set out his article as an essay in social reportage. Indeed, *Arts* misillustrated it with a photograph by Walker Evans.[16] 'Homes' assumed the mode of photojournalism, but only as cliché-form. From among new suburban 'tract housing,' Graham selected views that emphasized their serial, formulaic designs in row and echelon, without making judgments on their banality. This factographic method was extended to a systematic analysis of their semiotic structure; in the varieties of types, arrays, and colors in all permutations. The page layout resembled an estate-agent's brochure as much as a social report, but could also be read as an elaborate program for a serial system of 'specific objects;' an identical hyperformalism was seen to structure both minimalist art and the housing industry. Yet, again, this was not the subject of a judgment; rather, commentary in the article was made part of the same structure; but as the article was by an artist in an art magazine, the reader identified the text as an art proposal and to that degree identified with the builders of the tract 'homes' as well as the artist-author of the 'tractatus' 'Homes for America.' Such identicality of

subjects of popular representation. Quotation from 'Des Espaces autres', a lecture given in Paris, March 1967. Published in English in *Architecture Mouvement Continuité,* 5 (October 1984) and in *Lotus,* 48/49 (1984/5). Present citation from *Architecture Culture 1943-68,* ed. Joan Ockman (New York, 1993): 419.

[12] J.-F. Chevrier, 'Dual Reading', in *Walker Evans & Dan Graham.* Exh. cat., (Rotterdam: Witte de With, 1992): 14-25.

[13] Flavin's response to Graham's photography is discussed by Benjamin H. D. Buchloh in 'Moments of History in the Work of Dan Graham'. In *Dan Graham: Articles* (Eindhoven: Stedelijk Van Abbemuseum, 1978): 73-77.

[14] George Kubler's *The Shape of Time* was influential in Graham's 1960s circle. Kubler's opening hypothesis announces his dissent from the idealist historicism of then-current accounts of modernist art: "Let us suppose that the idea of art can be expanded to embrace the whole range of man-made things [...] By this view, the universe of man-made things simply coincides with the history of art."

[15] I adapt from Rosalind Krauss' essay 'Sculpture in the Expanded Field,' also from Smithson's essay in *Artforum,* June 1966 'Entropy and the New Monuments.'

[16] The inserted Walker Evans illustration is discussed in Chevrier 1992: 14.

[17] Chevrier 1992: 14.

[18] Buchloh 1978: 73.

[19] 'Live Kinks,' in *Articles* 1978: 48-50.

[20] 'Magazine Advertisements,' in *For Publication* 1975: n.p.

[21] 'Magazine Advertisements,' in *For Publication* 1975: n.p.

[22] 'Likes,' in *For Publication* 1975: n.p.

[23] *Likes* and *Income (Outflow) Piece,* in *For Publication* 1975: n.p.

subject and object would be a recurrent motif/method in Graham's work. Chevrier remarks: "The commentary is not a secondary reflection on a separate (and past) artwork. It is no longer a reflection of art's autonomy. The commentary is coextensive to the work (which neither negates nor denies itself). The work and commentary are copresent in a single space of perception, which is that of information. The latter is no longer information on; it is in-formation of. The commentary itself is artistic form."[17]

Although he would not repeat its formalistic performance ("a simulacrum of the object of history" as Buchloh, citing Barthes, put it[18]), 'Homes' set a model for Graham's writing on architecture in that its analysis worked to identify an invisible or repressed factor which became the subject of a new investigation in method, for instance in video, in cultural placement, or in restatement of the 'primitive hut.' One detail in 'Homes,' however, was indicative of an emergent issue in Graham's work. It is that part which turns from the impersonal structure of the housing's production to the subjective participation in their consumption, by listing customers' color-preferences on two scales of 'like' and 'dislike'. Replete with the ersatz individualism of marketing, their effect is to transfer the stereotype from the object to the subject, who has identified him/herself with the small range of manufactured options. Yet alienation is never complete, 'every cliché comes from the heart,' and like pop music, the 'homes' admit a zone of processed, jejune, yet still authentic feeling. As in Graham's review 'Live Kinks,' which closes by describing the habitat of a Ray Davies' song: "Mr. Pleasant lives in the suburbs where there isn't anything to dislike. All is pleasant, bland, empty [...] A housing development in Florida, which, for instance, features eight possible musical 'styles': A. The Sonata, B. The Concerto, C. The Ballet, D. The Overture, E. The Prelude, F. The Serenade, G. The Nocturne, H. The Rhapsody." These were, in fact, the names of the Cape Coral project featured in 'Homes.' In the last paragraph of 'Kinks', Graham links these 'likes' with pop astrology, invoking the Gemini sign common to Brian Wilson, Paul McCartney, and Bob Dylan, "But Davies was born June 21 – cusp with Cancer – so he is made more 'moony' and involved with things of the house."[19]

'Pop,' Andy Warhol proposed, 'is liking things.' But only in a commercial nirvana would everyone like everything all of the time. Until alienation is complete and universal, advertising will continue to work by identifying particular desires with particular objects, making those identifications into artificial subjectivity. As Graham noted, "the advertisement makes *public* – publicizes – a *private* need and, as a consequence, shifts categories of this relation."[20] Graham used the form of the advertisement in a number of works which anticipated the way that he would later use the form of the display window in pavilion works. Proceeding from adopting the site of advertisements to utilizing their method, he placed ads for a number of projects aimed at reconstituting the artist's practice in direct participation, such as *Income (Outflow) Piece,* which would alter "the larger homeostatic balance of my life."[21] *Likes* (1967-69) made astrological signs the basis of a matching agency which advertised: "You are guaranteed to receive names of three astrologically matched dates. You will also be getting a new questionnaire asking you how the time passed [...] So that with the passing time we will learn more about astrology as a social science [...] in order to better meet the more clearly defined needs of you, the participators."[22] It was a feedback system taking off from Graham's amusing accuracy in astrological characterization – like rock music, a hobby of the artist. One might almost have asked 'Dan, are you an astrologer now?' But this was another appropriation of a medium. His note of 1969 observes: "There is a relation of a *public* figure's *private* 'piece' to *public* exposure or the reverse (as in *Likes,* where the spectator exposes his private needs)."[23]

These works advanced on Warhol's remark in that they effected methods involving 'liking,' but exposed and defixated the ways in which narcissistic identification in objects of desire structure the ego. In a note titled "Glass used in shop windows/Commodities in shop windows," Graham observes "Under capitalism, just as the projectad ego is confused with the body image in the mirror, so that ego is confused with the commodity. The individual is made to identify himself (in his feeling for 'himself') with the image of the commodity. The commodity object is a substitute *(fetish)* for his lack – the lack his desire expresses. The glass and mirrors of the 'shop window' beckon the potential customer by arousing doubts and desires about his 'self-image/self-identity.' It is as if, looking at the product behind the glass showcase, the consumer is looking at an ideal image of himself (in the mirror). [...] The commodity reflects his desire for a more complete 'better self,' identified with the alter *ego.*"[24]

The word 'like' bears two reciprocal meanings. It can mean 'to enjoy' as an expression of appreciation or desire, or it can mean 'similar' or 'identical'. The two usages begin to converge when people describe their interrelations, two subjects will identify with each other when they feel their identities are identical: 'We are like each other: We like each other.' But people are not mirror images, still less commodities in shop windows which never deviate from one's model nor dissent from one's desire. As autonomous subjects, they are likely to answer back from other positions – even if they are the same star sign! Pop may be liking things, but liking people is quite another thing. Just as Graham transferred the minimalist site from gallery to the city, he transposed pop clichés from media to real situations in a series of performance works that began in December 1971 with *Like.* Its instruction is succinct: "Two performers have both been instructed to convince the other (the ways in which) he [or she] is like him (or her). This performance is continued with a continual coming closer together, until (perhaps as boundaries of self are reached) this is reversed. To communicate gesture verbal means, hand or skin manipulation, visualization, or sets of mental attention (or any form) may be used."[25]

Beholding *Like,* one might suppose that we are as far removed as could be from architecture. Neither walls nor windows stand between the two actors; nothing but their own difference and the limits intrinsic to language. There is, however, a temporal structure that spirals in towards a close – in the double sense of finitude and convergence – until identity is reached. We could compare this to that in a film which Graham shot in 1969, *Two Correlated Rotations.* It was made by having two cameramen film each other as they walk in counterspirals, one outward, the other inward towards the center. "Their aim, which is still in the state of a learning process, is to as nearly as possible be continuously centering their cameras' (and eyes') view on the frontal eye position of the other [...] The two-filmed images of the filmmakers [...] are simultaneously each other's subject (observer) and object (observed). The spectator's attention is part of a three-way relation (circuit) between the two performers' and the spectator's attention. In the spectator's view, it is impossible to separate the two cameras' mechanisms, the two minds and bodies from the feedback of reciprocal intelligence between them read in the image. In viewing the films on right-angle walls, both images are simultaneous and synchronous. Both filmmakers' and viewer's responses appear in the present time to them."[26] Graham adds a note which reminds us of the structure of *Schema* "(Systems of) information (information) exist halfway between *material* and *concept,* without being either one." "Here the 'self' is not a united center, but is located between the two performers' perceptions (of each other) and the viewer's perception: it is imminent in these interrelations which is

[24] 'Essay on Video, Architecture and Television,' in *Dan Graham: Video-Architecture-Television,* ed. Benjamin H.D. Buchloh (Halifax: Nova Scotia College of Art and Design and NYU Press, 1979): 72.
[25] *Like* is described in *Dan Graham, Theatre* (Gent: Anton Herbert, 1981): n.p. *Like* is not strictly the first performance in this catalogue. First listed is *Lax/Relax,* 1969. But this performance does not make use of individual identities or social personae. See also n. 41.
[26] *Two Correlated Rotations* is described in *Films* (Geneva: Éditions Centre d'Art Contemporain Salle Patino and Ecart Publications, 1977): 15.

(also) the structure of the film project."[27] When Graham designed a cinema rather than a film, he again had the audience face a corner between two right-angled walls; but where they had formed screens for *Two Correlated Rotations,* the walls of *Cinema* were made of two-way mirror glass that reflected the audience when lights were up, but were transparent to the street while films were projected onto a screen, which straddled the corner between the two walls. The fictions on-screen were thus sited amid exchanges of reflections and views among audience and voyeurs on the street. Graham commented: "In the Cinema all looks are two-way and inter-subjective for it is difficult to separate the optics of the materials of the architecture from the psychological identifications constructed by the film images."[28] The *Cinema* unravels relations of identity, recognition, and response that produce social subjects through imaginary identifications. It would in fact make a movie out of being at the movies. To be in *Cinema* is actually to be in a movie.

Donald Kuspit noted an imminent architecture of the identification process in Graham's performances. Comparing them against Bertalanffy's rules for feedback loops, which enable systems to gain states of higher organization by reacting to and assimilating information, he noted their reliance on pre-established arrangements, such as use of mirrors, positions of cameras, closed systems of rooms: "the internal establishment of a closed circuit – however involuted – of relationship between performer and audience is also architectural. Indeed, it is a supreme example of architectural meaning [...] the creation of an external space that influences social and self-perception, or that exists in a feedback loop with every kind of perception [...] It is the outer form of an inner map of social organization [...]."[29] Architecture is in its very inception a 'system of voyeuristic identifications,' organizing selves among patterns – collaborative, negotiated, or coercive – of identifications with, projections upon, or differences from, others.

In fact, some of Graham's most preliminary conceptions outlined protoarchitectural patterns among intersubjective relations. Grids of points, lines, and rectangles, in autonomous series comprise the initial pages of *Drawings 1965-69,* but later works in the sequence begin to make reference to human affects: *Strange and Square* and *I-They,* which sets into a six-square grid the set of pronouns which structure personal relations: I/We: You/You: (S)He(it)/They.[30] Their spatiality is apparent in dramatic exchange. When 'I' and 'You' address each other, we relate along a virtual axis in the direction of our mutual looking. A third person or thing is 'beside' this axis, perhaps at right angles to it, which would also be the axis of a viewer onto a s/he-s/he dialogue, as in a stageplay. Whereas in a film or TV drama the camera will often adopt the axis of I-You, alternating between the two subject-positions. Graham would explore these structures in videoworks, but already in *I-They,* its grid can be seen as an incipient plan for a two-way mirror pavilion in the series beginning with *Public Space/Two Audiences.* Two other pageworks suggest plans, but also meaning plan in time. Graham described them as "gridded data fields generating an optical-matrix perspective. They can be read as 'spatialized' 'effects' in time."[31] *Extended Distance/Extended Time* plots time and distance as X and Y axes, tracing their combined increments by arrays of lengthening diagonals which now seem to anticipate a plan of two-way mirrors. In fact, one of the first realized pavilions, at Argonne, used a diagonal resembling a cell from this work. *Side Effects/Common Drugs* plotted these two medical factors in a self-reflexive pattern of dots, showing how one drug's side-effects are corrected by another. Their mirroring like/unalike relays display a sequence of effect/responses whose density structures the reading and constitutes the content. "The extension of the data field (in the time

[27] *Films* 1977: 15.
[28] *Cinema* is described in *Dan Graham: Buildings and Signs* (Chicago Renaissance Society, 1981): 50.
[29] Donald Kuspit, 'Dan Graham, Prometheus Mediabound,' *Artforum* 23, 9 (May 1985): 78-79.
[30] *Dan Graham: Drawings 1965-1969* (Graz: Galerie Bleich-Rossi, 1990).
[31] Dan Graham, 'Information,' in *For Publication* 1975: n.p.

of the reading process) continues until all self-reflexive effects — points — are optically cancelled."[32]

Following Kuspit's idea of spatiotemporal structure, we find such strategies evident throughout Graham's early works, engaging (as Alberro relates) three overlapping models of visual experience: modernist, structural, phenomenological. Graham's encounter with the phenomenological model was immediately architectural, in witnessing how the logic of minimalist installation had led to the factoring-in to the work of its framing ambience. "Real materials in real space" had been a slogan of constructivists, but whereas their move had been into use-value via productivism, the first effect in minimalism was "an acute awareness of the phenomenology of rooms."[33] But it also, Graham perceived, induced an equal awareness of the beholder's own temporal part in the room; for its self-referential order intensified slight alterations of position and parallax with one's movement along, through, or about such work. Indeed, implicit in Graham's essay 'Photographs of Motion' was a reading of Muybridge's sequential shots of movement as anticipations of serial minimalist art.[34] Graham observed of a LeWitt work that it was simultaneously a representation of both itself and the interior in which it was installed. It defined itself in volume and extension as it defined its context: "It takes its own measure; the work is a measure of its place — of itself as placed."[35] It comprised inner and outer distances: that relating the object and room, and that between viewing subject and viewed object. But this was paralleled by a 'distance' between the viewer's sense of the present and the 'having taken place' of the work in the artist's mind in the past. Graham refers to this as a human relation 'related to the older architectural notion of scale;' it was connoted by the grid's bars 'literally barring access to the interior' of the structure. These three factors — human relation, representation of past time, and the medial function of scale — would feature throughout Graham's work. But he noted that they became active only in movement. So long as the viewer was still, there was a single frame of reference (as Renaissance perspective), but with movement, 'time begins,' exterior space in terms of extension is abolished, as "the entire 'interior' ensemble of relationships become nearly simultaneously available as 'perspectives' without spatial density or location. As the viewer moves from point to point about the art object, the physical continuity of the walk is translated into illusive, self-representing depth: the visual complication of representations develops a discrete non-progressive space and time [...] Object and subject are not dialectical oppositions, but one self-contained identity. All frames of reference read simultaneously: object/subject. The viewer as subject/object views subjectively/objectively a subjective/objective literal spatial exterior spatial 'illusion/reality'."[36] This description may go beyond LeWitt's own conception, but in doing so, Graham anticipates the phenomenological system of his own work with performance, video, and two-way mirrors.

The 'turn to the subject' after minimalism could be related, as in pop art, to the centrality in later capitalism of the consumer rather than producer; but it also bore an utopian aspect in conjecturing participant production in a new use-value — another dream convergence of subject-object. Installation became based on the interaction of three practices: reflexive inclusion of the beholder's mobile attendance, ambient context, and the assemblage in real space and time of lifeworld materials and signs. All three appeared in the work of Dan Flavin, which Graham was able to study on-site whilst running the Daniels Gallery 1964-65. This experience seems to have been formative, as it gave Graham the chance to test the effects of 'the white cube' on viewers, and to exper-

[32] 'My Works for Magazine Pages. 'A History of Conceptual Art', in *Dan Graham* (Perth WA: Art Gallery of Western Australia 1985): 13.
[33] Mel Bochner: 'Serial Art Systems: Solipsism,' *Arts Magazine,* 41 (Summer 1967). Cited by Alberro 1997: 26.
[34] Dan Graham, 'Photographs of Motion,' in *Articles* 1978: 14-15.
[35] Dan Graham, 'Photographs of Motion,' in *Articles* 1978: 14-15.
[36] Dan Graham, 'Two Structures/Sol LeWitt,' in *Articles* 1978: 29-32.

iment with placements and assemblies of artworks. Flavin's installations arranged common fluorescent lights so as to significantly alter their ambience; "not merely *a priori* philosophical idealizations," Graham wrote, but having "concrete relations to specific details of the architectural arrangement of the gallery, details which produce meaning."[37] Moreover, an effect of their ambient luminescence was to return viewers' attendance to their own relation to the space around and between them. In a letter to Benjamin Buchloh, Graham recalled: "I liked that as a side-effect of Flavin's fluorescents the gallery walls became a 'canvas'. The lights dramatized the people (like 'spotlights') in a gallery – throwing the content of the exhibition onto the people in the process of perceiving; the gallery interior cube itself became the real framework."[38] It is perhaps not insignificant how Graham here cites the subject-drama as a 'side-effect' highlighted like 'spots' in a figure of speech that recalls the interactive grid/sequence in *Side Effects/Common Drugs.*

Paul Virilio remarked how lighting, surveillance, and film are strategically linked in the history of the city: "The city that has been moved into the light has become, so to speak, the city moved into the movie theatre [...]"[39] Likewise Mark Wigley observes how the modernist white wall, against which subjects stand out so clearly, became an optical recording device.[40] It is conceivable that Graham might have gone straight from his experience as a gallerist to some work like the pavilions that he began to elaborate with *Public Space/Two Audiences* of 1976. If he didn't, it was because there were other factors in the art system which required investigation: from interventions in the codes of magazine media (which was actually the gallery's systemic site), he moved only subsequently, through detours, returns, and overlaps of method to re-plot the intersubjective dynamics he had glimpsed in the works of Flavin and LeWitt. These mixed phases and hybrid works exemplify Graham's reiterative *modus operandi,* not only within particular works (presenting subject/object sequentially and/or from several positions) but also through the chronology of his curriculum. Catalogued in a list like *Schema*, his artworks and writings unroll as a succession of recollections, running commentaries, and anticipations, recovering past moments and lateral histories to reconstruct (re-'in-form') his subject-matter by means of record, reference, and reflection. Such regeneration by iterative algorithms resembles the cybernetic models which interested Graham as his work began, around 1970, to ramify and cross-refer among several media. Nevertheless, it is possible to see an emergence from the pageworks through film and performance to the video-feedback installations in the 70s to the architectural pavilions of the 80s. An initial state is perceivable in *Lax/Relax,* the first work in Graham's performance catalogue *Theatre.* Performed in May 1969, it precedes any spatial division, presenting only a progression, via hypnotic breathing and delayed/overlaid reiteration of the words 'lax/relax,' towards an 'oceanic' merging of male/female speakers and audience. Here, one can barely speak even of subject/object opposition; this work occupies, in both the sense of Graham's artistic project and Lacan's account of ego inception, a position which might be termed "pre-mirror-stage."[41]

If architecture, primordial agent of division and distinctness, consists in fixing the spatial elements of an event, then it enters Graham's work via the scopic directions for his films, which *Body Press,* 1970-72, culminated within the confines of a cylindrical mirror. But the resultant images in Graham's films resist any oriented, let alone architectural fixations. *Body Press,* in particular, produces two swarming helical scans of bodily surfaces which repeatedly cross over each other and exchange subject/object paths. But almost

[37] From 'My Magazine Pages,' *Perth* 1985: 10.
[38] Graham's letter on Flavin is cited in Buchloh 1978: 76.
[39] Paul Virilio: 'Life in Cinecittà,' in *Splinter,* 4 (Summer 1991, Montreal): 10.
[40] "The white surface is the antifashion look, both in the sense of the 'look' of the *tabula rasa*, with every excess cleared away, and in the sense of an active look, a surveillance device scanning the very spaces that it has defined for the intrusions of fashion. The white wall is at once a camera and a monitor, a sensitive surface, a sensor." Mark Wigley, *White Walls, Designer Dresses* (Cambridge, Mass.: MIT Press, 1995): XXII. Wigley's arguments here are in art developments from Beatriz Colomia, *Privacy and Publicity* (Cambridge, Mass.: MIT Press, 1994).
[41] *Lax/Relax* is described in Dan Graham: *Theatre* 1981: n.p. Jaques Lacan's idea of the mirror stage is summarized in Graham's '*Essay on Video,* Architecture and Television,' in Buchloh 1979: 67.

Relation to Architecture

simultaneous with the films were Graham's first works with video. Here, architecture enters as directions of address, not only for actors but for studio apparatus such as cameras and monitors. Encountered from the start were those codes of real space and live time that distinguish video from recorded media such as film, and which Graham would expound in the essays for his 1979 anthology *Video-Architecture-Television.* After his first video work *TV Camera/Monitor Performance,* a performance which adapted directions from *Roll,* he moved to work with community cable TV, involving real disputants exchanging positions and viewpoints. Soon after, *Two Consciousness Projection(s)* moved from community to sexual politics. Here, participants refocused their relations through a sequence of reciprocal appraisals. These were performance works, similar in method to some of those in Graham's *Theatre* anthology, save for the mediation of video. Indeed, later performances such as *Performer/Audience/Mirror* seem to have been evolved from earlier video performance works.

With *Present Continuous Past(s),* 1974, however, a complete ambient chamber was constructed in which, by means of time-delayed video relay, viewers became actors of their viewing of their acting. Architecture framed the closure in the circuit. Here, the doubling of simultaneous reflections by right-angle mirrors was complicated by redoubled reflections of the visitors' images of themselves some seconds before in a CCTV monitor. These were developed in the series of later chambers through increasingly elaborate reiterations of the first premises of displaced and delayed spatial/temporal feedback. Initially enclosed cells, later variants occupied actual locations, becoming site-specific interventions in sightlines and social domains as perspicuous as those of Matta-Clark through walls and property lines. What was especially 'surgical' (in Benjamin's phrase for the analytical acuity of photography) was the way these works 'diverted' (situationist *detournment*) devices of control and surveillance. *'Picture Window' Piece,* 1974, a seemingly discrete example among these, would become the outset for one of Graham's most disturbing projects, *Alteration to a Suburban House,* 1978. Without video, but just by replacing a housefront with a picture window and lining the interior wall facing the street with a mirror, both the daily life of the house's occupants and the gazes of passing neighbors were put on mutually reflected display, as if in some inescapable soap opera; surely the repressed unconscious fantasy of all suburban life.[42]

Towards the end of this series of interventions (in architectural regimes rather than in built fabrics), Graham summarized his observations in 'Essay On Video, Architecture, and Television.' In contrast to film's discontinuous, distanced, and contemplative quality, Graham described video as a present-time medium, continuous and congruent with the real time of both its objects and viewers. But TV's tendency to centralization of information and propagation could be broken down by video and cable, becoming two-way and participative. Video could also erode codes of social order hitherto reinforced by architecture: "Video in architecture will function semiotically speaking as window and as mirror simultaneously, but subvert the effects and functions of both. Windows in architecture mediate separated spatial units and frame a conventional perspective of one unit's relation to the other; mirrors in architecture define self-reflectively, spatial enclosure and ego enclosure. Architecture defines certain cultural and psychological boundaries; video may intercede to replace or re-arrange some of these boundaries. Cable Television being reciprocally two-way, can interpenetrate social orders not previously linked; its initial use may tend to de-construct or re-define existing social hierarchies."[43] The 'Essay' develops these issues through a range of social situations and architectural devices – public/

42 *Alteration to a Suburban House* described in *Buildings and Signs* 1981: 35.
43 Dan Graham 'Essay on Video, Architecture and Television', in Buchloh 1979: 64.

private codes, conventions of the glass window, the mirror image/video image (here including a note on Lacan's idea of the 'mirror stage'), video feedback, the glass divider: light and social division, glass used in shop windows/commodities in shopwindows, and concluding with 'Glass Buildings: Corporate Showcases,' analyzing the ideology that 'transparent' glass walls conceal in the capitalist city. Functionalist and utopian origins of the ideals of transparency are traced from the 1920s to their cooptation by contemporary business offices where transparency is used as 'an alibi for the institution it houses.' Workers are displayed as demonstration of 'openness' in buildings whose formal self-containment in fact 'deny that they have an outside.' Later in the 'Essay,' Graham would note how corporate adoption of reflective mirror glass also served to present them as "ecologically minded."[44] Reflective glass was associated with reduced energy consumption, but in fact negated the city's public ambience, withdrawing behind reflections into apparently public, in fact exclusively policed, private atriums.

The penultimate illustration to the 'Essay' is of a glass office at street level: a scene quite as alienating as *Alteration to a Suburban House*. Workers at their desk are seen like actors on a studio-stage, yet there is no exchange with the street. Sound is cut out, and clarity occluded by reflectivity of the glass screen, in which we (the photographer) discern our own voyeuristic image. In the end, neither we nor they prevail over the insistent order of the curtain wall, which is displayed in the final illustration as an overwhelming reiteration of the national flag. The 'Essay' extends the method of 'Homes for America' in that it studies what is generic (if not always vernacular) to the commercial production of the contemporary city. No particular buildings or architects are identified, and critique is directed only at the most systemic levels of the corporate and technocratic apparatus. Architecture is treated in McLuhanesque terms as a medium, but also as a sign-system. These were now to be the terms of Graham's own work as he turned to concentrate on the properties of two-way mirror glass, beginning with *Two Adjacent Pavilions* and *Pavilion/Sculpture for Argonne,* his first free-standing architectural works.[45]

However, in adopting the medium of architecture, Graham could not avoid taking up debates within its internal discourse, no more than he could vis-à-vis the gallery and magazine media in his pageworks, or TV and music in his performance works. Accordingly, in February 1979 *Artforum,* Graham published the first in a series of essays on current architecture and its historical condition: 'Art in Relation to Architecture/Architecture in Relation to Art.' Here, for the first time, Graham discusses individual architects, notably Mies van der Rohe and Robert Venturi. But as in his essays on artists, Graham writes not as a critic of particular works but of ideological formations. In fact, Graham proceeds to identify an architectural dialectic similar to that which he had described between Minimalism and Pop, and likewise sets out to situate his work as a critical mirror among their reciprocal reflections. He begins by recapitulating once again the illumination by Flavin and Buren of crisis in the white gallery. He identifies the gallery as an 'aristocratic relative' of a broader category of unornamented utilitarian buildings idealized since the Enlightenment. As fabrications of and by virtue, such buildings became the model for utopian functionalists in the 1920s. For them, efficient buildings were necessarily beautiful forms, so that an ideal of beauty was sealed into their absolute formal/functional purity. The paragon of this ideal was found in the glass curtain wall advanced by Mies, which Graham then refers to the history of its corporate appropriation, as in his 'Essay on Video;' but he refers it also to the critique of artistic autonomy since minimalism: Functionalist architecture and Minimal art have in common an underlying belief in the Kantian notion

44 Buchloh 1979: 74.
45 *Two Adjacent Pavilions* and *Pavilion/Sculpture for Argonne* were described in *Buildings and Signs* 1981.

of artistic form as a perceptual/mental "thing in itself […] in which the spectator takes pleasure without interest."[46] Both are formally reductive, and both 'deny connotative social meanings and the context of other surrounding art or architecture.' Against this formation, Graham holds up alternatives from pop art which punctured exclusive values, either by imitating media clichés but using distancing devices within the vernacular code to 'estrange' and thus renew cultural signs, or by directly doubling low culture/high art readings in a single image, as in the work of Roy Lichtenstein. Graham points out Lissitzky's similarly complex relation to the cultural economy of the Soviet 20s, but emphasizes the futility (and elitism) today of neoconstructivist nostrums. At this point, he might have adopted an Adorno-like pessimism in relation to 'the culture industry;' but his rejection of idealist positions also leads him to avoid this 'negative utopia.' Instead, Graham finds in Venturi's architectural ideas a way of continuing a positive but resistant activity: 'This means taking […] commercial vernacular seriously,' including relations to surrounding built environment, program, and the public reading and cultural appropriation of the building – a 'dual reading' of connotative as well as denotative signs, and of both popular and art codes. Such work, he suggests, asks: "What is art and architecture's relation to and sociopolitical effect on their *immediate* environment? […] What Venturi appropriates from the Pop artists is the understanding that not only can the internal structure of the architectural work be seen in terms of a relation of signs, but that the entire built (cultural) environment with which the building is inflected is constructed from signs."[47]

Yet Graham is not an epigone of Venturi, let alone Post-modernism, which he later denounced in an *addendum* to 'Art In Relation….' Indicative of his position is the way the essay includes a dialectical comparison with a work by Buren, *In The Wind,* where flags are used connotively, but cancel out particular significations, rather as in Graham's own earlier work. Venturi is interested in connotive contradiction but in pursuit of complexity, not of radical dissociation. This is where Graham pitches his ambiguous project; never quite accepting architecture's affirmative mission but playing with humor on the unstable, even disturbing repressed fantasies in many common architectural scenarios, as in *Alteration to a Suburban House.* It explains why he chose to conclude his later *addenda* to 'Art in Relation…' with a passage from Rem Koolhaas, whose *Delirious New York* presented a comparable interpretation. In fact, his pavilions have proceeded from a Miesian basis, but inflected towards the vernacular by their common materials and connotive primary forms.[48] Graham's position is as strategically elusive (allusive) as in his performances, or the reflections in his pavilions. His citation of Buren's negation of the Hirschhorn's pompous bulk indicates an identification with the activity of Matta-Clark or Wodiczko, and suggests that Thierry de Duve's idea of Graham's work as "abolishing place"[49] is more apposite than De Duve realized. For it is the ontological site of practice itself, as art or architecture, that is shifted and displaced in Graham's work. Towards the end of 'Art in Relation,' Graham made a categoric statement of aim: "The task of the work of art or of architecture is not the resolution of social or ideological conflicts, and not the construction of a new ideological counter-content; instead, the artwork directs attention to the seams in various ideological representations (revealing the conflicting variety of ideological readings)."[50]

Graham's *addendum* to this conclusion was written against the travesties of post-modernism that betrayed history by denying memory of the utopian grain in the modern movement. As corrective, he proposed that "Strategically, the devalued architecture and ideas of the most recent 'just-pasts' have the strongest potential to reawaken the sense

[46] 'Art in Relation to Architecture/Architecture in Relation to Art.' This essay appeared in *Art Forum* (Feb. 1979). It was republished with an *addendum* and commentary in *Rock My Religion. Dan Graham Writings and Projects 1965-1990,* ed. Brian Wallis (Cambridge, Mass.: MIT Press 1993): 228.
[47] *Rock My Religion* 1993: 233.
[48] Graham developed comparisons of corporate logos with forms in minimalist art in his essay 'Signs,' *Artforum* (April 1981). Also, modified, in 1993, *Rock My Religion* 1993: 239-241.
[49] Thierry de Duve's 'Ex Situ' assigns Graham's work to a category described as 'Sacrificing place, linking space and scale.' In *Installation Art,* (London: AD, 1993).
[50] In *Addendum,* in *Rock My Religion* 1993: 239.

of past events and historical meaning, as they are the most strongly repressed missing links in the present ideological constructions."[51]

In thus moving towards an 'alter-architecture' at the close of the 70s, Graham was adapting his *Alteration* of the just-past from the microstage of intersubjectivity that had been the *Schema* of his performance and video works towards the historical stage and public milieu of a contemporary Benjaminian project.

[51] In *Addenda*, in *Rock My Religion* 1993: 240.

Dan Graham at Antwerp Zoo,
1996

Eric de Bruyn

The Filmic Topology of Dan Graham

Film as Event

Exhibit A

> The film is not exhibitionist. I watch it, but it doesn't watch me, watching it.
> Nevertheless, it knows that I am watching it. But it doesn't want to know.[1]
> Christian Metz

On taking my place in the movie auditorium I enter into a curious scenario of disavowal. A strange game of hide-and-seek ensues. What is this charade that I willingly succumb to in classical cinema?[2] To paraphrase Christian Metz, our self-delusion assumes the following form: "I'm here and I'm present. I watch and assist at the birth of the film. Only in my gaze does the film exist, it lives within me." In other words, the story of the movie does not simply happen of its own accord, it does not narrate itself; it is I who assume the empty place of the narrator. I become, as it were, the apparatus of exhibition. That is why the filmed scene might be caught unaware – it remains oblivious to my presence, because I appropriate the function of mediation for myself. I do the showing without showing myself. And that is also why I rest comfortable in the perceptual loop of exhibitionism, because I am removed from its tautological structure. The exhibitionist knows that the voyeur looks, derives pleasure from this look, and thus, at the same time, identifies with the other's look. But in the cinema I do all the looking while remaining impervious to the look of the other. It is not just the actor who never acknowledges my stare; it is the projective apparatus itself that is never caught in the act, which never shows up.

Exhibit B

> A camera's identity, in relation to the spectator's perception, may be part of the performer [...], or not part of him (a separate mechanical object) [...]. Its image may be read as inside the performer or outside of him, or can be seen as both inside and outside of the performer, appearing as simultaneously subject and object.[3]

The confidence of the spectator of classical cinema – "I'm here and I'm present" – crumbles on entering the filmic theater of Graham. There is no story anywhere in sight, only the filmic event itself which keeps repeating itself. Graham does not erase the actual traces of the filmic performance, either at the level of production or projection, and therefore the spectator is revealed in the glare of the projector's light to be a performer who is not substantially different from the performers on screen. The discursive structure of this filmic event has not disappeared behind the object of exhibition, it has been put on display as well. That is to say, the subject of this cinema is simply revealed in its anonymity or, better still, its multiplicity: I am no longer incarnated in the camera/projector for it is not one. Accordingly, I am led in a dizzying dance across the mirrored stage of Graham's cinema. We might be inclined to say that he returns to the "frenzy of the visible" that convulsed an earlier epoch of capitalism.[4] But he returns with a difference. If he can be said to restage such a historical moment then it is exactly not to retrieve it as an imaginary scene or as curiosity worth saving, like the *laterna magica, zoogyscope, stereoscopes*, and other optical inventions of the nineteenth century that are placed on view in film museums the world over.[5] On the contrary, the past returns in these films only in order to convulse the present, to disrupt the endlessness of its horizon. If this dance of film celebrates anything, it is the commemoration of such a critical task. This history, then, is also a politics and, most specifically, a practical politics of the present. Defining this filmic mediation of the past *in* the present will form our topic.

[1] Christian Metz 'Story/Discourse (A Note on Two Kinds of Voyeurism),' in *The Imaginary Signifier: Psychoanalysis and the Cinema,* trans. Celia Brittan and Williams C. Bloomington: University of Indiana Press, 1982): 94. This text rewrites the narrative or 'classical' model of cinema according to the linguistic terms of Emile Benveniste's *histoire/discours.* The 'history' is an utterance (written, verbal, or otherwise) which erases all traces of its enunciative situation. As Benveniste states, 'no one speaks here, the events seem to narrate themselves.' Benveniste opposes 'history' to the 'discursive event' as an utterance that calls attention to its own enunciative conditions (usually by organizing its verb tenses around the present and the use of pronouns like 'I', 'You', 'this' and 'that'). The source for Benveniste is 'The Correlations of Tense in the French Verb,' in *Problems in General Linguistics* (Miami: University of Miami Press, 1971): 205-215.
[2] The term classical cinema refers to movies that are narrative in form and based upon an industrial mode of production. Metz's discussion relies, as mine will as well, on Jean-Louis Baudry's celebrated critique of classical cinema, namely 'Ideological Effects of the Basic

Cinematographic Apparatus,' trans. Alan Williams, *Narrative, Apparatus, Ideology: A Film Theory Reader*, ed. Philip Rosen (New York: Columbia University Press, 1986).

[3] Dan Graham, 'Films and Performances/Sixs Films,' in *Films* (Geneva: Éditions Centre d'Art Contemporain/Écart Publications, 1977): 7.

[4] Jean-Louis Comolli, 'Machines of the Visible,' in *The Cinematic Apparatus*, ed. Teresa de Lauretis and Stephen Heath (New York: St. Martin's Press, 1980): 122.

[5] These devices are mentioned by Graham in the essay 'Photographs of Motion,' *End Moments* (New York: Artist publication, 1969).

[6] The adjective 'cinematic' crops up frequently in Graham's phenomenological descriptions of the multiple surfaces of the pavilions which alter their aspect under the changing conditions of atmosphere, light and the position of the viewer.

[7] A clear link between the films and the pavilions is established by the *Cinema* project. I consider *Cinema* to be one of Graham's most brilliant, and sadly unrealized, designs. The present text is concerned with locating the films in their historical context; a main oversight in the existing literature on the artist. My story will, therefore, end around 1973. Were I to include *Cinema* then I would need to give careful attention to the gap between 1973 and 1981 in which Graham develops his mirrored video installations and pavilion structures, which is not possible in the current space of my text. I hope to return to this 'post-history' of the films in the near future.

The Film Series

While rarely mentioned, Graham has produced a small but distinctive group of films between 1969 and 1973, alongside his other activities in the area of performance, video, and writing. Listed in chronological sequence the films are: *Sunset to Sunrise* (1969), *Binocular Zoom* (1969-70), *Two Correlated Rotations* (1969), *Roll* (1970), *Body Press* (1970-72), and *Helix/Spiral* (1973). After 1973 Graham did not return to the actual practice of making films, but the cinematic mode of experience that was first developed in these films would remain a reference point throughout the later pavilion projects and his writing.[6] My discussion shall not take us beyond the point of 1973, however its relevance to the later work shall be evident by the time of its conclusion.[7]

Before I continue, I need to insert a note on the quality of the cinematic experience projected by Graham's work. First of all, this experience, as mediated by the filmic apparatus, needs to be defined both in terms of the phenomenological *situation* of the observer versus the work of art and the historical *condition* of this relationship. The exhibition of this perceptual situation alongside its socio-economic conditions constitutes the actual 'subject matter' of Graham's films, which implies that the experience they have to offer is not aimed to please the self-identical spectator of classical cinema. In fact, to speak of 'an' experience at all is somewhat misleading, for Graham's films do not present a coherent, symbolic message to the spectator, not to mention the absence of any central point of view. His films unravel the perspectival field of vision that narrative cinema projects. Their space of projection is differentiated between the mobile, overlapping planes of observer, performer and apparatus. Therefore, I shall prefer to speak of these films less in terms of a specific experience than in terms of their exhibition of a performative event. I shall clarify this contention in due course, but let me stress right away that this filmic function entails a certain indeterminacy of the image itself. While narrative cinema basks its spectators in the glow of its radiant scene, there is an aspect to Graham's films that always exceeds the symbolic framework of representation. These films, in a manner of speaking, are unknowable, not only in a descriptive but also in an existential sense, for there is literally no 'single one' who has the experience, but only a multitude.

I do not wish to get too far ahead of my argument, but let me provide a brief glimpse of what lies in store. We might describe Graham's films as operating in the bipolar region between what Foucault identified as a *physics* and *phylum* of social identity. Physics refers to the historical regularity that underpins a social order, the phylum, which appears to its natives as a natural habitat, a cultural organization of genetic inheritance. Yet this physics of society is not a static structure, it concerns a relational and multiple power that is perpetually in motion. It consists of a technology that is not localizable, but mobilized as a disciplinary force within the social economy. The phylum might be called the imaginary horizon of totality aimed at by this physics. The former, namely, cannot form more than an ideological compromise as long as the latter remains at grips with the primary inertia of matter. To be sure, the mechanisms of power have a material field of application, but this field is not immediately apprehensible. The regularity of the social order must be extracted from a "region of irregular bodies, with their details, their multiple movements, their heterogeneous forces, their spatial relations."[8] The combinations and identities that are established within this homogenous order will therefore also include many gaps and discontinuities. Graham's films can be understood to show this physics of technology at work. They depict the spectacle of a body poised between a

In an interview with the author, Graham has offered some useful suggestions regarding the connection between *Body Press* and his *Two-Way Mirror Cylinder Inside Cube and Video Salon: Roof top Urban Park Project for the Dia Center for the Arts, New York, 1981/91*: "The Dia piece has all the things that the films have: there is the relation to the body of the spectator, the spectator's relation between a rectilinear form and the curved form. The film's rectilinear form was the box of the camera. There is the relation to the surrounding horizon line [...] the projection situation, the walls of the interior." See *Two-Way Mirror Power: Selected Writings by Dan Graham on His Art*, ed. Alexander Alberro (Cambridge, Mass.: MIT Press, 1999): 106.

8 Michel Foucault, *Discipline and Punish: The Birth of the Prison*, trans. Alan Sheridan (New York: Pantheon, 1978): 208.

9 *Two-Way Mirror Power* 1999: 105-106.

10 *Films* 1977: 11.

11 This same procedure had already been followed in *March 31, 1966*, a piece that mapped in a series of decreasing steps the distance between the outer 'edge of known universe' to the 'retinal wall' of the eye. Dan Graham referred to this work as a "(solipsistic) insight represented as a one-dimensional point-of-view extension making up a perspective from (at) my (its) limits of inception [...] the 'interior' plane inverted 'outside' as it is 'inside'." See 'Information,' in *End Moments* 1969: 54.

state of lucidity and dispersal. The films do not replicate this physics but neither do they simply negate it. What the films do achieve is a momentary suspension of the 'natural' progress of this disciplinary force. And in this interim, they indicate the historical threshold of its first appearance.

To return to the six films, what is immediately apparent is the rarity of this series. They manifest a stringent economy of structure and means. Graham has observed that there was no reason to continue beyond this limited group because the logical possibilities on which the set was based had been exhausted.[9] The six films constituted a permutational series that ran its full course. From the beginning, then, it is clear that Graham was not in the business of stocking the image banks of film history. He has not invested in the medium of film as such, for reasons that we shall yet come to explore.

Perhaps I seem to have contradicted myself. First I emphasized the differential state of these films, while I now propose that they constitute a closed series. But this contradiction is only apparent. The regularity of Graham's permutational series concerns the spatial and temporal deployment of their variables: camera, screen, performer, observer, etc. However, this regularity is not plotted according to the same code of a monocular space that governs narrative cinema. While these films might demarcate the boundaries of a logical space, it is not one that is geared to the position of an ideal spectator. Space is composed and decomposed before our eyes as we watch these films. To track these filmic interruptions of continuity is what deserves our close attention.

What are the empirical facts in so far as they can be established?

According to Graham's own notes, the first film, *Sunset to Sunrise*, was shot according to the following procedure:

> The film is made by continuously moving a 16 mm movie camera from a position oriented toward the sun on the horizon line at the moment of sunset, and proceeding in a slow spiral with gradual upward inclination toward the top of the sky [...] The next morning at sunrise [...] a reverse spiral downward in opposite right-to-left rotation is filmed, ending on the sun rising above the horizon.[10]

Leaving a discussion of the temporal hiatus within this movie aside for the moment, the fundamental gesture of *Sunset to Sunrise* is to instate a spiraling motion of the camera within the visual field. The film traces the outline of the viewer's visual hemisphere from the horizon to the zenith and back, and this rotating pattern will appear in all films but the following, namely *Binocular Zoom*.

Binocular Zoom, like *Sunset to Sunrise*, is shot directly against the light of the sun that in this case remains partially obscured by clouds rather than sunken behind the rim of the horizon. Yet the film applies another method than *Sunset to Sunrise* in order to map the interstitial space between the perceiver and the perceived object.[11] Instead of the spiraling motion of the camera, *Binocular Zoom* traverses the distance between the sun and the eye by zooming outwards. The sun, thus, appears to move further away from the viewer. It diminishes in size to a 'distance,' as Graham puts it. But there is an even more striking difference between *Sunset to Sunrise* and *Binocular Zoom*. The latter, namely, requires the simultaneous use of *two* cameras, as will be the case with all subsequent films made by Graham. In fact, *Sunset to Sunrise* was shot with a 16 mm camera, while *Binocular Zoom* uses lightweight Super 8 cameras which are placed flush to the eye. The manipulative quality of these cameras, which had only recently made it onto the market, forms a technical condition of Graham's film performances. The use of two cameras in *Binocular Zoom* necessitates also the synchronized projection of the two

films. To this purpose, Graham has stipulated that *Binocular Zoom* be shown on a split screen.

Binocular Zoom is followed by *Two Correlated Rotations* and *Roll*. These films return to the concentric movement described by *Sunset to Sunrise*, but the rotation is now executed by two cameras in tandem. In the case of *Roll*, one camera is placed on the ground facing the performer who rolls slowly toward the right of the framing edge of the camera's view. The other camera is attached to the performer's eye while he rolls in an attempt to keep it centered on the stationary camera opposite from him. The film is not destined for a split screen viewing as in the case of *Binocular Zoom*, but is projected on distant opposite, parallel walls. The exhibition of the film, therefore, reflects the spatial situation of the film performance. *Two Correlated Rotations* introduces a further duplication of a filmic 'unit': besides two cameras, this film also requires two performers. Graham describes the shooting procedure of *Two Correlated Rotations* in the following manner:

> The two cameramen each hold cameras so that their viewfinders are extensions of their eyes and visual fields. They begin facing each other one foot away. They walk in counter spirals, the outside performer moving gradually outward while the inside performer walks inward approaching the center.[12]

The installation of the film is again different from the preceding cases: *Two Correlated Rotations* is projected into the corner with each reel screened onto a separate, yet adjacent wall.

Two more films remain to be described, namely *Helix/Spiral* and *Body Press*. In these works, Graham adds yet another factor to the cinematic equation – the camera is not only treated as a 'viewfinder,' it also acquires tactile properties. In *Helix/Spiral*, for instance, the spiraling choreography of the camera harks back to the camera movement in *Sunset to Sunrise*, but it maps the outer surface of the body rather than tracing the inner surface of the celestial dome. *Helix/Spiral* calls for a stationary performer who slides the back end of the camera downward across his body, describing a gradually descending helix in space. A second performer places the camera's viewfinder before the eye and spirals inward towards the center axis occupied by the first performer. The second performer attempts to keep his camera centered on the first performer's camera while remaining within the field of vision of the latter's camera. The resultant films are to be projected simultaneously on opposite walls, as in the case of *Roll*.

The performative structure of *Body Press* is similar to *Helix/Spiral* except for the fact that neither camera is permanently attached to the eye or even the body of one performer. Furthermore, placing the performers inside a mirrorized cylinder doubles the reflective relationship between one performer and the other (and between one camera and the other). Let me draw once more on Graham's own lapidary style of description:

> Two filmmakers stand within a surrounding and completely mirrorized cylinder, body trunk stationary, hands holding and pressing a camera's back-end flush to, while slowly rotating it about, the surface cylinder of their individual bodies. One rotation circumscribes the body's contour, spiraling slightly upward with the next turn. With successive rotations, the body surface areas are completely covered as a template by the back of the camera(s) until eye-level (view through cameraman's eyes) is reached; then reverse mapping downward begins until the original starting point is reached. The rotations are at correlated speed; when each camera is rotated to each body's rear it is then facing and filming the other where they are exchanged so the camera's 'identity' 'changes hands' each performer handling a new camera.[13]

Film strips of Dan Graham's *Body Press* (1970-72).

[12] *Films* 1977: 15.
[13] *Films* 1977: 21.

The films are projected as loops on two opposite walls that stand close to each other. The tight compartment in which the original performers stood is therefore replicated in the compact space of projection. As a result, the loop projectors assume the nature of a physical barrier, acting like proxies of the original performers. The spectator must navigate these mechanical objects while straining to follow the orbital path of the cameras, which cross in virtual space from one bodily horizon to another, while remaining literally attached to one screen in the gallery space.

The preceding description has established in sufficient detail the permutational logic of Graham's artist-film. I have demonstrated the different combinations and series based upon the variables of camera and body, place and movement, recorded and reflected image, which are gathered together within the framework of a 'binocular' schema of film. Within this structural scheme, the artist subjects filmic space to a constant principle of temporal inversion between the inner and outer horizon of subjective perception. There is a truism of classical cinema that Graham likes to repeat, namely that the spectator tends to identify with the camera's viewpoint: "A movie camera's viewfinder is placed on the performer's eye to identify the image seen on the screen by the spectator with the performer's perception of the world at the moment of performance."[14] Yet this perceptual process of identification is simultaneously disrupted in Graham's films by foregrounding the alterity of the camera as an object. He radicalizes the 'freedom' of the camera, so often celebrated in avant-garde cinema, to such an extent that it no longer will submit to the authority of an ideal eye. The result of this procedure is to split asunder the visual field, literally, through the use of a double screen, but also in a phenomenological sense, for the spectator is dissociated from the 'objective' world projected on screen. To summarize, the effect of Graham's serial method is not to institute the continuity of a medium. Not, that is, to establish the continuity of the Modernist series wherein every instance manifests a complete *idea* of the medium as such. To the contrary, Graham's films release a surfeit of differential energy within the economy of perception that cannot be contained. These films stage, as it were, the downfall of the idealist subject of Modernism. To be at all times and everywhere, they seem to state, is to be at no time and nowhere.

There is another context, though, that might seem more relevant to Graham than Modernism, namely Minimalism. Indeed continuity exists between the films and Minimalism, however there is also an important difference. To consider the films as a 'cinematized' version of the Minimalist series would be a mistake. I will arrive at a discussion of Graham's reception of Minimalism by way of his earlier work in publishing. Although this might seem a circuitous root to take, my reasons for this approach shall become clear in due course. The period in question begins around 1966 and leads up to 1969 and is usually considered as Graham's 'conceptual' phase but I shall apply this term in a circumspect manner. The discursive procedure that Graham unfolds in these writings, advertisements and data grids will directly inform the filmic work. And this discursive field is itself informed by the *topos* of Minimalism. What shall emerge from my analysis of the publications is their fundamental principle of bivalency; a principle put to critical advantage by the artist.

A similar hybridity courses through the film notes that I have extensively quoted from – a fact that I have deliberately avoided up to this point. Less than a varying style of writing, this hybridity concerns a variance of enunciative positions which range from the descriptive and the instructional, to the interpretive and annotative. On the one hand,

[14] *Films* 1977: 7.

these texts formalize a kind of experimental method, provide it with a script of sorts, while, on the other hand, they propose a quasi-scientific mode of analysis. In a later section, I shall expand on this imitation of scientific procedures in Graham's writing and films. For now, what is significant about this shifting range of enunciative registers is that it points to the evasion of the filmic experience which happens, precisely, somewhere in between. The films, we might suggest, are experiments that happen to us.

Again, these considerations raise the problem of the mode of spatiality that is portrayed by Graham's films. Since I shall briefly retreat from the territory of the films to the earlier period of the publications, let me summarize the differences between the space of classical cinema and Graham's film in so far as they have appeared thus far. It will be helpful to bear this difference in mind while looking at the field of publications because a similar opposition will appear there as well. This opposition will be phrased in terms of a distinction between topographical and topological space.

The basic topography of the apparatus of classical cinema is quickly sketched: the projector beam originates from behind the immobile viewer and is directed at a screen rimmed in blackness. The phenomenological effect of cinema is to transform these limiting conditions of the apparatus into a spectacle of empowerment. The captive moviegoers, shackled to their seats in the dark of the auditorium, believe themselves nonetheless in total control through their primary identification with the apparatus of restriction. They experience the projected image to be more intense than reality itself because the world seems to exhibit itself, without reserve, on the screen. And this screen is not placed at an external distance, but seems to exist within some virtual depth; the viewer has internalized its physical limitations. There is no one who challenges the spectator's fusion with this projection, no other who threatens to divest this horizon of its subjective meaning: "Limited by the framing, lined up, put at the proper distance, the world offers up an object endowed with meaning, an intentional object, implied by and implying the action of the 'subject' which sights it."[15] Such is the viewer's pleasure of self-confirmation in the space of narrative cinema.

This topography does not survive in Graham's cinema. By distributing the viewer's attention across the room and catching this subject in the crossbeams of projected light, Graham disrupts the central perspective of classical cinema. Through this logic of duplication, he cancels out the viewer's illusion of supremacy. The screen does not repress its properties as a physical object but stands in a very real relationship to us, denying the transcendental operation of the frame in classical cinema. Moreover, Graham institutes a dynamic within the visual field, a mobility of reversible surfaces or 'switching termini' as he calls them. He uncovers a screen, that is, that has more than one side – "topologically, an optical 'skin,' both reflective and transparent inside and outside."[16] To define this topological skin as it first appears in the magazine pieces of Graham will form our next assignment.

A Topology of the Page

> The message is united with the schema (the schema being) used being its own definition so that the structure, in effect, structures itself (in place) as the *language*, in-forming an intermediate object between *concept* and *material*; the process consists in uniting both while simultaneously decomposing them.[17]

Graham initiates his filmic practice in 1969, around the same time that he discontinues the 'conceptual' strategy of the magazine pieces. I am not referring to the artist's

[15] Baudry 1986: 292.
[16] I deliberately cite this passage out of context, to once more draw attention to the functional continuity of the *Cinema* project with his films. Dan Graham, 'Cinema,' 1981, in *Two-Way Mirror Power* 1999: 95.
[17] *End Moments*, 1969.
[18] Examples of the data grid are formed by *Scheme* (1965), *Schema* (1966), *Side Effects/ Common Drugs* (1966), *March 31, 1966* (1966) and *Extended Distance/ Extended Time* (1969). Instances of the poem are *Figurative* (1965) and *I-They* (1967), while the advertisement category is represented by *Likes* (1967-69), *Income (Out-flow), Piece* (1969). I refer to *Homes for America* (1966-67) as an updated version of the avant-garde typophoto essay, but its case is obviously far more complex.
[19] Dan Graham, 'Other Observations,' 1969/73,

in Dan Graham, *For Publication* (Los Angeles: Otis Art Institute of Los Angeles County, 1975): n.p. *I-They* exemplifies the argument I will present in the following concerning the shift from a narrative to a performative mode of address in Graham's work. In this 'poem', Graham has mapped the personal pronouns into a grid. The pronouns of direct speech, 'I' and 'We', are entered into separate boxes at the top, while 'You' has been doubly inscribed in the two boxes below. The remaining two boxes contain on the left the series 'He-She-It' and on the right 'They.'

20 See Graham's own illuminating commentary on this period in 'My Works for Magazine Pages: A History of Conceptual Art' [1985], in *Two-Way Mirror Power* 1999: 10-13.

21 'Other Observations' 1969/1973: n. p. *Schema* can actually induce an infinite spiral of feedback rather than simply reflecting its own material base. See Graham's 'Thoughts on *Schema* (March 1966),' *For Publication* 1975: n.p.

22 All subsequent discussions of Michel Foucault's *The Archaeology of Knowledge* (New York: Pantheon, 1982) are indebted to the excellent study by Hubert L. Dreyfus and Paul Rabinow, *Beyond Structuralism and Hermeneutics*, 2nd ed. (Chicago: Chicago University Press, 1983).

23 A speech act forms a type of discursive event that involves a speaker and a listener and, more importantly, concerns a speaker who intends to influence the latter in some manner. The speech act, therefore, holds a 'performative' aspect. For more on this subject, see Oswald Ducrot and Tzvetan Todorov, *Encyclopedic Dictionary of the Sciences of Language* (Baltimore: Johns Hopkins University Press, 1979).

writing in general – Graham would continue to be prolific in this area – but to such works as the 'data grids,' the drawings and 'poems,' and other hybrid adaptations of the 'typophoto' essay and the magazine advertisement.[18] Without question the hybrid character of these pieces is key. Graham has suggested this typology of the data-grid, poem, etc., but never insisted on the absolute status of these categories. Quite the opposite, in fact. The magazine works do not comfortably fit within the conventional genres of mass publication. These works are designed to transgress the spatial 'architecture' of the magazine: the authorial perspective and the editorial and typographical framework that supports it. 'There is no composition,' as the artist observes. A data grid, like *Schema*, or a poem, like *I-They*, "subverts value" rather than expressing an artistic or authorial insight.[19]

This principle of de-composition forms at least one similarity between the magazine pieces and the films. They share a definite lack of conformity to established categories of the 'work.' Furthermore, the magazine pieces deny the authenticity of the art object that henceforth exists by sheer grace of exhibition alone.[20] The 'object' exists, that is, by virtue of its publicity and not despite of it, as Modernism was prone to argue. This object, i.e. the publication, assumes a discrete existence but only in the disposable form of printed matter. Hence, the magazine pieces acknowledge the basic modality of the art work, its exhibition value, which had been a constant subject of disavowal under Modernism. Graham's procedure does not so much show the gallery in its naked state as it reveals that the exhibition is always already 'covered' elsewhere. The procedure of de-composition enters into Graham's critical strategy, as it were, to exhibit the exhibition. To materialize this socio-economic condition of the art work, to sight its mediatized structure, is the prime point of overlap between the magazine and the film works.

How, then, is this moral of de-composition applied in the magazine pieces? First of all, it is achieved through a spatial inversion of the self-reflective principle of Modernism. The subject matter of *Schema (March 1966-67)*, for instance, consists of the statistical information created in the course of its own typesetting. The typographical event records itself in a potentially endless loop. Structuring itself in place, *Schema* "defines the limits and contingencies of placement."[21] It takes its own measure as place. But to structure itself does not mean to create a self-enclosed, autonomous object. To the contrary, *Schema* is contingent upon placement and therefore will exhibit the material conditions of enunciation that underpin this place. By which I mean to say that there is no individual subject of speech – any editor can fulfill the role – and there is no subjective message being relayed. *Schema* suspends all criteria concerning the legitimacy of who speaks and the validity of what is said, for it lacks a Modernist seriousness. Accordingly we might say that Graham puts his status as 'amateur' and 'autodidact' to good use here.

To clarify the discursive structure of *Schema* a slight detour will be in order. What I propose is that this work functions as a kind of performative event or speech act that in its *anonymity* bears comparison to Michel Foucault's notion of the statement *(enoncé)* that is expounded in *The Archaeology of Knowledge*.[22] Obviously, I do not hold that Graham explicitly followed this theoretical model. Only that it offers a tactical advantage in the present context.

Foucault's archaeological method disinters speech acts of a special kind. Foucault is not concerned with those everyday utterances that are pronounced within a local, pragmatic context and form the ordinary object of speech act theory.[23] He is exclusively interested in those 'serious' speech acts that can reveal the historical regularity of an epis-

24 Foucault 1982: 63.
25 Foucault 1982: 36-37.
26 Dan Graham, 'Informa-
tion,' in *End Moments*
1969: 45.
27 *For Publication* 1975,
n.p.
28 Dan Graham, '*Aspen:*
One Proposal,' in *Rock My
Religion,* ed. Brian Wallis
(Cambridge, Mass.: MIT
Press, 1993): 40. The
advertisement *Likes,* for
instance, is subtitled *A
Computer-Astrological
Dating-Placement Service.*
The questions are
addressed to 'you' and are
arranged under the follow-
ing categories: 'Defining
what you are like', 'Defin-
ing what would you like
your date to be like,'
'Defining what relationship
you like.' The ad is struc-
tured as a multiple-choice
questionnaire and the
receiver is asked to check
off the appropriate boxes.
The 'feedback' yields mul-
tiple benefits: each partici-
pant receives the names
of three dates, knowledge
is gained about astrology
as a social science, and
the expression of the par-
ticipants' needs can be
incorporated in a new
questionnaire.
29 See Benjamin H.D.
Buchloh, 'Moments of His-
tory in the Work of Dan
Graham,' in *Dan Graham:
Articles* (Eindhoven:
Stedelijk Van Abbemuse-
um, 1978) and Alex Alber-
ro, 'Reductivism in
Reverse,' in *Tracing Cul-
tures: Art History, Criti-
cism, Critical Fiction* (New
York: Whitney Museum of
American Art, 1994): 7-27.
30 *End Moments* 1969:
34.

temic formation. These utterances do not constitute a kind of topographical atlas of this discursive field, but indicate its structural rules of operation. The discursive rules are therefore not the mental property of individuals, but organize a discursive space as an "uniform anonymity."[24] It follows that within such a linguistic domain of performance only certain utterances will 'make sense.' In fact, serious speech acts are exceedingly rare, as Foucault maintains (a fact already ascertained in relation to the filmic 'statement' of Gra-ham). On the other hand, the regularity of the discursive formation does not exclude the appearance of contradiction and conflict. The statement, namely, functions in the logical space of a permutational series that allows the potential "of arousing opposed strate-gies, of giving way to irreconcilable interests, of making it possible, with a particular set of concepts, to play different games."[25] To get at this performative *function* of the state-ment one must therefore suspend belief in the seriousness of individual utterances because it is grounded at the relational level of meaningfulness as such. And this foun-dation of intelligibility is not ontological but fully historical in nature.

Where does this slight digression leave us in relation to *Schema*? I contend that Gra-ham's piece exhibits, exactly, the performative function of the statement. It constitutes a statement, that is, of the exhibition as such. *Schema* does not locate us within the truth game of Modernist art. *Schema* does not assume the same seriousness of tone, demand the same kind of aesthetic conviction. Rather it manifests and subverts the rules of the game as it was played during the sixties. This means, furthermore, that *Schema* does not take the tautological form of a proposition. A proposition has an apodictic char-acter that remains ignorant of its historical field of use. Joseph Kosuth's 'art as idea as idea' forms a contemporary example of such a proposition. A statement like *Schema*, on the other hand, depends on a specific, material set of conditions for its realization. Accordingly, there is no ideal version of *Schema*: "a specific variant, in a sense, does not actually exist, but under certain conditions can be made to *appear*."[26] Indeed, Graham seized any opportunity that emerged to publish *Schema* in order to make its contingent value apparent.

I would like to add one more comment regarding the performative structure of the magazine pieces before taking up a discussion of *Homes for America*, which in due course shall lead us back to the films. Graham was quick to realize that he was not just dealing with the anonymous rules of a discursive field, but also with the question of pow-er. Foucault makes an important remark that resonates strongly in the context of Gra-ham's work. His remark concerns the truth claims of scientific language. Science desires to speak a context-free truth, but to speak truth in a void is impossible, Foucault observes, as long as one wants to be heard and understood. To speak, in short, is to invite a 'policing' of speech. Graham's earliest work suffered from this fact. They were not accepted in magazines because they seemed to lack *sense* in the combined game of art and publishing. He decided, therefore, to mimic the language of publicity more closely by designing advertisements. An additional advantage was that he could play off the direct mode of address employed by advertising.

The basic statement of the advertisement, as Graham explains, takes the discursive form of tautological speech: 'You like it. It likes you.' His tactic is to decompose this play of mirrors. By emptying the enunciative place of the subject, he throws the discursive axis of speech into a kind of tailspin that incessantly alternates between private and pub-lic, inner and outer space: "There is a relation of a *public* figure's *private* piece to *public* exposure or the reverse."[27] This reversibility of intent was programmed to sidestep the

magazine's insertion of the reader into a predetermined framework of reference. Rather than the editorial content acting upon the reader, Graham sought to activate the reader and offer him new possibilities of use. Through means of this discursive feedback, an alternative network or collectivity might take shape. To that end, he would place the same ad in different magazines irrespective of their editorial identity (e.g. news, sports, fashion, science, and art). Furthermore, the advertisement would allow a multiplicity of messages: "it's art and it's science and it's the sociology of art (no history) or none of these definitions."[28] With the ads he remains poised, then, between an utopian moment of communality and a counter-moment of individual dispersion. He develops, that is, a kind of dialectic in suspension, which informs the films as well and to which we shall return.

The discursive function of Graham's magazine pieces is now sufficiently established in order to consider his *Homes for America*. This essay first appeared in the December 1966-January 1967 issue of *Arts Magazine* and has since received an almost canonical status. I do not presume to add to this rich field of historical interpretation, however it deserves our attention since it is the hinge on which his later films will turn.[29] The referential content of the page is not our primary concern – it is there to be read and not insignificant as such. Instead, I want to scan the temporal surface of this discursive event. What *Homes for America* presents is, as it were, a switchboard of information:

> This was the first published appearance of art ('Minimal' in this case) as place conceived, however, solely in terms of information to be construed by the reader in a mass-readable-then-disposable context-document in place of the fact (neither before the fact as a Judd or after the fact as in current 'Concept' art). Place in my article is decomposed into multiple and overlapping points of reference – mapped 'points of interest' – in a two-dimensional point to point 'grid'. There is a 'shell' present placed between the external 'empty' material of place and the interior 'empty' material of language; a complex, interlocking network of systems whose variants take place as information present (and) as (like) the medium – information – (in) itself.[30]

Leaving the question of Minimalism aside for now, it is Graham's concept of 'place' that deserves elaboration. Graham resists thinking about space in topographic terms or what he likes to call an 'architecture' of information. A proposition supposes exactly such a neutral support of communication, but Graham prefers the more confounding notion of a 'shell.' (Which even registers in the parenthetic style of the quote above). In doing so, he disrupts the binary logic of container and contained, inside and outside, figure and ground. This space is not the Cartesian extension but a malleable, shifting surface; a surface that is susceptible to the transformative processes of bending, stretching, and twisting (but not, and that is essential, of cutting).[31] In other words, Graham projects a mode of spatiality that is described by that branch of mathematics popularly known as 'rubber-sheet geometry' or topology. And I am merely following the cue of Graham in suggesting this spatial figure as a basic model in his early work.[32]

Homes for America demonstrates how such a topological space might be conceived in print.[33] This shell binds the surface of things to that of language but not to make the one transparent to the other. If anything, *Homes for America* parodies an idealist model of language which considers the sign as standing in a motivated relation to its referent. *Homes for America* forces the arbitrary structure of the sign into the foreground; it is entered into a permutational series. Hence, the several lists of *names* which just as easily could have been substituted by others or could have been chosen to designate some-

[31] I only know one occasion in Graham's films where the editorial technique of 'cutting' forms an essential element in the film, namely *Sunset to Sunrise*. *Body Press* is mounted from separate takes but all transitions are masked.

[32] See my exchange with Graham on the subject of topology in *Two-Way Mirror Power* 1999: 114-115. Topology represented for him the idea that "the inside and the outside were the same surface and that you could make a loop, like a Möbius strip, identifying inside and outside." He also calls it the "dominant mathematical metaphor" of the sixties. In the interview, he lists the magazine *Radical Software*, edited by Paul Ryan, as his most important source on the topic of topology.

[33] *Homes for America* renders obsolete the avant-garde concept of the 'typophoto' as a perfect, technological medium for the transmission of knowledge. In 1925, for instance, Moholy-Nagy answered the question "What is typophoto?" by stating: "Typophoto is the visually most exact rendering of communication." He concludes the same essay by suggesting that "this mode of synoptic communication may be broadly pursued on another plane by means of the kinetic process, the film." Laszlo Moholy-Nagy, *Painting Photography Film*: (Cambridge, Mass.: MIT Press, 1973): 39.

thing else, such as the series of housing developments (e.g. Belleplain, Brooklawn, Colonia, etc.), the standard house plans (e.g. The Sonata, The Concerto, The Overture, etc.), or the pre-programmed color schemes (Moonstone Grey, Lawn Green, Coral Pink, etc.).

Most importantly, this dispersion of the sign entails a dispersion of subject positions. *Homes for America* does not establish a single point of view, but juxtaposes an array of intersecting perspectives. It does not present so much a static tabulation of information as places in motion a series of discursive transformations and combinations. If this photo-essay recycles the figure of the grid *ad nauseam* then, it is not to survey a static, unified 'architecture' of place. He dismantles the totality into its variable units, releasing them to a performative function of distribution: "Thus the art's in-formational structure upholds the breakdown (collapse, decomposed parts, deposition) of its 'architecture' in terms of the base constituents of place."[34] This ruinous topology of *Homes for America* forms a far cry from the ambient space of Modernism, which knew no distinction between occupied space and space at large. For the Modernist viewer was offered a transcendental framework onto this transparent continuum, while the subject of *Homes for America* threatens to dissolve into an atopic space where each point might exist anywhere and everywhere at the same time.

The subject threatens to dissolve, but does not completely do so. We should not be too hasty to conjecture that *Homes for America* collapses all difference into a simulacral realm of equivalence. Certainly, its recipient is placed within a rhythm of repetition, but there is always a factual difference that reappears from one moment to the next. What *Homes for America* literalizes is the enunciative function of the topological screen. If only in the *process* of reading, for this differential surface can never be completely grasped in isolation. We do not survey the total discursive field of "coordination and coexistence," but embody certain stations within its "space of use and repetition."[35] Space is thus constituted as a reversible 'shell,' but there is no perfect symmetry of interior to exterior. Placed within this medium of 'in-formation' the subject will be both the subject and object of performance.

This same paradox is contained, for instance, in the objective procedures of the social sciences, which would take its own background practice for granted.[36] The problem is compounded by the fact that its skills, e.g. the use of statistics, are internal to the disciplinary field to a degree that laboratory skills are not. Hence, the systematic grid of socio-economic categories employed by political science threatens to replicate the very reified, calculable order of late capitalism that forms its object of study. This was the problem of Max Weber who attempted to give an objective account of the administrative regulation of everyday life, while he realized that his own theorizing could not escape from this dominant mode of self-realization. This is also the political question of Foucault (and Jean-Luc Godard who Graham greatly admired) who argues that to render society visible, to analyze its distributions and series, is also to police it.[37] Such is the contradiction that is so brilliantly exhibited in *Homes for America*.

There is perhaps one alternative to the self-objectifying approach of the human sciences. Namely, the observer who adopts the actor's point of view within the social game and considers what these background practices *mean* to him, rather than silently imposing the objective grid of rationality. For the generalizing methods of social science could not foresee or explain the emergence of countercultural practices during the sixties. The Hippies, for instance, were to contest the contractual relationship of individuals in capitalist society by establishing other forms of collective existence. But if these social actors

[34] *End Moments* 1969: 45.
[35] Foucault 1978: 106.
[36] See Dreyfus 1983: 163-65.
[37] In conversation with the author, Graham has often compared *Homes for America* to the essayistic film method of Godard.

understood for themselves the significance of their counter-practice, they could not be clear about its place within the progressive administration and rationalization of society. Such was the losing game of the late sixties and it is one that Graham mimics with equal duplicity in his contemporary performances, just as he parodied the disciplinary matrix of sociology in *Homes for America*. I shall address the ambivalent structure of Graham's performance in the last section, but first I need to establish the genealogical link between the page and the filmstrip.

Photographs of Motion

> One way to fight the dogmatism was to take a completely empty area that was undefined and then to give it definition in terms of itself, but looking at it from a very peripheral point of view, like photography. I always liked it because the work was sort of art but it wasn't art; it had pretensions of being art but it was really very empty, it was really a technological thing.[38]

The foregoing raises a host of questions, but I shall stick to only one. What I am essentially getting at is the coupling of visuality and technology in Graham's work. In *Homes for America* the material apparatus, i.e. the grid of the printed page, is what both implements and manifests the shifting topology of 'multiple and overlapping points of reference.' While a full explication of this discursive logic would benefit from a further consideration of the printed medium, a task already initiated by Graham's *Information* essay, I prefer to switch my approach at this moment. Actually, we have been shunted onto a sidetrack by a retroactive act of history. I introduced *Homes for America* in its printed format since that is how it is primarily known today. However, this was not the first version of the work. Graham first conceived of the piece as a slide projection. He started shooting the slides of the New Jersey housing developments in 1965, after the demise of the John Daniels Gallery he had worked for. They received their first public presentation during the 'Projected Art' exhibition at the Finch College Museum of Art in 1966.[39] The Finch College projection thus initiated a trajectory that would lead Graham from the serialized space of Minimalism via the rotating mechanism of the slide projector to the spiraling loops of film.

The slide projection was intended to adopt the basic technical procedures of Minimalism, namely mechanical production and serial logic, without the need of fabricating objects. The 35 mm slide literalized the spatial structure of Minimalism, what Graham called its "transparent 'flat,' serialized space."[40] The artist suggests, in other words, an isomorphism between the translucent, colored surface of the slide and the semi-transparent, planar constructions of Minimalism. One might think, as Graham obviously did, of the Donald Judd box of 1965 that was assembled from sheets of pink Plexiglas so that that the inner suspension wires that held the structure together were revealed on the outside.[41] In this manner, Graham marks a topological series from the Plexiglas planes of Judd, to the 'shells' of tract housing, to the celluloid support of the slide. A planar series that can easily be added to or subtracted from as he writes of the structure of the housing developments.

In December 1966, during the 'Projected' Art exhibition, Graham conceived of a second piece for a slide projector that introduced a more direct form of self-mediation than the slides of housing developments allowed. A structure structuring itself in terms of place, to adopt Graham's terminology, this work superimposes the function of decomposition onto the material apparatus of the slide projector and projects it into the gallery space. As a result, the viewer is situated *within* the time and place of production. What

[38] Dan Graham, 'An Interview with Simon Field,' *Art and Artists* 7, no. 10 (January 1973): 19.
[39] The piece was listed as *Project Transparencies* in the brochure that accompanied the exhibition. The 'Projected Art' show ran from December 8, 1966 to January 8, 1967.
[40] *End Moments* 1969: 34.
[41] Rhea Anastas has brought it to my attention that Judd's work was exhibited during the 'Plastics' show (March 16 – April 3, 1965) at the John Daniels Gallery where Graham was director.

Donald Judd, "Untitled", 1965, stainless steel, with pink fluorescent plexiglas, 129 x 48 x 34 in./ 50.8 x 121.9 x 86.4 cm

this procedure emphasizes, above all, is the inability of the viewer to fully identify with the projective apparatus. The rotary movement of the carousel (and the camera) occurs, namely, outside the representational frame of the static slides.

Graham's instructions for the construction of the piece, as always, are exceedingly precise:

> A structure is built utilizing 4 rectangular panes of glass joined to form a box with 4 sides. The top is open and the base is a mirror. A 35 mm camera takes a shot on a parallel plane directed dead on focused on that plane and including nothing more than that plane in its periphery. Shot #2 is made similarly but of the next side of the box rotating clockwise and the lens focused further back – on a point inside the box. Shot #3 is focused still nearer the center of the box and an equal distance from the first to the second one as the camera is aimed at the third side. #4 follows the same scheme, the focused point now at dead center of the box's interior. Next, 4 new planes are added to form a box within a box, building up a mirroring perspective within a perspective.[42]

And so forth, until twenty shots have been taken. The slides are copied four times and then inserted into the carousel first in proper sequence, then flipped over and placed in reverse sequence; this disposition is then repeated with the remaining forty slides.

We might now comprehend how this work implants the architectural theme of *Homes for America* within the medium itself and its physical context of exhibition. The work constructs and deconstructs itself in *time*, while the superimposed planes of glass endlessly shift on the screen from a state of transparency to opacity and back again. In doing so, Graham pushes a specific Modernist logic of ambient space to a point of breakdown. Ambient space refers to a crossing of sculpture and architecture in what Greenberg called the 'new construction-sculpture.' He located its properties in an appearance of openness and weightlessness and notes the use of translucent, industrial materials, such as glass, plastics, and celluloid that are handled as architectural units to be assembled and arranged.[43] The new sculpture, he holds forth, is characterized by its preoccupation with 'surface as skin' alone. While this skin metaphor might echo the discursive terms of Graham, the comparison clearly does not hold at a structural level. For Greenberg assumes the existence of a projective self who can provide a transcendental frame of reference for this optical space which dissolves thinghood into a modality of light. Graham, on the other hand, materializes the dispersed modality of the viewer who can never fully meet up with the projective apparatus, just as the intervals of 'negative space' are made absurdly palpable by focusing the camera on an empty point in space.[44] In the process, Graham addresses Modernism's disavowal of the functionalist strategy of Russian Constructivism, without necessarily subscribing to its utopian figure of the glass house.[45]

It would take too long to recapitulate the full series of transformations that this historical figure of the glass house underwent, from Expressionism through Constructivism to the modern office building (and Minimalism), although its relevance to the later pavilions of Graham is abundantly clear. What I want to draw attention to in the slide projection is the making and unmaking of this narrative series before our very eyes. This discontinuity of the narrative axis, i.e. the projected slides, is offset by the emphatic presence of the discursive axis, i.e. the projector, in the gallery space.[46] The obsessive repetition of its clicking mechanism patiently constructs the flat, serialized space like a stack of cards, only to dismantle it again and again. What this exhibition underscores is an insurmountable difference between the narrative and discursive axis, the two never quite aligning

[42] *End Moments* 1969: 35.

[43] Clement Greenberg, 'The New Sculpture,' in *Art and Culture* (Boston: Beacon Press, 1961): 142.

[44] Both *Sunset to Sunrise* and *Binocular Zoom* make a similar play on the materialization of this empty, in between space. There is a tradition in Modernism of being mesmerized by the distance between things, or so-called negative space, which reaches from Georges Braque to Willem de Kooning. Bruce Nauman relates his decision to cast *Platform made up of the space between two rectilinear boxes on the floor* and *A cast of the space under my chair*, both of 1966, to de Kooning's remark about painting the space *between* rungs of a chair rather than the chair itself.

[45] Benjamin H.D. Buchloh has done much to counter this formalist 'cover up' of the history of Productivism. See, for instance, his 'Cold War Constructivism,' in *Reconstructing Modernism*, ed. Serge Guilbaut (Cambridge, Mass.: MIT Press, 1990).

[46] On the application of these terms in pictorial space, see Louis Marin, 'Towards a Theory of Reading in the Visual Arts: Poussin's *The Arcadian Shepherds*, in *Calligram*, ed. Norman Bryson (Cambridge: Cambridge University Press, 1988).

themselves with the position of the spectator, as in cinema, or falling together, as in the absorptive space of Modernist opticality. And to get at this difference, we are in need of another historical figure. One that is placed between the static photograph and the mobile image; a figure, moreover, that was introduced by Minimalism.

On more than one occasion, Sol LeWitt has advised us that his serial method of production was prefigured by a specific technological device, to wit cinematography. The artist, in fact, has likened the systemic logic that drives his artistic practice to the narrative structure of cinema. However this parallel is not drawn so much in the present but in relation to the prehistory of cinema:

> A man running in Muybridge was the inspiration for making all the transformations of a cube within a cube, a square within a square, cube within a square, etc [...] it led to the motion picture that was the great narrative idea of our time. I thought that narration was a means of getting away from formalism: to get away from the idea of form as an end and rather to use form as a means.[47]

Such is the curious twist that LeWitt gives to the primitivist legacy of Modernism. Not only does he stake out a difference from the recent past of 'formalism' through his embrace of the present of serial production and industrial materials, such as baked enamel and steel. The artist registers this difference, as well, in an archaic trace of nineteenth-century technology. Graham will repeat this archaeological discovery, with the help of LeWitt, but we shall see that Graham arrives at another conclusion. By which I mean to say more than the simple fact that LeWitt did not make films.

LeWitt's interest in Muybridge is made explicit in such early works as *RUN I-IV* (1962) and *Muybridge II* (1964). One might easily observe how the example of his sequential photographs enabled LeWitt to break with the self-contained logic of Modernist painting. These two works even introduce a rare imagery into his work, *Muybridge II* being the most cinematic in its use of photography and blinking lights. Consisting of a rectangular box with ten separate compartments, the viewer must draw near in order to view a photographic sequence of a seated, female nude shown at an increasing closer range of focus. LeWitt thus shifted Muybridge's vector of movement from the viewed body to the camera and from the lateral, or narrative axis, into the perpendicular, or discursive axis (if still requiring a lateral shift of the spectator's body).[48] This displacement in depth is literally mirrored in the contemporary *Wall Structures* that project physical shapes beyond the frontal plane of the painting. But this shift of the visual axis does something more than just change direction in an otherwise neutral and objective space. There is a phenomenological difference in that the work now points directly at the viewer. It addresses itself towards the viewer and physically engages him. In other words, we are dealing with a performance of sorts, which is staged for the viewer's body in relation to a kind of proto-cinematic apparatus. We will need to sort out this spatial disposition of the seen versus the seeing body and the body versus the viewing apparatus itself, in order to define Graham's own overlap and discontinuity with Minimalism.

Narrative, as we know, suppresses the enunciative conditions of speech. 'No one speaks here,' linguistics explains. The narrated events seem to happen by themselves. Which is how one might be tempted to describe the appearance of Muybridge's photographs, as Graham in fact does. The empty spatial continuum that Muybridge's series portray forms an exact precondition for the thematic development of narrative. Yet these photographs are also performed, which is to say, there is an observed performer – the running man – and there is the discursive performance of the camera. The 'no one' who

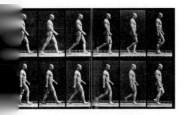

Muybridge, Eadweard, 'Man Walking' (1886). In E. Muybridge, *Animal Locomotion*, Philadelphia; Photogravure Company of New York, 1887, plate 247.

47 Andrew Wilson, 'Sol Lewitt Interviewed,' in *Sol Lewitt Critical Texts*, ed. Adachiara Zevi (Rome: I Libri di AEIUO, 1995): 124.
48 Rosalind Krauss presents a careful analysis of this work in 'The LeWitt Matrix', in *Sol LeWitt – Structures 1962-1993* (Oxford: The Museum of Modern Art Oxford, 1993): 25-33.

is here is the camera. To identify with this empty place clears a narrative horizon of plenitude before the subject by suppressing the physical conditions, the irruptive force of the discursive event itself. LeWitt, of course, did not actually propose a narrative art since that would invoke the authorial presence of the artist. Nonetheless, one might argue that his modular series provide the support for a more abstract mode of narrative, not biographic but ontogenetic. A narrative, that is, of the formation of subjectivity itself.

As I mentioned, LeWitt's 'narrative idea' of seriality does not inscribe an authorial position within itself. The number systems function as anonymous rules along the lines of a Foucauldian statement. They simply serve a logic of spatial distribution. Not a proposition, therefore, the idea bears no claim to seriousness and does not illustrate a mathematical or philosophical truth.[49] Indeed, in this respect we might adopt the motto of Graham's *Schema*, namely that a specific variant does not exist, but can be made to appear. LeWitt's idea can take various discursive and material forms: 'scribbles, sketches, drawings, failed works, models, studies, thoughts, conversations.' But, as the statement of a certain series of permutational possibilities, all are equally acceptable – even without the fabrication of an actual object, as the artist asserts.[50] Hereby, LeWitt opened the door to a conceptual strategy of art, as the 1967 'Paragraphs on Conceptual Art' confidently let us know. But this essay did not condone a theoretical method, which was to read the reader out of the text, as Graham came to deplore in some contemporary examples of Conceptualism.

Still, Minimalism never completely bracketed the seriousness of art that was its Modernist legacy. At least, not to the extent of *Schema* or *Homes for America*. Let us not confuse, by the way, Graham's suspension of seriousness with a lack of criticality. What the magazine pieces refuse is a referential order of the sign, while Minimalism retained a lodestone in the authentic experience of the lived body. Which is to say, such is the phenomenological reading of Minimalism which, by now, has become well established. According to this perceptual model, the embodied existence of the viewer, in the organic wholeness of its image, provides the world with an inner horizon of meaningfulness. This anterior depth of the body, as Merleau-Ponty writes, is "the darkness needed in the theatre to show up the performance, the background of somnolence or reserve of vague power against which the gesture and its aim stand out."[51] In sum, if there is a narrative in Minimalism, then it is formed by the gradual exploration of this inner threshold as it is projected outwards, opening an intentional clearing within the world.

Graham's take on Minimalism, however, is slightly different. And this difference is highly pertinent to our discussion. The artist distinguishes two separate moments in the perception of a Minimalist work. The first moment is static in nature. In this immobile space, the passive observer receives the Minimalist 'idea' as a mere representation of itself. As a result, the viewer is distanced from the work of art: "the artist and the viewer are read out of the picture," while Graham adds, "both *concepts* (first definitions) and *objects* are either before the fact — as *in fact* is the viewer in relation to viewing the art object — or *after the fact* (re-presentations), thus defining an *a priori* (static) 'architecture' between what is sent and what is received."[52] However, once the spectator is placed in movement, this conceptual edifice crumbles before our eyes:

> As the viewer moves from point to point about the art object, the physical continuity of the walk is translated into illusive, self-representing depth: the visual complication of representations 'develops' a discrete, non-progressive space and time. *There is no distinction between subject and object.*[53]

[49] "Conceptual art does not really have much to do with mathematics, philosophy or any other mental discipline [...] The philosophy of the work is implicit in the work and it is not an illustration of any system of philosophy." Sol LeWitt, 'Paragraphs on Conceptual Art,' in *Sol Lewitt* 1995: 80.
[50] Sol LeWitt, 'Sentences on Conceptual Art,' in *Sol Lewitt* 1995: 88.
[51] M. Merleau-Ponty, *Phenomenology of Perception*, trans. Colin Smith (London: Routledge, 1962): 100-1.
[52] Dan Graham, 'Subject Matter,' in *Rock My Religion* 1993: 40.
[53] Dan Graham, "Two Structures/Sol LeWitt," in *End Moments* 1969: 66.

And with a sudden leap we have entered the domain of performativity. This leap occurs 'in depth' – like *Muybridge II* – for it involves the discursive axis of enunciation, but the subject does not determine this situation, he is also modified by it. In other words, the discursive axis has been placed in alternation: subject and object, self and other become interchangeable: "object and subject are not dialectical oppositions, but one self-contained identity: reversible interior and exterior termini."[54] In this topological space, there is no center to occupy, no interior perspective, only an infinite regress of self-reflectivity. Here, we are not in the presence of seriousness, i.e. the intentional 'depth' of a Minimalist phenomenology, but face the sophistry of an artist who revels in the antinomies of reason spun by Epidemes the Cretan who stated that "all Cretans are liars."[55]

The slide piece of 1966 was not fully successful in entering this reversibility into the visual field, although we saw how it already caused a visual disparity between the narrative and discursive axis (which repeats the transition from the static to the dynamic moment in his reading of Minimalism). A further doubling of the mechanism was required, which was achieved by the introduction of a binocular structure in another slide projection piece from 1967. Graham provides the following instructions for the piece:

> The device to be used is a square fence constructed with rectangular slats spaced at regular intervals coming to neck height.... There is a walker (me) with a camera at dead center *inside* the enclosure and a second walker with a camera at one of the corners *outside* the device and maybe 3 feet away from its sides. The exact distance is determined by having both performers aim their respective cameras at each other so as to locate the top of the slats with the top of each other's headlines... They walk when the piece commences counter-directionally to each other, spiraling.... They walk at the same speed, aiming the camera at each other.[56]

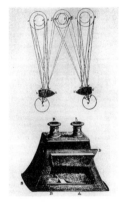

David Brewster's lenticular stereoscope (1849)

[54] *End Moments* 1969: 66.
[55] *End Moments* 1969 : 67.
[56] *End Moments* 1969: 37.
[57] Dan Graham, 'Two Related Projects for Slide Projectors,' in *Two Parallel Essays* (New York: Multiples, Inc., 1969): 7.

Graham has made it clear that the idea for this work derived from an optical device of the nineteenth-century, namely the stereoscope. The stereoscope is an apparatus that employs two separate eyepieces or lenses to impart a three-dimensional effect to two photographs of the same scene that are taken at slightly different angles. The work also makes a reference to Peter Mark Roget's accidental discovery of the stroboscopic principle of apparent motion. The British physician and compiler of the *Thesaurus* happened to notice that the spokes of the wheel on a passing cart seemed to stand still while he looked through the bars of a slatted fence. This experience lead Roget to the realization that the periodic movement can be decomposed into static units and then recomposed again, a realization that would greatly contribute to the invention of cinema.

The motives behind Graham's archaeology of technique will be examined in the next section, but there is another historical figure which has already been alluded to, namely the photographic series or 'chronophotography' of Muybridge, which can further clarify the structure of the slide installations. It will also illuminate why he could afford to eliminate the 'discontinuous aspect' of the slide projects at the formal level of their narrative axis. An elimination which was the result of his taking up a Super 8 camera.[57] He discovered, namely, a more fundamental principle of disruption at the technical level of the discursive event.

Graham is the first to admit that the figure of chronophotography provides a genealogical link between his films and Minimalism:

> Ironically it wasn't the new medium of cinema which devolved from Edison's invention, but the steps along its path – the analysis of motion – which first 'moved' artists. Marey's work is

Filmic Topology
343

Etienne-Jules Marey,
'Seagull, transverse flight'
(1886), chronophotograph
B.N. Cabinet des Estampes.

recalled by the Futurists and most notably by Marcel Duchamp's paintings [...] Léger, Moholy-Nagy and others did utilize the motion picture (also Duchamp at a later date), but only as an available tool and not in terms of its structural underpinnings. It wasn't until recently, with the 'Minimalist' reduction of the medium to its structural support in itself considered as an 'object' that photography could find its own subject matter.[58]

What Graham admired in serial photography was the disjunctive appearance of its spatiality which subjects the body to a process of multiplication – the one repeated as many. 'Each image is always in the present,' Graham explains, 'No moment is created: things – moments – are sufficient unto themselves.' What presents itself is a spatial juxtaposition of moments where 'things don't happen; they merely replace themselves relative to the framing edge and to each other.' It follows that the series of Marey lack a transcendent subject for there is no single, fixed point of view. All changes from one frame to the next are strictly positional, he remarks, and "only involve the motion of the reader's eye (not the artist's 'I')."[59] The eye is moved by the rhythm of photographic device, rather than intending a visual depth of field. There is no perspectival presence of the world to the viewer, but only a succession of locomotive phases against a flat, black ground. Before this lateral shift of planes, the viewer becomes disassociated from its object.

The chronophotograph does nothing so well as picture the spatialized time of commodified experience. No moment is created, each moment is sufficient unto itself: that is a perfect definition of the commodity image. Seemingly always lodged in the present, nothing ever truly 'happens' to the subject placed before this screen of perpetual return. Faced by this spectacle of shifting planes, the subject is transformed into the Baudelairean figure of a kaleidoscope gifted with consciousness, but for one major difference: the chronophotograph does not completely conceal the structural underpinnings of its display.[60] Likewise, to use the camera not as an available tool but to disclose its material conditions of performance is the difficulty posed by Graham's 'subject matter.' To do otherwise, is to condemn oneself to the losing game of phenomenology.

How is this game of phenomenology played? A two-fold tactic is required. First, to render the contingency of the body into a condition of transcendence, as in the 'vague power' of Merleau-Ponty. Secondly, this inversion must be accompanied by the identification of the body as a projective apparatus. The techniques of the body, therefore, are given a more metaphorical than literal sense. The lived body incorporates depth through its tools, it settles within the complex of instrumental practices as within a house. The alternative would be to face an 'unsettling' dispersion of the body. And this alternative of a metonymic contiguity between body and machine has been presented by Merleau-Ponty's former student, Michel Foucault, in his genealogy of the corporeal techniques of disciplinary power. Somewhere in the interstice between the two, resides a marvelous movie by Buster Keaton called the *Electric House* (1922) in which an engineer-impostor becomes increasingly controlled by the malfunctioning contraptions of modern comfort. *Homes for America* presents a less acrobatic if not less humorous version of the house as machine: an architecture not of place but of decomposition.

We might now comprehend the motive behind LeWitt's shift into depth with *Muybridge II*. We can, that is, provide a phenomenological rationale for this shift. The lateral series of Muybridge presents a model of subjectivity that exists *within* time, precipitating the need for another observer at the back of consciousness to string along this succession for the first, and then a third to do the same for the second, etc. To pre-empt such a scattering of the self, Merleau-Ponty insists, we must understand time as the subject and the sub-

[58] Benjamin H. D. Buchloh was the first to identify the importance of this passage in his essay 'Process Sculpture and Film in Richard Serra's Work,' in *Richard Serra: Arbeiten 66-77* (Tübingen: Kunsthalle, 1978).

[59] *Two Parallel Essays* 1969: 2.

[60] See Crary's discussion of the kaleidoscope as a composite figure of the modern spectacle in *Techniques of the Observer* (Cambridge, Mass.: MIT Press, 1990): 113-116.

ject as time. In other words, subjectivity must fall together with the apparatus of projection. At this moment, the inward collapse of consciousness halts and reverses itself. And subjectivity itself becomes the producer of a difference: a temporality that temporalizes itself. Rather than the decomposition of the bird's flight into static instants, we have the "grayish power of flight [...] this flurry of plumage still here, which is already there in a kind of ubiquity, like the comet with its tail."[61] Better still, we have the phenomenon of a 'pure transition' in which the temporal dimensions of past, present and future perpetually overlap, each destined and implied by the other, 'aimed at *as* something other than itself.' Aimed at, that is, by the gaze of the subject who stands at the center of time.[62]

Muybridge II suggests but does not fully implement this 'pure transition' of time. However, a filmic analogy exists of such a projective self that was well known to Graham. I am referring, of course, to Michael Snow's *Wavelength*.[63] This movie consists of a continuous zoom across a loft interior, yet the backwash of past moments lap against the stern of the camera as it continues to plow a passage through depth. Within the span of its attentive gesture, *Wavelength* presents the temporal pulsation of a lived present through a superimposition of frames. The film objectifies, so to speak, the intentionality of a gaze that "holds a past and a present within its thickness."[64] And the directionality of this gaze becomes a head-long, 'ecstatic' rush into the future, a kind of ingestion of space, which makes even the event of death that momentarily intrudes before the camera seem irrelevant.

And, then, there is Graham's *Binocular Zoom*...

A Topology of Skin

The ego is first and foremost a bodily ego; it is not merely a surface entity, but is itself a projection of a surface.[65]
Sigmund Freud

A photograph exists of Graham that could form an illustration to an instructional manual on cinematography, were it not that Graham's mode of instruction is utterly deviant. The image is quite unassuming in quality, a mere document of the artist at work. Yet, the camera is not handled in accordance with any industrial standard. The photograph in question accompanies Graham's notes on the film *Binocular Zoom* of 1969. The illustration is not a still culled from the film, but a mise-en-scène of the film performance, which requires that the cinematographer zoom into the sun with two Super 8 mm cameras placed against the eyes. Looking downwards, the photograph projects the foreshortened contours of the filmmaker's body against the pebbly ground. Graham's head strains backward in order to stare into the sun. Or is it the look of the camera he returns? We cannot be sure, because instead of looking into his eyes, we only see the diaphragms of the Super 8 camera boxes. Two black holes rimmed in white like two strangely dilated pupils, which do not acknowledge our look so much as point at us with their wide, blank stare.

In staging this photograph, Graham accomplishes a number of things at once. First of all, he indicates how the filmic experience itself exceeds representation. The two film-strips are aligned next to his portrait but this procedure does not unite cause and event within the 'architecture' of the whole. We do not survey a topographical scene in all its spatio-temporal dimensions at once, because the perspective of Graham, which itself is internally split, never matches up with our own. We strain to locate ourselves within this space wherein we are substituted by the sun 'behind our heads' like the projector beam

Dan Graham documenting
Binocular Zoom, 1969-70

[61] Merleau-Ponty
1962: 275.
[62] Merleau-Ponty
1962: 422.
[63] See Annette Michelson, 'Toward Snow,' *Artforum* 9, no. 10 (June 1971): 30-37.
[64] Merleau-Ponty
1962: 275.
[65] Sigmund Freud, *The Ego and the Id*, ed. James Strachey (New York: W. W. Norton, 1960): 20.

in the cinema. The photograph does not illustrate the film. It cannot because the mediation of one gaze by another produces a series of infinite regress, as Graham acutely observed in relation to the serialized space of Minimalism.

And then there is an additional aspect to the photograph that hardly bears representation, namely its humorous quality. Graham handles the Super 8 cameras in an improper fashion, at least when judged against their marketed use. He diverts the instrument towards another end. He re-invents, as it were, the device as a *scientific toy*.[66] What this strategy attests to, first of all, is the utter familiarity of the speech act it transgresses. We might encounter this statement on our daily trips to the store: 'Please read the instructions. This device might cause you harm if used improperly.' But the notion of the scientific toy in its welding of pleasure and reason, science and entertainment, is also a figure of the past. What the photographic *mise-en-scène* of *Binocular Zoom* seems to recreate most of all is the mythical event of the birth of cinema, which began, precisely, with a blinding of vision. Not 1896, that is, but the summer of 1829 during which Jacques Plateau could be encountered staring into the sun. The Belgian physiologist was studying the temporal effect of the after-images that were burned into his retina. In the course of these observations he was to lay the groundwork for the principle of the persistence of vision. Whether possessing scientific validity or not, this principle was to enable the later nineteenth-century to conceive of a cinematographic synthesis of movement. Plateau lost his eyesight in the end, but not before he helped one phantasm beget another. The Belgian, in fact, constructed his own device to replicate his scientific findings, the *phenakistiscope*. This device consists of a slotted wheel, which the observer holds close to his eye while standing before a mirror. When turned, an image sequence depicted on the other side of the wheel is transformed into the animated illusion of, for instance, a horse galloping in place. And this scientific invention was also to enjoy a commercial success.

What the case of Plateau exemplifies is the performative nature of the observer in modernity. The observer, that is, in its historical construction as a specific modality of perception. Graham's portrait superimposes this past on the present. What Graham's snapshot resembles, therefore, most strongly is Walter Benjamin's dialectical image of the past that, like "a flash of lightning" suddenly disrupts the empty continuum of the eternal present.[67] In this spacing of past and present, in its superimposition of two moments, the myth of progress is shown to be a sham. Indeed, cinema did not simply improve upon the earlier devices such as the *phenakistiscope*, but submitted this earlier moment to a dialectical process of inversion and concealment. To stop the dialectic in its tracks, to produce an image of the dialectic at a standstill, is to conduct a politics of history demanded by both Benjamin and Graham alike.

But what is it that cinema must conceal? That is what the 'instructional' image of Graham truly demonstrates. For the photograph indicates both the archaeology of knowledge and genealogy of power that cinema suppresses. The optical techniques of physiology established the subject's body as the combined site of the production and consumption of images. And here we approach the true lesson of the past as it figured in the physiological experiment of the nineteenth century and is defined, with superb intelligence, by Jonathan Crary in his *Techniques of the Observer*: the spectator combines successively the sites of viewing subject, object of observation and optical apparatus.[68] And within this institutionalized field of visuality there is no permanent synthesis, only a temporal spacing of subject positions in depth.

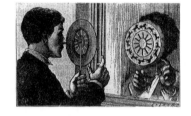

Phenakistiscope used
before a mirror

[66] The *locus classicus* of this term is Charles Baudelaire, 'A Philosophy of Toys,' *The Painter of Modern Life and Other Essays*, trans. Jonathan Mayne (New York: Da Capo Press, 1964): 201.
[67] Walter Benjamin as quoted in Eduardo Cadava, *Words of Light: Theses on the Photography of History* (Princeton: Princeton University Press, 1997): 64.
[68] The following discussion will draw extensively on Crary's study.

What is striking about the optical devices of the 1830's and 1840's, such as the *phenakistiscope* or the stereoscope, first of all, is the exposure of their structural mechanism. The observer is fully aware of his physical contiguity with an apparatus of vision, which, in its turn, openly displays its material procedure of subjectivication. This lack of mediation between body and technique is of the metonymic order of the machine not the metaphorical order of the available tool. In short, the apparatus both enforces and exhibits the passivity of the observer who is captivated by the spectacle conjured within the coupling of body and machine. Secondly, these devices materialize a temporal differential within the domain of perception. Rather than affirming the presentness of the world to an ideal eye, this transcendent point of view is severed from its moorings. Particularly the stereoscope, as Crary notes, attests to this eradication of an external point of reference in the knowing subject. The perception of depth in stereoscopic vision does not permanently coalesce, as in normal, binocular vision, but appears as a temporal effect of the spatial distanciation between the binary images. Moreover, this material difference irrupts within the perceptual field, which assumes an ambiguous, disjunctive quality.[69] Depth is arranged as a visual succession of planes, yet the intermediate space is difficult to comprehend and becomes strangely tangible in quality. In other words, the scenic relationship of the viewer to the world has been disturbed in this coition of flesh and machine. And that, we might say, forms the Copernican reversal of the nineteenth-century, an age that established the body as part of a machinic assemblage.

The physiological gaze reconfigured the body as a skin-like topology of "permeable, overlapping screens of planar space," but it also reproduced the world in its own image through its optical techniques.[70] But this organization of the body as a mobile and multiple network was not restricted to science, but also operative in the realm of industrial production which implemented its own disciplinary techniques of corporeal inscription, admired by the likes of both Frederick Winslow Taylor and Sergei Eisenstein. Where this technical subjectivication of the body was suppressed, however, was in the institutional domain of cultural production. Nevertheless, the autonomy of the Modernist beholder and the voyeurism of the cinematic spectator are both predicated on such a physiology of vision. From the hallucinatory presence of Greenberg's optical space, to the phantasmatization of reality in the cinema, we might continue to dream ourselves into the center of the world.

Of course, Modernism and science did not need to be enemies (as Modernism and industry did). After all, they share the same cognitive subject who confirms his/her self-identity by testing the laws of the discipline. But the complicity of the experimentalist in the experiment must not be spoken, for to pronounce this disavowal would cause a rude awakening. And, of course, this is exactly the scandal performed by Graham's films. If he returns to the prehistory of cinema, then it is precisely to underscore the corrective function of scientific technique that this toy was to repress. 'Learning exercises,' he calls his performances, and not totally in jest. In fact, his films might be called experimental, but not in an artistic sense of formal investigation. Graham mimics the procedural approach of scientific research, yet this does not entail that he projects the methodological ground plan of science onto the gallery floor. Although the spectator of his films and performances seems submitted to a kind of psycho-physical training or behavioral test, this does not make the museum into a laboratory. What Graham's procedure does state is his ambivalence concerning the disciplinary nature of these institutional spaces.

The films also emphasize Graham's ambivalent response to the productivist strategies of the historical avant-garde. The artist was attracted to the possibilities opened up

69 Although I will not further develop the argument here, any discussion of the 'differential' function of the medium needs to engage the work of Rosalind Krauss as well. See, in particular, her *A Voyage on the North Sea. Art in the Age of Post-Medium Condition* (London: Thames & Hudson, 1999).
70 Lisa Cartwright, *Screening the Body: Tracing the Medecine's Visual Culture* (Minneapolis: University of Minnesota Press, 1995): 92.

by new technology but not to the point of succumbing to a utopian enthusiasm. For the avant-garde replicated the metaphorical relationship of the body to the available tool. Its favorite figure of the camera-eye returns in an uncanny sense in Graham's films. There is almost something grotesque about the mingling of flesh and camera, which underscores the weight of the historical trauma he exposes.

The suspended dialectic of past and present in Graham's cinema is also a pause between a utopian and lapsarian moment of time. In order to comprehend the nature of this pause, we must realize what it means to perform an archaeology of the cinema in the sixties. Which is not the same thing as performing it today – a fact that often is occluded in the current resurgence of the artist film. The dialectical image of these films appear in a space marked by the passing of Minimalism and Pop art and the emergence of the expanded field of Post-Minimalist practices, such as Conceptual, Process and Performance art. Within this already divided space of the present, the filmic 'shell' of Graham was wedged. And within this series a 'new' possibility was entered, that of the Super 8 camera:

> A great thing happened when the Super 8 camera came in, or a particular one which had a fixed focus, which made possible all the film pieces I did really. First that it was very small so I could put it right on my eye, so that it was an extension of my eye…And secondly being fixed focus you could have both the periphery of your body [...] and also the horizon line. Also as you moved you didn't have to change focus. If it wasn't for that I wouldn't have been able to do *Two Correlated Rotations* or the *Roll* film [...][71]

The introduction of the Super 8 film camera during the mid-sixties made it possible for him to return to the historical figure of the camera-eye, not to simply repeat it but to transform it under the varying circumstances of the current context. The Super 8 camera brought movie making home to a mass audience of producers, the industrial response to the revolutionary hopes of the twenties. But in this expansion of a do-it-yourself spectacle, the former ideal of productivism has been all but extinguished. Everyone a filmmaker did not quite live up to the promise of its original statement.

During the late fifties, experimental filmmakers could take heart in the transfiguration of suburban yards into movie sets. Graham's films do not regress to such a state of naïveté, but neither do they cancel the essence of utopian thought: to disrupt the continuum of time. In the raking light of the twin projectors, endlessly repeated, endlessly decomposed, Graham catches the shadow of another time flitting across the seamless surface of the image: "I was interested in that same surface appearance [...] which is a kind of optical surface somewhere [...] the spectator, the thing itself – the camera, the lens, the mechanism, the time relationship in the mechanism being recorded and then played back [...] the performance."[72] This performance is the malfunction of the machine, the differential that interrupts the perpetual present of the spectacle.

The Super 8 camera no longer formed the prop of a 'free' subject in the hands of Graham. Ordinarily, the camera conceals the more disturbing aspects of the earlier optical devices, that is, their materiality and differential effect. The lightweight automatic camera releases us from our passivity while we take snapshots of our tour around the world. Improved shutter speed and sharpness of focus divest the visual field of its more ambiguous qualities. But little is needed to turn this relation around, to materialize the difference it conceals. To show, that is, the neutrality of the instrument as a skin-like 'interface':

> A camera on the eye or on the body is the interface between the visual world ('outside') and the body's cylindrical perimeter bounding its own ('interior') 360° space.[73]

[71] Simon Field, 'Dan Graham: an Interview with Simon Field,' *Art and Artists* vol. 7, no. 10 (January 1973): 19.
[72] Field 1973: 19.
[73] *Films* 1977: 9.

74 *Films* 1977: 7.
75 "The appearance of the Other, on the contrary, causes the appearance in the situation of an aspect which I did not wish, of which I am not master, and which on principle escapes me since it is *for the Other* [...] It is the unpredictable but still very real *reverse side*." Jean-Paul Sartre, *Being and Nothingness* (New York: Washington Square Press, 1992): 355.
76 "But *the Other* is still an object for *me*. He belongs to *my distances* [...] hence the disintegration of my universe is contained within the limits of this same universe; we are not dealing here with a flight of the world toward nothingness or outside itself. Rather it appears that the world has a kind of drainhole in the middle of its being and that it is perpetually flowing off through this hole." Sartre 1992: 343.
77 Graham's remark can be found in *Films* 1977: 9. Andre's comment was made during a symposium held at Bradford Junior College, Bradford, Mass. (February 8, 1968). An excerpt of the transcript was published in Lucy Lippard, *Six Years: The Dematerialization of the Art Object* (New York: Praeger, 1973): 40.
78 *Sunset to Sunrise* was first executed as a photographic sequence.
79 *End Moments* 1969: 38.

This interface is not a ground against which things stand out for me. It is a constantly shifting, reversible screen of consciousness. When Graham speaks of the phenomenology of his cinema, it is not one in which Merleau-Ponty would recognize himself:

> Phenomenologically, the camera, its representations, and the spectator's view are the meeting point between, and can be seen to be any of, the elements of visual *consciousness* — if consciousness is partly external (situated in the object simulated in what is seen), partly internal (situated in the eye or camera), and partly cybernetic or *interpretive* (situated in the central nervous system or the process of attention which, with the body's muscle/skeletal systems, achieves orientations in the world).[74]

These switching termini of Graham's cinema, consciousness as both internal and external, present a kind of phenomenological project in ruins. The camera posited as an 'interface' does not just subtend a subjective vector of projection. The camera will take on a material aspect, and it will exist not only as an object for the self but as an object for a possible other as well. It will, in short, manifest an "unpredictable but still very real *reverse side*."[75] To capture this reversibility of the visual axis, Jean-Paul Sartre has spoken of a drain hole in the middle of the world through which being is continually flowing off.[76] Likewise Graham suggests that the body forms nothing but a cylindrical "hole" within the 360° environment of outside space, although a more familiar source of this thought would be a statement of Carl Andre: "A thing is a hole in a thing it is not."[77]

The phenomenological horizon of meaning has been thoroughly debased by the filmic function of Graham. *Sunset to Sunrise* of 1969 was the only film that was not shot according to a binocular schema of two cameras.[78] But it also rests on a structural principle of doubling which turns the horizon, as it were, inside out. We believe that we experience one extended pan, mirroring our own continuity in space, but it contains a temporal elision — the gap between sunset and sunrise. But there is a further disturbance of our implantation in space. As Graham remarks, we observe "the inside 'dome' of the sky as if the observer was situated outside the spherical surface; so the earth rotates about itself and about the sun, the viewer rotates in relation to the sky."[79] Man is not the center of this filmic universe.

Body Press presents an altogether more complex experience to the spectator. However, I hesitate to call it a culmination of Graham's series (which chronologically it definitely is not). We are not dealing with a perfection of Graham's method, its climactic moment represented by *Body Press*. The statement of Graham's cinema is contained in the films as a series. Which is to say, not in their discrete identity as objects, but in their temporal dispersion of the structural elements of the camera and the body. The films are to be used and repeated, not to be collected as things. This discursive function is contained as well in Graham's film notes with their combination of descriptive and interpretative, instructional and demonstrative language. The same function, furthermore, is enacted in Graham's alternation between the roles of artist and scientist, performer and observer, self and other.

We are now able to fully appreciate the fact that the actual experience of these films remains beyond representation, as I have suggested before. The projective space of the film is not homogeneous, but an aggregate, visual field split between the two screens, like the two images of the stereoscope, and this field never completely converges in one point. The viewer as a result enters into a chiasmic loop of endless transposition and exchange. The spiraling movement of the camera, its lens never coinciding with the performer's eyes, makes the viewer's identification with the mechanical eye problematic, at times even impossible:

A camera placed on another part of the performer's body or within his field of vision may be part of the performer's body feedback system. A camera's identity, in relation to the spectator's perception, may be part of the performer, one part of him but not another part of him, or not part of him (a separate mechanical object). Its image may be read inside and outside the performer, appearing as simultaneously subject and object.[80]

No longer the exhibitor of an objective space, the camera becomes a phantasmatic object in its own right. The camera appears to belong both to me and to an other, therefore I am forced to acknowledge that the other knows that I know that the other knows, etc., in an endless falling away of self from self.

Placed in an eccentric orbit in space, the gaze of the camera is continuously turned around and set upon the spectator. *Body Press*, for instance, submits the viewer to an incessant inversion of active and passive subject positions similar to the nude male and female performers placed in their tight spot of confinement. Furthermore, the visual field alternates between a perspectival clarity and an anamorphic distortion of boundaries, casting the subject, as it were, again and again from its center. This split within the visual field opens and closes again, yielding a brief glimpse of an undistorted reflection of camera and body. Yet, only seconds later, the image flows off along the curved surface of the mirror in a boundless mass of flesh, glass, and metal while the camera continues its helical path, slipping from one horizon to another. *Body Press*, like Graham's other films, places the phenomenological loop of seeing/seen, touching/touched, in a kind of 'anonymous' space, its axis revolving outside the center of the subject. A constant confusion of tactile and visual cues is the result, an indistinctiveness of subject and object that derives from the physical proximity of the camera to the body.

In sum, *Body Press* appears as a literal pun on the French *pellicule* with its double meaning of skin and film. The film's visual structure indeed resembles that of a skin stretched between inner and outer space, both concave and convex, a scroll endlessly twisted inside out.

> To the spectator the camera's optical vantage is the skin. (An exception is when the performer's eyes are also seen reflected or when the cameras are seen filming the other.) The performer's musculature is also 'seen' pressing into the surface of the body (pulling inside out). At the same time, kinesthetically, the handling of the camera can be 'felt' by the spectator as surface tension – as the hidden side of the camera presses and slides against the skin it covers at a particular moment.[81]

The filmic topology of Graham projects consciousness as a surface or, as Freud suggested, a 'skin-ego.' An ego, that is, which always remains on the verge of dispersal for it can never fall together in a founding act of self-reflection. We can draw a topographical chart of this skin-ego, as Freud has done on several occasions, however he also warned against the misleading aspect of such diagrams. The psychic economy of differentiation cannot be reduced to the spatial terms of representation; there is no external, atemporal perspective. Similarly, Graham likes to dose his texts with several diagrams, illustrations and demonstrational photographs. Yet, these supplementary figures cannot graph the filmic event as such. Unless, perhaps, it comes in the distorted version of Ernst Mach's drawing which featured on a flier for a performance at 98 Greene Street in 1971 and again on the cover of the 1977 *Films* catalog. This image shows a skewed perspective of space seen from one eye, framed by the distinct arch of the brow nose, and moustache on the right and a foreshortened book case on the left that dissolves into the periphery of vision. Jutting into the center of this space, the prone, lower body of the scientist is

[80] *Films* 1977: 7.
[81] *Films* 1977: 21.
[82] Obviously, Jacques Lacan's model of the image-screen is highly relevant to the films and Graham was certainly aware of the mirror essay (although not until the mid-seventies). I will leave this topic mostly aside, however, although it clearly operates in the background of my text. A discussion of Lacan in the context of Graham's video performances and installations is taken up by Thierry de Duve in 'Dan Graham et la critique de l'autonomie artistique,' in *Dan Graham: Pavilions* (Bern: Kunsthalle, 1983) and Birgit Pelzer in 'Vision in Process,' *October* 10 (Fall 1979).
[83] Stanley Cavell, *The World Viewed* (Cambridge, Mass.: Harvard University Press, 1979): 114.
[84] R. D. Laing, *Knots* (New York: Random House, 1970): 1.
[85] 'Performance as film' should not be confused with a 'filmic performance.' I would reserve the latter term for intermedia prac-

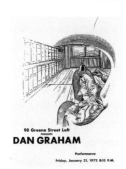

Ernst Mach's drawing that was used as announcement for 98 Greene Loft Performance (1972)

tices that combine film projection and live performance as, for instance, in the work of Carolee Schneeman or Robert Whitman.

[86] Graham refers to the "medium" in both a literal sense – performance as a specific technique or discipline of art – and a "meta-psychological" sense – the artist as a kind of "art-guru" which, Graham, explains, became "enhanced by media reproduction and occupied by artists such as Joseph Beuys, politicians such as the Kennedys, rock figures such as the Beatles." 'Performance: End of the '60s,' in *Two-Way Mirror Power* 1999: 142.

[87] 'Anti-Illusion: Procedures/Materials' ran from May 19 to July 6, 1968, at the Whitney Museum of American Art, and was curated by James Monte and Marcia Tucker.

[88] The performers were Bruce Nauman and Meredith Monk. Graham identifies the third performer in 'Subject Matter' as Nauman's wife.

shown, resting on a sofa. This body, however, has no spatial connection to the curved facial segment of brow, nose and moustache. And then from the right comes a disjointed hand holding a pencil as a kind of measuring device. This index of scale and distance might analytically draw the contours of this disjunctive field but not project its unity from the beginning.

The self as a projection of a surface – yes, but located on which side of this curving screen?[82] – Graham's films do not draw the lineaments of a place, they do not establish a definite locale that we might inhabit. This self-evidence of location, the very possibility of locating ourselves in space, is called into doubt. This filmic topology could not stand at a greater remove from the topography of Modernist painting. What Modernism states is that the painting 'faces me, draws my limits, and discovers my scale; it fronts me, with whatever wall at my back, and gives me horizon and gravity.' In short, it "reasserts that, in whatever locale I find myself, I am to locate myself."[83] Modernism proposes the present-ness of the 'performance' of art, a proposition that Graham does not share. But should I seem indiscriminate in my use of the word performance, let me place it in a more specific historical context. By this means, we can establish in what sense the 'performative' nature of Graham's films is not to be confused with performance at large.

Postscript: Performance as Film

> They are playing a game. They are playing at not playing a game. If I show them I see they are, I shall break the rules and they will punish me. I must play the game, of not seeing I see the game.[84]
> R. D. Laing

Film and Performance is the prosaic title that Graham gave to his collection of film notes published in 1976. In light of the foregoing, we might rewrite this title to spell *Performance as Film*.[85] The performance does not consist of some gesture in space that exists prior to its filmic mediation; it is *developed* on film in a quite literal sense. Likewise, the screening does not take place after the fact as in the case of a narrative of documentary film. The screening is an exhibition *and* a performative event. The viewer is enveloped in the folds of its 'skin.'

But Graham's reception of contemporary performance art needs further elaboration. As always, Graham was wary of identifying himself completely with a particular medium and, therefore, his role as performer was to take an ambivalent form.[86] He resisted any specialization as a performance artist, just as he refused to obey the preceding division of labor under Modernism. Hence, when Graham states that he organized performances 'because many other artists then also did,' this statement should not be interpreted as a self-disparaging comment, but as an indication of the underlying strategy of 'de-composition' that provides his work with such remarkable critical strength.

Graham's interest in performance art was incited after becoming acquainted with the work of Bruce Nauman. In 1969, Graham attended a live performance of Nauman for the first time. It was *Bouncing in a Corner* that he witnessed at the Whitney Museum during the landmark exhibition 'Anti-Illusion: Procedures/Materials.'[87] As performed at the Whitney, *Bouncing in a Corner* consisted of three performers with arms held slack to their sides, who repeatedly fell with their backs against the walls of the stage, causing a thumping sound to reverberate throughout the auditorium space.[88] The performance lasted until bodily fatigue set in. In Graham's crucial essay 'Subject Matter,' which

describes his formation as an artist, he provides ample space for the description of *Bouncing in a Corner*.[89] Graham would also have had an earlier opportunity to see Nauman's work during his one-man exhibition at Leo Castelli Gallery in early 1968.[90] In the Castelli exhibition, Nauman used a projection box to show two of his own films, namely *Thighing* and *Playing a Note on the Violin While I Walk around the Studio*.[91]

The precedent set by Nauman's films is unmistakable. Particularly the *Studio Film* quartet to which *Playing a Note on the Violin* belongs and that was shot during the winter of 1967-68.[92] Graham has certainly never downplayed the importance of Nauman's filmic practice to his own work. What the films of Nauman and Graham hold in common is the interrelation of the performer's body and the camera that produces a doubled surface, or interface, of mutual reflection. But there is also a significant distinction between the two filmic methods, which I can only briefly indicate at present.

Nauman's *Studio Film* series employs a static camera to depict the artist, alone in the studio, while performing a repetitive task. The movements of his body are correlated to a taped square on the floor, which is tightly framed by the camera aperture. But this is not strictly a documentary device. Contrary to common opinion, Nauman did not create a neutral record of the performance, although that might have been the original plan. Nor, should I add, do these films indulge the same mode of self-dramatization that motivated Graham's colleagues Vito Acconci and Dennis Oppenheim and who shared his interest in Nauman's work. Nauman revels in the execution of a 'bad' performance, both on the level of his motoric skills and technical knowledge of film. A dysfunctional method is structural to the work. Nauman exhibits a deskilled notion of 'training' that counters the habituality of the phenomenological self who embodies space by means of his 'tools.' What registers most strongly in viewing Nauman's films is a sense of disassociation; an awareness, that is, of the artist's losing game of inhabiting the empty studio which is invaded by the camera.[93] And together with this dispossession of the self, who incessantly alternates between private and public space, arrives an impression of physiological fatigue, of a faltering rhythm of the body, that is echoed in a breakdown of the filmic apparatus itself.[94]

In turning the camera on the performer, Nauman and Graham situate the subject in the space of the gaze, rather than placing the subject at its core (as in the case of *Wavelength*). As a result, the subject's involvement in its projects becomes marked by ambivalence; the connection between the subjects' possibility and the instrument is objectified. In the gaze of the other, Sartre would say, my possibilities appear alien to me. They appear, that is, as no more than a probability that resides outside of me and "the ensemble 'instrument-possibility' made up of myself confronting the instrument, appears to me as surpassed and organized into a world by the Other."[95] Hence, the wavering concentration of Nauman, the intermittent loss of control and occasional sense of frustration played out before the camera. (Which implants a similar discomfort in the viewer.) But for all the similarities between the films of Nauman and Graham, Nauman's work does not alter the scenic relationship of the viewer to the projected situation. The camera in the *Studio Films* remains outside the space so that the viewer can master the situation to a degree that Nauman cannot. Nauman will sometimes make a vain gesture of defiance by walking off-screen, but this only succeeds in acknowledging the primacy of the camera's gaze. Even my possibility of hiding in the dark corner, Sartre writes, is surpassed by the other who always already casts its light there before I can make my move. As a result, the spectator in Nauman's cinema retains the furtive position of a voyeur (Nauman never looks directly at the camera), unlike the discursive conditions of Graham's cinema. The

89 Graham offered 'Subject Matter' to both *Artforum* and *Arts Magazine* but both magazines rejected it. He then published it on his own in *End Moments*, which had an edition of circa 150 copies.
90 The pieces Nauman exhibited at Castelli Gallery, such as *Flour Arrangements* and various body casts, manifested several areas of overlap with Graham's preoccupations. For instance, the use of mechanical media of reproduction, the exploration of serial procedures and metonymic relationships, the literalism of execution, not to mention the undercurrent of humor. The model of space employed by Nauman at this time, however, is still predominantly topographical in kind with some major exceptions, such as the casts of negative space. But even though these objects present a kind of phenomenological paradox, they do not completely remove the gaze from the viewer's hold. His later video installations would completely change the nature of the game.
91 John Perreault mentions the projection box in 'The Act of Seeing,' *The Village Voice* 13, no. 17 (February 8, 1968): 19-21. He also identifies what is presumably *Playing a Note on the Violin While I Walk Around the Studio*, by the title *Playing The Violin Even Though I Don't Know How To Play*. *Thighing* performs an interesting play on the (de-) differentiation of Freud's 'ego-skin' by presenting a fragmentary close-up of a thigh which is being pinched by a hand. The soundtrack con-

sists of a disembodied voice that is enlisted in the task of repeatedly sighing. The perception of sound, touch, and vision, thus, keeps slipping from one register to the next without ever converging on one single sense.

[92] The other films were *Bouncing Two Balls between the Floor and Ceiling with Changing Rhythms, Dance or Exercise on the Perimeter of a Square,* and *Walking in an Exaggerated Manner around the Perimeter of a Square. Dance or Exercise* and *Playing a Note* were both screened during the 'Anti-Illusion' exhibition.

[93] I have argued this point more fully in a lecture titled 'Filmic Habitats: Bruce Nauman and Marcel Broodthaers.'

[94] Since Nauman was unfamiliar with the film equipment, he was not able to correctly synchronize image and sound. Upon discovering this accidental feature, he decided to leave it unmodified.

[95] Sartre 1992: 355.

[96] See the text by Thierry de Duve 1983.

[97] Metz 1982: 94.

[98] See on this subject Denis Hollier, *The Politics of Prose: Essay on Sartre* (Minneapolis: University of Minnesota Press, 1986): 176-80.

[99] The chief proponents of this debate during the later sixties are Michael Fried, Stanley Cavell, and Rosalind Krauss.

[100] Cavell: "An exemplary stage performance is one which, for a time, most fully creates a character [...] An exemplary screen performance is one in which, at a time, a star is born." Cavell 1979: 28.

viewer, as well as the performer, in Graham's work is placed in a literal state of perpetual revolution within the material context of the gallery/film apparatus. In short, the situation escapes the spectator as much as the performer on screen; he is situated in the space of the gaze at a third remove.[96]

This voyeuristic quality of Nauman's films prompts a return to Metz's theory of the cinema, for he opposes the voyeuristic gaze of cinema with the look supported by another medium, namely theater. Metz maintains that the theater almost automatically manifests the reversibility of the exhibitionist relationship that is suppressed in classical cinema. There is a different economy of desire (and money) at work in the theater, he claims. In this space the actor and the spectator enter into an active form of mutual complicity. Neither actor nor spectator are isolated, but form the participants in a collective event. The theater retains, that is, an archaic trace of its origin in a Greek ceremony of civic proportions, a public festival during which a whole population "puts itself on display for its own enjoyment."[97] The present-day audience of the theater, of course, carries little memory of this celebration of the 'we', of being together. A fact that would lead to the ambivalent appraisal of the theater in Sartre who would both detect a possibility of reprieve from the other's gaze – in the dark we all become co-spectators – and a possibility of its institutionalization – the spectators who offer themselves up as a spectacle during the intermission.[98] An ambivalence, of course, already contained in Metz's own words and which speaks closely to the concerns that Graham manifested in his performance work. For he is to become interested in the political possibilities (and probabilities) of collective activity.

There is a lot to be gained from considering this dialectic of theater vs. cinema, because we know its ramifications within the field of the visual arts during the sixties.[99] However, this is not the time or the place to develop this argument. I will, therefore, conclude my discussion by merely pointing how this dialectic might lead beyond film into video. At which point my story will come to an end.

To resume, Graham's model of performance as film clearly combines the antithetical terms of theater and cinema. His films, after all, take place as much on the darkened floor of the gallery as on the reflective screen mounted on the wall. And I say this not only because their installation makes it sheer impossible for the viewer not to step in front of the light. Graham's films combine cinema and theater because they are not concerned with preserving a unique performance within time, as in the case of cinema, or with conducting a perfect performance over time, as in the case of theater.[100]

But for all that, these films cannot materialize Metz's 'festivities' of collective performance. The projective structure of cinema and its idealist subject might be subverted by Graham's performance as film. Yet the subject of the filmic apparatus will always remain confined to the epistemic situation of the physiological gaze. Classical cinema attempts to transform this limiting condition of the embodied viewer into the illusion of transcendence, only to exact the further isolation of the viewer from the social body. The question that performance art posed to Graham, however, was less concerned with the socio-economic process of individuation than the emergence of an alternative politics of the group during the sixties.

The rise of performance art, as Graham notes, relied on the organization of alternative art spaces where the rules that governed access to the traditional art world could be ignored. But this institutional shift participated in the broader social phenomenon of countercultural practices represented by, for instance, the antipsychiatry movement of Gregory Bateson and Ronald D. Laing, the foundation of collectives, the popularity of

meditation exercises, consciousness-raising sessions and encounter groups. Performance, by embedding itself within this context, presented a combination of social therapy and political activity that promised to transform the very structure of the art world. And Graham was to 'quote' freely from these sources. In this respect Performance art offered the opportunity of exploring a more democratic practice of art that could replace the 'hermetic, anonymous information quality' of early conceptualism.

But in quoting, Graham was not completely embracing a countercultural role because he was also very clear about its susceptibility to cooption. We confront here the issue of the mode of self-understanding that is ingrained in the act of cultural resistance. An issue I have raised before. While alternative forms of 'being-together' might have emerged from the shadowy margins of society, they were also being increasingly circulated in the mass media channels, as Graham was quick to grasp. The phenomenon of marginality, the artist suggests, never exists in a pure state. In becoming visible a counterculture is necessarily marked by its relationship to the dominant spectacle, even if this relationship takes a negative form.

And this heteronomy of the group necessarily flows from the perceptual structure of the collective space itself. A collective space is not binocular in the sense of Graham's films, but requires three looks. For two to feel as one, they must be placed under the surveillance of a third. Of course, the films intrinsically prepare for such a triangulation of the visual field in their tri-partite structure of performer, observer, and apparatus, but the performer and observer do not occupy the same physical space. The medium of video, on the other hand, offers just this possibility of co-existence:

> Unlike film, where both sound and visual tracks are of necessity in the past and constructed
> from discontinuous segments, edited and reordered according to the conventional rules
> of syntax, video is assumed to correspond/be congruent to the real, present-time/space
> continuum [...] shared by the producers and receivers of the video.[101]

To exhibit the collective of producers and receivers is to materialize this third look as it penetrates within the real, present-time/space continuum. While resistance to the instrumentality of this other gaze forms the collective's common cause, it also remains outside and in view of a 'televised' end that escapes the 'we.'

To submit this dialectic of the gaze to an entropic pull is again the favored tactic of Graham. An early performance, such as *TV Camera/Monitor Performance* of 1970, for instance, consists of the artist rolling back-and-forth on a stage while holding a video camera directed at a monitor that is installed at the back of the audience. The monitor transmits the live image from the camera that reflects parts of Graham's body and members of the audience, besides the video camera itself. As a result the audience, performer, and the technical apparatus differentiate themselves out into three separate, yet overlapping surfaces: "the machine to itself, I to my task, and the audience to its bodies in place are all closed feedback systems or 'learning' loops."[102] Only in this incessant coming together and falling apart of the collective can the possibility of a future politics reside. To seek a permanent status of the group is to disavow the reifying properties of this panoptic gaze. And, once more, Graham would underscore this double bind by holding the utopian promise of performance art in suspension.

But I am now entering another future that will need another time to be told. A future of the video monitor that already is past. Today it is the video projector that awaits exhibition. And in the background the voice keeps repeating: 'I am at the cinema. I am present.' Are you still there?

101 Dan Graham, 'Notes on *Yesterday/Today*,' in *Video-Architecture-Television* (Halifax: Nova Scotia College of Art and Design, 1979): 44.
102 'TV Camera/Monitor Performance (1970),' *Interfunktionen* 7 (1971): 88.

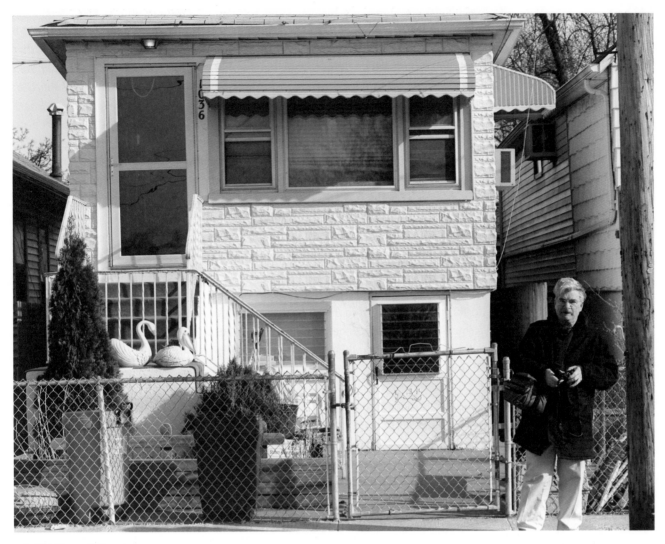

Untitled (Home with Swans),
c. 1996

John Miller

Now even the Pigs're groovin'

My first record was a '45: the Hollies' 'Look Through Any Window.' It was something I got in my Boy Scout troop's Christmas gift exchange. At the time, my family couldn't afford a record player, so other guys tried to get me to trade. I held onto it. Later, my mother bought a cheap portable made by Lionel, the same company that makes toy trains. Looking back, the song seems sentimental, but to a boy growing up in a lily-white suburb of Cleveland, its premises were radical. Chagrin Falls was the town – midway between Shaker Heights, originally a Shaker commune, and Kent, home of Kent State University. The lyrics considered society as an object. The singer looks at his place in the social order, but draws no conclusions. That alone, though, was tantamount to saying we are born into a set of social relations that might otherwise be different. That alone made the song seem modern and revelatory.

During his career, Dan Graham has produced Glenn Branca's Static, collaborated with Sonic Youth and written about the Kinks and punk bands. His videotape, *Rock My Religion* (1984), is a vision of that music as *Jetztzeit*, i.e., apocalyptic 'now time,' in which repressed contents of history are actualized in the space of the present. He also wrote a libretto for a rock opera, *Wild in the Streets*, with Marie-Paule MacDonald. Even so, Graham's interactive pieces, concerning the viewers' experience of themselves *as viewers*, come closer to the experiential nature of rock. Here, *Alteration to a Suburban House* (1978) is the signal work.

Alteration to a Nuclear Family

Alteration to a Suburban House is a model of a phantasm. One might dismiss it as facetious, pop architecture, were it not for its looming 'monumental expression of apocalypse and historical tragedy,' in the words of Jeff Wall. Writing as though it were a fait accompli, Graham proposes this:

> The entire facade of a typical suburban house has been removed and replaced by a full sheet of transparent glass. Midway back and parallel to the front glass facade, a mirror divides the house into two areas. The front section is revealed to the public, while the rear, private section is not disclosed. The mirror as it faces the glass facade and the street reflects not only the house's interior but the street and the environment outside the house. The reflected images of the facades of the two houses opposite the cutaway 'fill in' the missing facade.[1]

Since *Alteration...*'s dry title conceals its fantastic aspect, Wall's assessment may seem hyperbolic. Such an alteration would not be difficult. Nor would it pose overt moral questions. The only real problem would be getting someone to move into a fish bowl and pretend nothing's wrong.

To be precise, however, Graham's proposal allows for a private rear section. This, in effect, isolates the front living room as a symbolic display space. Ironically, the living room may be the deadest one in any house. The middle class uses it mostly to show off its taste. Thorstein Veblen called this process prestation, a technical term for the ritual display of sumptuary objects, i.e., status symbols. The flaneur was someone known to make the street his[2] living room; Graham instead makes his living room the street. In either case, the picture window is the apparatus that brings these discontinuous realms together. The scant partition promises, tantalizingly, to disappear. On one hand, this prospect suggests ending private property; on the other, owning everything within the window's purview. So, Parisian department store displays fascinated the Surrealists – and later, Walter Benjamin:

[1] Dan Graham, 'Works & Writings: Models & Pavilions,' *Dan Graham* (Barcelona: Fundació Antoni Tàpies, 1997): 122.

[2] I deliberately use the masculine possessive here because, as Susan Buck-Morss asserts, a female flaneur would have been taken for a prostitute, "[...] sexual difference makes visible the privileged position of males within public space. I mean this: the flaneur was simply the name of a man who loitered; but all women who loitered risked being seen as whores, as the term 'street-walker' or 'tramp' applied to women makes clear [...] The popular literature of flânerie may have referred to Paris as a 'virgin forest,' but no woman found roaming there was expected to be one," 'The Flâneur, the Sandwichman and the Whore: the Politics of Loitering,' *New German Critique*, no. 39 (Fall 1986): 119.

The window became an important conceptual device for many surrealist artists, a conduit for sexuality and desire, a stand-in for the interior world separated from the outside only by a transparent glass membrane, a divider through which one could look but that also returned the gaze with its reflective surface.[3]

A similarly uncanny, sexual charge issues from Claes Oldenburg's Bedroom Ensemble (1963). Building a garish bedroom set within an art gallery, Oldenburg conflated domestic and commercial space. A 'mysterious door' marked 'Private' punctuated this tableau. The door led to the gallery's office; so labeled, it offset the exhibition space as a showroom. Ordinarily, exterior and interior, public and private, commercial and domestic spaces are mutually exclusive. Graham cites Benjamin on this score:

> For the private person, living space becomes, for the first time, antithetical to the place of work. The former is constituted by the interior; the office is its complement. The private person who squares his accounts with reality in his office demands that the interior be maintained in his illusions.[4]

In a gesture that anticipates Alteration..., Michael Asher removed the wall separating the office from the exhibition space at the Claire Copley Gallery, Inc. in 1974. In so doing, Asher implied that the dichotomy between the two is false.

Some call Alteration... 'an unrealized project.' That is a misnomer. The model itself resembles Graham's other models for pavilions which, in fact, have been built. Remaining unbuilt brings it into proximity with Claes Oldenburg's proposed monuments. Graham says it is more meaningful that way. Instead of experiencing a full-scale work firsthand, the viewer must project into a miniature scene. This defers literal interactivity. It invites fantasy play instead of the kind of apperceptive encounter that is nominally lived experience. The model itself is a stand-in. Any number of replicas might replace it. Herbert Marcuse once claimed that if we lived in a society that could erect Oldenburg monuments, that society would be free – or, in his words, polymorphously perverse. Now, almost every major city in America has an Oldenburg centerpiece to call its own and corporate perversity reigns supreme. Still, because moral inhibitions present economic constraints, the information-age political economy needs repressive desublimation. Procreation becomes less exclusively the aim of sexuality. The family's ideological primacy starts to erode; this, of course, dislocates old forms of patriarchal authority. The desire for monumentality, in turn, becomes ambiguous – the result: ambiguous monuments. Utopian visions are always refractory, but here, the visionary element that prompted Oldenburg's works has been absorbed and negated. This assimilation helps clarify what Wall meant when he called Alteration... 'the first ruin in the building of a new conceptual art' – the sublation of art as social critique. Ultimately, the New Left had to admit art could not instrumentally change social relations. Even transgression was a dead end. Thus, negative dialectics compel Graham not to build his proposal. Alteration is a euphemism for the liquidation of privacy – or the illusory freedom afforded by privacy. Call it the lure of the real, but some people have been surprisingly willing to give up just that.

In 1973 PBS aired an unusual twelve-hour documentary: An American Family. It was a cinéma vérité chronicle by Craig Gilbert, who previously directed Margaret Mead's New Guinea Journal. Now pursuing an auto-anthropology, Gilbert aimed to "[...] expose the myths, the value systems, the ways of interacting that are American and apply in some way to all of us."[5] He chose to record the day-to-day life of Bill and Pat Loud's family for seven months. With their affluent California lifestyle, this couple and their five children had realized the American Dream. So they readily agreed to let Gilbert and his crew film

Claes Oldenburg Bedroom Ensemble 1/3, 1963. Mixed media; wood, vynil, metal, fake fur, muslin, dacron, polyurethane foam, lacquer, etc.
Overall:
10 ft x 17 ft
303 x 512 x 648 cm.
Coll. National Gallery of Canada, Ottawa.

[3] Donna de Salvo, 'Memoirs of a Saint: Staging Surrealism,' Staging Surrealism (Columbus, Ohio: The Wexner Center for the Arts, Ohio State University, 1997): 14.
[4] Dan Graham, 'Art as Design/Design as Art', in Rock My Religion, ed. Brian Wallis (Cambridge: Massachusetts Institute of Technology, 1993): 208.
[5] Anne Roiphe, 'An American Family: Things Are Keen But Could Be Keener,' The New York Times Magazine (February 18, 1973): 8.

them. At first they were slightly reserved. Bill said it was like having a maid around the house. The whole family, however, soon dropped its guard, taking the cameras for granted; besides, it had issues which couldn't wait. Lance, the eldest son, had just moved from Santa Barbara to New York to join the city's homosexual underground. In one episode, he even introduces his mother to Holly Woodlawn. Despite his success as a mining equipment salesman, Bill was a philanderer with a drinking problem. After years of putting up with her husband's infidelities, Pat confronts him in a noisy Mexican restaurant, telling him he has become no more than "a sad comedy."[6] Later, when Bill returns home from a long business trip, she presents him with her lawyer's card and demands a divorce. He responds, unruffled, "At least I won't have to unpack, will I?"[7] The series became a sensation; its audience got more than it expected. That, however, may be the definition of loss of innocence. Initially pleased with the film, the Louds voiced recriminations right after the first broadcast. During the shooting, Pat had bonded emotionally with the director. Gilbert, however, felt he had to break this bond to complete the project. For his part, Bill thought that the film maker focused too much on family problems and that this bias betrayed a tacit, leftist agenda. One wonders why the Louds ever agreed to be filmed. Gilbert paid none of them. Perhaps they just wanted attention – thinking they too were entitled to the infatuation ordinarily reserved for stars. Lance, for one, had learned to see himself through the 'mirror' of Andy Warhol. Having come out on national TV, he did become a cult celebrity. *The Dating Game* invited two of the other children, Dehliah and Grant, to appear as contestants. Producers even courted Bill as a host for another game show – without success.[8] All over the country, viewers tuned in and felt oddly complicit; the unspoken suspicion remained that somehow the cameras had brought everything to a head, that, without all the fuss, the family would have stayed the way it was before.

In an article about this documentary, Graham discusses the reciprocity between TV and the family. The family is TV's main subject *and* its main audience:

> TV might be metaphorically visualized as a mirror in which the viewing family sees an idealized, ideologically distorted reflection of itself represented in typical genres: the situation comedy, the domestic comedy, or the soap opera. Other types of programs, while not overtly representing the American family, are organized covertly as family structures.[9]

Watching TV is America's preeminent ritual. It draws familial coherence from a source of familial dissolution. This paradox concerns the medium's mimetic capacity. Like a mirror, it enables viewers to see themselves as Other. Like a holiday snapshot, it convinces the family that it exists as a discrete entity with a modicum of shared experience. In other words, it convinces the family it's really there. The suburbs house this version of the family. The car makes suburban life possible. TV gives it definition:

> The very architecture of the suburban home seems predicated on the existence of television: what else are those rec rooms, dens and family rooms for? As often as not, those rooms are what we see reflected back at us: a couch planted squarely in the thoroughfare between front door and kitchen, with a staircase slanting upward behind it.[10]

Through TV's revival of its 'primitive' mimetic powers, the family experiences itself as present within its own alienation, although it is neither the social nor economic building block it is made out to be. This representational inversion is part of the Situationist, i.e., capitalist, spectacle. The suburbs are the symptom of the family's covert transience; that is the lesson of the Louds. The cover of Guy Debord's *Society of the Spectacle* features a novelty photo: a theater full of people wearing 3-D glasses. Obviously, these glasses mark the crowd as spectators. Yet they also suggest the collective power to make illu-

[6] Pat Loud quoted by John J. O'Connor, 'TV: *An American Family* Is a Provocative Series,' *The New York Times* (January 23, 1973).
[7] Bill Loud quoted by Roiphe 1973: 45.
[8] John J. O'Conner, 'Mr. & Mrs. Loud, Meet the Bradys,' *The New York Times* Section 2 (March 4, 1973): 20.
[9] Dan Graham, 'An American Family,' *in TV Guides – A Collection of Thoughts About Television,* ed. Barbara Kruger (New York: Kuklapolitan Press, 1985): 13.
[10] A.O. Scott, 'The Medium is the Mind-Set' *The New York Times Magazine* (April 9, 2000): 29.

sions seem palpable, to grant inanimate objects an animus. This animus corresponds to the congealed labor the commodity represents as profit. The ghostly reality becomes superabundant. Incessant mirroring is the end product of mass culture, i.e., modernity. An *American Family* turned the Louds into a slippery allegory. The audience first laughed at their foibles, then saw them as victims. The Louds' exact status never completely stabilized, complicating the viewers' ordinarily sanctioned voyeurism. According to Graham, "The images of the Louds were literally too close to a mirror image to establish an unproblematic identity to empathize with."[11] Graham's *Video Projection Outside Home* (1978) hypostatizes just that kind of ideal, unproblematic image. Here, a video projection in the house's front yard shows what the family inside is watching. It's a tautology. Ultimately, the Louds appeared on the talk show circuit to discuss how the public's response to *An American Family* had affected their lives – as if this might clear the air once and for all!

More recently, the city of Copenhagen renovated its zoo's primate house. Because the work disrupted the zoo's most popular display, the director tried to compensate with a special attraction. A heterosexual couple would live inside a cage made up to look like a prototypical living room. In an interview, when a BBC reporter asked if the two could leave the cage, the director responded, 'Of course, the natural habitat of the human is broader than that of the living room.' Clearly, he was poking fun at the mandate of progressive zoo-keeping: to re-situate the specimen naturally, as if within nature. His good-natured wit concealed the more onerous issues raised by this seemingly innocent prank: museological credibility, animal rights, racism, social engineering, bio-determinism, scientific objectivity. In some sense, this was an effort to display everyday private life. The public was to be amused by the way it was portrayed – which was, of course, not as a public at all.

In 1966, Graham surveyed suburban starkness in *Homes for America*. This photo project wryly equated tract housing with serial minimalist sculpture. Carried over into housing developments, minimalist composition comes across severely, even more so than in art galleries. This effect, however, is a question of neither 'the brutality of contemporary life' nor life imitating art. Serial minimalism derives from the balloon frame, which American farmers devised to construct barns. The balloon frame allows a structure to be expanded module by module. By turning a building into an aggregation of variables, it breaks with the organicism of post-and-lintel or masonry construction. Carried over into residential housing, the balloon frame yields oft-derided 'stick houses.' Modularity defined suburban tract housing; the single-family house became a fixed unit –, i.e., one with only trivial variation – within a flexible, yet regimented, meta-system. If the module once signified opportunity and social mobility to individual homeowners, developers commandeered those prerogatives.

When Graham conceived of *Alteration…* in 1978, for most Americans suburbia still evoked upward mobility. Even when cosmopolitan life came back into vogue a few years later, the suburbs continued to grow inexorably. Today, most of the U.S. populace lives there. Although the detached house symbolizes independence and autonomy, all along heavy government subsidies have propped up both the suburbs and the transportation web (the auto and oil industries, highways) in which they are entwined. After the Second World War, the Home Owners Loan Corporation and the Federal Housing Administration offered special mortgage insurance which made it possible for more people than ever before to buy homes. Yet, by red-lining integrated and minority neighborhoods, these

[11] Kruger 1985: 13. More recently a Dutch television station initiated a program called *Big Brother*. It combines the game show with Loud-like voyeurism; a group of young people agrees to live in a hermetically sealed container under constant surveillance. Their only contact with the world outside is the programming piped in by Big Brother. From time to time, celebrities pay surprise visits to the group. With an added *Lord of the Flies*-like touch, each week the group votes to eject one member from the container. The last survivor wins a cash prize.

agencies institutionalized segregation in the guise of housing policy.[12] Not surprisingly, this policy also fueled rampant urban decay. Ten years after *Homes for America*, punk invented itself as garage band music; it was the music of suburban kids. It didn't matter how many ended up in L.A. or New York; sprawling greater Detroit always lurked in the background. With artists and bohemian types, punks inadvertently softened abandoned city neighborhoods for real estate speculators. Together, they were the avant-garde of gentrification. During the affluent 1960s, pundits optimistically prophesied an end to the old economy of scarcity. Within this projection, the figure of the artist promised to reconcile the division between work and leisure. By the mid-1970s, however, art dealers and collectors were beginning to buy and sell so-called dematerialized forms of conceptual art, much to the dismay of the artists who made them. Meanwhile, the American economy slowed to a crawl. There was no place in the gallery system for young artists just coming out of schools. They formed bands.

People naturally focus on what they can see through a window, not on themselves as viewers, not on the window itself. Caspar David Friedrich's drawing *View from the Artist's Studio (Right-Hand Window)* (1805-6) is one of the first pictures of a window with nothing remarkable lying beyond. Because this drawing redirects viewers' attention to the picture and the picture frame, some see it as a precedent for literalist painting. Depicting a mirror instead of a window, Manet's *A Bar at the Folies Bergère* (1882) similarly calls attention to its own flatness. Here, the mirror in the picture parallels the picture plane, but the reflection does not. This makes it impossible for the viewer to triangulate his or her virtual position, as T. J. Clark explains:

> The mirror must [...] be frontal and plain, and the things that appear in it be laid out in measured rhythm. And yet it is clear that some of those things will not be allowed to appear to be safely attached to the objects and persons whose likenesses they are.[13]

Clark further notes that Manet's portrayal of modern life – this glitzy bar in particular – is not very animated, familial or proletarian, "It lacks the composure of real private life, but equally the energy of a public one."[14] Bataille further observes that "a sly, underhand moral complacency weighs heavy on this picture."[15] According to Clark, the barmaid's lackluster demeanor speaks to this point:

> [...] it does not seem to me that she is animated by her alienation; she is posed and composed and confined by it; it is felt as a kind of fierceness and flawlessness with which she seals herself against her surroundings. She is *detached:* that is the best description. She looks out steadily at something or somebody, the various things which constrain and determine her, and finds that they all float by "with the same specific gravity in the constantly moving stream of money."[16]

By turning the picture window into a proscenium arch, *Alteration*... turns routine voyeurism into a painfully self-conscious encounter. The picture window offers the family a picturesque view of the world, but it also turns the family itself into a picture. Sure, it's possible to look into such a window, but is it allowed? If one cannot avoid looking, one does so inadvertently. This impulse accounts for the quirky popularity of the Japanese photo book, *Tokyo Style*, a compendium of apartment interiors. The photos themselves are nondescript. The apartment interiors, though diverse, are ordinary in every respect. They are vacant – that is, without people. That is their fascination. Knowingly unfocused and anti-sensational, the book sells better than coffee table books about cars, animals, fashion, nudes or rock stars. Because Japanese interior architecture sometimes employs paper screens as walls, its material insubstantiality calls attention to walls and windows as

E. Manet, *Bar at the Folies-Bergère*, 1881-82, oil on canvas; 37⁴/₅ x 51¹/₅ in. 96 x 130 cm. Courtauld Institute Galeries, London.

12 See Kenneth J. Jackson, 'Federal Subsidy and the Suburban Dream,' *Crabgrass Frontier: the Suburbanization of the United States* (New York: Oxford University Press, 1985): 190-218.
13 T. J. Clark, 'A Bar at the Folies Bergère,' *The Painting of Modern Life: Paris in the Art of Manet and His Followers* (Princeton: Princeton University Press, 1984): 253.
14 Clark 1984: 245.
15 Georges Bataille, 'From Doubt to the Supreme Value,' *Manet* (New York: Rizzoli International Publications, Inc., 1983): 102.
16 Clark 1984: 259.

manifest social conventions. They are less things than matters of consensus. The picture window, however, is like a wall that is barely there. Its utopian promise cuts two ways, 'No more barriers!' 'Nothing to hide!' It offers utter moral transparency. Such a utopian longing asserts itself in the *Air Curtain* (1969) Michael Asher made for the Whitney Museum's 'Anti-Illusion: Procedures and Materials' show. Here, Asher constructed an air wall to the manufacturer's specifications, but reduced the air flow so that it was barely perceptible.

The imperative for the picture window derives, in part, from still life painting. By showing the means of the patrons who had commissioned it, the still life seemingly contradicts Protestant asceticism. Ordinarily, Protestantism demands a suppression of ornament and pageantry – what Veblen called 'barbaric ostentation.' Thus, simplicity and restraint can represent both social power and a blameless life – a pernicious combination. Yet, the still life, by offering to square accounts with society, expresses the same secular spirit that wants to purge archaic rituals from everyday life. It's like an audit or an inventory. If the Catholic confessional concealed sinner's identity while absolving his guilt, Protestantism typically hides and abstracts its riches as capital. One makes a show of frugality while carrying one's past like an eternal ledger. Thus, the pride of blamelessness combines with a guilty, masochistic desire to be incessantly scrutinized. Tract housing affords a stage set for this moral charade; its regular order turns even the happenstance into something of notice:

> All the details stand out – it's a weirdly charged environment – a peculiar zone between an anonymous urban environment and the old-fashioned rural environment. In suburbia, there's a combination of display and spying that happens sort of simultaneously – voyeurism and exhibitionism.[17]

With *Present Continuous Past(s)* of 1974, Graham initiated a series of works that reflexively concern their viewers.[18] In other words, these works led onlookers to look at themselves. *Present Continuous Past(s)* featured a chamber with floor-to-ceiling mirrors on two adjacent walls. On a third wall was a recessed video camera, VCR and monitor. These comprised a closed-circuit loop with an eight-second delay, through which people could see images of themselves not only in the present, but also a few moments earlier. Graham notes:

> The mirror at right-angles to the other mirror-wall and to the monitor-wall gives a present-time view of the installation as if observed from an 'objective' vantage exterior to the viewer's subjective experience and to the mechanism which produces the piece's perceptual effect. It simply reflects (statically) present time.[19]

Vito Acconci made audience-reflexive works, too, but his approach is decidedly behavioristic. He typically manipulates his audience to prove a point. In contrast, Graham's work is open-ended. The audience need only be present. If anything, Graham tries only to make it more aware of its presence. To call this interactivity is misleading; inter-*affectivity* is more accurate.[20] Interaffectivity galvanizes the audience's self-consciousness as a collective body. It constitutes this work's affinity to the rock festival. With *Alteration to a Suburban House*, Graham casts an indeterminate public as the audience. As Michael Fried asserted, "Presentness is grace."

Guitar Army... Unknown Soldier... I'll Be Your Mirror

> The New Left sprang, a predestined pissed-off child, from Elvis' gyrating pelvis [...] Affluent culture, by producing a car and a car radio for every middle-class home, gave Elvis a base for recruiting.[21]

17 A. M. Homes, 'Children of the Cul-de-Sac,' *The New York Times Magazine* (April 9, 2000): 86.
18 Other works in this vein include installations such as *Two Viewing Rooms* (1975), *Yesterday/Today* (1975), *Public Space/Two Audiences* (1976), *Video Piece for Two Glass Office Buildings* (1976) and *Video Projection Outside Home* (1978) and performances such as *Two Consciousness Projection(s)* (1972), *Past Future Split Attention* (1972), *Performer/Audience/Mirror* (1977) and *Musical Performance and Stage-Set Utilizing Two-Way Mirror and Time-Delay* (1983).
19 Dan Graham, 'Video Installation,' *Dan Graham* 1997: 103.
20 Jörn Schaffaf suggested this idea to me in conversation.
21 Jerry Rubin, 'Do It!: Elvis Presley Killed Ike Eisenhower,' *The Sixties Papers: Documents of a Rebellious Decade*, eds. Judith Clavir Albert and Stewart Edward Albert (New York: Praeger Publishers, 1984): 439-441.

Rock is part and parcel of pop culture. It serves as its defining element and perhaps only recently has it begun to relinquish that authority. George Melly, a British critic, characterized pop as hedonistic, parasitical and motivated by material envy. Pop, as opposed to traditional popular culture, dovetails with youth culture. Being young is a state of grace. Being young is also a matter of being present, not mired in nostalgia. As Graham announced in *Rock My Religion*, pausing dramatically between phrases, "In the 1950s a new class emerges... a generation whose task is not to produce but to consume... *This*... is the teenager... . Their philosophy is fun... Their religion is rock'n roll."[22] Compared with former kinds of popular music, rock was essentially experiential, with few demands for erudition and interpretation. In its early years, adult celebrities used standards of grownup literacy to denigrate the new music. When Elvis Presley appeared on Steve Allen's variety show, Allen dressed him in a top hat and tails to sing 'Hound Dog' for an obliging basset hound.[23] TV talk show host David Susskind similarly lashed out at Phil Spector. He dryly intoned the repetitive lyrics of 'A Fine, Fine Boy' (mostly just the title) *sans* music, as if to prove their inanity. An angry Spector started tapping the rhythm on his chair and told Susskind what he was missing was the beat.[24] He then stormed off the set. Susskind rightly sensed that this beat undermined genteel culture. That's why he attacked the young producer. In Spector's case, living well was the best revenge. He became the first 'teen tycoon,' beating the adults at their own game.

Rock now has a fifty-year history. It is not one music, but many. Its contents have become so diversified that the term itself has lost specificity. Talking about rock *per se* seems senseless. Even so, Dan Graham's audience-reflexive works are keyed to a particular moment in that history, centered around the symbolic year of 1968. It begins with late San Francisco psychedelia and ends with the proto-punk of Jim Morrison, the MC5, Iggy Pop and the Velvet Underground. Just as political dissent came to head, rock dreams went through a cataclysmic inversion.

Psychedelic concerts intensified live rock's collective sense of presence and participation. LSD and light shows fed into a total sensorium which broke down the separation between audience and performer. "To be one with music was to be one with the moment," as Robert Nickas put it.[25] Now largely forgotten, George Hunter's Charlatans pioneered light shows in Virginia City, Nevada – for a community of isolated acid heads. These included mirrors, strobe lights and other special effects. Hunter drew inspiration from the Happenings movement and the music of John Cage. Rockers had long come from the ranks of art schools. Now, for the first time, they adopted avant-gardistic techniques. Meanwhile, the civil rights and antiwar struggles which polarized the nation, politicized the rock audience. These struggles raised apocalyptic fears that made time itself pregnant with anticipation. Flower Power, a style of political protest conceived by Allen Ginsberg, stressed presentness. This went beyond mere novelty; it *was* actualization. Where activists formerly construed political demonstrations as acts of self-sacrifice, Ginsberg insisted they be celebrations or festivals – gratifying in themselves. Moreover, Herbert Marcuse, guru of the New Left, supplied a theory for this new hedonism – as Graham has pointed out. Marcuse thought Freud's death drive had become anachronistic. According to him, this drive sought, not death itself, but the cessation of pain. For this, science and technology offered solutions which now made it seemingly easy to reconcile the old threat of Thanatos with Eros. Thus, Marcuse argued, sublimation had become gratuitous. He saw no need to renounce immediate pleasure for a higher purpose. He believed life could only be lived in the present.[26]

[22] Dan Graham, *Rock My Religion*, videotape.
[23] Peter Guralnick, 'Elvis is Back: March 1960-January 1961,' *Careless Love: the Unmaking of Elvis Presley* (New York: Little, Brown & Co., 1999): 61.
[24] Mark Ribowsky, *He's a Rebel* (New York: E. P. Dutton, 1989): 190.
[25] Robert Nickas, 'A Brief History of the Audience,' *Performance Anxiety* (Chicago: the Museum of Contemporary Art, 1997): 19.
[26] Dan Graham, 'McLaren's Children,' *Rock My Religion* 1993: 147.

The Summer of Love may have prompted Graham to start reflecting on what a spectator or an audience means as a literal presence. He mentions this twice in separate articles written in 1967. One was a brief note on hippie culture:

[…] a hippie newspaper advocates setting up 'shops that are called Calm Centers […] Places where people just come and sit […] It's *softness* and *hereness* […] just people being together.'[27]

Another was an account of a visit to a New Age nightclub in Lower Manhattan:

[…] I squat down on the platform, which has a small square in the middle containing several plugs, into one of which a large, round light is plugged. Rock music pours into the room and, from two projection rooms, slide images are simultaneously sprayed onto the walls. I feel suddenly out of place.
[…] Guides hand each group a toy – a *prop* – to be played with. It seems quite bland. Balloons are brought in and a couple begins to pat one about – until it bursts. Just then I become aware: I (we?) am to be the player in the drama and not merely part of the audience. The props are brought to me so that I might play myself.
[…] As more props are brought in and are related to, we relate to our own bodies and to those of our neighbors. There is no need to relate or to project onto others our experiences. Nothing is happening on stage and we are not being used by the performers; we ourselves are on stage. We are our own entertainment tonight (if 'stoned,' 'living' our fantasies) as we are here.[28]

The last comes from an article about Dean Martin as a Brechtian performer. Martin played at being 'himself' on TV, that is, he took on the exaggerated persona of a drunkard, an image not based on fact, but on public perception. He played with tautology – not self-parody, but 'self' mimicry. Whether Martin was ultimately present or absent as a performer is guesswork. Here, Graham's juxtapositions of epic theater, mummery and self-realization suggest the schismatic nature of presentness. The self is not a unified entity; subjectivity is instead an effect of language. The experience of selfhood is mutable. Moreover, as sociologist Erving Goffmann maintains, one's sense of self is performative, arising out of intersubjective discourse:

[The self] does not derive from its possessor, but from the whole scene of his action […] A correctly staged and performed scene leads the audience to impute a self to a performed character, but this imputation – this self – is a product of a scene that comes off, and is not a cause of it. The self, then, as a performed character, is not an organic thing that has a specific location […] it is a dramatic effect arising diffusely from a scene that is presented.[29]

The alienation effect, namely disrupting naturalistic identification in drama, forms the basis of Brecht's epic theater. Ordinarily, the audience looks to the 'self' the actor presents. Brecht wanted to show that such identifications are ideologically constructed and somewhat irrational. Yet alienation means madness in French. Graham's realization inside the nightclub partly arises from the way a modest apparatus, a prop, helps wrest him away from the dominant fiction of a master historical narrative.

By pillaging all sorts of exotic and historical material and mixing it together – primarily for the sake of disorientation – psychedelia intimated postmodernity. The result was a disconcertingly eclectic, if not shabby, patchwork of former styles that jettisoned linear progression. What is more important, it shifted aesthetic paradigms from the Kantian sublime to ecstatic experience. Where sublimation is ultimately patriarchal, keyed to the subject's sense of inadequacy before an awe-inspiring force, ecstasy concerns breaking down habitual identifications that produce the effect of selfhood. At rock festivals, music was the nominal draw, but the real action happened offstage. Absorbing individuals into

27 Dan Graham, 'Eisenhower and the Hippies,' *Rock My Religion* 1993: 9.
28 Dan Graham, 'Dean Martin/Entertainment as Theater,' *Rock My Religion* 1993: 64-5. This hypostatizes the club or the health spa as a locus for interactive art. Since Rodchenko, leisure, not production, has served as the site for artistic engagement More recently, this is reflected by a whole genre of interactivity that includes Xavier Veilhan, Liam Gillick, Tobias Rehberger, Jorge Pardo, Maria Eichhorn, Eva Grubinger, Andrea Zittel, Angela Bulloch and Rirkrit Tiravanija among others.
29 Erving Goffmann, *The Presentation of Self in Everyday Life* (Garden City, New York: Doubleday, 1959): 253-253, quoted in Amelia Jones, 'Postmodernism, Subjectivity, and Body Art,' *Body Art: Performing the Subject* (Minnesota: University of Minnesota Press, 1998): 44.

the fold, the crowd took on a life of its own. As such, the festival cultivated both an indifference toward outside authority and a communal vision unto itself. It also became a catalyst for counter-cultural resistance. So, John Sinclair, MC5 manager and founder of the White Panther Party, considered the counterculture to be the expression of youth as a nascent political class. He believed that building this new culture overrode knee jerk activism, namely protesting. Rock could be a political weapon. That is the meaning of 'guitar army:'

> Rock and roll music is one of the most vital revolutionary forces in the world – it blows people back to their senses and makes them feel good, like they're *alive* again in the middle of this monstrous funeral parlor of western civilization.[30]

Coming to the rock scene through a love of jazz, Sinclair considered rock an essentially live – not recorded – music. As opposed to the symphony orchestra's division of labor – which, according to Sinclair, anticipates the assembly line – psychedelic music is improvised. Because improvisation integrates the musician's subjectivity, it precludes alienation. This effect extends to the audience as well. Although Sinclair's analysis may make too much of what are simply different ways to play music, it nonetheless reflects aspirations the radical left attached to rock festivals at that time.

Not surprisingly, this utopianism soon soured. Woodstock, considered the paragon of rock festivals, was the brainchild of hip entrepreneurs, not visionaries. The enduring image from 'Woodstock,' the movie, is the mountains of waste left behind by the muddy festival-goers. This was the audience that considered itself on the right side of history – beyond guilt. The movie depicted the event as paradise, but paradise only meant averting certain disaster. What it didn't show were the rapes and bad trips that went on behind the scenes. In *Rock My Religion* Graham pronounces, "Drugs produce a foretaste of death, devaluing death."[31] This foretaste promises liberation, but death remains inevitable. Altamont was the latent potential of Woodstock. Still, even before Altamont, the counterculture had gone to seed. Ever since the Merry Pranksters courted the Bay Area Hell's Angels, the acid scene infused bliss with danger. More often than not, psychedelic experience devolved into superficial self-indulgence. Changing one's perceptions with dope obviously differs from changing the world – although many then believed otherwise. Conversely, getting high sometimes led to addiction and overdose. Making and selling LSD also opened new venues for organized crime. There were casualties. Youth proved to be not so much a class in itself, as it was a newly entitled demographic, subject to the same class divisions in adult society:

> The problem with the hippies was that there developed a hostility within the counterculture itself, between those who had, like, the equivalent of a trust fund versus those who had to live by their wits. It's true, for instance, that blacks were somewhat resentful of the hippies by the Summer of Love, 1967, because their perception was that these kids were drawing paisley swirls on their Sam Flax writing pads, burning incense, and taking acid, but those kids could get out of there any time they wanted to.
> They could go back home. They could call their mom and say, 'Get me outta here.' Whereas someone who was raised in a project on Columbia Street and was hanging out on the edge of Tompkins Square Park can't escape. Those kids don't have any place to go. They can't go back to Great Neck, they can't go back to Connecticut. They can't go back to boarding school in Baltimore. They're trapped.
> So there developed another kind, more of a lumpen hippie, who really came from an abused childhood – from parents that hated them, from parents that threw them out. Maybe they

[30] John Sinclair, 'Rock and Roll is a Weapon of Cultural Revolution,' *Guitar Army: Street Writings/Prison Writings* (New York: Douglas Book Corp., 1992): 113.
[31] Dan Graham, *Rock My Religion*, videotape.

The MC5

came from a religious family that would call them sluts or say 'You had an abortion, get out of here' or 'I found birth control pills in your purse, get out of here, go away.' And these kids fermented into a kind of hostile street person. Punk types.[32]

Moreover, the lumpen hippies, the ones Sinclair wanted to mobilize, lacked the political will of their African-American counterparts: the Black Panthers. With their berets and black turtlenecks and titles like Minister of Information – or Defense – the Panthers played on the threat of becoming an operational guerilla army. First the media, then, more malevolently, the FBI's COINTELPRO, took their posturing at face value. For COINTELPRO, it served as a pretext to wipe them out. The White Panthers were a fantasy of a fantasy. Sure, the MC5 were into guns – just like they were into muscle cars. Wayne Kramer recounts:

> [...] our political program became dope, rock & roll, and fucking in the streets. That was our original three-point political program which later got expanded to our ten-point program when we started to pretend we were serious. Then we started the White Panther Party, which was originally the MC5's fan club. Originally it was called 'The MC5's Social and Athletic Club.' [...] The official party line from the Black Panther Party in Oakland was that we were 'psychedelic clowns.' They said we were idiots and to keep the fuck away from us.[33]

Then came the Festival of Life debacle. This was an antiwar event the Yippies staged during the 1968 Democratic National Convention in Chicago. The MC5 saw it as their big chance for a breakthrough, but discovered, after rumors of impending violence, that they were the only band on the program to show. Barely escaping the police riot in Lincoln Park, the band later took calls for 'solidarity' with a grain of salt. Sinclair himself ultimately renounced the platform he had become known for:

> [...]we had all these goofy ideological ideas like 'youth is a class.' That was one of my timeless contributions to the dialog – which, of course, is full of shit. But, at the time, we thought we were a mutant race that had broken with the past. And there would be this whole new thing and that all youth after would be like us. We were wrong, you know. (laughter) All of our actions were predicated on that fact that it was inevitable we were going to win. What a concept![34]

New Left liberation struggles, however, inflected the category of youth with race, class and gender consciousness. The pragmatic transformation of everyday life steadily overtook the goal of national revolution; popular dissent turned to more subcultural modes of resistance. As the music industry steadily turned rock into business as usual, certain musicians sought more nuanced and challenging ways to engage their audience, turning the stage itself into "a theatricalized and politicized site."[35] When Jim Morrison played at the University of Michigan, he taunted the mostly jock concert-goers by singing 'Light My Fire' in a falsetto, Betty Boop voice. Only after the Doors launched into 'Love Me Two Times,' did the jocks stop booing, but Morrison came back again with Betty Boop. The jocks rioted. The concert lasted only fifteen minutes, but none of it was lost on Iggy Pop who would later torture his own audience with interminable repetitions of 'Louie Louie.'[36] Morrison had grown bored with cranking out hits. Inspired by Antonin Artaud, he turned his concerts into experimental theater. He dove offstage into the audience, which became a punk trope. During a 1969 Miami concert he caused a scandal by allegedly showing his penis to the audience. In *Rock My Religion*, Dan Graham says this action toppled Morrison's phallic rock star status – and, by extension, the concert as spectacle:

> By 'exposing himself' on stage [...] Morrison wanted to expose the audience's corrupt desires. In this ritual, intended to question the mystique of rock as spectacle, Morrison chose to reenact the castration complex [...] His gesture of showing 'it' destroyed his former aura of phallic mystery; the phallus had become – Morrison had become – pathetically physical.[37]

[32] Ed Sanders quoted in 'Prologue: All Tomorrow's Parties: 1965-1968,' *Please Kill Me: the Uncensored Oral History of Punk*, ed. Legs McNeil and Gillian McCain (New York: Penguin Putnam, Inc., 1997): 21-22.
[33] Wayne Kramer quoted in 'I Wanna Be Your Dog: 1967-1971: The Music We've Been Waiting to Hear,' McNeil, McCain 1997: 46-49.
[34] John Sinclair, interviewed by Frank Lutz and the author.
[35] Robert Nickas 1997: 19.
[36] McNeil, McCain 1997: 38-40.
[37] *Rock My Religion*, 1993: 93.

The resulting scandal, however, was a spectacle, too. For groupies, the most rabid type of fan, the rock spectacle always boils down to the star's penis. Acting out in another way, Morrison became more pathetically physical a year later when he started to put on weight and his face got puffy. What he wanted in Miami is unclear. The night before, he had seen the Living Theater performance of 'Paradise Now' at U.C.L.A.[38] The play was an exercise in antagonism, famous for the final scene in which the cast removes all its clothing and runs naked through the streets. The reports about whether he ever did expose himself are conflicting.[39] He may have been too drunk to do it. Arrested for *maybe* doing it, he considered the whole affair an embarrassment. When asked about his own theatrical gestures, Morrison downplayed them, "It's all done tongue in cheek. It's not to be taken seriously. It's like if you play the villain in a western; it doesn't mean it's you."[40] Coming at the outset of his nervous breakdown, clearly more was at stake than what the Lizard King was ready to admit. Even so, his reluctance to merely entertain shifted the onus of performing onto the audience.

Before he became Iggy Pop, Jim Osterberg was an asthmatic, record shop clerk. His band, The Stooges, started out as the MC5's 'baby brother' band, but went off in a totally different direction. While The Stooges played psychedelic drones, Iggy would throw himself around the stage until he bled, vomit on his audience, and drag girls around by their hair: "My theory of entertainment has always been the less the better [...]"[41] Sinclair likened it to *Waiting for Godot* meets ballet. Iggy upped the ante for what it meant to appear on stage – both its artifice and its reality. He made himself stand out. He shaved his eyebrows, dyed his hair, and smeared peanut butter or paint or oil and glitter all over his body. He wore just underpants or tutus and Danskins. As a joke, he once exposed himself as an encore. He didn't believe in encores; he was more involved with scrambling gender codes. Favoring the circus over mystical revelation, he ditched Doors-style shamanism for direct assault:

> [...] I was scared, actually nervous, but so exhilarated, and so involved in the sound of this band and this unbelievable guy Iggy – this wiry little thing – who could cause more damage than all the tough guys I knew in my neighborhood.
> Other guys would punch you in the mouth, that would heal, but Iggy was wounding me psychically, forever [...]
> [...] every time I saw that band [...] there was never a yesterday, there was never a set they'd played before, there was never a set they were ever gonna play again. Iggy put life and limb into every show.[42]

Partly it boiled down to being a junkie; Iggy could just as easily be vomiting behind an amplifier stack as out into the crowd. What he wanted was excess, which was unpredictable. Sometimes he was too stoned to move:

> I hitchhiked to Atlanta to see The Stooges, and before the show, I watched them do handfuls of angel dust. It must have been one of their last shows, and the weirdest thing that happened was that Elton John had flown into Atlanta because he was trying to sign Iggy or something. Elton had dressed up in a gorilla costume, and he jumped onstage and picked up Iggy, picked him up from the top of his head.
> Iggy was so fucked-up on dust he had no idea what was happening to him. Iggy was really shrinking in terror like he didn't know that it wasn't a real gorilla.[43]

The next morning Iggy awoke, unable to even speak, in a clump of bushes behind a Day's Inn. His provocations, however, could sometimes turn into a strange rapport. That's what happened in a 1970 performance at Crosley Field in Cincinnati. There, he walked off

[38] Dylan Jones, *Jim Morrison: Dark Star* (New York: Viking Studio Books, 1990): 134-135.
[39] Jones 1990: 137-8.
[40] Jim Morrison, in Jones 1990: 108.
[41] Iggy Pop, 'Drugged in the City,' *I Need More* (Los Angeles: 2.13.61 Publications, Inc., n.d.): 86.
[42] Scott Kempner, quoted by McNeil, McCain 1997: 66.
[43] Jim Marshall, quoted by McNeil, McCain 1997: 219.

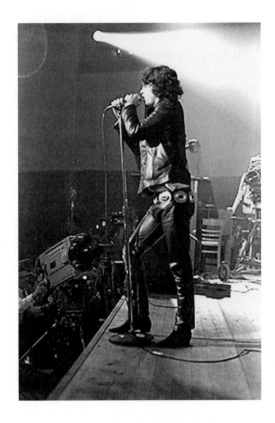

Jim Morrison in
performance.

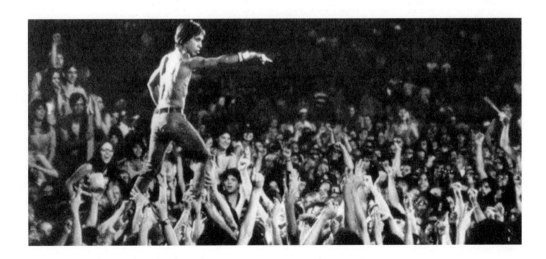

Iggy Pop at Crosley Field, in
Cincinnatti, Ohio, 1970

the edge of the stage and the audience buoyed him up with their hands. NBC broadcast this as 'A Midsummer Night's Rock,' startling viewers with footage that oddly resembled the miracle of Christ walking on water.[44] For the Velvet Underground, hippies personified hypocrisy. So, instead of LSD, they took methedrine. Instead of cosmic consciousness, they embraced S & M. Instead of bell bottoms and headbands, they wore black leather. When they toured California, The Doors were the only thing they liked about it.[45] When Andy Warhol started managing The Velvets, he promoted them with a multimedia show: Andy Warhol's 'Exploding Plastic Inevitable.' Under this aegis, the psychedelic concert mutated into psychodrama. Having already worked with La Monte Young, John Cale joined the band with one foot in minimalist music. (Cale also produced Iggy's first album, *The Stooges*.) Young's compositions sometimes extended a single note for hours. Through sensory deprivation, the listener's perception shifted over time. One heard over-tones not actually played. These compositions became not so much about what was 'in' the music as they were about the experience of it. Cale brought this approach to bear on the Velvets. Most of the songs were extended drones. The band members hardly moved while playing, and they often played with their backs to the audience. The 'dry' part of the light shows (as opposed to the liquid, 'lava' effects) included double-projected Warhol films. Mary Woronov, Gerard Malanga and Ronnie Cutrone added pantomimes to the mix, first for 'Venus in Furs,' then for other songs. Narcissism – not showmanship – governed their tableaux, though it sometimes led to shining flashlights into the eyes of the onlook-ers and snapping whips in their faces. *Vinyl* captured the 'Exploding Plastic Inevitable':

> Seeing *(Vinyl)* [...] made me realize [...] how deeply the then admired theories attacking the 'ego' as the root of all evil [...] had become for the avant-garde the grounds for a deeply engaged metaphor of sexual sadism [...] for 'blowing the mind,' assaulting the senses; it came home to me how the 'obliteration' of the ego was not the act of liberation it was advertised to be, but an act of compulsive revenge and resentment wholly entangled [...] with the knots of frustration. The fabled expansion was a contradiction; the senses did not explode into liberty but imploded into withdrawal.[46]

Morrison, Iggy and the Velvets all turned the tables on the audience. They felt no obli-gation to provide the unadulterated pleasure which, in opposite ways, had been the mis-sion of both pop and psychedelia. Now pleasure came at a price and everyone was cul-pable. The musicians' diffidence was ultimately passive-aggressive – akin to that of the New Novel or minimal sculpture.[47] Alain Robbe-Grillet, for example, strove to purge his writing of metaphors. These, he argued, are intrinsically anthropomorphic; as such, they only confirm the reader's romantic self-image. With 'writing degree zero,' Robbe-Grillet instead tried to force a confrontation with the reader. Although minimal sculpture antici-pated the viewer, it too was decidedly anti-anthropomorphic. It radiated aloofness. Deny-ing the plenitude of 'content,' minimal objects simply deflected the gaze. This deflection ostensibly made viewers more aware of their corporeal presence. All these forms of music, writing and sculpture try to throw their audience back on itself, leaving it to con-tend with the nature of its repression. The salient difference between them is the compo-sition of the audience: individualized for writing and sculpture, collective for rock. Accord-ingly, Graham believes that music can still express a transcendent emotion, now denied by art and literature. Even so, they all partly derive from Artaud's Theater of Cruelty:

> A real stage play upsets our sensual tranquillity, releases our repressed subconscious, drives us to a kind of potential rebellion (since it retains its full value only if it remains potential), call-ing for a difficult heroic attitude on the part of the assembled groups [...]

Poster for The Exploding Plastic Inevitable

[44] Iggy Pop with Anne Wehrer, *I Need More: The Stooges and Other Stories* (Princeton: Karz-Cohl Pub-lishing, Inc., 1982): 69-73.
[45] Evidently, the feeling was mutual. Nico ended up going to bed with Mor-rison and Morrison ended up copying Gerard Malan-ga's leather pants. Nico had a fling with Iggy as well.
[46] Stephen Koch, 'The Talkies,' *Stargazer* (Lon-don: Calder and Boyars, 1973): 72.
[47] One New Wave band, the Erasers, later took its name from Robbe-Grillet's *Les Gommes*.

If fundamental theatre is like the plague, this is not because it is contagious, but because like the plague it is a revelation, urging forward the exteriorisation of a latent undercurrent of cruelty through which all the perversity of which the mind is capable, whether in a person or a nation, becomes localised [...][48]

In his videotape *Rock My Religion*, Dan Graham equates punk (mainly Patti Smith, 'rock's Mary Magdalene') with the ascetic or ecstatic religious practices of the Shakers or Pentecostal groups. For him, punk is secularized religion. Just as theology prefigures socialism, so the Shakers and punks invoked premonitions of utopia and counter-memories of the past. Later, Greil Marcus proposed a kindred 'secret history' in *Lipstick Traces*; a constellation that brought together Anti-Baptists, Dada, Situationism, serial killers, nihilism with British punk. Graham's 'secret history,' however, is more playful and less cultish than Marcus's. Graham doesn't even call his 'secret.' He doesn't try to make it real history. It's more like a rough montage. Yet, it has room for both ecstatics speaking in tongues and preteens somersaulting down a grassy hill. It has no room for bloodbaths. Graham chooses play to break with historiography's inertia, "Rock's creed is fun. Fun forms the basis of its apocalyptic protest."[49] Rarely in the tape do sound and image synch up. The notable exception is a long tracking shot down a suburban street. The hypnotic rows of houses recall Jean-Luc Godard's traffic jam in *Weekend* – tracking down an endless line of cars.[50] For Graham, Glenn Branca composed the ethereal 'Theme for a Suburban Drive.' Together, sound and image create a woozy, disorienting vision. The suburbs are the architectural equivalent of a traffic jam. With both, the point is that monotony produces a longing for rupture. The street becomes a hallucination. The camera moves and everything around is static, passing in and out of view, in and out of existence. Walter Benjamin's messianic history is the philosophical model to which both Graham's and Marcus' accounts are indebted. Marcus, however, believed negation to be an implicitly complete act that exposes "the possibility that the world may be nothing, that nihilism as well as creation may occupy the suddenly cleared ground."[51] For Benjamin, however, the world is not nihilistic and time is never empty:

History is the subject of a structure whose site is not homogeneous, empty time, but time filled with the presence of the now *[Jetztzeit]*.[52]

Living Theater

The ponderous illusions of solidity, the non-existence of things, is what the artist takes for 'materials.'[53]

The suburbs are the spatial equivalent of empty time:

John Sinclair: The main thing wrong with our world, at least since World War II, is that it's a world made by developers. Nobody ever talks about the developers.

John Miller: Good point. Everybody's fixated on architects.

JS: The developers hire architects to 'give it that look.' It's the developers who shaped the character of modern life; they invented the suburbs. The culture of the suburbs is based on greed: selling the cheapest housing for the highest profit. The roots of these guys are the gangsters who invented Las Vegas. That's the ultimate development, wouldn't you say?

Frank Lutz: Los Angeles.

JS: Las Vegas.

FL: And Los Angeles, too. In *City of Quartz* Mike Davis talks about how developers sold

[48] Antonin Artaud, 'Theatre and the Plague,' *The Theatre and Its Double* (London: Calder Publications, 1999): 19-21.
[49] Dan Graham, *Rock My Religion*, videotape.
[50] Originally, tracking shots required actually laying tracks for the camera. To shoot a traffic jam is ironic, at least from an American standpoint. In the U.S., freeways meant the death of the railroad.
[51] Greil Marcus, 'Prologue,' *Lipstick Traces: a Secret History of the Twentieth Century* (Cambridge: Harvard University Press, 1989): 9.
[52] Walter Benjamin, 'Theses on the Philosophy of History,' *Illuminations: Essays and Reflections* (New York: Schocken Books, 1969): 261.
[53] Robert Smithson, 'Incidents of Mirror-Travel in the Yucatan,' *The Writings of Robert Smithson*, ed. Nancy Holt (New York: New York University Press, 1979): 103.

Suburbs

the idea of Los Angeles as a metropolis to middle-American school teachers from Iowa. It was still provincial but the developers put up row after row of houses.

JS: The purpose of the suburbs is to reduce people by putting them into these environments. That's the model. The environments are created to make people who are easily manipulated, happy just to have a job and willing to drive fifty miles a day at five miles per hour just to get to work. You know, the suburbs of Detroit are organized along increments of salary. If you make $ 25,000, you can live in these three suburbs; if you make $ 30,000, you can live in the next three… and so on.

JM: I grew up near a high-class development called Pepperwood Estates. We used to like to drive through there because it was such a joke. People built *moats with drawbridges* around their houses.

JS: If it had been in our area, they would have called it Peckerwood Estates.[54]

The suburban housing tract is the profane realization of the universalized, Bauhaus design grid. Each unit is interchangeable with every other. For the developer, parking space is the ultimate expression of civilization, individuality and time – and time equals convenience.[55] The developer is the engine of change.

Minimal sculpture divides into two types. One is serial sculpture, composed of uniform components. It suggests the assembly line and mass production. The other type is monolithic, roughly corresponding to the scale of a human body. Its hard, reflective surface and its indivisibility are ostensibly non-anthropomorphic. Even so, it invokes an uncanny human presence.

In *Art and Objecthood*, a polemic against minimal sculpture – or literalist art –, Michael Fried identified presence as minimalism's distinctive trait. Here, he concerned himself chiefly with monolithic works.[56] Operating within a given architectural shell, these works, said Fried, create a situation that includes the beholder. By constantly comparing one's size with that of the displayed object, the viewer becomes more aware of his or her own body. These comparisons underscore the object's nonrelational, unitary character that, in turn, distance or alienate the beholder both viscerally and psychically.

> […] Someone has merely to enter the room in which a literalist work has been placed to *become* the beholder, that audience of one – almost as though the work in question has been *waiting for* him. And inasmuch as literalist work *depends on* the beholder, is *incomplete* without him, it *has* been waiting for him.[57]

Theatricality, according to Fried, drastically changed the way viewers looked at artworks. For him, Brecht and Artaud are exemplars of this condition. Both playwrights broke with the identitarian logic of naturalistic drama. A Greenbergian modernist, Fried abhorred theatricality because it represented 'the space between the arts.' Conversely, the theatrical condition can be understood as fundamentally architectonic: "The traditional relationship between performer and audience, whether in the worlds of art or entertainment, is architecturally and psychologically defined by the stage."[58] Although Fried blames minimalism for dragging Epic Theater and the Theater of Cruelty into exhibition spaces, the possibility for *staging* artwork as an encounter coincides with modernism's outset. This staging impulse forcefully asserted itself, for example, in Viennese Secessionist *Raumkunst* and the Secession museum. In its interior, the Secession served as a stripped-down container, a white cube in which ensembles of art and decor could be changed according to the exhibition schedule:

> With respect to the practicalities and technicalities of exhibiting, as well, there is a rejection of (art) history; in a space [the Secession museum] that for its period is highly modern,

54 John Sinclair, interviewed by Frank Lutz and the author.
55 Joel Garreau, 'Detroit,' *Edge City: Life on the New Frontier* (New York: Anchor Books, 1999): 111.
56 The serial forms of minimalist sculpture derive from the grid, which eliminates figuration altogether.
57 Michael Fried, 'Art and Objecthood,' *Minimal Art: a Critical Anthology*, ed. Gregory Battcock (New York: E.P. Dutton & Co., 1968): 140.
58 Nickas 1997: 19.

functional, and in a certain sense radically empty, art can be presented and contextualized anew, over and over again [...] not as a place of certain knowledge and a stable relation to existing reality, but one where knowledge and the modes of representation are continually being 'staged,' constructed,' and 'inverted' anew by the viewer, curator, designer, architect, etc.[59]

Modernist critical practice accordingly called for the formulation of art as a quasi-autonomous institution, not as the distillation of the genres of art-making (which Clement Greenberg called mediums). Conceptual art questioned the way art's institutional status promised such autonomy. Minimal sculpture initiated that line of inquiry.

Graham's installation and performance work leading up to *Alteration to a Suburban House* was a series of laboratory experiments conducted on the audience. These correspond to the monolithic form of minimal art. One is the aforementioned *Present Continuous Past(s)*. Another is *Performer/Audience/Mirror* (1977). It began with the performer (Graham) facing the audience. Behind him was a panoramic mirror. The performance broke down into four stages: 1) The performer facing the audience, describing his own appearance and behavior. 2) The performer facing the audience, describing its appearance and behavior. 3) The performer facing the mirror, describing his own appearance and behavior. 4) The performer facing the mirror, describing the appearance and behavior of the audience. In both works Graham makes the viewer feel more present *and* more alienated by replacing the ostensible minimalist object with technical viewing apparatuses: mirrors, videos. Only a reiteration of the act of viewing remains. The viewer becomes an object. So alienated, the viewer tastes madness. A mirror reflection seemingly confirms the viewer's literal presence. Yet, the mirror also hollows out an absence. Specular projection makes the viewer feel like a ghost. Jacques Lacan's mirror stage postulates that the mirror instrumentalizes the recognition of a coherent, autonomous self. In other words, the mirror interpellates the beholder as a human subject. This recognition is a misrecognition. It represses the fragmentation and lack undergirding human identity.

By alienating the beholder, who vaguely experiences a psychic vertigo, Graham's mirrors do the opposite of regular mirrors. The mirrors in department stores and shopping malls do the same thing. These create a phantasmagoria where shoppers' identities slip away and multiply uncontrollably. The shoppers romantically identify with the panoply of things around them; they want to buy them. The mirror has the advantage of seeming to present things just as they are; it implies sheer presence. This immanence obscures the mirror's aggression. There is the Chinese parable of the emperor who arranged a competition for his two foremost artists to create the greatest artwork in the land. The first labored for years, painting the most ambitious mural ever. The second simply installed a mirror opposite the mural. After the unveiling, he was the natural winner. In Graham's theatricalized space, viewers become performers. The production of selfhood is extravagant, excessive. They become the authors of their own actions, but the mirror denaturalizes that causality. Objectified, they experience themselves as commodities, or more precisely, commodity fetishes. Commodities, by repressing the labor power that made them, present themselves as autonomous entities. Likewise, the viewer's struggle to reconstitute her or his lost sense of autonomy culminates in more harrowing re-objectification.

Homes for America treated tract housing as serial minimalist sculpture. It examined Cape Coral, a Florida development. Cape Coral's master plan combined eight types of homes with a choice of eight exterior colors. Graham sequenced the logical permuta-

59 Gottfried Fliedl, 'The Secession as a Sacred Center,' *Secession: Permanence of an Idea* (Ostfildern-Ruit, Germany: Verlag Gard Hatje, 1997): 68.

Robert Smithson, *Partially Burried Woodshed*, January 1970. Kent, Ohio, USA.

tions: AABBCCDD, AABBDDCC, etc. The houses themselves were lightly constructed shells, useless outside what he called their 'here-and-now context.' Cape Coral exemplifies the kind of plan popularized by the best known of all suburban developers, William J. Levitt. Levitt got his start in 1941 when his father's company received a government contract to build war workers' housing in Norfolk, Virginia. There, he learned to pour concrete foundations quickly and to assemble structures from prefabricated parts. After the war, came a housing crisis. Some soldiers had no home to return to. In 1946, Levitt built Island Trees near Hempstead, Long Island, at first reserving these houses exclusively for veterans – except blacks. Segregation still ruled America. Levitt wrote off his part in this as mere pragmatism, 'We can solve a housing problem, or we can try to solve a racial problem. But we cannot combine the two.' In fact, he controlled every aspect of Island Trees: 'We planned every foot of it – every store, filling station, school, house, apartment, church, color, tree and shrub.' He renamed it Levittown shortly after it was finished – the first in a series of Levittowns planted across the eastern seaboard. His genius was to apply Fordist assembly-line techniques to housing. Mass-produced, everything had to be standardized. Levitt was not the first to try it, but he was the one who did it best, making it cheaper to buy a house than to rent one.[60] Ironically, in these cookie-cutter neighborhoods, street names are where the displaced fantasies came home to roost:

> [...] what was with all those prissy 'boulevards' and 'drives,' all those 'ways' and 'terraces' and for cul-de-sacs, 'courts?' Understand that in the suburbs a developer will go to heroic lengths not to call a street a street. Street says city, and city is precisely the last thing you want to say.[61]

For Graham, suburbia sprawls aimlessly, that is until 'it is abruptly terminated by pre-existing highways, bowling alleys, shopping plazas, carhops, discount houses, lumberyards or factories.' Moreover, "[d]esigned to fill in 'dead' land areas, the houses needn't adapt to or attempt to withstand nature. There is no organic unity connecting the land site and the home. Both are without roots – separate parts in a larger, predetermined, synthetic order."[62] In 1970 Robert Smithson argued that the landscape is coextensive with gallery space.[63] Graham accordingly saw the suburban housing development coextensive with the architecture of the exhibition space. This is the premise of *Alteration...* The artifice of the development made houses seem autonomous in much the same way that the modernist exhibition space did individual artworks. Using a ranch house for an installation/performance, Graham could deepen the schism between viewers' discontinuous subjectivities and their more predictable roles. He proposed a space within a space: the altered house inside the 'shell' of the development. The mirror inside the house, by reflecting houses across the street, reiterated the relational logic of the development as a whole. Yet, this metonymy is paradoxical. The part stands for a whole that is intrinsically undetermined: an Anti-Gestalt. In formal terms, Graham plays minimal sculpture's monolithic and serial logics off each other. Even if the work awaits the viewer, the viewer is incidental. The viewer need only to be a passerby, not necessarily someone seeking the work.

Alteration to a Suburban House is not site-specific. It is a non-site work. The suburban grid, like the modernist grid, annihilates the foregoing locale:

> [...] the grid is the means of crowding out the dimensions of the real and replacing them with the lateral spread of a single surface. In the overall regularity of its organization, it is the result not of imitation, but of aesthetic decree. Insofar as its order is that of pure relationship, the grid is

60 Jackson 1985: 234-8.
61 Michael Pollan, 'The Triumph of Burbopolis,' *The New York Times Magazine* (April 9, 2000): 52.
62 Dan Graham, 'Homes for America,' *Rock My Religion* 1993: 16-21.
63 Robert Smithson, quoted from 'Discussions with Heizer, Oppenheim, Smithson,' *Avalanche*, No. 1 (Fall 1970): 62. Quoted by Dan Graham in 'Gordon Matta-Clark,' *Rock My Religion* 1993: 194.

a way of abrogating the claims of natural objects to have an order particular to themselves; the relationships in the aesthetic field are shown by the grid to be in a world apart and, with respect to natural objects, to be both prior and final.[64]

Even the style of the houses is uprooted from various regions and redeployed indiscriminately: ranch, Cape Cod, colonial, Mediterranean... Of course, Graham never built *Alteration...*, but its non-site character offers one more reason not to. Smithson's *Partially Buried Woodshed* (1970), as an inadvertent anti-monument, foreshadows not only the tragic character of that piece but also the Kent State massacre. It was Kent State University that commissioned Smithson's work. Smithson simply piled dirt on a woodshed until its roof collapsed. Its staged breakdown shows how, ultimately, buildings become base matter. As an artificial ruin, the woodshed allegorized architecture's transience. On May 4, 1970, shortly after Smithson completed the shed, Ohio National Guardsmen shot and killed four student, antiwar demonstrators on the school's campus. People subsequently considered the work a makeshift memorial to the massacre. The school administration long considered it a thorn in its side and, years later, replaced it with a parking lot.

Alteration to a Suburban House is a memorial to nothing. If it ever existed, it would exist only in the here and now, not yesterday, not tomorrow. Where the woodshed became a de facto memorial, *Alteration...*, by pretending everything's O.K., only tempts fate. The suburban house evinces no sense of decay or ruin. It is timeless. That, at least, is the way it's meant to look. Via construction – not decay, Smithson saw the suburbs as ruins:

> That zero panorama [Rutherford, New Jersey, seen from Passaic] seemed to contain *ruins in reverse* – that is, all the new construction that would eventually be built. This is the opposite of the 'romantic ruin' because the buildings don't *fall* into ruin *after* they are built but rather *rise* into ruin before they are built. This anti-romantic *mise-en-scene* suggests the discredited idea of *time* and many other 'out of date' things. Oh, maybe there are a few statues, a legend, and a couple of curios, but no past – just what passes for a future.[65]

Calculability governs the material form of suburban housing. Architects and developers have come to think in terms of a house's 'life span.' Instead of using 'permanent' materials and techniques, they use those rated for a standard duration. These minimum standards cut costs and yield greater profits. American homeowners, for their part, want mobility. They move, on average, once every six years. Consequently, they need 'disposable,' standardized houses that are easy to resell. Albert Speer conceived of the Third Reich's architecture with an eye toward how it would look in ruins. Thus, destruction anticipated its very conception. Speer wanted to look back on ruins of the future three-thousand-year Reich as one would those of ancient Rome or Athens. He too thought about life span, only on a more grandiose scale. Suburban developers don't mean to make monuments. The suburbs could disappear without a trace and, because of their expendability, no one would know the difference. That matter-of-factness devalues time. In contrast, Jeff Wall uncovers a macabre historical allusion in Philip Johnson's Glass House, a key referent in *Alteration...* Johnson wanted the structure to be as transparent as possible; the brick hearth and chimney are its only opaque elements. Wall says a picture of an incinerated village, where only chimneys were left standing, inspired the Glass House.[66] This, no doubt, was the aftermath of a Nazi blitzkrieg. Developers have come to refer to 'master planned' communities with no intended irony. Glenn Branca later teased Graham about his love for suburbia:

> **GB:** This is where you grew up. We cannot avoid the fact that there was a personal attraction to these tract houses, there is something deep there in this child's mind that interested him and then he found a way to incorporate that into...

[64] Rosalind E. Krauss, 'Grids,' *The Originality of the Avant-Garde and Other Modernist Myths* (Cambridge, Mass.: MIT Press, 1988): 9-10. Levittown, however, was not a pure grid; it was laid out with an artful system of curvilinear streets.

[65] Robert Smithson, 'A Tour of the Monuments of Passaic, New Jersey,' *The Writings of Robert Smithson* 1979: 54-55.

[66] Jeff Wall, 'Dan Graham's Kammerspiel (Toronto: Art Metropole)' 38. Furthermore, the glass house is an architectural folly in the guise of modernist reductivism. Its moral transparency is buffered by the rolling sylvan estate on which it is erected. Just as The Doors, Iggy and the Velvets retrieved rock from an idyllic pastoral setting, so Graham takes the glass house back to the suburbs. Bob Nickas notes that for its first and only New York City concert, Public Image, LTD. played behind a screen, exaggerating the stage's symbolic separation. This caused the audience to riot after fifteen minutes. More recently, during Fashion Week in New York, Fischerspooner performed in a plexiglass cube. The performance included not only a musical segment, but also the elaborate make-up and costume sessions preceding it. Clearly both these events extend the discourse running from Johnson to Graham.

DG: That your father was in the military – does that have anything to do with the army idea?[67]

Since *Detumescence* (1966), Graham has pursued alternate historical narratives. This means dredging up ordinarily repressed material, presumably because it matters. In *Detumescence*, he advertised for a qualified medical writer to describe the loss of a penile erection after orgasm, and the subjective changes that accompany it. Only one writer responded. Graham rewrote parts of his text, to detail the corporeal and psychic contraction that follows sexual climax:

> [...] The body slackens its tension. There is a loosening of physical tautness, and a simultane- ous sense of release and relaxation. Sensations of orgasm or desire are extinguished; emo- tions recede; and ego is again bounded [...][68]

Graham claims that, before, no such description ever existed in medical literature and concludes that, "It may be culturally suppressed – a structural 'hole' in the psycho-sexual- social conditioning of behavior."[69] A climax, either in drama or in sexual intercourse, con- ventionally represents the moment of self-realization. Graham asks what happens after that. He militates against the consummation of selfhood, empirical identity. It is identitarian- ism that drives the logic of fashion, whose promise of eternal newness operates through taste. 'That shirt is really you'– the gaily tricked-out corpse. Identity comes to mean 'identi- cal.' The political economy constructs the identities it needs through the libidinal pull of consumption. Every commodity carries a utopian promise that is, at least in part, real. This utopianism feeds the myth of progress. After the Surrealists, Walter Benjamin argued that the most powerful historical material could be found in the just out of fashion, in goods that had forfeited the promise of the new, in products languishing in the dusty windows of pre- historic arcades. Paradoxically, newness, according to Benjamin, occludes presence:

> The dreaming collective knows no history. Events pass before it as always identical and always new. [...] that which is newest the face of the world never alters, that the newest remains, in every respect, the same. – This constitutes the eternity of hell. To determine the totality of traits by which the 'modern' is defined would be to represent hell.[70]

The way Graham frames his messianic narrative, the day of reckoning never comes. Instead, he seeks momentary liberation in the fissures of everyday life. Accordingly, noth- ing – rock and youth culture included – can guarantee freedom. Teenagers once rebelled against suburban stultification. Stultification means convenience and convenience means not having to think or have an experience. Yet, the Woodstock generation grew up and took its rightful place in corporate America, mortgaging its music's liberating prom- ise. If developers once razed the landscape like the glaciers of Smithson's reveries, the developments themselves have become picturesque – stereotypical, yet complex and contradictory images. Classic rock has, conversely, supplanted the advertising jingle. It's a perfect fit; buy me and be free. Now, even the pigs're groovin'. New pop is less idealis- tic and less self-righteous, not yet ready to be used to sell cars and sports drinks, but maybe ready to sell specialty jeans and sneakers. It's all demographics. But the story doesn't end there. In *Wild in the Streets*, the ten-year-olds rise up against the twenty- four-year-olds, because the new twenty-four-year-old President, Neil Sky, killed his son's friend's crayfish. This suggests an infinite regress. What's next, Wild in the Womb? Re- enchantment of the world is always possible, best in the guise of farce – a farce more grave than historiography. Graham has started promoting his 'second childhood.' In announcement cards for recent exhibitions, he appears dressed in khaki shorts, bending over to sniff a flower or peering out at the horizon in wide-eyed wonder.

[67] Glenn Branca, 'Glenn Branca and Dan Graham in Conversation,' *BE Magazin*, No. 4 (Summer 1996): 116.
[68] *Rock My Religion* 1993: 55.
[69] *Rock My Religion* 1993: 53.
[70] Walter Benjmain, 'Paint- ing, Jugendstil, Novelty,' *The Arcades Project*, trans. Howard Eiland and Kevin McLaughlin (Cambridge: The Belknap Press, 1999): 545-6.

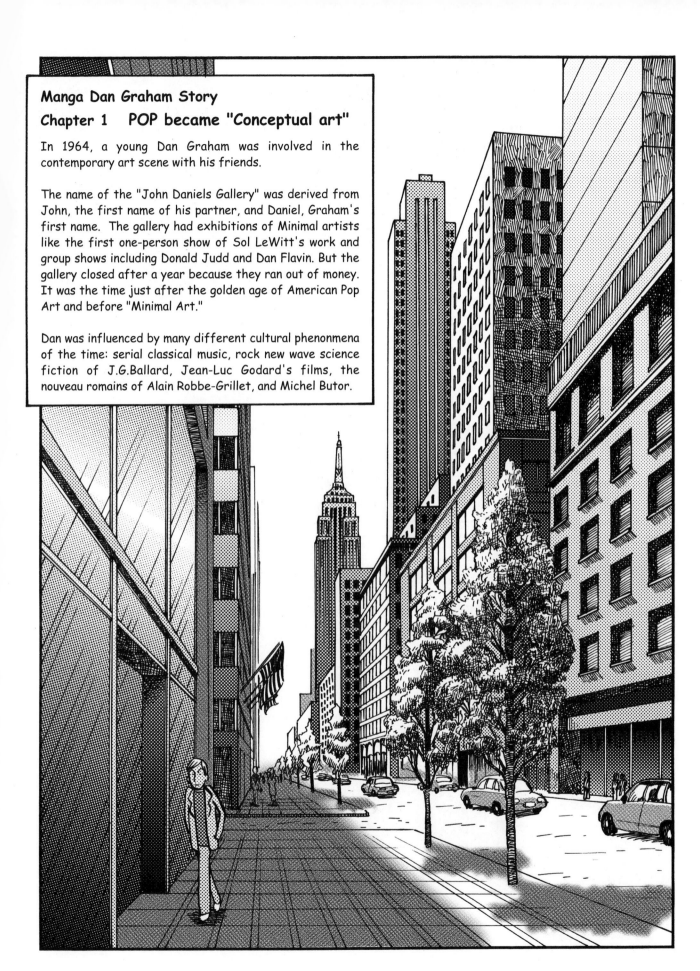

Manga Dan Graham Story

Chapter 1 POP became "Conceptual art"

In 1964, a young Dan Graham was involved in the contemporary art scene with his friends.

The name of the "John Daniels Gallery" was derived from John, the first name of his partner, and Daniel, Graham's first name. The gallery had exhibitions of Minimal artists like the first one-person show of Sol LeWitt's work and group shows including Donald Judd and Dan Flavin. But the gallery closed after a year because they ran out of money. It was the time just after the golden age of American Pop Art and before "Minimal Art."

Dan was influenced by many different cultural phenonmena of the time: serial classical music, rock new wave science fiction of J.G.Ballard, Jean-Luc Godard's films, the nouveau romains of Alain Robbe-Grillet, and Michel Butor.

Our gallery has collapsed.

Flavin's pieces undermine the way

the white cube of the gallery supports art works,

by replacing the usual neutral lighting

with space-destroying colored lighting.

It didn't upset Flavin. He wanted his work to be disposable.

Don't worry about it.

Sol LeWitt denied all value of his art in those days.
I loved his dry sense of humor.

The exhibition was a success.

The pieces should be used for fire wood.

At his studio, Sol told me the first grids were used as playgrounds for his cats.

LeWitt, Dan Flavin and I saw a show at the Museum of Modern Art based on the book, "Russian Art 1863-1922," by Camilla Grey.
Tatlin was a huge influence on Flavin's work.

It's time to close the gallery. We have sold nothing and can't pay the rent.

Yes, suburban space.

まんがダン・
Manga Dan Graham Story

Chapter 2 Homes for America

グレアム物語

By Fumihiro Nonomura
Illustrated by Ken Tanimoto

ROBERT SMITHSON

Dan, can we display your photograph at our house?

Robert Smithson

Nancy Holt

The photographs are traces or "evidence."

!

I see two books on the table: "Robert Smithson: Photoworks," a catalogue of the exhibition at Los Angeles County Museum, and "Rock My Religion," by Dan Graham.

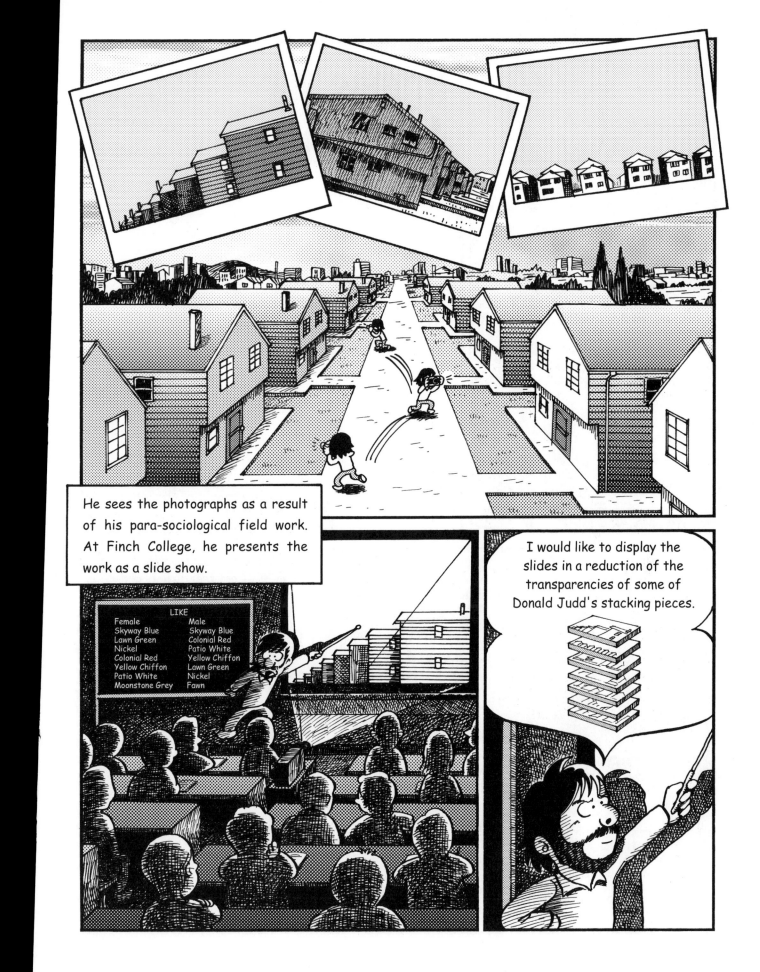

I am an editor of "Arts Magazine."

Can we publish this piece in our magazine?

Really? I would be honored.

Homes for America

D. GRAHAM

THE SERENADE

I love magazines because they are like pop songs, easily disposable, dealing with momentary pleasures. They are full of clichés. We all love the cliché. We all like tautologies, things that seem to be dumb and banal but are actually quite intelligent.

Large-scale 'tract' hou stitute the new city. whore. They are not p ing communities; they gional characteristics o 'projects' date from th when in southern Cali erative' builders adapt niques to quickly build fense workers over-c

Then I begin to write articles about music. I get free tickets and backstage passes. I meet my hero Ray Davies of the Kinks.

Dan's slide-show lectures led to his interest in motion pictures. But, at the time, it was too expensive to make films. Dan begins teaching at the Nova Scotia School of Art in Canada. He uses the video equipment with excitement.

Canada had lots of money to invite artists to make new conceptual works. Dan visited Nova Scotia at Halifax every summer to produce film and video works. "Sunset to Sunrise" was a film Dan made using the school's equipment.

Dan noticed Richard Long's landscape piece and Bruce Nauman's collaborations with Ann Halprin.

The choreography was especially important to him — it made clear the engagement of our bodies in the world.
All of the artists were reading Merleau-Ponty.
Nauman's big hero was the quantum physicist, Richard Feynman, who lectured at Berkeley.

In 1964, at the Filmmakers Co-op in N.Y., Jonas Mekas introduced Chris Marker's films to America. Warhol, influenced by Mekas, began to make experimental films.

Art in late 60's meant you could do anything: writing, philosophy, film, video, photography and performance. Carl Andre and Lawrence Weiner were writing poetry.

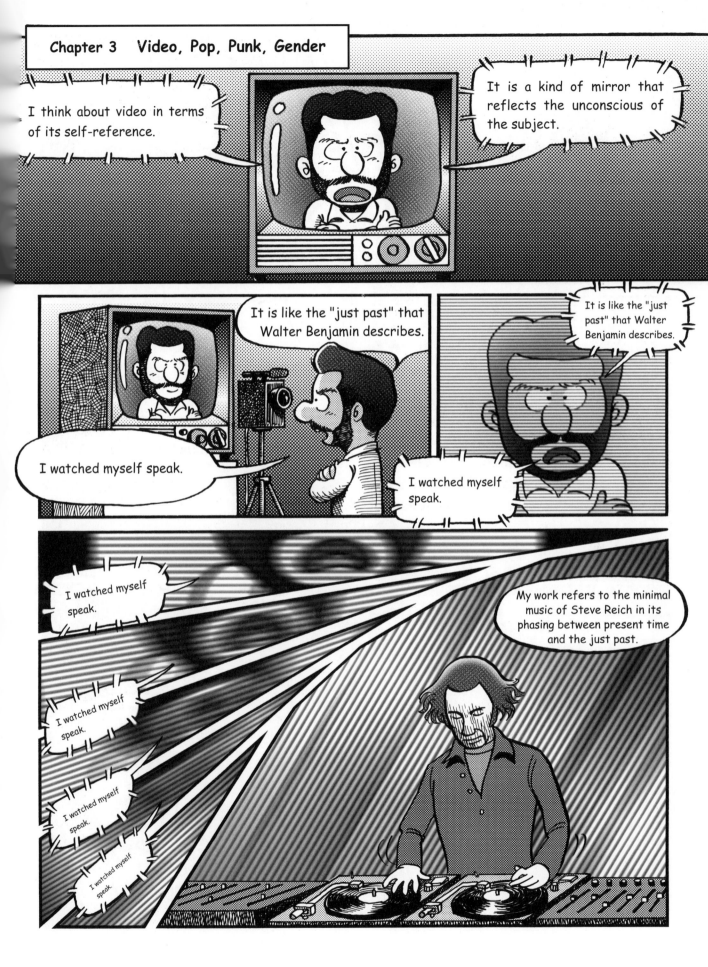

I am skeptical of models that implicitly recognize the world as it is.

I want to show that our bodies are bound to the world whether we like it or not.

I speak about Bruce Nauman's performances in my article, "Subject Matter."

Video is good for describing these principles.

At Nova Scotia School of Art in Halifax, Canada, I speak with Kasper Konig about inviting a theorist who specializes in art and gender. Kasper is an independent curator and editor of catalogues. I first suggested Shulamith Firestone, a Marxist-oriented feminist, who wrote "The Dialectics of Sex."

But I gave up film because I couldn't afford to produce the pieces.

An important aspect of the film is the curved mirror cylinder that I made to film the work.

And I also have an interest in gender issues.

I started to collaborate with three women musicians. They could barely play their instruments. Kim Gordon of Sonic Youth was one of them. I was interested in female bonding in women's rock groups.

Although some female rockers imitate male rock heroes, others are interested in women's power.

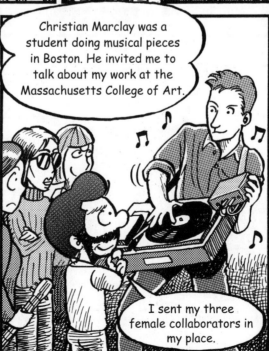

Christian Marclay was a student doing musical pieces in Boston. He invited me to talk about my work at the Massachusetts College of Art.

I sent my three female collaborators in my place.

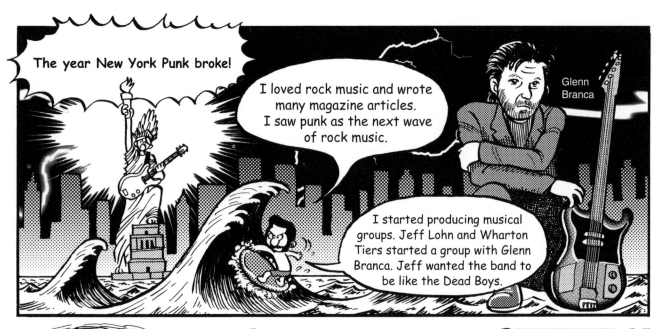

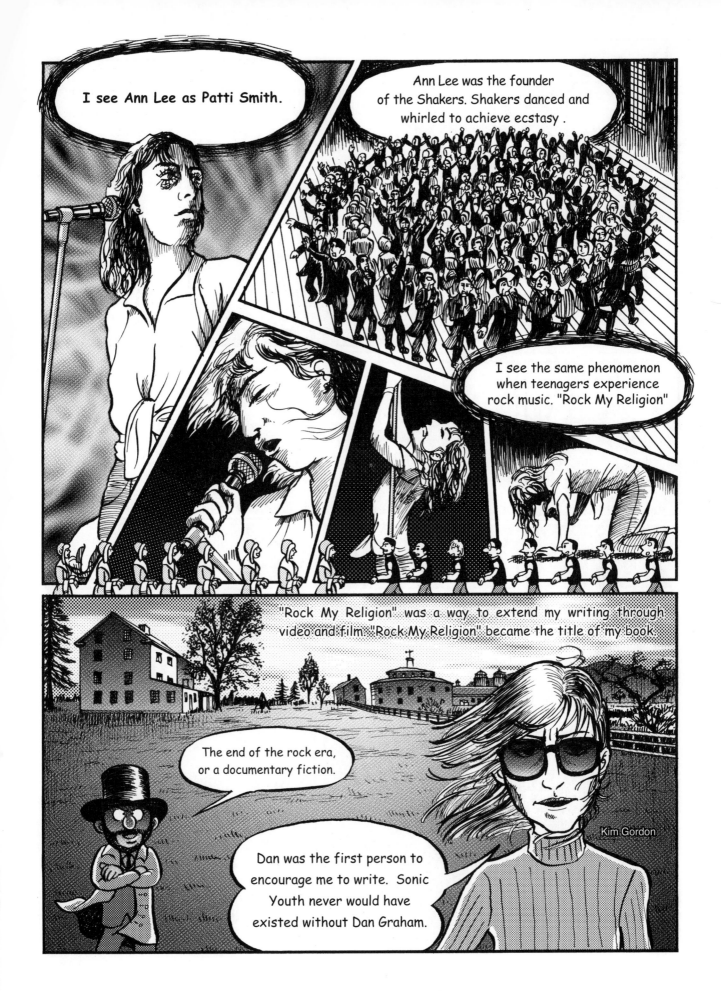

Chapter 4 To the Pavillion

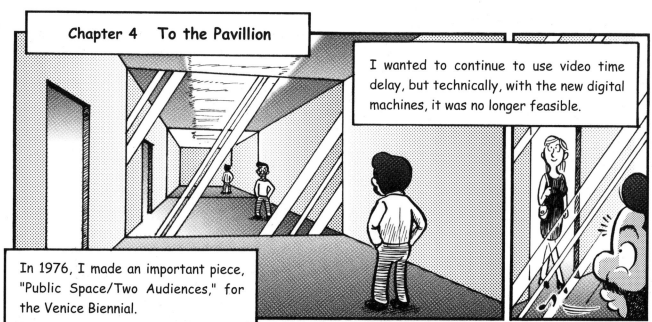

I wanted to continue to use video time delay, but technically, with the new digital machines, it was no longer feasible.

In 1976, I made an important piece, "Public Space/Two Audiences," for the Venice Biennial.

I wanted the audience to be like the commodity inside the showcase window.

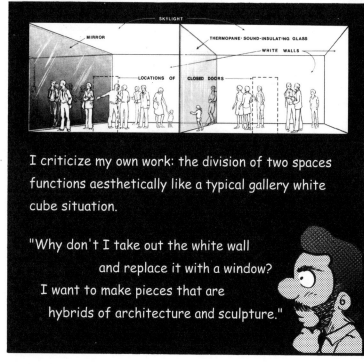

I criticize my own work: the division of two spaces functions aesthetically like a typical gallery white cube situation.

"Why don't I take out the white wall
 and replace it with a window?
 I want to make pieces that are
 hybrids of architecture and sculpture."

Gordon Matta-Clark and I were influenced by the same architects and architectural theorists.

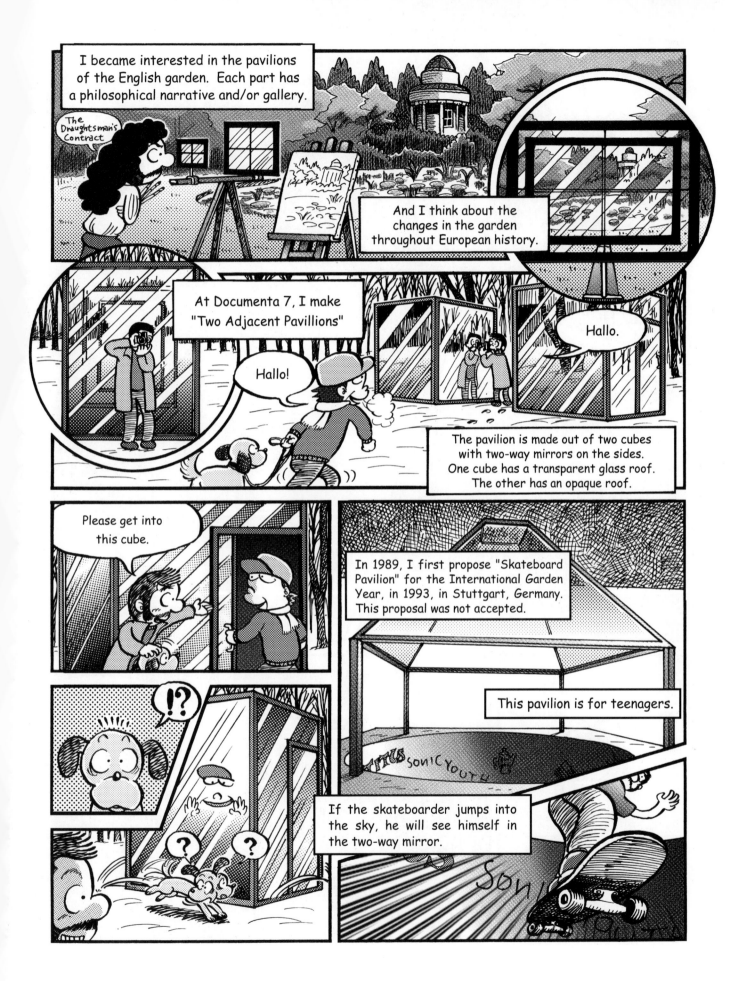

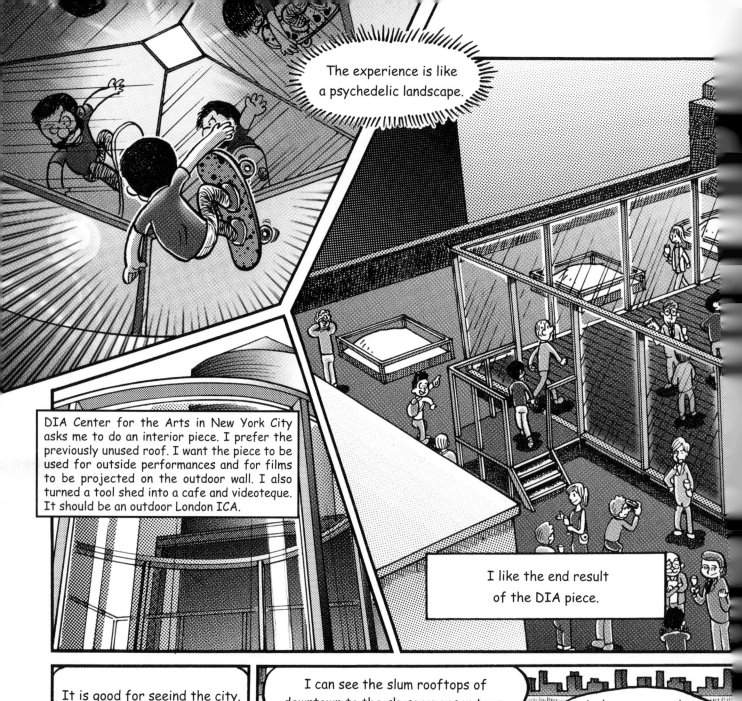

The experience is like a psychedelic landscape.

DIA Center for the Arts in New York City asks me to do an interior piece. I prefer the previously unused roof. I want the piece to be used for outside performances and for films to be projected on the outdoor wall. I also turned a tool shed into a cafe and videoteque. It should be an outdoor London ICA.

I like the end result of the DIA piece.

It is good for seeind the city.

I can see the slum rooftops of downtown to the skyscrapers uptown.

And we can see the clouds changing their faces in the New York sky.

I want to change the function of DIA. After touring the building, I realize that the roof is unused at this time. It has a 360 degree view of the city. I particularly like the fact that one can see the sky there.

So I design a two-way mirror cylinder to be situated in a two-way mirror cube. The cylinder echoes the water tower above.

Dan, the party doesn't come alive until the leading actor is there.

I imagine the legendary alternative spaces, which had many great performances in the 70's,

and also the corporate atriums of buildings in the 80's. I want to combine both, making the audience aware of the just-past.

Bibliography of Writings, Interviews and Catalogues

Note: This bibliography includes writings by Graham, supplemented by interviews and selected exhibition catalogues produced for solo or major exhibitions. Graham's writings were first published in periodicals and exhibition catalogues and have been reprinted in several collected writings books. This bibliography lists all articles by Graham by year of first publication. Some writings on works are included in this listing if they have appeared in a periodical'. For the first publication of Graham's writings on his works, see Chronology organized by project and year. For abbreviations, see Chronology abbreviations page 87. This bibliography was compiled with the assistance of Mele Mauala.

Articles by Dan Graham

1966

'Homes for America: Early 20th Century Possessable House to the Quasi-Discrete Cell of '66,' *Arts Magazine* 41, 3 (December 1966 - January 1967): 21-22. See cat. no. 9.1.

1967

'Muybridge Moments,' *Arts Magazine* 41, 4 (February 1967): 23-24. See also 'Photographs of Motion,' in *End Moments* 1969: 31-38 and 'Photographs of Motion' and 'Two Related Projects for Slide Projectors,' in *Two Parallel Essays/Photographs of Motion/Two Related Projects for Slide Projections*. New York: Multiples, Inc., 1970.

'Models and Monuments,' *Arts Magazine* 41, 5 (March 1967): 32-35.

'Of Monuments and Dreams,' *Art and Artists* Vol. 1 no. 12 (March 1967): 62-63.

'The Artist as Bookmaker [II]: The Book as Object,' *Arts Magazine* 41, 8 (Summer 1967): 23. See later version 'Information,' in *End Moments* 1969: 39-42.

'Dan Flavin,' in *Dan Flavin: Pink and Gold*. Exh. cat. Chicago: Museum of Contemporary Art, 1967: n.p. Also published as 'Flavin's Proposal,' *Arts Magazine* 44, 4 (February 1970) 44-45.

'Carl Andre,' *Arts Magazine* 42, 3 (December 1967 - January 1968): 34-35.

'Exchange: Discussion between Carl Andre and Dan Graham,' conducted for *Aspen*, 1967, unpublished.

'Monuments,' manuscript for a book for the Museum of Contemporary Crafts, New York, 1967, unpublished.

1968

'Oldenburg's Monuments,' *Artforum* 6, 5 (January 1968): 30-37.

'Holes and Lights: A Rock Concert Special,' *Straight* Vol. 1 no. 1 (April 1968): 1-2.

1969

'Eisenhower and the Hippies,' *0 to 9* no. 6 (July 1969): 30-37.

'Live Kinks,' *Fusion* (1969).

'Synthetic High & Natural Low: Dean Martin on TV,' *Fusion* (1969): 12-13. Reprinted as 'Dean Martin/Entertainment as Satire,' in *End Moments* 1969: 7-14. Alternate title: 'Dean Martin/ Entertainment as Theater.'

'Subject Matter,' in *End Moments* 1969: 15-30.

'Two Structures/Sol LeWitt,' in *End Moments* 1969: 65-68. Also as 'Thoughts on Two Structures,' in *Sol Lewitt*. Exh. cat. The Hague: Haags Gemeentemuseum, 1970: 24-25.

'Art Worker's Coalition Open Hearing Presentation,' (April 10, 1969) in Art Workers Coalition. *An Open Hearing on the Subject: What Should be the Program of the Art Workers Coalition Regarding Museum Reform and to Establish the Program of an Open Art Workers' Coalition*. New York: Art Workers' Coalition, 1969: n.p.

'Foams,' and 'March 31, 1966,' in *Extensions* no. 2 (1969): 34-35, 59. See cat. no. 12.

1970

'Late Kinks,' *Revista de Letras* (Universidad de Puerto Rico Mayaguez) II, 5 (March 1970): 43-48 and in *Performance* 1970: 23-28.

'Ecological Rock,' in *Assembling*, ed. Henry J. Korn and Richard Kostelanetz, Brooklyn, 1970: n.p. Also as 'Country Trip,' in *Performance* 1970: 32-34.

'Several Works,' *Interfunktionen* no. 5 (November 1970): 153.

'Editorial: One Proposal,' *Aspen* no. 8 (Fall-Winter 1970-71). Earlier version dated 1967-68 was published in *For Publication* 1975. See cat. no. 14.1.

'Live Kinks,' in *Performance* 1970: 28-31.

'Ecological Art,' partial manuscript dated to 1969-70 for a book to be published by John Gibson Gallery to the accompany exhibition, 'Ecological Art,' May 17 – June 28, 1969, unpublished.

1971

'Several Works,' and 'Performance as Perceptual Process,' *Interfunktionen* no. 7 (1971): 83-89.

'TV Camera/Monitor Performance,' *Radical Software* (Fall 1971). Reprinted in *TDR* (June 1972). See cat. no. 31.

'Like,' in 'Future's Fictions,' special issue ed. Richard Kostelanetz, *Panache* (New York 1971): n.p. See cat. no. 20.

1972

'Film Pieces: Visual Field,' and documentation of works, *Interfunktionen* no. 8 (January 1972): 27-33.

'Eight Pieces by Dan Graham, 1966-72,' *Studio International* Vol. 944 no. 183 (May 1972): 210-213.

'Dan Graham, Galleria Toselli, Milano,' *King Kong International* no. 2 (July 1972): 12.

'Pieces,' *Flash Art* no. 35-36 (September – October 1972): 8.

1973

Graham, Dan, and Tomasso Trini, 'Dan Graham I/Eye,' *Domus* no. 519 (February 1973): 51.

'Intention Intentionality Sequence,' *Arts Magazine* 47, 6 (April 1973): 64-65: 5. See cat. no. 38.

'Dan Graham, Various Pieces,' *Interfunktionen* no. 9 (1973): 57-64.

'Magazine/Ads,' and 'Income (Outflow) Piece 1969,' in *Deurle 11/7/73*. Exh. cat. Brussels: MTL, 1973: n.p.

'Two Correlated Rotations,' in *Breakthrough Fictioneers*. Ed. Richard Kostelanetz. Barton: Something Else Press, 1973. See cat. no. 28.

1974

'Two Consciousness Projection(s),' *Arts Magazine* 49, 4 (December 1974): 63-66. See cat. no. 36.

'Das Buch als Objekt/The Book as Object,' and 'Notes on Income (Outflow Piece),' *Interfunktionen* no. 11 (1974): 108-119.

1975

'Income (Outflow) Piece 1969,' and documentation of works, *Control Magazine* no. 9 (1975): 5-7.

'Architecture/Video Projects,' *Studio International* Vol. 190 no. 977 (September 1975): 143-146.

1976

'Environment/Time-Delayed Reflections,' *Casabella* 411 (March 1976): 29-33.

'Dan Graham,' various documentation of works, and 'Public Space/Two Audiences,' *+ - 0 (Revue d'Art Contemporain)* no. 14 (September 1976): 6-7. See later version of 'Public Space/Two Audiences,' in *Buildings and Signs*. 1981: 23-24. See cat. no. 62.

'Dan Graham,' documentation of works and the essay 'Elements of Video/Elements of Architecture,' in *Video by Artists*. Ed. Peggy Gale. Toronto: Art Metropole, 1976: 84-94; 193-195.

'Film and Performance/Six Films, 1969-74,' in *Six Films*. New York: Artists Space, 1976. Xerox brochure for film program January 2 and 3, 1976 with texts by Graham on his films. See cat. nos. 26.1, 27, 28, 29, 30, 39.

1977

'Duchamp/Morris,' response to questionnaire by Phillipe Sers on 'What does Duchamp Mean to You Today? Do You Consider Him to Already Belong to the Past?' *Connaissance des Arts* no. 299 (January 1977): 47-55.

'Three Projects for Architecture and Video/Notes,' *Tracks* Vol. 3 no. 3 (Fall 1977): 52-61.

1979

'Art in Relation to Architecture/Architecture in Relation to Art,' *Artforum* 17, 6 (February 1979): 22-29.

'Punk: Political Pop,' *Journal: Southern California Art Magazine* no. 22 (March-April 1979): 27-33 and as 'Punk: Politischer Pop/Punk als Propaganda,' *Überblick* no. 3 (March 1979). Reprinted in *Post-Pop Art*. Ed. Paul Taylor. Cambridge, Mass: MIT Press and Flash Art Books, 1989: 111-137.

Graham, Dan, and L. Licitra Ponti, 'Dan Graham a Milano: Architectural Models and Photographs,' *Domus* no. 594, (May 1979): 55.

'The Lickerish Quartet,' in *12 Films*. Exh. cat. Ed. Barbara Bloom. Amsterdam: De Appel, 1979: 28-32.

'Video Arbeit für Schaufenster,' 'Schaufenster aus Glas,' 'The Glass Divider,' 'Bild-Fenster Arbeit,' *Zweitschrift* no. 4/5 (1979): 108-113.

'Essay on Video, Architecture and Television,' in *Nova Scotia* 1979: 62-76.

'Notes on Yesterday/today,' in *Nova Scotia* 1979: 44-46. See cat. no. 57.

'Notes on Video Piece for Showcase Windows in a Shopping Arcade,' in *Nova Scotia* 1979: 53-54. See cat. no. 60.

Graham, Dan, and Dara Birnbaum, 'Local television news program analysis for public access cable television,' in *Nova Scotia* 1979: 58-61. See cat. no. 69.

1980

Response to questionnaire, 'Situation Esthetics: Impermanent Art and the Seventies Audience,' *Artforum* 18, 5 (January 1980): 24-26.

'The Destroyed Room of Jeff Wall,' *Real Life* no. 3 (March 1980): 5-6.

'L'Espace de la Communication,' *Skira Annuel* 1980: 90.

'Video Piece for Two Glass Office Buildings (1976),' in *En torno al Video*. Eds. Eugeni Bonet, Joaquim Dols, Antoni Mercader, Antoni Muntadas. Barcelona: Editorial Gustavo Gili, S.A., 1977: 212-213. See cat. no. 59.

'Larry Wayne Richards' Project for Conceptual Projects,' in *Larry Richards, Works 1977-80*. Halifax: Library of Canadian Architecture, Nova Scotia Technical College, 1980: 18-22.

'Dan Graham,' and documentation of works, *New Art* no. 3/4 (Fall 1980): 24-33.

1981

'Signs,' *Artforum*, 19, 8 (April 1981): 38-43.

'Bow Wow Wow,' *Real Life* no. 6 (Summer 1981): 11-13. Reprinted as 'McLaren's Children (We're Only in it for Manet),' *ZG* no. 7 (Summer 1982). See later version 'Malcolm McLaren and the Making of Annabella,' in *Impresario: Malcolm McLaren & The British New Wave*. New York: The New Museum of Contemporary Art and MIT Press, 1988: 60-71. Reprinted in *Plus* 3-4 (May 1988): 54-56. Unabridged version in *Rock My Religion*. Ed. Brian Wallis. Cambridge, Mass: MIT Press, 1993: 142-161.

'New Wave Rock en Het Feminiene,' *Museumjournaal* No. 26/1 (1981): 16-32. Reprinted as 'Semio-Sex: New Wave and the Feminine,' *Live* no. 6-7 (1982): 12-17 and in *Open Letter* no. 5-6 (Summer-Fall 1982): 79-105.

'Not Post-Modernism: History as Against Histo-ricism, European Archetypal Vernacular in Relation to American Commercial Vernacular and City as Opposed to the Individual Building,' *Artforum* 20, 4 (December 1981): 50-58.

'Cinema,' *A.E.I.U.O.* anno II no. 4 (July-December 1981): 38-47; *Buildings and Signs* 1981: 46-51; and as 'Bioscoop,' *Museumjournaal* 27/5+6 (1981): 239-243. See cat. no. 79.

'The End of Liberalism,' (Part I) *ZG* no. 2 (1981): n.p.

'Films/Video/Performances,' *Art Present* no. 9 (Summer/Fall 1981): 14-19.

'Pavilion/Sculpture for Park Setting,' in *Performance Text(e)s & Documents*. ed. Chantal Pontbriand. Montreal: Parachute, 1981: 199.

'Alteration to a Suburban House (1978),' in *Buildings and Signs* 1981: 35. See cat. no. 66.

'Clinic for a Suburban Site (1978),' in *Buildings and Signs* 1981: 32-33. See cat. no. 67.

'Two Adjacent Pavilions,' in *Buildings and Signs* 1981: 31. See later version in *Perth* 1985: 46-51. See cat. no. 81.

'Pavilion/Sculpture for Argonne,' in *Buildings and Signs* 1981: 27-29. See cat. 76.

1982

'My Religion,' *Museumjournaal* no. 27/7 (1982): 324-329; 'Rock Religion.' in *Scenes and Conventions in Architecture by Artists*. Exh. cat. London: Institute of Contemporary Arts, 1983: 80-81. Later versions: 'Rock-Religion.' in *Dan Graham Parilions*. Exh. cat. Ed. Jean-Hubert Martin. Bern: Kunsthalle Bern, 1983: 12-17; *Just Another Asshole* no. 6 (1983); *Video by Artists 2*. Ed. Elke Town. Toronto: Art Metropole, 1986: 81-111. See cat. nos. 86 and 86.1.

'The End of Liberalism (Part II),' in *The Un/Necessary Image*. Eds. Peter D'Agostino, Antoni Muntadas. New York: Tanam Press, 1982: 36-41.

1983

'Sur Gordon Matta-Clark,' *Art Press*, Special Architecture no. 2 (June-August 1983): 13, first short version. Later versions 'Gordon Matta-Clark's Projects,' in *Flyktpunkter-Vanishing Points*. Exh cat. Ed. Olle Granath, Margareta Helleberg. Stockholm: Moderna Museet, 1984: 90-102; *Kunstforum International*, no. 81 (October-November 1985): 114-119; *A Pierre et Marie: Une Exposition en Travaux*. Exh. cat. Paris: Association pour l'avenir de l'art actuel, 1986: 114-115; *Parachute* no. 43 (June-August) 1986: 21-25. See cat. no. 83.

'Theater, Cinema, Power,' *Parachute* no. 31 (June-August 1983): 11-19. See also Bern 1983: 19-44.

1984

'On John Knight's Journals Work,' *Journal: A Contemporary Art Magazine* no. 40 (Fall 1984): 110-111.

1985

'My Works for Magazine Pages: A History of Conceptual Art,' in *Perth* 1985: 8-13.

'Darcy Lange: Work and Music,' *New Observations* no. 29 (1985): n.p.

'An American Family,' in *TV Guides – A Collection of Thoughts About Televsion*. Ed. Barbara Kruger. New York: Kuklapolitan Press, 1985: 13-14.

1986

'Urban/Suburban Projects,' *Zone* no. 1/2 (1986): 363-365. See cat. no. 73.

'Pavilion/Sculpture Works,' in *Chambres d'Amis*. Exh. cat. Gent: Museum van Hedendaagse Kunst, 1986: 80-81.

'Chamberlain's Couches,' in *Interior Design for Space Showing Videotapes*. The Hague: Stichting Kijkhuis, 1986: 1-2. See cat. no. 93.

'Kunst als Design/Design als Kunst,' *Museumjournaal*, 3+4 (1986): 183-195. See also 'Art comme Design/Design comme Art,' *Des Arts* no. 5 (Winter 1986-87): 68-71.

1987

'Legacies of Critical Practice in the 1980s,' *Dia Art Foundation/Discussions in Contemporary Culture*, Number One. Ed. Hal Foster. Seattle: Bay Press, 1987: 88-91, discussion 105-118.

Graham, Dan, and Robin Hurst, 'Corporate Arcadias,' *Artforum* 26, 4 (December 1987): 68-74 and as 'Odyssey in Space: Dan Graham and Robin Hurst on the US Corporate Atrium,' *Building Design* (October 21, 1988): 38-43. See cat. no. 98.

1988

'Pavilions, Stagesets and Exhibition Designs, 1983-1988,' in *Munich* 1988: 36-58.

1989

'Garden as Theater as Museum,' in *Theatergarden Bestiarium: The Garden as Theater as Museum*. Exh cat. Long Island City, NY: The Institute for Contemporary Art, P.S. 1 Museum and MIT Press, 1990: 53-64. See also 'Garden as Theater as Museum/El jardín como teatro como museo,' in *Teatrojardin Bestiarium*. Exh. cat. Sevilla: Junta de Andalucia, Consejeria de Cultura, 1989: 83-120; 'Garden as Theater as Museum/Le Jardin comme théâtre comme musée,' in *Bestiarium Jardin-Théâtre*. Exh cat. Poitiers: Entrepot-Galerie du Confort Moderne, 1989: 53-63; See cat. no. 90.

Artists' Statement in section 'Forum – 1989,' *M/E/A/N/I/N/G* no. 5 (1989): 9.

Graham, Dan, and Jeff Wall. *A Guide to the Children's Pavilion*. Exh. brochure. Santa Barbara: Santa Barbara Contemporary Arts Forum, 1989: n.p. and 'The Children's Pavilion/Der Kinderpavillon,' *Parkett 22* (1989): 66-70. See later version *Children's Pavilion Dan Graham en Jeff Wall*. Exh. brochure. Rotterdam: Rotterdamse Kunststichting and Museum Boijmans Van Beuningen, 1993. See cat. no. 104.

1990

'Video in Relation to Architecture,' in *Illuminating Video: an Essential Guide to Video Art*. Eds. Doug Hall and Sally Jo Fifer. New York: Aperture Foundation, Inc. in association with Bay Area Video Coalition, 1990: 168-188.

1991

'Two-Way Mirror Cylinder Inside Cube and a Video Salon: Rooftop Park for Dia Center for the Arts,' in *The End(s) of the Museum*. Exh. cat. Barcelona: Fundació Antoni Tàpies, 1991: 126-128. See cat. no. 116.

'Skateboard Pavilion,' in *Jahresring 38: Der öffentliche Blick*. Munich: Verlag Silke Schreiber, 1991: 200. See cat. no. 105.

1992

'Urban Allegory: Museum/Park as Microcosm of the City,' in *Dan Graham: Two-Way Mirror Cylinder Inside Cube and a Video Salon*. New York: Dia Center for the Arts, 1992: 8-55. Video (19:34 minutes, color) and printed catalogue. See cat. no. 116.

'Ma Position,' in *Ma Position: Écrits sur mes œuvres*. Vol. 1. Villeurbanne: Le Nouveau Musée/Institut, Les Presses du Réel, 1992: 10-54.

'Performance: The End of the 60s' (1985) in *Ma Position: Écrits sur mes œuvres*. Vol. 1. Villeurbanne: Le Nouveau Musée/Institut, Les Presses du Réel, 1992: 114-116.

1993

'City as Museum,' in *Rock My Religion*. Ed. Brian Wallis. Cambridge, Mass: MIT Press, 1993: 244-263. Revised text including material from previously published articles 'Signs' (1981) and 'Not Post-Modernism: History as Against Historicism, European Archetypal Vernacular in Relation to American Commercial Vernacular and City as Opposed to the Individual Building' (1981).

'Video in Relation to Architecture,' in *Dan Graham: Public/Private*. Exh. cat. Philadelphia: Goldie Paley Gallery, Levy Gallery for the Arts in Philadelphia, Moore College of Art and Design, 1993: 6-17. Compiled from previous articles including 'Essay on Video, Architecture and Television' (1979), 'Art in Relation to Architecture/Architecture in Relation to Art' (1979), 'Signs' (1981), 'An American Family' (1985).

1994

'Arcadia,' *Peep* no. 1 (Spring 1994): 10-11.

1996

'Short Statement on My Two-Way Mirror Pavilions,' in *Dan Graham: Two-Way Mirror Pavilions/Einwegspiegel-Pavillons 1989-1996*. Exh. cat. Eds. Martin Köttering and Roland Nachtigäller. Nordhorn: Städtische Galerie Nordhorn, 1996: 87.

1997

'The Development of New York From the 1970s to the 90s in Relation to Urban Planning,' *in [Realisation]: Kunst in der Leipziger Messe/Art at the Exhibition Centre Leipziger Messe.* Cologne: Oktagon, 1997: 246-249.

1998

'Zweiweg-Spiegel-Macht/Two-Way Mirror Power,' in *Peripherie ist Überall*. Ed. Walther Prigge. Frankfurt am Main and Campus Verlag, 1998: 240-245. See also version in *Two-Way Mirror Power* 1999: 174-175.

'Der Künstler als Produzent/The Artist as Producer,' in *Crossings: Kunst zum Hören und Sehen*. Exh. cat. Vienna: Kunsthalle Wien and Cantz Verlag, 1998: 117-122. See also versions in Two-Way Mirror Power 1999: 1-9; *Dan Graham: Rock/music textes*. Ed. Vincent Pécoil. Dijon: Les presses du réel, 1999: 131-146.

Collected Writings by Dan Graham

1978

Dan Graham: Articles. Eindhoven: Stedelijk Van Abbemuseum, 1978. Includes the articles: 'Homes for America,' 'Photographs of Motion,' 'Information,' 'Eisenhower and the Hippies,' 'Two Structures/Sol LeWitt,' 'Oldenburg's Monuments,' 'Dean Martin/Entertainment as Theater,' 'Live Kinks,' 'Country Trip,' 'Duchamp/Morris,' 'Subject Matter.'

1979

Dan Graham: Video-Architecture-Television, Writings on Video and Video Works, 1970-1978. Ed. Benjamin H. D. Buchloh with contributions by Michael Asher, Dara Birnbaum. Halifax: Nova Scotia College of Art and Design Press and New York University Press, 1979. Includes writings on works 1970-78 and the essay, 'Essay on Video, Architecture and Television.'

1992

Ma Position: Écrits sur mes œuvres. Vol. 1. Villeurbanne: Le Nouveau Musée/Institut Les Presses du Réel, 1992; *Dan Graham: Rock My Religion*. Vol. 2. Dijon: Le Nouveau Musée/Institut Les Presses du Réel, 1993. Collected essays and writings on works with introduction by Anne Langlais and extensive bibliography, in two volumes. French.

1993

Rock My Religion. Ed. Brian Wallis. Cambridge, Mass: The MIT Press, 1993. Collected essays and selected writings on works, introduction by Brian Wallis.

1994

Dan Graham: Ausgewählte Schriften. Ed. Ulrich Wilmes. Stuttgart: Oktagon Verlag, 1994. Collected essays and selected writings on works, and extensive bibliography by Rainer Metzger. German.

1996

Dan Graham: Selected Writings and Interviews on Art Works, 1965-1995. Ed. Adachiara Zevi. Rome: I Libri di Zerynthia, 1996. Text by Adachiara Zevi, selected texts by Dan Graham and interviews by Simon Field, Daniela Salvoni, Ludger Gerdes, Mark Thompson, Hans Dieter Huber. Includes extensive bibliography. Italian and English editions.

1999

Dan Graham: Rock/music textes. Ed. Vincent Pécoil. Dijon: Les Presses du Réel, 1999. Collected writings on music with introduction by Vincent Pécoil and interview by Eric de Bruyn. French.

Two-Way Mirror Power: Selected Writings by Dan Graham on His Art. Ed. Alexander Alberro. Cambridge, Mass: MIT Press, in association with Marian Goodman Gallery, New York, 1999. Collected writings on works with selected essays, introduction by Jeff Wall and interviews by Ludger Gerdes, Eric de Bruyn, Brian Hatton, Mike Metz.

Selected Interviews

1972
Pluchart, Francois, 'Entretien avec Dan Graham,' *ArTitudes* no. 3 (December 1971-January 1972): 22.

1973
Field, Simon, 'Dan Graham: an interview with Simon Field,' *Art and Artists* vol. 7, no.10 (January 1973): 16-21.

1977
Von Graevenitz, Antje, 'Dingen gebeuren binnen het gezichtsveld/Things Happen in the Visual Field: A Discussion with Dan Graham,' *Museumjournaal* vol. 22 no. 2 (April 1977): 74-79.

1987
Dercon, Chris, 'Interview with Dan Graham (28 November 1984),' in *L'Epoque, La mode, la morale, la passion*. Exh. cat. Paris: Centre Georges Pompidou, 1987: 341.

Pelzer, Birgit, 'D'apres un interview avec Birgit Pelzer,' in *Dan Graham*. Exh. cat. Paris: Musée d'Art Moderne de la Ville de Paris, ARC, 1987: 33-38.

1989
Tsai, Eugenie, 'Interview with Dan Graham by Eugenie Tsai, New York City, October 27, 1998,' in *Robert Smithson Drawings*. Exh. cat. Münster: Westfälischer Kunstverein, 1989: 8-22.

1990
Salvioni, Daniela, 'Interview with Dan Graham/I'll Call Myself a Conceptual Artist, Though I Don't Like Conceptual Art,' *Flash Art International* no. 152 (May-June 1990): 140-144.

1991
Dercon, Chris. 'Dan Graham, I Enjoy that Closeness Where I Take Things That Are Very Close and Just Slightly Overlap Them,' *Forum International* no. 9 (September-October 1991): 73-80.

Hatton, Brian, 'Conversation: Dan Graham,' *Galeries Magazine* no.46 (December 1991-January 1992): 58-61.

---, 'Dan Graham in Conversation with Brian Hatton,' in *Talking Art* 1. Ed. Adrian Searle. London: Institute of Contemporary Art, 1993: 53-65.

1992
Thomson, Mark, 'Dan Graham: an Interview,' *Art Monthly* no. 162 (December 1992-January 1993): 3-7.

1993
Ardenne, Paul, 'A Modern Archaeology of Perception,' Art Press no. 178 (March 1993): 10-16, E1-6.

1994
Metz, Mike, 'Dan Graham Interviewed by Mike Metz,' *Bomb* no. 46 (Winter 1994): 24-29.

1995
Branca, Glenn, 'Glenn Branca and Dan Graham in Conversation,' *Be Magazin* (Künstlerhaus Bethanien) no. 3 (Summer 1995): 113-117.

Doroshenko, Peter, 'Dan Graham,' *Journal of Contemporary Art* Vol. 7 no. 2 (1995): 12-17.

Schöllhammer, Georg, 'Dara Birnbaum und Dan Graham im Gespräch über Familie, Fernsehen, Techno,' *Springer* 1, 5 (June 1995): 12-16.

1996
Alberro, Alexander, 'The Most Recent Past/Interview with Dan Graham and Jacqueline Donachie,' *Index* no. 2 (1996): 40-43, 75-78.

Fricke, Marion, and Roswitha Fricke, 'Interview par Marion & Roswitha Fricke,' *Art Press* special issue no. 17 (1996): 55-57.

Gerdes, Ludger, 'Dan Graham Interviewed by Ludger Gerdes,' in *Dan Graham. Selected Writings and Interviews on Art Works, 1965-1995*. Ed. Adachiara Zevi. Rome: I Libri di Zerynthia, 1996: 175-200.

Huber, Hans-Dieter, 'Dan Graham Interviewed by Hans-Dieter Huber,' in *Dan Graham: Selected Writings and Interviews on Art Works, 1965-1995*. Ed. Adachiara Zevi. Rome: I Libri di Zerynthia, 1996: 219-236.

Nonomura, Makoto (Interview with Dan Graham), BT (Bijutsu Techo) Bijutsu Shuppan-sha, Ltd. (December 1996): 100-113.

1997
de Bruyn, Eric, 'Dan Graham Interviewed by Eric de Bruyn,' in *Dan Graham*. Exh. cat. Ed. Gloria Moure. Santiago de Compostela: Centro Galego de Arte Comtemporanea, 1997: 195-205.

Hatton, Brian, 'Feedback: An Exchange of Faxes, Dan Graham and Brian Hatton,' *Dan Graham, Architecture*. Exh Cat. London: AA Publications, Architectural Association, 1997: 7-19.

Huber, Hans-Dieter. *Dan Graham Interviews*. Stuttgart: Cantz Verlag, 1997: 5-45.

Köttering, Martin, and Roland Nachtigäller, Roland, 'Dan Graham im Gespräch,' *Neue Bildende Kunst* Vol. 7 no. 2 (April-May 1997): 50-58.

Metzger, Rainer, 'Dan Graham in Conversation with Rainer Metzger, Vienna, October, 1995,' in *KünstlerInnen: 50 Positionen*. Bregenz: Kunsthaus Bregenz, 1997: 111-115.

Sustersic, Apolonija, 'One Morning Talking with Dan Graham,' in *Dan Graham*. Exh. cat. Ed. Gloria Moure. Santiago de Compostela: Centro Galego de Arte Comtemporanea, 1997: 31-36.

1998
Bader, Joerg, 'Les kaleidoscopes de Dan Graham/The Architecture of Seeing,' *Art Press* 231 (1998); 20-25.

Müller, Markus, and Ulrike Groos, 'Interview with Dan Graham: New York, May 1998,' in *Jahresring 45: Make it Funky, Crossover Zwischen Musik, Pop, Avantgarde und Kunst*. Ed. Markus Müller and Ulrike Groos. Cologne: Oktagon, 1998: 139-145.

Ramos, Maria Elena, (Interview with Dan Graham) in *Intervenciones en el espacio*. Exh. cat. Caracas: Fundacion Museo de Bellas Artes, 1998: 145-169.

Skooj, Lief, 'Interview with Dan Graham,' *Paletten* Vol. 59 no. 4 (1998): 16-19.

1999
de Bruyn, Eric, 'Conversation avec Dan Graham,' in *Dan Graham: Rock/music textes*. Ed. Vincent Pécoil. Dijon: Les presses du réel, 1999: 147-157.

2000
Kaijima, Momoyo, (Interview with Dan Graham), SWITCH, Switch Publishing (June 2000): 108-113.

Selected Catalogues and Books

1969
End Moments. New York: Dan Graham, 1969. Includes the articles: 'Dean Martin/ Entertainment as Satire,' 'Subject Matter,' 'Photographs of Motion,' 'Information,' and 'Two Structures/Sol LeWitt.'

1970
Two Parallel Essays/Photographs of Motion/ Two Related Projects for Slide Projectors.

New York: Multiples Inc., 1970. Texts by Dan Graham.

Dan Graham: Some Photographic Projects. New York: John Gibson, 1970.

1966 Dan Graham. New York: John Gibson 1970.

Performance 1. New York: John Gibson, 1970. Texts on works and articles by Dan Graham.

1972
Selected Works 1965-1972. Exh. cat. London: Lisson Publications and Cologne: König Brothers, 1972. Texts by Dan Graham.

1974
Dan Graham: Textes. Brussels: Galerie 17 and Editions Daled, 1974. Texts by Dan Graham.

1975
For Publication. Los Angeles: Otis Art Institute of Los Angeles County, 1975. Reprinted New York: Marian Goodman Gallery, 1991.

1976
Dan Graham. Exh. cat. Basel: Kunsthalle Basel, 1976.

Six Films. New York: Artists Space, 1976. Xerox brochure for film program January 2 and 3, 1976 with texts by Dan Graham.

1977
Films. Exh. cat. Geneva: Éditions Centre d'Art Contemporain, Salle Patino and Écart Publications, 1977. Texts by Dan Graham.

1978
Dan Graham: Articles. Eindhoven: Stedelijk Van Abbemuseum, 1978. Notes by R.H. Fuchs and text by Benjamin H. D. Buchloh.

1979
Dan Graham: Video-Architecture-Television, Writings on Video and Video Works, 1970-1978. Ed. Benjamin H. D. Buchloh with contributions by Michael Asher, Dara Birnbaum. Halifax: Nova Scotia College of Art and Design Press and New York University Press, 1979.

1980
Dan Graham at Riverside Studios: The Static at Riverside Studios. London: Audio Arts, 1980. Sound recording (cassette) with interview by William Furlong (textual sheet), recorded at Riverside Studios, London, February 24, 1979.

1981

Dan Graham: Buildings and Signs. Exh. cat. Ed. Anne Rorimer. Chicago: The Renaissance Society at The University of Chicago and Museum of Modern Art, Oxford, 1981. Texts by Anne Rorimer and writings on works by Dan Graham.

Dan Graham: Theatre. Gent: Anton Herbert, 1981. Texts by Dan Graham.

1982

Dan Graham. Brussels: Editions Daled, 1982.

1983

Dan Graham: Pavilions. Exh. cat. Ed. Jean-Hubert Martin. Bern: Kunsthalle Bern, 1983. Texts by Thierry de Duve, Jean-Hubert Martin and Dan Graham, with Glenn Branca 'Acoustic Phenomena' (13 minutes, 45 rpm, stereo).

1984

Flyktpunkter/Vanishing Points. Exh cat. Ed. Olle Granath, Margareta Helleberg. Stockholm: Moderna Museet, 1984. Group exhibition catalogue including texts by Graham and Marie-Paule Macdonald.

1985

Dan Graham. Exh cat. Perth: Art Gallery of Western Australia, 1985. Texts by Gary Dufour, Jeff Wall and Dan Graham.

1986

Interior Design for Space Showing Videotapes. The Hague: Stichtung Kijkhuis, 1986. Exhibition brochure and video program with text by Dan Graham.

1987

Dan Graham. Exh. cat. Paris: Musée d'Art Moderne de la Ville de Paris, ARC, 1987. Texts by Suzanne Pagé and Dan Graham.

Dan Graham. Exh. cat. Madrid: Centro de Arte Reina Sofia, Ministerio de Cultura, 1987. Text by Eugeni Bonet.

Dan Graham: Art As Design-Design As Art. Exh. cat. Edinburgh: Fruitmarket Gallery, 1987. Texts by Mark Francis and Dan Graham.

Dan Graham: Pergola/Conservatory. Exh. brochure. New York: Marian Goodman Gallery, 1987. Text by Anne Rorimer.

1988

Dan Graham: Pavillons. Exh cat. Munich: Kunstverein München, 1988. Texts by Zdenek Felix, Anne Rorimer and Dan Graham.

Dan Graham: Sculpture-Pavilions. Exh. cat. Ed. Ulrich Bischoff. Kiel: Kunsthalle Kiel, 1988. Texts by Ulrich Bischoff and Jeff Wall.

1989

Dan Graham, Jeff Wall: Children's Pavilion. Exh. cat. Lyon: Villa Gillet - FRAC Rhône-Alpes, 1989. Texts by Dan Graham and Jeff Wall, Frédéric Migayrou.

Graham, Dan, and Jeff Wall. *A Guide to the Children's Pavilion*. Exh. brochure. Santa Barbara: Santa Barbara Contemporary Arts Forum, 1989.

Teatrojardin Bestiarium. Exh. cat. Sevilla: Junta de Andalucia, Consejeria de Cultura, 1989.

Bestiarium Jardin-Théatre. Exh cat. Poitiers: Entrepot-Galerie du Confort Moderne, 1989.

1990

Theatergarden Bestiarium: The Garden as Theater as Museum. Exh cat. Long Island City, NY: The Institute for Contemporary Art, P.S. 1 Museum and Cambridge, Mass: MIT Press, 1990.

Dan Graham. Exh. cat. Yamaguchi City: Yamaguchi Prefectural Museum of Art, 1990. Texts by Dan Graham.

Dan Graham: Drawings: 1965-69. Exh. cat. Graz: Galerie Bleich-Rossi, 1990.

1991

Dan Graham. Exh. cat. Rivara (Torino): Castello di Rivara, Franz Paludetto, 1991. Texts by Anne Rorimer, Benjamin H. D. Buchloh and Dan Graham.

1992

Dan Graham: Two-Way Mirror Cylinder Inside Cube and a Video Salon. New York: Dia Center for the Arts, 1992. Video (19:34 minutes, color) and printed catalogue. Text by Dan Graham.

Dan Graham: Rooftop Urban Park Project. New York: Dia Center for the Arts, 1992. Brochure. Text by Lynne Cooke.

Dan Graham: Triangular Pavilion for Secession Wie. Exh. cat. Vienna: Wiener Secession, 1992.

Walker Evans & Dan Graham. Exh. cat. Rotterdam: Witte de With, Center for Contemporary Art; Marseille: Musée Cantini de Marseille; Munster: Westfälisches Landesmuseum; New York: Whitney Museum of American Art, 1992. Texts by Jean-François Chevrier, Allan Sekula, Benjamin H. D. Buchloh.

1993

Dan Graham: Public/Private. Exh. cat. Philadelphia: Goldie Paley Gallery, Levy Gallery for the Arts in Philadelphia, Moore College of Art and Design, 1993. Texts by Mark Francis, Christina Ritchie, Dan Graham and introduction by Elsa Longhauser.

Dan Graham: Kunst und Architektur/Architektur und Kunst. Exh. cat. Munich: Museum Villa Stuck and Van Abbemuseum, Eindhoven, 1993. Texts by Jo-Anne Birnie Danzker, Birgit Pelzer, Adachiara Zevi and Dan Graham.

Children's Pavilion Dan Graham en Jeff Wall. Exh. brochure. Rotterdam: Rotterdamse Kunststichting, and Museum Boijmans Van Beuningen, 1993. Text by Dominic van den Boogerd.

1994

Graham, Dan, and Marie-Paule Macdonald. *Wild in the Streets*: The Sixties. Gent: Imschoot Publishers, 1994. Text and photographs by Dan Graham, scenography and pop-up design by Marie-Paule Macdonald, preface by Chris Dercon.

Dan Graham: Nouveau Labyrinth pour Nantes. Exh. cat. Nantes: Ville de Nantes/DGAU, 1994. Text by Jean-Marc Ayrault.

1995

Dan Graham. Paris: Éditions Dis Voir, 1995. Texts by Alain Charre, Marie-Paule Macdonald, Marc Perelman.

Dan Graham: Video/Architecture/Performance. Ed. Sabine Breitwieser. Vienna: EA Generali Foundation, 1995. A video under the same title was produced in 1996, see List of Works in the Exhibition.

1996

Dan Graham: Two-Way Mirror Pavilions/Einwegspiegel-Pavillons 1989-1996. Exh. cat. Eds. Martin Köttering and Roland Nachtigäller. Nordhorn: Städtische Galerie Nordhorn, 1996. Texts by Martin Köttering and Roland Nachtigäller and Dan Graham.

Dan Graham: Raumkonzept Buchberg XII, Star of David Pavilion. Exh. brochure. Gars am Kamp: Kunstraum Buchberg, Dieter und Gertraud Bigner, Schloss Buchberg, 1996. Text by Brian Hatton.

Dan Graham: Models to Projects. Exh. cat. New York: Marian Goodman Gallery, 1996. Text by Alexander Alberro.

1997

Dan Graham - The Suburban City. Exh. cat. Ed. Theodora Vischer. Basel: Museum für Gegenwartskunst, 1997. Texts by Dan Graham, Rem Koolhaas, Herzog & de Meuron.

Dan Graham Interviews. Ed. Hans-Dieter Huber. Ostfildern-Ruit: Cantz, 1997. Interviews, Parts 1 and 2, and text by Hans-Dieter Huber.

Dan Graham: 12 May – 12 July 1998. Exh. cat. Ed. Gloria Moure. Barcelona: Fundació Antoni Tàpies, 1997; *Dan Graham*. Exh. Cat. Santiago de Compostela: Centro Galego de Arte Contemporánea, 1997. Texts by Gloria Moure, Christine van Assche, Alexander Alberro, Apolonija Sustersic, Dan Graham, Friedrich Wolfram Heubach, Eric de Bruyn, Brian Hatton, Adachiara Zevi, Marc Francis, Mike Metz.

Dan Graham: Architecture. Exh cat. London: Camden Arts Centre and AA Publications, Architectural Association, 1997. Texts by Brian Hatton, Mark Pimlott, Adachiara Zevi, Brian Hatton and Dan Graham interview.

1998

Sharawagdi. Exh. cat. Ed. Christian Meyer and Matthias Poledna. Baden: Felsenvilla with Verlag Walther König, Cologne, 1988.

2000

Dan Graham: Two Different Anamorphic Surfaces. Ed. Marika Wachtmeister. Laholm: The Wanås Foundation, 2000. Text by Anette Østerby.

Monographs

1988

Wall, Jeff. *Kammerspiel de Dan Graham.*
Brussels: Daled-Goldschmidt, 1988.

---, *Dan Graham's Kammerspiel.* Toronto: Art
Metropole, 1991. English edition.

1996

Metzger, Rainer. *Kunst in der Postmoderne: Dan
Graham.* Cologne: Walther König, 1996. Revision
of doctoral dissertation 1994. Includes first
extensive list of works and articles with publica-
tion references.

4 original replies from students at Nova Scotia College of Art (#3 is a re-creation as original was accidently lost, #4 was done by me as a joke, putting my [illegible] information in place of original).

A month after returning to New York, I used questionnaires on an individual, rather than group basis to people who had already read "March 31, 1966" privately without pre-defining by me of its content. These were individuals who previously had known me and some work.

Dan Graham
Time/Place Extension, 1969

Scheme, 1965
Printed matter in Dan Graham, 'Discrete Poem
Without Memory,' *0 to 9* no. 4 (June 1968): 94.
$8\frac{1}{2}$ x 11 in.
21.6 x 27.9 cm
Collection Dan Graham, New York, USA
Cat. no. 1

Figurative, 1965
Printed matter
2 framed works:
15 x 22 in. and 24 x $24\frac{2}{5}$ in.
38 x 56 cm and 61 x 62 cm
Collection Herbert, Gent, Belgium
Cat. no. 2

Scheme, 1965/73
(book version)
Master production proof
Computer printout in binder
$11\frac{2}{5}$ x $9\frac{4}{5}$ in.
29 x 25 cm
Collection Gerald Ferguson, Halifax, Nova Scotia,
Canada
Cat. no. 1.1

Scheme, 1965/73
(book version)
Book: 130 leafs, front and back cover of mylar,
bound with pins
$7\frac{1}{4}$ x $8\frac{1}{2}$ in.
18.4 x 21.6 cm
Edition of 10: $1\frac{1}{6}$-$\frac{6}{6}$ and 4 printers proofs
Designed by Dan Graham and Gerald Ferguson
Published by Gerald Ferguson, Halifax
Collection Gerald Ferguson, Halifax, Nova Scotia,
Canada
Cat. no. 1.1

March 31, 1966
Typewriter ink on paper
$3\frac{1}{10}$ x 9 in.
7.9 x 22.9 cm
Collection Daled, Brussels, Belgium
Cat. no. 5

Detumescence, 1966
Printed matter
3 framed sheets:
$4\frac{1}{2}$ x $26\frac{1}{3}$ in. (each)
11.4 x 66.9 cm (each)
Collection Dan Graham, New York. Courtesy
Marian Goodman Gallery, New York, USA
Cat. no. 6

Side Effects/Common Drugs, 1966
Offset lithography on paper
46 x 30 in.
117 x 76 cm
Collection Daled, Brussels, Belgium
Cat. no. 7

One, 1966
15 wooden puzzle pieces with container and
cardboard box
$1\frac{1}{2}$ x $1\frac{1}{2}$ in. (each)
3.8 x 3.8 cm (each)
Box: $1\frac{3}{4}$ x 7 x 7 in.
4.4 x 17.8 x 17.8 cm
Collection Dan Graham, New York, USA
Cat. no. 8

Foams, 1966
Poem: printed matter in *Extensions* no. 2
(1969): 34-35.
Magazine: 9 x 6 in.
22.9 x 15.2 cm
Collection Dan Graham, New York, USA
Cat. no. 12

Schema (March 1966), 1966-67
Printed matter and handwriting on paper
15 framed parts: $20\frac{1}{2}$ x $16\frac{1}{2}$ in. (each)
52.1 x 41.9 cm (each)
Collection Daled, Brussels, Belgium
Cat. no. 4

Homes for America, 1966-67/97
(slide projection)
20-35 mm slides and carousel projector
Dimensions variable according to installation
Collection Dan Graham, New York, USA
Cat. no. 9
 List of slides:
 1. Tract Houses, Bayonne, NJ, 1966
 2. Two Entrance Doorways, 'Two Home
 Houses,' Jersey City, NJ, 1965-70
 3. Row of Tract Houses, Bayonne, NJ, 1966
 4. Pink Kitchen Trays in Discount Store,
 Bayonne, NJ, 1966
 5. Hall of Model Home, Staten Island, NY,
 1967
 6. Courtyard, New Development,
 Jersey City, NJ, 1966
 7. High School Corridor, Westfield, NJ, 1965
 8. Housing Development, Bayonne, NJ,
 1966
 9. High School Doors, Westfield, NJ, 1965
 10. Row of New Tract Houses, Bayonne, NJ,
 1966

11. First Day Opening of Highway Restaurant, Jersey City, NJ, 1967
12. New Highway Restaurant Opening, Jersey City, NJ, 1967
13. Untitled (Family in New Highway Restaurant), Jersey City, NJ, 1967
14. Row Houses, Bayonne, NJ, 1966
15. Row of Houses, Jersey City, NJ, 1966
16. Back of New Housing Project, Jersey City, NJ, 1966
17. Warehouse in Neocolonial Style, Westfield, NJ, 1978
18. Hotel with Yellow Doors, Minneapolis, MN, 1975
19. Tourist Bus, Lisbon, Portugal, 1977
20. Tennis Lady, Palo Alto, CA, 1978

Homes for America, 1966-67
(article for *Arts Magazine*)
Layout boards: printed texts, handwriting, black and white and color photographs
$40\frac{1}{5}$ x $30\frac{1}{3}$ in.
102 x 77 cm
Collection Daled, Brussels, Belgium
See cat. no. 9.1

Proposal for Aspen, 1967-68
Printed matter
Page from catalogue *For Publication*, Los Angeles: Otis Art Institute of Los Angeles County, 1975. Reprinted New York: Marian Goodman Gallery, 1991: n.p.
$10\frac{3}{4}$ x $8\frac{3}{4}$ in.
27.3 x 22.2 cm
Collection Dan Graham, New York, USA
Cat. no. 14

Income (Outflow) Piece, 1969
Black and white photographic reproduction of printed matter
$21\frac{1}{4}$ x 17 in.
54 x 43 cm
Collection Daled, Brussels, Belgium
Cat. no. 18

Like, 1969
Sound piece: tape recorder, tape loop
Dimensions variable according to installation
Collection Dan Graham, New York, USA
Cat. no. 20

Time/Place Extension, 1969
Black and white photographs, reproduction of *March 31*, 1966, xerox questionnaires with handwriting on boards
$30\frac{1}{3}$ x $40\frac{1}{5}$ in. (each)
77 x 102 cm (each)
Collection Daled, Brussels, Belgium
Cat. no. 22

Sunset to Sunrise, 1969
16 mm film, 8 minutes, color, silent
Dimensions variable according to installation
Collection Dan Graham, New York. Courtesy Marian Goodman Gallery, New York, USA
Cat. no. 26.1

Roll, 1970
2 super 8 mm films, enlarged to 16 mm for double projection on parallel and opposite walls
1 minute, color, silent
Private collection. Courtesy Marian Goodman Gallery, New York, USA
Cat. no. 29

TV Camera/Monitor Performance, 1970
Documentation: black and white photographs with text
22 x 56 in.
56 x 142 cm
Collection Daled, Brussels, Belgium
See cat. no. 31

Aspen no. 8 (Fall-Winter 1970-71), 1970-71
Edited by Dan Graham. Cover designed by Jo Baer. Designed by George Maciunas. Contains editorial statement by Dan Graham and contributions by the following artists: David Antin, Terry Atkinson and Michael Baldwin, Philip Glass, Dan Graham, Richard Serra, Steve Reich, La Monte Young, Yvonne Rainer, Jo Baer, Jackson MacLow, Robert Morris, Dennis Oppenheim, Robert Smithson, and Edward Ruscha. Sound recording $33\frac{1}{3}$ rpm by MacLow
Magazine: $11\frac{1}{5}$ x $11\frac{1}{5}$ x $\frac{1}{5}$ in.
28.5 x 28.5 x 0.5 cm
Collection Jo Baer, Amsterdam, Holland
Cat. no. 14.1

Body Press, 1970-72
2 16 mm films, 2 synchronized projectors, xenon
lamps, loop cabinets
Edition of 3
8 minutes, color, silent
Dimensions variable according to installation:
2 films are projected on 2 opposite and parallel
walls
Collection Serralves Foundation, Museum of
Contemporary Art, Porto, Portugal
Cat. no. 30

Body Press, 1970-72
Documentation: photograph, drawing, and signed
text on board
19^2/$_5$ x 34^1/$_3$ in.
49.3 x 87.3 cm
Collection Serralves Foundation, Museum of
Contemporary Art, Porto, Portugal
See cat. no. 30

Two Consciousness Projection(s), 1972
Documentation of 2nd performance, Lisson
Gallery, London, March 1972
Black and white photograph on cardboard
50 x 41^1/$_3$ in.
127 x 105 cm
Collection Herbert, Gent, Belgium
See cat. no. 36

Past Future Split Attention, 1972
Documentation: photograph with text
24^2/$_5$ x 39^2/$_5$ in.
62 x 100 cm
Collection Nicole Verstraeten, Brussels, Belgium
See cat. no. 37

Present, Continuous Past(s), 1974
Mirrored wall, video camera, monitor with
time delay
Circa 96 x 144 x 96 in. (overall)
244 x 366 x 244 cm (overall)
Collection Musée National d'Art Moderne,
Centre de Création Industrielle-Centre Georges
Pompidou, Paris, France
Cat. no. 42

**Opposing Mirrors and Video Monitors on Time
Delay, 1974**
2 mirrors, 2 video cameras and 2 monitors with
time delay, plywood, paint
Circa 72 x 96 in.
183 x 244 cm
Flick Collection, St. Gallen, Switzerland
Cat. no. 52

Two Viewing Rooms, 1975
Two-way mirror, fluorescent lights, video camera
and monitor
98^2/$_5$ x 98^2/$_5$ x 236^1/$_5$ in.
250 x 250 x 600 cm
Collection Marc and Josée Gensollen, Marseille,
France
Cat. no. 56

Yesterday/Today, 1975
Video camera and sound recording device in
room A, video monitor (displaying what camera
in room A records) and sound playback device
in room B with 24-hour time delay
Dimensions variable according to installation
Collection Stedelijk Van Abbemuseum,
Eindhoven, Holland
Cat. no. 57

**Video Piece for Showcase Windows in
Shopping Arcade, 1976**
2 monitors, 2 cameras, 2 mirrors, time delay
device installed in two facing and parallel shop
windows in a modern shopping arcade
Dimensions variable according to installation
Collection Dan Graham, New York, USA
Cat. no. 60

Public Space/Two Audiences, 1976
Exhibition copy
Installation: two rooms divided by glass, one
mirrored wall, muslin, fluorescent lights, wood
Circa 86^2/$_3$ x 275^2/$_3$ x 86^2/$_3$ in. (overall)
220 x 700 x 220 cm (overall)
Collection Herbert, Gent, Belgium
Cat. no. 62

Alteration to a Suburban House, 1978
Architectural model, edition of 3
Painted wood, synthetic material, plastic
24^4/$_5$ x 25^1/$_5$ x 36^2/$_3$ in.
63 x 64 x 93 cm
Base: 48^2/$_5$ x 48^2/$_5$ x 59^2/$_5$ in.
123 x 123 x 151 cm
Collection Daled, Brussels, Belgium
Cat. no. 66

Alteration to a Suburban House, 1978
Architectural model, edition of 3
Painted wood, synthetic material, plastic
12^2/$_3$ x 39^2/$_5$ x 57 in.
32 x 100 x 145 cm
Collection Kunsthaus Bregenz, Austria
Cat. no. 66

Clinic for a Suburban Site, 1978
Architectural model, edition of 3
Painted wood, plexiglas, landscape material
$12^{1}/_2$ x 30 x $23^{1}/_2$ in.
31.8 x 76.2 x 59.7 cm
Collection Bown-Taevernier, Gent, Belgium
Cat. no. 67

Video Projection Outside Home, 1978
Architectural model, edition of 3
Painted wood, plastic
9 x $30^{1}/_3$ x 20 in.
22.9 x 77 x 50.8 cm
Collection Dan Graham, New York. Courtesy
Marian Goodman Gallery, New York, USA
Cat. no. 68

Two Adjacent Pavilions, 1978
Architectural model, edition of 3
Two-way mirror, aluminum
$9^{4}/_5$ x $9^{4}/_5$ x $13^{3}/_4$ in.
25 x 25 x 35 cm
Collection Micheline Szwajcer Gallery, Antwerp,
Belgium
Cat. no. 81.1

Dan Graham and Ernst Mitzka
Westkunst (Modern Period): Dan Graham
Segment, 1980
Single channel videotape, 7:10 minutes, color,
sound
Script: Dan Graham. Produced by WDR and
Ernst Mitzka. Camera: Michael Shamberg.
Sound: Glenn Branca
Distributed by Electronic Arts Intermix, New York
Collection Dan Graham, New York, USA
Short version of cat. no. 73

Cinema, 1981
Architectural model, unique
Foam core, wood, two-way mirror, plexiglas,
super 8 projector and super 8 film with loop
$23^{2}/_3$ x $22^{2}/_5$ x $22^{2}/_5$ in.
60 x 57 x 57 cm
Collection Musée National d'Art Moderne,
Centre Georges Pompidou, Paris, France
Cat. no. 79

Cinema, 1981/2000
Architectural model, artist's proof/exhibition
copy
Foam core, wood, mirror, plexiglas, super
8 projector and super 8 film with loop
13 x $21^{2}/_3$ x $21^{2}/_3$ in.
33 x 55 x 55 cm
Collection Städtisches Galerie im Lenbachhaus,
Munich, Germany
Cat. no. 79

Rock My Religion, 1982-84
Single channel videotape
55:27 minutes, black and white and color,
stereo sound
Distributed by Electronic Arts Intermix, New York
Collection Dan Graham, New York, USA
Cat. no. 86

Dan Graham and Marie-Paule Macdonald
Project for Matta-Clark Museum, 1983
Architectural model, unique
Cardboard
6 elements: 12 x 20 x $19^{2}/_3$ in. (each)
30.5 x 50.8 x 50 cm (each)
1 element: $11^{4}/_5$ x $28^{1}/_3$ x $19^{2}/_3$ in.
30 x 72 x 50 cm
Collection Le Consortium, Dijon, France
Cat. no. 83

Minor Threat, 1983
Single channel videotape, 38:18 minutes, color,
sound
Distributed by Electronic Arts Intermix, New York
Collection Dan Graham, New York, USA
Cat. no. 84

Pavilion/Sculpture II, 1984
Exhibition copy
Glass, mirror, aluminum
$96^{2}/_5$ x 144 x 144 in.
245 x 366 x 366 cm
Collection Moderna Museet, Stockholm, Sweden
Cat. no. 85

Cinema-Theater, 1986
Architectural model, unique
Wood, mylar, two-way plexiglas, super
8 film, projector
$23^{2}/_3$ x $47^{1}/_4$ x $78^{3}/_4$ in.
60 x 120 x 200 cm
Collection Fonds National d'Art Contemporain,
Puteaux, France. Long-term loan from Château
d'Oiron, Oiron, France
Cat. no. 90

Two Cubes/One Rotated 45°, 1986
Two-way mirror, glass, aluminum
88²/₃ x 94¹/₂ x 118 in.
225 x 240 x 300 cm
Collection Frac Nord-Pas de Calais, Dunkerque,
France
Cat. no. 92

**Three Linked Cubes/Interior Design for Space
Showing Videos, 1986**
Two-way mirror, glass, wood frames, video
monitors and players
6 panels: 88²/₃ x 39²/₅ x 1²/₅ in. (each)
225 x 100 x 3.5 cm (each)
Collection Onnasch, Berlin, Germany
Cat. no. 93

**Altered Two-Way Mirror Revolving Door and
Chamber with Sliding Door (for Loie Fuller), 1987**
Two-way mirror, glass, aluminum
88²/₃ x 118 x 157¹/₂ in.
225 x 300 x 400 cm
Collection Le Consortium, Dijon, France
Cat. no. 97

**Dan Graham and Robin Hurst
Private 'Public' Space: The Corporate Atrium
Garden, 1987**
Layout boards for magazine article: black and
white and color photographs with printed texts
manted on cardboard
6 framed panels: 40 x 30 in. (each)
101.6 x 76.2 cm (each)
Collection Generali Foundation, Vienna, Austria
Cat. no. 98

**Dan Graham and Marie-Paule Macdonald
Wild in the Streets: The Sixties, 1987**
Libretto for rock opera published as a book
and drawings by Marie-Paule Macdonald
Drawings: mixed media and photo collage
on paper
9⁴/₅ x 19²/₃ (each)
25 x 50 cm (each)
Collection Dan Graham, New York, USA and
Marie-Paule Macdonald, Halifax, Nova Scotia,
Canada
Cat. no. 99

Cinema-Theater, 1988
Drawing: pencil and colored pencil on paper
27 x 24 in.
68.5 x 61.2 cm
Collection Gallery Shimada, Tokyo, Japan
See cat. no. 90

**Dan Graham and Jeff Wall
Children's Pavilion, 1989**
4 architectural drawings on silk-screen
27¹/₂ x 39²/₅ in. (each)
70 x 100 cm (each)
Collection Galerie Roger Pailhas, Marseille,
France
See cat. no. 104

Skateboard Pavilion, 1989
Architectural model, unique
Two-way mirror glass, brushed aluminum, steel,
wood, graffiti
57 x 57 x 51²/₅ in.
145 x 145 x 130.5 cm
Base: 81 x 57 x 57 in.
206 x 145 x 145 cm
Collection Generali Foundation, Vienna, Austria
Cat. no. 105

Skateboard Pavilion, 1989
Scotch tape model unique
Mirror, wood, scotch tape
31⁴/₅ x 22²/₅ x 22²/₅ in.
81 x 57 x 57 cm
Base: 80⁷/₁₀ x 57 x 57 in.
205 x 145 x 145 cm
Collection Bruno van Lierde, Brussels, Belgium
Cat. no. 105.1

Two-Way Mirror Hedge Labyrinth, 1989
Architectural model, edition of 3
Aluminum, glass, chrome, metal
6¹/₃ x 43¹/₃ x 48 in.
16 x 110 x 122 cm
Collection Kunsthaus Bregenz, Austria
Cat. no. 120.1

**Triangular Solid with Circular Inserts, Variation B,
1989-91**
Two-way mirror glass, clear glass, mirror,
aluminum
83¹/₂ x 83¹/₂ x 72²/₅ in.
212 x 212 x 184 cm
Collection Musée d'Art Contemporain de Lyon,
Lyon, France
Cat. no. 121

Model for Triangular Pavilion with Shoji Screen, 1990
Architectural model, edition of 3
Glass, aluminum, maple wood
34¼ x 34⅖ x 30 in.
87 x 87.5 x 76 cm
Base: 43 x 45⅓ x 41 in.
109 x 115 x 104 cm
Collection Dan Graham, New York, USA. Courtesy
Lisson Gallery, London, UK
Cat. no. 114.1

Dan Graham and Jeff Wall
Children's Pavilion, 1991
Architectural model, unique
Concrete, glass, metal, wood, plexiglas,
cibachrome transparencies, fluorescent light,
cork, plastic trees
50 x 110¼ in. (height x diameter)
127 x 280 cm (height x diameter)
Collection Galerie Roger Pailhas, Marseille,
France
Cat. no. 104.1

Heart Pavilion, 1991
Architectural model, edition of 3
Two way mirror, aluminum
25⅔ x 25⅕ x 35 in.
65 x 64 x 89 cm
Collection Dan Graham, New York, USA. Courtesy
Lisson Gallery, London, UK
Cat. no. 117.1

Star of David, 1991-96
Architectural model, edition of 3
Aluminum, glass, wood
14½ x 26⅓ x 26⅓ in.
37 x 67 x 67 cm
Base: 43⅓ x 39⅖ in.
110 x 100 cm
Collection Bogner, Vienna, Austria
Cat. no. 142.1

New Design for Showing Videos, 1995
Oak frames, transparent glass, two-way mirror,
punched aluminum, 6 video sets on shelves,
cushions
86⅔ x 244 x 342½ in.
220 x 620 x 870 cm
Collection Generali Foundation, Vienna, Austria
Cat. no. 133

Elliptical Pavilion, 1995
Architectural model, edition of 3
Two-way mirror, punched aluminum
22½ x 30 x 40 in.
57.2 x 76.2 x 101.6 cm
Collection Dan Graham, New York. Courtesy
Marian Goodman Gallery, New York, USA
Cat. no. 159.1

Double Exposure, 1995-96
Architectural model, edition of 3
Two-way mirror, cibachrome transparency
19⅔ x 41⅓ x 41⅓ in.
50 x 105 x 105 cm
Collection Dan Graham, New York, USA. Courtesy
Galerie Marian Goodman, Paris, France
Cat. no. 130

Double Exposure, 1995-2000
Steel, two-way mirror, glass, cibachrome
transparency, cement
90½ x 157½ x 157½ in.
230 x 400 x 400 cm
Collection Serralves Foundation, Museum of
Contemporary Art, Porto, Portugal
Cat. no. 130

Two-Way Mirror Triangle with One Curved Side, 1996
Architectural model, edition of 3
Two-way mirror, aluminum
35⅖ x 35⅖ x 22⅔ in.
90 x 90 x 57.5 cm
Private collection, Brussels, Belgium
Cat. no. 138.1

Curved Two-Way Mirror and Punched Aluminum Solid Triangle Pavilion, 1996
Architectural model, edition of 3
Two-way mirror, punched aluminum
36⅕ x 50 x 40⅕ in.
92 x 127 x 102 cm
Collection Dan Graham, New York, USA. Courtesy
Galerie Marian Goodman, Paris, France

Café for the Terrace of Fundació Tàpies, 1996-2000
Architectural model, unique
Architect: Pedro del Llano
Meth-acrylate, vinyl
7⅘ x 34¼ x 7 in.
20 x 87 x 18 cm
Collection Serralves Foundation, Museum of
Contemporary Art, Porto, Portugal

Swimming Pool/Fish Pond, 1997
Architectural model, edition of 3
Coated glass, lead foil, wood, acrylic,
sheet aluminum
$12\frac{1}{2}$ x 42 x 42 in.
31.8 x 106.7 x 106.7 cm
Flick Collection, St. Gallen, Switzerland
Cat. no. 148

Funhouse for the Children of Sint-Jansplein, 1997
Architectural model, edition of 3
Glass, wood, acrylic
$9\frac{4}{5}$ x $42\frac{1}{8}$ x $42\frac{1}{8}$ in.
25 x 107 x 107 cm
Base: $51\frac{1}{5}$ x $43\frac{1}{3}$ x $43\frac{1}{3}$ in.
130 x 110 x 110 cm
Collection City of Antwerp, Openluchtmuseum
voor Beeldhouwkunst Middelheim, Antwerp,
Belgium
Cat. no. 152

Dan Graham and Apolonija Sustersic
Liza Bruce Boutique Design, 1997
Mixed media on paper
8 framed works: $9\frac{4}{5}$ x $12\frac{2}{3}$ in. (each)
25 x 32 cm (each)
Collection Galerie Meyer Kainer, Vienna, Austria
Cat. no. 153

Yin/Yang, 1997-98
Architectural model, edition of 3
Two-way mirror, lead plexiglas, linoleum, acrylic,
small stones, water, Zen-sand garden
$11\frac{4}{5}$ x $42\frac{1}{8}$ x $42\frac{1}{8}$ in.
30 x 107 x 107 cm
Base: $47\frac{1}{4}$ x $42\frac{1}{8}$ x $42\frac{1}{8}$ in.
120 x 107 x 107 cm
Private collection, Gent, Belgium
Cat. no. 149

Johanne Nalbach
Café Bravo, 1998
Architectural plans
5 pieces: $11\frac{4}{5}$ x $20\frac{1}{3}$ in. (each)
30 x 51.5 cm (each)
Collection Nalbach + Nalbach Architekten, Berlin,
Germany
See cat. no. 156

Café Bravo, 1998
Scotch tape model, unique
Cardboard, plastic, scotch tape
2 x 8 x 8 in.
5.1 x 20.3 x 20.3 cm
Collection Dan Graham, New York, USA
Cat. no. 156.1

**Children's Day Care, CD-ROM, Cartoon and
Computer Screen Library, 1998**
Architectural model, edition of 3
Aluminum, concave mirror glass, wood, various
plastic toys, plastic toy screens
$10\frac{4}{5}$ x $28\frac{3}{4}$ x $37\frac{4}{5}$ in.
27.5 x 73 x 96 cm
Courtesy Hauser & Wirth, Zurich, Switzerland
Cat. no. 164.1

Girl's Make-up Room, 1998-2000
Two-way mirror glass, perforated stainless steel
67 x 118 in.
170 x 300 cm
Courtesy Galerie Hauser & Wirth, Zurich,
Switzerland
Cat. no. 165

Girl's Make-up Mirror, 1998-2000
Multiple edition
Reflective plastic with 'fish-eye' lens and
magnetized back
$11\frac{2}{3}$ x $8\frac{1}{4}$ x 1 in.
29.5 x 21 x 2.5 cm
Courtesy Galerie Hauser & Wirth, Zurich,
Switzerland
Cat. no. 165.2

**Curved Hedge Proposal for Garden of Serralves
Foundation, 1999-2000**
Architectural model, unique
Architect: Pedro del Llano
Meth-acrylate, vinyl, sponje
6 x $10\frac{1}{3}$ x $13\frac{1}{2}$ in.
15.4 x 26.2 x 34.4 cm
Collection Serralves Foundation, Museum of
Contemporary Art, Porto, Portugal

Documentation

Lax/Relax, 1969
Videotape of performance at Lisson Gallery,
London, July 1995
Edition of 25
24 minutes, color, sound
Filmed by Rory Logsdail
Courtesy Lisson Gallery, London, UK
See cat. no. 21

Project for a Local Cable TV, 1971
Printed matter reproduced from catalogue
Dan Graham: Video-Architecture-Television,
Writings on Video and Video Works, 1970-1978,
ed. Benjamin H. D. Buchloh. Halifax: Nova Scotia
College of Art and Design Press and New York
University Press, 1979.
18 x 11⁴/₅ in.
46 x 30 cm
Collection Dan Graham, New York, USA
See cat. no. 34

Past Future Split Attention, 1972
Single channel videotape of performance at
Lisson Gallery, London, March 1972
17:03 minutes, black and white, sound
Distributed by Electronic Arts Intermix
Collection Serralves Foundation, Museum of
Contemporary Art, Porto, Portugal
See cat. no. 37

Video Piece for Two Glass Office Buildings, 1976
Printed matter reproduced from catalogue
Dan Graham: Video-Architecture-Television,
Writings on Video and Video Works, 1970-1978,
ed. Benjamin H. D. Buchloh. Halifax: Nova Scotia
College of Art and Design Press and New York
University Press, 1979.
18 x 11⁴/₅ in.
46 x 30 cm
Collection Dan Graham, New York, USA
See cat. no. 59

Production/Reception (Piece for Two Cable TV
Channels), 1976
Printed matter reproduced from catalogue
Dan Graham: Video-Architecture-Television,
Writings on Video and Video Works, 1970-1978,
ed. Benjamin H. D. Buchloh. Halifax: Nova Scotia
College of Art and Design Press and New York
University Press, 1979.
18 x 11⁴/₅ in.
46 x 30 cm
Collection Dan Graham, New York, USA
See cat. no. 61

Performer/Audience/Mirror, 1977
Single channel videotape of performance at
Video Free America, San Francisco, 1978
22:52 minutes, black and white, sound
Distributed by Electronic Arts Intermix, New York
Collection Serralves Foundation, Museum of
Contemporary Art, Porto, Portugal
See cat. no. 65

Video Projection Outside Home, 1978
Videotape documentation of temporary in-
stallation in Santa Barbara, California, 1996
50 seconds, color, sound
Collection Dan Graham, New York. Courtesy
Marian Goodman Gallery, New York, USA
See cat no. 68

Two Adjacent Pavilions, 1978-82
Videotape documentation, 2:15 minutes, color,
sound
Collection Dan Graham, New York, USA
See cat. no. 81

Dan Graham and Glenn Branca
Musical Performance and Stage-Set Utilizing
Two-Way Mirror and Time-Delay, 1983
Single channel videotape of performance at
Kunsthalle Bern, March 1983
45:45 minutes, black and white, stereo sound
Designer: Dan Graham. Camera: Darcy Lange
and Judith Barry. Music: Glenn Branca.
Musicians: Alex Gross, Margaret De Wys and
Glenn Branca.
Distributed by Electronics Arts Intermix,
New York
Collection Dan Graham, New York, USA
See cat. no. 82

Two-Way Mirror Triangular Pavilion with
Shoji Screen, 1990
Videotape documentation, 3:00 minutes, color,
sound
Collection Dan Graham, New York. Courtesy
Marian Goodman Gallery, New York, USA
See cat. no. 114

Star of David Pavilion for Schloss Buchberg
Austria, 1991-96
Videotape documentation, 4:12 minutes, color,
sound
Collection Dan Graham, New York. Courtesy
Marian Goodman Gallery, New York, USA
See cat. no. 142

Dan Graham: Two-Way Mirror Cylinder Inside Cube and a Video Salon, 1992
Videotape, 19:34 minutes, color, sound
Director Michael Shamberg. Music: Glenn Branca
Distributed by Dia Center for the Arts, New York
Collection Dan Graham, New York, USA
See cat. no. 116

Heart Pavilion Version II, 1992-93
Videotape documentation, 2:45 minutes, color, sound
Collection Dan Graham, New York. Courtesy Marian Goodman Gallery, New York, USA
See cat. no. 127

Video/Architecture/Performance, 1996
Videotape, 11:45 minutes, color, sound
Directed by Michael Shamberg. Written and narrated by Dan Graham. Director of photography: Moritz Gieselmann. Editors: Christy MacKarrel and Michael Shamberg. Graphics: Jane Nisselson. Produced by Generali Foundation and Sabine Breitwieser, Vienna
Collection Generali Foundation, Vienna, Austria

Two-Way Mirror Triangle with One Curved Side, 1996
Videotape documentation of Artscape Nordland Project, Norway
2:20 minutes, color, sound
Collection Dan Graham, New York. Courtesy Marian Goodman Gallery, New York, USA
See cat. no. 138

Pavilions-Documentations, 1996
Videotape, circa 60 minutes, color, sound
Collection Gallery Shimada, Tokyo, Japan

Anne Daems
Dan Sniffling Flowers (Portrait of Dan Graham), 1997
Color photograph
$13^2/_5$ x $19^2/_3$ in.
34 x 50 cm
Sammlung Hauser & Wirth, St. Gallen, Switzerland

Two Pavilions in Italy, 1999-2000
Videotape, 45 minutes, color, sound
Courtesy Galleria Massimo Minini, Brescia, Italy
See cat. no. 157

Dan Graham and Apolonija Sustersic
Six Sculptures/Pavilions for Pleasure, 2000
Videotape, 21:21 minutes, color, sound
Produced by Galerie Hauser & Wirth, 2000
Camera: Apolonija Sustersic. Editing: Apolonija Sustersic and Dan Graham.
Collection Dan Graham, New York, USA. Courtesy Galerie Hauser & Wirth, Zurich, Switzerland
Segments documenting cat. nos. 120, 156, 159

Photo-graphic Credits

Note: If a photographer for an image is not credited here the photo credit is unknown.

Jon Abbott
18, 20, 23, 28, 31, 32, 35, 48, 91,
108, 109, 129, 187, 213 (top), 230, 277

© Blaise Adilon
267

Ricardo Armas
283

Hans Biezen
167 (bottom)

Jean Brasille/Villa Arson
242

Eric de Bruyn
332

Ken Burris
290

Geoffrey Clements
89 (top)

Erik Cornelius
208

Angela Cumberbirch
180 (top, bottom), 182 (top)

Anne Daems
328

Philippe De Gobert
105, 122, 133, 409

© Documentation Génerale du Centre Georges Pompidou/Musée National d'Art Moderne
166

Volker Döhne
248

Nicole Forsbach
161 (top)

Fred/Pedram
252

Dan Graham
162, 170, 233, 234, 262, 282,
308, 312, 315, 316 (bottom)

Michael Goodman
236, 271

Barbora Gorny
303

Avraham Hay
311

Annick Herbert
173 (top)

Werner Kaligofsky
228, 281

Laura Larson
134, 278 (bottom), 306

Nicholas Logsdail
67

Attilio Maranzano
219 (top)

Adelaide de Menil
89 (bottom)

Philippe Migeat/© Centre Georges Pompidou
201 (top)

M. Kathryn Mish (diagrams)
147, 148, 149, 150, 151, 152, 153, 155, 156,
157, 159, 161, 162, 164, 165, 169, 170

Ahikide Musakami
255

© Museum Moderner Kunst Stiftung Ludwig Wien
284

Stanley Niehoff
195 (bottom)

Julian Pozzi
112

Ken Regan
367

Anne Rorimer
213 (bottom)

Franz Schachinger
291

Katrin Schilling
263

Lothar Schnepf
235

Harry Shunk
55

Leni Sinclair, www.musiclegends.net
365

Studio Blu
221, 249

Jean-Luc Terradillos
215

Rudolf Wakonigg
222

Peter White
278 (top), 280

Steven White
241 (top), 256, 266 (bottom)

Ellen Page Wilson/Courtesy of PaceWildenstein
© Donald Judd Art © Donald Judd Estate/SPA
339